PLANT DISCOVERIES

A FIREFLY BOOK

Published by Firefly Books Ltd. in 2003

First published by Scriptum Editions in 2003
565 Fulham Road, London, SW6 1ES
in association with the Natural History Museum, London.

Created by Co & Bear Productions (UK) Ltd.

First printing

Publisher Cataloging-in-Publication Data
(Library of Congress standards)

Knapp, Sandy.
 Plant discoveries : a botanist's voyage through plant exploration / Sandy Knapp._1st ed.
[336] p. : ill. (chiefly col.) ; cm.
Includes bibliographical references and index.
Summary: Plant anatomy, botany, and their history and discovery.
Includes botanical drawings from the collections of the Natural History Museum of
London, England.
ISBN 1-55297-810-9
1. Plants _ History. 2. Botany – Popular works. 3. Natural History Museum (London). I. Title.
580/ .022 21 QK50.K63 2003

National Library of Canada Cataloguing in Publication

Knapp, Sandy
Plant discoveries : a botanist's voyage through plant exploration / Sandy Knapp. – 1st North
American ed.
Includes bibliographical references and index.
ISBN 1-55297-810-9
1. Plants. 2. Botany. I. Title.
QK50.K563 2003 581 C2003-901984-5

Published in the United States in 2003 by
Firefly Books (U.S.) Inc.
P.O. Box 1338, Ellicott Station
Buffalo, New York 14205

Published in Canada in 2003 by
Firefly Books Ltd.
3680 Victoria Park Avenue
Toronto, Ontario, M2H 3K1

Publishers Beatrice Vincenzini & Francesco Venturi
Executive Director David Shannon
Art Director Pritty Ramjee
Botanical Art Librarian Judith Magee
Editor Nikky Twyman
Publishing Assistant Ruth Deary

Printed and bound in Italy, at Officine Grafiche DeAgostini.
Color Separation by Bright Arts Graphics, Singapore.

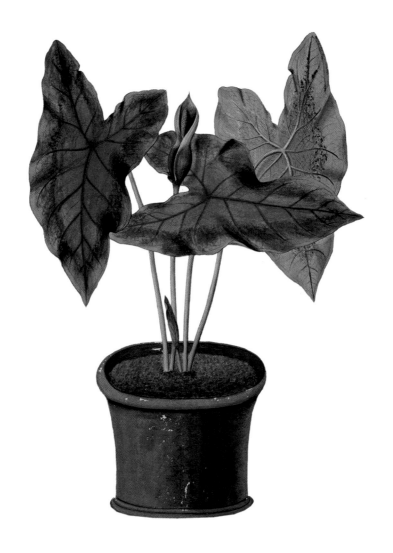

SANDRA KNAPP

PLANT DISCOVERIES

A BOTANIST'S VOYAGE THROUGH PLANT EXPLORATION

FIREFLY BOOKS

Ipomoea aquatica, Chinese Water Spinach, Anon., Reeves Collection, c. 1820s

PREFACE

Peter H. Raven and Patricia D. Raven

MISSOURI BOTANICAL GARDEN, ST LOUIS, MISSOURI, USA

For as long as humans have existed on this earth, flowers – shining like glimmering stars in forests, grasslands and wetlands – have attracted people, arousing their curiosity and imagination. Artistic representations of flowers are among our most ancient images, and for centuries we have studied and depicted their beautiful features, fascinated by their mystique, impressed by their symbolism and passionate about their beauty. To cultivate flowers, to enjoy their fragrances, forms, exotic foliage, beauty and grace at close range, came naturally, and horticulture (the cultivation of ornamental plants) has therefore become one of the most important agricultural branches and a major factor in global trade.

In *Potted Histories*, Dr Sandra Knapp draws on the rich archives of the Natural History Museum to illustrate the qualities of twenty groups of cultivated plants that have come to our gardens and greenhouses from the four corners of the earth. Most of the paintings and illustrations have not been published before, and provide a rich and beautiful record of works by some of the finest artists to have illustrated plants and, in doing so, deepened our understanding and appreciation of them through the centuries. In the accompanying text, she weaves scientific, historic, cultural and artistic threads into a rich fabric of plant lore that will deepen our appreciation and enjoyment even of the most familiar garden residents. Nuggets of modern information and fascinating scientific interpretations supplement the messages of the paintings themselves, often in unexpected and delightful ways. Adding the excitement of the hunt, the global search for new and unique plants, gives plant exploration and collection a new reality.

Modern plant breeding, involving selection and hybridization, has been carried out over the past 200 years, but over the course of millennia people have selected individual plants with superior characteristics for cultivation. This volume tells riveting (yet often poorly known) tales of the ways the improved varieties that we enjoy today have been produced as a result of these processes and by developing best practices of cultivation for individual kinds of plants. The genetic modification of our favourite garden plants proceeds rapidly, and each year many new varieties are introduced. The illustrations depicting garden flowers, therefore, are often valuable records of the state of breeding and improvement of the individual plants at a given date in the past.

Today's burgeoning human population, a widespread desire for increased consumption of what the world produces and the intensive use of often inappropriate technologies are all threatening the continued existence of many species of flowering plants, although maybe a third of the estimated 300,000 validly described species are already in cultivation in botanical gardens or elsewhere. Another 50,000–100,000 species may await discovery, and it is vital that exploration continues, with a concentration on the world's least-known areas, so they may be known and preserved before disappearing from nature entirely. The Andes and Amazon, moist forests of Southeast Asia, New Guinea and many other areas house large numbers of species that we have merely to discover, describe and illustrate. Up to two-thirds (200,000) of all species of plants, animals, fungi and microorganisms could vanish before the end of the century unless we intervene effectively…and soon.

It is fitting that the Natural History Museum should be the resource for the stunning images in this volume. For over two centuries, it has provided valuable knowledge about these plants and many other organisms, and will continue to do so in the future.

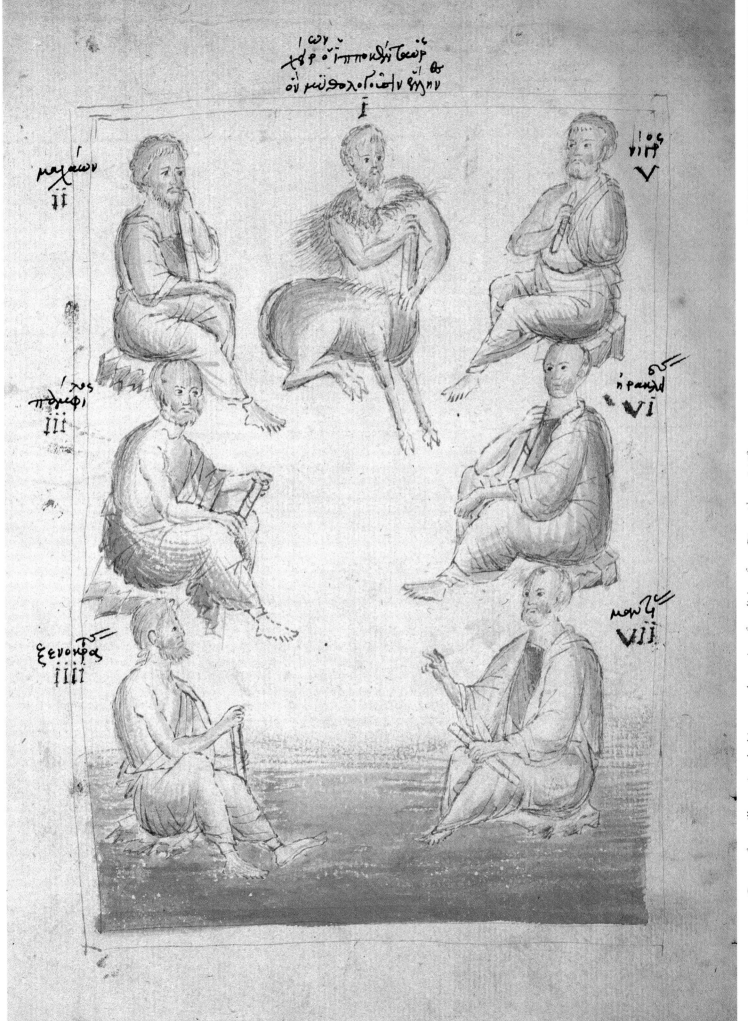

Group of men illustrating the history and practice of medicine, from *Dioscorides*, c. 1458

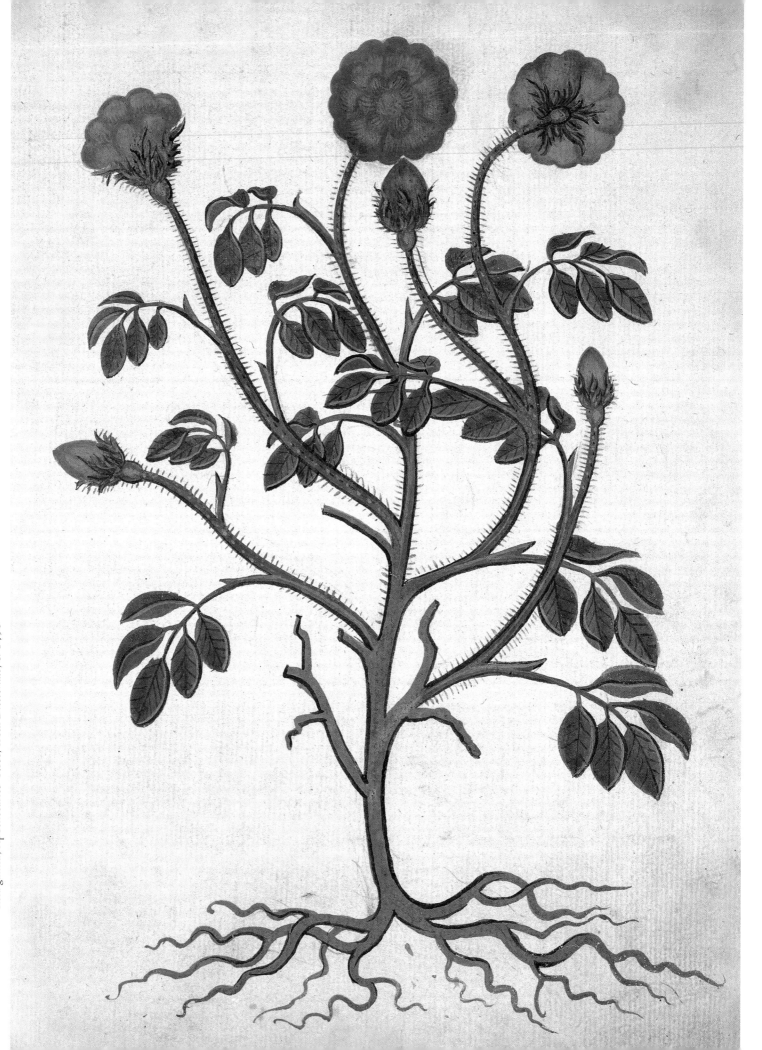

Rosa gallica, Apothecaries' Rose, from *Dioscorides*, c. 1458

FOREWORD

Sandra Knapp

The seed for this book was planted in my mind a decade ago, when I first saw the painting (on vellum) of *Magnolia grandiflora* by Georg Dionysius Ehret. I had just come to London from Mississippi, where such trees line the entrance drives to the plantations of the Old South – so I was intimately familiar with the real thing – but the painting had a glow and a beauty that literally took my breath away. The occasion was a breakfast given for potential donors to the Natural History Museum, at which some of the treasures of the Museum's collections were put out on display. We have so many treasures in the Museum, and space in the galleries is limited, so it is nice to share them with our friends. Being new to the Museum then, I had no idea as to the extent of the botanical art collections held by the institution – the scale and scope of this was a real surprise. So, I thought to myself, we have many more friends than those who walk through the Museum's doors to special days or exhibitions. How can we share some of our treasures with more people?

However, being a scientist, I also wanted to show the connection between this visual art I so appreciated and the science I practise – a tenuous connection, one might say. As art, botanical art is special: it began as a way of depicting things that were too difficult to describe in words; it was photography before cameras.

Today when I go in the field collecting plants, I take my camera with me to record what I see, especially close-up details of flowers and fruits. The images I record allow me to describe the plant fully when I get back, and if it is new to science these photographs are especially important. When Joseph Banks set out aboard Captain Cook's ship the *Endeavour* to explore the riches of unknown worlds, he didn't have a camera – he took Sydney Parkinson along to record what they saw. For me, botanical art has an unbreakable link with exploration, not just exploration of places unknown, but of morphology: what plants look like in all their amazing detail and variety.

In this book, I have tried to explore this link by choosing a few of the many paths that lead from a single plant, and following them – telling some of the stories that plants and their discovery have generated. This means that there are many stories I have left untold, and many more to be discovered or unearthed. I have told only a few, but in their telling I have unveiled many things myself. These things are surely known to others, but personal discovery is always exciting. I am a specialist in the nightshade family – Solanaceae – but only one appears here!

This book will not teach the reader how to identify plants, nor all the ins and outs of the history of botany, nor will it serve as a complete treatise on botanical art and flower painting. It is a voyage through the history of my science – taxonomy – using plant paintings made over the centuries as the vehicle. These images are the tip of the iceberg that are the art collections of the Natural History Museum. We have selected plants here for which we had a number of images and, for those selected, paintings that show the diversity of the collection itself. It is an eclectic set of both ideas and images, and is not intended to be the last word.

The entrance to the Natural History Museum in London, with its two towers and arched portal, is like that of a cathedral – imposing and grand. The cathedral parallels do not end there, either, for visitors walking through these arched portals enter a vast, cathedral-like space – the central hall, or Index Museum. Alfred Waterhouse's intricate decorations in the terracotta facings of the building, inside and out, coupled with his sense of the spectacular in architectural design, made this building, purpose-built as a natural history museum in the late nineteenth century, an embodiment of the vastness and wonderfulness of nature. But the Museum is much more than its lovely buildings, or its fascinating exhibits: behind the wonderful objects, and is one of the finest natural history collections in existence. However, collections are much more than just objects held in cupboards: to be truly relevant, they must have people working with them, constantly improving understanding. The Museum is a centre for scientific research in taxonomy and systematics – the documentation, description and study of the origins of the diversity of life on our planet – and the science of the Natural History Museum contributes not only to the mere understanding of the identities of the organisms with which we share our earth, but how they are all related and how they live (or have lived) their lives. In the Museum, studies of the past, present and future are all linked to today's changing world. The enormous

INTRODUCTION

Sandra Knapp & Judith Magee

façade are kept the collections, held in trust for the nation and for generations of scientists studying the diversity of the earth.

Sir Hans Sloane, a distinguished London physician, amassed the nucleus of the collections now held in the Museum in the late seventeenth and early eighteenth centuries. In 1753, he bequeathed his private collection to the nation, stipulating a national museum be created to house it – and this was the birth of the British Museum. His extensive natural history collections became the 'Natural History Department', the forerunner of today's Natural History Museum, now an independent institution, which has grown over the centuries and houses around 70 million specimens of animals, plants, fossils and mineralogical

collections of scientific specimens and the concomitantly collected bibliographic resources that underpin them are held by the Museum in order to maintain, develop and assist in this understanding of the earth upon which we all live.

The collections of fossils, herbarium specimens and pinned insects are well-known to many. They are sometimes on display in the public galleries, but unknown to many is that nearly half a million works of art are conserved within these collections. These art works, painted on paper or vellum, are only seen rarely in special exhibitions, and are curated and conserved by the library staff of the Museum. The collection is made up of original drawings, watercolour paintings and prints dating from the fifteenth century

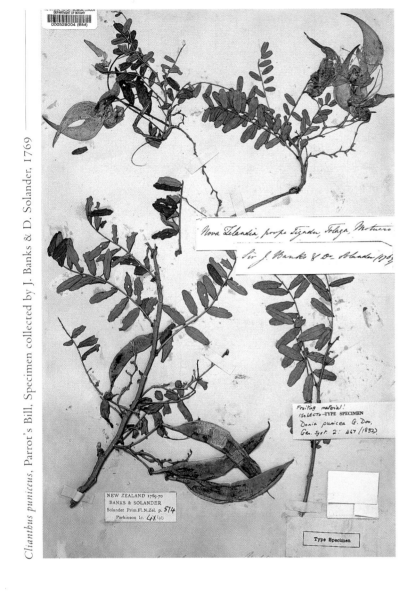

Clianthus puniceus, Parrot's Bill, Specimen collected by J. Banks & D. Solander, 1769

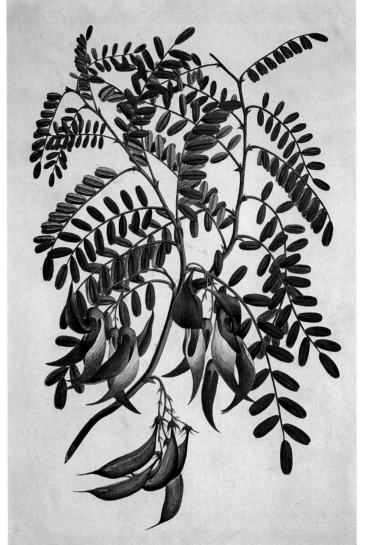

Clianthus puniceus, Parrot's Bill, Anon., 1775

through to the present day, and includes one of the finest and most extensive collections of botanical illustrations in the world.

The foundation of this collection is the library of Sir Joseph Banks, President of the Royal Society for forty-one years. The library came to the British Museum (of which the Natural History Museum was then part) via Robert Brown, Banks' librarian and curator (later Keeper of the Museum's Botanical Department), in 1827. This library, along with Banks' natural history collections (also held in the Natural History Museum) was a product of the explosion of interest in the natural world that occurred in the seventeenth and eighteenth centuries. At that time, public interest in natural history was stimulated by the tales, artefacts, plants, animals and minerals brought back by sailors, traders, naturalists and collectors from trade and exploration voyages to the far-flung corners of the world. The immense number of new plants and animals that were observed by explorers and naturalists travelling to distant lands was far in excess of those that they managed to take home. This meant that throughout this period images were

often the only means of learning and exchanging information about the natural world outside Europe. Specimens, if they were collected, were often decayed or destroyed, and also looked quite different from the live objects seen in the field. Natural history art, particularly botanical illustration, has played an essential role for scientists, who in the past may have had nothing but a dried specimen to help in identification and reconstruction of the whole organism. This role for natural history art remains important for scientists today.

The purpose of botanical illustration is to further the understanding of the science, to provide the botanist, physician and gardener with an aid in identification. The beauty expressed in many of the drawings has always been secondary to the function of capturing the essence or character of the plant itself and thereby developing knowledge of the plant as a whole. In the identification of a plant, a full text description is essential (it is also required for new species by the naming *Code* of botany), and when accompanied by an accurate illustration the information provided is greatly enhanced. George Edwards, an eighteenth-century naturalist-artist working in London, stated that 'Art and nature, like two sisters, should always walk hand in hand, that so they may reciprocally aid and assist each other' (Edwards, G. 1743. *A Natural History of Uncommon Birds* part 1, xiv–xv).

A detailed and accurately coloured image is not only an aid to identification, but in the past has often been accepted as a substitute for, and of equal worth to, the specimen of the plant itself. When a new plant is named, a single type specimen must be designated so that the name is linked to an object, ensuring a permanent reference point and enabling the name to be grounded in reality. But the 'type method' is really only a recent invention, as the stipulation that each new name must have a type specimen only came into the botanical rules of nomenclature in the early twentieth century. Before that, botanists sometimes used several elements, including works of art, as the concrete evidence

Mandragora officinarum, Mandrake, from Dioscorides, c. 1458

upon which they based descriptions of new plants. Thus, when no specimens exist that can be unequivocally linked to the original description of a species, an image accompanying that description can become what is known as the type, the 'specimen' forever linked to that name.

The portrayal of plants has existed from the earliest civilizations, often as decorative art adorning pottery, painted on walls or as stone relief. However, it was with the ancient Greeks that the first illustrations were made to accompany the cataloguing of plants with economic and healing properties: the first herbals. The oldest surviving illustrated botanical work is *De Materia Medica* by Dioscorides, with illustrations by Krateuas, both of whom were physicians in first-century Greece. The earliest copy of their work dates from the sixth century and is known today as the *Codex Vindobonensis*, and the 400 rather stiff and unnatural illustrations contained in the *Codex* were copied and recopied by hand to illustrate herbals in Europe over the centuries. It was in the second half of the fifteenth century that artists of the Renaissance, influenced by humanist studies, began to portray nature in more realistic detail. Leonardo da Vinci was one such artist who was inspired by the natural world, and he wrote in his *Codex Atlanticus* that he had produced 'many flowers portrayed from nature' and depicted plants in the various stages of flowering. His detailed drawings of the architecture of trees show a deep knowledge of plant structure, and anticipate by several centuries the landmark twentieth-century theories of tree architecture and development. In Nuremberg, Albrecht Dürer also portrayed plants in a more naturalistic and realistic style. His painting of turf, 'Das grösse Rasenstuck' (1503), is considered one of the finest examples of naturalism and has been described by the art historian Wilfrid Blunt as the first ecological painting of all time.

While the artists of Renaissance Europe were making great strides in technique and representation of plants, depictions of plants in the herbals (using woodcut reproductions) continued to be rather crude and inelegant. Good reproductions that would

'Asphalatus Acacia altera Mauk', from Dioscorides, c. 1458

provide multiple copies of illustrations were technically very difficult and extremely costly. But the turning point came with the publication in Germany of Otto Brunfels' *Herbarum Vivae Eicones* in 1530 and Leonhard Fuchs' herbal, *De Historia Stirpium Commentarii Insignes* (1542), whose illustrations were produced from direct observations of living plants and were superior to anything that had preceded them, setting the standard for the illustration of herbals for the next 100 years. Both authors influenced succeeding artists, including the interesting and sometimes humorous Crispian van de Passe and, like those from Dioscorides' *Codex*, these illustrations tended to be copied by other artists for use in their own works. They were still produced from woodblocks, a method of printing, introduced in Europe in the late 1300s, that continued to be used for herbals for some time after the invention of engraving of metal plates in the mid-fifteenth century. It was only with the decline of the herbal, about 150 to 200 years after the invention of metal engraving, that woodblocks were abandoned. By then, interest in botany was no longer confined to the study of medicinal and economic plants, but had expanded to the study of the natural world in its own right, not just as an aid to the human species. The scholarly study of useful plants has continued to this day, ethnobotany continuing to be a popular field for study, but by the eighteenth century it was no longer the only motivation behind botanical exploration and plant cultivation.

As Europeans became wealthier, as a result of increased trade through colonial expansion, an interest in plants as exotics and ornamentals developed, and plants that were exciting and pleasing to the senses were increasingly cultivated. Beautiful or peculiar plants became as important as those that served an economic purpose. The Dutch and English progress in navigation, and the resultant increase in exploration in the sixteenth century, laid the cornerstones for a worldwide trading mechanism, and it was via this trading mechanism that exotic and previously unknown plants were introduced into European gardens at a rate never before experienced. This gave rise to the magnificent Dutch and French

Bouquet of chrysanthemums, fritillaries and a tulip, A.M.S. Merian, 1680

flower painting schools, but also provided the material for a major development in the understanding of the science of botany itself. Scientists were presented with a vast number of species that they needed to describe and classify but which had no reference in the standard compendia of the classical authorities. Everything was new. New methods and standards of classification that could be universally applied were essential in order for the frontiers of science to be pushed back and the work to move forward, and botanical illustration became more important than ever. As a result, the art itself developed to meet the demands of the scientists and new ways of seeing and depicting nature evolved.

By the eighteenth century, the exchange of knowledge through illustration became as important as the text as more and more plants were discovered. Mark Catesby, author of the one of the most successful natural history books of the early eighteenth century, argued that 'The illuminating of Natural History is so particularly essential to the perfect understanding of it, that I may aver a clearer idea may be conceived from the Figures of Animals and Plants in their proper colours, than from the most exact Description without them' (Catesby, M. 1730. *The Natural History of Carolinas,* vi–vii).

With the decline of the herbal and a growing interest in plants as things of beauty, a type of publication known as the florilegium came into its own. In the botanical and private gardens of the wealthy, exotic plants were being cultivated and portraits of plant collections were commissioned. Basil Besler produced the *Hortus Eystettensis* in 1613, which consisted of 367 engravings of plants from the garden of the Prince Bishop of Eichstatt in Germany. These included many of the latest Oriental imports and are among the first European images of Asian plants in cultivation. A century later, Johann Simula completed his *Flora Exotica* in 1720, a florilegium of the plants from the garden of the Count Johann of Dernatt, again in northern Germany, and some of these images are reproduced here in this book. Other artists began depicting insects and birds together with the plants they fed upon, displaying a more

rounded view of nature. One of these was Maria Sibylla Merian, who published a magnificent book entitled *Metamorphosis* (1705). This book was a product of her two-year expedition to Surinam and recorded many of the plants and insects she encountered there. Merian was one of the earliest of many distinguished women artists who made important contributions to botanical art. All of these early botanical artists drew from living plants and strove to reproduce the image as real to itself as possible, whether as an engraving or as a painting.

As the number of known plants increased, the classifying and naming of the many new plants became increasingly chaotic, and it was the Swedish botanist and medical doctor Carolus (or Carl) Linnaeus who brought order to this chaos. In 1737, Linnaeus published *Systema Naturae*, which introduced his readers to a plant classification based on the sexual characteristics of the plant – the numbers of flower parts. The repercussions were immediately felt in the botanical art world, resulting in a new style of depicting the plant on the page. Linnaeus' sexual system is simple, ingenious and arithmetical, based on the numbers of male (stamens) and female (pistils) parts of the flower. The number and arrangement of these parts of the 'fructification' of a plant were diagnostic for classification, and by detailing these parts and their structure the illustration served as a means by which the identity of the plant could be determined. So important was this new style of botanical illustration that, for many, the illustration was considered a means in itself for the imparting and exchange of knowledge. Sir Joseph Banks, in his praise of the artist Franz Bauer, stated that 'each figure is intended to answer itself every question a botanist can wish to ask, respecting the structure of the plant it represents;…nothing therefore appears to be wanting' (Banks, J. 1796. *Delineation of exotick plants cultivated in the Royal Botanic Garden at Kew,* ii–iii).

The move to greater order within the science had an enormous impact on botanical art, and the greatest exponent of the Linnaean style of drawing was Georg Dionysius Ehret. Ehret was born in Germany, but eventually settled in London in the mid-eighteenth

century. He became the leading artist in his field at a time when London itself was the centre for botanical art. The mid-eighteenth to early nineteenth century was the golden period of botanical illustration, and was dominated by Ehret during his lifetime. What made him so influential was his expert botanical knowledge, together with excellent draughtmanship and a wonderful eye for composition, with the placing of the subject on the page. This is revealed not only in his beautifully finished renditions on vellum but also in his sketches, which reveal a deep understanding of morphology and botanical form. A whole school of botanical artists flourished under Ehret's influence, including Peter Brown, Simon Taylor, William King and the young Sydney Parkinson.

The Linnaean style of drawing demanded a more accurate and clinical portrayal of plants, but these artists managed to bring a new form of beauty to their work, broadening the range of materials and media used in painting. Many worked on vellum and used an array of washes, watercolour and body colour (gouache), and applied gum arabic to give greater richness and depth to the piece. New styles and techniques emerged and were adapted throughout Europe. One such technique was a favourite of the Dietzsch family of Nuremberg, who portrayed their plant subjects in opaque colours on a black or dark-brown background. The Dutch schools continued to produce flower painters, but there were also some who became more botanically orientated, including M.J. Barbiers, Vincent and Jan Van der Vinne, D.J.H. Joosten and Gerard van Spaendonck. Spaendonck travelled to Paris in about 1770 to work for King Louis XV at the Jardin du Roi, in Versailles. He became the king's miniaturist, and in later life taught the most famous of all flower painters, Belgium-born Pierre-Joseph Redouté.

Germany, in particular Nuremberg, was second only to London in the wealth of botanical artists producing very high-quality illustrations in the mid-eighteenth century. Many Germans travelled to England, where some of them settled, while others returned to their home country after several years. Among

Erysimum cheiri, Wallflower, from *Herbarum Vivae Eicones*, H. Weiditz, 1530

Methodus plantarum sexualis in sistemate naturae descripta, The sexual system of Linnaeus, G.D. Ehret, 1736

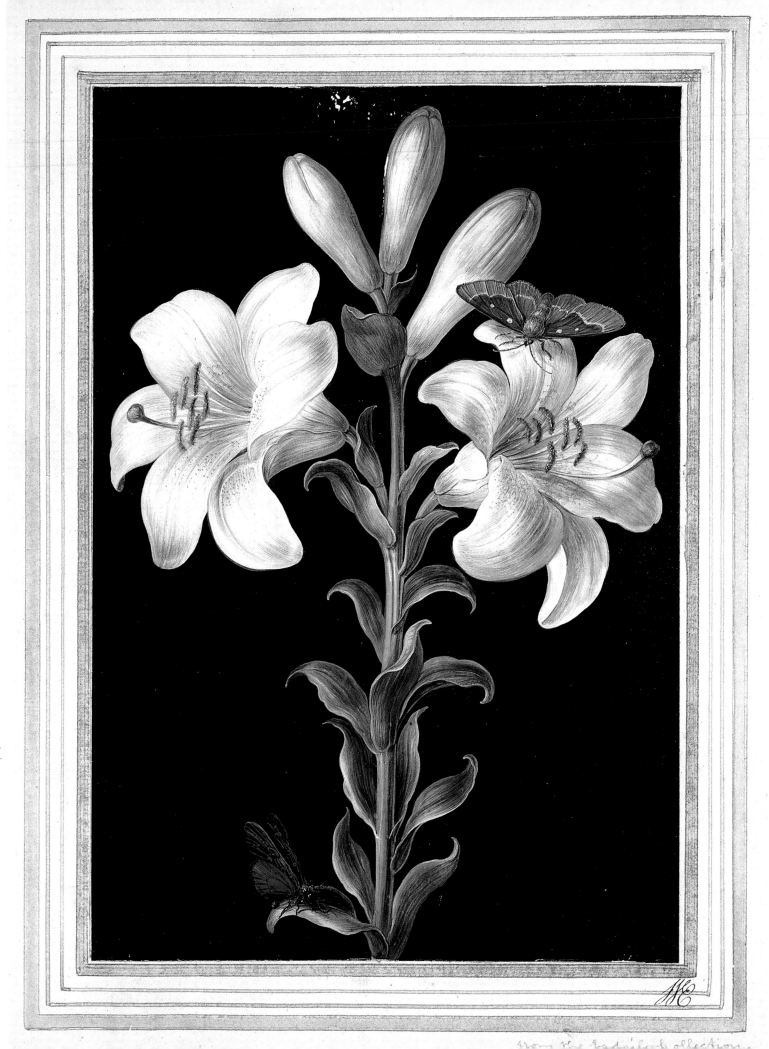

Lilium candidum, Madonna Lily, J.C. Dietzsch, c. 1750

these artists of German extraction were Gertrude Metz and Johann Miller, along with his two sons, John and James. The Miller brothers were part of a group of artists that included Frederick Polydore Nodder and John Cleavley, all of whom worked on the completion of Sydney Parkinson's drawings brought back by Sir Joseph Banks from his travels on HMS *Endeavour* and Captain Cook's first great voyage around the world.

By the mid-eighteenth century the gardens of Europe were bursting with plants from around the world. Owners of these gardens were often keen to retain an image of their favourite plants when in perfect bloom. John Fothergill, the famous Quaker physician, was one of many who commissioned artists to capture on paper the beauty of plants from his garden or greenhouse. In his lifetime, he owned the largest private botanical garden in the country, at Upton in Essex: 'in order that science might not suffer a loss, when a plant he had cultivated should die, he liberally paid the best artist the country afforded to draw the new ones as they came to perfection, and so numerous were they at last, that he found it necessary to employ more artists than one' (Banks mss.).

It was not only explorers and botanists and wealthy garden owners who required artists to paint the plants discovered, but also nurserymen, who would commission artists to draw the plants they sold. Many of the Dutch paintings of tulips from the seventeenth century are examples of advertisements for the sale of bulbs. By the late eighteenth century, engraving of artists' work was commonplace and this led to the birth of magazines and serial publications, each of which exhibited hand-coloured plates. The *Botanical Magazine* (also known as *Curtis's Botanical Magazine*), founded in 1787 by William Curtis of London, provided a means for the less affluent household to possess beautiful pictures of plants in cultivation that had previously only been affordable to the wealthy. The *Botanical Magazine* has continued with only a few interruptions to this day, producing portraits of plants recently brought into cultivation from all around the world. A whole series of artists over many years have made significant contributions to

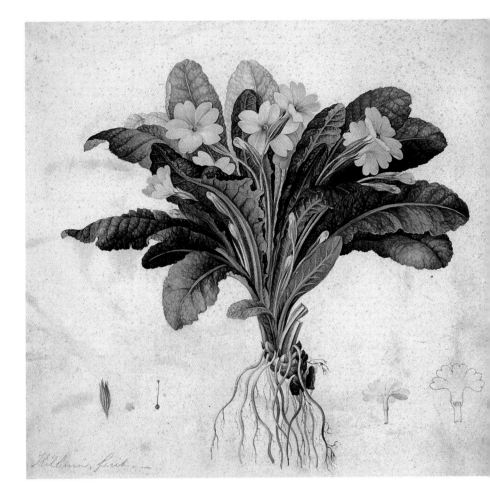

these journals, including William Kilburn, Walter Hood Fitch and Lillian Snelling.

The golden years of the great botanical artists can be said to have culminated with the Austrian-born brothers Franz and Ferdinand Bauer, who raised the art to near perfection – truly capturing the essence of the organism – and their work is some of the most scientifically accurate and artistically sophisticated of all botanical illustration. They both possessed superb artistic technique and exhibited the most delicate and subtle sense of touch; indeed, the detailed microscopic work by Franz Bauer is unsurpassed, done in collaboration with a growing community of botanists at what was to become the Royal Botanic Gardens at Kew. His paintings are not only botanically wonderful, but also

Primula vulgaris, Common Primrose, W. Kilburn, c. 1770

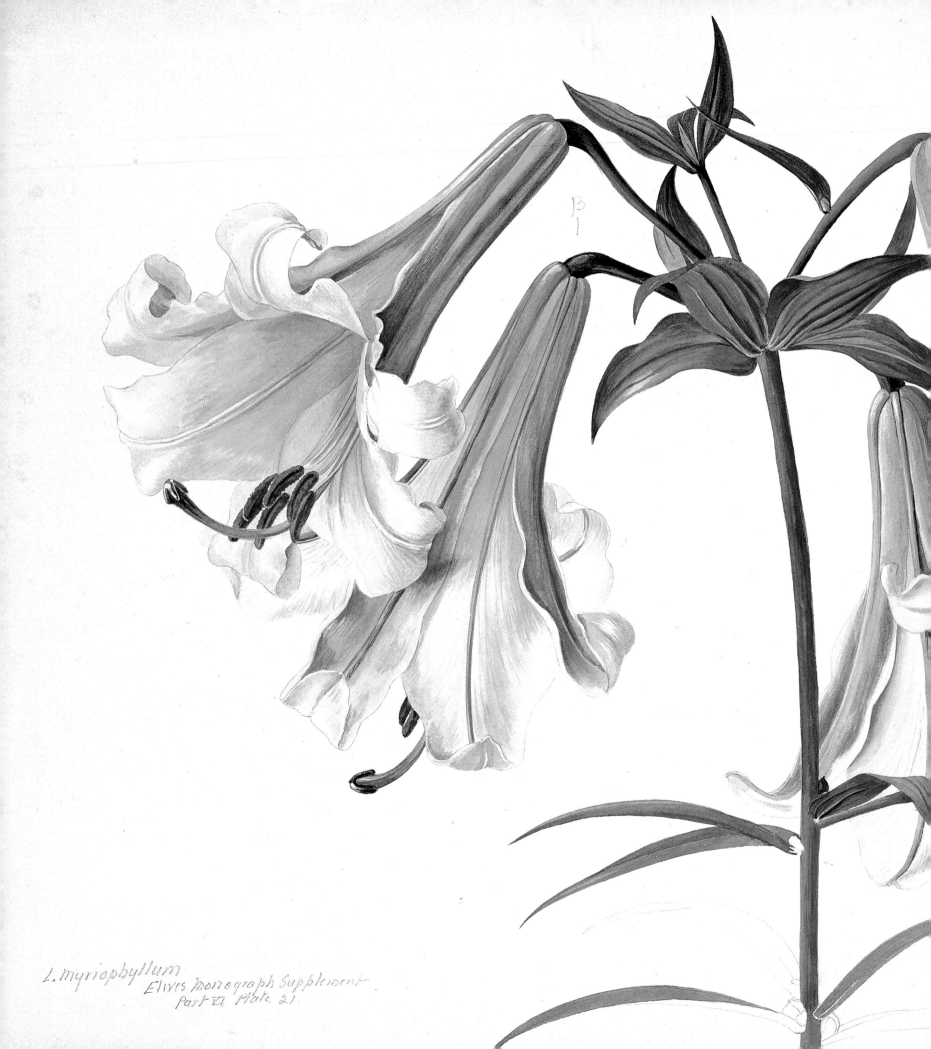

L. myriophyllum
Elwes Monograph Supplement
Part VI Plate 21.

give a snapshot of what was being cultivated at the time. Ferdinand's renditions of Australian plants are some of the finest – equal to (or to some minds surpassing) the work of the revered and lauded flower painter, Redouté. His paintings of flower details, including depictions of pollen grains – done in collaboration with Robert Brown, the botanist aboard the *Investigator* and later Keeper of the Botanical Department at the British Museum – are the first to include such fine anatomical detail. Intricate detail like this is now standard, but was then only just being deemed vital to plant classification. Bauer's accurate images certainly must have helped to convince the botanical community that Brown's emphasis on pollen had merit.

Ferdinand Bauer's talent was not confined only to botanical art, for he was an excellent zoological artist, reproducing the first accurate portrayals of Australian wildlife from his travels at the beginning of the nineteenth century. The numerical colour-coding system used by Ferdinand (invented perhaps jointly by the Bauer brothers back in Germany), where each of 140 colours was represented by a number, allowed him to combine quick and accurate sketches in the field with almost photographic accuracy in colour reproduction once the work came to be finished (sometimes many years later).

While Sydney Parkinson and Ferdinand Bauer travelled around the world in search of plants to illustrate, others who were not so artistically gifted, but who through their work were stationed abroad, commissioned local artists to reproduce images of their local flora. This was particularly so in India and China, and by the late eighteenth century the British East India Company had established a powerful base in several states of India and in Canton, China. In India, the Company stations created botanical gardens at Calcutta, Madras and Saharunpore in the northwest provinces, primarily for cultivating plants of medicinal value. At each of these gardens a Company surgeon/botanist was appointed as director, many of whom recognised the need to record the plants growing in their gardens and employed local artists trained

Lilium sulfureum, Sulphur Lily, L. Snelling, 1936

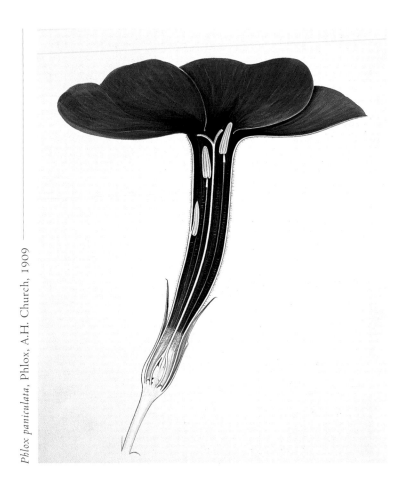

Phlox paniculata, Phlox, A.H. Church, 1909

Paintings commissioned by Reeves have found their way into a great many collections, most notably that of the Museum and the Royal Horticultural Society in London.

Artists continued to produce botanical illustrations throughout the nineteenth and twentieth centuries, but the Victorian period witnessed a shift towards the more decorative arts and, with the development of photography, illustration became less significant as the primary method of portraying plants for scientific purposes. The number of artists also decreased, and only a few key figures stand out as displaying an understanding of the science and the art as one. John Lindley and Walter Hood Fitch are two of the best known of this period: they both display a boldness in their work, but are rather heavy-handed in comparison to some of the earlier artists, and Lindley (who was first and foremost a botanist) never truly comes across as an excellent draughtsman.

Towards the end of the nineteenth century, Arthur Harry Church, a botanist working at Oxford University, produced a series of drawings for his book *Types of Floral Mechanism* (1907). These drawings are delineated in brilliant colours that contrast wonderfully with his incredibly accurate pen-and-ink diagrams of structural details of plants. Church was inspired by Ferdinand Bauer's use of paint, and was truly revolutionary in his portrayal of the anatomy of plants. The images are vibrant and exciting, and his obsessional attention to detail is daunting. Other early twentieth-century artists include Lillian Snelling, who was certainly one of the more accomplished artists of her time, and Frank Round, who worked as a schoolmaster and produced a large collection of *Iris* drawings for N.C. Rothschild and W.R. Dykes.

Woven in and amongst the strands of the history of botanical art is the history of exploration, for without exploration and discovery none of these plants would ever have been brought to the artists' doors. Botanical exploration has many faces, from the great state-sponsored voyages of discovery (such as those to Australia undertaken by the *Endeavour* or the *Investigator*), to those

initially in the Mogul school of art (a distinctive and indigenous artistic style from what is now northern India and Pakistan) to draw the collections. Most of these unnamed artists were retrained in the European style of painting, but in many of the images the Mogul influence is distinctly present.

A similar system existed in China: in Canton and Macao, John Reeves (an inspector of teas for the East India Company) was primarily responsible for amassing an enormous collection of Chinese images of local flora and fauna executed by indigenous artists living near Canton in the early nineteenth century. Again, the distinctive style of Chinese art is noticeable in many of the drawings commissioned by Reeves. Some of the paintings shown here even record the common Cantonese names of the plants, making the paintings almost scroll-like in their composition.

underwritten by members of the Royal Horticultural Society in search of garden novelties, to those smaller-scale and more personal voyages undertaken by individual botanists nowadays. Whatever their scale, all these voyages share one thing – the thrill of discovery, not just of new species or new places, but of discovering more about one's own place in the scheme of nature. The more you find out, the more you realize just how little you know. The voyage is endless. Science, like exploration itself, opens new frontiers, whose sheer diversity is sometimes overwhelming.

With the advent of photography, botanical illustrations no longer became necessary for the depiction of the live plant, but botanists describing new species still normally include pen-and-ink drawings with the publication – usually showing details of flower, fruit and leaf morphology. These drawings are the direct descendants of the wonderful artwork of the Bauer brothers, but serve a slightly different purpose.

Nowadays, botanical illustration is becoming more and more popular and increasingly appreciated, not only by those who have had a long-term interest in and appreciation of the subject, but also by a growing number of artists who are turning their hand to the delineation of all aspects of plant life. New techniques are continuously being explored, and a good example of this is the beautiful magnolia by Olga Makrushenko, a contemporary Russian artist who uses modern techniques while simultaneously managing to retain the traditional concepts of botanical illustration.

The illustrations reproduced in *Potted Histories* have all come from the Natural History Museum Botany Library's collection of original artwork, with only a few being hand-coloured engravings. The works span across four centuries – from the early seventeenth century to the late twentieth century – and represent some of the many styles, techniques and media that have been used by botanical artists throughout this period. Some of the illustrations have been reproduced before, in other books about art or botany, but by grouping them together botanically we hope to have shed a different perspective on the connection between art and science.

These varied illustrations, a sample of the collection, demonstrate beautifully how artists across the centuries have managed to fuse their accurate scientific observations with a superb artistry, to create lasting images of the diversity of life on earth.

Hypericum paramitanum, M. Tebbs, 1990

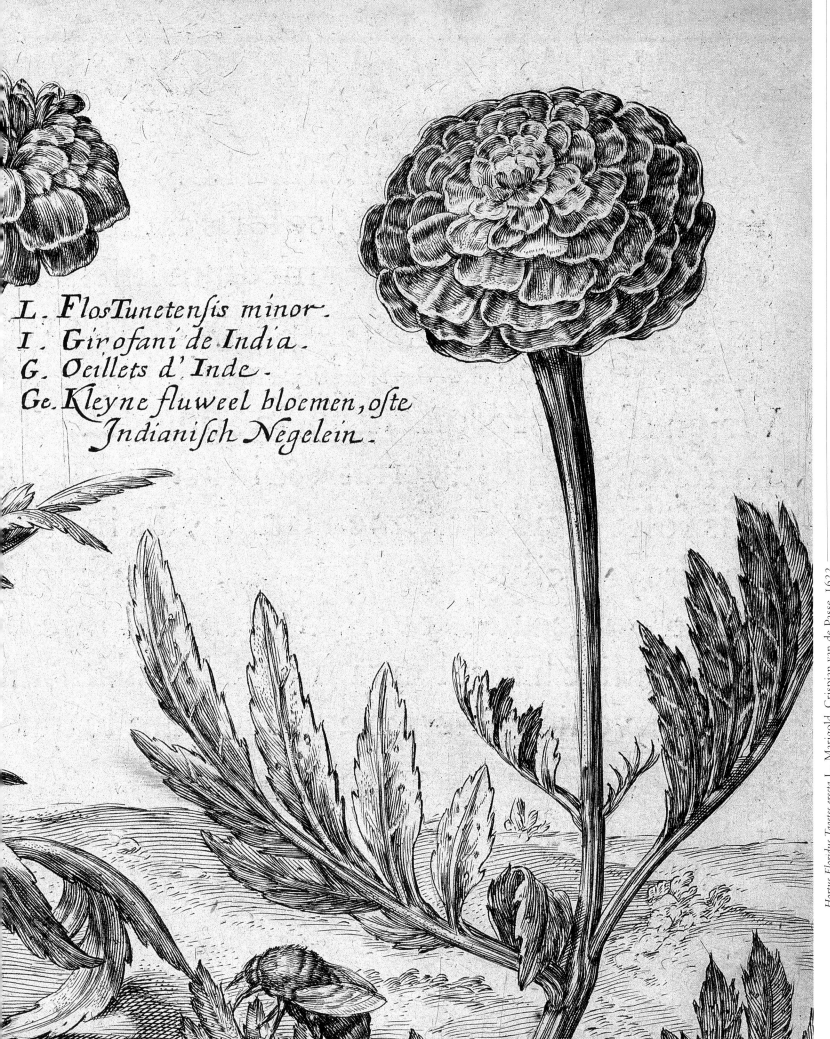

L. *FlosTunetensis minor.*
I. *Girofani de India.*
G. *Oeillets d' Inde.*
Ge. *Kleyne fluweel bloemen, oste Indianisch Negelein.*

Hortus Floridus, Tagetes erecta L., Marigold, Crispian van de Passe, 1622

'Eccentric' is not an adjective one would automatically think of applying to a plant, but it seems just about perfect for the aroids. But what is an aroid? We all know what a lily is, or a rose – but an aroid? Members of the Araceae family are commonly known as aroids, so the term refers to a multiplicity of different plants – from philodendrons to skunk cabbages to arum lilies to taro root. Although quite different in form, all aroids share a common 'floral' structure. An aroid 'flower' is not really a flower at all, but an inflorescence, a group of flowers. Common to all aroids is the spathe and spadix inflorescence – a deceptively simple arrangement consisting of a petal-like leaf (the spathe) at the base of and surrounding a flower-bearing stalk (the spadix). The

recognized – *Arum, Dracontium, Pothos* and *Calla* – as 'Gynandria Polygynia'. Following the earlier French botanist Joseph Pinnon de Tournefort, Linnaeus saw the aroids as having a single-petalled flower. Antoine Laurent de Jussieu, another French botanist, working around thirty years after Linnaeus, first identified the aroid 'flower' as an inflorescence, made up of many male flowers and many females flowers grouped together. In a way, Linnaeus missed a trick when he identified the inflorescence as a flower – his system of classification of the flowering plants depended upon the arrangement of their male and female reproductive parts (sex organs). The fact that plants reproduced sexually and had sex organs was relatively well-known, but the use of this in

ARUMS

I, therefore proclaim the Amorphophallus titanum *(giant krubi) as the official flower of the Bronx, as its tremendous size shall be symbolic of the largest and fastest growing borough of the City of New York. There are many other sweeter-smelling flowers, but none as large and distinctive.*

ISSUED ON THE FLOWERING OF THE TITAN ARUM IN NEW YORK (BRONX PRESIDENT 1939)

spathe looks a bit like an odd petal and is often brightly coloured and functions in attracting pollinators, but it is in fact a modified leaf, held right at the bottom of the inflorescence (spadix). The spadix itself is club-shaped and has on it flowers that are usually too small to be seen easily with the naked eye – a hand lens reveals their delicate, perhaps not beauty, but structure. Looking a bit closer repays the effort, however, for aroid flowers are fantastic in their diversity, and spadices vary incredibly as to how these flowers are arranged.

Carl Linnaeus, when he first used flower sex to classify the known plants of the world in 1753, didn't appreciate the reality of the aroid inflorescence. He classified the four genera he

classification was somewhat controversial. In fact, a contemporary labelled Linnaeus as a 'botanical pornographer', and the sexual system was not thought suitable for use by ladies. His system used the numbers of male and female parts, so all plants with five stamens and one carpel (ovary) were placed together. He clearly differentiated between plants that had hermaphrodite flowers (bearing sex organs of both types) and unisexual flowers (bearing only male or female sex organs). Unisexual flowers were further differentiated into those 'living in the same house', with both types of flower on a single plant, and those 'living in separate houses', where different plants had male and female flowers. Botanists today call the former types of plants monoecious, and

26

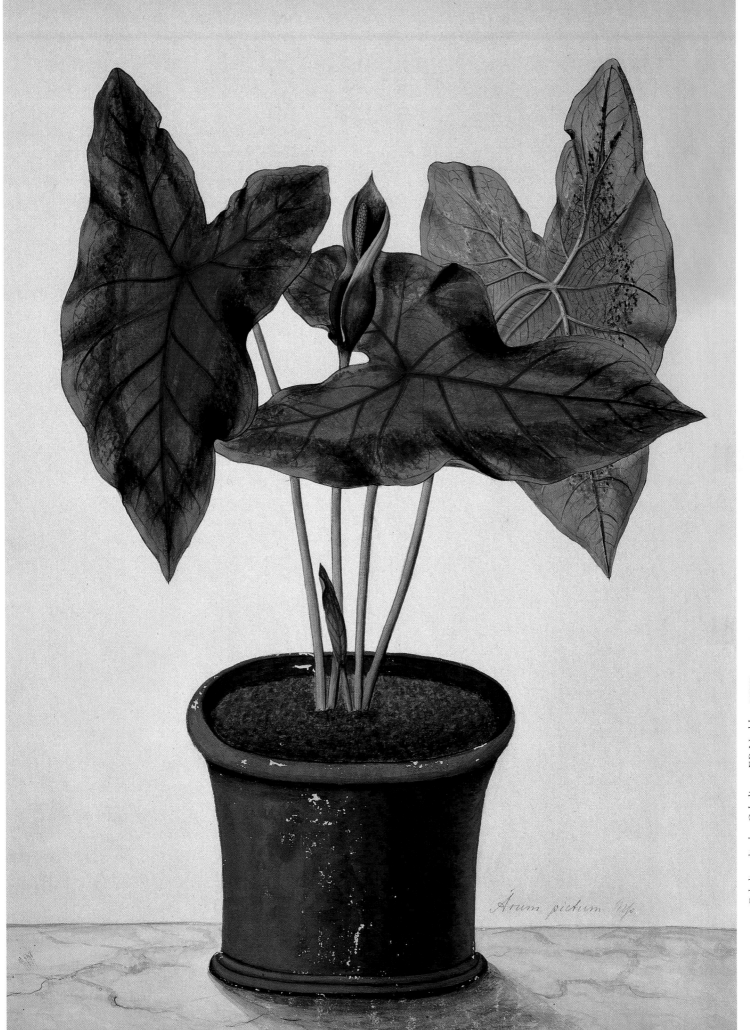

Arum pictum. Uts.

Caladium bicolor, Caladium, F.P. Nodder, 1777

colocasia

ARUM, Maximum Ægyptiacum
quod vulgo Colocasia. C.B.P.

Linn: Sp: Pl. 965.

G.D.Ehret. fecit

the latter, dioecious. Many aroids have bisexual (or hermaphroditic) flowers – producing both pollen and seeds from the same flower. Aroids with bisexual spadices usually have the spadix completely covered with flowers, often in beautiful geometric patterns, such as can be seen on arums. Usually the female parts of these hermaphroditic flowers are receptive first: botanically speaking, the flowers are protogynous, which means that the flowers can only be fertilized by pollen from another plant, as, by the time pollen is shed from the anthers of a particular individual, the female parts are no longer receptive. This encourages cross-pollination and is a way of increasing genetic diversity and experimentation. Spadices of many bisexual flowers often change texture sequentially, first shiny with the resinous surfaces of receptive stigmas, then fluffy-looking and covered with the masses of pollen extruded from the minute anthers. The spathe of these flowers is usually either held away from the spadix or cups it gently, but it does not hide the flowers from view.

It is the monoecious species of aroids, however, that have truly eccentric inflorescences. These spadices usually have the female flowers at the base – several rows of tiny, often flask-shaped ovaries in rings around the bottom of the structure. The male flowers, consisting of just a few anthers, are borne in rings above this. The variations on just how many female and male flowers a spadix has are tremendous, varying from just one or two of each to many thousands. The zones of female and male flowers are often separated by a ring of sterile flowers with no reproductive parts at all, but just rudimentary stunted bits. Unlike the situation with bisexual aroids, where flowers generally cover the surface of the spadix, these unisexual flowers do not cover the entire surface of the spadix, the end portion of the spadix is often sterile and can be modified to be what seems like an infinite variety of strange and wonderful shapes. Some are tiny, and hidden within the enclosing spathe, while others are huge and fungoid, and still others are elongated into fantastic whip-like structures sometimes more than

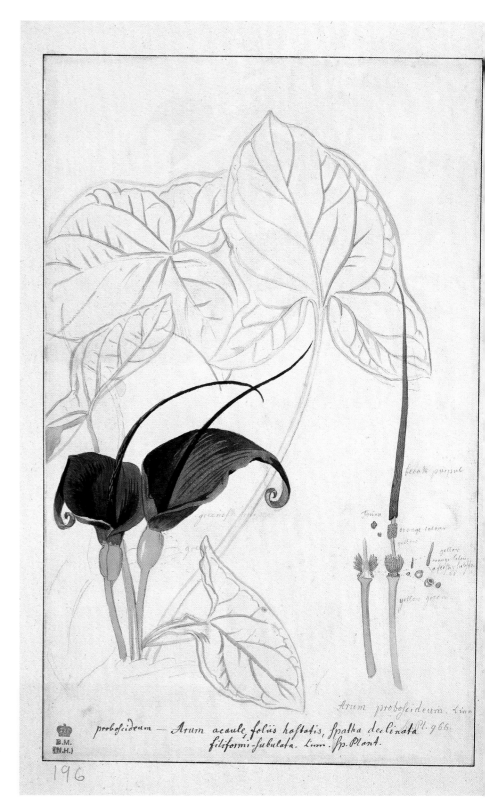

each of these had
2 apices full of farina

The whole
the spatha
all the rest o
the inside of
spoongy n
The petala o
are a fleshy
is also unce
the most pa
fleshy, it fee

most of the Spathas have

Note in Millers last Number is a figure
like this, which he cals Arum caulescens
foliis sagittatis Linn sp. plant 967

The stalks of the leaves of this, are not
spotted or variegated, like that of Millers Figure

B.M.
(N.H.)

155

Arum caule geniculato, fonna fudica
folris, fummis labris deguftantes modes
reddens. Sloan. Cat
The Jumb Come.

fixed to
fters from
ms·
of a loof

emale Flower
spire numb
ut counted for
The Germen is
e 3 berrys.

Flower

The Stem is above 5 feet high
and as bey as on stem. it had 70
round marks on the Stem

Drawn at Marly near Winburn
in Dorset June 1760

Amorphophallus muelleri, Anon., Fleming Collection, c. 1795–1805

1m (3ft) long. These sterile appendages – which botanists call appendices – are absolutely unique among flowering plants and have inspired some of the imaginative and evocative scientific names given to aroids – *Amorphophallus* means 'deformed phallus' and *Anthurium* means 'tail flower', for example. The sexual imagery inspired by the forms of spadices is inescapable, causing titters or horror depending upon your susceptibilities, and is a unifying feature of many of the common names for these plants as well. The most northerly European aroid, *Arum maculatum*, is often called the cuckoopint (from Anglo-Saxon roots, with *cucu* meaning 'lively' and *pintle* being one of many words for a 'penis'). The appendix has functions beyond causing ribald laughter or acute embarrassment to those seeing the flowers and, along with the spathe, has an important role to play in attracting pollinators to these unusual flowers.

The brown and green spathes of many of these aroids are not the sort of things one immediately thinks of when imagining pollinator attractants. It entirely depends on who the pollinators are, of course! The spathes of many unisexual aroids not only occur in odd colours (at least, to human eyes), but also in a bewildering variety of shapes. Some are large and vase-like, cupping the spadix loosely; others have a flattened and rough main portion 'like a pigs' ear'; but many have a constriction just above the flowering zone so a chamber is formed. The entrance to this floral chamber is sometimes tight up against the spadix, while in other species it is protected by a valve-like flap. All this sounds rather counterproductive if what a plant 'wants' is to attract pollinators to the flowers in order that pollen from one plant be carried to another, but in fact the incredible constructions of many aroid flowers are a way of ensuring just that. Some aroids are the arch-deceivers of the flower world, tricking insects into visiting their flowers and acting as pollen vectors, often for no reward at all.

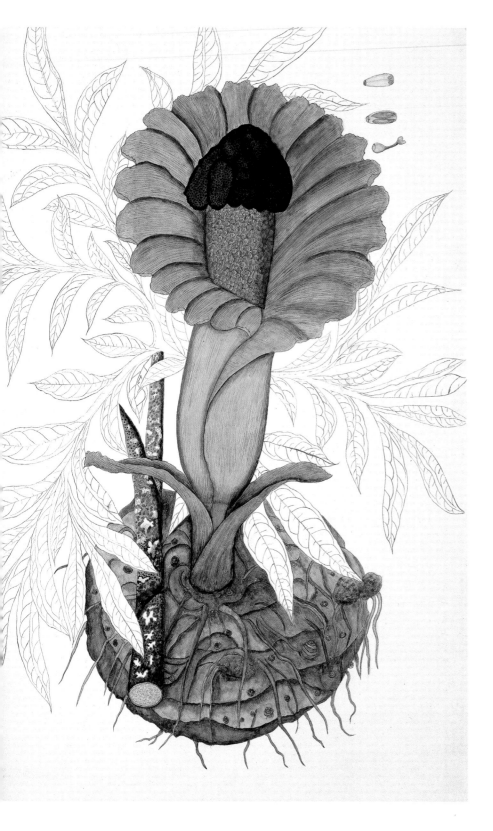

Pollination by insects is usually a symbiotic relationship, with the insect transporting pollen from one plant to the stigmas of another, and the plant providing nectar or excess pollen for nourishment of the pollinator. But sometimes a plant can get away with deceiving an insect into working it for free.

The dead horse arum, *Helicodiceros muscivorus*, occurs only in a few places in the Mediterranean along rocky coastal cliffs where seabirds breed. The flowers are horrific – or amazing, depending on your point of view – and have been described as 'the sort of thing Beelzebub might pluck to make a bouquet for his mother-in-law – a mingling of unwholesome greens, purples and pallid pinks, the livery of putrescence'. What really knocks one out is the smell of these liver-looking things – like a dead horse, basically (hence the common name!) The entire upper surface of the spathe is covered with shaggy hairs and the appendix of the spadix is also densely hairy. The whole thing is huge – nearly 50cm (20in) long – and has been likened by some to 'the hide of an animal, complete with tail and anus'.

The dead horse arum is pollinated by carrion flies that lay their eggs in dead and rotting flesh, where the maggots grow to maturity. The arum blooms at the peak of the seabird breeding season, when it must compete with dead and rotting chicks and discarded, undigested fish for the attention of these insects. The combination of the stench and the appearance of the spathe and appendix must be irresistible! Flies push their way past a zone of downward-pointing hairs at the constriction of the spathe, and find themselves in the floral chamber, slipping down through the as-yet-unopened male flowers to the zone of female flowers at the base. If they are carrying pollen from another dead horse arum, it falls on the female flowers as the flies struggle to escape. While trapped in the floral chamber for two or three days, flies lay their eggs in the chamber, where the maggots will starve once they hatch. When the female flowers end their receptive phase, the male flowers begin to release pollen, and this in turn triggers changes in the chamber structure – the flies can now get out, crawling over

Amorphophallus paeoniifolius, Anon., Fleming Collection, c. 1795–1805

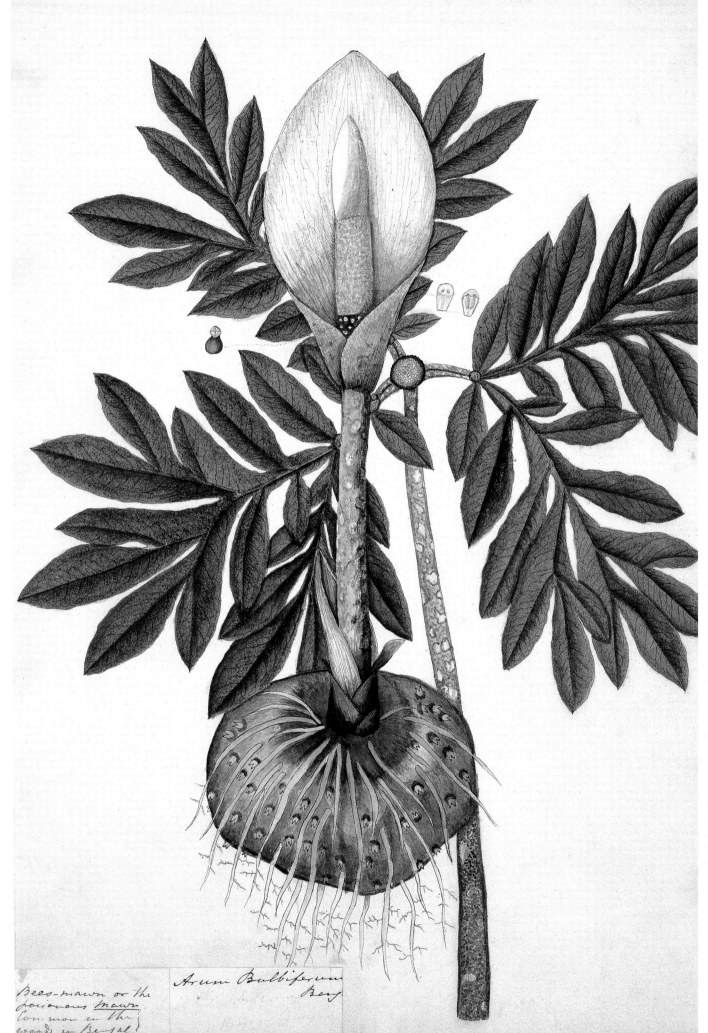

Bees-mawn or the
poisonous mawn
common in the
woods in Bengal

Arum Bulbiferum
Bery

Amorphophallus bulbifer, Anon., Fleming Collection, c. 1795–1805

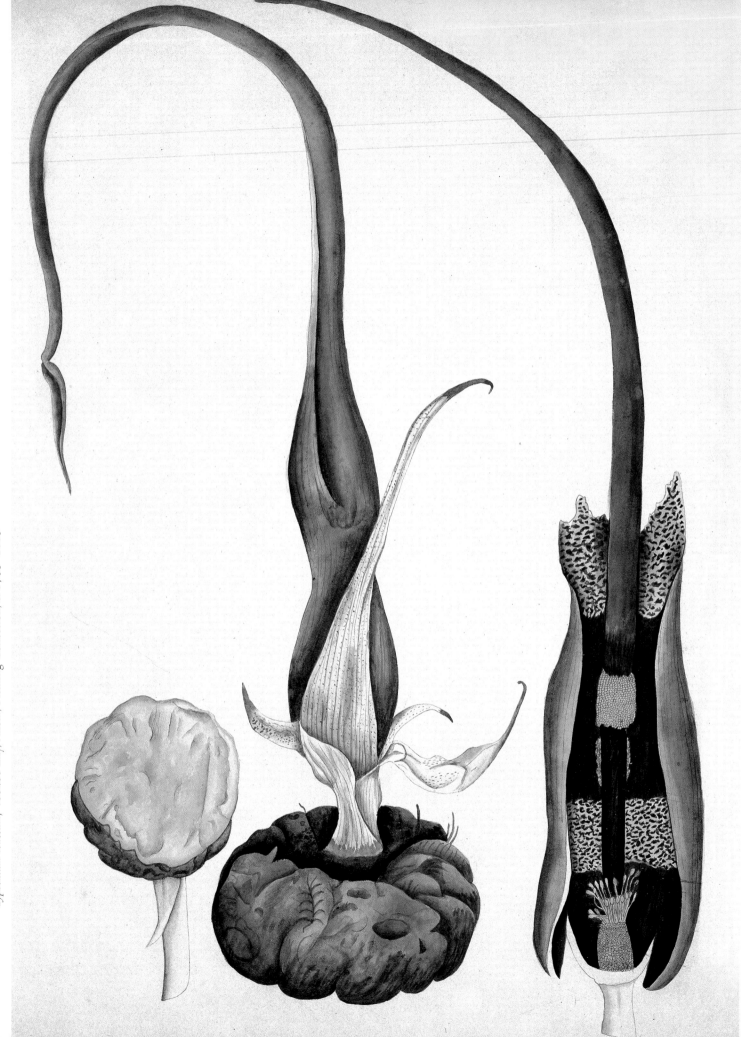

Typhonium venosum, Voodoo Lily, Anon.. Fleming Collection, c. 1795–1805

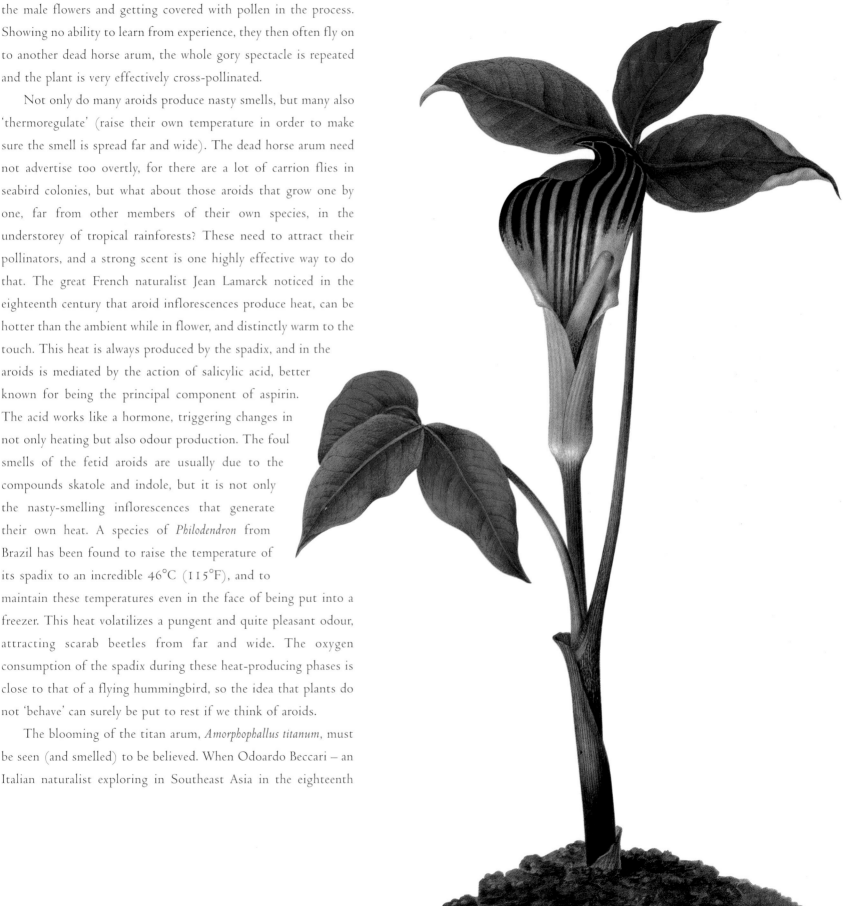

the male flowers and getting covered with pollen in the process. Showing no ability to learn from experience, they then often fly on to another dead horse arum, the whole gory spectacle is repeated and the plant is very effectively cross-pollinated.

Not only do many aroids produce nasty smells, but many also 'thermoregulate' (raise their own temperature in order to make sure the smell is spread far and wide). The dead horse arum need not advertise too overtly, for there are a lot of carrion flies in seabird colonies, but what about those aroids that grow one by one, far from other members of their own species, in the understorey of tropical rainforests? These need to attract their pollinators, and a strong scent is one highly effective way to do that. The great French naturalist Jean Lamarck noticed in the eighteenth century that aroid inflorescences produce heat, can be hotter than the ambient while in flower, and distinctly warm to the touch. This heat is always produced by the spadix, and in the aroids is mediated by the action of salicylic acid, better known for being the principal component of aspirin. The acid works like a hormone, triggering changes in not only heating but also odour production. The foul smells of the fetid aroids are usually due to the compounds skatole and indole, but it is not only the nasty-smelling inflorescences that generate their own heat. A species of *Philodendron* from Brazil has been found to raise the temperature of its spadix to an incredible 46°C (115°F), and to maintain these temperatures even in the face of being put into a freezer. This heat volatilizes a pungent and quite pleasant odour, attracting scarab beetles from far and wide. The oxygen consumption of the spadix during these heat-producing phases is close to that of a flying hummingbird, so the idea that plants do not 'behave' can surely be put to rest if we think of aroids.

The blooming of the titan arum, *Amorphophallus titanum*, must be seen (and smelled) to be believed. When Odoardo Beccari – an Italian naturalist exploring in Southeast Asia in the eighteenth

century – sent back the description of an inflorescence so large that, 'for the purpose of transporting it, it had to be lashed to a long pole, the ends of which were placed on the shoulders of two men', he was greeted with a certain amount of disbelief. Even the botanists were incredulous: Sir Joseph Hooker, then Director of Kew Gardens, only believed the tales when they were confirmed by a second (read 'British') naturalist. Beccari sent back seeds of the titan arum, which grew, and eventually bloomed for the first time in 'captivity', in 1889. Sensation! Not only was the spadix huge – the range is 2–3.5m (6½–11ft) – but the stench of the fleshy, deformed-looking yellow appendix was quite overpowering. Nauseating in the extreme, it is 'perhaps the most powerful and disgusting odor produced by any plant'. The Indonesian common name for the titan arum is *bunga bangkai*, meaning 'corpse flower', which perhaps gives some indication as to the character of the odour. While the plant is in bloom, the scent comes in waves and, close to, makes your eyes water. When a titan arum bloomed at Kew in 1996, chemists analysed the scent and found that it contained dimethyldisulphide and dimethyltrisulphide – sulphur compounds that are also responsible for the smell of rotting eggs. Peaks of smell production coincided with times of female and male flower receptivity over the course of flowering, so probably it has some function in pollination in the wild. *Amorphophallus* bloomings are of more than just botanical interest; they are also media events. When a plant recently bloomed in California, nearly 100,000 people visited the Huntingdon Botanical Gardens in the few weeks before and during flowering. The plant is cultivated in many botanic gardens all over the world, so it is not difficult to find one in bloom somewhere. However, the titan arum is not the largest flower in the world. That honour belongs to *Rafflesia arnoldii* (also discovered by Beccari), a huge dish-shaped parasite from the same Sumatran forests where the titan arum grows. *Amorphophallus* has become much more than a plant – it is a happening.

The titan arum, the dead horse arum and many other aroids are terrestrial, with their roots firmly in the ground. But many members of the Araceae are epiphytes (especially the tropical ones). Epiphytes grow on other plants, using them as support and as a way to get to the light, which in the tropical rainforests is brightest in the canopy, far above the darkness of the forest floor. Most seedling plants begin their lives by growing immediately towards the light, but many epiphytic aroids (being eccentric in the extreme) do things differently!

When the large seeds of some species of the tropical American genus *Monstera* germinate, they produce a long, colourless runner with tiny scale-like leaves along it. This runner, fuelled by the reserves from the seed, grows towards the dark, which in the forest understorey is most likely to be the trunk of a large tree – just the thing if a way up is what you need. When the runner hits a vertical or sloping surface, things change. The seedling exhibits more conventional behaviour, puts out a pair of flattened leaves and roots that grip the tree trunk – now it is seeking the light. On the way up the tree, the plant produces leaves that hug the trunk; flattened against it they look like green shingles. Leaves clamped to the bark like this keeps water loss to a minimum and also probably minimizes damage from debris falling from the canopy (a definite hazard to understorey vegetation). Once the plant reaches the light, things change again: adult leaves are produced – usually large and, in *Monstera*, often with holes or cuts in them. The Swiss cheese plant cultivated as a houseplant is *Monstera deliciosa*, and anyone who has grown one will testify to the fact that younger leaves usually have fewer holes. It gets its scientific name from its edible fruit, which tastes something like a cross between a pineapple and a banana.

The fruits of a few aroids are eaten, especially in the American tropics, but it is the tubers of a few terrestrial species that really make their contribution to human nutrition. Taro root is quite probably the oldest cultivated crop in the world and has been grown in parts of tropical and subtropical Asia for more than 10,000 years. The tubers of *Colocasia esculenta* are quite high in protein and contain appreciable amounts of minerals, vitamin C,

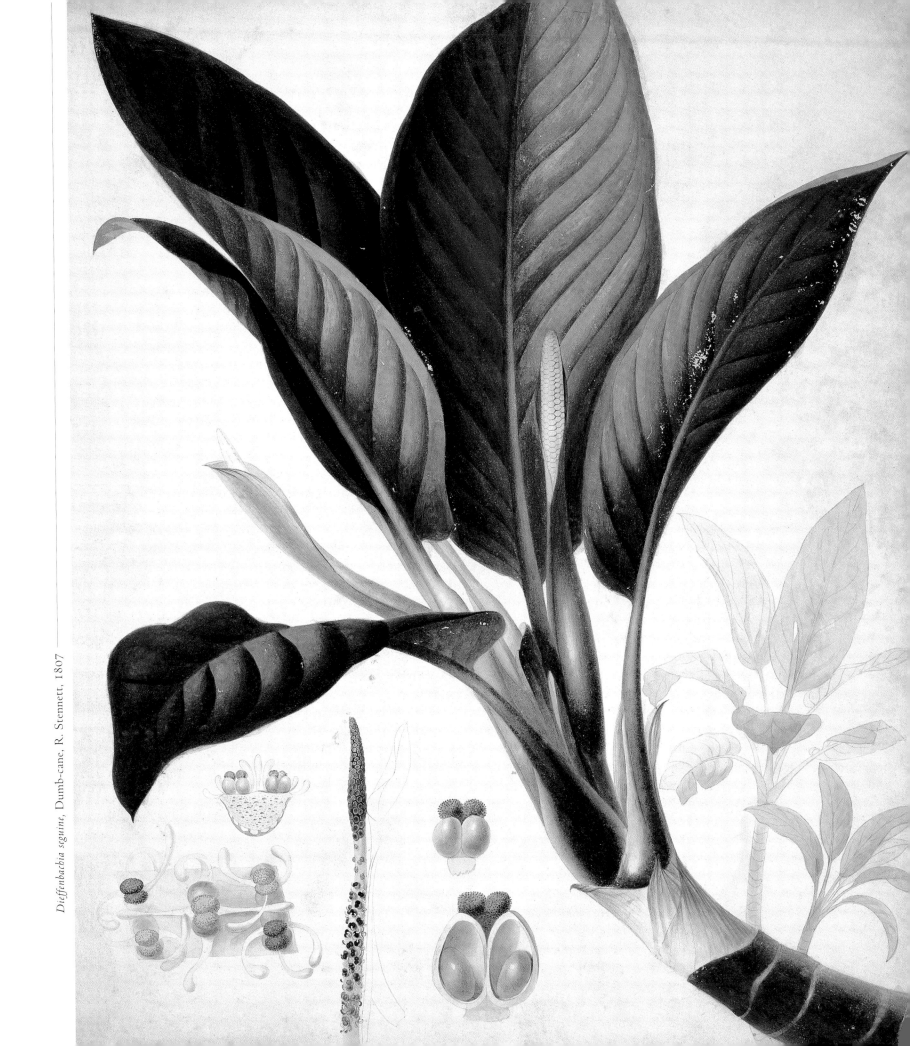

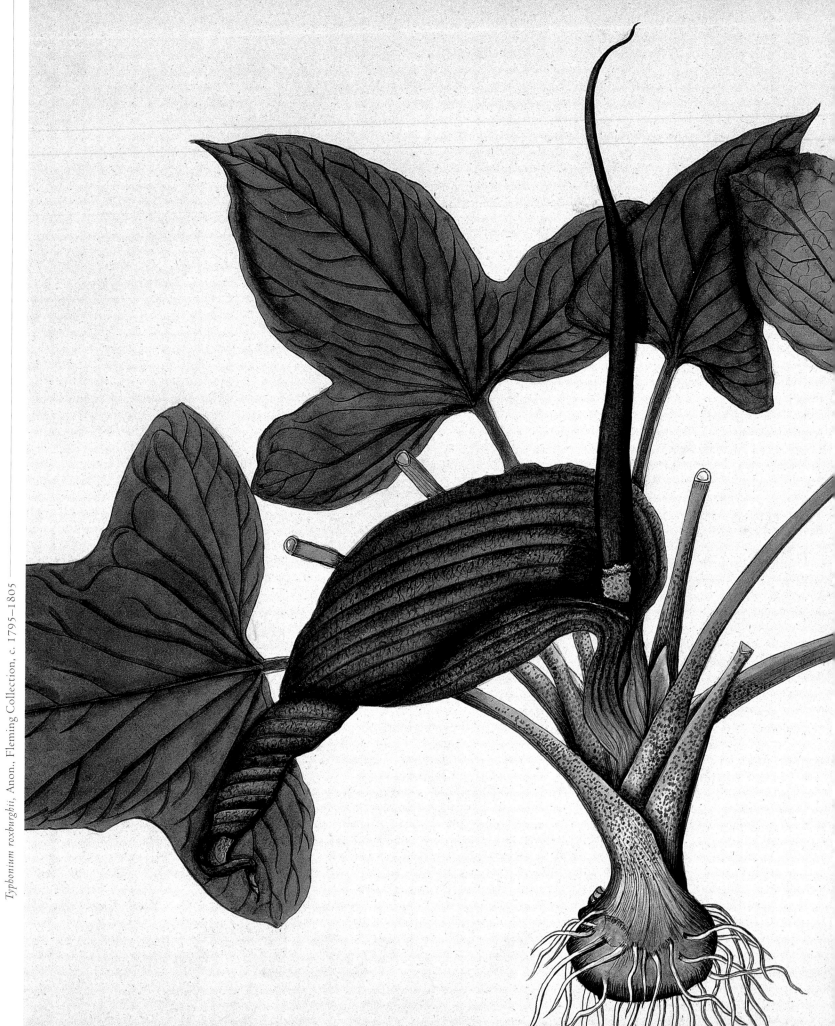

and especially the B vitamins. They are full of dangerous calcium oxalate crystals in the raw state (the same ones that cause the tingling in the mouth from dumb-cane, or *Dieffenbachia seguine*), and the usual method of preparation involves cooking. In the Pacific region, especially in Papua New Guinea and Hawaii, taro is the staple food. Taro in these cultures is not only a food, however, but also an integral part of local culture. In the creation myth of the ancient Hawaiians, the firstborn of Father Sky and Mother Earth was a taro plant, and the second was a human being – one depended entirely upon the other. One favourite dish in Hawaii is poi, a paste made from the ground, cooked roots of *Colocasia*. Poi is usually made from reddish varieties of taro, so is a dark pinkish-grey and (despite being a bit glutinous and difficult to get used to) quite delicious. One of the most unique food plants ever is also an aroid – swamp taro. Not a species of *Colocasia*, but instead a member of the genus *Cryptosperma*, it is grown on coral atolls in the Pacific, where cultivating anything at all is a real challenge. Plants are grown in holes dug out of the coral, in wet baskets filled with compost. The tuber, when harvested after three to six years of growth, weighs upwards of 60kg (132lb), so is pretty difficult to haul out of a pit more than 1m (3ft) deep. Even the tubers of some species of *Amorphophallus* are eaten. In Japan, *konjac* is a real delicacy, and is used to make noodles and *konnyaku*, gelatinous cakes used in both savoury and sweet dishes. *Amorphophallus konjac* tubers have high concentrations of the polysaccharide manna – the commercial source of mannose, an essential ingredient in foods for diabetics.

It is amazing to think that the same genus that has a species that sends waves of revolting scent through the rainforest understorey also contains species that help feed the world's ever-increasing numbers. Perhaps some members of the family are a bit offputting at first glance or sniff, but they definitely deserve a second chance. Aroids are endlessly fascinating – the true eccentrics of the plant world.

The fantastically colourful leaves of Caladium bicolor *make the flowers almost insignificant. Since its introduction to cultivation in the eighteenth century, this species has not only been selected for colour variation but also crossed with other closely related species with equally vibrant leaves. The result is a rainbow of variety.*

Caladium
Caladium bicolor (Aiton) Vent. (Araceae)
Frederick Polydore Nodder
1777, bodycolour with watercolour on paper
533mm x 373mm (21in x 14¼in)

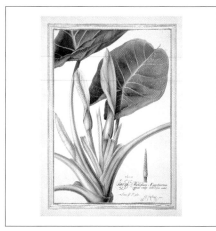

Poi, the staple diet of the ancient Hawaiians, is made from taro roots. It is made by cooking the roots, peeling them, then pounding the results into a pinkish, mushy mass. According to how much water is added, poi is 'one-finger', 'two-finger' or 'three-finger' — the number of digits needed to scoop up a mouthful. The tiny starch grains in taro roots make poi easily digestible and almost non-allergenic.

Taro
Colocasia esculenta (L.) Schott (Araceae)
Georg Dionysius Ehret
c. 1740s, watercolour with bodycolour on paper
519mm x 360mm (20½in x 12¼in)

In the eighteenth century, there was much confusion surrounding the identity of many aroids. Ehret was unsure about the identity or origin of this plant (calling it 'Arum proboscideum', a European species), but his sketch is so detailed that identification is now easy, and he may have sketched the plant in Philip Miller's Chelsea Physic Garden. Miller's 1760 published illustration is thought to be the first of this plant, but Ehret's sketch may predate it.

To-hange, Hange (Japan)
Typhonium blumei Nicolson & Sivadasan (Araceae)
Georg Dionysius Ehret, Ehret Sketches
c. 1760s, watercolour on paper
307mm x 202mm (12in x 8in)

Despite being the most poisonous genus of the aroid family, Dieffenbachia is a very popular houseplant, commonly known as dumb-cane. It is full of tiny crystals known as raphides, held in special ejector cells called idioblasts. Raphides are needle-sharp crystals of calcium oxalate, when injected into the skin cause intense burning sensations. In serious cases, swelling can be so severe that both speech and breathing are impaired — hence the common name.

Dumb-cane
Dieffenbachia seguine (Jacq.) Schott (Araceae)
Georg Dionysius Ehret, Ehret Sketches
1760, watercolour on paper
300mm x 405mm (11¼in x 16in)

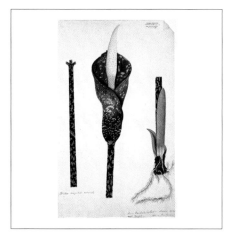

This picture is copied from a painting of plants collected in 1795 by Dr Francis Buchanan in the Nicobar Islands. Buchanan travelled to the 'Kingdom of the Barmans' (now known as the Andaman and Nicobar Islands) in his capacity as surgeon to the East India Company. He called this plant 'Arum optimum', and gives its common name as kuang kuang puin or pain tazoung.

Amorphophallus muelleri Blume (Araceae)
Anon. Fleming Collection
c. 1795–1805, watercolour on paper
469mm x 289mm (18½in x 11½in)

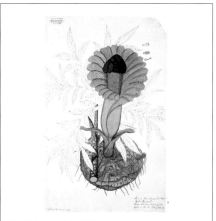

The genus Amorphophallus is aptly named. Translated, it means 'deformed phallus', which is certainly what the sterile appendage of this species looks like. In her book Aroids, *Deni Brown says that 'in a genus renowned for its nightmarish blooms* Amorphophallus paeonifolius *is surely one of the ugliest'. It also stinks, emitting 'an abominable and putrid odor' when it is in flower.*

Amorphophallus paeoniifolius (Dennst.) Nicolson (Araceae)
Anon. Fleming Collection
c. 1795–1805, watercolour and ink on paper
465mm x 295mm (18¼in x 11½in)

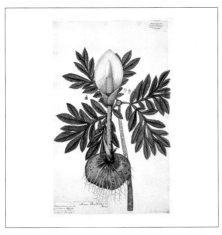

Most species of Amorphophallus *flower only rarely, and when they do the event is spectacular. A plant will produce a huge leaf every year for several years; then it happens only when reserves in the massive tuber have built up to enable flowering. This species also produces small bulbs on the leaves, each of which produces a new plantlet when it falls to the ground.*

Amorphophallus bulbifer (Roxb.) Blume (Araceae)
Anon. Fleming Collection
c. 1795–1805, watercolour with bodycolour on paper
456mm x 283mm (18in x 11¼in)

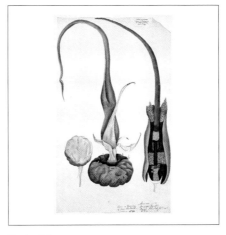

The voodoo lily – though not a lily at all, but a most evil-looking aroid – is named not only for its sinister dark-brownish, purple colour but also for its apparent ability to magically grow. A bulb of the plant, placed on a dish, will flower without soil or water, as if under an evil magical spell. Sometimes the voodoo lily is put in its own special genus, called Sauromatum.

Voodoo Lily
Typhonium venosum (Dryand. ex Aiton)
Hett. & P. Boyce (Araceae). Anon. Fleming Collection
c. 1795–1805, watercolour on paper
470mm x 288mm (18½in x 11¼in)

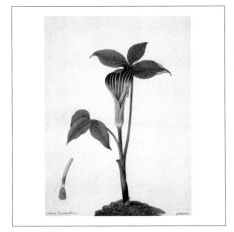

The jack-in-the-pulpit is a sex-switcher. Aroids usually have male and female flowers, but in the jack-in-the-pulpit young plants bear only male flowers, as they are too small and lack the stored reserves to 'finance' fruit production. Small plants that set fruit usually die. The plants resprout every spring from underground stems and, when enough reserves have been accumulated to fuel the fruit development, the plant switches sex and bears female flowers.

Jack-in-the-pulpit
Arisaema triphylla (L.) Torr. (Araceae)
Peter Brown
c. 1760s, watercolour with bodycolour on vellum
294mm x 224mm (11½in x 8¾in)

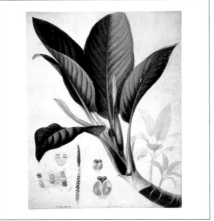

The aroids' individual flowers are a stripped-down model. Often unisexual (either male or female), they have no clearly defined petals or sepals; in fact, they really don't look like flowers at all. Stennett's careful dissections show the simplicity of the dumb-cane's flowers – just an ovary with two tiny ovules, or the peculiar male flowers extruding pollen in strands.

Dumb-cane
Dieffenbachia seguine (Jacq.) Schott (Araceae)
Ralph Stennett
1807, bodycolour and watercolour with gum arabic on paper, 550mm x 440mm (21¼in x 17¼in)

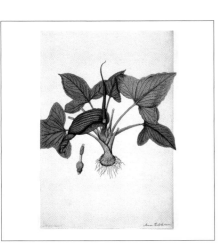

Even though the artist was probably botanically untrained, the fine detail in this painting is enough to allow identification of this plant to species. Differences in Typhonium *species are found in the sterile area on the spadix between the male and female flowers, and here it has tiny downturned appendages. Botanical art serves a dual purpose – beauty and utility.*

Typhonium roxburghii Schott (Araceae)
Anon. Fleming Collection
c. 1795–1805, watercolour and ink on paper
456mm x 297mm (18in x 11¼in)

Imagine being an Englishman, used to the mild and muted, but gently beautiful flora of your native land, and stepping ashore in Australia for the first time. It must have been like stepping on to another planet. The forests of eucalyptuses and banksias would have been completely foreign, and utterly fascinating to botanists and sailors alike – no wonder Cook honoured his scientists by coining the name Botany Bay. The European discovery of the flora and fauna of Australia – and thus of the fantastic banksias – did not, however, begin with Captain Cook. The 'mad, bad' but infinitely interesting buccaneer William Dampier first set foot on the shores of what he called New Holland in the late seventeenth century – he accidentally circumnavigated the globe in an epic

observations of the transit of Venus – taken in Tahiti in 1769 – to ascertain its existence and extent. In 1768, young Joseph Banks – an immensely energetic, amiable landed gentleman and amateur botanist – had just returned from a plant-collecting expedition undertaken as the companion to a friend in the Royal Navy to Newfoundland. His ambition was to devote himself to botany, going to Sweden to study with the great botanist of the age, Carolus (Carl) Linnaeus – he planned to undertake a journey to Lapland in the footsteps of his hero. Somewhere along the line he changed his mind and offered himself, plus an entourage of eight, as the gentleman-scientist aboard the Admiralty's ship sent to observe the transit of Venus from Tahiti. By observing the transit

SUGAR BUSHES & BANKSIAS

3 [May 1770] Our collection of Plants was now grown so immensely large that it was necessary that some extraordinary care should be taken of them least they should spoil in the books.

JOURNAL WRITTEN ABOARD THE *ENDEAVOUR* (JOSEPH BANKS 1770)

journey that began in 1679 and finished twelve years and a world of information later. He observed that 'The Land is of a dry sandy Soil, destitute of Water except you make Wells, yet producing diverse sorts of Trees. But the Woods are not thick, nor the Trees very big…sorts of Tree were not known to us… We saw no Trees that bore Fruit or Berries.'

Dampier was no scientist, but was an assiduous recorder of natural history information, and his observations on the animals and plants of many parts of the world certainly were a sign of the expansionist times in Europe. The thought that an entire continent lay to the south, a 'Terra Australis Incognitis', spurred explorers such as James Cook to continue on from his

of the planet across the face of the Sun, the parallax of the Sun could be directly measured, of great aid to navigation and thus to exploration. The Royal Society, of which Banks was a member, had petitioned King George III for such an expedition, and the result was full funding and enthusiastic support.

The Society offered Banks as the naturalist for the voyage, and were lucky that a fully trained, professional botanist – Linnaeus' ex-pupil Daniel Solander, then resident in London and working at the British Museum – also offered to come along. He apparently was apprised of Banks' plans for the voyage at a dinner party and, leaping to his feet, proposed himself as a fellow adventurer. In addition to Solander, Banks also had a party consisting of two

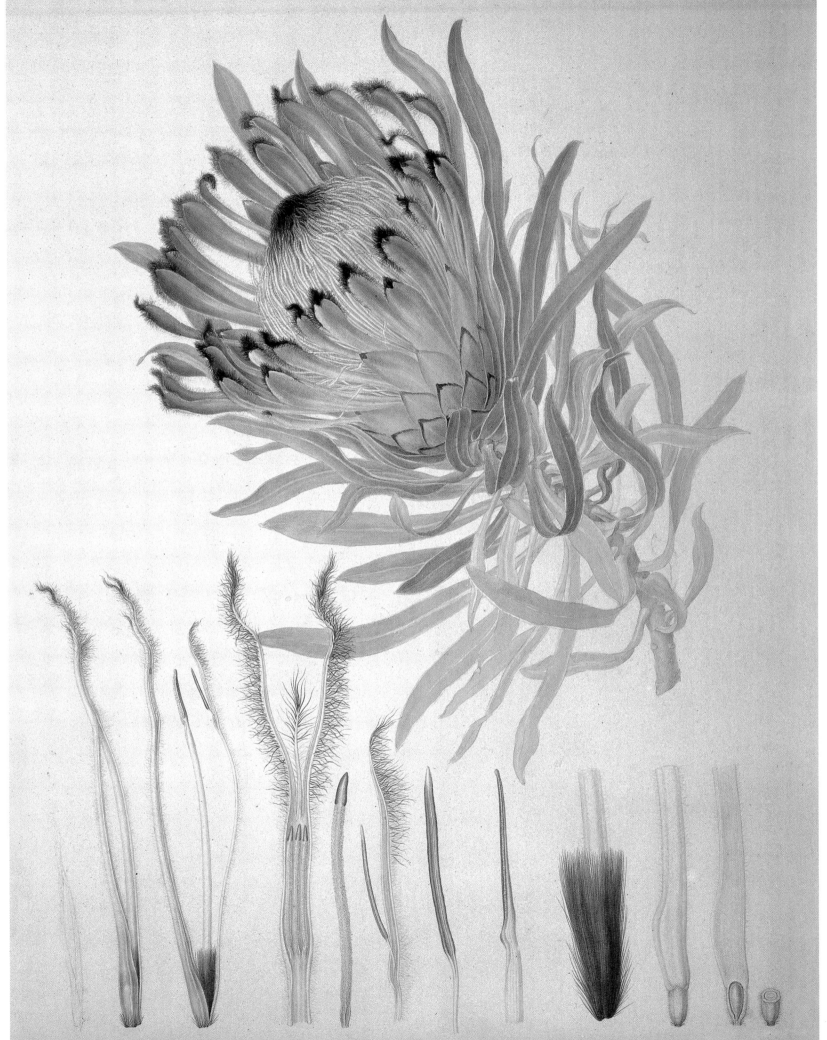

Protea burchellii, Burchell's Protea, Fr. Bauer, Kew Plants Collection, c. 1800

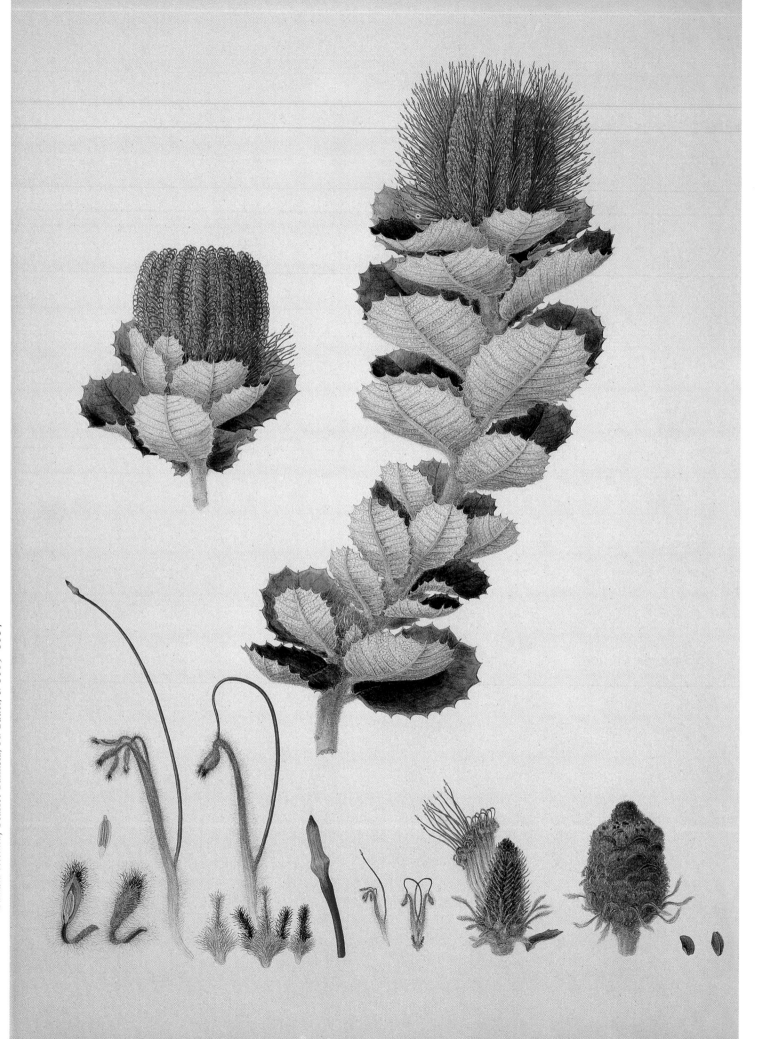

artists, a clerk for Solander, and four servants. Banks, Solander and the artists and draftsmen, plus all Cook's officers and their followers, all shared Cook's 4.3m by 7m (14ft by 23ft) cabin. Imagine sharing your eating and private space with enthusiasts whose work involved bringing great sheaves of vegetation on board, cutting it up, painting it and generally creating a great mess! Plant collecting is not an occupation for tiny enclosed spaces, so it is great testament to the good natures of all concerned that there were no major quarrels during the voyage (which lasted nearly three years).

Not only did Banks and Solander press and dry small snippets of plants, but they also prepared large herbarium specimens of everything they could. A herbarium sheet is about the size of A3 paper, and the pressed specimen fills the space. Specimens had to be prepared, sketched and the colours recorded, then they had to be dried in order that they might be taken back for later study. This was a logistical problem of the first order, since both space and ingenuity were required. Banks used methods common to botanists of the time, more difficult by far than today's portable plant dryers run by kerosene or the ever-expedient collections done in preserving fluids such as formalin or alcohol. In Banks' own words, he dealt with his increasing collections at Botany Bay as follows: 'I therefore devoted this day to that business and carried all the drying paper, near 200 quires of which the larger part was full, ashore and spreading them on a sail in the sun kept them in this manner exposed the whole day, often turning them and sometimes turning the quires in which were plants inside out. By this means they came on board at night in very good condition.' The collections made by Banks and Solander are now housed in the herbarium of the Natural History Museum in London, providing evidence of the incredible flora of Australia brought back to Europe for the first time.

When the *Endeavour* returned in 1771, the collections made were worked on by many botanists, but Banks never quite got around to publishing his great work on the botany of the voyage.

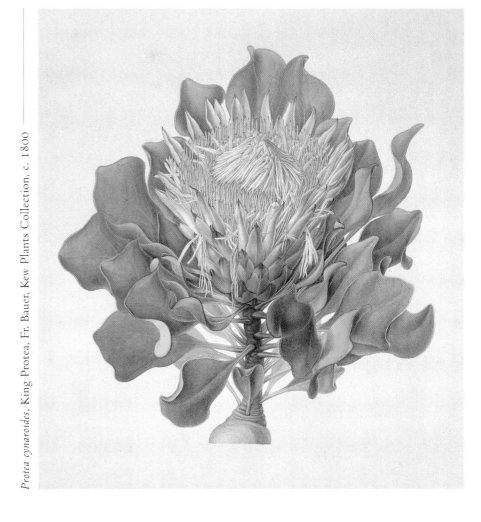

Protea cynaroides, King Protea, Fr. Bauer, Kew Plants Collection, c. 1800

The son of the great botanist Carl Linnaeus, known as Carl Linnaeus filius, recognized that four of the plants collected by Banks and Solander were clearly related, and in 1782 he erected the new genus *Banksia* to hold them – eponymously honouring Banks' contribution to botany. Linnaeus filius recognized that *Banksia* had some similarities to the genus described by his father – *Protea* of South Africa – and put them into the same category, 'Tetrandria Monogynia'. Both genera are today considered to be members of the family Proteaceae, an ancient Gondwanan lineage. The Proteaceae family is confined to the southern hemisphere, and its distribution pattern is typical of other organisms, like the monkey puzzle trees or the marsupials, whose ancestors were once

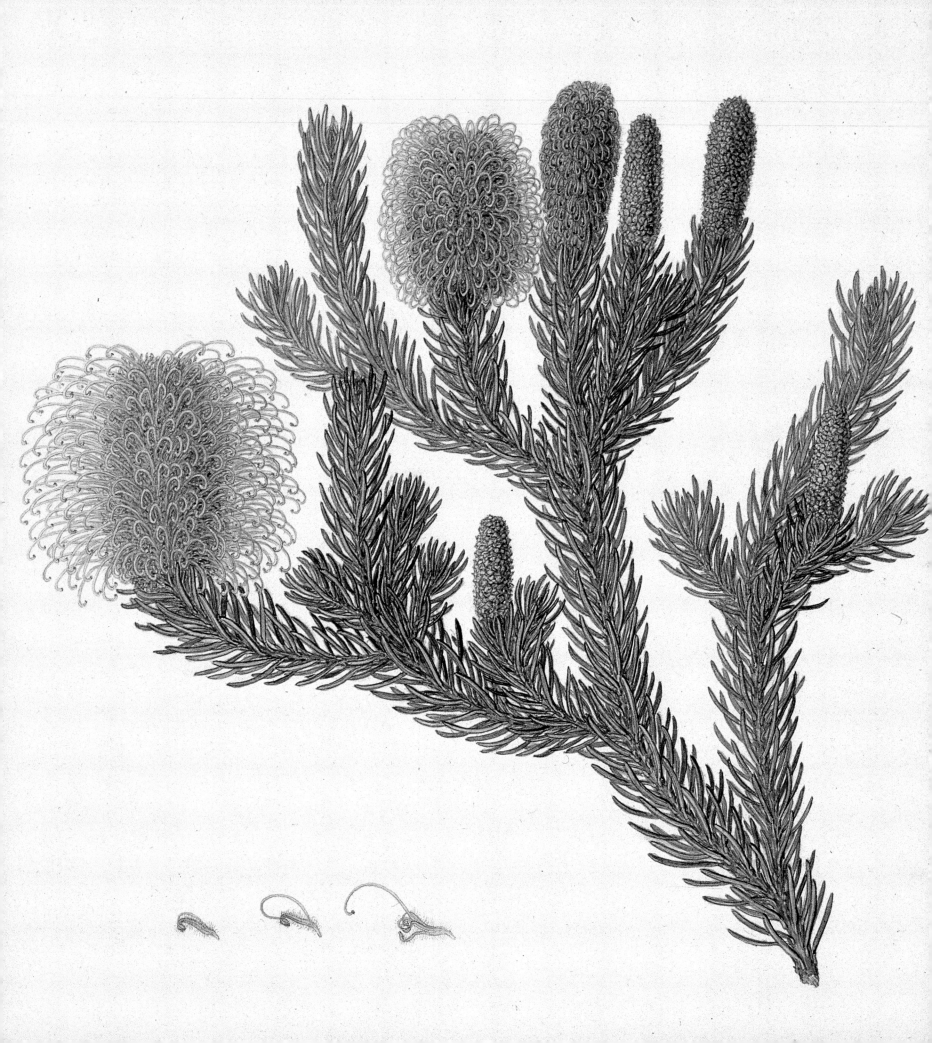

inhabitants of the supercontinent of Gondwanaland, which once spanned the southern part of the globe, a huge connected landmass. About 140 million years ago the continent began to break up and drift – eventually becoming what we recognize as the southern continents today (South America, Australia, Antarctica), plus India and Madagascar. Fossils of plants recognizable as Proteaceae have been found on all these landmasses, providing good evidence for the phenomenon of continental drift.

Botanists recognize members of the family (which include not only the genera *Banksia* and *Protea,* but also their relatives such as *Grevillea*, *Hakea*, *Embothrium*, *Leucadendron* and *Macadamia* – many associate this last native to Australia with Hawaii) by their unusual flower structure.

The cone-like 'flowers' of the proteoids are not single flowers at all, but inflorescences – groups of flowers. The effect is attractive in the extreme, not only to humans, but also to the animals that pollinate these plants. *Protea* inflorescences are especially flower-like – the often brightly coloured bracts that subtend each inflorescence have the look of petals to the casual glance – and the king protea, *Protea cynaroides*, is sold in the cut-flower trade as a giant bloom. Each individual flower in the inflorescence is quite small and consists of four tepals (undifferentiated sepals or petals, as no one is sure which of the two they are, structurally) united into an elongate tube, in the middle of which sits an elongate style. Each tepal has a pollen-producing anther fused on to it and, before the flower opens, the style elongates even more. Since the style head is held tightly in the still-fused tepals, it bows out, creating an amazing loopy effect, made even more incredible by the intricate spiralling of the individual flowers in many of the inflorescences. When the tepals open, or when a pollinator lands on the inflorescence causing the tepals to split apart, the style springs out and straightens, then making the bottlebrush flowers that are so common in both *Banksia* and *Protea*.

Most flowering plants produce pollen in the anthers, from where it is blown by the wind, deposited upon or gathered by pollinating animals. Proteoids produce their pollen in the anthers, but have evolved an entirely novel way of presenting this pollen to the outside world. Styles are attached to the ovary and are the structure down which pollen tubes grow in order to effect fertilization – normally, pollen is deposited upon the sticky surface of the stigma at the tip of the style. The stigmas of *Banksia*, for example, are tiny grooves in the style, and the knob at the tip is what is called the 'pollen presenter'. Before the tepals open and the styles spring out, pollen is shed on to this structure, where it sits, bright yellow and inviting, as an attraction to pollinators. Once the pollen presenter is relieved of its pollen, the stigma becomes receptive, thus preventing inbreeding.

This sort of innovation, which is the same in the many types of proteoids, tells us that they are evolutionarily related, and characters like these provide the evidence of evolution in action. But the proteoids show another type of evolutionary pattern of interest to biologists – that of convergence. Diversity in the family (despite its occurrence on all the landmasses derived from the Gondwanan supercontinent) is highest in southern Africa, especially in the Cape region, home of *Protea* and *Leucadendron*, and Australia, home of *Banksia* and *Grevillea*. In Australia, *Banksia* species ring the continent, and all seventy-six species of the genus occur only there. Sixty of these occur in the southwestern part of the country, in dry habitats with winter rainfall and hot summers. This type of climate is called Mediterranean, as it is similar to that found around the Mediterranean Sea in southern Europe. Funnily enough, this climatic regime is just like that of the Cape region of southern Africa, where the highest diversity of *Protea* occurs.

Banksia and *Protea* are not particularly closely related within the family – they are members of two different subfamilies, two evolutionary lineages, in the group – but in their similar habitats,

Banksia pulchella, Teasel Banksia, Fer. Bauer, c. 1803–1814

fynbos in South Africa and kwongan in Australia, they have evolved incredibly similar strategies for survival and reproduction.

Not only do proteas and banksias (and their relatives) look superficially similar with those cone-like inflorescences, but they also have similar roles in the environment. The copious nectar

produced by the many flowers in the inflorescences is sought after by nectar-feeding birds – in Africa, the sunbirds and sugar birds and, in Australia, the honey-eaters probe deeply into the inflorescences seeking nectar out, getting covered with pollen in the process. Nectar provided by these plants is a major source of energy for these birds.

Bird-pollinated species tend to have bright-yellow or vivid-red flower heads, making them all the more attractive to their customers. Structural specializations for bird pollination are found in flowers such as those of the South African genus *Mimetes*, which can only be accessed by birds with particular-shaped beaks, such as the sunbirds. *Mimetes* flowers are not in large cones, but instead are held in small groups held under brightly coloured bracts, and to get at the nectar the bird must probe the flower at a special angle, forcing contact with any receptive stigmatic surface.

Other types of proteoids are visited by birds, but also by beetles and butterflies. Some, in both Australia and in South Africa, bear their flowers right near the ground, almost out of sight. These flowers often give off a yeasty odour: in the Cape they are visited by small rodents in search of nectar, who inadvertently get their heads covered with pollen while rummaging in the flowers. The same relationship holds with honey possums in Australia, but there these tiny marsupials even visit the large, showy banksias.

The vegetation in Mediterranean climatic regions is structurally very similar – short and scrubby, the plants often have thick tough leaves and are full of resins and oils. This vegetation is found in Australia, South Africa, Chile, California and around the Mediterranean. Because Mediterranean climates are often very fire-prone (with their hot, dry summers), plants in these habitats have adaptations to resist fire and its effects. In addition to the climatic conditions, Australia and South Africa have extremely poor soils, lacking in many essential nutrients, which leads to high flammability of the vegetation, and fires are more common in the fynbos and kwongan than in other types of Mediterranean

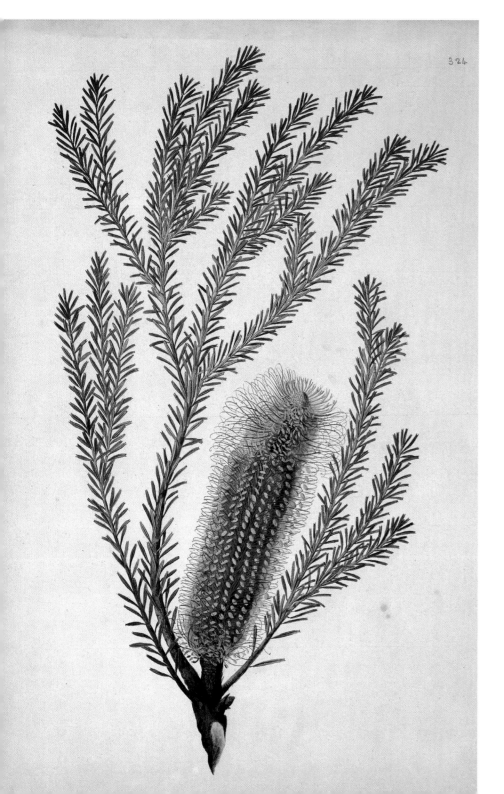

Banksia ericifolia, Heath-leaved Banksia, J.F. Miller, Cook Collection, 1773

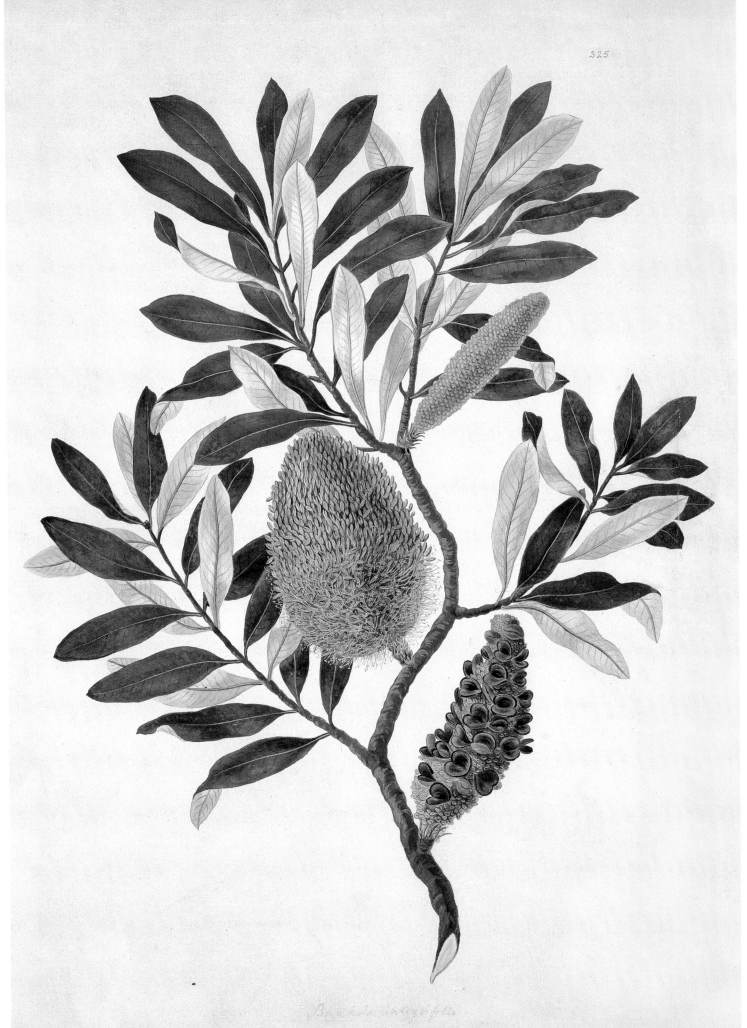

Banksia integrifolia, Coast Banksia, Anon., Cook Collection, c. 1770s

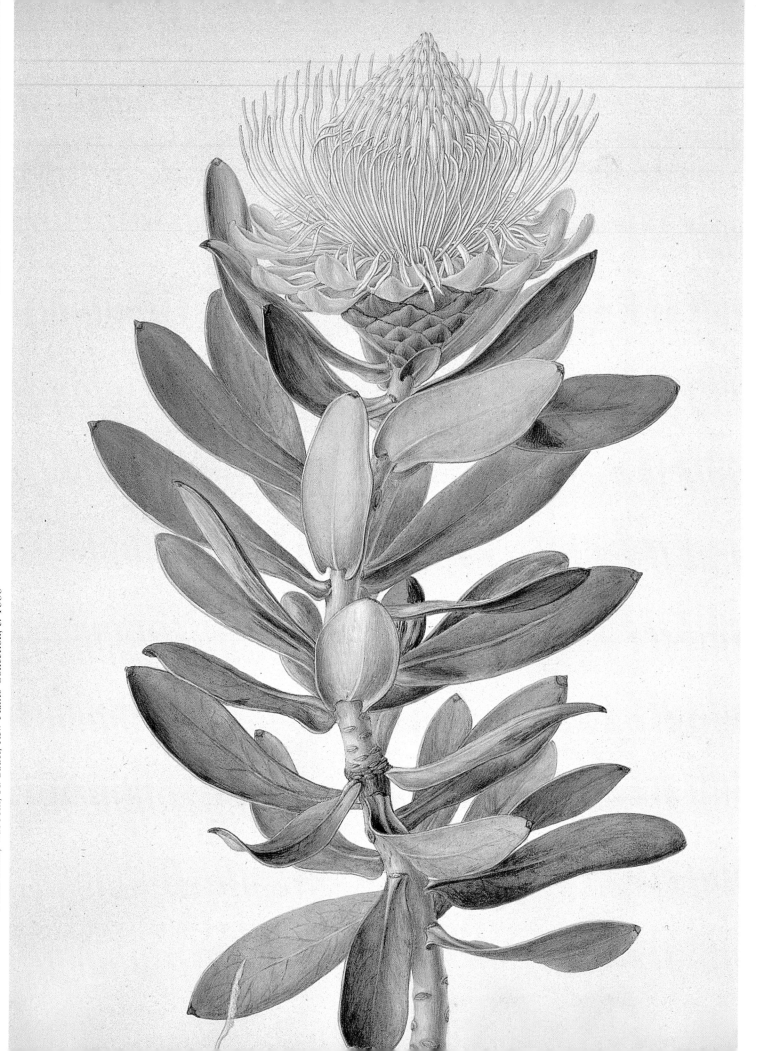

vegetation. The family Proteaceae and the genus *Protea* both take their names from the Greek sea god Proteus (son of Oceanus and Tethys, who could change his shape at will), perhaps referring to these plants' ability to regenerate after fire, but maybe also alluding to their strange flower shapes.

Many proteas and banksias have similar strategies to deal with the effects of fire; indeed, it has been said that there would be no proteas without fire, since they all depend upon it to some extent or another. Some Australian species – such as *Banksia attenuata* or the creeping *Banksia chamaephyton* – have a fire-resistant lignotuber from which the plant resprouts after a fire kills all the overground parts. In South Africa, *Leucadendron spissifolium* does the same thing, from a similarly woody, fire-resistant rootstock. Other species are completely killed by fire, but these plants have a spectacular survival mechanism.

Serotiny is a fire-protection strategy that involves storage of seeds in thick cones that remain closed, holding the seeds in a sort of suspended animation – sometimes for many years – until a fire sweeps through the habitat. The heat of the fire causes the follicles (the technical name for the fruits of proteoids) to open and release the seeds – *Banksia* follicles have two seeds, which are kept from falling by a stiff-winged structure called a separator. In some species the separator holds the seeds in the open follicle until rain falls, opening the wings and allowing the papery-winged seeds to waft out on to the (now) cool, wet ground, which is perfect for germination. In South Africa, woody 'cones' are similarly split after fire, and seeds are blown on to newly burned soil. Many species of *Protea* have seeds with fluffy tails, aiding in their dispersal out into the newly created habitat.

All this similarity is due to convergent evolution. Faced with similar environmental challenges, over evolutionary time these related plants have come up with similar solutions, but not identical ones. Although biologically speaking, convergent evolution is interesting, it can also cause problems when plants from one place are introduced into another.

Banksia ilicifolia, Holly-leaved Banksia, Fer. Bauer, c. 1803–1814

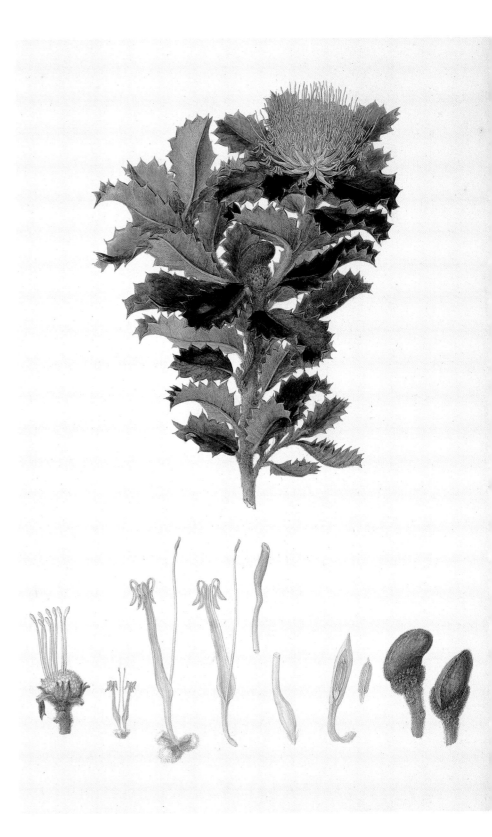

In the mid-nineteenth century, three species of the Australian genus *Hakea* were introduced to South Africa as hedge plants and for firewood production. These needlebushes, members of the Proteaceae family, had come from a similar habitat in southern Australia and did extremely well in the Cape Peninsula – so much so, in fact, that they became invasive pests, obliterating the habitat of native species and causing their demise. Imported to form fences, the needlebushes do this job exceedingly well: left to their own devices, they spread rapidly and form spiky, impenetrable thickets, sucking water from the ecosystem and becoming a major fire risk due to the high biomass of flammable material.

Needlebushes also exhibit serotiny – the seeds are held in hard follicles, whose opening is stimulated by fire. In the absence of natural seed predators, a single *Hakea* bush can produce huge numbers of winged seeds, which fall not only near the parent plant but are also distributed far and wide throughout the habitat. The seedlings compete with those of native species for space and water and, until the problem was recognized, were having a major impact on the biodiversity of the Cape Peninsula. The native proteoids just did not stand a chance against these marauding invaders, with their incredible seed production.

Nowadays, the spread of *Hakea* species in the Cape region is being aggressively controlled by several methods, some of which are extremely labour-intensive. Since the *Hakea* species do not resprout after there has been a fire, stands of the shrubs are cut down, so stimulating the release of seeds and, once these seeds have germinated, the area is burned, in order to kill the seedlings. Considerable progress has been made by dedicated people to conserve habitat for native plants. The cost of clearing just 1 hectare (2½ acres) of infested land – for it truly *is* infestation –

has been estimated to be ten times that of prevention by physical removal of seedlings from the same area before infestation. A biocontrol agent – a weevil that is a seed predator of the most invasive species of *Hakea* – has been introduced to the Cape region, to some good effect. Ironically, this means that some populations of *Hakea* will need to be conserved in order to maintain the populations of this weevil. Two introductions for the price of one!

Invasives are difficult to identify *a priori*, before they become invasive and a problem for native species. One recent introduction, which hardly needs rocket science to identify as a potential problem, is *Banksia* in South Africa, where several species are cultivated for their spectacular flowers (although those of *Protea* are equally lovely), and are a potential disaster waiting to happen. One species in particular, *Banksia ericifolia* – a lovely plant with huge, reddish inflorescences – has started to invade native habitat and, just like the hakeas, its seed production is prodigious. It is estimated that more than twelve times the amount of seed is produced by plants in South Africa than is produced by the same species in its native habitat in Australia. Fortunately, dedicated conservationists in the Cape region are devoting much of their time and effort to the control of alien species, and to the spotting of threats before they spiral out of control.

The problem of invasives is not just an Australia–South Africa one, for it could easily happen in reverse, and they are a problem in native habitats across the world. These unwelcome colonisers choke out native plants, competing with them for light and space. Not all invasives have been introduced by accident or for commercial purposes – some have been brought in as garden novelties, prized for their oddness or just their sheer beauty – but even though we thought we had these plants under our control, biology has a way of producing surprises, not all of them good. As we ourselves become globalised, we need to make sure that we do not ruin the future of much of the world's flora by unwittingly sowing the seeds of our own and other species' destruction.

This protea species is named in honour of William J. Burchell, the son of a Fulham nurseryman, who travelled extensively in South Africa in the early part of the nineteenth century. After his fiancée became engaged to the captain of the ship that was bringing her to him in St Helena, Burchell dedicated himself to botany. (For him, flowers were clearly less fickle than females).

Burchell's Protea
Protea burchellii Stapf. (Proteaceae)
Franz Bauer, Kew Plants Collection
c. 1800, watercolour on paper
509mm x 344mm (20in x 13½in)

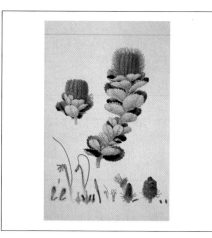

The amazing detail that Ferdinand Bauer put into his paintings from the voyage on the Investigator is proof not only of his powers of observation but also of advances in science, for the microscope allowed botanists to see tiny structures such as pollen grains or stigma structure. Bauer's careful dissections, drawn to scale, show just how intricately the workings of banksia flowers are put together.

Scarlet Banksia
Banksia coccinea R.Br. (Proteaceae)
Ferdinand Bauer
c. 1803–1814, watercolour on paper
526mm x 356mm (20¼in x 14in)

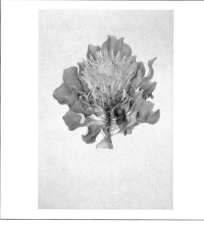

The king protea is the national flower of South Africa. It has the largest flower heads of any member of the Proteaceae; indeed, some varieties are as large as a dinner plate. Seeing one of these beautiful flowers in the wild is incredible even nowadays, so imagine how the early European botanists in the Cape must have felt.

King Protea
Protea cynaroides (L.) L. (Proteaceae)
Franz Bauer, Kew Plants Collection
c. 1800, watercolour on paper
522mm x 369mm (20½in x 14½in)

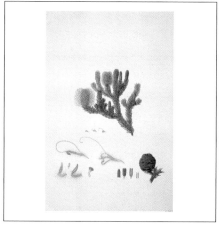

Robert Brown first collected the teasel banksia in January 1802, in Lucky Bay, Western Australia. He named it in honour of its pretty flowers (*pulchellus* means 'pretty' in Latin). The woody, follicular fruits stay on the plant unopened until a fire sweeps through the brush, killing the plant but stimulating the release of seeds into the nutrient-rich soil.

Teasel Banksia
Banksia pulchella R.Br. (Proteaceae)
Ferdinand Bauer
c. 1803–1814, watercolour on paper
526mm x 358mm (20¼in x 14in)

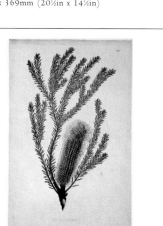

The tall flowering spikes and the tiny insignificant leaves of the heath-leaved banksia make it a natural for the cut-flower market. Planting it far from its home in eastern Australia might seem the kiss of death, but the habitat in South Africa is so similar to that in Australia that the banksia is running amok, invading fragile native shrubland.

Heath-leaved Banksia
Banksia ericifolia L.f. (Proteaceae)
John Frederick Miller, Cook Collection
1773, watercolour and ink on paper
535mm x 350mm (21in x 13¾in)

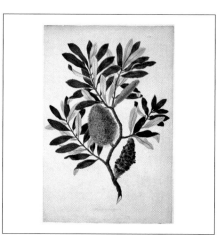

The place where Joseph Banks and Daniel Solander collected this and many other banksias was originally going to be named Stingray Bay by Captain Cook. However, the richness of the haul the young scientists gathered during their short few days making trips ashore made Cook change his mind. In their honour, he christened it Botany Bay.

Coast Banksia
Banksia integrifolia L.f. (Proteaceae)
Anon. Cook Collection
c. 1770s, watercolour on paper
535mm x 360mm (21in x 14¼in)

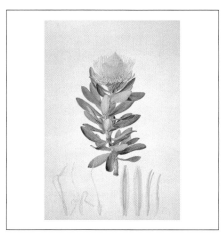

The scrubby fynbos of the Cape region of South Africa does not have many large trees, yet Protea nitida *can grow to 1m (3ft) in diameter, which is quite a size for a fire-swept habitat! Wood from this species was used by Boer settlers for making wagon wheel rims – hence its common Afrikaans name ('waboom' or 'wagon tree'). The leaves were used for making ink, and the bark for tanning leather.*

Waboom; Wagon Tree
Protea nitida Miller (Proteaceae)
Franz Bauer, Kew Plants Collection
c. 1800, watercolour on paper
511mm x 360mm (20in x 14¼in)

During the Investigator's *circumnavigation of Australia, Brown collected live plants for His Majesty's gardens at Kew. Taking the plants back to England, Captain Flinders (who had commanded a leaking* Investigator *around the continent) was imprisoned by the French on Mauritius, on suspicion of being a British spy. He finally made it home, but died just as his account of the voyage was published.*

Holly-leaved Banksia
Banksia ilicifolia R.Br. (Proteaceae)
Ferdinand Bauer
c. 1803–1814, watercolour on paper
525mm x 355mm (20¼in x 14in)

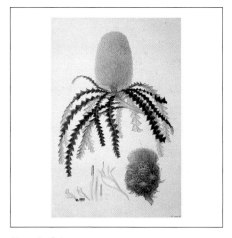

The showy banksia was named by Robert Brown, who went on to be the first Keeper of the British Museum's Botanical Department. Brown was the botanist aboard the Investigator, *under the command of Captain Matthew Flinders, on the first of the great expeditions sent to circumnavigate the continent of Australia. He was also one of the first botanists to encounter the fantastic vegetation of southwest Australia.*

Showy Banksia
Banksia speciosa R.Br. (Proteaceae)
Ferdinand Bauer
c. 1803–1814, watercolour on paper
523mm x 356mm (20½in x 14in)

eonies are the garden's story of East meets West, and yield spectacularly successful results for everyone. However, this is not a universal opinion, for the excitable Reginald Farrer, a great early twentieth-century British plant hunter who made several trips over two years exploring the Tibetan mountains (mostly for alpines such as gentians), thought quite the opposite: 'But remember, only the Japanese and Chinese tree peony can claim the true Japanese ecstasy of affection. Where the West has touched the products of the East a disastrous degradation has resulted; and Europe now swarms with truly horrible European tree peonies – lumpish, double, semi-double, in tones of washy lilac and magenta... The true peony of the East has a loose arrogant

In general, peonies come in two sorts: herbaceous peonies that die back to the ground every winter and resprout as 'dear rosy snouts', to use English gardener and landscape designer Gertrude Jekyll's telling phrase; and tree peonies, which in reality are not trees at all, but woody, multi-stemmed shrubs. Wild tree peonies are only found in China, but herbaceous peonies occur all across the northern hemisphere – from Japan and China, through Central Asia and the Caucasus, to Turkey and Asia Minor, southern Europe and North Africa, and (crossing the seas) there are also two species native to North America. The genus *Paeonia* takes its name from Paeon (or Paean), helper of the god of medicine, Aesculapius. In the *Iliad*, the poet Homer tells of Paeon's healing

PEONIES

There is a gruesome storm in the Garden of Peonies,
And the raindrops are like stones, and the wind like a broom.
Yet the petals fall like lovers' tears,
The flowers will blossom until the end of time.
POPULAR CHINESE SONG FROM THE LATE NINETEENTH CENTURY

splendour; the flowers are vast, shiny in texture and sheen, sometimes torn and fringed at the edges, sometimes double, sometimes single, but always of the most imperious yet well-bred loveliness, in every pure shade of colour.' This somewhat crabby-sounding admonishment was written some years after Farrer's return from the field, so maybe the remembrance of sights past was rosier than the reality of seeing many other gardeners with the peonies he had seen in their native habitats. Who knows, but clearly peonies of both sorts have long had a hold on the imaginations of people from many cultures, and deservedly so, since they are the most exquisite of flowers, possessing both beauty and a fantastic variety of scents – spicy and sweet.

of both Hades (god of the underworld) and Ares (god of war), with ointments made from roots given to him by Leto (mother of Apollo). Aesculapius was jealous of Paeon's success and in revenge had him killed, but in gratitude for his healing touch Ares turned Paeon into an exquisitely beautiful flowering plant – a peony.

Peonies have a long history of medicinal use in both the East and West. They are one of the plants recorded as planted in monastic gardens and were supposed to work against nightmares, jaundice, 'torments of the belly', falling sickness and diseases of the mind. The herbalist John Gerard, writing in 1597, records the magical properties of peonies (so magical were they that peonies were not to be harvested by hand but by dogs pulling up the

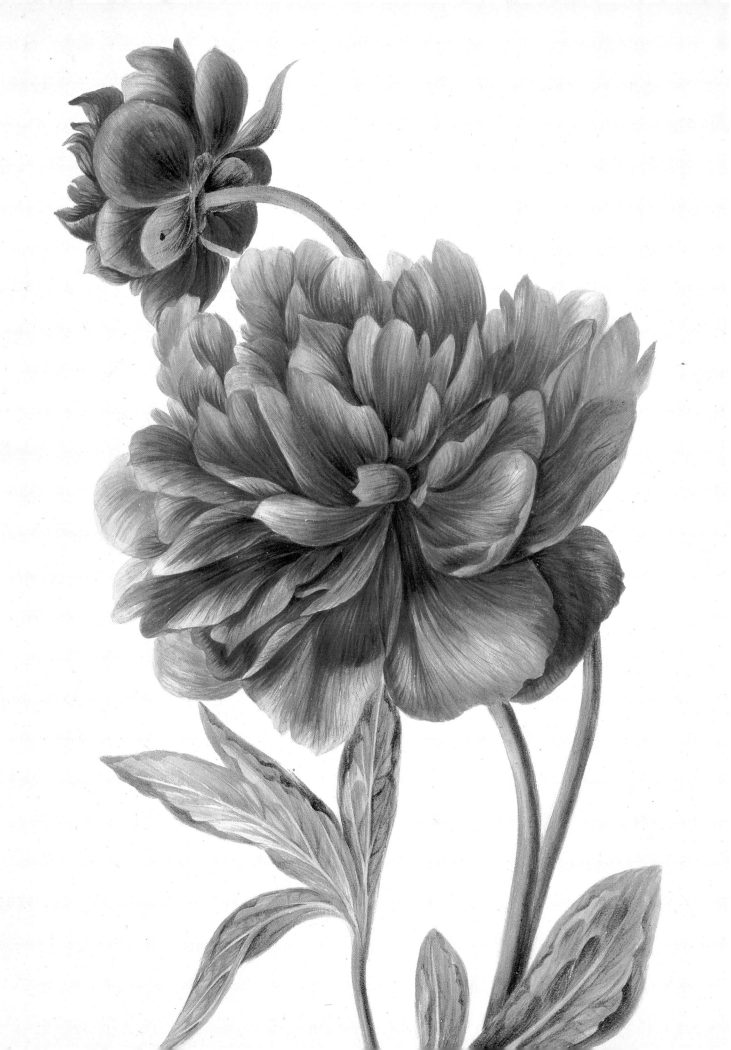

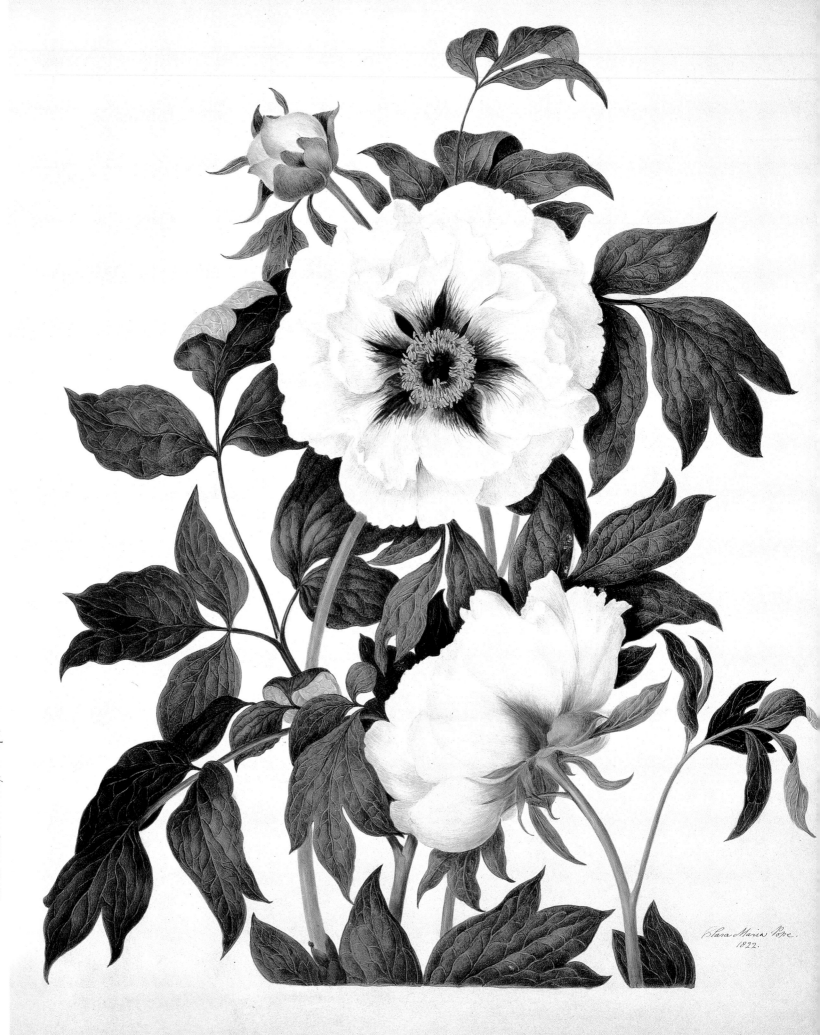

Paeonia rockii, Tree Peony, C. Pope, 1822

roots). These stories were taken from the ancient Greek botanist Theophrastus and, though repeated by Gerard, were dismissed by him as ludicrous and fanciful. At least the peony was not thought to scream, as was the mandrake (also harvested by dogs). Peony root was so valuable that perhaps the myths associated with its harvest were a way of protecting dwindling supplies. Apparently, Gerard was not averse to a bit of hoaxing himself; indeed, he records a peony growing 'wilde upon a conie berrie [rabbit hill] in Betsome, being in the parish of Southfleete in Kent, two miles [3km] from Gravesend, and in the ground sometimes belonging to farmer there called John Berry'. In the second edition of the *Herball*, published in 1633 after Gerard's death, Thomas Johnson, the editor, reprovingly suggested that Gerard himself was responsible for the peony's occurrence in Britain, and that he perhaps planted it in Kent himself and 'afterwards seemed to finde it there by accident'. Johnson had been told this somewhat scurrilous tale about Gerard by someone, but peonies have never since been found truly wild in Britain. The plants of *Paeonia mascula* – a species otherwise only found in forests around the Mediterranean, known from the uninhabited island of Steepholm in the Bristol Channel between Wales and England that so entranced the Romantic poets – are perhaps another botanical hoax. They are more likely the long-forgotten relics of a medieval monastic garden, left behind when the Augustinian monks who lived there at the turn of the thirteenth century abandoned the island.

Many of the European herbaceous peonies are not hardy in cold climates, and therefore have never been used in the process of creating the plants so loved in gardens. One such, *Paeonia cambessedesii*, is native only to the precipitous cliffs of the tiny island of Majorca, where Jacques Cambessedes collected it in the nineteenth century by shooting bits of plants down with a shotgun. Not surprisingly, it is not widely found in cultivation. The commonest medieval peony of medicine was *Paeonia officinalis*, so named for its sale in shops and offices (both the roots and the seeds were used). *Paeonia officinalis* was also the first peony to be

developed as a garden plant for its flower in Europe, with double, red and white forms figured in seventeenth-century botanical works. Wild plants of *Paeonia officinalis* are now extremely rare, though it is not known whether this is due to over-collection in ages past or to wholesale change of their native habitat.

Japanese gardens are monuments to the expression of beauty in simplicity. It often seems that flowers such as peonies – with their huge, sometimes blowsy flowers – would have no place in such artistic expressions. But nothing could be further from the truth, for only two species of peonies are native to Japan, neither

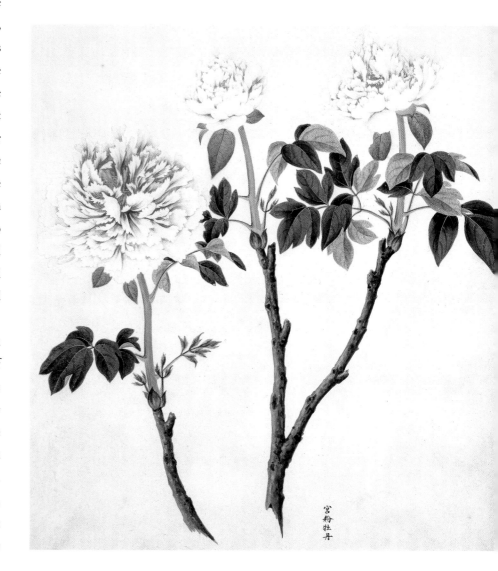

Paeonia suffruticosa, Tree Peony, Anon., Reeves Collection, c. 1820s

parts of the flower were in fact just modified leaves. We know now that the identity of the whorls of organs in the flower is modified by a deceptively simple system termed the ABC model. In the simplest form of the model, possession of varying combinations of the genes A, B and C gives identity to each floral whorl – thus A gives sepals; A + B, petals; B + C, stamens; and C, carpels. Mutants, mostly studied in the genetic 'model organism' *Arabidopsis* (an otherwise insignificant crucifer; a tiny plant related to the mustards), can have all petals, all stamens, or strange and wonderful combinations of the floral organs. Imperial peonies are even more fantastic than these mutant forms, however: rather than a simple peony flower with a whorl of petals and a central boss of stamens, these have modified stamens that appear to be narrow petals, sometimes of a different colour to the outer (or guard) petals. Horticulturalists put these flowers in their own peony class – with the most extreme versions – where the centre of the flower is completely filled with narrow staminodes, termed 'anemone-flowered' (a perfectly descriptive name). These flowers are a relatively recent innovation to peony culture in Japan. The first cultivated peonies on the islands came from China, and were not herbaceous at all: they were tree peonies, brought to Japan by Buddhist monks in the eighth century for their medicinal roots. The plants, known as Botan, were soon appreciated as much for their flowers as for the qualities of their roots, and many Japanese varieties were bred, especially in the sixteenth and seventeenth centuries. These were among the varieties so prized by the plant hunter Reginald Farrer – to the denigration of the European attempts at tree-peony breeding. The tree peony is one of only three flowers to have royal rank in Japan, and was known as the Flower of Twenty Days (surely a reference to its short, but intense, flowering season) and the Flower of Prosperity.

The true home of the tree peony, however – where all the native species occur – is China. Known as Mudan, or Moutan, they have been cultivated and bred there for at least 1000 years. The tree peony is thought to be a flower full of essential 'male'

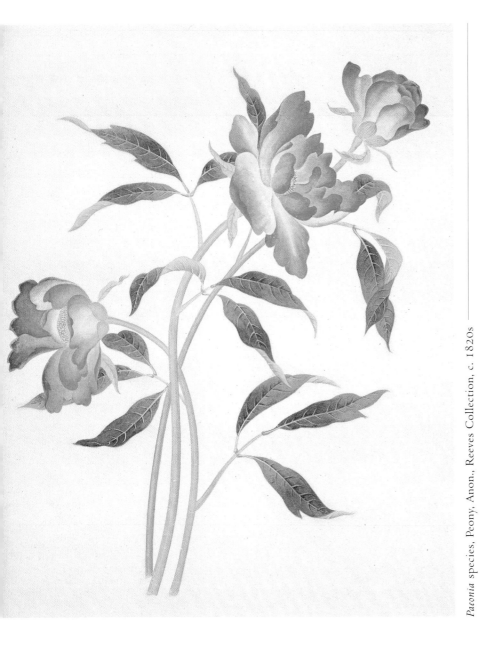

Paeonia species, Peony, Anon., Reeves Collection, c. 1820s

Paeonia officinalis, Peony, G.D. Ehret, c. 1750s

of which is commonly used in plant breeding, although *Paeonia obovata* has received recognition from horticulturalists. Japanese peonies, or imperial peonies, are hybrids of exceptionally lovely flower form, exploiting the developmental ambiguities of flower parts. Based on his observations of naturally occurring and hybrid forms of many sorts of flowers, the German poet and plant morphologist Johann Wolfgang von Goethe suggested that the

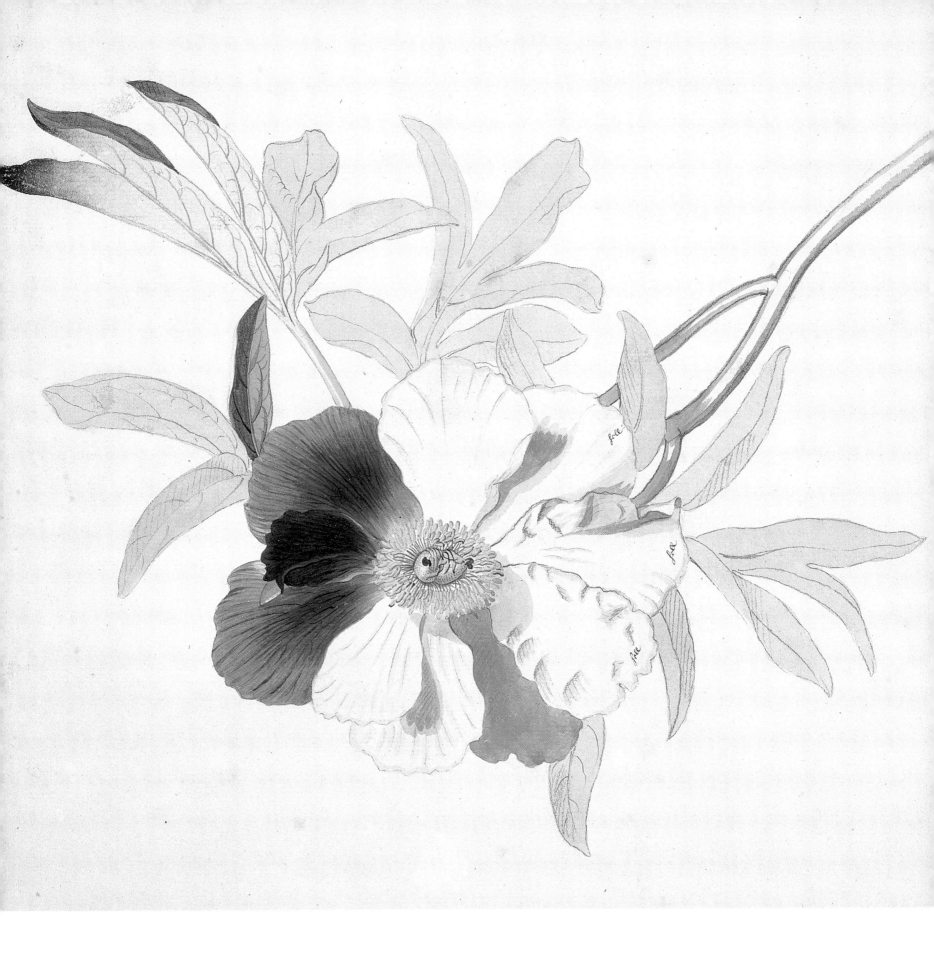

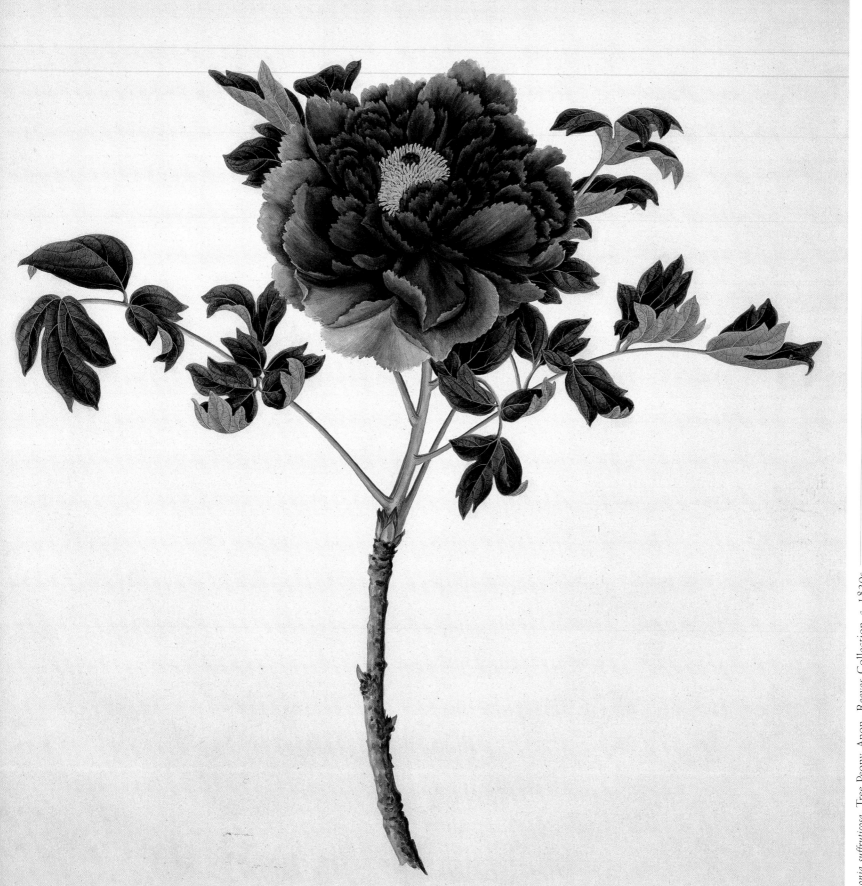

Paeonia suffruticosa, Tree Peony, Anon., Reeves Collection, c. 1820s

characteristics, for the derivation of the common name Mudan either comes from 'male scarlet flower' or from Mudang, the Emperor of Flowers in Chinese mythology. In the seventh century, during the Tang dynasty, peonies became a fashionable flower at court, and rows of peonies adorned the imperial palaces in Changan in the province of Shaanxi (home of many wild species of tree peonies), so Chinese gardeners surely had ample material with which to experiment at that time. During the reign of Empress Wu Zetian, peonies became a mania, with plants selling for a hundred ounces of gold, and her capital (Luoyang) is still the centre of Chinese tree peony cultivation. Favoured varieties were often double forms, with the inner petals forming a compact dome, and with the right cultivation methods and careful breeding gardeners produced flowers measuring as much as 30cm (1ft) across! During the great cultural flowering of the Ming and Ching dynasties (fourteenth to early twentieth centuries), tree peonies were planted everywhere – both for medicinal use and for the beauty of their flowers. Tree peonies were considered a symbol of vitality, opulence and the active male essence of the universe, so peony roots (no great surprise!) were and still are used medicinally in China. In today's traditional Chinese pharmacopoeia, *Radix paeoniae alba* (the root of *Paeonia lactiflora*, an herbaceous species) is used as a cold substance to consolidate the yin and to pacify the liver.

The first Chinese peony to reach Europe arrived in the late eighteenth century, via England, where the ever-energetic and incredibly powerful botanist and president of the Royal Society, Sir Joseph Banks, had imported it from imperial China. 'Paeonia Moutan' immediately caught the imagination, and was cultivated in royal gardens throughout Europe. A plant with flowers like a rose, with a sweet perfume but no thorns, was bound to catch on, and as plant exploration to the East expanded, more and more varieties of peonies were introduced to the gardens of Europe – not only wild species, but some of the incredible Chinese cultivated forms as well. Crosses between the European *Paeonia officinalis* and a Chinese species, *Paeonia lactiflora*, produced many

beautiful garden plants, but tree peonies were still a rarity. John Reeves, a tea inspector for the East India Company in the first half of the nineteenth century, commissioned paintings of Chinese plants by local artists. He also had plants sent from Canton to England, carefully packed and sent with special instructions to ships' captains as to their care and maintenance. Sadly, many of these varieties did not persist in cultivation, perhaps due to their heavy blooms – at 30cm (1ft) in diameter, a flower was bound to be quite heavy. Reeves was influential in sending Robert Fortune

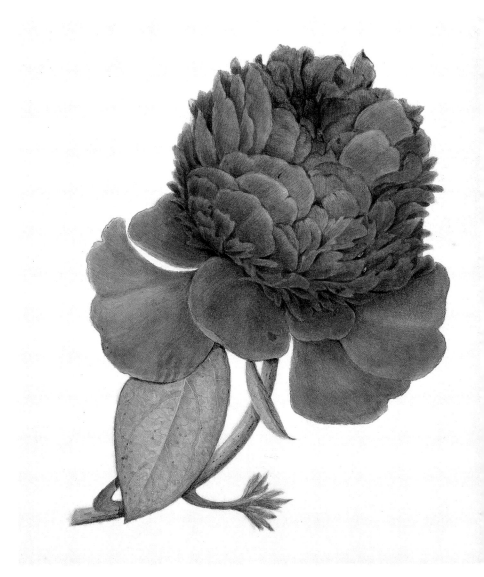

Paeonia suffruticosa, Tree Peony, Anon., Reeves Collection, c. 1820s

to China to hunt for a blue peony (among other non-existent plants). Fortune sent back many new plants for cultivation, including many cultivated peonies, but most prized of all were the wild parents of these cultivated varieties – both the tree and herbaceous peonies – which were hunted assiduously. Père Jean-Marie Delavey, a French missionary sent to China in 1867, sent back two species of wild tree peonies: *Paeonia lutea* and *Paeonia delavayi*, the latter named in his honour. Both of these wild species have been extremely important in the subsequent hybridization of European garden varieties of tree peonies, those so looked down upon by Farrer. Perhaps he was angry his wild species had not been used in creating new hybrids.

One of the rarest and most famous of these wild species is *Paeonia rockii* – 'Rock's Variety'. In 1802, James Prendergast, a ship's captain, brought a wild tree peony back from China that had large white flowers with deep-purple blotches at the base. It was planted in Sir Abraham Hume's garden in Hertfordshire, north of London, and by 1835 was reported as bearing over 300 flowers. It was never found again in the wild, until Reginald Farrer and William Purdom found it on the Gansu–Tibet border in the early twentieth century. Farrer's description of the plant matches exactly the plant cultivated in Hume's garden, and his encounter with the plant was an almost mystical experience: 'holding my breath with growing excitement as I reached my goal…the breath of them went out upon the twilight as sweet as any rose. For a long time I remained in worship.' Unfortunately, Farrer did not manage to bring back live material of the plant, so it remained an elusive goal. By the early twentieth century the United States government had embarked upon plant exploration itself, and Dr David Fairchild – who also gave his name to the Fairchild Gardens in Florida – was in charge of the Office of Seed and Plant Introduction. In 1920, he sent Dr Joseph Rock, who at that time was the professor of both Chinese and Botany at the University of Hawaii, to Indochina, Siam and Burma to obtain seeds of the chaulmoogra tree, whose oil was used in the treatment of leprosy.

Rock went to China in 1922, and collected there on and off for the next twenty-seven years. He no longer worked for the United States government, but collected birds, seeds and plants for various scientific societies, studied aboriginal tribespeople and translated local literature for ethnographic study. Clearly he spoke fluent Chinese – something none of the British plant hunters had truly achieved. In 1926, he sent seeds of a tree peony that had been cultivated for many years at a lamasery (monastery of lamas) in Cho-ni in Gansu province to Charles Sargent, director of the Arnold Arboretum at Harvard University, who (with the Museum of Comparative Zoology at Harvard) had employed him to explore in the region of the China–Tibet border. The resulting plant matched that described by Farrer and the tree peony grown in Hume's garden, and Sargent sent seeds to many major botanical gardens on both sides of the Atlantic. This tree peony was originally cultivated under the name *Paeonia suffruticosa* 'Rock's Variety', but Professor Hong Tao, the expert on tree peony classification, recognized it as a species in its own right, *Paeonia rockii*. In a twist of fate and a pleasing example of symmetry in the love of plants, the lamasery at Cho-ni was burned to the ground and all its peonies destroyed in 1938. When it was rebuilt, Rock himself sent seeds of the original collection, grown on the other side of the world, to replant the gardens in the restored lamasery.

The revolution of 1949 that gave rise to the People's Republic of China effectively isolated the country from the rest of the world for almost forty years. But love of peonies persisted, and in 1994 the tree peony was voted the Chinese national flower. During those years of isolation, peony breeding and trade was still going on, and many exquisite hybrids based on *Paeonia rockii*, with dark centres, known collectively as 'Gansu Mudan', are now becoming available in the West – East goes West for a second time. A variety with green petals, *Paeonia* 'Dou Lu', is also known, so perhaps the elusive blue tree peony will arrive one day. Crossing for the production of hybrids is extensively carried out within peony classes – herbaceous peonies can be crossed with other

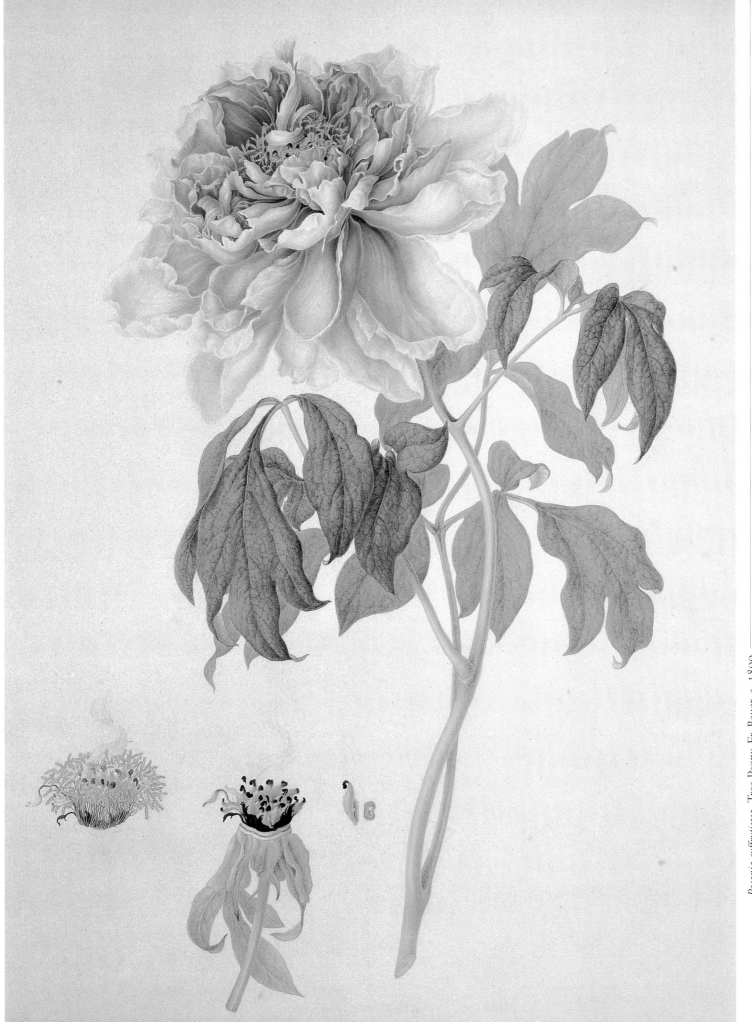

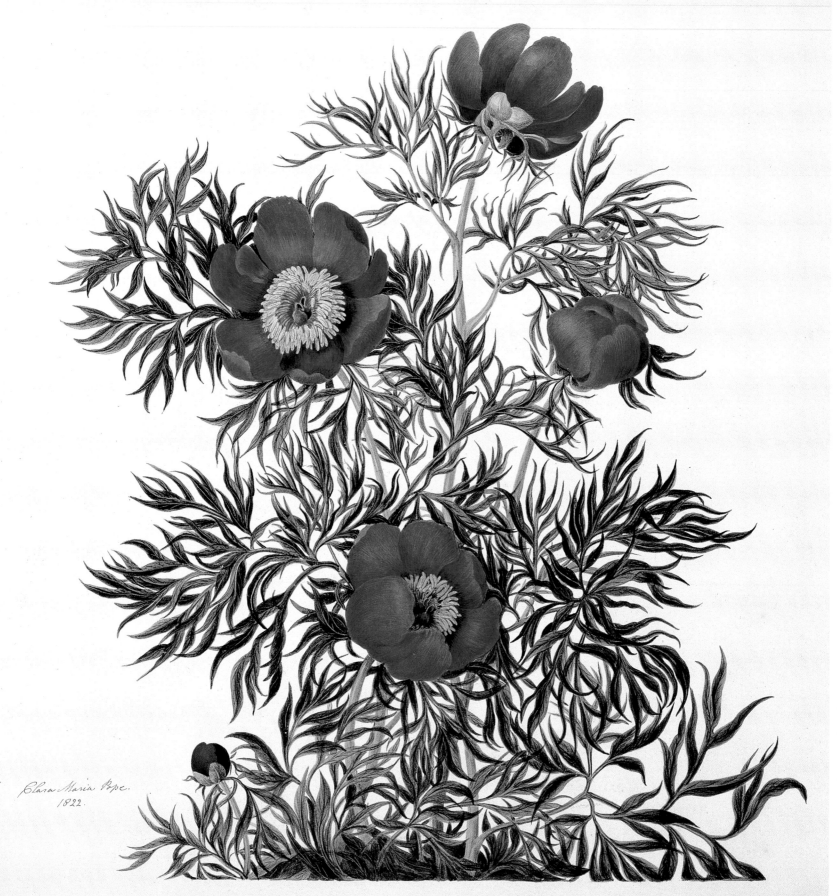

Clara Maria Pope.
1822.

herbaceous peonies – such as the *officinalis* x *lactiflora* crosses available centuries ago, or tree peonies with other tree peonies – but intersectional hybrids were thought impossible (they were attempted, but still impossible). Peony breeders in North America, searching for novelty, wanted to create a herbaceous variety with double yellow flowers – only the tree peonies such as *Paeonia lutea* and hybrids based upon it have truly bright-yellow flowers. The closest they came was to cross *Paeonia mlokosewitschii* (commonly called Molly the Witch, quite understandably) with pale yellowish flowers with a double variety of *Paeonia lactiflora*, to create a pale-yellow single peony, *Paeonia* 'Claire de Lune'. The flowers were yellow, but not bright yellow and not double. But a breakthrough did come about, the result of dogged persistence and incredible hard work.

The Japanese nurseryman Toichi Itoh painstakingly pollinated 1200 individual peony plants in 1948, crossing a yellow tree peony hybrid with a double white Japanese variety of *Paeonia lactiflora*. From all those pollinations he obtained only thirty-six seedlings, most of which resembled the herbaceous peony parent in growth form. Itoh died in 1956, before any of his precious seedlings had flowered, so sadly he did not see the stunning results of all his hard work. His son-in-law Shigao Oshida carried on with Itoh's work and the first of the seedlings reached maturity and flowered in 1963. The flowers were magnificent – deep yellow, double and with red petal bases, the flowers were just what peony breeders had been trying to achieve. The North American peony grower Louis Smirnov was allowed by Itoh's widow to register the hybrids with the American Peony Society and to sell the hybrids developed by Itoh and brought to maturity by Oshida. These yellow-flowered hybrids are today called 'Itoh Hybrids', in recognition of Toichi Itoh's creation of a completely new class of peonies. Peony breeders in the United States soon tried to recreate the intersectional hybrids themselves, and achieved success in the late 1980s with an astounding range of flowers in a bright palette of colours, from the original yellow to deep purple. This collaboration

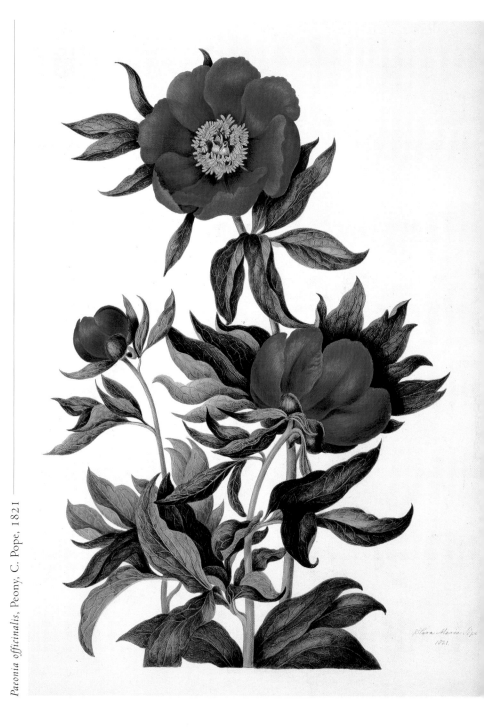

Paeonia officinalis, Peony, C. Pope, 1821

between East and West has benefited all gardeners, with a range of peonies never before imagined. The peony is indeed eternal – everchanging and the subject of festivals and poetry – and will certainly blossom until the end of time in the gardens of both East and West.

Double forms of the wild European peony were soon developed in European gardens. Peonies were one of the essential plants for a 'noble garden' in medieval times, along with roses, lilies, sunflowers, violets and various medicinals and herbs. They were grown not only for their flowers, but also for their seeds, which were used as a spice.

Peony
Paeonia officinalis L. (Ranunculaceae)
G. van Kouwenhoven, Dutch Collection
c. 19th century, watercolour with bodycolour on paper,
408mm x 232mm (16in x 9¼in)

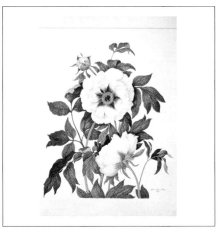

Paeonia rockii is one of the ancestral species from which all cultivated tree peonies are probably derived. This painting, done before the scientific description of the species in 1914, may in fact be another species, or a cultivar that was brought to England by Captain James Prendergast in 1802 and grown in the gardens of Sir Abraham Hume in Hertfordshire.

Tree Peony, Rock's variety
Paeonia rockii (S.G. Haw & Lauener) T. Hong & J.J. Li
(Ranunculaceae), Clara Pope, 1822, bodycolour with
watercolour and gum arabic on paper, bound in volume
727mm x 516mm (28½in x 20¼in)

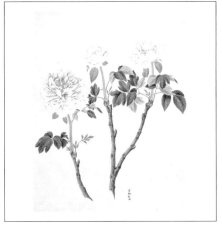

The poetic Chinese common name for this peony, written by the artist in the lower right-hand corner of the painting, is gong fen mudan, *meaning 'the pink-coloured peony used in the palace'. No cultivar of this name exists among today's list of Chinese tree peony varieties, so perhaps it died out or was hybridized with others to create still more variety in these most extraordinary ornamentals.*

Tree Peony; Mudan
Paeonia suffruticosa Andrews (Ranunculaceae)
Anon. Reeves Collection
c. 1820s, watercolour with bodycolour on paper
462mm x 370mm (18¼in x 14½in)

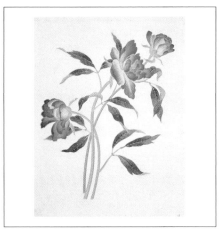

This very Chinese composition looks like it might be an herbaceous peony of hybrid, garden origin – perhaps a hybrid between the Chinese species Paeonia lactiflora and the European Paeonia officinalis. Chinese gardening was sophisticated and well developed long before European contact, and peonies were especially prized.

Peony
Paeonia species (Ranunculaceae)
Anon. Reeves Collection
c. 1820s, watercolour with bodycolour on paper
351mm x 275mm (13¼in x 10¼in)

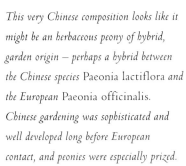

Ehret noted his observations on his sketch: 'Paeonia folio nigricante splendido quae mas/Paeonia mas major/Male = piony'. He crossed out his identification 'mas major', as he probably decided that his plant was indeed the 'male peony', supposedly native in England. The flowers of his plant are very dark, and from his notes we can suppose the entire plant was highly pigmented.

Peony
Paeonia officinalis L. (Ranunculaceae)
Georg Dionysius Ehret
c. 1750s, watercolour with bodycolour and gum arabic
on paper, 442mm x 290mm (17½in x 11½in)

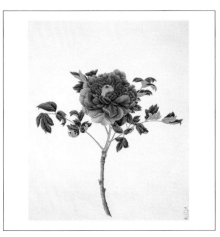

The pink and white Chinese tree peonies are all horticultural varieties derived from only eight wild species – all distributed in central and south-central China. Four separate cultivar groups have been developed in different regions of China, each apparently derived from the original, ancient cultivars of the 'Central Plains', the basin of the Yangtze River. These cultivars do not really have a species name, and are probably derived from Paeonia rockii and Paeonia spontanea.

Tree Peony; Mudan
Paeonia suffruticosa Andrews (Ranunculaceae)
Anon. Reeves Collection
c. 1820s, watercolour with bodycolour on paper
453mm x 377mm (17½in x 14¼in)

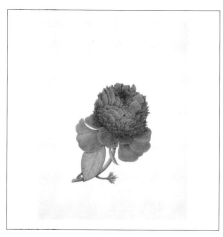

This flower has a crown form like the classic variety 'Wang Hong', or 'Red of Royalty.' The Chinese Tree Peony Association characterizes these forms as having 'wide and expanded outer petals. Completely petaloid stamens usually with the appearance of becoming larger from outside to inside…centre of the flower is raised, forming a crown shape.'

Tree Peony; Mudan
Paeonia suffruticosa Andrews (Ranunculaceae)
Anon. Reeves Collection
c. 1820s, watercolour on paper
320mm x 247mm (12⅛in x 9¾in)

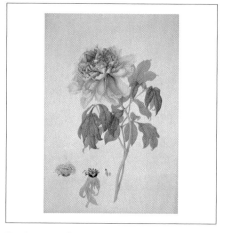

Joseph Banks, President of the Royal Society and botanical adviser to King George III, commissioned Alexander Duncan, a surgeon with the British East India Company, to collect a live specimen of the famed Chinese tree peony for cultivation at Kew. In 1789, Sir Joseph planted the specimen in the garden, so perhaps this is the plant Bauer painted.

Tree Peony; Mudan
Paeonia suffruticosa Andrews (Ranunculaceae)
Franz Bauer
c. 1800, watercolour on paper
512mm x 360mm (20¼in x 14¼in)

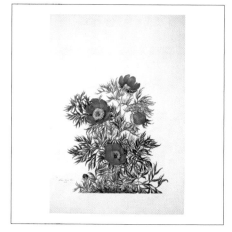

The contrast between the bold flowers and the finely dissected, delicate leaves of the fern-leaved peony give it a fragile beauty that other peonies cannot match. Native to the Caucasus mountains north of the Black Sea, this peony has been sold for use in European gardens since the mid-eighteenth century.

Fern-leaved Peony
Paeonia tenuifolia L. (Ranunculaceae)
Clara Pope, 1822, bodycolour with watercolour and gum arabic on paper, bound in volume
727mm x 516mm (28½in x 20¼in)

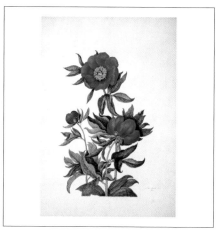

The peony was valued for its medicinal properties – the single, red native peony of Europe is known as the apothecaries' peony. The sixteenth-century herbalist John Gerard, a keen observer of peonies, gives the recipe: 'the black graines (that is the seed) to the number of fifteene taken in wine or mead is a speciall remedie for those that are troubled in the night with the disease called the Night Mare.'

Peony
Paeonia officinalis L. (Ranunculaceae)
Clara Pope, 1821, bodycolour with watercolour and gum arabic on paper, bound in volume,
727mm x 516mm (28½in x 20¼in)

The ancient Egyptians revered the water lily: flowers of the Nile lotus were associated with the emergence of the light of the world, and were worshipped at Memphis as the symbol of the god Nerfertum. The fact that the flowers of the day-flowering blue water lily, *Nymphaea caerulea*, opened up in the morning, then sank beneath the water at the setting of the sun, was seen as evidence of a magical link between the water lily and the morning star. The rising of the beautiful blooms of the water lily, pure and clean, from the slimy muddy river bottom was like the two aspirations of humankind – purity and immortality. Offerings of the two species of water lily commonly growing in the River Nile were made to the dead; in fact, petals of both the day-flowering

The white water lily of the Nile was commonly called the lotus – the source of its scientific name *Nymphaea lotus*. This causes a certain amount of confusion, as the true sacred lotus (*Nelumbo nucifera*) is a native of India and Southeast Asia and, although it is an aquatic with large, round leaves, is a very different plant. The mature leaves of the water lily float on the surface, while those of the sacred lotus are held above the water and are completely peltate, with the stalk placed exactly in the centre of the leaf. Botanists place *Nelumbo* in a different family from the rest of the water lilies – the Nelumbonaceae, as opposed to the Nymphaeaceae – and the two are not even closely related! The *Nelumbo* flower is seen as the seat of Buddha and the epitome

WATER LILIES

A land where all things always seem'd the same!
And round about the keel with faces pale,
Dark faces pale against that rosy flame,
The mild-eyed melancholy Lotos-eaters came.
'THE LOTOS-EATERS' (ALFRED LORD TENNYSON 1832)

Nymphaea caerulea and the night-flowering *Nymphaea lotus* were found in the sarcophagus of Rameses II. Water lilies are commonly portrayed in Egyptian tomb art, and pictures of gardens show the cultivation of the white water lily, *Nymphaea lotus*, in square ponds attached to the rest of the gardens, where nobles are depicted receiving the blossoms of water lilies and twining them in their hair as a mark of respect to the giver. However, it is in the temple at Karnak that water lily art is at its most astounding. The pillars of the temple are topped with what appear to be water-lily blossoms, and their use in the enigmatic narcotic cult of the water lily is perhaps the origin of the clearly drugged lotus-eaters of Tennyson's poem.

of female beauty, and all parts of the plant are edible – the rootstocks are sliced and either cooked or eaten raw, and the seeds are thought to be the legendary Pythagorean beans eaten in Egypt. Lotus seeds, in fact, are notoriously long-lived: some seeds stored in the herbarium of London's Natural History Museum were exposed to water when the herbarium roof was firebombed during World War II and, despite being over 100 years old, and having been stored in the collections for all that time, a few of the seeds germinated when they got wet.

In spite of their differences, which to the uninitiated appear relatively minor, all water lilies must cope with the pressures of living in the water. Living on the land involved a huge number of

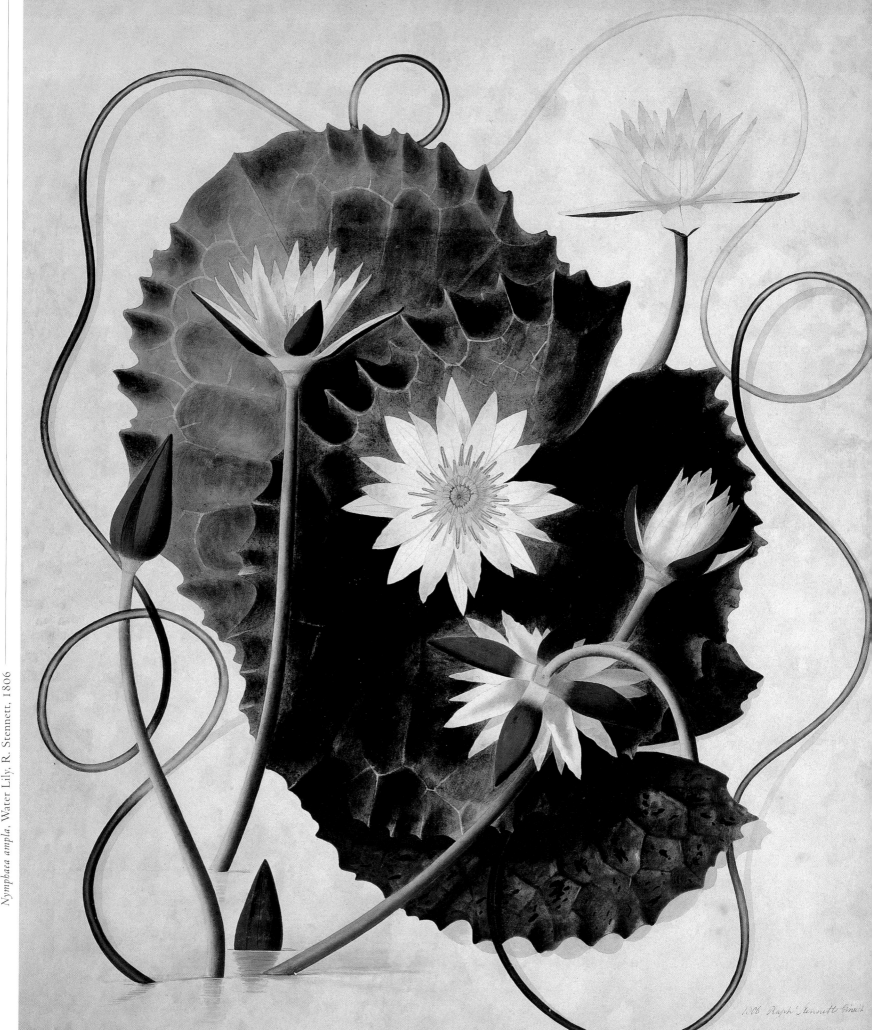

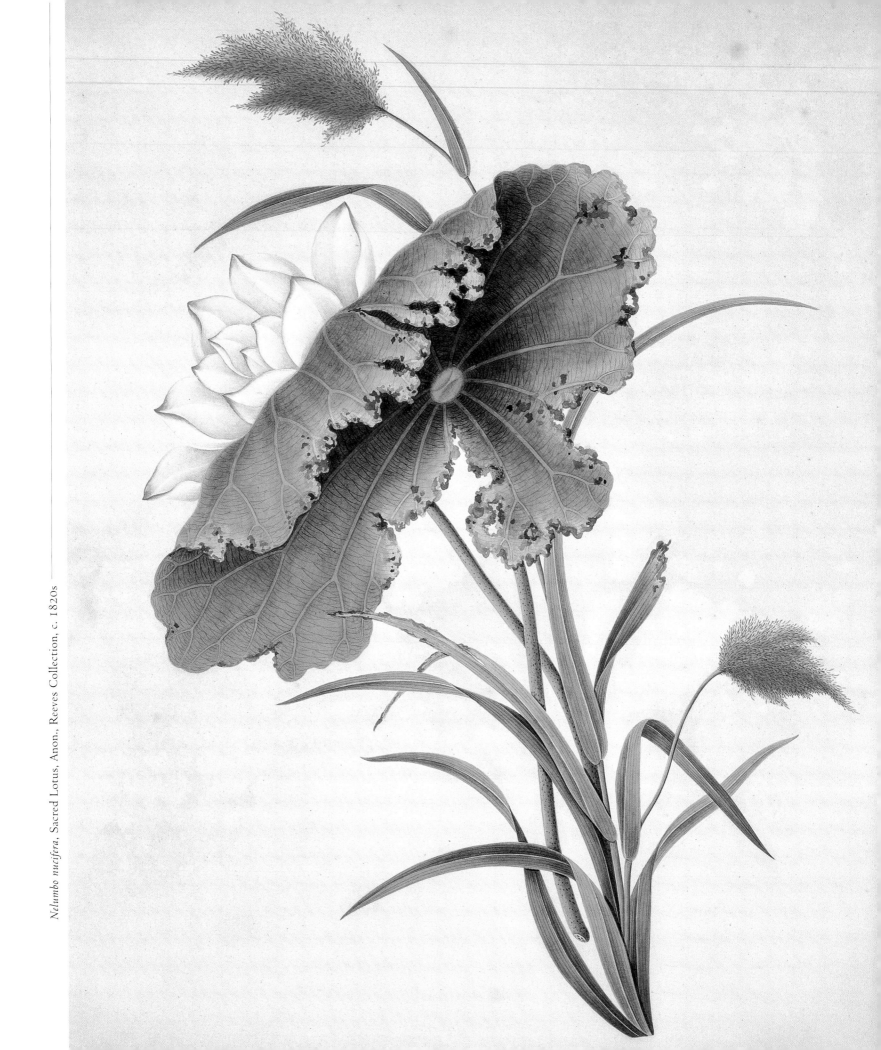

Nelumbo nucifera, Sacred Lotus, Anon., Reeves Collection, c. 1820s

structural changes for plants but, conversely, re-adapting to life in the water has also involved change. All water lilies grow from rhizomes or tubers that sit buried in the nutritious mud of the pond or lake bottom. The leaves and flowers arise directly from the rootstalk and are borne on long, flexible petioles. These whip-like petioles are capable of continuous growth in order to allow the leaf to rereach the surface, should it become submerged by changing water levels. In a nineteenth-century book about the flora of Shropshire, England, a petiole length of more than 4m (13ft) was recorded, but most are shorter. Inside the petiole are cells filled with air – what botanists call aerenchyma – which help to float the leaf. The floating leaves are not the only sort produced by water lilies, though: in fact, three basic leaf types are common to all three types of water lilies (*Nymphaea*, *Nelumbo* and *Nuphar*). Submerged leaves never reach the surface of the water; instead, they are produced at the very beginning of the growing season or on newly germinated seedlings. They look very like the floating leaves, but are very rarely seen. Some tropical species of *Nymphaea*, the sacred lotus and any overcrowded water lilies all produce aerial leaves that are borne above the surface of the water. However, the leaf we all think of as a lily pad is the floating leaf – in *Nymphaea* and *Nuphar*, the mature leaves float, but in *Nelumbo* only the juvenile leaves float (the stronger adult leaves lift free of the surface as the plant reaches maturity). The upper surface of lily pads is strongly water-repellent – if you put a drop of water on a *Nelumbo* leaf, it rolls off like liquid mercury due to the thin coating of wax, which give the leaves a whitish bloom. The leaves of *Nymphaea* are usually shiny, but equally water-shy, and often reddish or purplish on the underside (which is thought to restrict the passage of light through the leaf, making more of it available for photosynthesis in the green parts of the leaves). The mathematical precision and absolute regularity of the veining of lily pads surely helps to keep them afloat, and legend has it that the design of the Crystal Palace for London's Great Exhibition (1851) was inspired by the structure of royal water lily leaves.

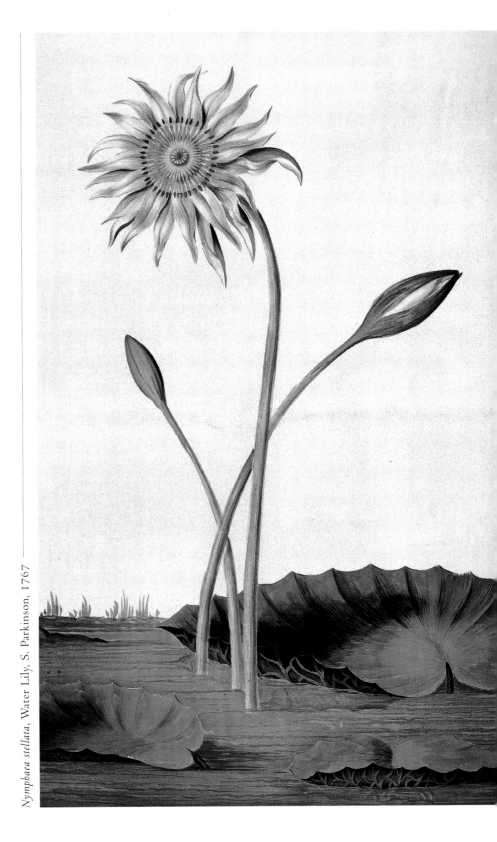

Nymphaea stellata, Water Lily, S. Parkinson, 1767

Water lilies have solved the problem of how to disperse seeds in water in a number of ways – the fruits of many species of *Nymphaea* sink to the bottom when the seeds have developed, where they rot in the mud, releasing the seeds into fertile ground near the parent or further along the stream. The fruits of both *Nuphar* and *Nelumbo* are held above the water, whereas those of *Nelumbo* are a curious structure, with the seeds in holes in a flattened receptacle. When they are ready to germinate, they shake out and float to a suitable site.

Water lilies have relatively short-lived flowers, usually only lasting a few days. All of the species that grow in temperate climates are day-blooming, but in the tropics, as is so often the case, variety reigns. Night-blooming species are usually white, and often have a sweet or sickly fragrance. Some species, however, have reddish or yellowish flowers, or are unscented. On overcast days, the flowers often remain open, indicating that light levels are certainly involved in the closing of the flowers in the morning. The Nile lotus of the Pharaohs, *Nymphaea lotus*, is one of these tropical night-bloomers, with white, incredibly scented flowers. A form of *Nymphaea lotus* grows in hot springs in Hungary. Some have suggested it is a relict of wider distribution of the species in past times, but it is more likely that it is an ancient introduction.

Day-flowering water lilies are many and variable – flower colour in the temperate species is usually white, but in the tropics reds and blues abound. The flowers close up at night and, as observed by the ancient Egyptians and many others since, are pulled down into the water overnight. Many water lilies have flowers that last for two days, changing colour as they age. Sacred lotus flowers change from a vivid rose to a delicate pale pink as they age, while some of the blue species fade gradually to a pale white. Many water lily species are apparently not visited by any pollinators, but others are visited by insects, attracted by the strong scents and bright colours of the flowers.

The flowers' size, colour and scent make them attractive to humans and insects alike, and water lilies are masters at the art of

Nymphaea capensis, Cape Blue Water Lily, Anon., c. early 1800s

74

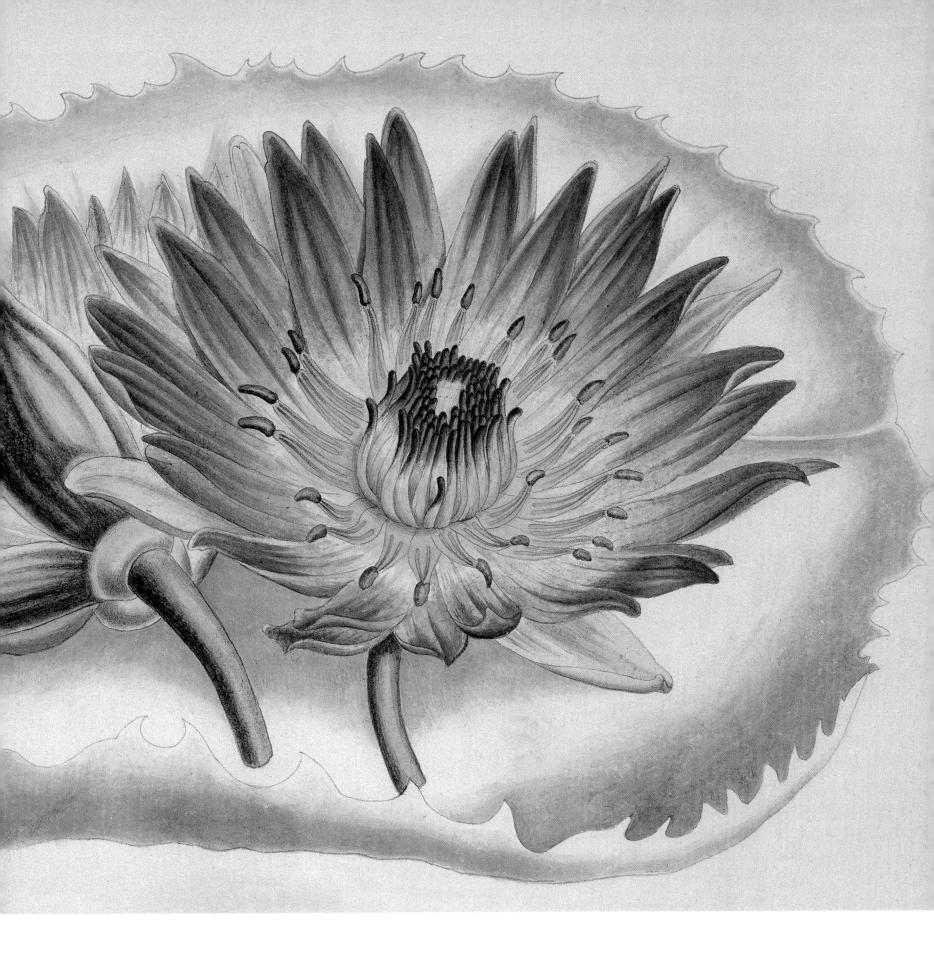

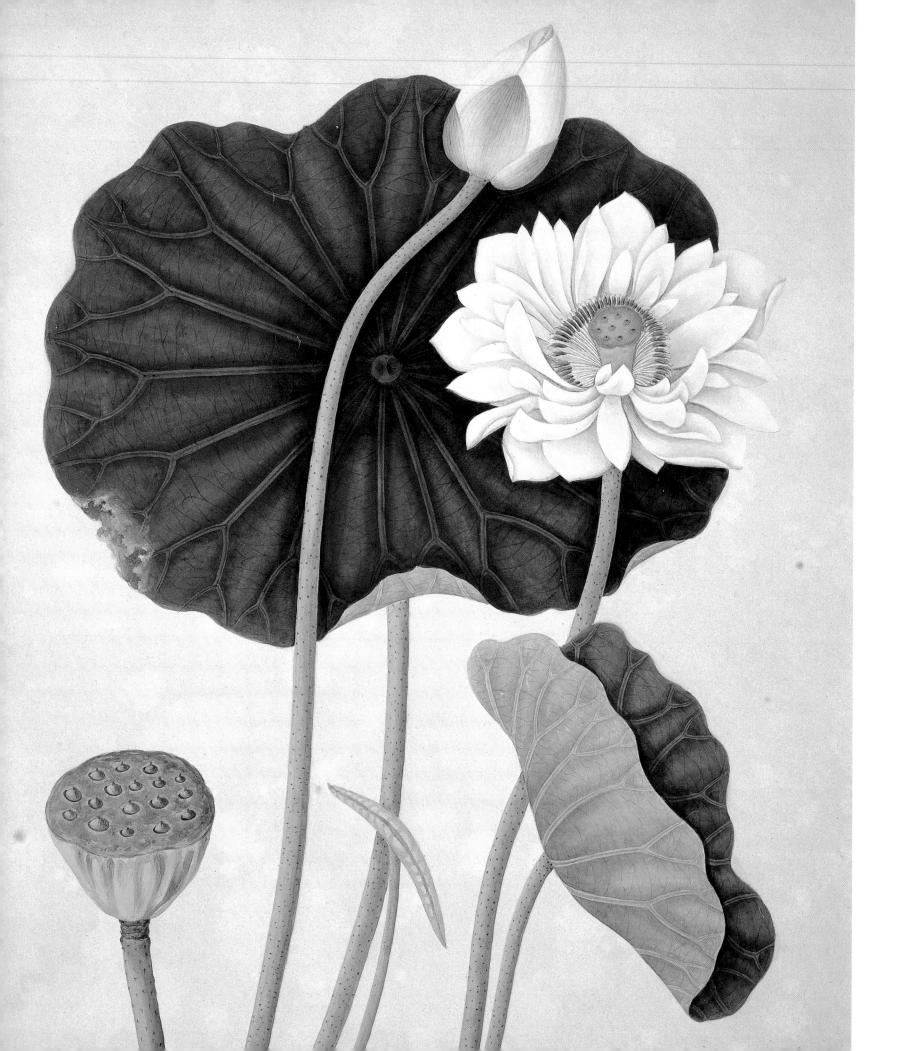

advertising. Insect visitors come for the copious pollen offered by the water-lily flowers in the male stage of their development. The stamens are crowded in the centre of the brightly coloured flower and shed pollen for three or four days running. Each night, as the temperatures and light levels drop, the flower closes, opening the next morning with a new load of abundant, sticky pollen. The water lily appears to be a reliable and abundant source of nutritious food, for pollen is high in nitrogen and is eaten by flies, bees and beetles, all of whom visit the flowers and carry pollen on their bodies from flower to flower.

This bucolic scene of satisfied pollinators and pollinated flowers is, however, only one small part of the picture. On the first day of its life, the water-lily flower is in the female phase of its development and the stamens shed no pollen. Instead, they form an erect ring around a circular pool of liquid in the centre of the flower. The inner ones are coloured yellow (the colour of shed pollen), but it is all splendid fakery. At the bottom of the pool is the stigma, into which pollen grains must grow to fertilize the flower. Insects visiting the flower seem oblivious to the subtle difference in shape on this first (female-phase) day and clamber about looking for pollen, but teetering on the edge of the yellow centre they find – not the masses of sticky pollen they seek – but a slippery, waxy surface devoid of any grip and leading straight into the fluid-filled depths. If an insect ventures too far, in it goes! The fluid contains a wetting agent and, since the waxy surface of the ring of closed stamens offers no grip to aid the trapped creature to climb out, even the smallest insect soon sinks and drowns. Any pollen sticking to the insect's body from a previous visit to a male-stage flower is washed off, sinks to the bottom of the pool on to the stigma and fertilizes the flower. The water-lily flower then closes for the night, and when it opens the next morning the stamens have closed over the pool and started to shed their pollen, ready for the next set of insects to come along and dine.

The most spectacular flowers of all water lilies (at least, to many eyes) are the nocturnal ones of the royal water lily – *Victoria*

amazonica – first seen at the beginning of the nineteenth century by botanists exploring in South America, and described by the German botanist Eduard Frederich Poeppig in 1832 as *Euryale amazonica*. In 1837, while surveying the border of British Guiana (now Guyana) for the British government, the explorer Robert Schomburgk came across this magnificent plant growing in the Berbice River. His description of the sight was the start of a universal desire to have the plant in cultivation, and his suggestion that it be named after the reigning British monarch, Queen Victoria, was avidly taken up by British botanists, who felt themselves in world ascendancy. For a long time the water lily was known as *Victoria regina* or *Victoria regia*, but the rules of botanical naming mean that the first published species name, in this case Poeppig's 'amazonica', takes priority. Botanists agree that the genus is different from *Euryale* – the African giant water lily – so at least part of the royal water lily's name still commemorates Queen Victoria. Schomburgk wrote from British Guiana to the Geographical Society (a letter that was widely published in popular journals of the times): 'we arrived at a part where the river expanded, and formed a currentless basin; some object on the southern extremity of the basin attracted my attention, and I was unable to form an idea of what it could be; but, animating the crew to increase the rate of their paddling, we soon came opposite the object which had raised my curiousity, and, behold, a vegetable wonder! All calamities were forgotten; I was a botanist and felt myself rewarded! There were gigantic leaves, five to six feet [1.5–2m] across, flat, with a broad rim, lighter green above and vivid crimson below, floating upon the water; while, in character with the wonderful foliage, I saw luxuriant flowers, each consisting of numerous petals, passing in alternate tints, from pure white to rose and pink.'

No wonder the race was on to bring this 'vegetable wonder' into cultivation. Various botanists collecting in South America sent seeds back to Britain, as did Thomas Bridges from Bolivia in the early 1840s, but to no avail (they all rotted and died, no

Nelumbo nucifera, Sacred Lotus, Anon., Reeves Collection, c. 1820s

matter how they were treated). By the mid-nineteenth century, however, fresh seeds were sent from Guyana, and they germinated at Kew. Once of an appropriate size, the seedlings were then distributed throughout England and, fortunately, one was sent to Joseph Paxton, chief gardener to the Duke of Devonshire at his estates in Chatsworth. Paxton made a tank for *Victoria*, in a special greenhouse that was constructed so that maximum light would enter. The water lily grew, and its leaves grew bigger and bigger;

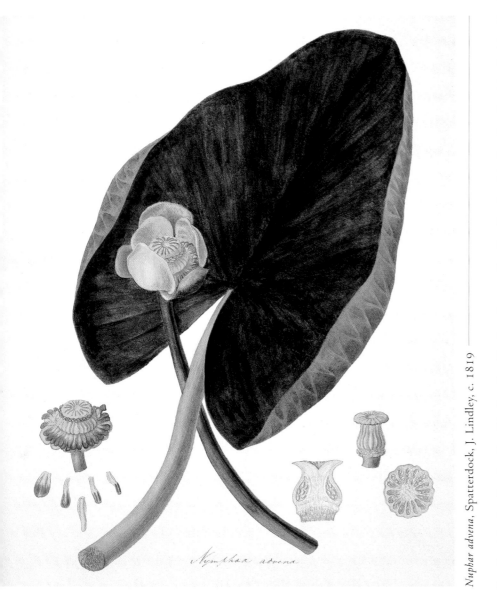

Nuphar advena, Spatterdock, J. Lindley, c. 1819

Paxton even showed how strong they were by having his daughter Annie stand on a board placed on one of the larger leaves. The illustration in the *Illustrated London News* of 17 November 1849 shows a little girl standing primly, dressed for company in crinoline and frilly drawers, in the centre of the leaf – a bit of artistic licence, no doubt, was required, as a board of some sort would have been needed to spread the weight, however small. In November, four months after Paxton received the seedlings from Kew, a flower bud appeared. The size of a cabbage, it opened at night as a pure white flower measuring 30cm (1ft) in diameter, and gradually turned pink that night. The smell is faintly reminiscent of pineapple on the second night of flowering, the flower closing during the day. Paxton was summoned to London to bring a flower and a leaf of the wondrous plant to Queen Victoria, and botanists and members of the public streamed to Chatsworth to view the plant while it flowered, described as 'one of the most elegant objects in nature'. Paxton's tank was so successful that the plants flowered repeatedly, even setting fruit from which seedlings developed. Others soon succeeded in getting the plants to flower in similar tanks: the key, apparently, was constantly to change and agitate the water in which the plants were growing.

Paxton credited *Victoria* with his inspiration for the design of the Crystal Palace for the 1851 Great Exhibition. One time he stated that the lily house he constructed at Chatsworth – having large panes of glass interspersed with girders of a light metal – was the inspiration for the structure: 'It occurred to me, that it only required a number of such structures as the Lily-house, repeated in length, width and height, to form, with some modifications, a suitable building for the Exhibition of 1851. Hence arose the design for that structure.' Later, quoted in a contemporary account, he apparently attributed his design to the structure of the water-lily leaves themselves – 'Nature was the engineer,' said Paxton; 'nature had provided the leaf with longitudinal and transverse girders and supports that I, borrowing from it, have adopted in this building.' Whichever story is true, the Crystal

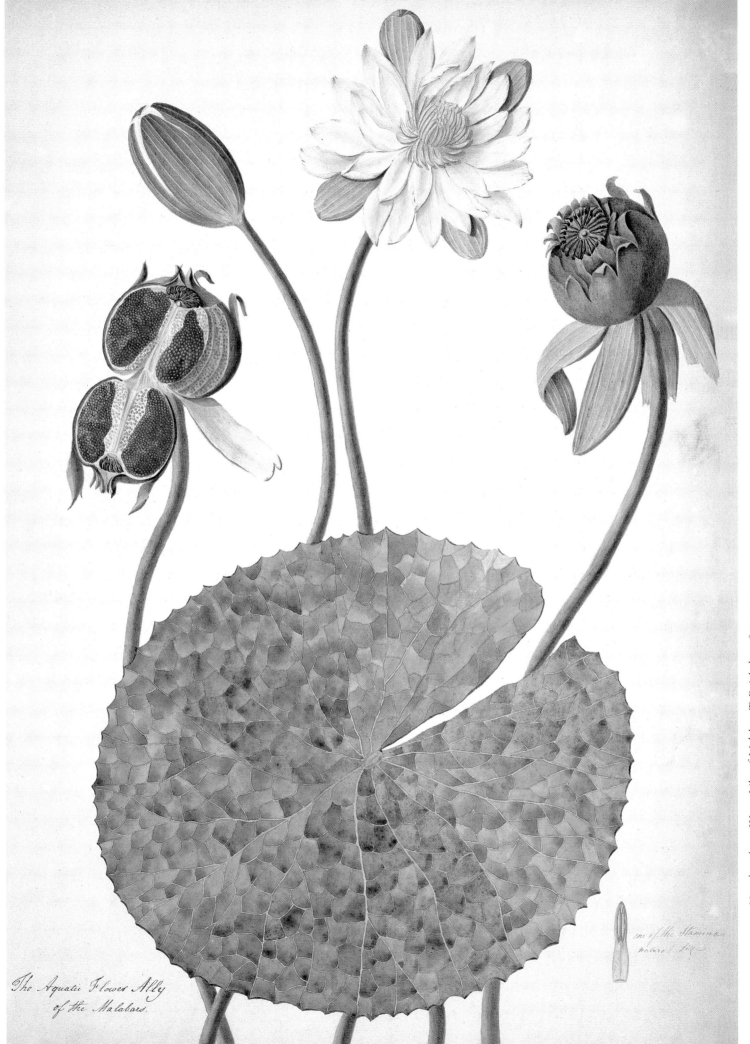

The Aquatic Flower Ally
of the Malabars.

one of the Stamina
nature'd Size

Nymphaea lotus, Water Lily of Malabar, T. Reichel, 1789

Palace was a marvel, and influenced greenhouse design for a long time. And all due to a marvellous tropical water lily…

Beautiful as *Victoria amazonica* is, it is not a plant that everyone can grow, for not everyone has access to the same facilities as a duke. The hardy water lilies are lovely, but are a bit dull, as they all have white flowers. It took the remarkable abilities of a French horticulturalist, Joseph Bory Latour-Marliac, to change the world of water-lily culture. Inspired by an article written in 1858 lamenting the lack of bright colours and exquisite shapes in hardy water lilies, Latour-Marliac set about changing things, and judiciously crossed the brightly coloured tropical species – perhaps the blue *Nymphaea caerulea* or the red *Nymphaea rubra* – with the hardy European *Nymphaea alba* or the North American *Nymphaea odorata*. It took him thirty-two years and his hardy successes (called *Nymphaea* x *marliacea* hybrids) are still immensely popular. Producing some seventy beautiful varieties in the years he spent breeding these plants, Latour-Marliac's work was then carried on by his son-in-law and by others all over the world. Just how he obtained his hybrids is not known, for their parentage was never revealed and he kept his methods strictly secret. Since water lilies are easy to propagate vegetatively by rootstocks, his cultivars are still available and have in turn been used in hybridizations for the creation of more new hardy varieties. Growing water lilies en masse creates a marvellous impression; indeed, many consider Claude Monet's magnificent series of paintings of water lilies at Giverny (his garden in northern France) to be the epitome of Impressionism. Monet was the leading spirit of the Impressionist school, and he painted the world as he saw it – quivering with light and atmosphere. He and Latour-Marliac were exact contemporaries and the first of the water-lilies series was painted in 1903, twenty-four years after Marliac's first hybrid successes had been introduced to the gardens of the time. The pale-pink water lilies in Monet's exquisite Giverny masterpiece are Marliac creations – another incidence of the inspiration these most wonderful of flowers have given to all sorts of people.

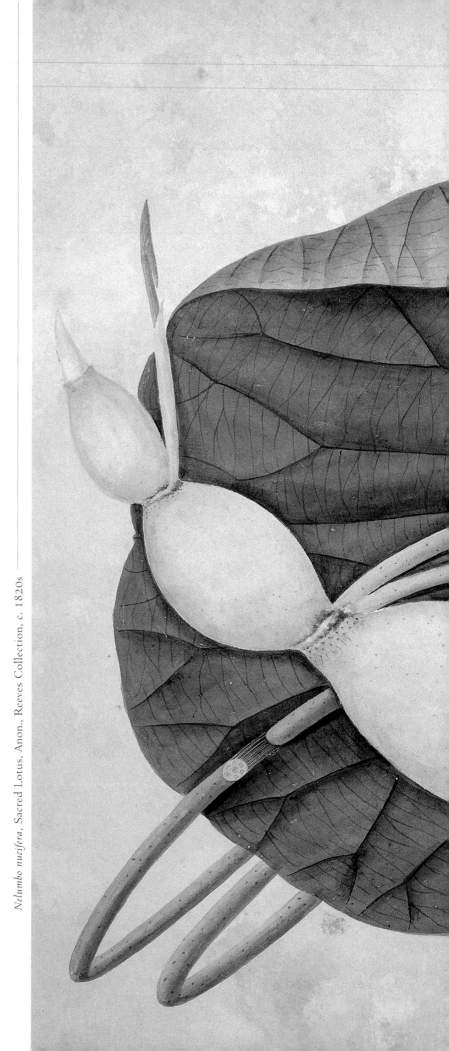

Nelumbo nucifera, Sacred Lotus, Anon., Reeves Collection, c. 1820s

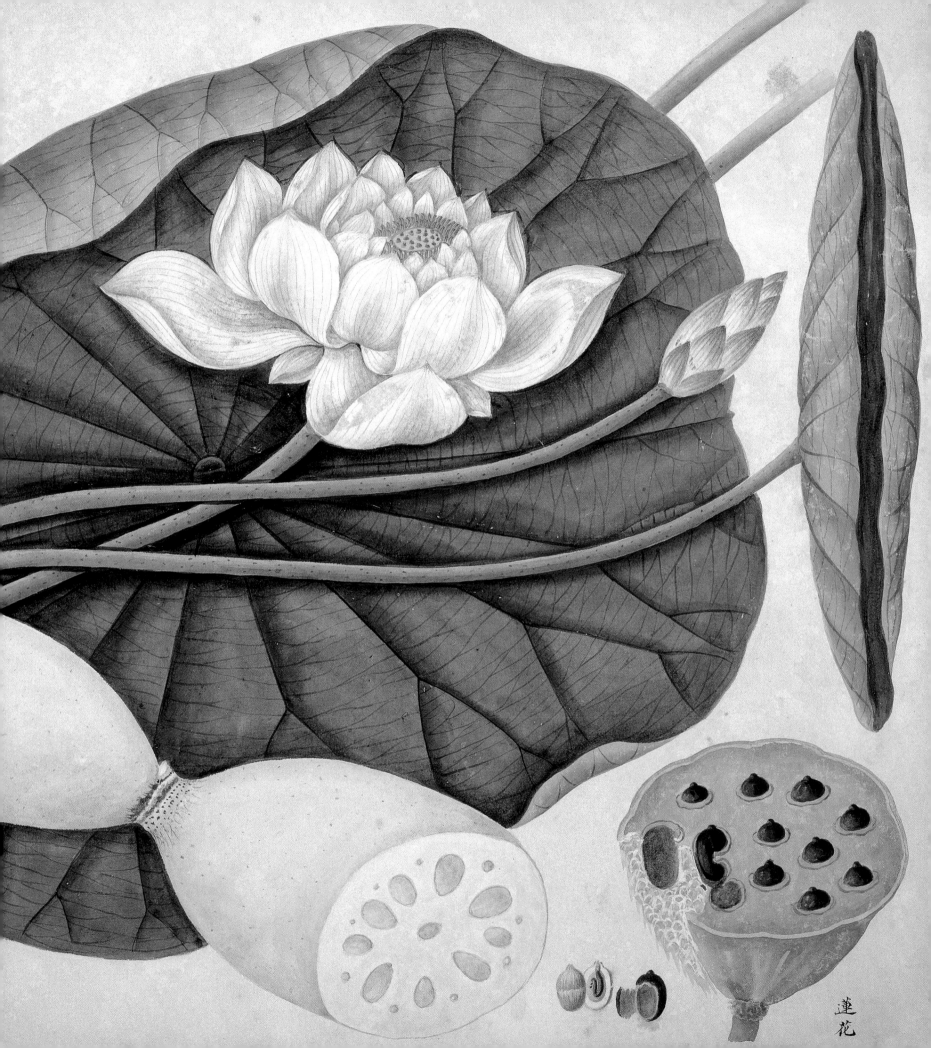

蓮花

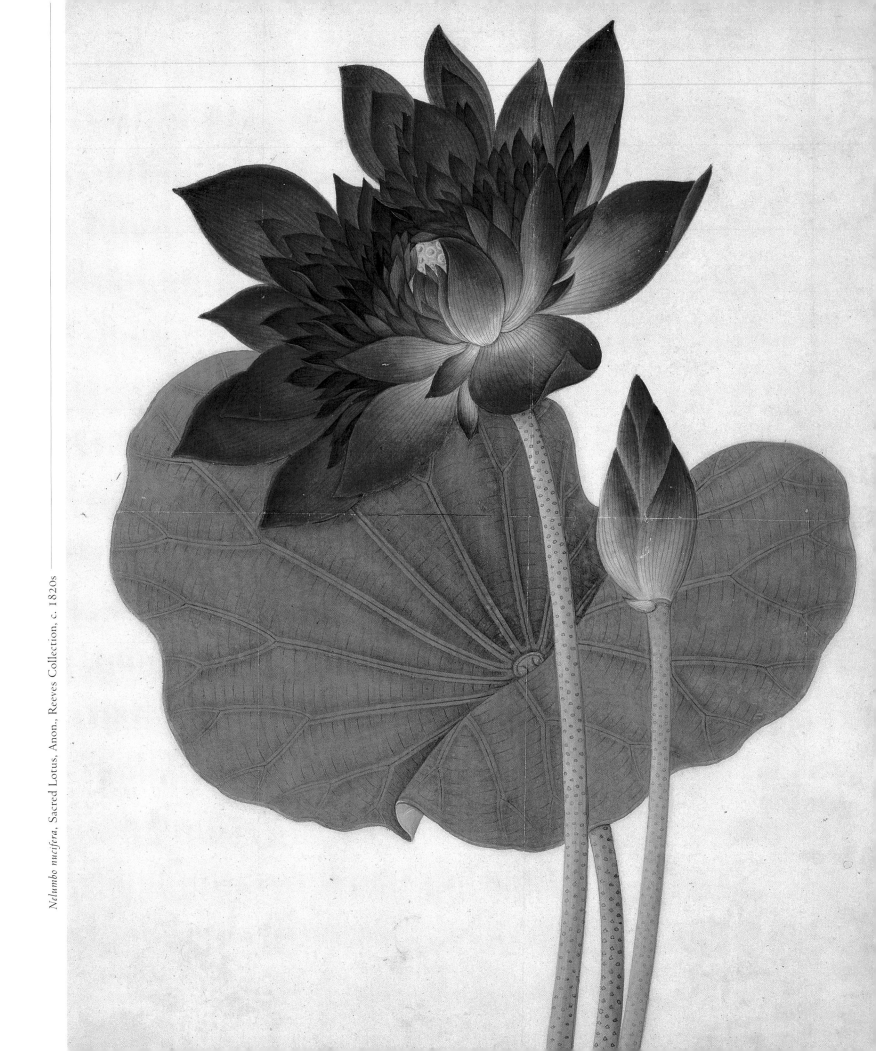

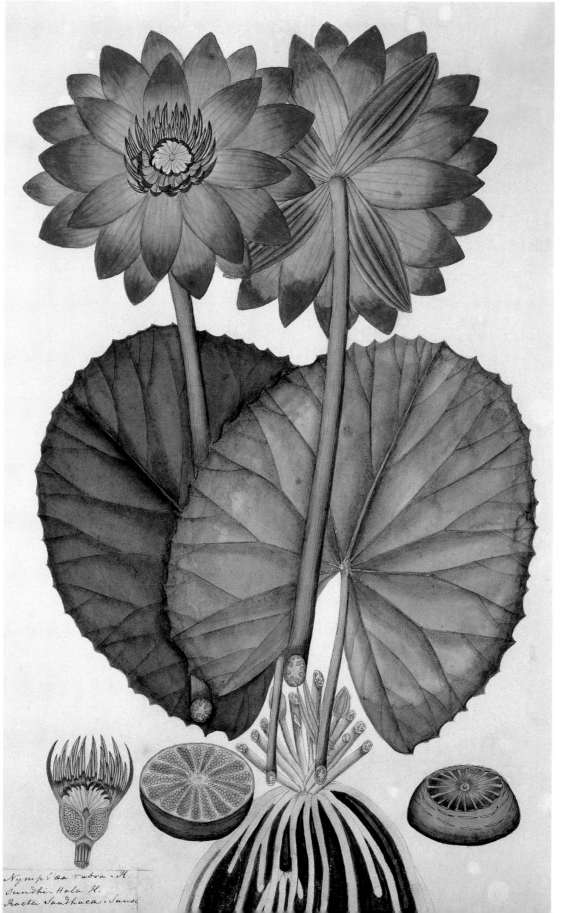

Nymphaea rubra, Red Indian Water Lily, Anon., Fleming Collection, c. 1790s

This water lily is a tropical, day-blooming species from South America. It also goes by the common name of 'dot leaf', but is not often grown for ornament (except by enthusiasts). In the nursery trade, the nocturnal species Nymphaea amazonum is often sold as Nymphaea ampla – with live plants, it is easy to tell them apart, but it is more difficult with a painting!

Water Lily
Nymphaea ampla (Salisb.) DC. (Nymphaeaceae)
Ralph Stennett
c. 1806, bodycolour with watercolour and gum arabic on paper, 505mm x 358mm (19¼in x 14in)

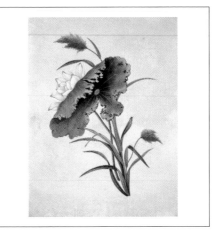

The composition of this painting is more suggestive of traditional Chinese scroll style than of botanical art. The lotus flower hides behind the semi-decomposed leaf, with two stems of what looks like Phragmites australis, the common reed grass, luwei. The lotus was the symbol of summer, so this could be an image about the passing of the seasons.

Sacred Lotus
Nelumbo nucifera Gaertn. (Nelumbonaceae)
Anon. Reeves Collection
c. 1820s, watercolour with bodycolour on paper
478mm x 368mm (18¼in x 14½in)

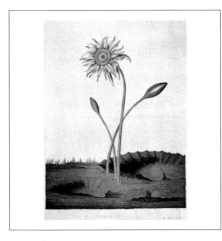

Before he went on Captain Cook's Endeavour *voyage as artist to Joseph Banks, the young Sydney Parkinson taught drawing to the 13-year-old daughter of the west London nurseryman, Mr James Lee. The Lee and Kennedy nursery specialized in new and interesting introductions, and Mr Lee introduced his talented employee to Banks, who hired him on the spot to draw plants he had collected in Newfoundland.*

Water Lily
Nymphaea stellata Willd. (Nymphaeaceae)
Sydney Parkinson
1767, watercolour with bodycolour on vellum
369mm x 284mm (14½in x 11¼in)

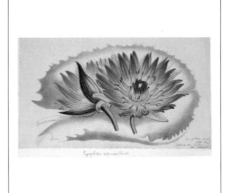

The Cape blue water lily was first brought into cultivation in the Western world in the late eighteenth century from plants collected by Francis Masson in South Africa. In the 1770s, Masson travelled in the (then unknown) province of South Africa in the company of Carl Per Thunberg, a student of Linnaeus. Thunberg was said to be as loud and bragging as Masson was quiet and unassuming.

Cape Blue Water Lily
Nymphaea capensis Thunb. (Nymphaeaceae)
Anon.
c. early 1800s, watercolour on paper
180mm x 318mm (7in x 12½in)

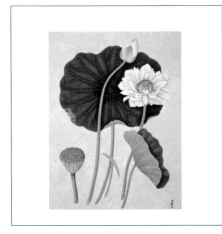

The seed head of the lotus is as peculiar as the flowers are spectacular. Known as lian peng, they consist of a spongy receptacle in which are embedded the separate carpels of the flower, each in its own hole. At maturity, the head breaks off and floats until the receptacle rots and the seeds are released into the water. Sinking to the bottom, they germinate in the nutrient-rich mud.

Sacred Lotus
Nelumbo nucifera Gaertn. (Nelumbonaceae)
Anon. Reeves Collection
c. 1820s, watercolour with bodycolour on paper
485mm x 375mm (19in x 14¼in)

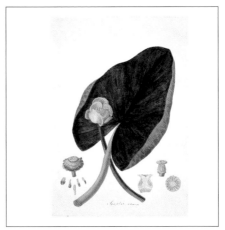

The Aitons were successive head gardeners at Kew's Royal Botanic Gardens. William Aiton was a Scottish apprentice of fellow Scot, Philip Miller, at the Chelsea Physic Garden – in 1759 he went to Kew, and by 1784 was in charge. He described this North American species in the genus Nymphaea (the 'true' water lilies) in 1789. Promoted to head gardener in 1795, his son – also William – transferred it to Nuphar in 1811.

Spatterdock
Nuphar advena (Aiton) W.T. Aiton (Nymphaeaceae)
John Lindley
c. 1819, bodycolour with watercolour and gum arabic on paper, 505mm x 358mm (19¼in x 14in)

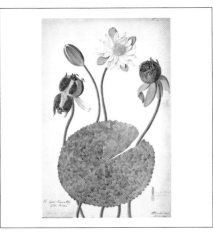

The white water lily was introduced to India from Egypt in ancient times, and in Egypt was revered as a mystical flower. The Book of the Dead chronicles its transformation: 'I am the pure lotus which springeth up from the divine splendour that belongeth to the nostrils of Ra. I have made [my way] and I follow on seeking for him who is Horus. I am the pure who cometh forth out of the Field.'

Water Lily of Malabar
Nymphaea lotus L. (Nymphaeaceae)
T. Reichel
1789, watercolour on paper
524mm x 353mm (20½in x 13¼in)

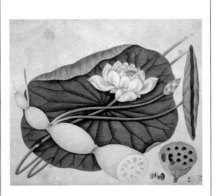

In China, the sacred lotus is called he-hua, lian or furong – lots of names for a plant with many uses! The seeds are considered a delicacy and the underground root, or rhizome, is a popular foodstuff. The harvesting of these underwater roots is traditionally the task of children – considered great fun, it has been the inspiration for many folk songs.

Sacred Lotus
Nelumbo nucifera Gaertn. (Nelumbonaceae)
Anon. Reeves Collection
c. 1820s, watercolour on paper
409mm x 484mm (16in x 19in)

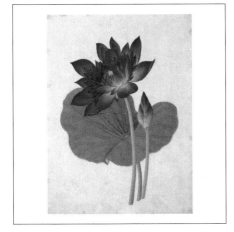

The lotus is a symbol of purity and integrity, a fusion of Confucian and Buddhist concepts. It is the flower of He Xiangu, one of the Eight Immortals, and in Buddhism symbolizes the perfect man. The blooms of the lotus can be as much as 30cm (1ft) across, changing from white to pink with age, but all colour variations between the purest white and red are known.

Sacred Lotus
Nelumbo nucifera Gaertn. (Nelumbonaceae)
Anon. Reeves Collection
c. 1820s, watercolour with bodycolour on paper
390mm x 295mm (15¼in x 11½in)

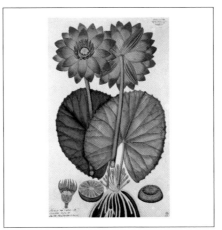

This water lily was described by William Roxburgh in 1803. Its large, slightly fragrant red blossoms open at dusk and close by sunrise. This nocturnal flowering is unusual in a red-flowered species: most red flowers are attractive to highly visual birds, and red is not visible in the dark. Stylistically this painting is very like other water lilies in the Fleming Collection. Perhaps there was a 'template' to which all these water lilies were drawn.

Red Indian Water Lily
Nymphaea rubra Roxb. (Nymphaeaceae)
Anon. Fleming Collection
c. 1790s, watercolour on paper
470mm x 301mm (18½in x 11¼in)

The delicately arching leaves of bamboos dancing across the pages of Chinese silk prints and paintings are very like the strokes of Chinese calligraphy. Forming words with pictures and brushstrokes, calligraphy is not only (literally) 'beautiful writing', but an art form in itself. The pens that are used to paint the characters are made from bamboo stems, and the plant itself lends itself to calligraphic treatment, for bamboos are essentially made up of lines, straight, arching and pictorial. The strokes taken to paint the characters are done not with the wrist, but from the elbow and shoulder, so the whole body – the true inner self – of the calligrapher is involved in what appears on the paper. The brushstroke itself is all-important, and reveals the inner feelings, poles are (weight for weight) stronger than steel, while still being flexible and resilient. Around 300 BCE, the paper on which calligraphy was done was made from bamboo; before that time, it was carried out on silk, or on bamboo blocks. Bamboo was one of the four noble plants in China – along with orchid, plum blossom and chrysanthemum – and symbolized worthy human characteristics. Evergreen and strong, bowing before the wind but rising and straightening again, bamboos encapsulated the Taoist principle of yielding in order to overcome. Imbued with the qualities of strength, lasting friendship, mutual support and perseverance, bamboo was a potent symbol of strength. A New Year card with a picture of bamboo on it sent the recipient wishes

GRASSES & SEDGES

Within the vegetable kingdom
There is a thing called bamboo
It is neither hard nor soft
It is neither herb nor tree.

ZHU PU (BAMBOO MANUAL), CHINESE 460 CE, TRANSLATED BY NEEDHAM (1986)

values and character of the artist. The fusion of literary and pictorial traditions that flourished in the Yuan dynasty of the twelfth and thirteenth centuries became known as *mozhu* ('ink bamboo'). This involved painting with ink on paper, all in black and white, with shape and form uppermost, and the painting itself capturing the true essence of its subject. How logical that these most structural of plants should inspire such wonderful art…

Some might say that bamboos are central to Chinese culture in ways no other plant can claim to be. These amazing plants are used for everything from water pipes to musical instruments, clothing, furniture and food. In much of Asia, even scaffolding is built from bamboo stems – with their high silica content, bamboo

of peace and tranquillity. The upright, hollow stems of the bamboo – of which, more a bit later – represented rectitude and humility. In Japan, as well, bamboo plays an important symbolic role. Many of the implements so critical to the tea ceremony can only be made from particular species of bamboo, and in Japan bamboo is one of the 'three friends', plants that symbolize the three great religious writers. Confucius is represented by the plum, Lao Tse by the pine and Buddha by the bamboo.

But what is bamboo? It is tall, upright, has hollow stems and delicate leaves. It is certainly a plant, but where are its flowers? Bamboos are grasses, in fact. It may be hard to imagine they have much in common with the lawn in one's own back yard, but they

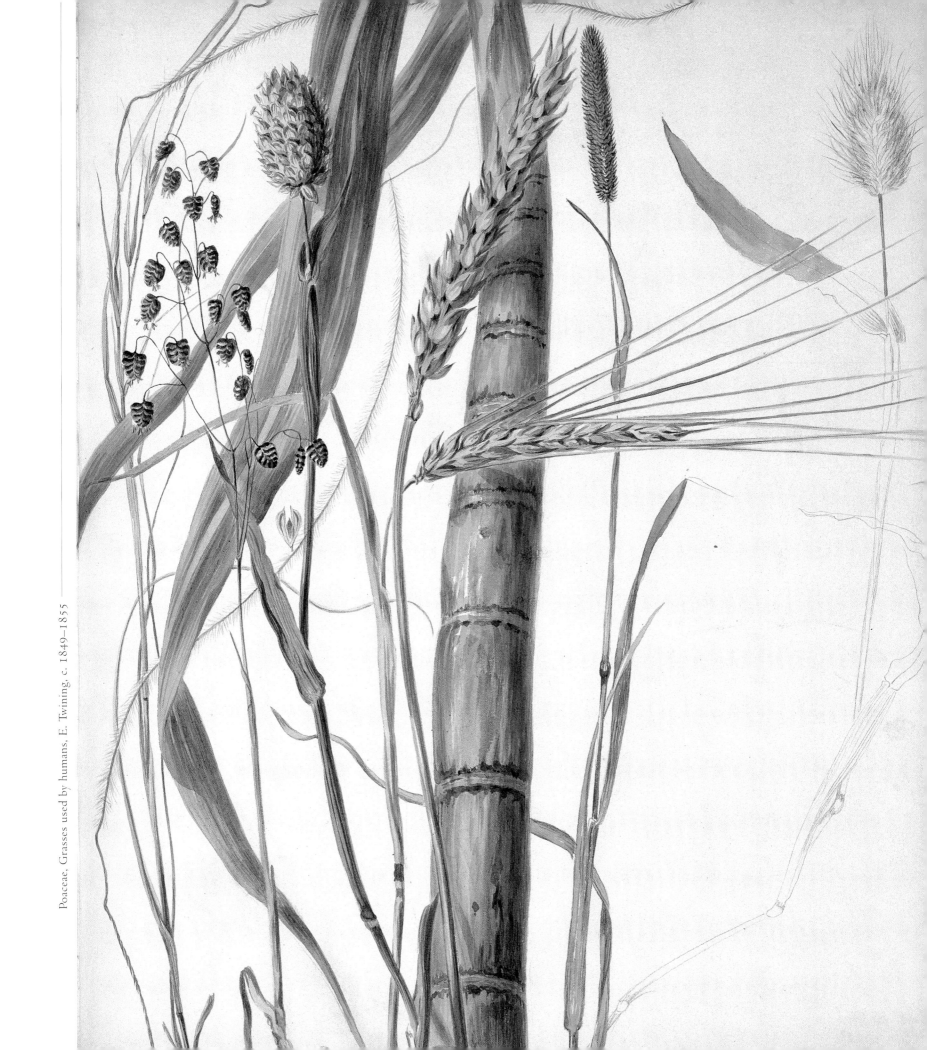

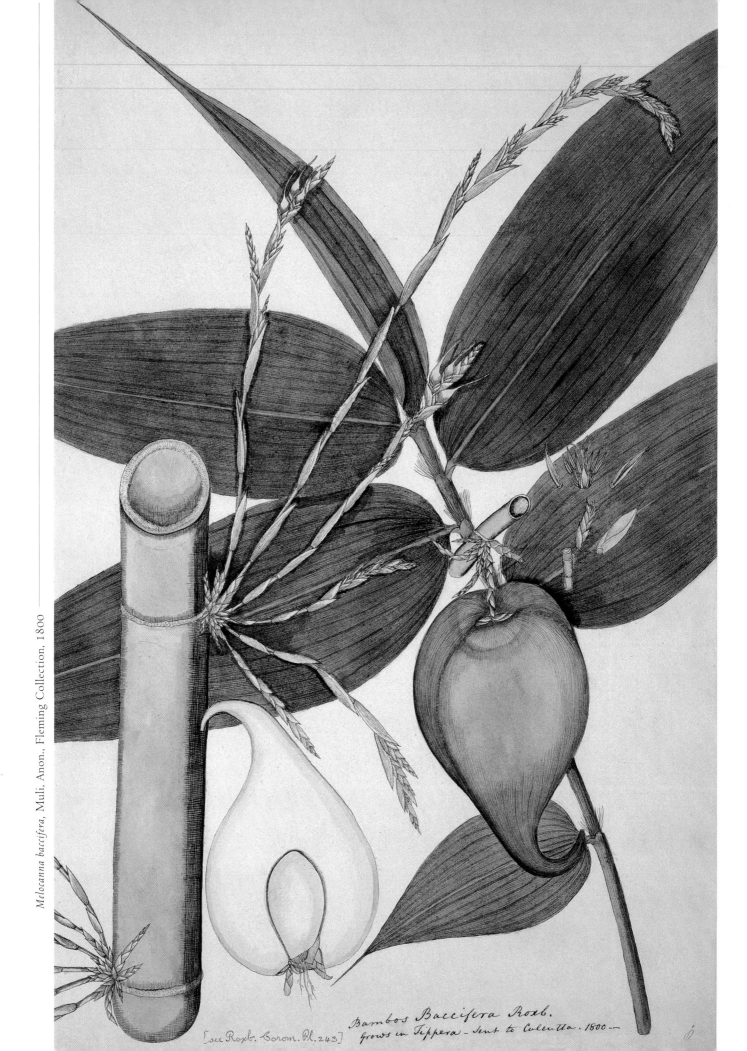

Melocanna baccifera, Muli. Anon.. Fleming Collection, 1800

Bambos Baccifera Roxb.

grows in Tippera – sent to Calcutta. 1800 –

[see Roxb. Corom. Pl. 243]

Cyperus species, Sedge, Anon., Fleming Collection, c. 1795–1805

share critical characteristics that reveal their relationship to the grass beneath our feet. Grasses are monocots – short for 'monocotyledons', so called because a single cotyledon (seed leaf) emerges from the seed as it germinates. Most, but not all, monocots have parallel venation (vein arrangements) in their leaves, which is one reason why grass leaves make such good, squealing whistles when they are blown across. Look closely at a leaf from the lawn and you will see the parallel lines, or veins. A bamboo leaf has much the same vein structure.

Grass flowers, on the other hand, are extremely inconspicuous, except perhaps at hayfever time to hayfever sufferers. Pared down to the absolute minimum of parts, they are extremely efficient structures for doing the job of a flower – getting pollen from one plant on to the stigma of another, effecting fertilization and thus reproduction. All grass flowers are borne in groups in what botanists call an inflorescence, which in the grasses is called a panicle and usually has many branches. The panicle is made up of many spikelets, each of which is a congested axis with structures called florets on it. The grass flower is so minimalist that botanists who study grasses (agrostologists) use special terms for the floral parts so as not to make undue assumptions about their structural likeness to the parts of 'ordinary' flowers. Each spikelet has tiny, leaf-like structures at the base – often a pair of them – called glumes. These glumes sometimes have incredible awns (spikes or hooks) on the back, with a special function at seed dispersal time, and the glumes surround and protect the florets, the 'flowery' part of a grass flower. Each floret has, from bottom to top (or outside to inside, depending on how you view it), a stiff structure like the glumes, but called the palea, which is interlocked with a thinner structure called the lemma. Between them, the palea and lemma hold two or three minute cushiony structures, which some people liken to the petals of 'normal' flowers, called lodicules. The lodicules swell when the floret opens, forcing the palea and lemma apart to reveal the reproductively functional parts of the flower. These important bits are the three anthers, the holders of the

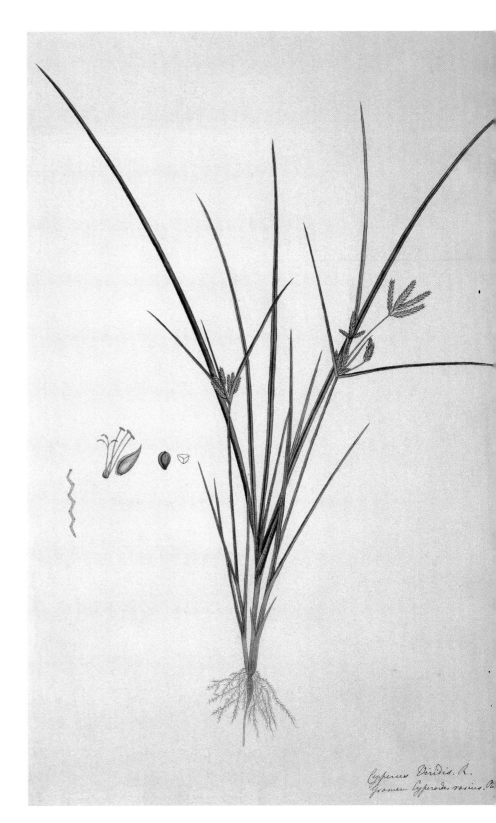

89

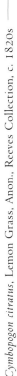

pollen, and the pistil with its feathery stigmas atop the ovary (the source of the seed). All grass ovaries develop into a single seed, usually called a caryopsis or grain, so wheat, oats and corn are also grasses. The grains we cultivate have been bred by humans for centuries to release their seeds without the rest of the floret attached – a great advantage to us for preparation and subsequent consumption – but wild grasses usually release the seed with the glumes, palea and/or lemma still attached. The awns on these structures can be tightly twisted, untwisting when they are wetted – so called hygroscopic (or active) awns. The untwisting of the awn propels the seed across the surface of the soil, hopefully into a suitable microsite for germination such as a crack or crevice.

There is a huge amount of variation in the composition of grass spikelets, but all grasses – including bamboos – share the basic minimalist plan, evolved from a lily-like ancestor. Although bamboos look different, with their woody, tree-like stems, they are perfectly good grasses, if perhaps a bit odd. Some of the species flower only rarely, for instance (some on a cycle of 100 years), dying after flowering. It is claimed that all the members of a single species of bamboo flower at the same time all over the world, then die, but this is certainly untrue, nor does it even make much evolutionary sense. It is true, however, that the gregarious or mast flowering of bamboos can cause problems for other species that depend upon them.

Giant pandas, the emblem of conservation worldwide, subsist almost exclusively on a diet of bamboo leaves, which puts them in direct competition with humans, who also use bamboo for housing and prize the fertile soil on which it grows for agriculture. Therefore, as the extent of the bamboo forests become smaller and smaller, the pandas come to rely on fewer species, so when these bloom at the same time and die back, or are reduced for several years, the pandas suffer. In the forests of Wolong, for example, the population of pandas was reduced from 150 to 20 individuals over eleven years following a flowering event and subsequent die-back. Although bamboo leaves are a pretty tough, nutritionally poor

Cymbopogon citratus, Lemon Grass, Anon., Reeves Collection, c. 1820s

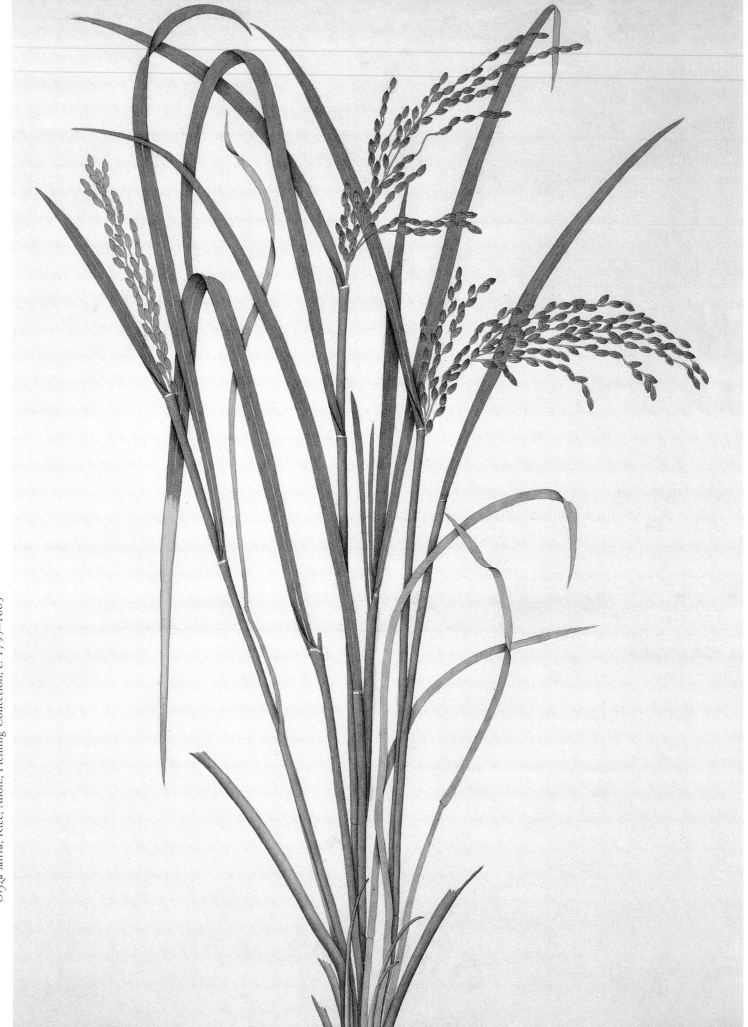

Oryza sativa, Rice, Anon., Fleming Collection, c. 1795–1805

diet, the pandas prefer them to more nutritious food, walking straight past more 'suitable' plants with disdain. The decades it takes for the culms (stems) of the bamboo to re-establish in order to support a population of munching pandas can spell the end for these most fantastic of bears.

Grasses dominate some habitats – the Great Plains of the United States, the Serengeti, the steppes of Central Asia, the pampas of Argentina – and one thing all these places have in common (besides grasses, of course!) is large, herbivorous animals: grazers. It seems obvious that grazers and grazed upon should co-occur, but the dominance of grasses in such places throws into focus some of the aspects of grasses that make them special and that have contributed to their success on a global scale. Many grasses thrive on disturbance – they tend to be primary colonists in open habitats, their nutrient-rich seeds allowing them to get a running start in life as a seedling. They are usually drought-tolerant and their many growth points (tillers) give them a competitive edge in the race for space. They are also opportunists, ready to take advantage of an open habitat, and will persist as disturbance continues. Grazing animals are terrible for plants with a single growing point, for once bitten off the plant dies. Grasslands where grazing animals are excluded, such as the chalk downlands of southern Britain, soon become invaded by shrubs and other woody plants and cease to be grasslands. But grasses are the primary opportunists, taking advantage of the open places – they come to be eaten by grazing animals, which depend upon them. It is a story of mutual advantage, as long as it lasts…

People, also, depend upon grasses. All of our major grain crops are grasses: wheat, oats, rye, maize, sorghum, millet, the list is truly long. Grasses have been domesticated by humans on all the continents – maize in the Americas; oats, wheat and rye in Eurasia; sorghum and millet in Africa; and in Australia grasslands are burned to control grass populations (a sort of incipient domestication). Of the changes in grasses that have accompanied domestication, many help with the retention of the grain at harvest time. A non-shattering spikelet falls as a unit, minimizing loss of precious grains as the plants are harvested. A naked grain means less trouble with winnowing, separating the grain from the chaff (the glumes, paleas and lemmas). Large seeds, like those of maize, provide more nutrition per plant, which is surely important in a crop. Humans have evolved with grasses just as much as the grazing animals have, and arguably more.

More surprising things come from grasses than bamboo scaffolding poles! Sugar cane is a grass (*Saccharum officinarum*), and probably native to New Guinea. It has been grown in India for millennia, and in Europe the sugar extracted from it was an expensive luxury obtained from Arab traders from about the twelfth century. Brought from the Old World to the New by early colonists in the sixteenth century, its cultivation sustained a brutal culture of slavery in the Caribbean. The cultivation of sugar cane requires much land and labour, and the industry was only kept going by the exploitation of generations of people sold into slavery. Sugar cane is a huge grass – quite bamboo-like in fact, but related to maize and to the amusingly named panic (or panicoid) grasses. The canes are planted as cuttings, so many of the vast fields of cane seen in the low elevation tropics are clones, a single genetic individual. Unlike many of the bamboos, the culms of sugar cane are solid; as the plant matures, the cells in the culm fill with sugar, until at harvest the cells can contain as much as fifteen per cent sucrose. This is extracted by pressure, and dried to crystalline form. The squeezed stalks, dried and crushed, are called *bagasse*, and in many parts of the world are used to fuel the sugar-processing machinery – representing a sustainable use for what could be seen as waste.

Grasses are full of surprises themselves, and not

Cortaderia cf. *selloana*, Pampas Grass, Anon... Saharunpore Gardens Collection, c. 1850s

places. In the early 1980s, I was collecting plants for the Missouri Botanical Garden in Panama, and one of my jobs was to go into the field and collect plants that my colleagues in St Louis wanted (it was efficient to have a person based in the field who could go and look for things in out-of-the-way places). One day I got a letter from the grass specialist at Missouri, Gerrit Davidse – at the time just another agrostologist to me, but today my colleague and co-editor of *Flora Mesoamericana*, a compendium of plants from southern Mexico to the border with Colombia. He wanted me to go and attempt to re-collect a grass that had been collected by Tom Antonio (my predecessor in Panama) and that Gerrit thought was a new genus. Finding new species is pretty exciting, but a new genus is a degree more thrilling, so off I went in search of the prize. I had not seen a specimen of this new plant, so really didn't have any idea what it looked like, other than it was small and grew at the base of a waterfall. The waterfall was on the Río Tife, a medium-sized stream flowing to the Caribbean from the continental divide several hours to the west of my Panama city base. A group of us walked all day to get to the small clearing farmed by a few local families, a stopping place on the way to the falls.

We went on the next day, accompanied by Didymo Oliveira, a local farmer, whose personality was just as colourful and exotic as his name. When we finally reached the Río Tife and the waterfall – about 50m (165ft) fall – I searched every stone beneath it, turning them over, looking in the vegetation at the riverside, everywhere, but to no avail. I failed completely to find the new grass. I found a lot of other exciting plants – among them the first collection of a tiny saprophytic gentian from Panama – but no small grass at the base of the waterfall. This was very disappointing, but common, for plant hunting is all about winning some and losing some (we normally only tell the winners!). But Gerrit was persistent and determined, and two years later he went back to the area, still looking for the new grass. With better grass-hunting eyes than mine, and better luck, he found it...but in a most peculiar place. It had been collected previously at the base of the

only in their amazing diversity of uses and of forms but also in the places where they grow. They do not all grow in open habitats or in hot places; indeed some of them are found in extremely peculiar

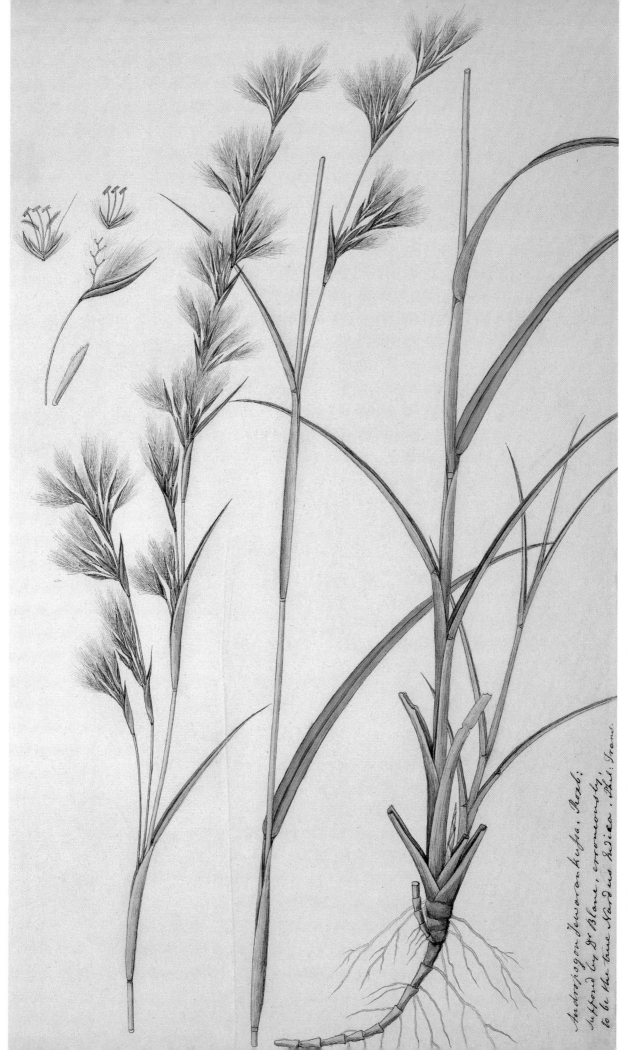

Andropogon Iwarancusa. Roxb.
supposed by Dr Blane, erroneously,
to be the true Nardus Indica. Phil. Trans.

Cymbopogon iwarancusa, Oilgrass, Anon., Fleming Collection, c. 1795–1805

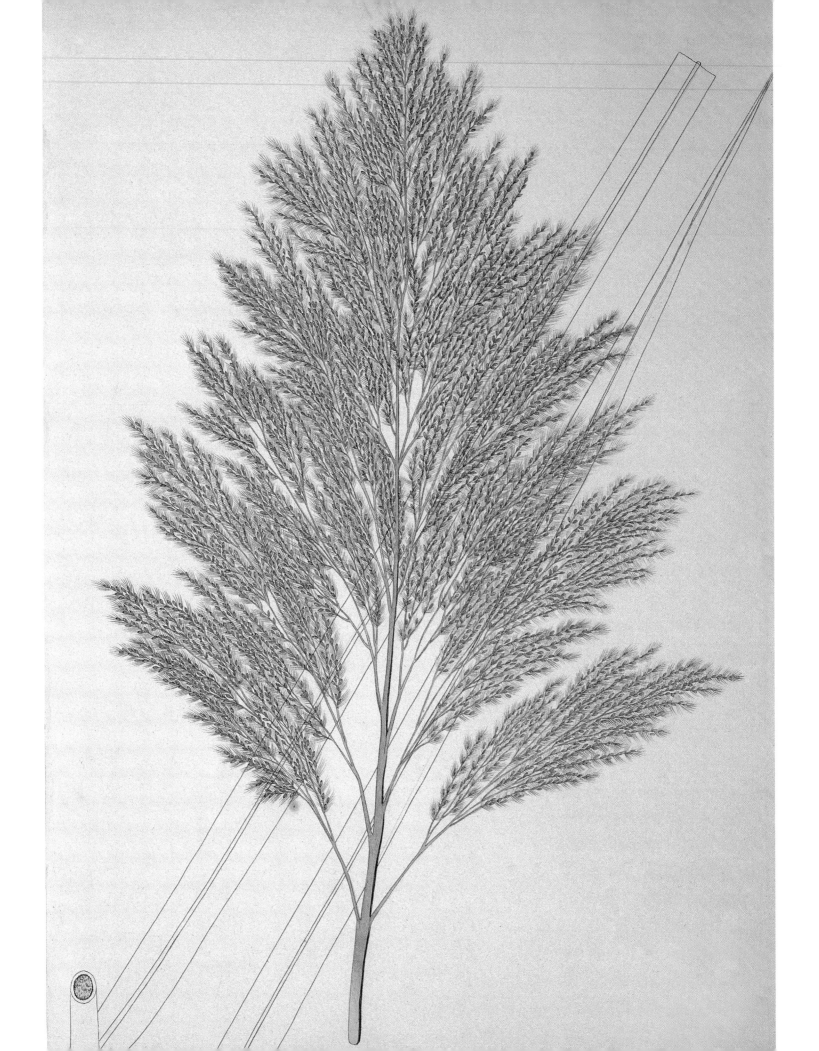

waterfall, where I had failed, but Gerrit found it above the waterfall in a deep gorge – on huge boulders several metres high in the middle of the stream. That first collection had probably been from a boulder that had come over the falls. The new grass, named *Pohlidium* in honour of another agrostologist, is a tiny thing, a mere 10cm (4in) tall, growing in the shade of ferns at the base of boulders – very un-grass-like, it seems. No wonder it had eluded collectors for so long.

Specialists in a particular group of plants are really the best people to find them; their eyes, and sometimes even their hearts, are tuned to just the right wavelength. The bambusoid grasses from the New World – related to the woody bamboos, but herbaceous – have always intrigued agrostologists. Many of them have very peculiar, seemingly primitive, flowers, and some have been through the botanical equivalent of 'lost and found'.

One such mystery involved a hunt that spanned more than a decade…in the forests of Brazil and in the archives of Paris. In the mid-nineteenth century, a French botanist described a most peculiar grass from plants growing in the botanical garden, which was said to have been sent from Brazil. He named it *Anomochloa marantoidea*, and it certainly is an anomalous grass. *Anomochloa* has wide leaves and a panicle with large bracts, and looks for all the world like a strange ginger, or prayer plant (*Maranta*), hence its specific name. The search for the plant began in the 1960s with the deciphering of the labels on specimens held in the Paris herbarium – did they say 'Bahia in Porto' or 'Bahia M. Porto'? One could mean Rio de Janeiro, while the other could refer to the state of Bahia. Handwriting is sometimes terribly difficult to read, and simple mistakes in transcription can lead one down all sorts of blind alleys. Some botanists felt that the Brazilian state of Bahia was too dry to harbour such a grass, obviously a wet-forest plant with its wide leaves. But collections of grasses by the Brazilian collector Romeu Belém from the region around Itabuna in Bahia were full of rainforest novelties, some of which were interesting bambusoid grasses. Thomas Soderstrom and Cleofé Calderón

(both renowned agrostologists) began to search for these grasses all over South America. Bahia was particularly rich in bambusoids, so was perhaps a good candidate locality for finding the elusive *Anomochloa*. Several trips to the region later, *Anomochloa* continued to elude them, but research by Soderstrom in the archives of the Paris herbarium led them to believe that Bahia was indeed the original source of *Anomochloa*, so they kept trying. Their efforts were finally rewarded, however, for Thomas Soderstrom relates that, near the town of Una, Bahia, 'Cleo felt a peculiar – or psychic, as she put it – urge to stop near a particular wooded area. Not far into the woods, which bordered a cultivated area of cacao on somewhat rocky slopes, they came across a colony of the grass.' From this and several subsequent collecting trips, enough material was collected to enable detailed study of this anomalous species. *Anomochloa* turns out to be even more interesting than was thought: it occupies a position at the very base of the family tree of the grasses, and is the most 'primitive' living grass. Knowledge about such species is critical to the understanding of the evolution of the grasses, so the rediscovery of *Anomochloa* was in many ways even more exciting than the discovery of a new genus.

The plant is known from only a few populations in a narrow strip of coastal rainforest in Bahia, which at the time of the rediscovery was under threat from cacao cultivation. The prospect for its survival was dim; indeed, Soderstrom speculated that, 'Unless there are colonies still to be discovered we are probably facing the imminent demise of this unique grass.' Today the Una region is a biological reserve, protected from further development and destruction. The Reserva Biológica do Mico-leão – the Una Reserve – is also home to many other endemics (species known from nowhere else). In the long run, the persistent search for this anomalous grass may have helped them too.

Saccharum officinarum, Sugar Cane, Anon., Fleming Collection, c. 1795–1805

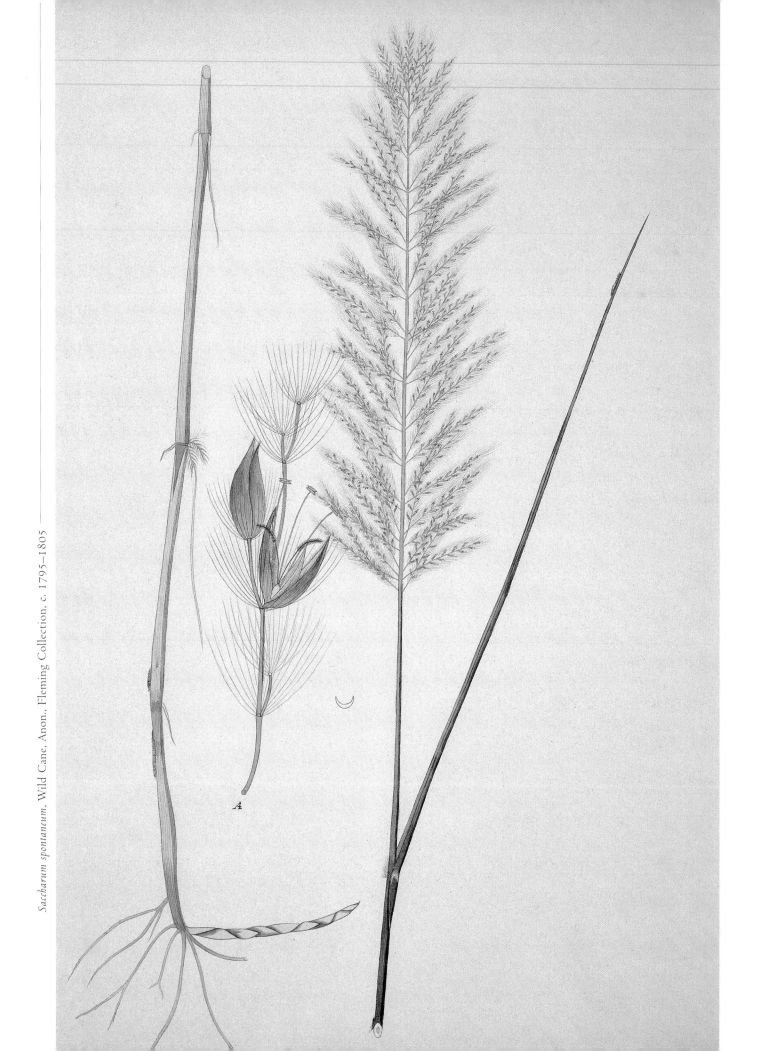

Saccharum spontaneum, Wild Cane, Anon., Fleming Collection, c. 1795–1805

Capillipedium parviflorum, Anon., Saharunpore Gardens Collection, c. 1850s

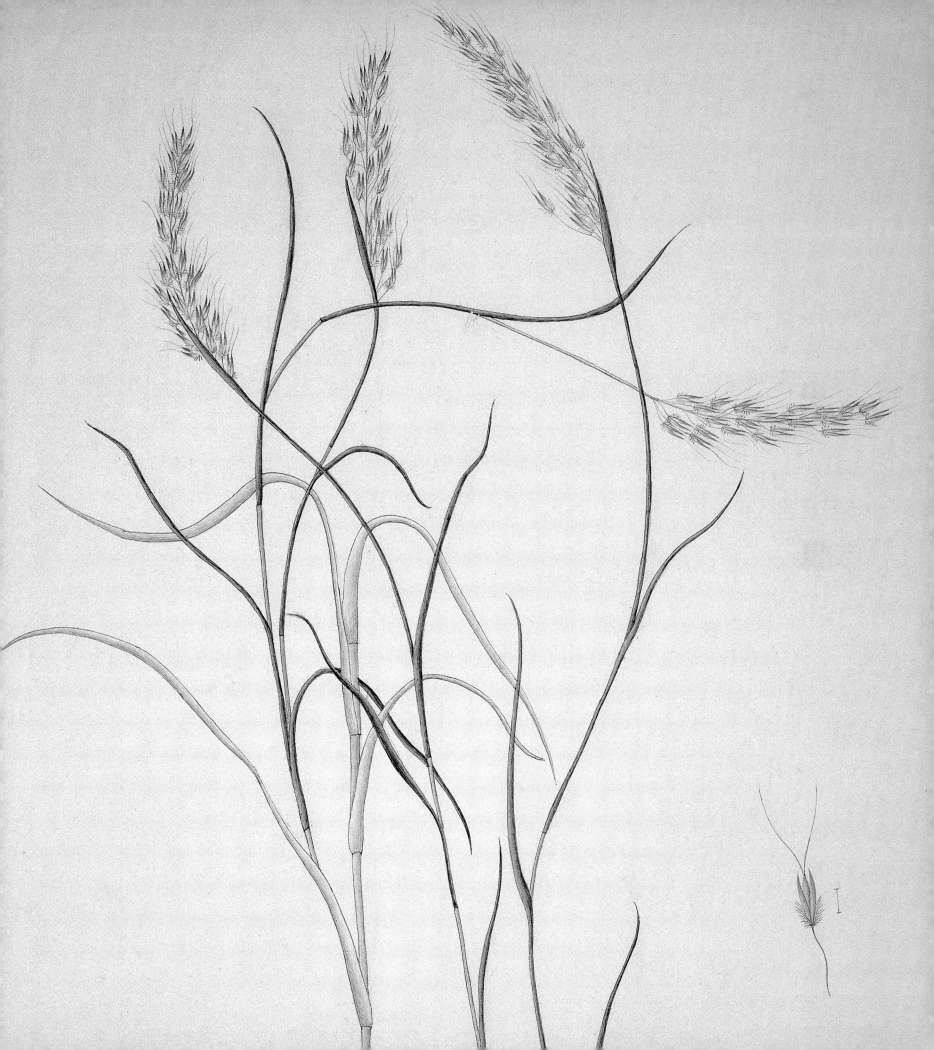

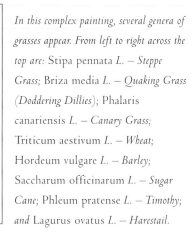

In this complex painting, several genera of grasses appear. From left to right across the top are: Stipa pennata L. – *Steppe Grass;* Briza media L. – *Quaking Grass (Doddering Dillies);* Phalaris canariensis L. – *Canary Grass;* Triticum aestivum L. – *Wheat;* Hordeum vulgare L. – *Barley;* Saccharum officinarum L. – *Sugar Cane;* Phleum pratense L. – *Timothy; and* Lagurus ovatus L. – *Harestail.*

Grasses used by humans
Various genera and species (Poaceae)
Elizabeth Twining
c. 1849–1855, watercolour on paper, bound in volume
400mm x 260mm (15¾in x 10¼in)

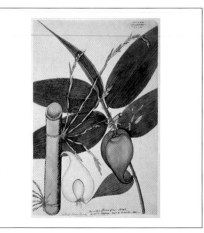

The fruit of muli is unlike that of any other bamboo – the size of a pear, its size and shape is entirely due to the thickened, tough outer covering, inside which there is but a single seed, just like in the grain of wheat. Melocanna *is one of the most important construction bamboos in eastern India and Pakistan, occurring in dense, pure stands in disused agricultural land. In the early twentieth century, 100 tonnes (100 tons) a day were made into paper in Chittagong.*

Muli
Melocanna baccifera (Roxb.) Kurz (Poaceae)
Anon. Fleming Collection
1800, watercolour with ink on paper
444mm x 296mm (17½in x 11¼in)

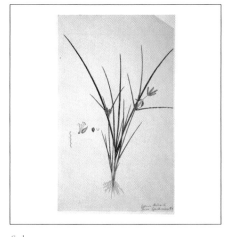

Sedges look very like grasses, until you look closely at the flowers. Sedge flowers are also quite simple, but each is subtended by a single glume. An easier way to tell the families apart, however, is by remembering that sedges have edges – the stems of members of the family are usually triangular in cross-section, rather than round.

Sedge
Cyperus species (Cyperaceae)
Anon. Fleming Collection
c. 1795–1805, watercolour on paper
468mm x 286mm (18½in x 11¼in)

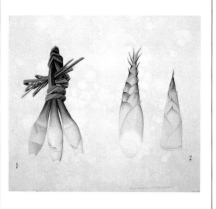

Prepared as for market, the shoots of lemon grass (jiao shun) and bamboo (zu shun) are an everyday part of Chinese cooking. Lemon grass is used for its heady fragrance, and several species are used, but the most common, and most fragrant, is Cymbopogon citratus. *Bamboo shoots are said to have 'consistency that of an apple, the taste that of an artichoke and the nutritional value that of an onion'.*

Lemon Grass; Bamboo Shoot
Left: *Cymbopogon citratus* (L.) Rendle (Poaceae)
Right: unidentified bamboo (Poaceae)
Anon. Reeves Collection, c. 1820s, watercolour on paper
368mm x 412mm (14½in x 16¼in)

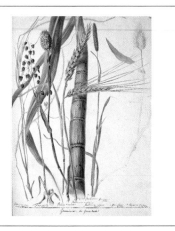

Rice is the second of the flowering plants to have had its entire genome sequenced. This means we now know the base pair sequence on every single chromosome, which is an incredible tool for studying resistance to diseases, the genetics of nutrient content and other characteristics of this ancient cultivated plant. More people depend on rice than on any other grain crop, so it is right that it should have been among the first.

Rice
Oryza sativa L. (Poaceae)
Anon. Fleming Collection
c. 1795–1805, watercolour on paper
627mm x 382mm (24¼in x 15in)

The artist who painted this was a fine close observer of botanical structure. Here we can clearly see grass flower structure in the one-flowered spikelet of Sporobolus. *First, there is a tiny bract on the left-hand side; then, two green glumes; next, the paler lemma (to the right side of the structure) – all enclosing the three dangly stamens and the bilobed stigma.*

Dropseed
Sporobolus coromandelianus (Retz) Kunth (Poaceae)
Anon. Fleming Collection
c. 1795–1805, watercolour and ink on paper
220mm x 168mm (8¼in x 6½in)

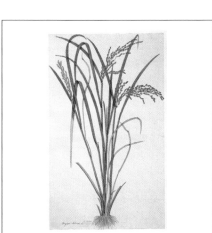

The pampas grasses are native to the great grassy plains of South America, and take their generic name from their vicious cutting edges (cortaderas in Spanish). These grasses are dioecious – plants bearing either all-female or all-male flowers. Female plants are more prized as ornamentals, as their spikelets are more densely covered with silky white hairs, giving the soft, feathery look to the huge inflorescences.

Pampas Grass
Cortaderia cf. *selloana* (Schult. & Schult. f.) Asch. & Graebn. (Poaceae) Anon. Saharunpore Gardens Collection, c. 1850s, watercolour with graphite and ink on paper, 478mm x 318mm (18¾in x 12½in)

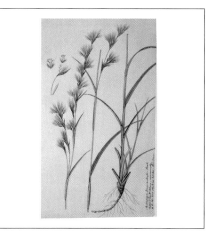

Fleming's note on this painting – 'Andropogon Jewarankufsa Roxb. supposed by Dr. Blane to be the true Nardus indica. Phil. Trans.' – sets a taxonomic puzzle. Publishing in the Philosophical Transactions of the Linnean Society, Dr Blane presumably thought this grass was citronella (correctly called Cymbopogon nardus), which is close, but grasses can be incredibly difficult to distinguish from one another.

Oilgrass
Cymbopogon iwarancusa (Jones) Schult. (Poaceae)
Anon. Fleming Collection
c. 1795–1805, watercolour on paper
465mm x 272mm (18¼in x 10¾in)

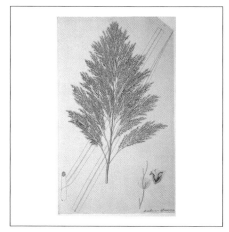

Sugar cane is propagated entirely clonally. This means that the types grown in one area can change radically from one generation to the next. In 1683, when Sir Hans Sloane (whose collections form the nucleus of the Natural History Museum's material) went to Jamaica, the principal cane variety was Indian, like this one. By the eighteenth century, clones from Java had taken over in the New World.

Sugar Cane
Saccharum officinarum L. (Poaceae)
Anon. Fleming Collection
c. 1795–1805, watercolour with ink on paper
463mm x 283mm (18¼in x 11in)

Cultivated sugar cane is a species of hybrid, horticultural origin. The wild cane, native to Asia, is important in plant breeding for the introduction of disease resistance and other desirable characteristics. A century ago, the 'noble canes' – Saccharum officinarum – were the only types cultivated, but today hybrids with wild cane are increasingly important.

Wild Cane
Saccharum spontaneum L. (Poaceae)
Anon. Fleming Collection
c. 1795–1805, watercolour and graphite on paper
467mm x 277mm (18¼in x 11in)

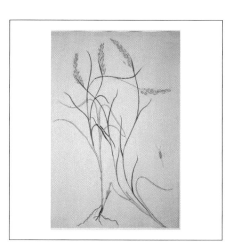

The schematic nature of the painting makes this grass difficult to identify. Several specimens of this grass from the Saharunpore Gardens are housed in the Natural History Museum herbarium, and look very like the image here. The two awns arise from sterile flowers in the spikelet – not an easy structure to interpret. Notes on a specimen collected by Frank Kingdon-Ward say that this grass is common in burned areas in the foothills of the Himalayas.

Capillipedium parviflorum (R.Br.) Stapf (Poaceae)
Anon. Saharunpore Gardens Collection
c. 1850s, watercolour and graphite on paper
490mm x 325mm (19¼in x 12¼in)

The genus to which all daffodils belong is *Narcissus*. This includes the daffs, poet's narcissus and jonquils – not just the paper whites we associated with the common name 'narcissus'. The beautiful youth Narcissus was the son of the water nymph Liriope (whose name was given to a lily by Linnaeus!) after her ravishment by Cephissus the river god. When his mother consulted the blind sage Tiresias to see whether he should enjoy a long life and a ripe old age, Tiresias replied, 'If he shall himself not know.' Narcissus was loved and lusted after by everybody, including the nymph Echo, who was condemned to repeat the last thing anyone said (as punishment from Juno, whom she kept engaged in conversation while the nymphs 'lying with Jove upon

of the Underworld. When his body was sought, nothing was found except a daffodil: 'white petals clustered round a cup of gold'. Some have suggested that Narcissus thought the reflection was the image of his long-lost sister, but the use of the daffodil as the emblem of self-love in the age-old language of the flowers indicates that it was Ovid's first-century Roman version of an ancient Greek legend that stuck. Others, including Ovid's contemporary Pliny, have suggested that the name 'Narcissus' comes not from the legend, but from the Greek root *narce*, which refers to the narcotic properties and perfume of the flowers. Victorian authors avowed that the flowers of daffodils produced a scent that induces madness, and that vases with narcissi kept in an enclosed room produced an

DAFFODILS

And then the brandished torches, bier and pyre
Were ready – but no body anywhere;
And in its stead they found a flower – behold
White petals clustered round a cup of gold!

METAMORPHOSES (OVID AD I, TRANSLATION A.D. MELVILLE, 1986)

the mountainside' made their escape). Echo followed Narcissus, echoing his words, until he mocked her and rejected her embraces, saying he would die before he would yield to her. She hid in lonely caves, withering away until only her voice remained ('just a sound'). Vain Narcissus continued to reject all advances, until one day – while hunting – he came upon a limpid pool undisturbed by any branch or shade. After slaking his thirst, he gazed into the pool and beheld a face, with which he fell desperately in love. Reaching into the pool to embrace and kiss the face, he in turn felt the rejection with which he had treated so many (including Echo) and, wasted by love, he dies – 'slowly he dissolves by hidden fire consumed' – to gaze hereafter upon his own reflection in the pool

odour that was extremely disagreeable and probably 'injurious to sensitive persons'. In any case, the Greeks' narcissus would have been *Narcissus tazetta*, whose white outer petals and bright-yellow corona match Ovid's plant. *Narcissus tazetta* is native to Greece and Italy, but there is ample evidence that trade in flower bulbs was widespread at the time of the Roman Empire, and the narcissi, with their beautiful flowers and sweet (if slightly overpowering) perfume must have been sought after and prized.

Daffodils were reported to have been cultivated in China as early as the thirteenth century, but which species these might have been is difficult to ascertain, as today daffodils are found growing as if wild in both China and Japan (in fact, all over the northern

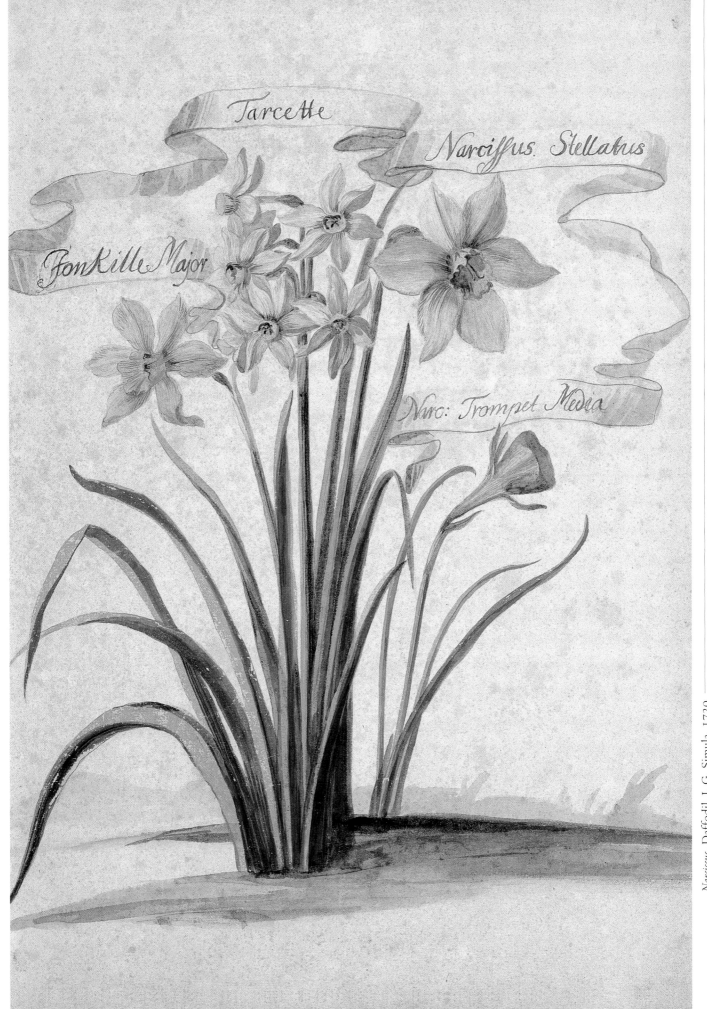

Tarcette

Narciffus. Stellatus

JonKille Major

Naro: Trompet Media

delin: March 20. 1765

B.M.
(N.H.)

hemisphere). The Ottoman Empire assisted greatly in the dissemination of plants: keen traders throughout their own empire, they also received visits from European travellers of all sorts. One such was the Bavarian physician Leonhard Rauwolff, whose three-year journey from Augsburg to Tripoli to Aleppo, on to Baghdad and then back via Jerusalem, was the first real modern botanical field trip to be undertaken by a western European to the Near East, so long a place of conflict between Christianity and Islam. Rauwolff left Augsburg in 1573, his journey undertaken in order to discover and verify the qualities of herbs described by the ancient Arabic and Greek physicians, upon whose works northern European doctors relied heavily and whose identities were known only by hearsay. The herbarium (a collection of dried plants that serves as a permanent record of what grew in a particular place at a particular time) that Rauwolff brought back from his three arduous years of travelling is the first of its kind, and in it we can see concrete evidence of what Rauwolff himself saw. It must have been incredibly difficult to preserve intact a growing collection of dried plants, all the while travelling with groups of local people whose schedules were not necessarily geared to botany. For most of his journey, Rauwolff was accompanied by just one other European (he made contact with the increasing communities of European traders – French, Venetians and Germans, who were establishing themselves in the opening markets of the Near East). His observations on the religions and cultures of the region make fascinating reading; indeed, he was probably one of the first Lutherans, and thus one of the first Protestants, to make a pilgrimage to Jerusalem. Rauwolff was also the last Protestant to undertake the journey as a true pilgrimage, as subsequent Protestant travellers came as curious travellers rather than as pilgrims. One English clergyman in 1600 was careful to let all and sundry know that he and his companions went to Jerusalem, 'not moved as Pilgrims with any superstitious devotion to see Relickes or worship places as they account holy; but as Travellers'. While Rauwolff was in Aleppo (in today's Syria), either on his way to

Baghdad or on the way back to Jerusalem, he saw daffodils, including a strange doubled variety: 'In their gardens the Turks love to raise all sorts of flowers, in which they take great delight and put them in their turbans, so I could see the fine plants one after another daily, without trouble. In December I saw violets with dark brown and white flowers… Then came the tulips, hyacinths, narcissus, which they still call by the old name *nergies*. Before all the others I saw a rare kind of narcissus with double yellow flowers called *modaph*.'

Specimens of both *modaph* and *nergies* (our old friend *Narcissus tazetta*), if Rauwolff collected them, are probably to be found in his

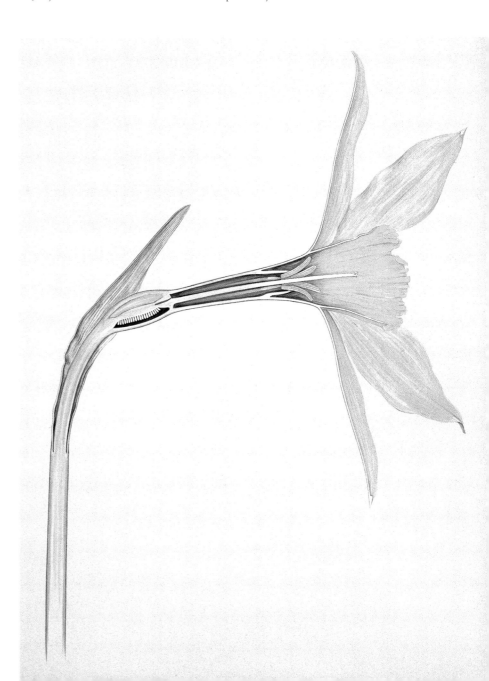

bound volumes of dried plants, now housed in the collections of the Leiden herbarium. These valuable volumes made their way to Holland from Augsburg via Sweden, where they were taken during the seventeenth century as a gift to Queen Christina, whose heirs then sold the volumes to the city of Leiden. Rauwolff did not bring live plants back to Germany – his mission was to record the identities and characteristics of plants used in the Near East, but during his lifetime plant introductions were then beginning to flood into Europe from the ever-expanding world outside its borders. Rather ironically, Leiden Rauwolff died in 1596, from dysentery contracted while fighting the Turks (among whom he had moved freely two decades before), who were fighting the Austro-Hungarian emperor in Hungary.

A year after Rauwolff's death, John Gerard published *The Herball, or Generall Historie of Plantes*. This monumental compendium of plants grown in gardens, for medicinal and decorative purposes, greatly expanded the scope of botanical works available at the time. Gerard was a qualified barber-surgeon in London in the late sixteenth century, and at that time the physicians, surgeons and apothecaries were all members of separate guilds and had different training – the physicians were versed in Greek and Latin, surgeons were trained only in Latin and more practical techniques, while the apothecaries were lumped with the grocers as purveyors of herbs. Around the time Rauwolff was returning from his travels, Gerard was appointed the superintendent of the gardens of Lord Burghley

– Sir William Cecil – the Lord Treasurer of England. In these gardens a collection of plants, both exotic and native, was being established, and many novelties were being grown there. In addition, Gerard had extensive collecting experience in Kent, and as far away as Bristol (where he went on Burghley's business). In his own and Lord Burghley's garden, Gerard grew many varieties of narcissus – he records more than fifty kinds in *The Herball*. By the time John Parkinson, Gerard's successor in the service of King James I, wrote his gardening manual *Paradisus Terrestris* in 1629, almost 100 different kinds of *Narcissus* were grown in the gardens of the English. Gerard, like Rauwolff, records double varieties, including one called the 'Double white daffodil of Constantinople', 'sent into England unto the right honourable Lord Treasurer, among other bulbed flowers; whose rootes when they were planted in our London gardens, did bring foorth beautiful flowers, very white and double with some yellowness mixed in the leaues [petals] pleasant and sweete in smell; but since that time we neuer could by an industrie bring them unto flowring again.' Gerard's narcissus descriptions are quite poetic. Of *Narcissus poeticus*, he says that the flower 'is a round circle or small coronet of a yellowish colour, purfled or bordered abut the edge of said ring or circle with a pleasant purple colour'; and he clearly was a keen observer of plants that he grew himself, as well as a careful and critical reader of other botanical works. In his lifetime John Gerard was held in high repute: through his connections with the Lord Treasurer he treated royalty, and he was ultimately appointed Surgeon and Herbalist to King James I, the first of the Stuart kings, and was elected Master of the Worshipful Company of Barber-Surgeons in 1607. He was one of the examiners of the Company of Barber-Surgeons, responsible for the maintenance of standards of practice in the profession. Herbs, or simples, were used by both physicians and surgeons, and Gerard felt that a good, solid knowledge of plants was essential to the proper practice of surgery. To this end he attempted to establish a physic garden for the Company of Barber-Surgeons in London, in order that apprentices might learn

Narcissus triandrus, Angel's Tears, J. Bolton, c. 1786

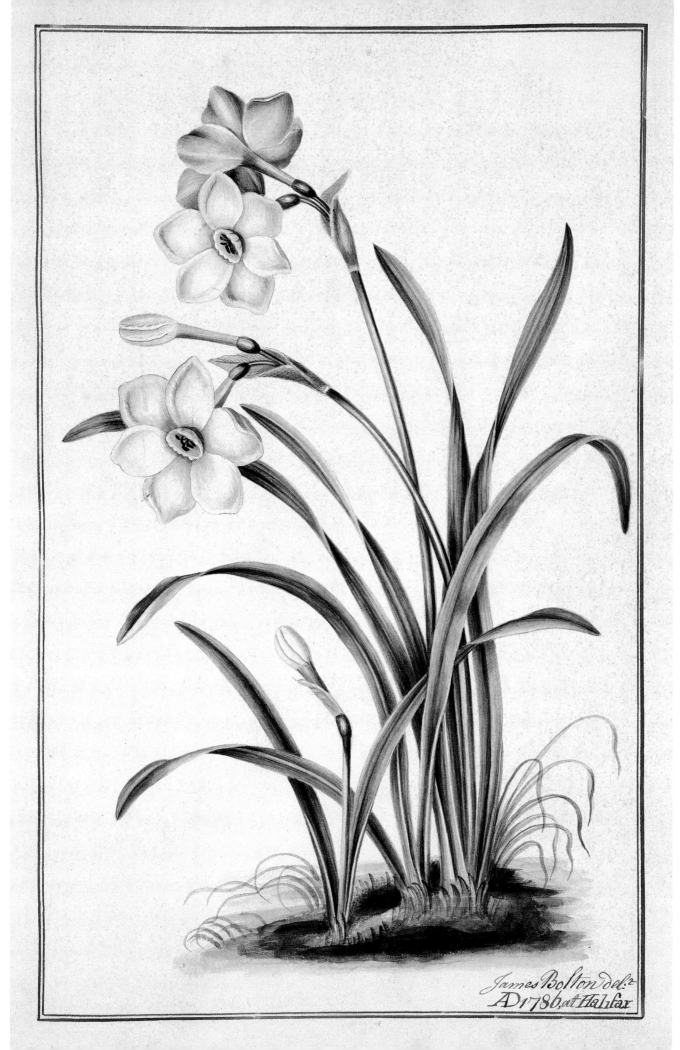

Narcissus x *medioluteus*, Peerless Primrose, J. Bolton, 1786

James Bolton del.
AD 1786, at Halifax

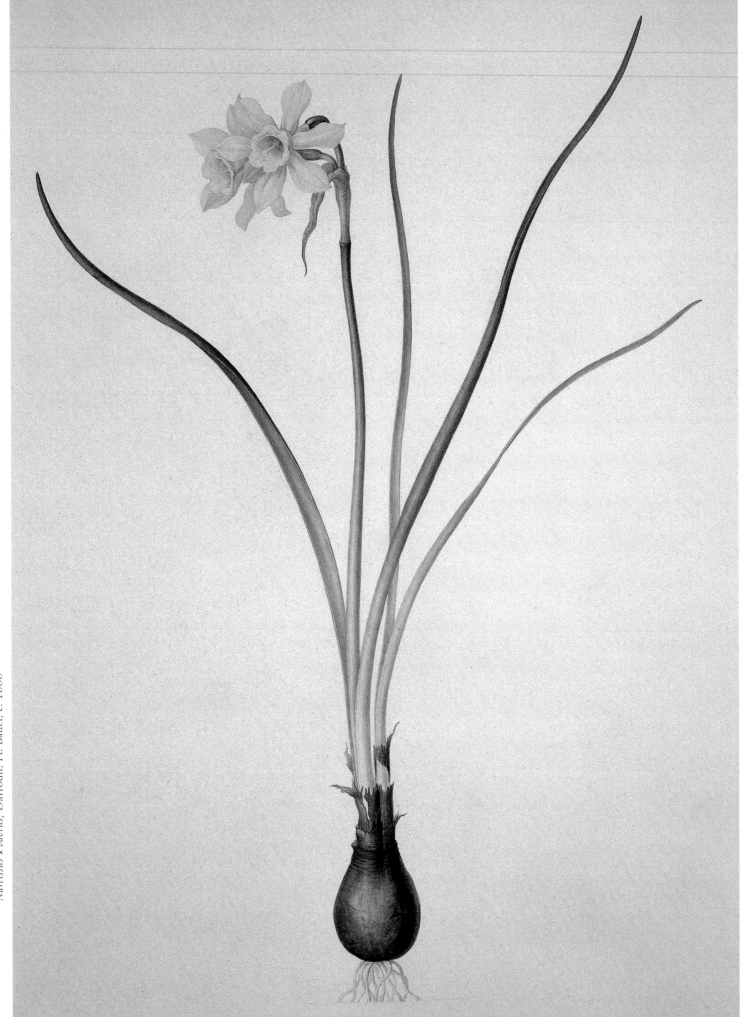

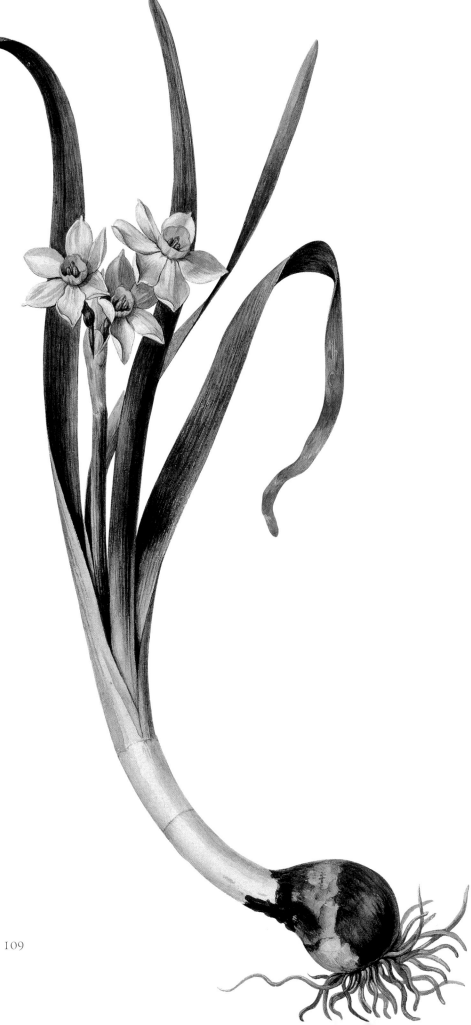

to identify correctly the plants they would later need to use when they began to practise independently. The establishment of such a garden was not thought of highly by the apothecaries who, as purveyors of herbs, perhaps thought that Gerard was invading their territory. Gerard's *Herball* was a masterpiece of Elizabethan botany – clear, concise and logical, he presented information in a standard way for each plant, and tried to reconcile the exploding amount of information from exploration with the knowledge of the ancients. It is hard to imagine what the Elizabethan gardeners must have thought when they saw so many new things they could not fit into the nomenclature of the Greek and Roman herbalists. *The Herball* was written in English – unusual among botanical works of the time – and was by all accounts a standard reference for many years. It is unfortunate that the legacy of John Gerard is marred by the stories of the discreditable circumstances supposedly linked with the publication of the book, for it has been said (and repeated in many subsequent books) that Gerard took a nearly completed English translation of a Flemish herbal, finished it off, added a few more things and rearranged the plants, then passed the whole work off as his own – plagiarism, essentially. It is also rumoured that Gerard lacked the botanical knowledge to have matched the illustrations, which the publisher bought after their use in a previous herbal in Germany (common practice at the time), to the plant names. This story – which has little basis in fact, for Gerard's botanical observations are quite accurate and, though not up to modern standards, are as good as many other contemporary accounts – comes from the editor of the second edition of *The Herball*, one Thomas Johnson. In 1632, twenty years after Gerard's death, Johnson had been employed by the newly created Company of Apothecaries to revise *The Herball*, in part (perhaps) as a way of establishing the Company's rights

Narcissus tazetta, Tazetta, G. van Spaendonck, c. 1800s

109

and privileges in respect to herbal remedies by producing, under their auspices, an authoritative work. The 'Address to the Reader' at the front of the book strongly criticizes Gerard's work, and introduces the plagiarism allegations as coming from an unknown source. It is likely that this source was Mathias de L'Obel, a Flemish botanist who had worked with Gerard in the first part of *The Herball*. Just what caused his hostility is not known, but jealousy has been the source of many a quarrel. It was easy in those days to accuse previous authors of incompetence and misapplication of names: knowledge was accumulating so quickly that works would have become out of date in a few years, never mind the three decades that passed before *The Herball* was revised! It is still easy to look at the botanical works of the past and think that the authors were woefully mistaken and quite ignorant of the realities of nature, but it is important to remember also that they were working in the conventions of their times, not ours.

By the time the English were colonizing North America, hundreds of daffodil types were being grown in European gardens. These were introduced to the newly colonized eastern seaboard via a Quaker plantsman called John Collinson, who was actively involved in the acquisition of new garden plants from the new colonies but also clearly sent European plants to the colonists for use in their gardens. Traffic in plants can be two-way; in fact, that has probably been the norm throughout history. Daffodils, growing as they do from bulbous bases, are easy to transport — they can lie dormant for a winter and sprout again, so are ideal for carrying on long sea journeys. This facility has made the true distributions of daffodils somewhat obscure and, coupled with the great antiquity of cultivation in the genus, has led to some truly remarkable journeys. One such was undertaken by the cultivated variety, the multiflowered *Narcissus tazetta* known as the 'Grand Emperor' in late Victorian times. This is the narcissus that was, decades ago, used as an indoor flowerer, a technique (whereby the bulbs were put in vases filled with only water and stones for forcing) that was learned from Chinese florists. The plant itself had a true

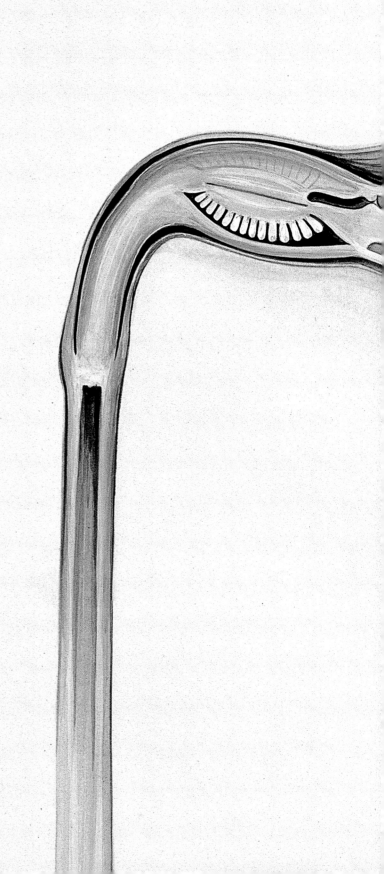

Tazetta
Narcissus tazetta L. (Amaryllidaceae)
Gerard van Spaendonck
c. 1800s, watercolour on paper, bound in volume
456mm x 290mm (18in x 11½in)

The tazettas are an incredibly complex group: species differences are fuzzy and the plethora of plants described from garden material makes identity uncertain. The European expert, David Webb, was pessimistic: 'I doubt that even a lifetime spent on these plants would evolve a really satisfactory species-list; the original facts are now blurred beyond interpretation by cultivation and naturalization.'

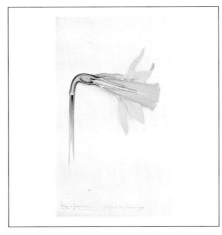

Daffodil
Narcissus pseudonarcissus L. (Amaryllidaceae)
Arthur Harry Church
1903, watercolour with bodycolour on Bristol board
317mm x 194mm (12½in x 7¼in)

Church's anatomically accurate paintings show clearly how the corona of the daffodil arises from the inner surface of the floral tube, just at the point at which the petals and sepals (tepals) become distinct from the tube. The floral tube in Narcissus pseudonarcissus *is relatively open and broad, but the nectar at its base is protected by the stamens, closely hugging the style.*

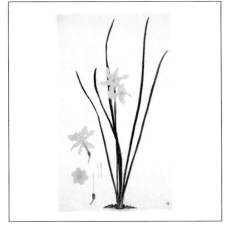

Daffodil
Narcissus x *odorus* L. (Amaryllidaceae)
Anon. Saharunpore Gardens Collection
c. 1850s, watercolour on paper
383mm x 228mm (15in x 9in)

The paintings of the Saharunpore Gardens Collection are said to be of native plants brought to the garden for painting by local artists. The inclusion of this daffodil in the set just illustrates how difficult it can be to assess the native or introduced status of many plants. Daffodils are also masters of the great escape: they naturalize with great ease wherever they are cultivated.

Desert life is hard for plants. Not only do those living in the world's deserts have to cope with little or no water during much of the growing season, but also extremely high temperatures during the day and very low ones at night. It can't be easy – but plants have developed a wide variety of methods to cope with these stresses. Some are ephemerals, only coming up to bloom for a week or so just following the rains of spring; others have tiny leaves that only appear for a short time; while still others have deep root systems that search for the tiniest drop of soil moisture. One of the most intriguing ways of coping with drought conditions is that of succulence – a body form that has also long intrigued enthusiasts. Succulence has arisen in a number of minimize the surface area to volume ratio of the plant body itself. Succulents can be thought of as coming in three basic sorts – leaf succulents, where the leaves themselves are the fleshy water-conserving parts; caudex-producing succulents, where water is stored in an underground storage organ; and stem succulents (the familiar cacti of horticulture and deserts fall into this category).

Stem succulents are a classic example of convergent evolution, where a structurally similar solution to similar problems has evolved in unrelated plant groups. They have taken the reduction of body size to an extreme and many stem succulents are nearly spherical – a good way to maximize the water-storing potential in relation to the surface area of green tissue for photosynthesis. The

CACTI & SUCCULENTS

An angry cactus does not good
To flowers in a pensive mood.
It riles them something horrible –
Oh well away, keep well away,

A BOOK OF NONSENSE, MERVYN PEAKE (1972)

unrelated plant groups, as a way to conserve water in water-limited environments, not just deserts. The key feature of succulent plants is their ability not only to find water and prevent water loss, but also to store water obtained in times of plenty for times of need. One way of coping with water loss is to discard leaves, for leaves have stomata (pores through which gases are absorbed and water is lost during the process of photosynthesis). However, if the plant discards the leaves, it also discards its very site of food production, which is not such a good idea. Many succulents have transferred the site of photosynthesis from the leaves to the stems – fleshy green stems with chloroplasts can photosynthesize just as efficiently as thin leaves. Another way of conserving water is to physical similarities between stem succulents in different parts of the world are amazing, and the two areas where this is best developed are the American and African deserts. In both areas, one can see huge candelabra-shaped plants, which means they must surely be the same thing, but if you look a bit more closely the differences become clear. Cacti dominate in the Americas, while in Africa it is the euphorbias, so how do botanists know these similar types of plants are not related but convergent? The answer lies in the study of systematics, or the distribution of characters. It is easy to be taken in by convergent evolution, for it is compelling to believe that overall shape and similarity are the most important indicators of relationships.

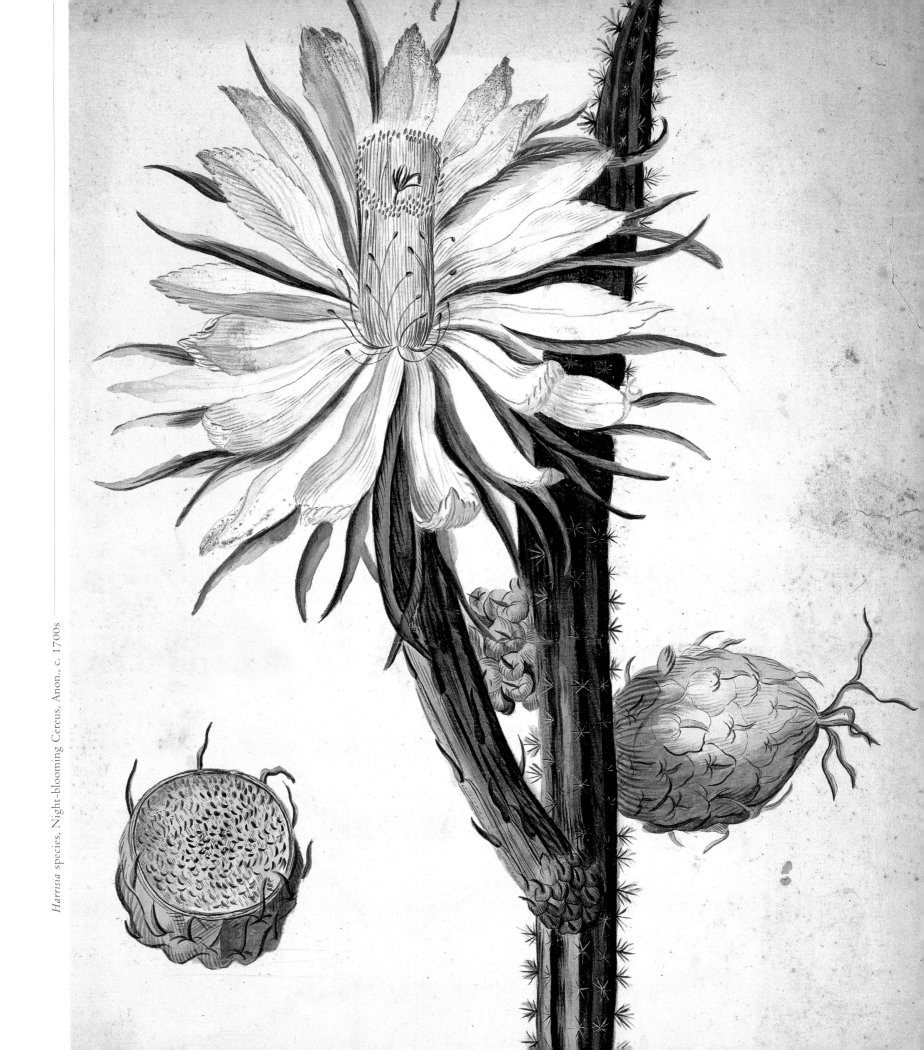

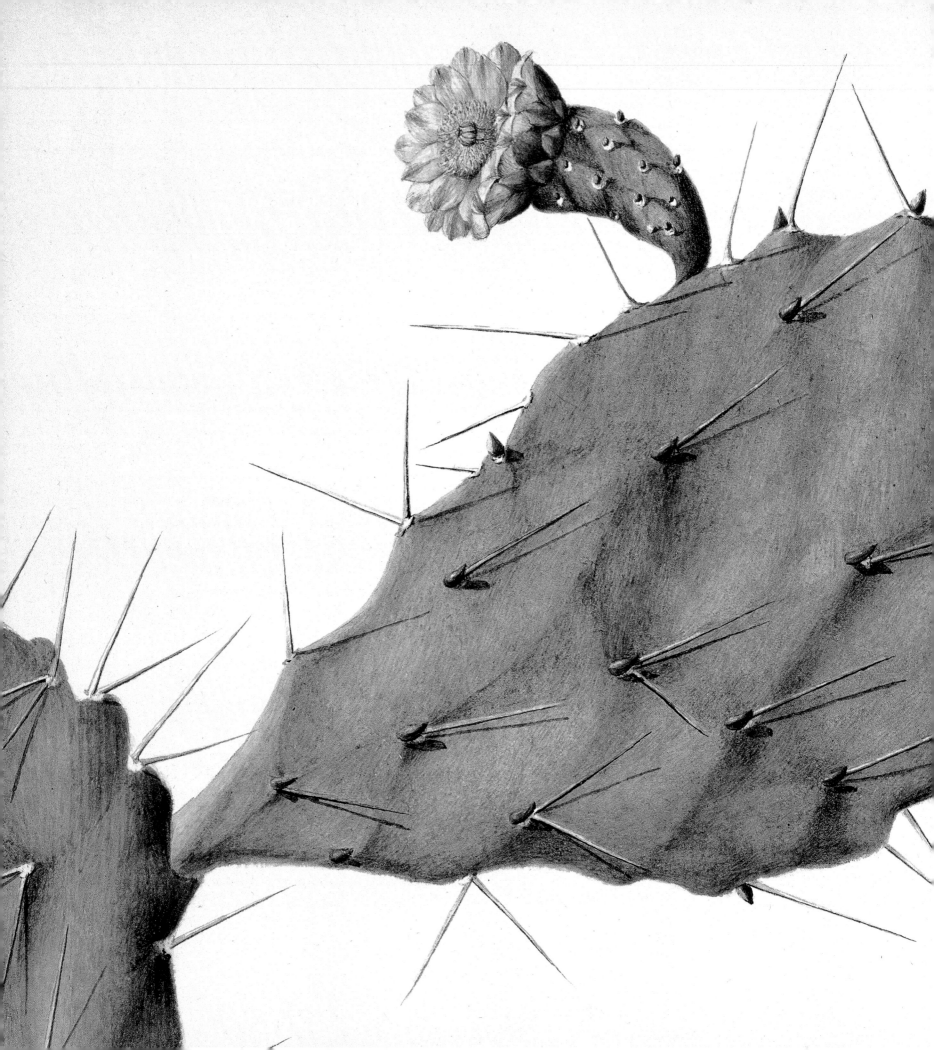

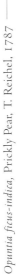

Opuntia ficus-indica, Prickly Pear, T. Reichel, 1787

Think of bats and birds. Both have wings, but one would never imagine that bats were more closely related to birds than to other mammals – after all, bats share with other mammals the live birth of their young, the possession of fur and the suckling of their babies. These are what biologists call shared derived characters. If we also study the wings of bats and birds carefully, we can see they are really rather different in fine structure. This is also true of the succulents – despite their overall body plan similarity, on closer scrutiny we can see how they differ. Both have photosynthetic, green and fleshy stems and, if you cut into a cactus, a sort of jelly-like, mucilaginous substance oozes out. Do the same to some of the succulent euphorbias, however, and you will see a milky latex, which can be poisonous. The sap of *Euphorbia virosa* of Namaqualand in southwest Africa, for instance, is used as an arrow poison, although most species are not that bad; more just irritating to the mucous membranes. The spines borne on the stem initially look the same, but are actually derived from completely different parts of the plant: cacti spines are borne on the areoles (modified buds), while the euphorbias' are technically the thorny tips of leaves. It is with the flowers of the two sorts of plants that we really see their relationships most clearly. What looks like a flower in a euphorbia is in fact an inflorescence, with one female flower and several male flowers held in a cup, which botanists call a *cephalium* (meaning 'little head'). These complex structures are the same as those found in other members of the euphorbia family, such as dog's mercury or poinsettias. It is one of the shared derived features of this group, showing us that the succulent habit is a convergent solution to similar problems faced by cacti and euphorbias on different sides of the earth.

Cactus flowers are an entirely different matter. Not small and relatively insignificant, like euphorbia flowers, those of many species almost beg to be noticed and are truly exotic beauties. The ground plan of cactus flowers is common across the Cactaceae family, but the variations are striking. All the flowers have inferior ovaries, where the petals arise from the top of the ovary instead of

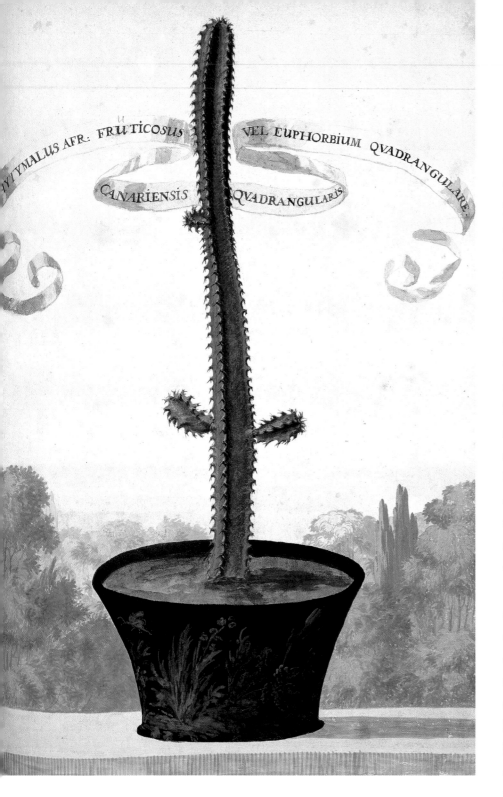

ITYMALUS AFR: FRUTICOSUS VEL EUPHORBIUM QVADRANGULARE

CANARIENSIS QVADRANGULARIS

from beneath it – and the seeds are borne on a central placenta. Cacti are members of a group of plants that was for years called the Centrospermae (meaning 'central seeds'). Other plant groups sharing this derived feature are the purslanes, the pokeweeds and the spinaches – strange bedfellows for cacti, it might seem.

Support for the interpretation of the central placenta as a derived character, and one that is important for classification, also comes from chemistry, for all these seemingly different plants produce pigments called betalains, with a nitrogen molecule in the chemical structure. This single little nitrogen molecule is part of what makes the red derived from betalains so different from other flower reds – betalain red is more like magenta, a shockingly brilliant pink. Betalains are another shared derived feature that tells us that cacti are more closely related to the pokeweeds than to the structurally similar (at least, in some cases) euphorbias. Cactus flowers all have many undifferentiated tepals (the term used when sepals and petals are structurally similar) – often brightly coloured and practically iridescent in hue. There are also many stamens and, in some cacti flowers, these move around amost imperceptibly when touched by a bee or a finger, perhaps helping to deposit pollen on a potential pollinator. The style arising from the inferior ovary is topped by the star-shaped stigma, often in vivid shades of green or yellow. One of the most spectacular of the cactus flowers is the night-blooming cereus, whose huge white blooms open as one watches at sunset.

An example of such a cereus is the 'Queen of the Night' – at sunset, the tepals begin to open, and by nightfall the flowers are around 20cm (8in) in diameter. Its scent has been described as 'an experience beyond belief' – sweet and overpowering. The flowers only last a single night, and by morning the tepals are crumpled and wilted. These night-blooming flowers are usually pollinated by bats or moths, which are attracted by the powerful scent. They have copious pools of nectar at the base of the flower tube, which is a valuable reward for these pollinators. Even as the flowers close in the morning, bees can be seen prising apart the wilted petals in order to get at the nutritious pollen, scooping up the leftovers. These spectacular night-bloomers are often epiphytic, growing high up in trees in tropical forest, or are the huge columnar cacti, such as the saguaros of the Arizona deserts. In order that bats can find them, its flowers need to be high up and unobstructed – echo location may

Euphorbia canariensis, Canary Islands Spurge, J.G. Simula, 1720

120

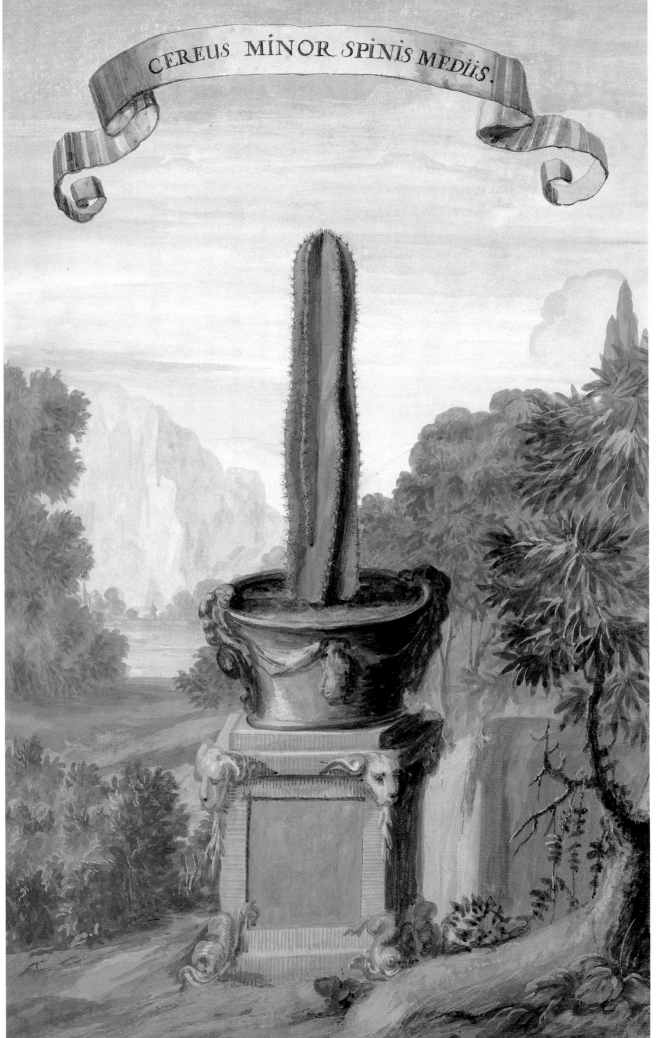

CEREUS MINOR SPINIS MEDIIS.

Cereus aff. jamaracu, Night-blooming Cereus, J.G. Simula, 1720

be precise, but it does not work well if there is a lot of background noise to contend with. In Hawaii, the wavy forest cereus *Hylocereus undatus* is used as a hedge, but what a thing to have around a swimming pool on a warm summer evening! This cactus came originally from the West Indies, and was taken to Hawaii very early on, presumably because of its wonderfully scented blooms.

Both the flowers and form of the cacti must have been incredible to the early explorers, and they were quickly taken across the world. The African succulents were quite a revelation to European botanists and plant enthusiasts, too, and one such became the envy of botanical gardens until it was again found in the wild almost a century later. At the end of the eighteenth century, Emperor Joseph II of Austria sent two gardeners to South Africa, from his Imperial Botanical Garden at Schönbrunn near Vienna, in order to collect novelties for cultivation. One of them, Franz Boos, came back to Vienna in 1788 with only some of the plants he had obtained in South Africa, and from the director of the botanic garden in Mauritius (one of the main objects of the trip). The other man, Georg Scholl, was left in Cape Town with the rest of the collection, as it did not fit on the ship Boos took back to Europe, and there he stayed for another ten years. Another two collectors were sent out from Vienna in the 1790s in order to get

more plants and to bring back Scholl, but they discovered that the captain of the ship on which they had obtained passage was intent on going to Malaga, 'where his intentions regarding them were not of the fairest' – an extreme understatement, to put it mildly, since to be sold as a slave to the Moors was not something even the hardiest botanist would wish to contemplate! (The collecting potential would not be great, either.) Scholl was left for a while longer, and he eventually made it back to Schönbrunn, safe and sound, with a cargo of live plants in 1799. Either Boos or Scholl brought back a curious plant to Schönbrunn – a tuberous mass that produced whippy, vine-like growths up to 4m (13ft) long; in October, the tuberous part was covered with grey-green flowers, whose petals were dotted with brownish red. It never set seed, nor could it be grown from cuttings. The plant – named *Fockea capensis* after Dr Focke, a German botanist from Bremen – was unique, the pride of the Schönbrunn, and envy of all the rest. The botanical authorities in Vienna claimed that it was the sole survivor of an otherwise extinct species, and therefore was very special indeed. This continued to be the case until 1906 (more than 100 years after *Fockea* was first brought to Vienna), when populations of hundreds of plants were found in the region of Cape Town. Still special, but no longer unique… *Fockea* is an example of another family of plants that has evolved the succulent habit independently, and is – of all things – a milkweed!

Succulents have a long history. One was documented in the first century by Pliny the Elder as being discovered on Mount Atlas by King Dubai of Numidia. Its sap was used as a medicine and it is thought that the species Pliny wrote about was *Euphorbia resinifera*, a small-branched plant native to Africa, with bluish-green, four-angled stems with thorns. The first succulent plant to be described by European scientists was one of the African euphorbias, but strangely enough it was described as being from the Malabar Coast of eastern India. The spice trade from the East Indies boomed in the seventeenth century, with the Dutch and the English battling for supremacy in the market for exotics such as

Euphorbia species, Spurge, Anon., Reeves Collection, c. 1820s

cinnamon and nutmeg. The spices brought back from the Indies were so valuable, in fact, that the stevedores who unloaded the boats full of nutmeg had to wear special overalls with no pockets, for even a few nutmegs were enough to make a man his fortune.

Both the Dutch and the English had waystations in India where boats would stop and supply before the long and perilous journey around the Cape of Good Hope, and in 1669 the Dutch governor stationed on the Malabar Coast, H.A. van Rheede tot Draakestein, also sent plant collections and descriptions back to botanists in Amsterdam. From these materials he compiled (with the help of fellow Dutchman Caspar Commelin) the monumental *Hortus Indicus Malabaricus* around 1700, the first catalogue of the plants of India and also one of the first scientific accounts of a tropical flora. One of the things, Rheede tot Draakestein sent to Commelin was a description of a hedge, made of a spiny succulent, that he considered indigenous to the Malabar Coast. How this African euphorbia came to be cultivated in India is a mystery — perhaps an earlier traveller picked up a plant and grew it out of interest in India — but it was not until 1915 that the species, *Euphorbia tirucalli*, was found to be definitely of African origin and not indigenous to India. A century and a half after Rheede tot Draakestein had first found his hedge, collectors were sending back euphorbias from southern Africa to the delight of European naturalists and a burgeoning community of plant enthusiasts. Maybe it was in the heyday of plant hunting that the collection of succulents became a hobby, initially only for the very rich — after all, who else could afford to send botanists scurrying all over the world in search of novelty? — but later for the many, as well.

Succulents are especially easy to carry from one place to another. Their ability to adapt to the stresses of living in a dry environment allow them to go into a sort of hibernation, storing water and reserves until they encounter conditions for growing again. Cacti are particularly good at this, and many of the American desert species, especially in the genus *Opuntia*, are masters of the art. Species of *Opuntia* come in two main sorts —

the prickly pears (with flattened, elliptical stem joints) and the chollas (with round, cylindrical stem joints). One desert species in northwest Mexico, *Opuntia fulgida*, is called the jumping cholla because the jointed stems seem to leap out at passers-by, latching on to clothing and skin alike. A new cactus plant can regenerate from a single fallen joint — a fantastically efficient form of vegetative reproduction. People have used this ability to their own advantage, transporting the cacti wherever they have gone; indeed,

Melocactus caroli-linnaei, Melocactus, Anon., (poss. S. Taylor), c. 1700s

CACTUS *Melocactus.*

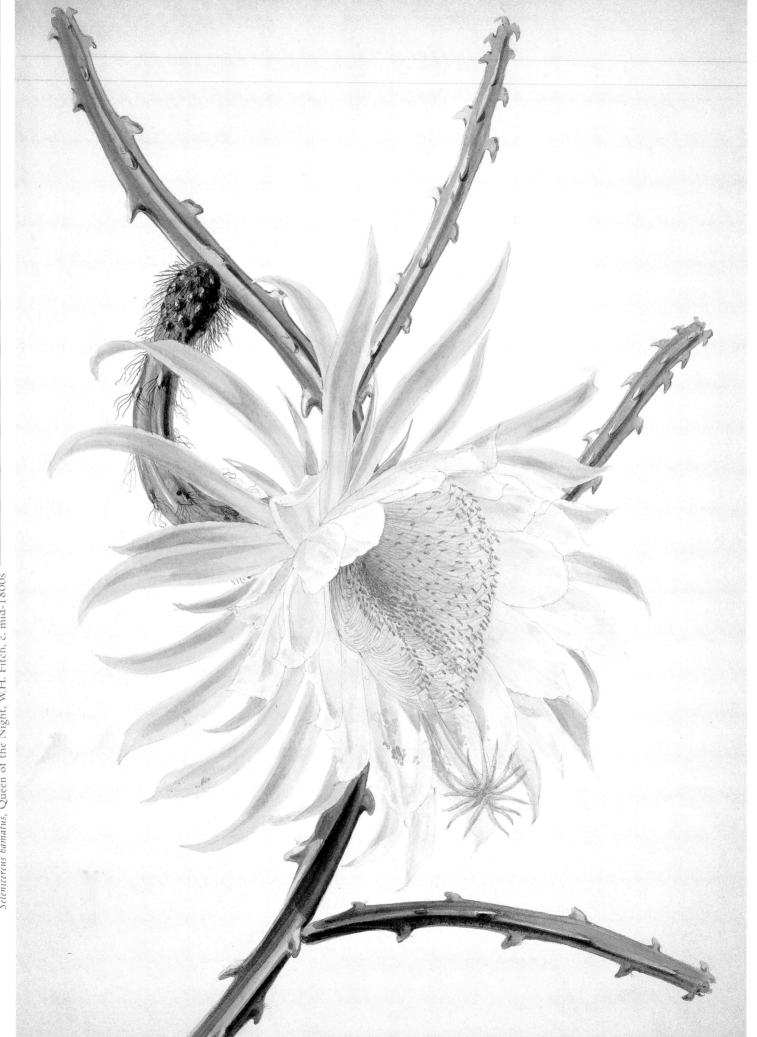

the ancient peoples of the southwestern United States, the Anasazi, who built the now-ruined cities of Chaco Canyon and Mesa Verde, used the slender flexible joints of *Opuntia whipplei* in the initiation rites of the cactus society, perhaps as a scourge. They brought the species (which has pale greenish-yellow flowers) with them as they migrated from the deserts of Utah and Arizona to New Mexico, where, in the mountains of the Jemez, another species of *Opuntia* with brilliant magenta flowers grows. The *Opuntia whipplei* cultivated for ritual use by the people hybridized with the native *Opuntia imbricata*, and some ruins of the ancients can still be found by looking for these hybrids with greenish-pink flowers. Prickly pears have been used as living fences all over the Mediterranean, and it is hard to convince some people that the cactus is not native there. The Spanish conquistadors may have brought pads back from the New World, but they brought a lot of other things too, foods and medicines from plants included. *Opuntia inermis* was introduced to Australia as material for living fences, as it was much cheaper than barbed wire and reproduced itself, so therefore seemed ideal for the purpose. The opuntia's almost supernatural ability to propagate itself (originally one of its good points) became a nightmare, however. The cacti thrived in the dry climate of Australia and soon huge thickets of *Opuntia* were formed that were impenetrable for man or beast – the cactus had become an invasive. This invasion was finally checked by the introduction of a noctuid moth, the appropriately named *Cactoblastus cactorum*, whose caterpillars burrow into the cactus stem and essentially eat it from the inside out, leaving the plant to collapse and die. Fortunately, the moth found no native plants to attack, thus sparing the native flora (so often the victim of ill-advised biological control attempts).

Not all succulents have the regenerative ability of the opuntias, however. Many of the more spherical types grow very slowly indeed – not surprising where water is limited and nutrients are only available to the plant when in the dissolved state. An individual of the barrel cactus – so called for their

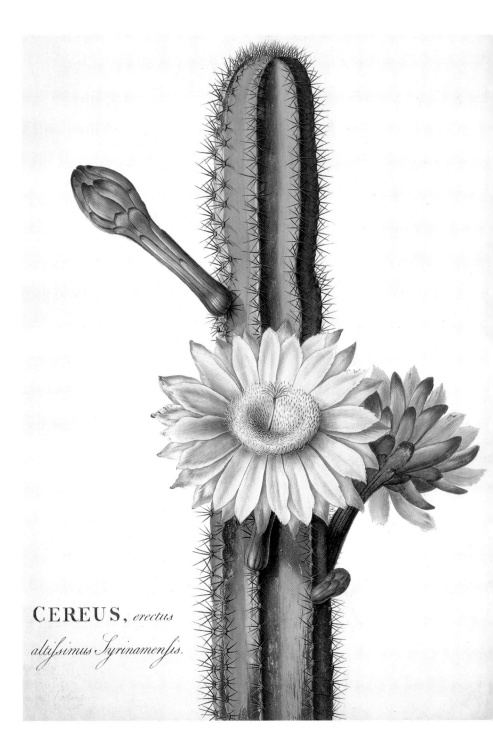

CEREUS, *erectus altissimus Syrinamensis.*

solitary stems with strong ribs and fierce spines – does not reach reproductive maturity, nor does it flower, for several decades. This slow growth is also true for other succulents, and is part of a

'strategy' for persistence in a harsh and unyielding climate where these plants are native. In 1935, the single *Fockea* at the Schönbrunn gardens was still flowering and had not noticeably grown since it was first brought to Vienna in the eighteenth century.

Their compact size and lovely flowers make cacti, and other succulents, ideal for collecting. Societies of succulent lovers can be found all over the world, and many of them have long and venerable histories – the German Cactus Society, for example, was founded in

1892 and is still going strong more than 100 years later. An interest in a particular group of plants can be a fascinating hobby, but where an interest exists a market grows, and in the past the market for cacti was largely fed by wild-collected plants. In the early twentieth century, books were written to stimulate interest in cacti and succulent collection, encouraging people to go out and collect specimens for themselves, even suggesting areas to visit to collect rarities. We think we know better now, but it takes a long time to bring a cactus (especially one of the smaller, single-stemmed sorts) to reproductive maturity. And reproductive maturity is usually the goal of any avid collector, for, however fantastic the plant's shape and size, it is a magical moment when a beautiful flower unfolds. The euphorbias, succulent milkweeds and cacti all have interesting flowers, but the sheer contrast between the robust, spiky bodies of cacti and their brightly coloured, almost gaudy flowers is truly special.

In Mexico, cacti are still under considerable threat from collectors, but collection on a commercial scale. A species of *Echinocereus* (a sort of hedgehog cactus) has been 'exterminated at

its roadside habitat by unthinking collectors', while still other, rarer cacti have suffered even worse fates. One rarity known as the pine cone cactus is being decimated population by population: 'Clearly the most serious threat to the survival of [this species] is collecting. During the 1960s, [a collector] came with a large truck to the [site] and hired the local inhabitants to collect all the specimens from the hill. Further collecting over the last twenty years has completely destroyed that population. There is ample evidence that the same sort of systematic removal of plants has occurred at [another site]....[people] have periodically come to the hills with trucks to collect large numbers of the cacti. Choice plants of [other cactus species] had also been removed from these hills... We feel that the collecting of this species has been very systematic and efficient in that all the plants are removed from one hill at a time. We do not feel there are any other serious threats to the survival of this species.'

Some of the tiny rock cacti have virtually been collected to the edge of extinction – they are very slow-growing and difficult to propagate from seed. But surely a hobby should not drive a species to extinction, for that just seems counterproductive. The rise in interest in artificial propagation of some of the rarest cacti hopefully will make this sort of rape of cactus populations a thing of the past (similar sorts of things happen to populations of euphorbias and succulent milkweeds in Africa, for example). However, to preserve the things we love does take willpower – the will to leave another living thing to grow in its own habitat. Perhaps the next generation of cactus and succulent enthusiasts will become like the birdwatchers of today: travelling to the ends of the earth in search of sightings of rarities. Birdwatchers are natural history enthusiasts *par excellence*, and they seem not to need to own an individual of each bird they spot. In the future, the sight of a plant blooming in its habitat will hopefully be more thrilling than the need to own the plant for oneself – a logical twenty-first-century extension of the plant-hunting ethos.

Hylocereus triangularis, Pitahaya Fruit, Anon., Reeves Collection, c. 1820s

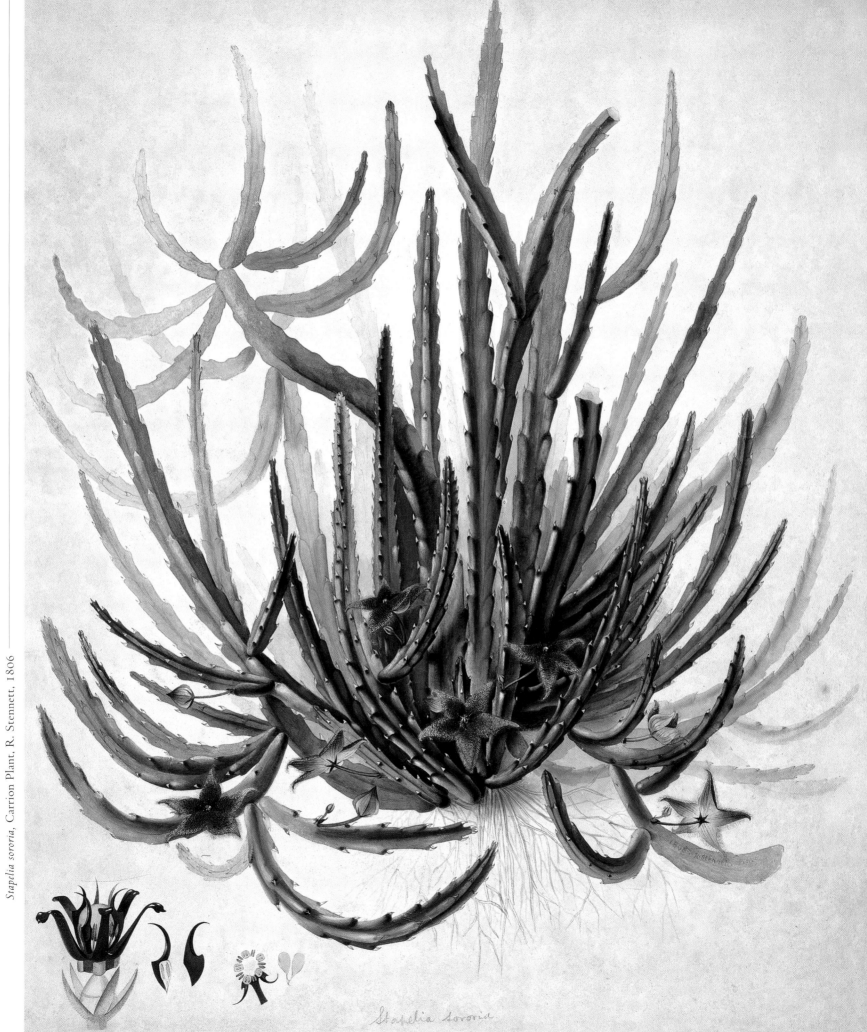

Stapelia sororia, Carrion Plant, R. Stennett, 1806

Stapelia sororia

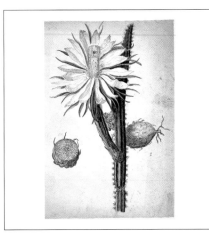

All of the cacti sharing the common name 'night-blooming cereus' share two major characteristics: night-flowering and large, showy flowers. These extravagant displays of scent and pale, ghostly beauty probably attract sphingids — night-flying hawk moths the size of hummingbirds, whose long tongues can reach the nectar hidden at the bottom of the floral tube. The flowers last a single night, and by dawn are withered and limply hanging.

Night-blooming Cereus; Midnight Lady
Harrisia species (Cactaceae)
Anon.
c. 1700s, bodycolour with watercolour on paper
435mm x 285mm (17¼in x 11¼in)

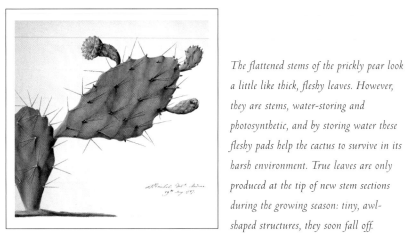

The flattened stems of the prickly pear look a little like thick, fleshy leaves. However, they are stems, water-storing and photosynthetic, and by storing water these fleshy pads help the cactus to survive in its harsh environment. True leaves are only produced at the tip of new stem sections during the growing season: tiny, awl-shaped structures, they soon fall off.

Indian Fig; Prickly Pear
Opuntia ficus-indica (L.) Miller (Cactaceae)
T. Reichel
1787, watercolour on paper
224mm x 225mm (8⅞in x 8⅞in)

The majority of the succulent euphorbias are native to the African continent. This species — which comes from the Canary Islands, off the west coast of Africa — demonstrates how the flora of these Atlantic islands has affinities to the great continent from which they were derived and to which they are so close.

Canary Islands Spurge
Euphorbia canariensis L. (Euphorbiaceae)
Johann Gottfried Simula
1720, bodycolour on paper
455mm x 285mm (18in x 11¼in)

All cacti were once called 'cereus'. Derived from the Latin word meaning 'waxen' or 'waxy', this certainly referred to their thick cuticle, which is sometimes covered with a waxy bloom. Imagine what curiosities these plants must have been to the botanists and artists of the time: apparently leafless, often horrendously spiny, with massive stems, they must have seemed like creatures from another world.

Night-blooming Cereus
Cereus aff. *jamaracu* DC.
'Cereus minor spinis mediis' (Cactaceae)
Johann Gottfried Simula, 1720, bodycolour on paper,
455mm x 285mm (18in x 11¼in)

Euphorbia is one of the largest genera of flowering plants. Its species range from tiny herbaceous weeds to the great columnar succulents of Africa — the variety is astounding. The genus takes its name from Euphorbus, the physician to the ancient King Juba of Numidia in North Africa. The milky sap of euphorbias is of great medicinal value, but can often be caustic.

Spurge
Euphorbia species (Euphorbiaceae)
Anon. Reeves Collection
c. 1820s, watercolour with bodycolour on paper
300mm x 126mm (11¼in x 5in)

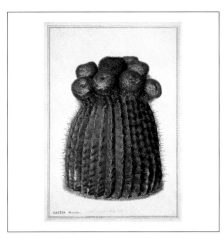

The peculiar structures on top of the Turk's head cactus (its turbans) look as though they have been grafted on to the plant, but they are natural. Cacti develop their flowers from areoles — specialized, highly condensed shoots, which we see as the spiny bits. Cephalia ('heads'), like those of Melocactus, are specialized flower-bearing areas, and only develop when the plant is reproductively mature (adult).

Melocactus; Turk's Head Cactus
Melocactus caroli-linnaei N. Taylor (Cactaceae)
Anon. (poss. Simon Taylor)
c. 1700s, bodycolour with watercolour on paper
600mm x 403mm (23½in x 15¼in)

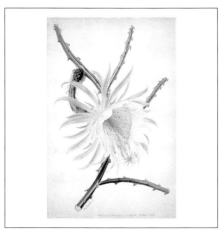

Watch one of these beautiful flowers opening and you will see why they are called queens of the night. At dusk, the petals slowly begin to unfurl, one by one, at an almost sensuous pace. They open to reveal the brush of creamy stamens, curved and ready to brush a bat or night-flying moth trying to reach the nectar at the bottom of the floral tube. The smell is sweet and overpowering – almost sickening.

Queen of the Night
Selenicereus hamatus (Scheidw.) Britton & Rose (Cactaceae)
Walter Hood Fitch
c. mid-1800s, watercolour with gum arabic on paper
550mm x 368mm (21¼in x 14½in)

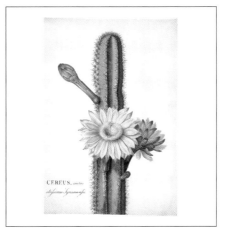

The stems of this species are not always perfectly hexagonal – they have from four to seven ribs. The ribs run down the columnar stems, allowing for diameter expansion of the stem when water is plentiful and contraction as water reserves are used by the plant. The dramatic candelabra forms of these columnar cacti in their native habitats are among the most spectacular in the Cactaceae family.

Blue Cereus; Queen of the Night – 'Cereus erectus altissimus Surinamensis'
Cereus hexagonus (L.) Miller (Cactaceae). Anon., c. mid-to late 1700s, bodycolour with watercolour on paper
500mm x 349mm (19¼in x 13¼in)

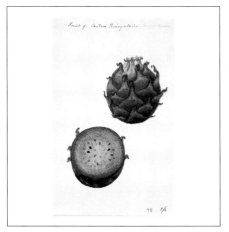

The magenta colour of the pitahaya fruit is due to betalains, colour-causing chemicals found only in cacti and their relatives. Betalain structure was discovered by chance when tests were needed to tell if wine had been adulterated to make it look stronger. It was common practice to add dark-red beet juice (beets, related to cacti, contain betalains), so checking for the presence of nitrogen – a peculiarity of betalains – soon put a stop to the practice.

Pitahaya Fruit; Queen of the Night
Hylocereus triangularis (L.) Britton & Rose (Cactaceae)
Anon. Reeves Collection
c. 1820s, watercolour on paper
197mm x 125mm (7¼in x 5in)

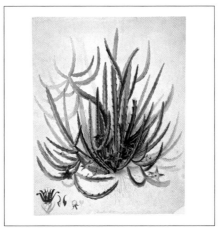

Francis Masson – King George III of England's first collector in South Africa – was a stapelia specialist, and his account of the new stapelias of the Cape was the first glimpse that European botanists had of these peculiar succulents. Masson collected many of them in the harsh and unforgiving region of the Karoo, to the north of the Cape, and probably went there without the permission of the Dutch authorities.

Carrion Plant
Stapelia sororia Masson (Asclepiadaceae)
Ralph Stennett
1806, watercolour and bodycolour on paper
535mm x 428mm (21in x 16¼in)

The luxury, and perhaps the decadence, of the pre-Civil War southern United States is epitomized in the creamy white petals of magnolias. Southern belles like Scarlett O'Hara of *Gone with the Wind* worked hard to maintain their magnolia complexions, but the society that maintained them decayed and disappeared in the end, just like the fleshy, fragrant flowers of the magnolia.

Magnolias have been on earth a very long time – fossils of flowers like magnolias have been found in deposits dating back to before the Cretaceous period, the time of the dinosaurs, between 144 and 65 million years ago. Fossil flowers that are nearly 100 million years old, found in the western United States, look amazingly like today's magnolia. The flowers of magnolias and

the other was a tiny, simple unisexual flower, probably wind-pollinated, as are today's grasses. Debate raged, but over the years the magnolia theory became accepted, until the advent of more sophisticated ways of looking at how we classify and determine relationships among living things. These methods, called cladistics, allow botanists to assess evidence without an a priori idea, and to let the plants themselves (through their characteristics) reveal their relationships. Applying these techniques to the problem of just what the flower of the first flowering plants looked like led botanists to discover that the very first flowers were probably not like magnolias at all, but instead were even more simple. Techniques of reading the nucleotide sequence of DNA (the code

MAGNOLIAS

Her eyes were pale green without a touch of hazel... Above them, her thick black brows slanted upward, cutting a startling oblique line in her magnolia-white skin – that skin so prized by Southern women and so carefully guarded with bonnets, veils and mittens against the hot Georgia sun.

GONE WITH THE WIND (MARGARET MITCHELL, 1936)

their relatives have long been thought to be of a primitive form – the petals and sepals are not differentiated into different structures like they are in many other familiar flowers, and the carpels (seed-bearing parts) are free from one another, sitting in a cone-like structure at the centre of flower. The stamens, or male flower parts, are fleshy and quite petal-like, and there are many of them – another characteristic believed to be primitive in flowering plants. The flowers of magnolias are central to the development of ideas about the first angiosperms, or flowering plants. Two basic ancestral types of flower were conceptualized – one was like a magnolia, with many undifferentiated parts arranged in a spiral (rather like the leaves) and both sexes present in the flower; and

found in all living cells that determines their outward form) have allowed botanists to probe even deeper into these relationships. Information from these data show that magnolias and their relatives are indeed among the first flowering plants, but that they are in fact rather specialized, as well as being special.

The rise of the flowering plants is intimately associated with the rise of the insects on earth. Insects are among the most numerous creatures on the planet, and beetles are among the most numerous of insects; a fact that led the eminent British biologist J.B.S. Haldane to remark that, if God existed, he must have had an inordinate fondness for beetles! Beetles have a special relationship with magnolias – they are attracted to the heavily scented flowers

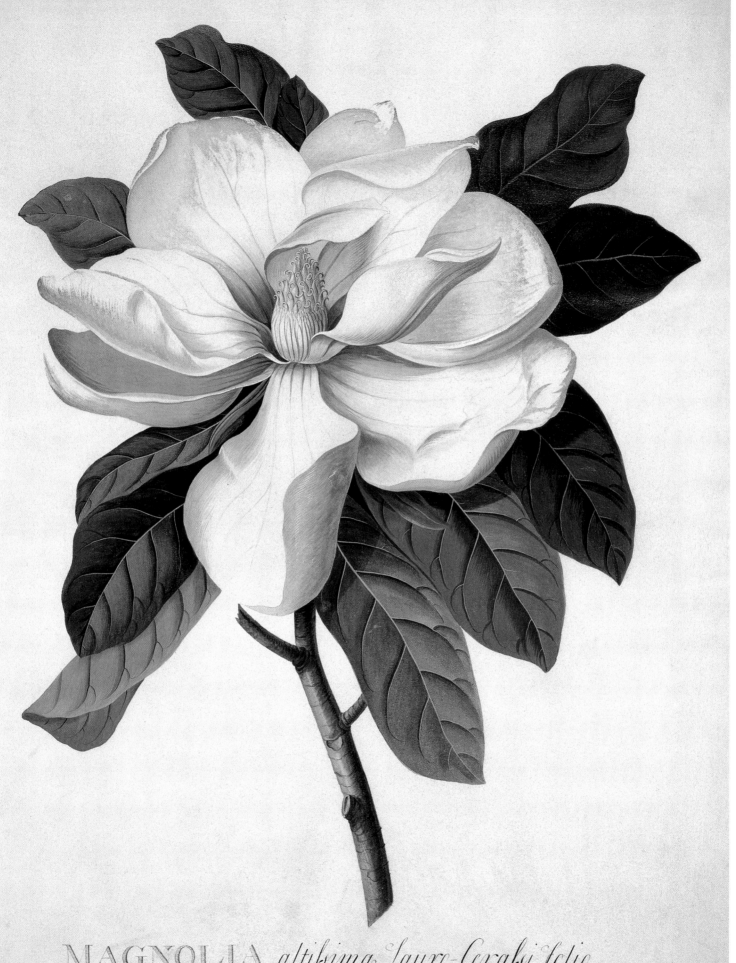

MAGNOLIA *altissima Lauro-Cerassi folie flore ingenti Candido. Catesby*

G. D. Ehret. p. 1744.

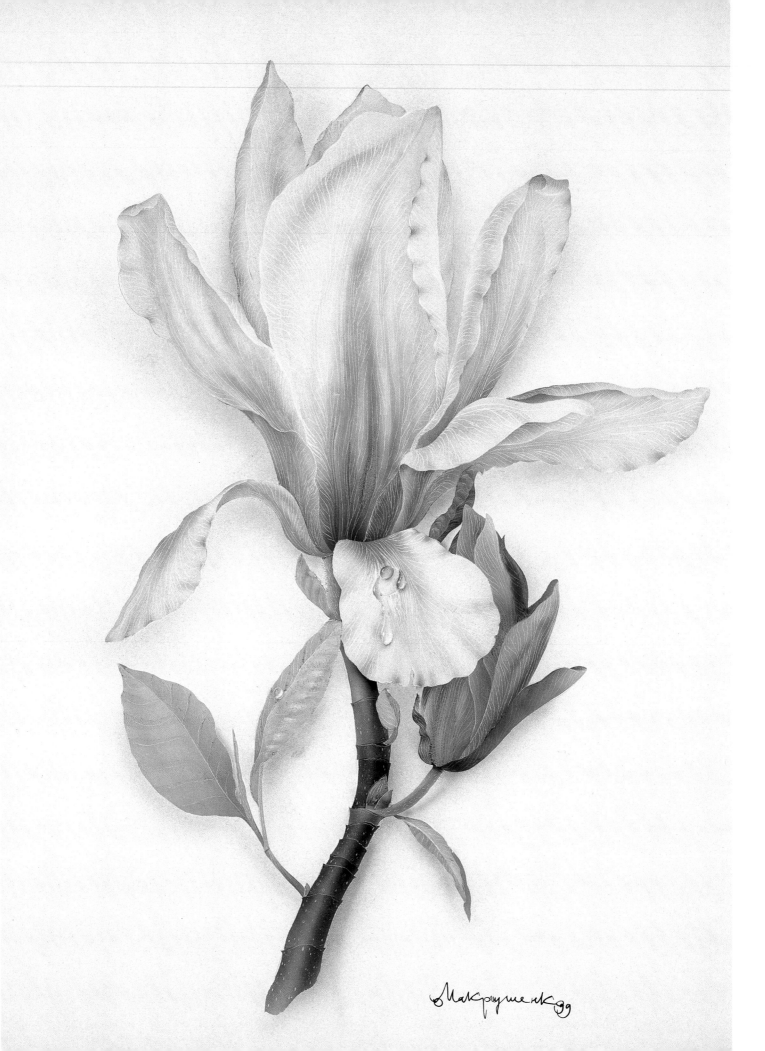

Magnolia x soulangeana, Magnolia, O. Makrushenko, 1999

and bumble around in and over them, clumsily eating the anthers full of nitrogen-rich pollen and secretions from the petals and the female parts of the flower, and all the while they are inadvertently collecting pollen on their bodies, which sticks to the stigma and petal secretions. The beetles then carry this pollen to the next magnolia flower that they visit, thus carrying the male gametes to a new flower and affecting pollination. Plants have sex, just like animals, but they do not actively seek out partners: instead, they rely on something else to do the seeking (in the case of the magnolia, a beetle or some other insect). The ideal is for the pollen of one plant to be carried to another individual of the same species, a phenomenon known as cross-pollination. But if a beetle is lumbering about in the flower, covered in pollen from that flower, how does the plant avoid having sex with itself (that is, how does it not self-fertilize)? In many magnolia species, this is avoided by the male and female parts of the flower being fertile at different times – the flower has a certain phase when is female, and another when it is male.

These flowers – which are large, sweet-smelling and definitely exotic – have long held gardeners in a fatal fascination. The first magnolias brought to Europe probably arrived in Britain in the late seventeenth century, from the southern part of what is now the United States. The colonization of the eastern seaboard of the Americas by the British opened new vistas for exploration, and for the acquisition of new and exciting plants for European gardens. Henry Compton, Bishop of London and of the North American Colonies, used his influence to send young men to the newly acquired colonies, both to preach the Gospel and to collect plants for his garden at Fulham Palace. In 1688, one of these men, John Banister, sent back a peculiar tree, which he called the Laurel-Leaved Tulip Tree. The tree was evergreen and bore huge, creamy-white flowers that emitted a sweet scent. It never did well in Bishop Compton's garden, despite his keeping it in pots and taking great care with it in the cold winter months. Mark Catesby, a botanist and artist, travelled to the Carolinas in 1710, and in his

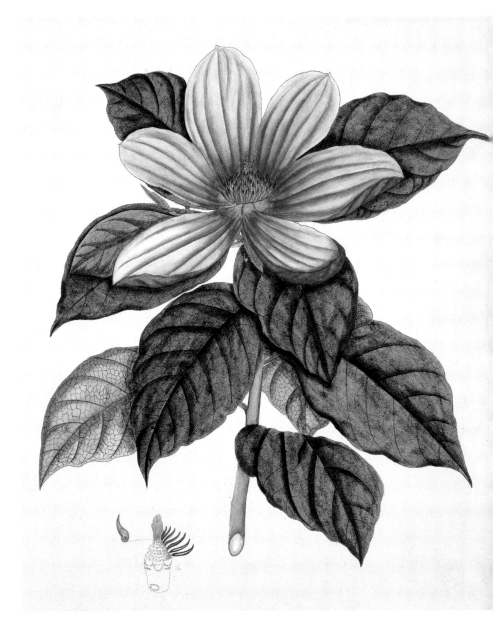

nine-year residence he collected and painted the plants he found in this new land. His findings were published as the *Flora Caroliniana*, in which he included the Swamp Bay (the same plant Banister had called the Laurel-leaved Tulip Tree). These trees grew in swamps or wet places in the Piedmont area of the southeastern United States, where they can still be found, although looking rather incongruous to those more accustomed to seeing magnolias in the garden.

Magnolia species, Magnolia (highly stylized), Anon., Fleming Collection, c. 1795–1805

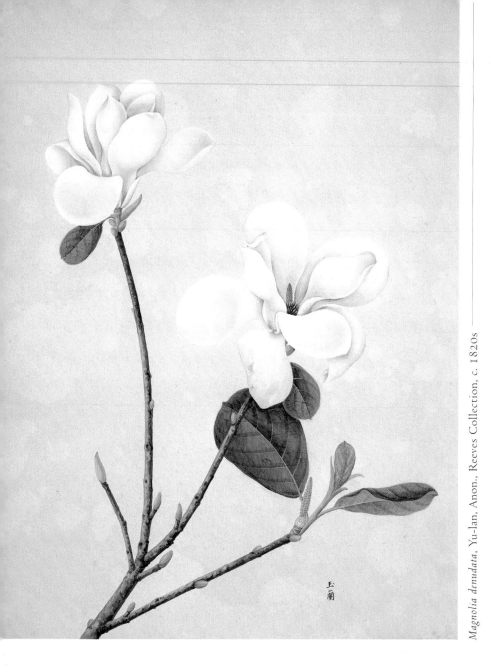

regarded by his contemporaries, including Charles Plumier, one of the first botanists to publish a botanical work about the American flora, who commemorated him by naming a magnificent West Indian plant 'Magnolia' in his honour in 1703 (during Magnol's own lifetime). Today we know this species by the Latin scientific name of *Magnolia dodecapetala*, 'the magnolia with twelve petals' (although it usually has even more petals than this).

The system we use today dates from the great *Species Plantarum* of Carl Linnaeus, published in 1753. This publication is used as the legal starting point for all naming, regardless of what went before. Linnaeus used many of the names coined by earlier botanists (such as Plumier) and co-opted many of these names in his new system. Magnol himself died long before Linnaeus conceived his system of classifying the plants of the world still in use today, but Magnol's ideas of putting plants into families strongly influenced the young Linnaeus as he learned botany. Magnol's flora (catalogue of the plants) of the Montpellier region was a book Linnaeus owned, and he greatly respected it as a model of what a flora should be. Linnaeus took Plumier's name 'Magnolia' and used it for plants then commonly cultivated in European gardens, like those brought back by Catesby or Banister, rather than for the West Indian plant Plumier had originally illustrated, for which he had very little information. So the French botanist is now linked to one of our most amazing cultivated trees. His name is truly honoured.

In their native habitat in North America, magnolias are trees, and sometimes quite large. Many southern plantation houses have long straight drives, lined by huge, dark trees of the second American magnolia to be brought to Europe, *Magnolia grandiflora*. It is easy to imagine children playing hide and seek in the low-hanging branches, the air in which they romped being heavily perfumed with scent. The plate-sized flowers of this species, called the Laurel-leaved Tulip Tree, made it a real novelty, and in the late seventeenth or early eighteenth century it too appeared in the gardens of the Bishop of London and Duchess of Beaufort.

Catesby described the leaves as 'pale green, having their backsides white', a characteristic that is readily apparent in his paintings of the plant.

We now know this plant as *Magnolia virginiana*, the name given to it by the great botanist Carl Linnaeus. The species name, 'virginiana', commemorates its homeland of Virginia and Carolina, but the generic name celebrates Pierre Magnol, a French Huguenot who lived from 1638 to 1715. Magnol suffered great persecution at the hands of the French government during his early life, but eventually rose to become the director of the botanical garden in Montpellier, in southern France. He was highly

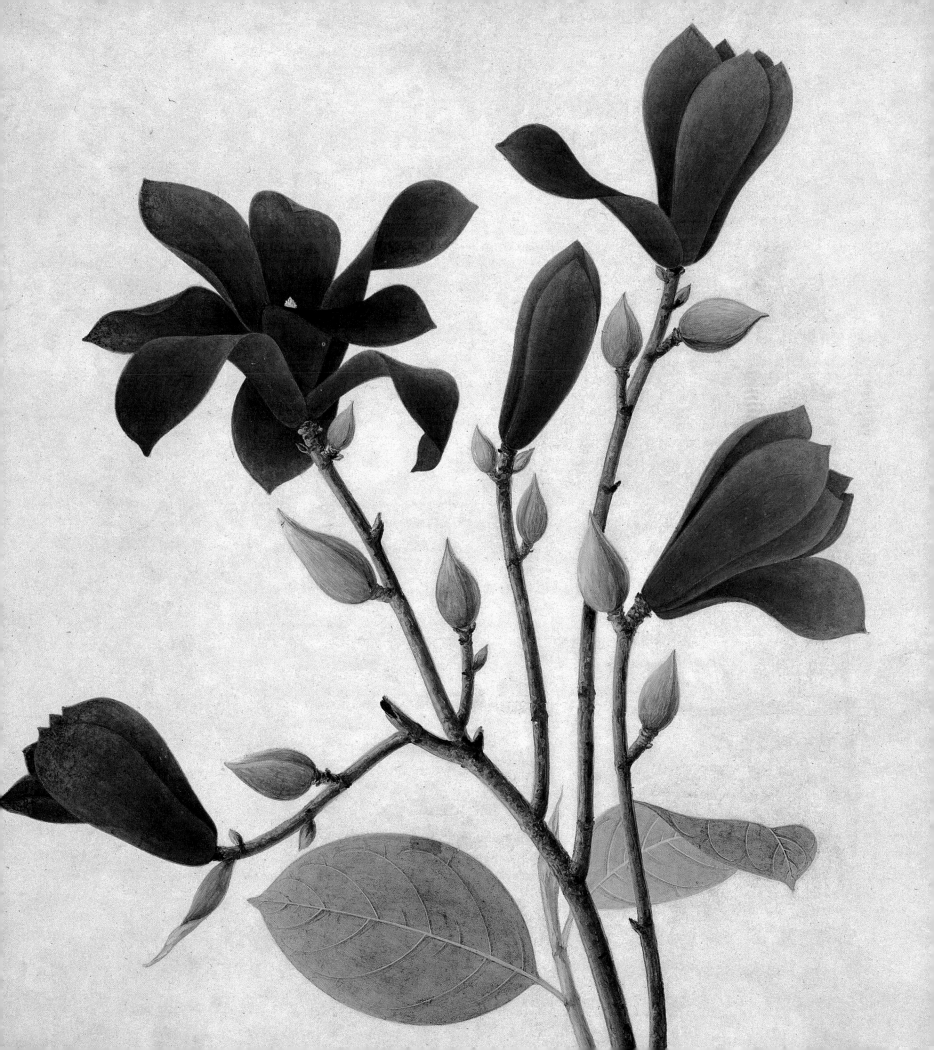

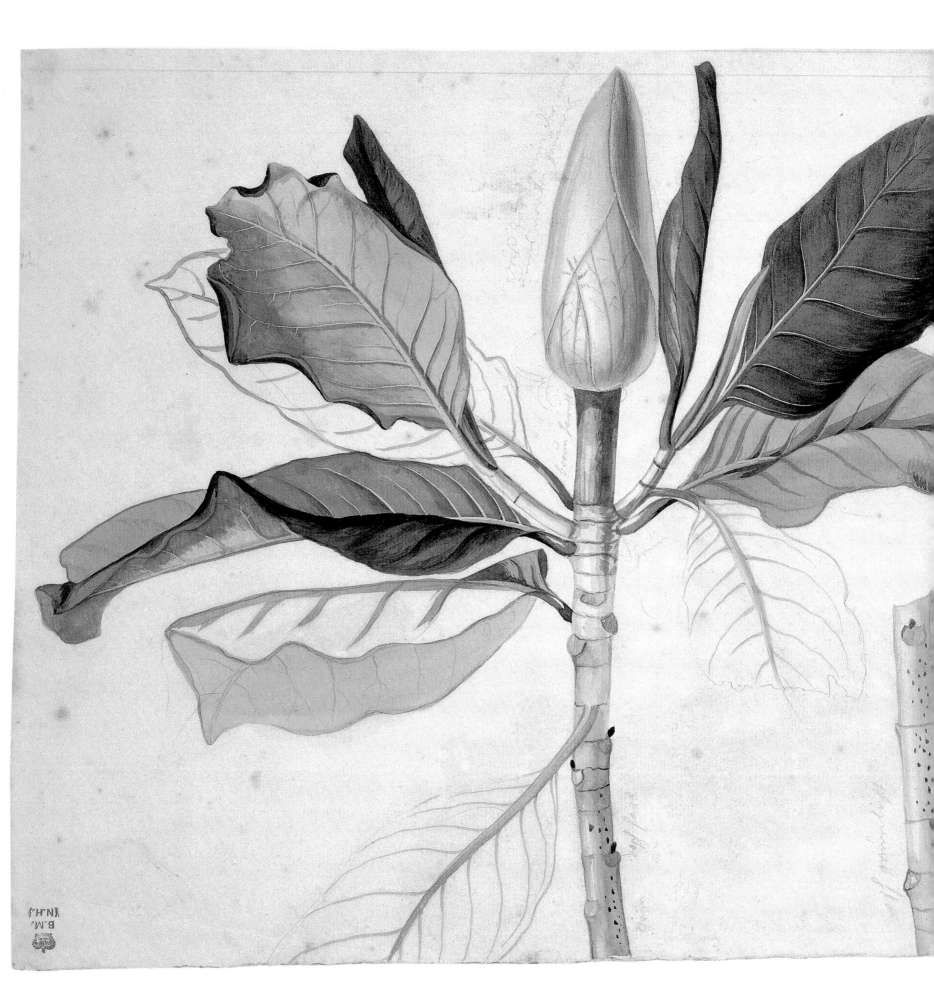

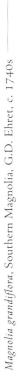

Magnolia grandiflora, Southern Magnolia, G.D. Ehret, c. 1740s

Philip Miller, curator of the Chelsea Physic Garden, wrote in glowing terms of this magnificent plant in 1731: 'This is esteemed one of the most beautiful trees in America where they usually grow in swampy woods and do often rise to the height of sixty feet [18m] or more…the flowers I am told, are very large of a whitish colour and very fragrant… It is in beauty from May to November and the leaves, always remaining green, do afford an elegant prospect in winter…since they are hardy enough to endure the cold of our climate in the open ground, I doubt not but in a few years we shall have the pleasure of seeing its beautiful flowers, there being several trees planted in the gardens of some curious persons near London… This tree must be obtained in plants from abroad and increased in layers… For seeds have not succeeded in any part of Europe where they have yet been sown… It is at present very rare in England, though formerly there were several of these trees in the gardens of the Bishop of London at Fulham and those of the Duchess of Beaufort at Chelsea; but these have been lost so that there are very few of them to be seen in English gardens.'

By 1759, Miller had seen flowers of this tree for himself in Exmouth, Devon, in the gardens of Sir John Colliton. The tree on Sir John's property was the largest of its kind known to Miller, and has passed into history as the 'Exmouth Magnolia', and after Sir John's death his garden went through several pairs of hands, usually as a rented property. Gardeners propagated the tree by layering – which was the common method at that time – as the trees did not reliably set fruit or seed; indeed, one such gardener in the latter part of the eighteenth century earned a half a guinea (52p/80c) per plant propagated, which was a pretty substantial price for the time. Eventually the garden passed into the hands of a merchant from Exmouth, who sent a man to the garden to cut down an apple tree. But, to his employer's horror, the great magnolia was cut down instead, so ending a long and illustrious life – at the time of its demise, the tree's trunk measured 46cm (18in) in diameter. Townspeople remembered the tree

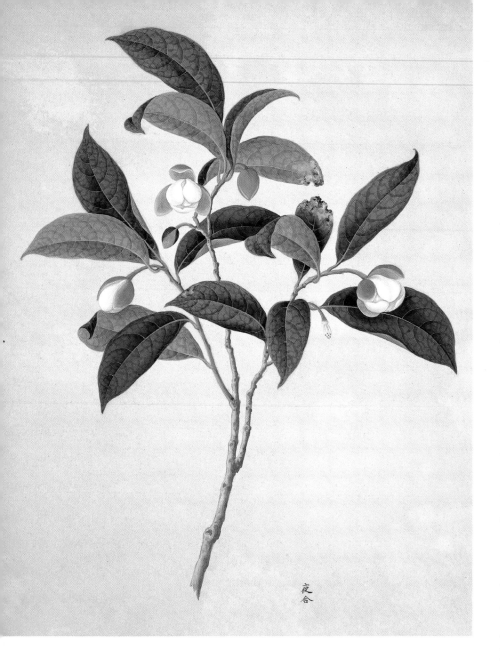

Magnolia globosa, Globe-flowered Magnolia, Anon., Reeves Collection, c. 1820s

supercontinent of Laurasia, which split and drifted to become today's North America and east Asia, and today magnolias occur in these two broad areas, demonstrating a pattern known as disjunction. Many plants exhibit this sort of distribution – here, with one set of species in the Carolinas, and a closely related set in China, but none in between. In some groups the species in the two far-flung places are remarkably similar, but the magnolias have diverged and diversified in their separate strongholds.

The flowers of Asian magnolias are very similar to their American cousins: large, fleshy petals surrounding many fleshy stamens and many free carpels arranged in a cone-like structure. But it is in their leaves that they differ in a way that is important to gardeners, for many of the Asian magnolias flower before the leaves emerge in the spring, which means the flowers can be admired in their full glory. Not all Asian magnolias are deciduous (lose their leaves in the winter), but many of them are – and it is these magnolias, and the hybrids derived from them, that grace our spring gardens.

The Chinese – who are justly famous for their use of plants in medicine – made reference to magnolias in their herbals (which were written long before European herbals), ascribing medicinal properties to the thick bark used in a tonic, and eating the petals. An eleventh-century herbal mentions three species of magnolia, at least one of which was used as a cultivated plant in the emperor's gardens. This plant was well-known to Buddhist monks as Yulan, or 'Lily Tree', and appears on early porcelain as a symbol of purity and honesty. Nineteenth-century British authors maintained that magnolias had been cultivated in China since the year 627 – which certainly seems likely, although not exactly chronologically correct – but just which *Magnolia* species these paintings and porcelain figures represent will possibly never be known. A mixture of several species of magnolia flower buds is still in use in many Asian countries to this day – known as *hsin-i*, it is used as a treatment for headaches, colds, fever and allergies. Chemical compounds extracted from the dried buds of one of the species included anti-

surrounded by scaffolding, on which were balanced wooden boxes in which layering was taking place for propagation. The town of Exmouth remembers this magnolia tree today in its coat-of-arms – a fortified tower flanked by the leaves and flowers of the magnolia. The motto 'Mare ditat flores decorant' ('The sea enriches, the flowers decorate') epitomizes the former glory of such port towns in the southwest of England.

Although the first magnolias brought to Europe and cultivated were from North America, it is Asian magnolias that we commonly see in gardens today. Millions of years ago the ancestors of magnolias were found throughout the great

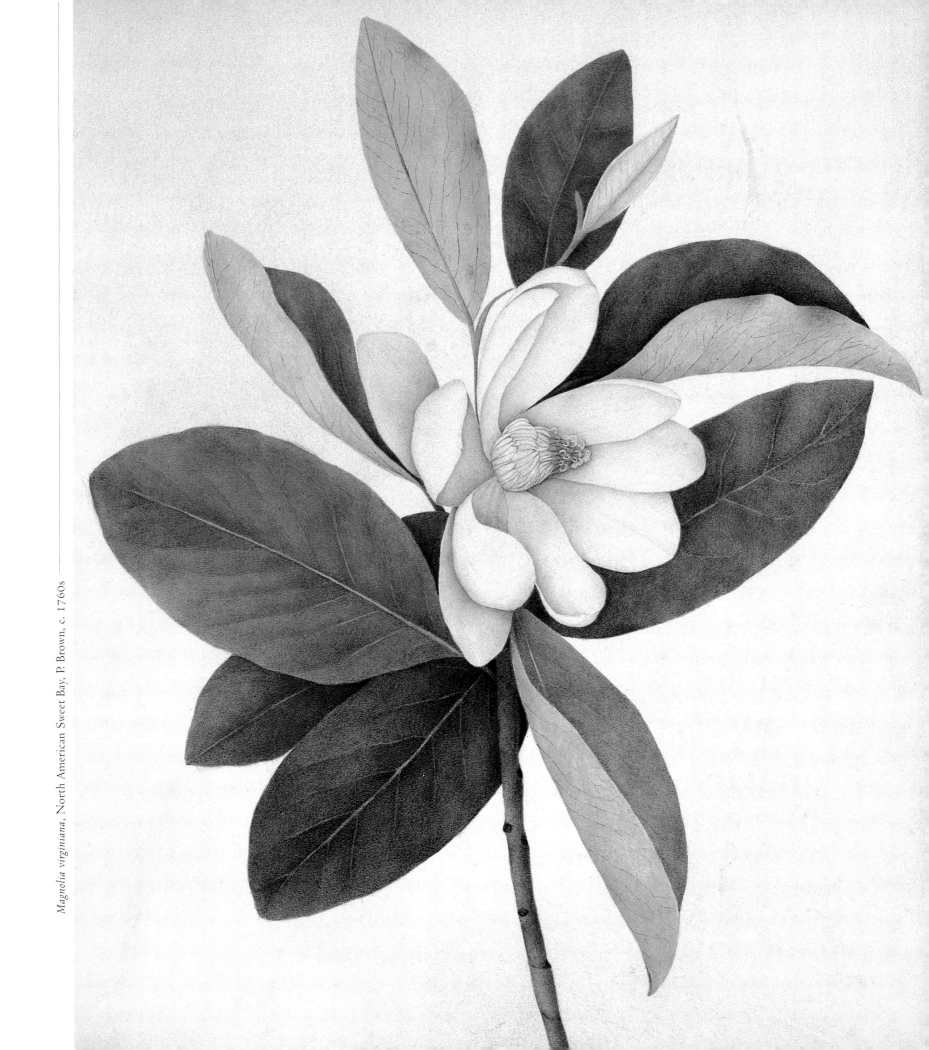

inflammatory agents and anti-allergens, so there is (as is commonplace with Chinese medicine) a chemical basis for the tonic's efficacy.

Just when the first of these lovely deciduous magnolias was introduced to Europe is not known for sure, but Sir Joseph Banks – eminent botanist, President of the Royal Society, cream of British scientists, and botanist on Captain James Cook's great voyage on the HMS *Endeavour* – is said to have introduced a magnolia with creamy-white flowers borne on naked branches. Exactly when this happened is unclear, but what is certain is that Banks arranged to have some paintings of allegedly Japanese magnolias made by Engelbert Kaempfer published in 1791. The images bore only the Japanese names for what was a mixture of cultivated Chinese and Japanese plants – the species we now know as *Magnolia denudata*, *Magnolia liliiflora* and *Magnolia kobus*. Early trade between Japan and China confused eighteenth-century botanists as regards the origins of many of the Asian plants – often introduced via Japan, they were in fact native to China. The species name 'denudata' refers to their spectacular habit of flowering before the leaves come out in the spring; indeed, these lovely plants were described by a French author in 1778 as 'a naked Walnut Tree with a lily at the end of every branch'.

It is not surprising that these trees, also hardy in European winters (although susceptible to frost when they are flowering), overtook the evergreen American magnolias in popularity. Another Chinese species, *Magnolia liliiflora*, the lily-flowered magnolia – also introduced to cultivation in the latter part of the eighteenth century – has deep-purple, erect, almost closed flowers. A hybrid created between this species and Banks' creamy-white-flowered plant by Etienne Soulange-Bodin, an important official in the cabinet of Prince Eugène (son of Napoleon Bonaparte and his empress Josephine) is probably the most commonly cultivated magnolia of all. *Magnolia* x *soulangeana* flowers later than either of its parents, thus escaping the ravages of frost that so damage the delicate flowers of all magnolias.

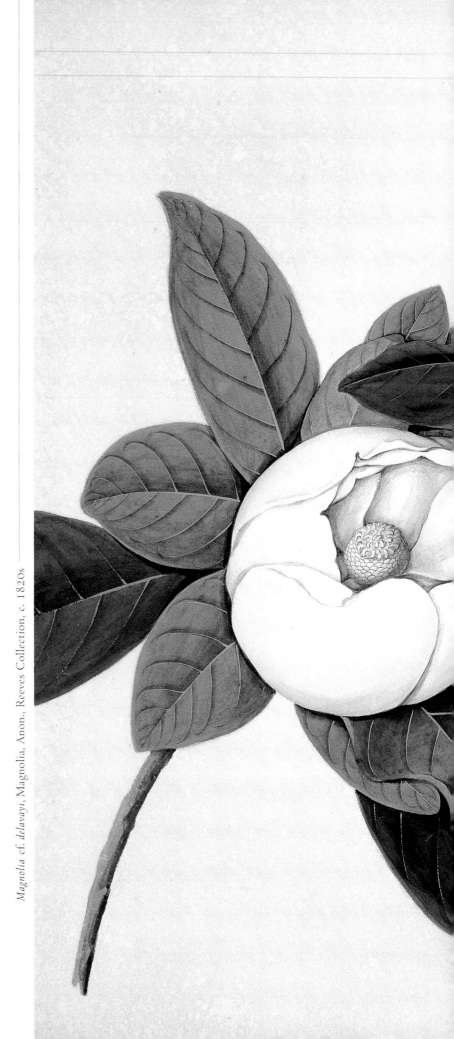

Magnolia cf. delavayi, Magnolia, Anon., Reeves Collection, c. 1820s

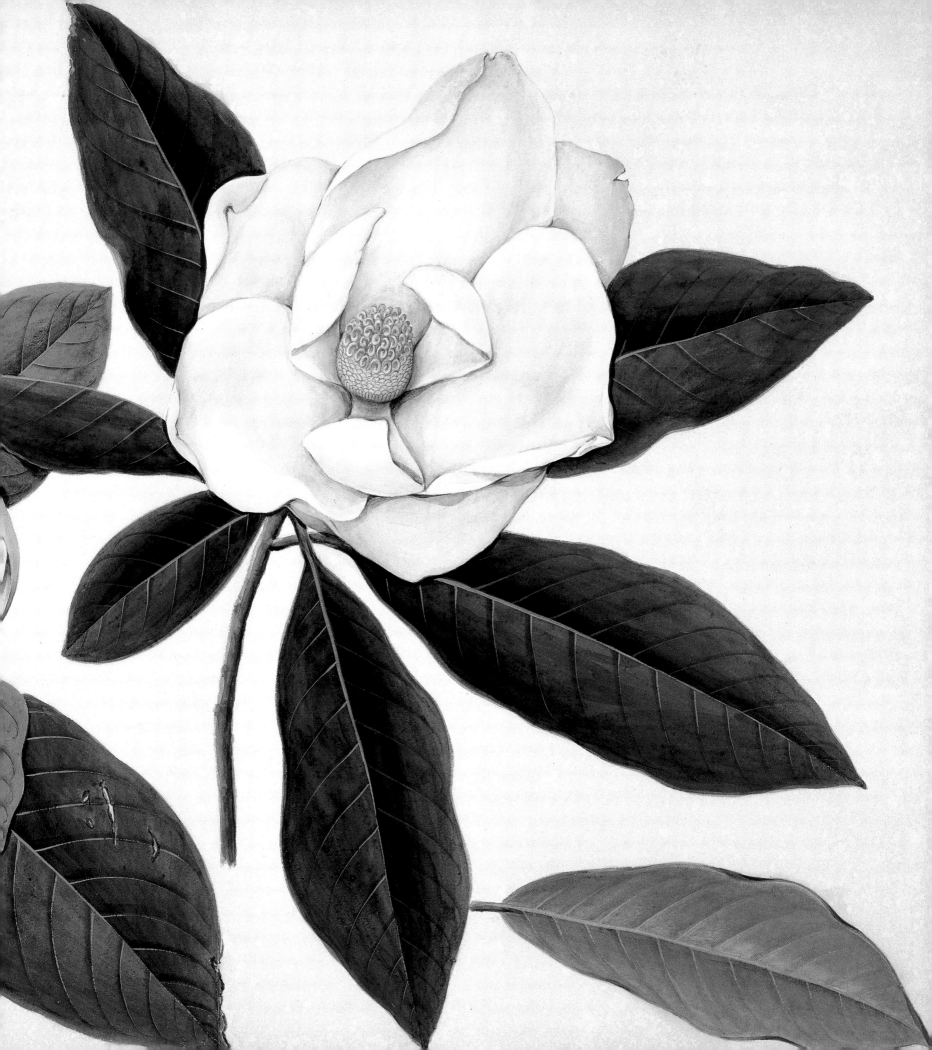

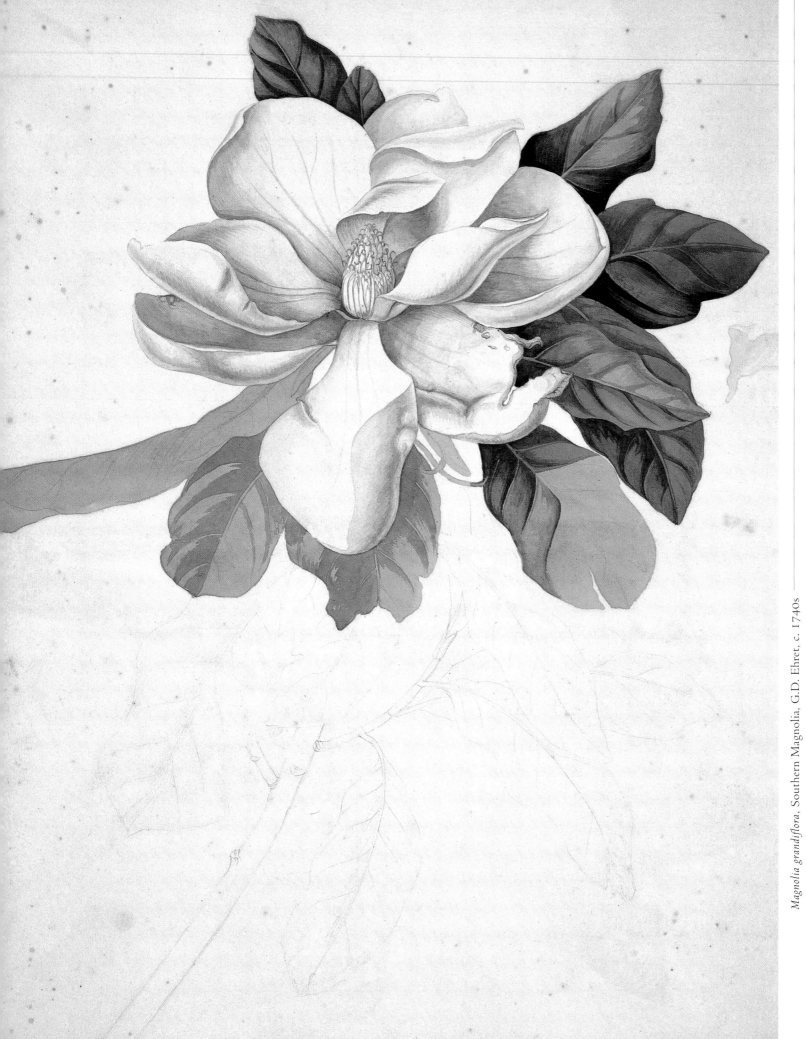

Magnolia grandiflora, Southern Magnolia, G.D. Ehret, c. 1740s

Quite probably the queen of cultivated magnolias is *Magnolia campbellii*, a mountain species from the kingdoms of Sikkim and Bhutan. Joseph Hooker, friend of Charles Darwin and the son of William Hooker, the first director of the Royal Botanic Gardens at Kew, saw whole hillsides in Sikkim turned pink with the blooms of this species. He named it in honour of Dr Archibald Campbell, the political resident of Darjeeling, who surely helped the young explorer as he travelled in search of new and fascinating plants for cultivation in the newly established botanical garden. The flowers of *Magnolia campbellii* are huge – the size of a child's head – and creamy-white or pale, clear pink. They are borne on the ends of leafless branches and are an unusual cup-and-saucer shape, due to the inner petals being held erect in a cone around the reproductive parts. These trees seldom flower until they are more than twenty years old, so the gardener who waits for this to happen will be well and truly rewarded. At the time of Hooker's journey to Sikkim, *Magnolia campbellii* was common, and cloaked hillsides in the spring. Sadly, its wood has been long used for tea boxes (in demand at the heyday of the tea industry in the British colonies), and for firewood and timber. Nowadays, these trees are scarce in their native habitat, so we are indebted to the early plant hunters for introducing us to this prize.

After Hooker, many botanists explored the forests of eastern Asia, in search of plants for European gardens. Many species of Asian magnolias have been introduced into our gardens, from the delicate, ephemeral *Magnolia kobus* var. *stellata*, whose narrow petals and sweet scent herald spring in many gardens throughout the northern hemisphere, to the more robust *Magnolia wilsonii*, with its nodding flowers and bright-red stamens. The many hybrids and species created by plant breeders and magnolia enthusiasts from these original introductions are widely grown in the more temperate parts of the north temperate zone (magnolias never like frost!).

Why exactly do we grow these plants? They take years to flower, the fleshy yet delicate flowers are destroyed by the slightest nip of frost, yet still they fascinate. Chinese, American, Korean and

Japanese species are all cultivated and ultimately hybridized in the search for ever more spectacular flowers. The sheer size and amazing texture of the flowers, coupled with the thought that the ancestors of these plants lived with the dinosaurs, will keep them in our gardens for many centuries to come. Yet magnolia flowers continue their hold on our imaginations because they truly remind us of life itself – fleeting and ephemeral, a treasure to be grasped.

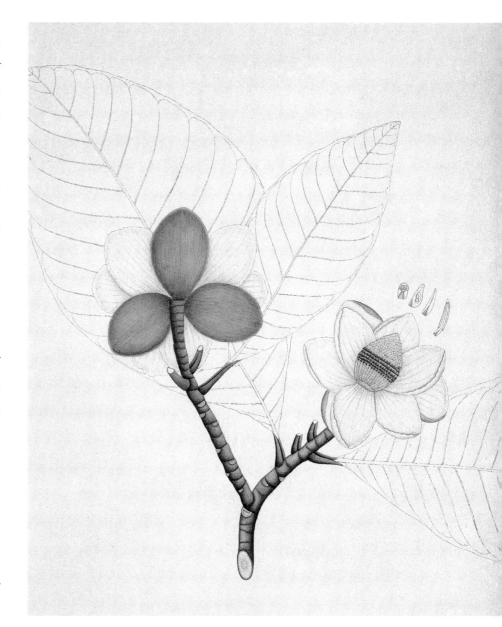

The luminosity of this painting owes much to the vellum, whose creamy colour and special texture bring out shades and nuances lost on paper. Easily one of my favourite objects in the Natural History Museum's collections, it also shows how Georg Ehret's talent for observation made his plant portraits not just paintings of individual plants but also true studies of the ideal organism.

Southern Magnolia; Bull Bay
Magnolia grandiflora L.(Magnoliaceae)
Georg Dionysius Ehret
1744, watercolour with bodycolour on vellum
469mm x 354mm (18½in x 14in)

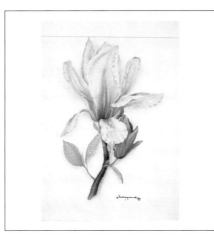

Magnolia x soulangeana is a hybrid between the two prized Asian species Magnolia denudata (seed parent) and Magnolia liliiflora (pollen parent). Etienne Soulange-Bodin made the first cross, at the Royal Horticultural Institute near Paris, but plants of the same hybrid were also 'created' in Japan. This is one of the most commonly cultivated magnolias in the world: hardy, and combining the beauty of both its parents, it has given rise to hundreds of cultivars.

Magnolia
Magnolia x *soulangeana* Soul.-Bod.
Olga Makrushenko
1999, mixed media on card
348mm x 249mm (13¼in x 9¾in)

This painting is labelled 'Liriodendron grandiflorum' in an unknown hand. Roxburgh named the same plant Magnolia pterocarpa and Liriodendron grandiflorum, but both names were not published until long after this was painted. Who wrote that name and when, and how did they decide that it was correct? The flowers of Magnolia pterocarpa are white – not pink as painted here – so this plant's identity is a mystery.

Magnolia (highly stylized)
Magnolia species (Magnoliaceae)
Anon. Fleming Collection
c. 1795–1805, watercolour with bodycolour and ink on paper, 405mm x 291mm (16in x 11½in)

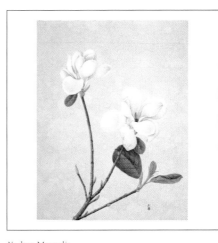

Both this species and Magnolia liliiflora were first figured by Engelbert Kaempfer. He saw both species cultivated in Japan in the very early eighteenth century, with the Japanese common name of mokuren. The Chinese common name, which means 'lily-tree', pays homage to the beautiful, pure white flowers. Grown in the imperial palaces in Beijing on rootstocks of Magnolia liliiflora, these plants were forced to give blooms at all times of year.

Yu-lan; Magnolia
Magnolia denudata Desr. (Magnoliaceae)
Anon. Reeves Collection
c. 1820s, watercolour with bodycolour on paper
479mm x 378mm (18¼in x 14¼in)

The Chinese name for magnolias, mu-lan, can be translated roughly as 'woody orchid', and its purple blooms (appearing at the tips of the branches before the leaves come out) are indeed orchid-like in effect. Magnolia liliiflora is not known in the wild, and has been cultivated for centuries in both China and Japan. This shrubby species is easy to grow in pots and it was often used as dwarfing rootstock for other species such as Magnolia denudata.

Purple Lily-flowered Magnolia; Mu-lan
Magnolia liliiflora Desr. (Magnoliaceae)
Anon. Reeves Collection
c. 1820s, watercolour on paper
380mm x 286mm (15in x 11¼in)

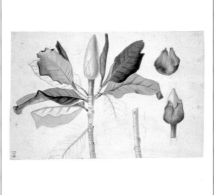

This spectacular southern magnolia flowered for the first time in England in the Parsons Green garden of Sir Charles Wager, First Lord of the Admiralty. The event was of great interest to the botanical community, including Georg Ehret – who walked every day from Chelsea to Parsons Green, a round trip of some 4km (2½ miles) – in order to observe and sketch every phase of the flower development, from 'button' to creamy dinner plate.

Southern Magnolia; Bull Bay
Magnolia grandiflora L. (Magnoliaceae)
Georg Dionysius Ehret, Ehret Sketches
c. 1740s, watercolour with bodycolour and graphite on paper, 277mm x 428mm (11in x 16¾in)

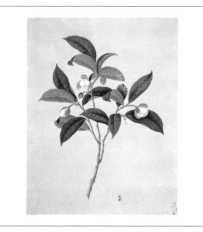

This Himalayan magnolia grows from China to India, and was first collected in 1849 in Sikkim (northeast India) by Joseph Dalton Hooker. Joseph was the son of Sir William Hooker, director of the Royal Botanic Gardens at Kew, and his expedition to the Himalayas was undertaken with the express purpose of obtaining plants for the gardens at Kew. Joseph was spectacularly successful, and went on to become director of Kew himself.

Globe-flowered Magnolia
Magnolia globosa Hook. f. & Thomson (Magnoliaceae)
Anon. Reeves Collection
c. 1820s, watercolour with bodycolour on paper
481mm x 380mm (19in x 15in)

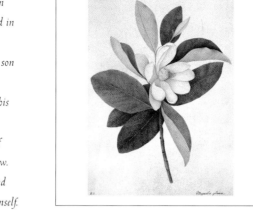

One of the first magnolias to have been brought to Europe from North America, the sweet bay was grown in 1688 in the gardens of Fulham Palace, residence of the Bishop of London (at that time Dr Henry Compton). The Reverend John Banister, whom he had sent to the new colonies, may have sent this magnolia to Compton.

North American Sweet Bay; Swamp Bay
Magnolia virginiana L. (Magnoliaceae)
Peter Brown
c. 1760s, watercolour with bodycolour on vellum
321mm x 239mm (12¼in x 9½in)

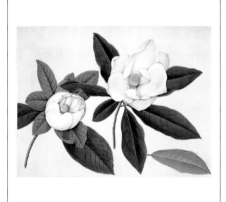

This wonderful evergreen species is named for the French Jesuit missionary Père Jean-Marie Delavay, who first collected it in 1886, near Langkong in southern China. A 230-year-old Magnolia delavayi tree grows in the gardens of the Yufeng temple in Lijiang, Yunnan. Recently, botanists at the Kunming Botanical Garden have developed red- and pink-flowered varieties, which are in demand in China and abroad.

Magnolia
Magnolia cf. *delavayi* Franchet (Magnoliaceae)
Anon. Reeves Collection
c. 1820s, watercolour with bodycolour on paper
371mm x 489mm (14½in x 19¼in)

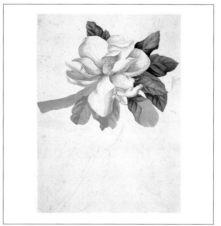

This sketch forms the basis for Ehret's finished painting of the flower of this species on vellum. In the finished product the flower is perfect, but here we can see how the elements have taken their toll on one of the petals. In a way, this sketch is more realistic and alive than the exquisite vellum portrait, being an absolutely accurate rendering of a live specimen.

Southern Magnolia; Bull Bay
Magnolia grandiflora L. (Magnoliaceae)
Georg Dionysius Ehret
c. 1740s, watercolour with bodycolour and graphite on paper, 547mm x 404mm (21½in x 16in)

Unwittingly, William Roxburgh named this plant twice: it was first published as Magnolia pterocarpa, and then again as Liriodendron grandiflorum. *This drawing from the Fleming Collection is a copy of the one made for Roxburgh when he first named the plant, and clearly shows the winged 'beak' on the carpels the species is named after.*

Magnolia
Magnolia pterocarpa Roxb. (Magnoliaceae)
Anon. Fleming Collection
c. 1795–1805, watercolour with graphite on paper
493mm x 326mm (19½in x 12¾in)

Flowers are associated with love and romance – the language of the flowers was invented to convey special meaning through symbols, many of which were associated with lover's messages. Of all the flowers symbolizing love, the silky, ruby-red hibiscus probably has the most luxuriant of associations, thanks to Paul Gauguin and his vividly coloured Impressionist paintings of Tahitian women and society. Gauguin's primitive, visceral paintings from the South Seas spoke of a world without walls, full of life and love – the very opposite of the restricted society that he had left behind in northern Europe.

The hibiscus flower instantly calls up the hot, humid tropics, for its extravagance seems out of place in the mild-mannered far

like they have a maypole or a garish hatstand at their centre. This effect is caused by the fusion of the filaments (the stalks that hold the pollen-bearing anthers) into a tubular structure. The golden-tipped spikes sticking out from this tube are the anthers themselves, and the filaments are of different lengths, so the anthers come out all up and down the tube – sometimes all near the tip, at other times spaced out over the entire surface. Inside the tube of filaments is the style, bearing at its top branches, each of which at maturity is tipped with a round, papillate stigma, looking for all the world like a fuzzy beach ball. The immature stigmas are held within the filament tube until after the pollen is released from the anthers, then the styles extend and the stigmatic

HIBISCUS

*[What] he saw with his other eye was a man sitting by a hibiscus bush and the face was the same,
only older, as the face in the snapshot. Also by a hibiscus bush. Tim Kendal had heard the
story the Major had been telling and he saw that the Major had recognized him.
So, of course, he had to kill him.*

A CARIBBEAN MYSTERY (AGATHA CHRISTIE, 1964)

north. The Hawaiian custom of wearing a hibiscus flower behind the ear is said to convey meaning: a red hibiscus behind the left ear means that a lover is sought, while one positioned behind the right ear suggests a lover is already in possession. Behind both ears? Well, who knows? The hibiscus is called Bunga Raya or the 'Queen of Flowers' in Malaysia, and a variety of different species of this genus are the national flowers of Malaysia, Jamaica, South Korea and the American state of Hawaii. The red hibiscus that springs to mind when we think of Paul Gauguin and Tahiti is *Hibiscus rosa-sinensis*, the China rose. Not even remotely related to the rose family, hibiscus is a member of the cotton family, the Malvaceae. The cottons all have the peculiarly characteristic flowers that look

surface expands and becomes ready to accept pollen for fertilization. This helps to avoid self-fertilization and promotes genetic recombination – which, evolutionarily speaking, is always a good thing.

The fact that we associate *Hibiscus rosa-sinensis* with the South Seas attests to the seafaring abilities of the early Polynesians, who took products such as dogs, chickens, breadfruit and bananas all over the Pacific long before these places were first visited by Europeans. The plant was cultivated in China centuries before the birth of Christ – it was sometimes called *Fusang*, after the fabulous island in the eastern sea behind which the sun rose and on which a gigantic tree that made men immortal bore fruit. Perhaps it

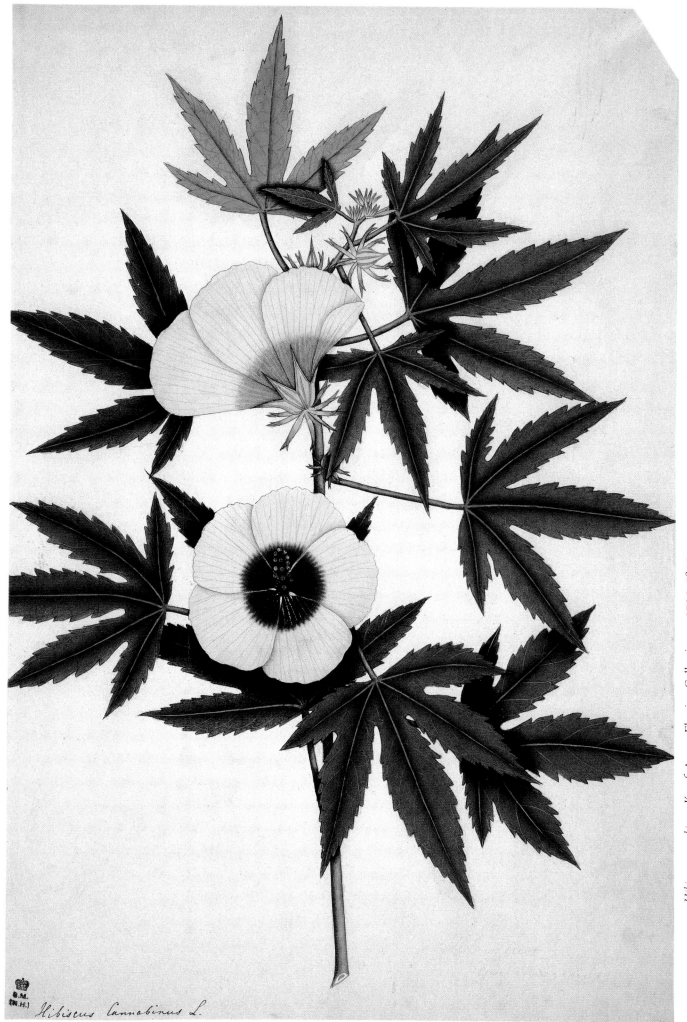

Hibiscus cannabinus, Kenaf, Anon., Fleming Collection, c. 1795–1805

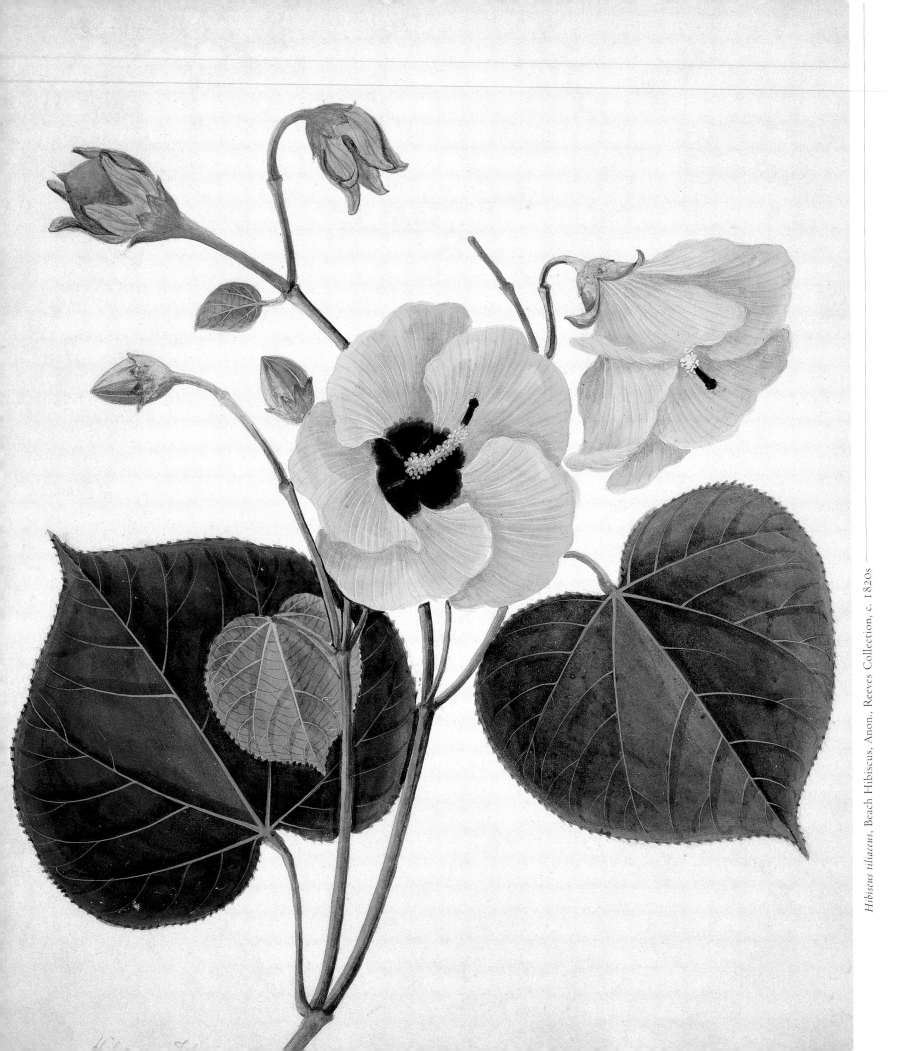

originally did come from the Pacific, as an eastern sea does certainly suggest this. The origins of *Hibiscus rosa-sinensis* are lost in the mists of time and, given its long history of cultivation and its popularity worldwide, they are likely to remain lost for ever. The China rose is a member of a particular section of the genus, section *Lilibiscus*, the lily-flowered ones. Other members of the section are found on islands in the Pacific – from the Mascarenes and Madagascar in the Indian Ocean to Hawaii far out in the Pacific. One characteristic shared by these species is that they are all island endemics, with the exception of *Hibiscus rosa-sinensis*, which is cultivated all over the world. Island endemics are special to those who are concerned for the future of the species that share this planet with us. Their fate hangs in the balance, perhaps foreshadowing our own situation if we continue down the destructive path we are currently following.

Islands harbour special organisms: isolated from continental populations, organisms that set up housekeeping on islands develop characteristics that lead to speciation – that is, they become different. They can also develop peculiar behaviours in the absence of predators that on larger continental landmasses would exert selective pressures on them. The lack of ground predators on many of the Pacific islands made ground nesting a perfectly safe thing to do for many bird species, but when rats jumped ship on to the islands from passing marine traffic, that previously safe habit became distinctly unsafe, and several species were driven to extinction. Galapagos tortoises were collected and eaten in their hundreds by buccaneers stopping at the islands for food and water, and dodos suffered a similar (but worse) fate on Mauritius.

Plants on islands are also at risk. For a start, the available land area is small – the island of Kauai in the Hawaiian archipelago is 1433 square kilometres (533 square miles) in extent, but the island of Rodrigues in the Mascarenes is a mere 109 square kilometres (42 square miles), and that is simply not enough room to support huge populations of woody plants! Second, if a species is endemic to an island, it is found absolutely nowhere else. *Hibiscus storckii*, a relative

of the China rose once known from the Pacific island of Fiji, is extinct, gone forever. When *Hibiscus liliiflorus*, the mandrinette, was down to three plants on Rodrigues in the late 1990s, extinction seemed inevitable. Replanting has boosted the population to more than a thousand plants, however, but that is still not very many.

Rodrigues is a good example of how humans can relatively quickly devastate the environment of a small island. In 1708, when François Legat first saw the uninhabited island, he described it as a lush, green paradise where 'springs never ran dry'. People arrived, colonized and proceeded to bend the land to their will, and in less than 200 years the British botanist Isaac Bayley Balfour was describing Rodrigues as a 'barren spot, clothed with weeds'. What a difference…

Hibiscus tiliaceus, Beach Hibiscus, Anon., Saharunpore Gardens Collection, 1847

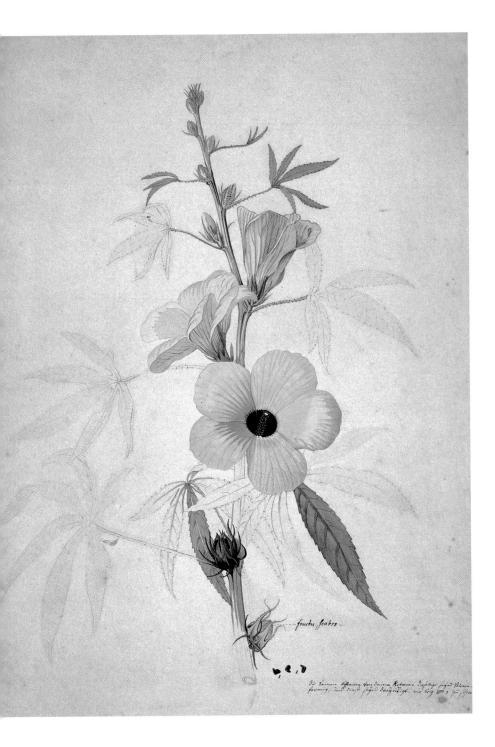

inflict that can cause problems. As islands are inhabited, alien species colonize, usually in association with humans, and sometimes these newcomers out-compete the older endemics, which are not able to produce many seeds or colonize the disturbed habitats created by humans. Many of the invaders are weedy and quickly establish themselves in native habitats. In Hawaii, the shrub *Miconia*, imported for its lovely green and purple foliage, has aggressively entered native rainforest and is spreading rapidly. Conservationists are trying to control these species by physically removing them, but it is an enormous task. There are also several species of section *Lilibiscus* in Hawaii, which is a long way from the Mascarenes. All of them are endemic, and some of them (such as *Hibiscus waimeae*, found only on Kauai, and *Hibiscus kokio*) are threatened in the wild. One of these species, *Hibiscus arnottianus*, endemic to Oahu, has been brought into cultivation, but mainly as a species to hybridize with *Hibiscus rosa-sinensis*. The variability of *Hibiscus rosa-sinensis* in cultivation leads to a great deal of confusion – it has white, pink and yellow forms; double forms and single forms; forms with pink leaves and forms with white leaves; so just where this marvel of adaptability came from, among all those island endemics, is still a mystery. Perhaps it is of hybrid origin? Its wildly varying chromosome numbers – from 36 to 168 – suggest that it might be.

Hybrids in plants are quite common, certainly more so than with animals. One sort of hybridization, apparently quite rare in animals but common in plants, is a feature of several genera in the Malvaceae, including *Hibiscus*. Most organisms have one set of chromosomes – in pairs, one chromosome from the mother and the other from the father. Human beings have 46 chromosomes, in 23 pairs. We are diploid, with one set of chromosomes, but many plants are what is known as polyploid – they can have multiple sets of chromosomes, acquired through doubling. Some polyploid species are not hybrids; their multiple chromosome sets are just doubles of what they already had, and these species are called autoploids. Others, however, acquire multiple chromosome

Restoration work by dedicated Rodriguan volunteers has helped to save many plant species (like *Hibiscus liliiflorus*) from extinction, but it is not just the physical damage that people

Hibiscus cannabinus, Kenaf, G.D. Ehret, 1742

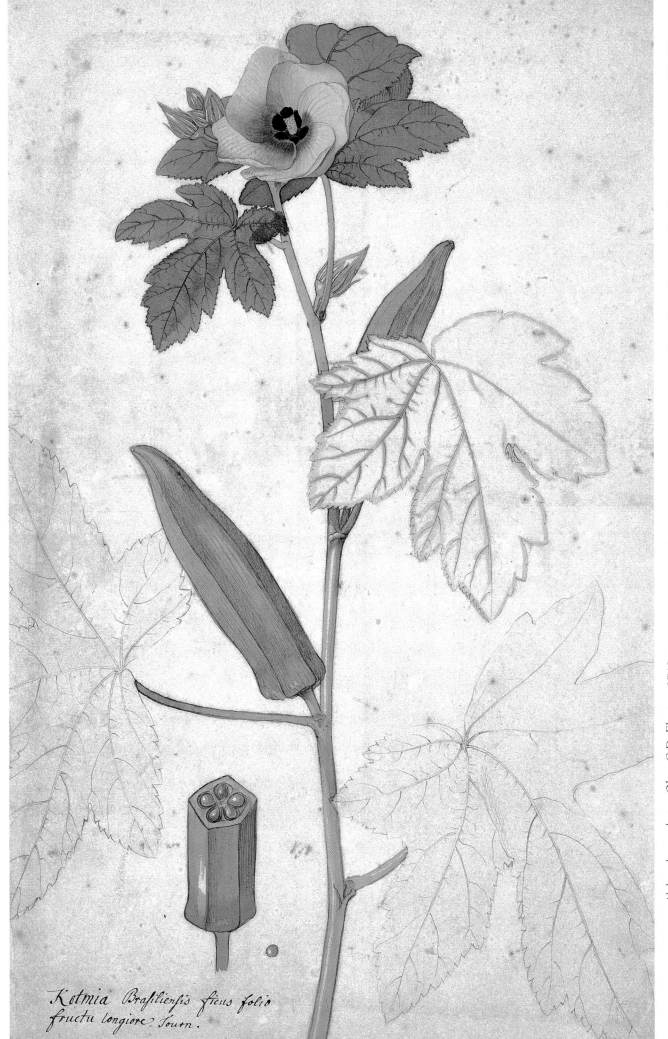

Kotmia Brasiliensis ficus folio fructu longiore. Tourn.

Abelmoschus esculentus, Okra, G.D. Ehret, c. 1740s

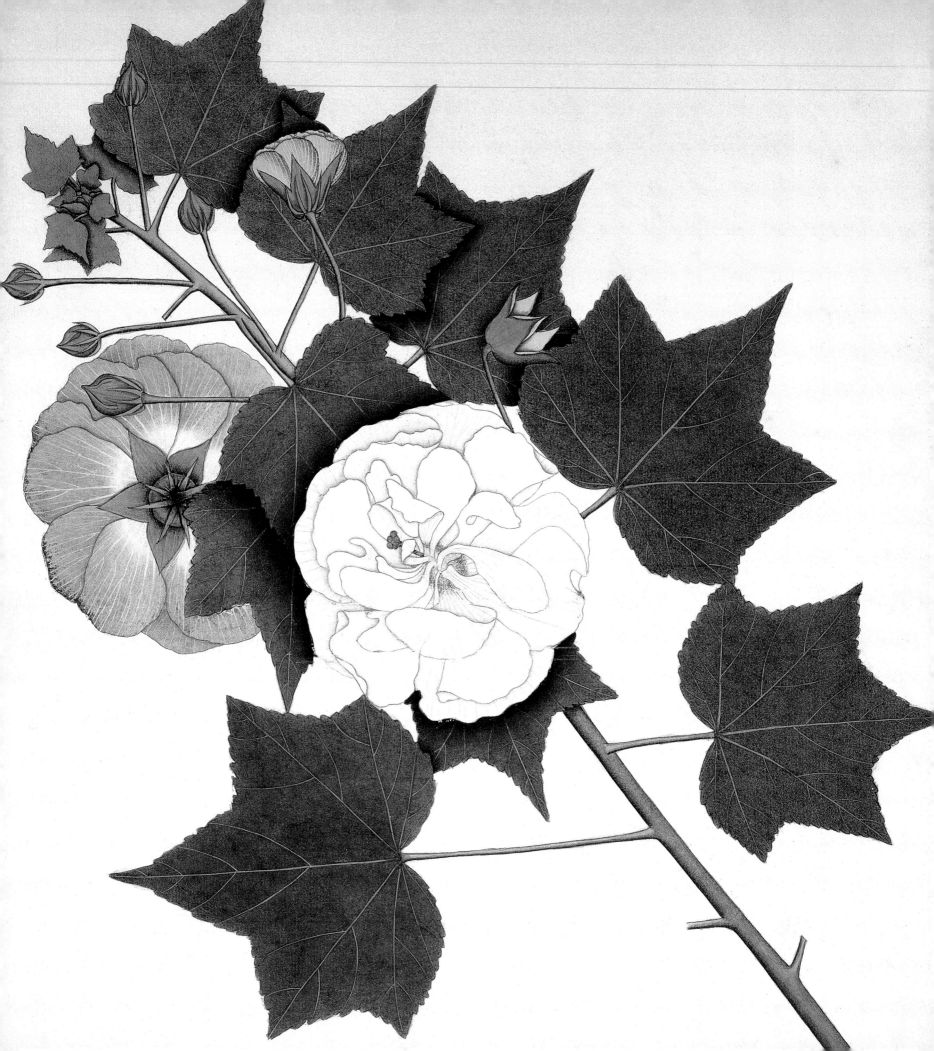

sets by hybridization, ending up with one set from each parent, for example, and these are the alloploids. Just where the chromosome sets come from has only been investigated in a few economically important plants, such as cotton, the genus *Gossypium* – another member of the Malvaceae and closely related to *Hibiscus*. The cultivated cottons are mainly tetraploid – they have two sets of chromosomes from two parents (that is, they are alloploids). Some *Hibiscus* species appear to be of hybrid origin, as well – like *Hibiscus rosa-sinensis*, they have a wide range of chromosome numbers, perhaps indicating a degree of instability. Other species just seem to have undergone chromosome doubling or perhaps reduction in chromosome number, but unravelling such patterns is complex and requires a great deal of detailed work with the chromosomes themselves. This is why, in general, polyploidy is often well understood in economically important plants such as cotton.

Species of *Hibiscus* are found all over the tropics, in both the New and Old worlds. Some native species of Malvaceae also occur in Europe, such as *Althaea officinalis,* the roots of which were the original source of marshmallow (soaked in water they contained enough sugar, starch and gelatinous matter to be turned to jelly). Probably the first exotic mallow to be brought back to northern Europe was the hollyhock, *Althaea rosea*. Most likely of western Asian origin, seeds were brought back to England by returning Crusaders, although now it behaves as a wild plant, cropping up along ditches everywhere. The more flamboyant hibiscus only became known as exploration (rather than purely warfare) expanded outwards. Ogier Ghiselin de Busbecq – issued from Vienna to the court of Selim (also called Suleyman the Magnificent) by the Holy Roman Emperor Ferdinand I in the mid-sixteenth century – sent back a lovely pink-flowered plant called the Syrian rose or the rose of Sharon. Botanists of the time thought it was native to Syria and that it was the 'rose of Sharon' from the Song of Solomon. In fact, *Hibiscus syriacus* (as it was later named by Carl Linnaeus in 1753) is probably an eastern Asian plant, brought to the sophisticated court of Suleyman along the

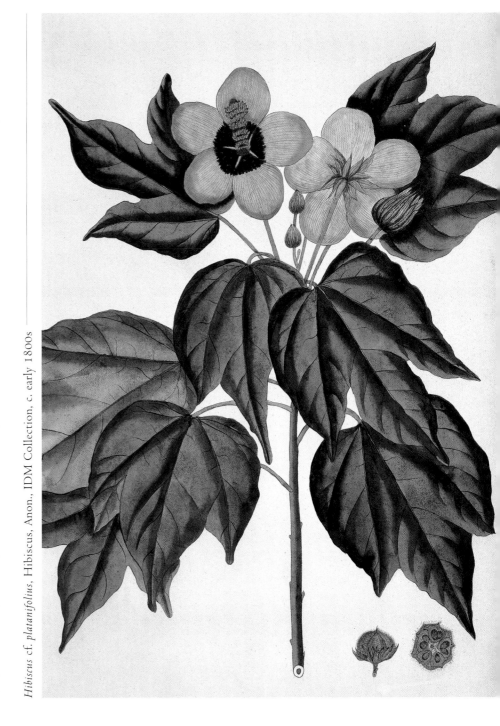

Hibiscus mutabilis, Cotton Rose, Anon., IDM Collection, c. early 1800s

Hibiscus cf. *platanifolius*, Hibiscus, Anon., IDM Collection, c. early 1800s

Silk Road. Double forms of this flower are depicted in ancient Chinese manuscripts, its pink flowers fading to purple with age. Busbecq was a swashbuckling character, quick and adventurous,

and was fascinated by the rich and colourful history of the Ottoman Empire as well as by its plants and flowers. He was responsible for the unearthing of a precious manuscript copy of *De materia medica* – the book of medicine compiled by Pedanius Dioscorides, a Greek citizen of Cilicia who in the first century served as a soldier and doctor in the Roman army. *De materia medica* carefully recorded the plants used in the medicine of the day, and was the bible for medicine, but by the early sixteenth century knowledge about medicine was becoming rather sketchy. No copies of Dioscorides were in the hands of northern European doctors; instead, knowledge had been passed down by tradition

and was to a certain extent corrupted. It seems amazing to us now that medieval doctors did not just try to invent new herbal medicines – surely some did – but classical knowledge was highly prized, however corrupted it might have become. The book that Busbecq acquired for the Holy Roman Emperor was a transcription of the original, made hundreds of years after Dioscorides died. Ferdinand negotiated for several years with Suleiman's physicians, who knew full well the value of what they had. Once the book got to Vienna, it was copied and circulated, and this single 'collection' (now called the *Codex Vindobonesis*) sparked the thirst to see these medicinal plants in the wild.

Busbecq was followed to the East in 1546 by a French doctor, Pierre Belon, in the pay of the Cardinal of Tournon. He was searching for the plants of the classical scholars, now for the first time within the grasp of northern Europeans. But Belon did not bring back plants, for he only observed, which was probably quite frustrating for those left at home, who also would have liked to see

the plants used by Dioscorides. One of the first to concern himself with what we might call complete sampling today, Belon apparently collected small twigs or branches of everything he saw during a day, then noted them down in the evening, 'just to show they are found in these places as well as with us', presumably meaning that he noted common European species as well. In his travels in the Middle East – he went to Constantinople, Gallipoli and Rhodes, as well as stopping to see the Pyramids and to climb Mount Sinai – he surely saw many species, such as those cultivated hibiscus that had come to the edges of Europe along the Silk Road from China.

Flowers are the thing one notices about hibiscus. Showy and florid, they seem only to come in the brightest of colours and the most shocking of colour combinations, like the shocking-yellow flowers of the common strand plant *Hibiscus tiliaceus* that turn hot orange at the end of the day. But the pleasure is fleeting: the flowers of many sorts of hibiscus last a single day, then wither and shrivel, hence the common name of the African species *Hibiscus trionum*, Flower-of-an-Hour or Goodnight-at-Noon. These yellow flowers with red centres open only in the mid- to late morning and close by early afternoon. They even close in the shade, so are sensitive flowers indeed! Flowers that open only briefly need to be pollinated quickly or else their production has been a waste of the plant's precious resources. Self-pollination is one answer to this problem, but the way hibiscus flowers are constructed – with the anthers along the filament tube and shedding their pollen long before the stigmas appear from within it – seems to make this rather difficult. Colour changes in flowers are sometimes 'signals' to pollinators. Perhaps this is why the flowers of *Hibiscus syriacus* change from pale rose to purple over the course of the day, and may explain the spectacular flower colour changes of the Chinese species, *Hibiscus mutabilis* (given its scientific name to commemorate its changing flowers). In Chinese, *Hibiscus mutabilis* is called *mufurong* (tree lotus) or *jushuanghua* (frost-resisting flower, for its relative hardiness). Buddhist temples are sometimes decorated with the blossoms of *Hibiscus mutabilis* when the lotuses

Hibiscus cf. syriacus, Syrian Rose, Anon., Saharunpore Gardens Collection, 1847

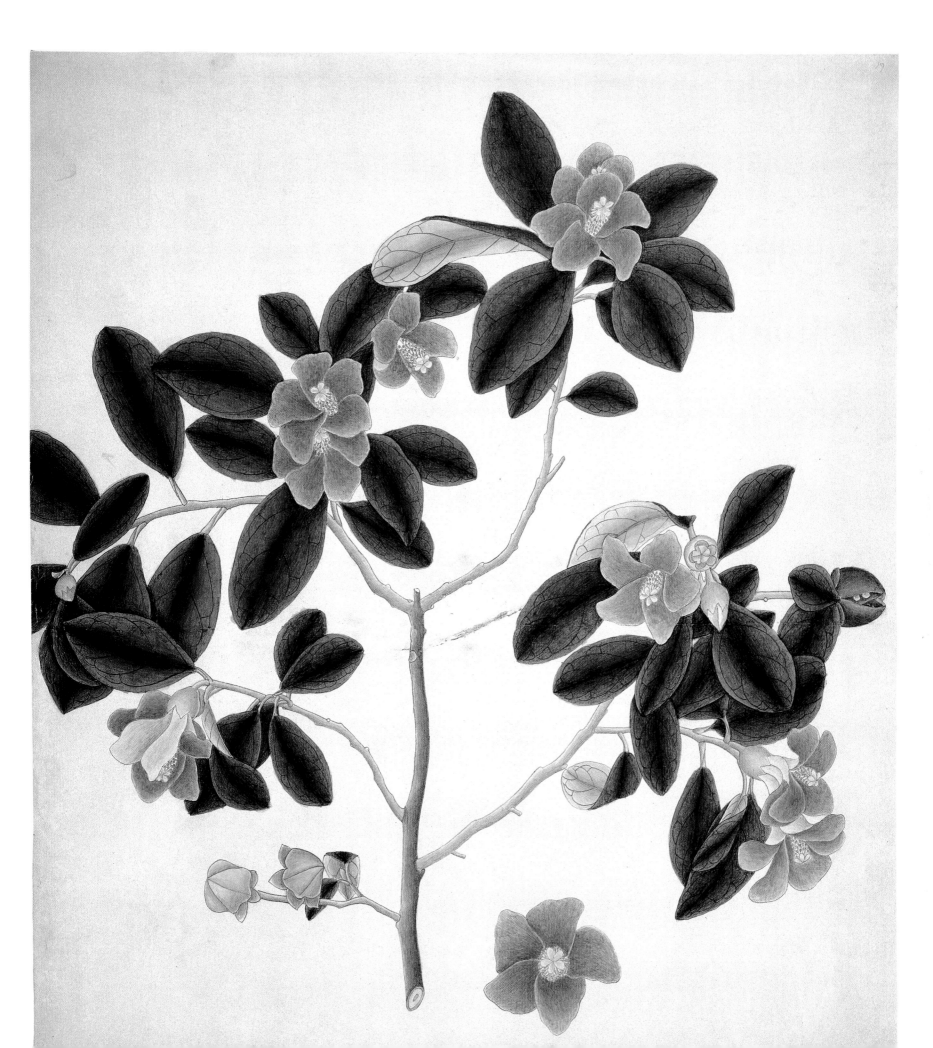

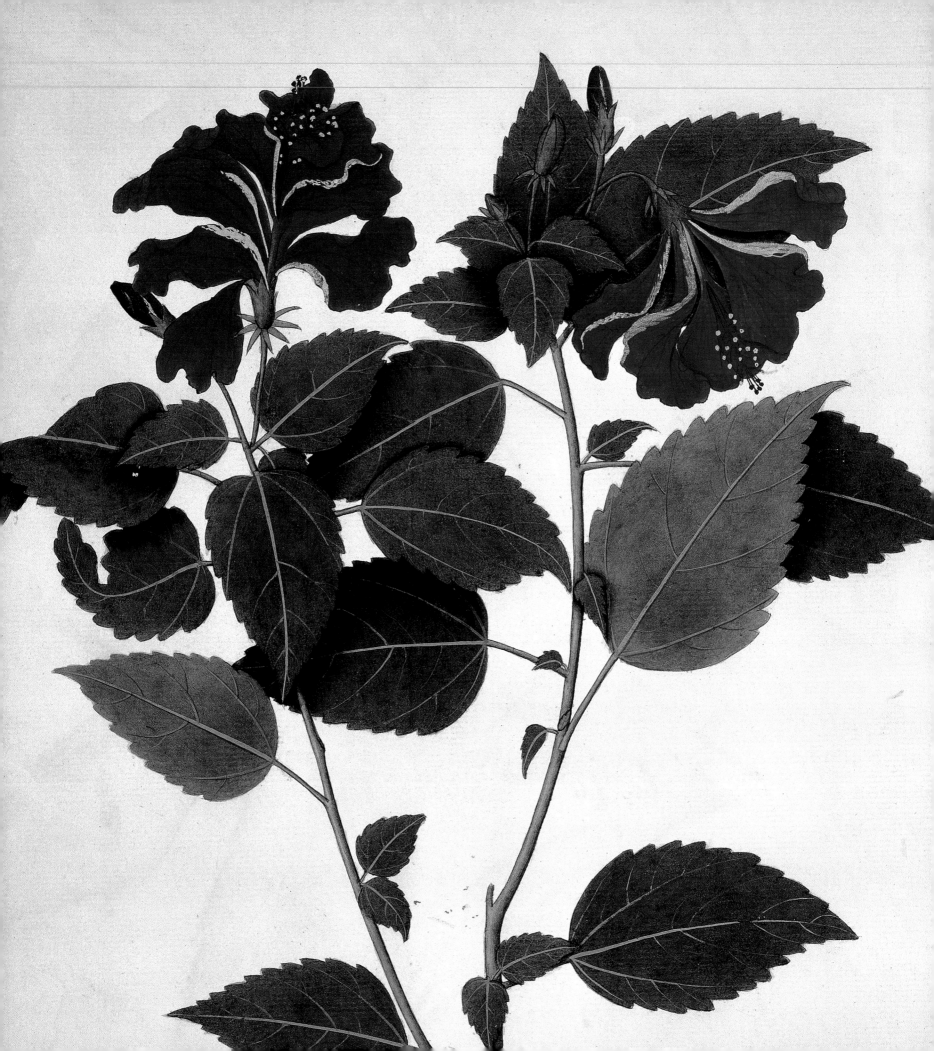

are not in bloom. The species has both double and single forms – the doubles are propagated entirely by cuttings, so possibly they do not set seed. Over the course of a day, the flowers of *Hibiscus mutabilis* change from white in the morning, to the palest of pink at noon, to dark pink by afternoon, to deep red (in some forms) by nightfall. Some flower-decorating books suggest cutting the flowers in the morning, keeping the cut flowers in the refrigerator during the day, then arranging them on the table at dinner parties to amaze guests who watch as they turn from white to pink during the course of the meal. In the United States, this species is sometimes called the Confederate rose – perhaps (although unlikely) because its flowers are as ephemeral as the secessionist republic of the southern states.

Although a great many plants were carried around the world by ambassadors, and later by specialized plant hunters, plants used by people tend to travel the fastest of all. By the time Linnaeus had given *Hibiscus sabdariffa* its scientific name in 1753, it had almost certainly moved from its place of origin in Africa far across the Atlantic Ocean to the slave-dominated economies of the West Indian sugar plantations. This movement was not due to continental drift or long-distance seed dispersal, two common factors in the natural distribution of plants, but rather to the actions and desires of human beings – our own species. *Hibiscus sabdariffa* is an annual herbaceous species with bright-yellow flowers housing a bright-red centre and filament tube. The unusual scientific name (Linnaeus liked to give plants names with classical roots, and avoided the vernacular and presumably vulgar) comes from the Turkish name for this plant. All its parts are used – the seeds of roselle are roasted and ground into flour; the leaves and shoots are slightly acidic and are eaten as a vegetable; and fibres derived from the stems were considered in the early twentieth century as a potential jute substitute – but the most unusual use of *Hibiscus sabdariffa* is derived from its bright-red calyx, which is fleshy and acidic, and when squeezed, made into a fresh or fermented drink. All over the West Indies the drink is called sorrel, but in Spanish-speaking Latin America is called *rosa de Jamaica*, 'rose of Jamaica'. The use of *Hibiscus sabdariffa* was recorded among the slave population in Jamaica in 1707, and the plant was probably brought from Africa by some brave and enterprising soul. Just how a person could have concealed and kept safe seeds in the brutal, dehumanizing conditions of a slave ship is a mystery but plants are important to people and always have been.

Apparently, the best *rosa de Jamaica* grows in the mexican state of Oaxaca – a long way from its home in Africa. Just where this plant is native is (again) difficult to determine, as human spread has so overlaid the patterns of distribution of plants that are useful to us that unravelling the tale can be a real challenge. Some think that the origins of *Hibiscus sabdariffa* lie with an unknown wild hibiscus species in the Angola region that was brought into domestication and taken all over Africa via the dry forest and savannah areas. In the Sudan, people drink *kirkadi*, made from the fleshy calyx of *Hibiscus sabdariffa*, just like they sip sorrel in the New World.

In general, plants that are used by humans for food or drugs spread like wildfire – look at tobacco in Europe after its discovery in the West Indies! It spread so fast that people have speculated it was native in Egypt or Russia. This is a fiction, however: it is just that people prized the plant, it is weedy, so it spread. Prized plants do not necessarily stay put in gardens or fields. If the conditions are right they produce offspring and increase their numbers. This can lead to invasiveness or integration into the local flora – looking and behaving like natives, their true origins are obscure. In a way, *Hibiscus rosa-sinensis* is a horticultural plant that has spread in a similar fashion, for it is easy to grow, it is beautiful, and people have taken it everywhere it will grow and turned it into a marvel of variation. Its phenomenal success in invading (with human aiding and abetting) all sorts of places is in paradoxical contrast to the narrowly restricted ranges of its supposed progenitors – proof positive, if ever one needed it, that you never know how plants will respond to our interventions in their lives.

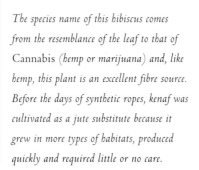

The species name of this hibiscus comes from the resemblance of the leaf to that of Cannabis (hemp or marijuana) and, like hemp, this plant is an excellent fibre source. Before the days of synthetic ropes, kenaf was cultivated as a jute substitute because it grew in more types of habitats, produced quickly and required little or no care.

Kenaf; Ambary
Hibiscus cannabinus L. (Malvaceae)
Anon. Fleming Collection
c. 1795–1805, watercolour with bodycolour on paper
457mm x 312mm (18in x 12¼in)

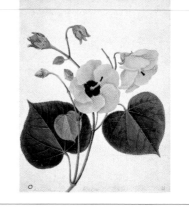

On the Pacific islands of Hawaii, where this species is perhaps native, the indigenous name for the beach hibiscus is hau. The light wood of these trees — which grow up to 20m (66ft) tall and can be dominant in sheltered forested ravines — was used for making spars for outrigger canoes, although it was not the first choice for this purpose.

Beach Hibiscus
Hibiscus tiliaceus L. (Malvaceae)
Anon. Reeves Collection
c. 1820s, watercolour with bodycolour on paper
252mm x 200mm (10in x 7¼in)

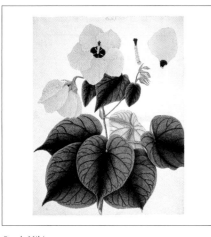

The beach hibiscus is found on coastal shores throughout the Pacific. Its native range is a mystery, although the plants were used by the ancient Polynesians for fibre and wood, and they may have transported them throughout the region. The seeds float, however, so the beach hibiscus may have done its travelling on its own.

Beach Hibiscus
Hibiscus tiliaceus L. (Malvaceae)
Anon. Saharunpore Gardens Collection
1847, watercolour with bodycolour and graphite on paper, 475mm x 374mm (18¼in x 14¼in)

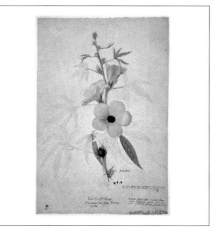

This plant was grown from seed in England, 'sent by Mr. Charles Manningham from Bombay 1742', and Ehret may have drawn it at the Chelsea Physic Garden, where he lived and worked. Ehret married Susanna Kennet, sister-in-law of Philip Miller (who was in charge of the Physic Garden for the Worshipful Company of Apothecaries), so Ehret clearly strengthened his botanical ties by marriage.

Kenaf; Ambary
Hibiscus cannabinus L. (Malvaceae)
Georg Dionysius Ehret
1742, watercolour and graphite on paper
533mm x 369mm (21in x 14½in)

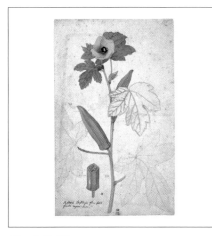

Okra is not native to the New World, as botanists of the day appear to have thought. Indeed, Ehret's label reads 'Ketmia Brasiliensis ficus folio fructu longiore? Tourn.' ('Tournefort's fig-leaf ketmia from Brazil but with longer fruits?'). The plant was taken to the New World by African slaves and became a characteristic element in the cookery of slave communities — it is a key ingredient of gumbo, a Louisianan stew, for example.

Okra; Ladies' Fingers
Abelmoschus esculentus (L.) Moench (Malvaceae)
Georg Dionysius Ehret
c. 1740s, watercolour and graphite on paper
437mm x 274mm (17¼in x 10¼in)

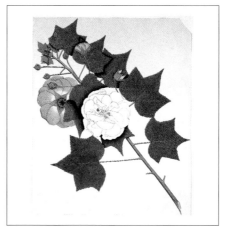

Rather than just being a dinner-party conversation piece, the changing colours of the cotton rose are probably a signal to the plant's pollinators about the status of the flower. Changing colour can let the pollinator know the nectar or pollen is used up or available — in some plants, pollinators avoid flowers of a particular colour, for both bees and birds can see colour well.

Cotton Rose; Confederate Rose
Hibiscus mutabilis L. (Malvaceae)
Anon. IDM Collection
c. early 1800s, watercolour with graphite on paper
460mm x 380mm (18in x 15in)

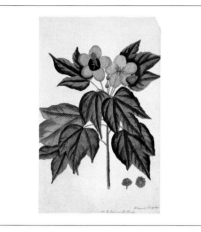

This painting clearly represents a species of Hibiscus, but it is so schematic that its species identity can only be guessed at by combining the place (India) with the description ('bark used for hemp') and going from there. The flowers are slightly wrong for Hibiscus platanifolius, as they should be white with dark-pink spots at the base of each petal.

Hibiscus
Hibiscus cf. *platanifolius* (Willd.) Sweet (Malvaceae)
Anon. IDM Collection, c. early 1800s, watercolour with
bodycolour and ink on paper
462mm x 292mm (18¼in x 11½in)

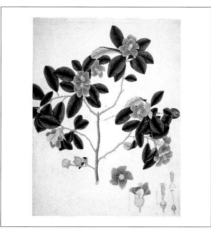

This is a very odd, stylistic painting, as it barely resembles a hibiscus at all. For instance, it lacks the characteristic epicalyx – a sort of add-on calyx beneath the regular one that all hibiscus possess – and the stamens are not pictured as being in the strange (but familiar) bottle-brush arrangement. The artist may have tried to paint what he or she saw, but preconceptions kept getting in the way, which is easy enough to do.

Syrian Rose; Syrian Ketrina
Hibiscus cf. *syriacus* L. (Malvaceae)
Anon. Saharunpore Gardens Collection
1847, watercolour with bodycolour and ink on paper
487mm x 380mm (19¼in x 15in)

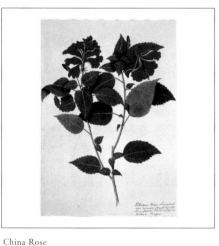

The Bengalese common name for this plant is recorded here as orhool, *although its origins in cultivation are lost in the mists of time. Although thought to have come from China, and certainly brought to Europe from there,* Hibiscus rosa-sinensis *is probably a species of hybrid (possibly horticultural) origin – from somewhere in the region between the Indian and Pacific oceans.*

China Rose
Hibiscus rosa-sinensis L. (Malvaceae)
Anon. IDM Collection
c. early 1800s, watercolour with bodycolour on paper
416mm x 298mm (16¼in x 11¼in)

The roses given in their millions on Valentine's Day have very little in common with the sixteenth-century roses used as symbols of the fragility and ephemeral nature of love and female beauty. The rose is one of the most highly bred flowers in existence – new hybrids are continually being produced, and fashions in rose types wax and wane rapidly. Today's roses, with their perfect pointed buds, long-lasting flowers and minimal scent, are far removed from roses of previous ages, both wild and cultivated.

Roses have been cultivated for such a long time that the birthplace of the cultivated rose can probably never be pinpointed with certainty. Many different wild species have contributed to the genetic makeup of the rose – from both the Orient and the West –

thought to have been created from the white, usually through contact with female blood. One legend tells how Aphrodite ran to comfort her lover Adonis, who had been gored by a wild boar. She scratched herself on a white rosebush and her blood turned the flowers to red. The Greeks may also have introduced the rose to the Egyptians – Ptolemy, Alexander the Great's successor, developed rose cultivation in his port, Ptolemais. It is thought that the Egyptians began trading roses all around the Mediterranean.

When the Romans became dominant in Europe, they took over Greek myths wholesale and, along with them, the rose. Some say the rose came to Rome with Greek settlers, others that it was from the Nile, traded with the Egyptians. However they arrived in Rome,

ROSES

Gather therefor the Rose, whilst yet is prime,
For soon comes age that will her pride deflower:
Gather the rose of love, whilst yet is time,
Whilst loving thou mayst loved be with equal crime.

THE FAERIE QUEENE (EDMUND SPENSER, LATE SIXTEENTH CENTURY)

but one thing is certain: roses have been important to people in many cultures. In Europe, roses are said to be depicted in Minoan art from 1500 BCE, but scholars have questioned the authenticity of the identifications made of the pictures. The ancient Greeks certainly used rose-scented oil, so we know early roses had scent. Theophrastus suggested ways of planting roses in the third century BCE, and felt that the most sweet-scented came from Cyrene (he even mentioned the 'hundred-petalled' rose, perhaps an indication that people were modifying wild species, which normally have only five petals). Aphrodite's flower was the rose, said to have been created by the earth in her honour, as she was born from the ocean. The Greeks clearly knew both red and white roses, red roses

roses were very important in their society, appearing in literature, art, food and religion. The rose had really arrived. Now it became the flower of Venus, the goddess of love, and was used in many aspects of Roman society. The emperor Nero, well-known for his excesses, is said to have showered his banquet guests with rose petals, so much so that they were smothered under the weight. Other Roman leaders had rose garlands, slept on rose petals and had them spread on the floor in order to scent rooms. These Roman roses were intensely fragrant and, rather than being used primarily as symbols, appear to have had a more utilitarian purpose. Several centres of rose cultivation supplied the urban Romans with roses, one of which was Paestum, an ancient Greek colony south of

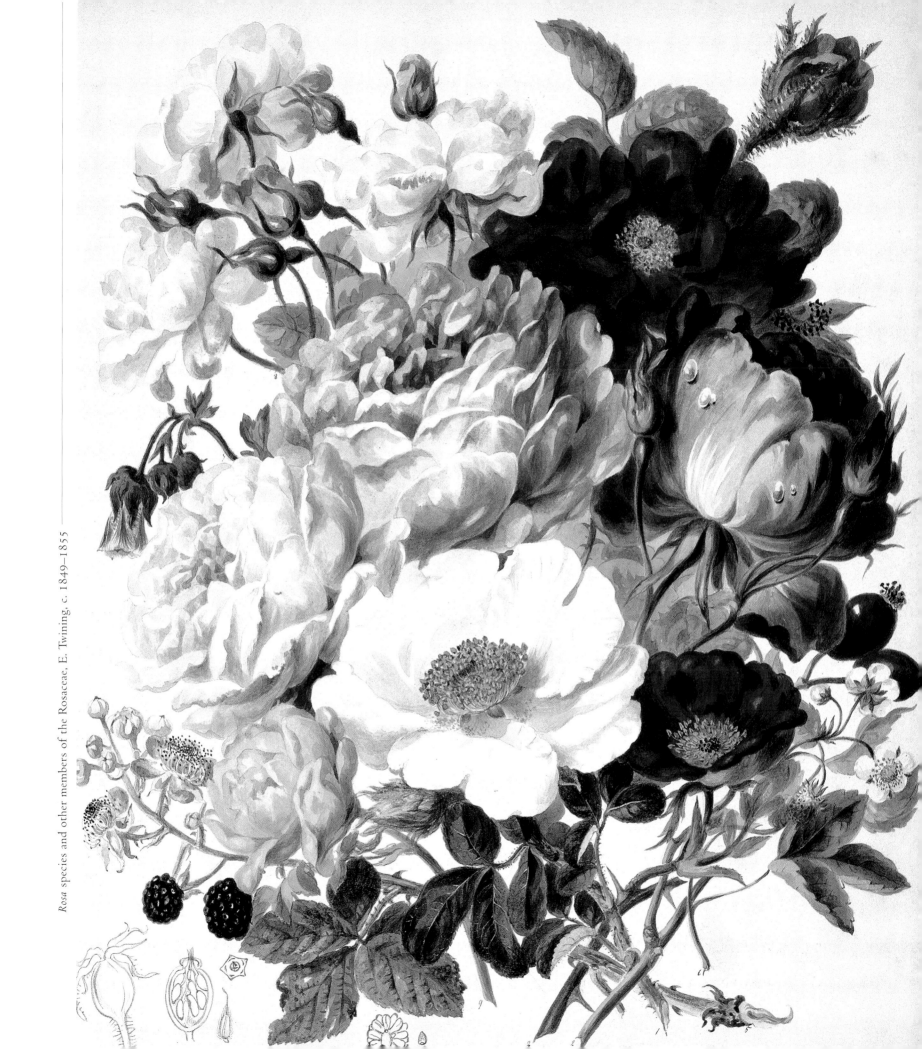

Rosa species and other members of the Rosaceae, E. Twining, c. 1849–1855

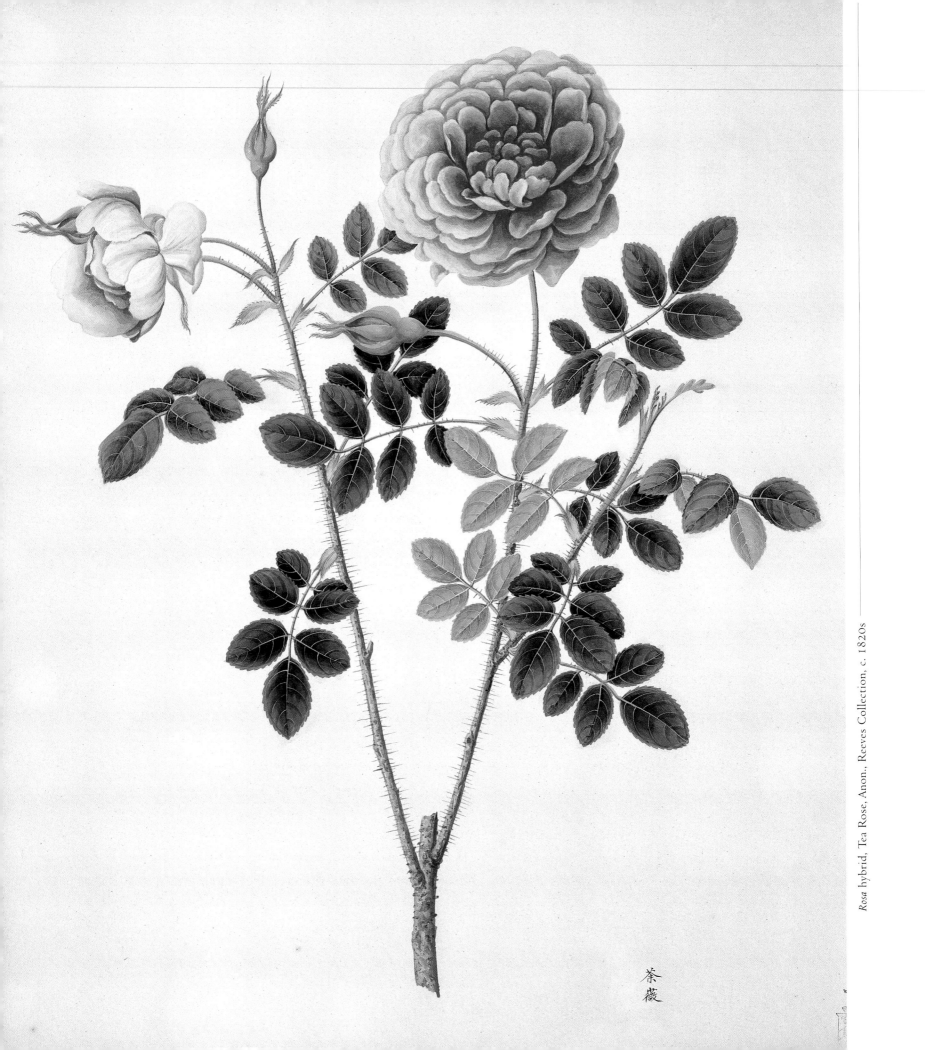

茶
薇

Rosa hybrid, Tea Rose, Anon., Reeves Collection, c. 1820s

Naples, where it is thought the cultivated rose was a form of *Rosa damascena* (damask or cabbage rose). We do not know the botanical identity of the rose petals strewn at the feet of the Romans, but clearly it was fragrance that mattered, for Pliny deemed a variety with no fragrance unworthy of the name 'rose'.

Fragrance also mattered in Persia, where rose culture was highly advanced. Red roses arose here when the nightingale became so enamoured of the white rose plant – the Queen of Flowers – that she flew down to embrace it, but as she did, her breast was pierced with the thorns and, where the drops of blood touched the ground, red rose plants grew. Roses in Persia were also fragrant; indeed, the fourteenth-century Persian lyric poet Hafiz extolled the virtues of the rose, along with those of wine, both intoxicating:

> Crimson roses in profusion
> Float their petals on the stream,
> While I wake in grave confusion
> From the mazes of a dream,
> Sighing: 'When so well together
> The bloom of rose and wine accords,
> Why should I, in such sweet weather,
> Shun the solace wine accords?'

The Persians' rose was taken around the Mediterranean, with the spread of Islam, adding its genes to the cultivated European roses.

By medieval times in Europe, roses had become the flower of Mary, mother of Jesus, so were critically important in the expression of faith. Roses had additional symbolism in that their five petals represented the five wounds of Christ on the cross, and their prickles stood for the crown of thorns. White roses were taken over as symbols of the virginity of Mary, and had the same symbolic meaning in Roman times as well, while red roses represented the blood of the martyrs. Roses have pain behind their beauty – fourteenth-century paintings of the Madonna in a rose garden foretell her suffering by the depiction of the thorny stems. The

rose was too potent a symbol for the Christian faith to ignore, so Christianity, ever adaptable, just absorbed the rose: the rosary (not only a set of devotions, but also the string of beads used to assist the memory in prayer) is based on the number five, and in a mystic sense represents Mary's rose garden. The medieval cult of the Virgin Mary involved garlands of roses hung on statues during the month of May, bringing the virginal and triumphant together in the service of the Church. The intervention of the Virgin Mary in miracles was often shown by the appearance of roses – a maiden being burned at the stake entered the fire appealing to the Virgin and it went out; the burning faggots became red roses, while the unlit ones were white ones. Roses accompanied the Christian fathers as they conquered the New World, both as plants and as symbols. The Virgin of Guadelupe (the first vision of the Madonna as a dark-skinned native of the New World) was seen by a peasant near Mexico City. She filled the peasant's simple cloak with roses several times, and finally his cloak was imprinted with the image of Mary standing on a half-moon, rising from a cloud of roses. So was the love of God for the newly conquered peoples of Mexico symbolized...

From the Virgin Mary to women in general is but a short step, and the rose came to symbolize all that was female. The transitory nature of the rose season came to represent the transitory nature of female beauty, which the poets saw fading as the rose. Early cultivated roses bloomed only once, although it was rumoured that the roses of Paestum bloomed more than once, but this 'twice-

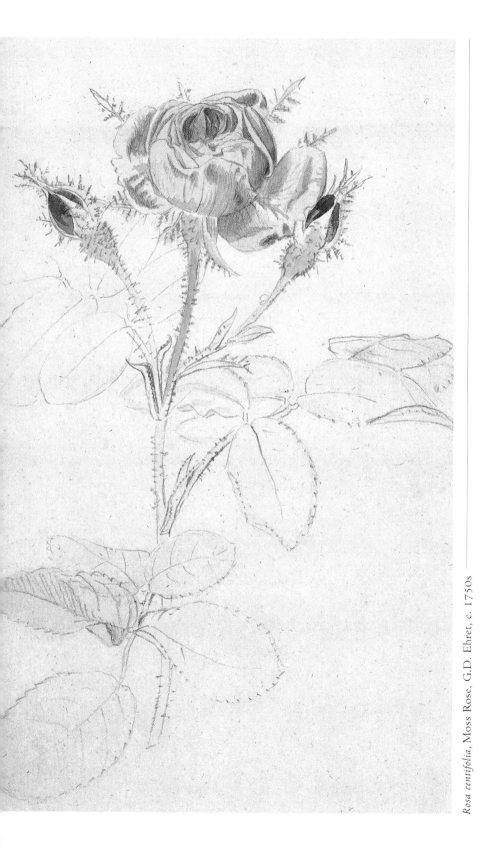

Rosa centifolia, Moss Rose, G.D. Ehret, c. 1750s

blooming' is more likely to have been the ability of the rose growers to force roses, or the cultivation of two varieties that bloomed at different times, than to a single variety that bloomed twice. Throughout the Middle Ages, roses were kept in monastery gardens, for their symbolic value as well as for their use in the manufacture of oil of roses. Oil of roses was first developed in the tenth century by Avicenna, an Arabian physician, by distilling rose petals with water. Extraction using alcohol was developed in the fourteenth century, and the oil of roses obtained was very pure and highly concentrated. It was used medicinally for a huge variety of ills, including the purification of the mind. In fact, a ninth-century German monk, Walahfrid Strabo, wrote, 'No man can say, no man can remember, how many uses there are for Oil of Roses as a cure for mankind's ailments.' Since Elizabeth I's time, oil of roses has been used in the coronation ceremonies of British monarchs.

By the sixteenth century, gardeners had a new rose to use in creating a profusion of blooms – *Rosa centifolia*, the Provence or cabbage rose. A complex hybrid involving the Provence rose (*Rosa gallica*), the wild dog rose (*Rosa canina*), the late-blooming wild musk rose (*Rosa moschata*) and the cultivated damask rose (*Rosa damascena*), the origins of *Rosa centifolia* are obscure. These roses are the somewhat fluffy-flowered old-fashioned roses so beloved of Gertrude Jekyll and Vita Sackville-West, both of whom deplored the development of 'modern' hybrid roses. Some early cultivars of *Rosa centifolia* are still around – witness 'Rosa Mundi', with a lovely, striped red and white flower, which is said to have been named for the Fair Rosamund, mistress of the English king Henry II and killed by his queen in the twelfth century. However, it is more likely that this story came later, as the rose is only mentioned by name in the 1580s. Another striped rose variety, this time of *Rosa damascena*, is called 'York and Lancaster', after the so-called Wars of the Roses between the English houses of York and Lancaster. At the time, roses were not really involved; Shakespeare, and more recently, Sir Walter Scott, are responsible for the rose element (Scott, in fact, coined the phrase 'Wars of the Roses'). The romance of such an

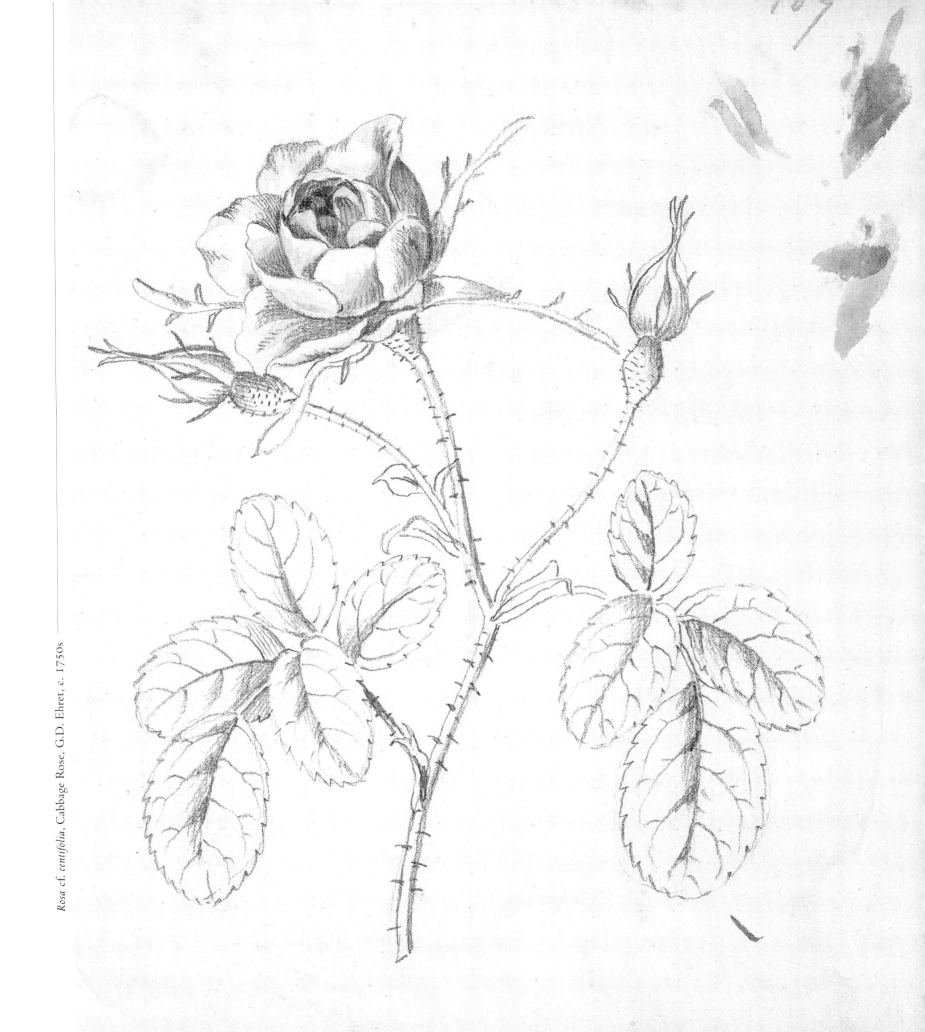

Rosa cf. *centifolia*, Cabbage Rose, G.D. Ehret, c. 1750s

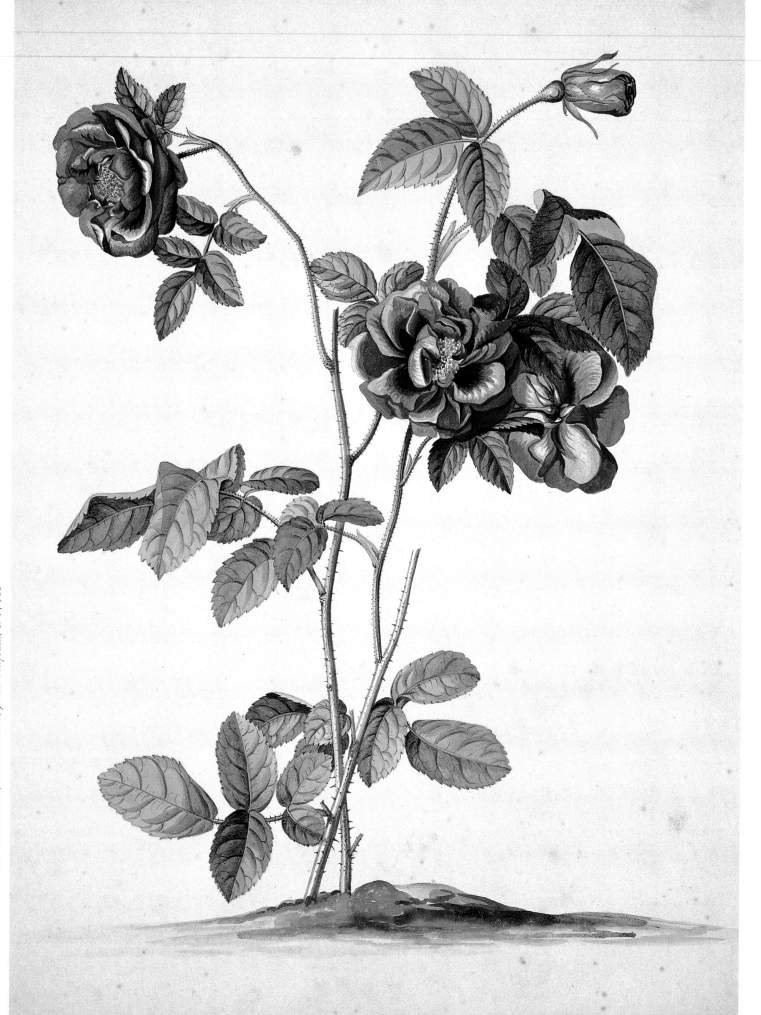

image couldn't help but stick, and the ease with which roses can be vegetatively propagated via cuttings and grown on via grafting allowed early gardeners quickly to multiply these hybrids, most of which were sterile. Dutch breeders produced the moss roses while trying to improve the Provence rose by hybridizing it with the 'wild' species *Rosa phoenicia*, which had very desirable groups of large flowers. These roses had fantastic moss-like hairs on the calyces, and were prized by seventeenth- and eighteenth-century rose growers, one of whom was Philip Miller.

Miller was the nurseryman son of a nurseryman, whose first establishment in Southwark (along the River Thames) was devoted to the production of flowering ornamentals, among them roses. He grew them against the walls of the nursery and, by judicious pruning and budding, managed to produce flowers in August and September, for which he found a ready market, as roses normally bloomed for only a few weeks in June and July. In 1722, he was appointed Director of the Company of Apothecaries' garden – the Physic Garden – in Chelsea, then a tranquil country village up the Thames from the hubbub of London. The Garden had been first established by the Company in the seventeenth century as a place to grow and study plants of economic and medicinal importance, but by the beginning of the eighteenth century was facing troubled times. They had originally leased the land upon which the Garden was built, but never had enough money to buy it outright. When Sir Hans Sloane, fashionable physician and eminent naturalist, found that the Garden was faced with closure due to financial difficulties, he stepped in and saved the Physic Garden for perpetuity. He also appointed Philip Miller as director in 1722, on the recommendation of a botanist friend. Miller put the Physic Garden on the gardener's map – two years after beginning his tenure, he produced the first edition of *The Gardeners and Florists Dictionary*, a compendium of gardening technique, including methods of cultivation and preferred plants for all sorts of gardens. Among Miller's favourite flowering shrubs was the rose: in the 1724 edition of the *Dictionary*, he stated that roses were the most

diverse type of tree or shrub propagated by gardeners, and listed twenty-nine varieties available in the London nurseries. He also mentioned that the Duchess of Beaufort had more varieties in her gardens at Badminton (the rich were at that time patrons of botany, and the Duchess was particularly interested in having a large

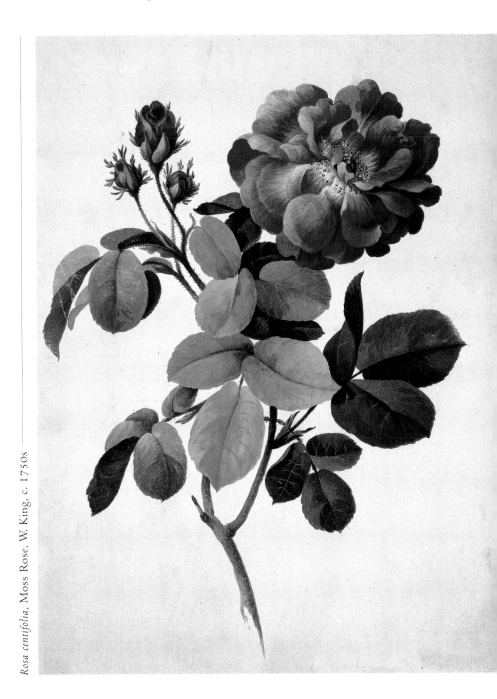

Rosa centifolia, Moss Rose, W. King, c. 1750s

167

collection of as many cultivated plants as possible, which was emulated later at Malmaison by Napoleon's wife, Josephine). In his 1730 *Catalogue of Plants at the Physic Garden*, Miller lists four rose species – *alba*, *canina*, *damascena* and *rubra* – the last being the red rose of the Apothecaries, and medicinally very important. He continued to increase his rose inventory, adding novelties as he came across them. He had moss roses – very new in London, and seen by Miller for the first time 'in the garden of Mr. Boerhaave near Leyden [Holland] who was so good as to give me one of the plants, but from where it came I could not learn. It was probably a variety which was obtained by seeds from some other roses.' His favourites were Provence roses (*Rosa centifolia*), and he frequently stressed their fragrance, an important consideration in the eighteenth-century flower garden, maintaining that roses were 'the most valuable of all the sorts of flowering shrubs…the great Variety of different Sorts of Roses make a collection of Flowers, either for Basons or in the Garden, without any other additional mixture and their Scent, being the most inoffensive Sweet, is generally esteemed'. He criticized nurserymen who sold the Yellow Rose (what he called the single *Rosa lutea*) for charging too much for a rose that lasted a short time and had no scent at all. Miller listed many species of roses in the various editions of the *Dictionary*, but by the eighth edition he was clearly distinguishing between wild species, which he often obtained via other gardeners overseas, and garden varieties – 'a great variety of double roses [are] now cultivated in English gardens. Most of them have been accidently obtained by seeds so they must not be esteemed as different species, therefore I shall only insert their common names by which they are known in gardens, that those who are inclined to collect all the varieties may be at no loss for their titles.'

Imagine being able to collect all the known garden varieties of the rose! How times have changed since Miller's day… At the Physic Garden, Miller himself developed several varieties of his beloved Provence roses, raised from seeds of the pale Provence rose. He carefully detailed a flowering sequence of different types,

beginning with the cinnamon and damask roses, through to the musk roses, which would last until October in a mild year. Miller also included instructions for propagation and pruning, detailing methods still in use today. The ease of propagation has meant that roses developed in one place could easily be sent around the world to another interested grower, which is supposedly what happened with the Bourbon rose. Various different stories about these roses abound, but common to all is the discovery of a strange new rose on the island of Réunion in the Indian Ocean, where French settlers had hedges of native and cultivated roses to protect their properties. A cutting was sent to a gardener in France under the name 'Rose Edouard' in the early 1800s, where it was propagated and distributed around the world. Empress Josephine made the gardens at her chateau at Malmaison the ultimate in rose gardens. She attempted to gather a sample of every living rose, and her enthusiasm for roses, while it did not start a French trade in roses, certainly gave the rose trade in France a decisive impetus. She was helped by the first man known to have physically crossed roses, Mr André DuPont, a commercial rose breeder. It is too bad she died before the discovery of the Bourbon rose, for she would have appreciated the discovery of a new type of rose on a tropical island (she herself came from Martinique). Her rose garden will be ever linked with Bourbon roses, however, for in 1843 a Lyon grower named a new variety of Bourbon 'Souvenir de Malmaison'.

As roses from China and India came to Europe and were crossed with the already existing cultivated varieties, rose varieties exploded in numbers. Repeat flowering was introduced by hybridizations with the Bourbon roses and the Portland rose, first found in the famous Italian nurseries at Paestum. Perhaps this is where the tale of the twice-flowering roses of Roman times came to be concocted. Roses from China had multiflowered inflorescences, and were truly recurrently flowering. These Chinese roses, varieties of *Rosa chinensis*, were smoother-stemmed than European types and flowered throughout the summer, with peaks in the spring and autumn. Pot-grown in China, the plants were brought back by

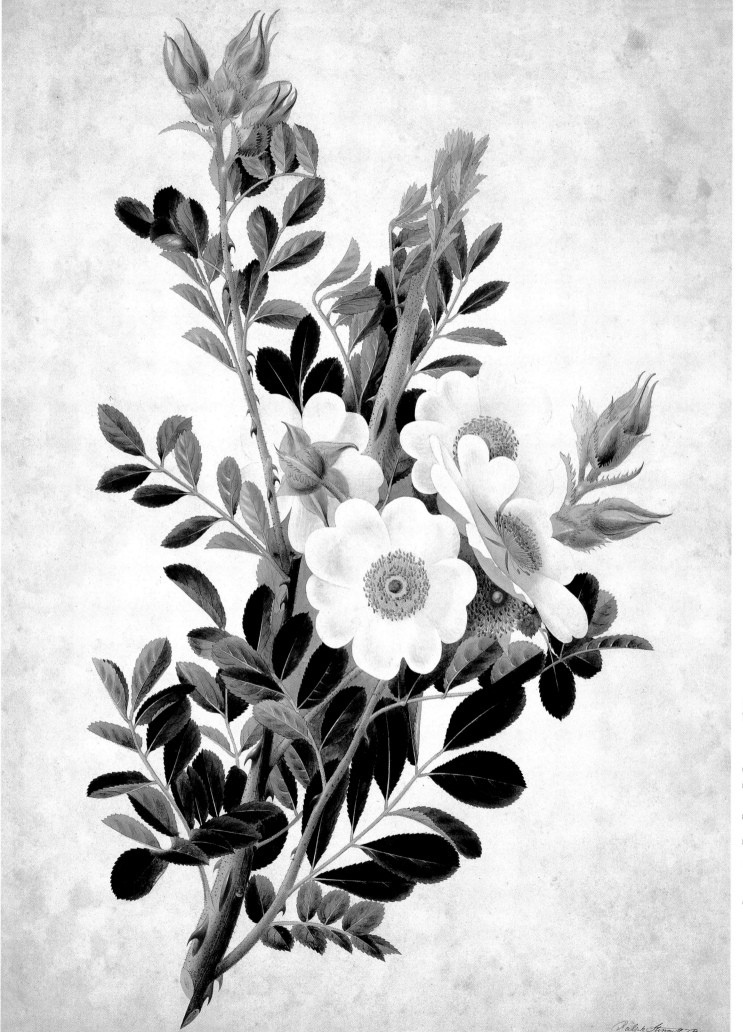

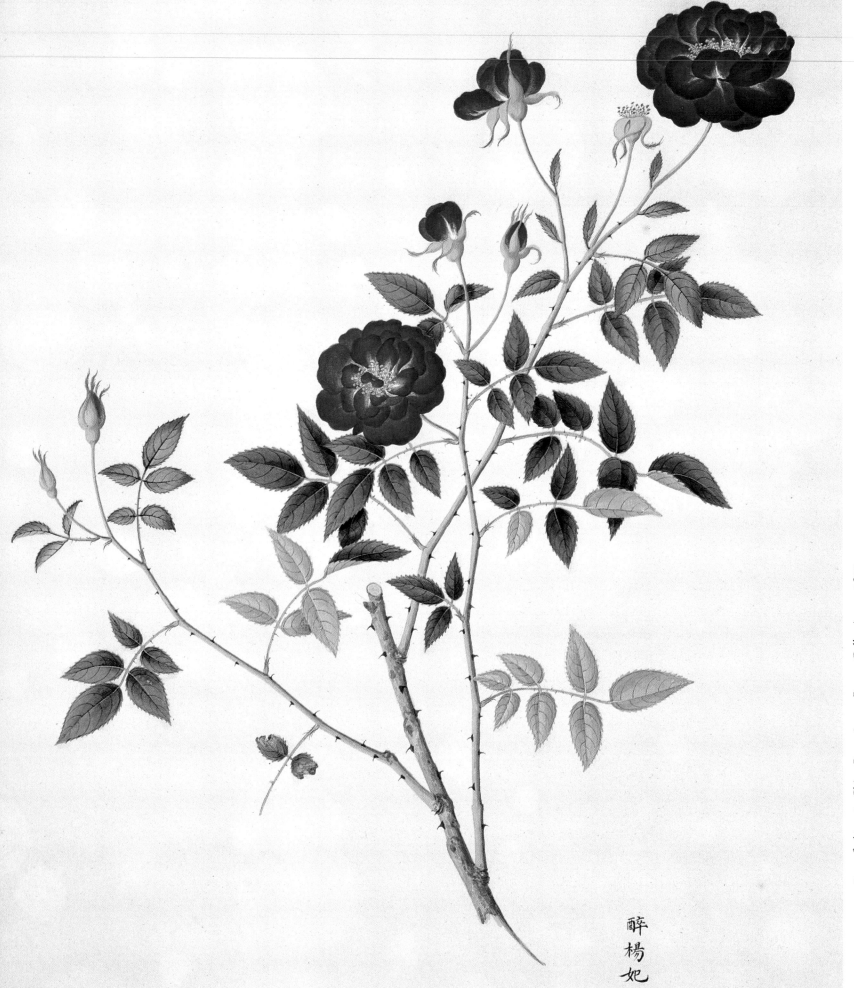

醉
楊
妃

Rosa cf. *chinensis*, China Rose, Anon., Reeves Collection, c. 1820s

travellers and given to rose growers, sparking an intense period of rose hybridization. Crosses between two species of Chinese roses, both ramblers, resulted in the tea roses (said to be so named because their flower scent reminded people of fresh China tea), with pointed buds and large flowers. The use of these hybrids in subsequent hybridizations led to a range of shape and colour, and by the turn of the twentieth century the orangey reds and bright yellows of the Austrian briar (*Rosa foetida*), a native of Iran, were added to the colour palette available to rose breeders. Miniatures were produced by crossing garden varieties with *Rosa pimpinellifolia* from Scotland. Floribunda types have flowers in a bouquet-like spray, and these flower repeatedly over a long period, too, giving good value for money to the non-specialist gardener.

A principle of nature, articulated by Sir Isaac Newton, is that for every action there is an equal and opposite reaction, and a reaction there was to the 'perfection' of the rose. Arts writer and poet Sacheverell Sitwell remarked in the late 1930s that 'Modern innovation has gone too far, where Roses are concerned, until it has been forgotten what is the meaning of a Rose.' This romantic view of old-fashioned flowers, epitomized by cottage roses, was to influence perceptions of roses in cultivation strongly. In the 1950s, Vita Sackville-West, gardening correspondent for the *Observer*, sneered that 'conventionally-minded people remark that they like a rose to be a rose, by which they apparently mean an overblown pink, scarlet or yellow object, desirable enough in itself, but lacking the subtlety to be found in some of the traditional roses'. Her championing of Sitwell's old-fashioned flowers meant that the traditional varieties of roses, like those grown by Philip Miller, enjoyed a renaissance. But have rose breeders forgotten what a rose is? Perhaps not, for about the same time as Sitwell was lamenting the meaning of the rose, Gertrude Stein wrote 'A rose is a rose is a rose', reminding us all that the rose is after all just a flower; the word itself carried no meaning, so (if overused) needed to be repeated to become real in the imagination. The rose is more than a flower, but a symbol – one that humankind has held on to and changed throughout history.

Rosa multiflora, Baby Rose, Fr. Bauer, c. 1800

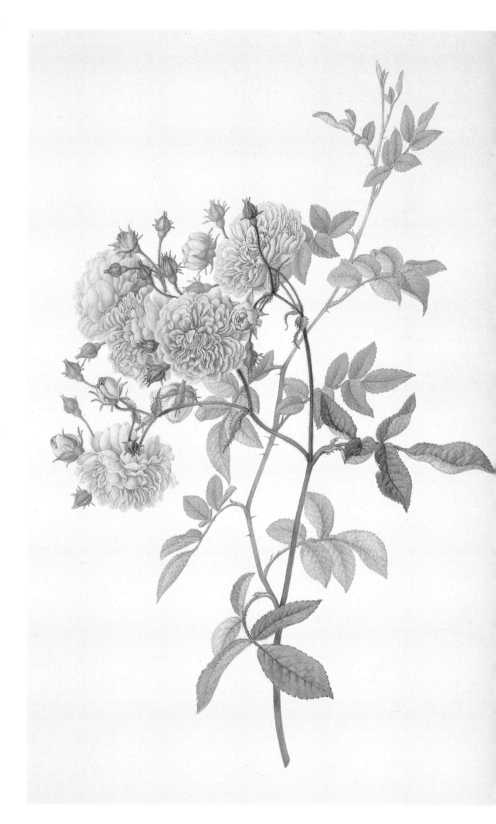

The incredible variety of the Rosaceae is well depicted here – the orange flower is Rosa foetida, *the Austrian briar, a parent of many of the cultivated roses, with orangeish flowers. The flowers are said to have smell, but no fragrance. The origins of most of the cultivated species of roses are unclear, but involve many wild species from both East and West.*

Roses; Raspberries; Strawberries
Rosa species and other members of the Rosaceae
Elizabeth Twining
c. 1849–1855, watercolour on paper, bound in volume
400mm x 260mm (15¾in x 10¼in)

The poetic common name of this rose is cha wei – tea rose or camellia rose. It is commonly thought that the tea roses are so called because of their tea-like scent, which is faint but unmistakable. Perhaps the name 'tea rose' comes from China, like so many of our garden plants, and refers to the flower's resemblance to flowers of camellia (the genus to which tea belongs).

Tea Rose
Rosa (possibly *gigantea* x *rugosa*) (Rosaceae)
Anon. Reeves Collection
c. 1820s, watercolour with bodycolour on paper
453mm x 345mm (17¾in x 13½in)

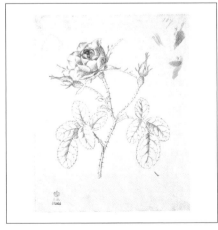

The apothecaries' rose is said to have been brought to northern Europe from the Holy Land by Thibault IV of Provins in northern France in 1250, when he returned from the Seventh Crusade. Its medicinal properties were linked to its symbolic and mystical connections with the Virgin Mary, and vast acreages of roses grown near Provins supplied the raw material for medicinal preserves.

Apothecaries' Rose
Rosa gallica L. (Rosaceae)
Margaret Meen
c. late 1700s, watercolour with bodycolour on card
457mm x 324mm (18in x 12¾in)

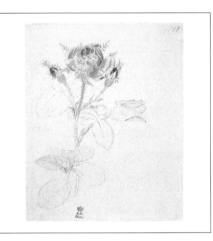

The 'moss' in the name of the moss rose refers to the densely packed projections on the flower stalks and calyx. These are modified hairs, halfway to being prickles. Philip Miller rightly identified this as a variety of the Provence rose: 'the flowers are the same shape and colours as the provence Rose and have the same agreeable odour'.

Moss Rose
Rosa centifolia L. (Rosaceae)
Georg Dionysius Ehret
c. 1750s, graphite with watercolour on paper
220mm x 180mm (8¾in x 7in)

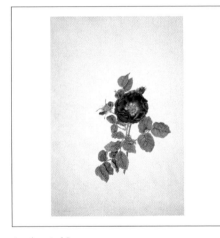

*Roses have complex hybrid origins, as is often true of plants we cultivate and endlessly improve. The 'centifolia' roses are thought to have originated in Holland in the late sixteenth century, the result of crosses between 'autumn damask' roses (*Rosa damascena, *itself of hybrid origin) and 'alba' roses (an ancient Roman rose, perhaps a hybrid of a damask and the wild dog rose).*

Cabbage Rose; Provence Rose
Rosa cf. *centifolia* L. (Rosaceae)
Georg Dionysius Ehret
c. 1750s, graphite with watercolour on paper
199mm x 161mm (7¾in x 6¼in)

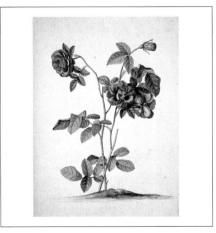

When Jacobus van Huysum was in London during the last decades of his life, he was acquainted with Georg Ehret, who settled in England in 1736. 'Van Huysum', a lovely pink damask rose variety currently in cultivation, has been named after Jacob's brother, Jan van Huysum, one of the greatest of the Dutch flower painters.

Damask Rose
Rosa cf. *damascena* L. (Rosaceae)
Jacobus van Huysum
c. 1730s, watercolour with bodycolour on paper, bound in volume, 525mm x 365mm (20¾in x 14¼in)

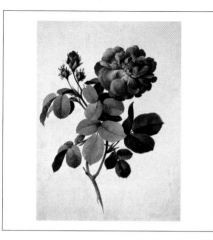

Moss Rose
Rosa centifolia L. (Rosaceae)
William King
c. 1750s, watercolour with bodycolour on paper
336mm x 253mm (13¼in x 10in)

Philip Miller of the Chelsea Physic Garden acquired the moss rose from a friend: '[it] was in 1727 in the garden of Dr Boerhaave near Leyden who was so good as to give me one of the plants, but from where it came I could not learn. It was probably a variety which was obtained by seeds from some other roses.'

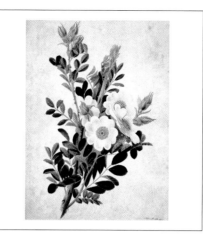

Dog Rose
Rosa canina L. (Rosaceae)
Ralph Stennett
1807, watercolour with bodycolour and gum arabic on paper, 545mm x 406mm (21½in x 16in)

The dog rose grows wild as a scrambler in hedgerows all over Britain. An old riddle – passed down through the late William T. Stearn of the Natural History Museum's Botany Department – uses the sepals to distinguish the dog rose from any other:
'On a summer's day in sultry weather
Five brethren were born together
Two had beards and two had none
And the other had but half a one'.

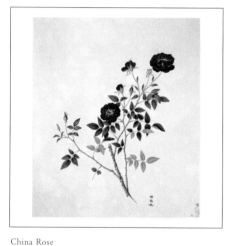

China Rose
Rosa cf. *chinensis* L. (Rosaceae)
Anon. Reeves Collection
c. 1820s, watercolour with bodycolour on paper
439mm x 378mm (17¼in x 14¼in)

The Chinese name for this delicate rose is yang gui fei, meaning 'tipsy imperial concubine Yang'. Yang was a famous beauty, and the favourite concubine of the emperor. While walking in the gardens, she smelled this rose and became tipsy, staggering around in a daze as if drunk on the mere beauty of its scent.

Baby Rose
Rosa multiflora Thunb. (Rosaceae)
Franz Bauer
c. 1800, watercolour on paper
506mm x 340mm (20in x 13¼in)

The scrambling Chinese Rosa multiflora *is the parent of many cultivated rose varieties – especially the 'ramblers', whose habit owes much to this species. Double forms are not common now, but clearly were in cultivation in the nineteenth century.* Rosa multiflora *was popular as an understock for the cultivation of more delicate roses in the past, its toughness the product of natural rather than human selection.*

Palms are the 'big game' of the plant-hunting world. To make a herbarium specimen of a palm is no simple, straightforward task, for it requires planning, skill and above all dedication, but to collect a herbarium specimen of, say, a poppy or a magnolia, the botanist's task is relatively easy. Cut a piece of the plant more or less the length of your own forearm (or gather several individuals if the plant is much smaller), then place the sample in a folded piece of a small newspaper. The set of plants in their newspapers are then placed in a press, where absorbent blotting paper and corrugated cardboard or aluminium are alternated with the plants. Next, the press is pulled tight – squishing all the specimens within quite flat, or as flat as they will go – and the whole thing is placed

bit of branch attached can be a real challenge. Some collectors, like David Douglas (of the Douglas fir), shot branches out of the tops of trees in order to get flowering or fruiting material.

When it comes to acquiring specimens, palms – those stately, magnificent denizens of tropical forests – represent another level of difficulty again. Despite their size, palms are not really trees in the scientific sense. True trees have secondary growth – the rings we see on a cut-down pine or mahogany – and the rings are made up of xylem, the water-conducting tissue of the trunk, laid down year after year. Palm trunks, however, have a different sort of structure altogether. Their water-conducting tissue does not occur in rings, but instead is scattered throughout the trunk, and

PALMS

In these places there is no underwood to break the view among interminable
ranges of huge columnar stems rising undisturbed by branch or leaf to the height of eighty
or a hundred feet, – a vast natural temple which does not yield in grandeur or subliminity
to those of Palmyra or Athens.

PALM TREES OF THE AMAZON (ALFRED RUSSEL WALLACE, 1853)

on a drier so that heat goes through the corrugates, drying the plants as it rises. After hours, or sometimes days, the newspapers are taken out and, lo and behold, the plants within are flat and dried – like pressed flowers, but branches or stems with flowers or fruits attached. In the tropics it is essential to get the plants on to the drier as soon as possible – micro-organisms work fast in the hot, wet atmosphere, and fungal growth can completely ruin a lovely specimen in no time at all. The whole process seems quite straightforward if one thinks about collecting small plants like poppies or daffodils, but becomes more complicated as the plant gets bigger, and getting the prize becomes more difficult. Trees can have their flowers right near the top, so getting them down with a

resemble little islands, rather than rings. The structure of the palm stem comes from fibres, packed very densely and terribly strong – so strong, indeed, that palms are often the last plants left standing when a patch of primary forest is cut down (the trunk can break a machete blade). The vegetative body of the palm is a shoot, a stem that ends in a crown of leaves, but to the person looking up a palm tree is a tree –perhaps illustrative of the mismatch between common and scientific usage that sometimes bedevils communication.

When a plant hunter wants to collect a palm, an obvious question arises. Where does one start? A good collection is one that is representative of the plant – ideally with stem, leaves, flowers and fruit – and a way of preserving the hard evidence of

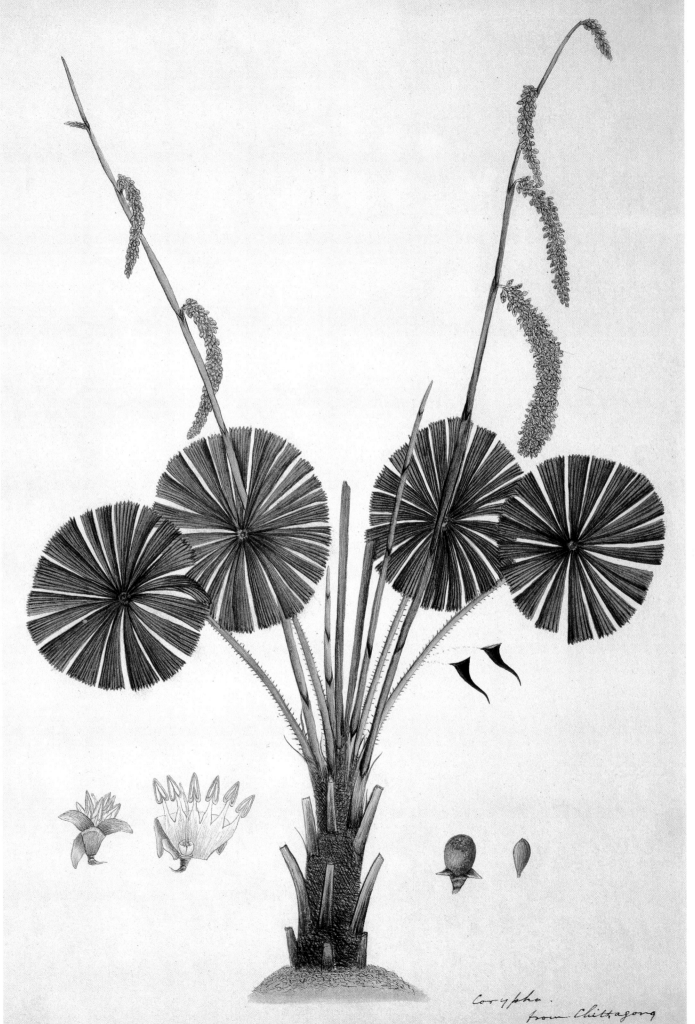

Corypha.
from Chittagong

Licuala peltata, Licuala Palm, Anon., Fleming Collection, c. 1795–1805

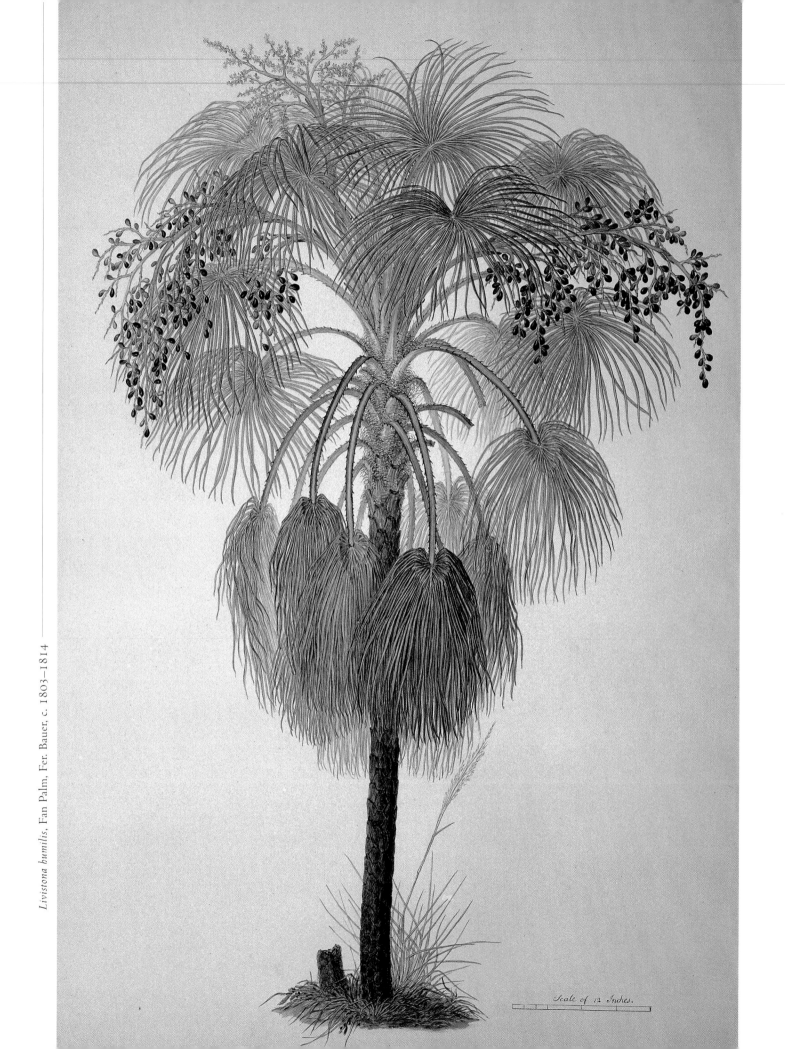

Scale of 12 Inches.

what the organism looks like, from its habit to its microscopic structures. But what does one do when the stem is thick and solid, when the leaves are sometimes more than 1m (3ft) long, and the flowers and fruit are borne in inflorescences that can be the size of small elephants? Awkward plants indeed, palms are a real challenge and are often ignored by general collectors. To lovers of palms, however, 'the unhurried careful collection of a majestic palm can be immensely satisfying'. First you have to get to the top – by climbing, usually – which can be fraught with danger due to spines, or ants, or wasps. Then you need a leaf, complete with its base (often important for identification). Leaves can be massive, so the careful palm collector 'samples' the leaf by taking a bit from the bottom, a bit from the middle and the tip, recording the total length, the hang of the leaflets and the colour in the notes, along with the height of the plant, size of the trunk, and so on. Usually even the 'samples' of a palm leaf must be folded to fit the newspapers used to house the specimen – a little like origami, but reducing three dimensions down to two. By this time it has already taken several hours, but the palm collector is still not finished, for there is also the inflorescence to sample, and nowadays close-up photographs to take, as well. The result (packed in newspapers, just like other herbarium specimens, as they are collected in the field) is a bulky bundle the size of an orange crate. And that is just one specimen, the beginning of the job, since botanists usually collect what we call duplicates – another specimen from the same plant, so the specimens can be shared among institutions. So much work…but the result is something really special. Few people collect palms, so good specimens are highly prized. Special people collect palms, and it is certainly not an occupation for the faint-hearted or the easily discouraged.

One might think, therefore, that palm collecting or an interest in these most difficult of plants might not be the enthusiasm of an elderly man, but you would be wrong. Liberty Hyde Bailey was the grand old man of American horticulture, and dedicated his life to 'speaking for the farmer and the rural stage', making his

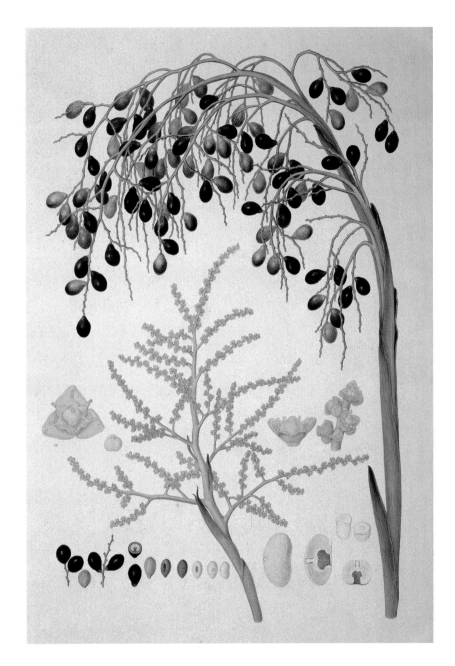

priority the provision of botanical knowledge to those who made their living by tilling the soil. For a son of pioneers, this made perfect sense. Bailey was born in 1858 and he lived much of his life in close contact with the land – first on his father's farm, then at agricultural college in Michigan, then as a botanist in the hallowed halls of Harvard University. When offered a job in

Livistona humilis, Fan Palm, Fer. Bauer, c. 1803–1814

horticulture and landscape gardening at his alma mater, fellow botanists predicted that Bailey would never be heard of again – botanists were scientists, whereas horticulturalists were mere gardeners. But Bailey proved them wrong, and over the course of his career (first at the Michigan Agricultural College, then at Cornell University) he studied the botany and classification of plants used by humans – raspberries, gourds and, towards the end of his life, palms. His published output was phenomenal: a photograph of Bailey shows him standing next to a pile of his published books that reaches his eyes (and he was a tall man)! The story goes that he began on his palm adventures when his wife chided him for calling himself a proper botanist and still not knowing the name of a palm they had seen on holiday in the Caribbean. Bailey was 68 years old at the time. He spent near enough the next three decades in pursuit of knowledge about these most fascinating of plants, and soon realized that here were true 'trees of life' in the tropics. Palms provided people with food, fibre, thatch, oil, vegetable ivory – they had a world of uses. He collected them all over the world, even planning a trip to Africa (no mean jaunt from the United States in 1949, and at the ripe old age of 91). His friends were horrified. What if he died there? Legend has it that he replied, 'Then, they would bury me.' In the end, he never went, as a fall broke his hip, and he never properly recovered to go in the field again. Like other palm specialists before him – like the great Prussian explorer Alexander von Humboldt, the mild-mannered Englishman Richard Spruce, the German aristocrat Karl Friedrich Phillip von Martius or the Italian naturalist-botanist Odoardo Beccari – he had been well and truly hooked. His name lives on to all interested in horticulture, and also in the name of the institution he founded and where he donated his incredible collection, the Liberty Hyde Bailey Hortorium. Bailey coined the word 'hortorium' to denote the institution's dedication to cultivated plants of the garden as well as to the plants of the wild normally stored in a herbarium (museum for dried plant specimens).

Bailey invented a special way to store bulky palm specimens that is still used today at Cornell and other collections with palm specialists, such as the Royal Botanic Gardens at Kew. He realized that the sheer bulk of a palm specimen made gluing it down on to a sheet of paper – the usual way of preserving a plant specimen – not very practical, so decided instead to store the palm specimens in boxes. That way all the many parts could be together, and a botanist could turn the pieces over to see the backs, which is highly useful for something that really was only a sample of a much larger live organism. Palm taxonomy is still a thriving tradition in the Bailey Hortorium due to Bailey's influence and forethought. In the late 1940s Bailey (by then the dean of American botany and the President of the American Association for the Advancement of Science) met a botanist from Harvard whom he took to immediately. He wrote to some friends, proposing a visit to their gardens in the Bahamas, that 'he is a very keen young man' – high praise from someone as energetic as Bailey.

Harold E. Moore, that 'keen young man', went on to completely transform palm taxonomy through his steady acquisition of knowledge of these plants in the field. He travelled widely, seeing most of the many genera of palms in the wild, which was a phenomenal feat. His expeditions were focused on collecting palms – clearly hard work, but also fun. In a letter to a colleague, he described the collection of a new genus in Fiji (*Alsmithia*, named in honour of the author of the flora of Fiji) as 'involv[ing] a bit of fun'. The fun involved spending a night being battered by Cyclone Tia, walking over a carpet of blown-down leaves, branches and trees up the ridge to get to the plants, and (on seeing the destruction) remarking, 'let no one tell you coconuts only bend in hurricanes', for they had been snapped off. The new genus was a prize indeed, because that trip was the last Hal Moore was to make. His illness and quite sudden death shocked the palm world

Pandanus species, Screw Pine, Anon., Fleming Collection, c. 1795–1805

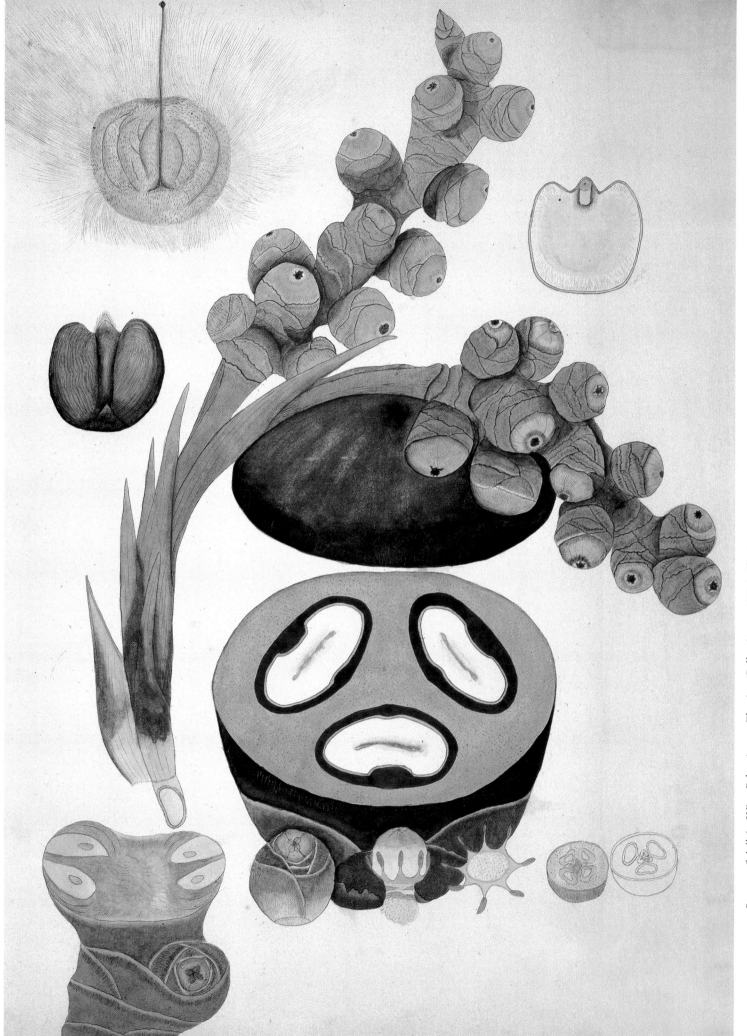

Borassus flabellifer, Wine Palm, Anon., Fleming Collection, c. 1795–1805

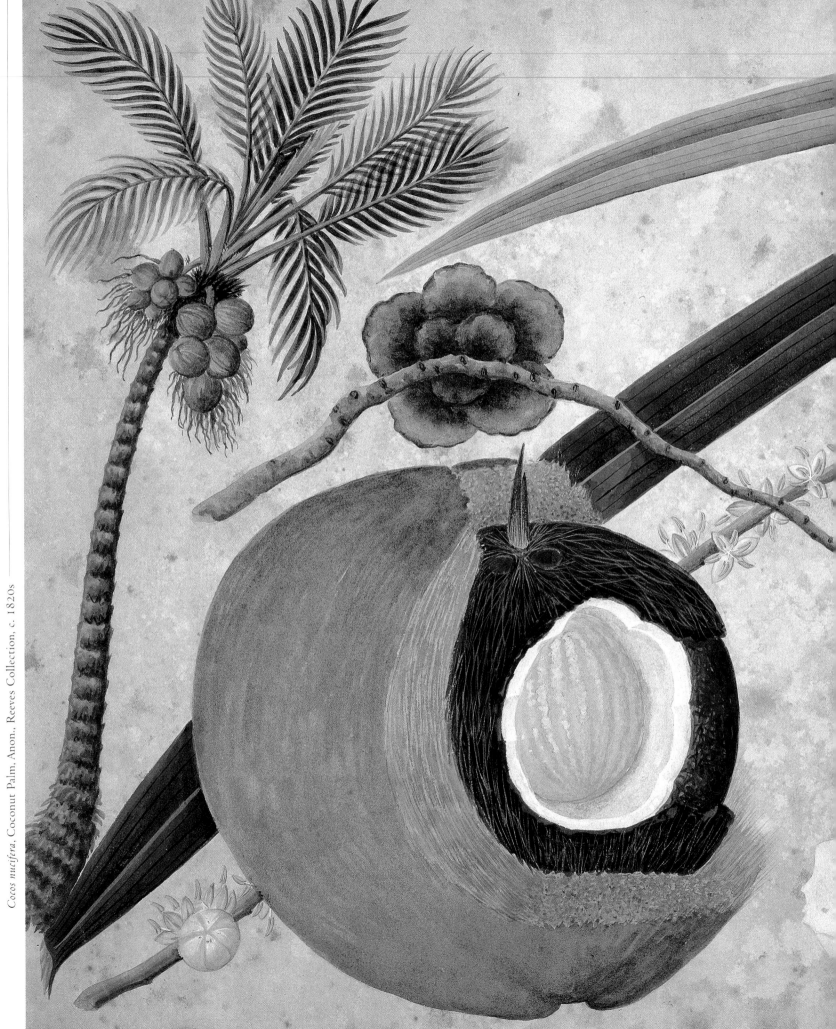

– he was as much involved with amateur palm enthusiasts as he was with professional taxonomists. His expertise with (and explorations in search of) palms, those princes of the plant world, had ranged so widely that he influenced far more than just the palm community. Moore's enthusiasm for the tropics and his dedication to careful research made him the inspiration for a generation of students – unlike the plant hunters of Victorian times, this modern-day explorer had deliberately passed on his knowledge and his passion for the subject to the next generation. In a way, this is how plant hunting differs today from that carried on in the past. For many of the plant hunters of the last centuries, finding a plant and bringing it back into cultivation at 'home' was the goal – a worthy goal, for it has beautified our gardens and lives immeasurably. Today, collectors are after information to improve our understanding of the natural world. The adventures are similar, the work just as hard, but the motivation is subtly different. After Moore's death, two of his colleagues – John Dransfield of Kew and Natalie Uhl of Cornell – completed and brought to publication his life's work, a compendium of the genera of palms of the world. The best tribute to Moore, that great collector and seeker of knowledge, is that they found the task 'the most exciting project of our lives'.

Palms are exciting and romantic. For many, they epitomize the tropics, beaches rimmed with waving coconuts, a lone palm rising from the canopy of the rainforest. The coco de mer has the largest seeds in the world, and a single one can weigh more than 20kg (44lb). The origins of these amazing seeds, found washed up on the shores of islands in the Indian Ocean or seen floating on the ocean currents by early mariners, was a mystery, and some said they must have come from the Garden of Eden itself. Maybe not the biblical garden, but the islands of the Seychelles are the home of this incredible plant, *Lodoicea*. Found only on two small islands, it is as rare as it is interesting and, with the rise in sea levels predicted by global warming, it is surely under threat. Palms can be vicious – the climbing rattans (climbing palms) get up into the rainforest canopy by means of backwards-pointing spines at the

leaf tips, acting as a sort of vegetable-grapping hook, so clearly not nice if you happen to brush by one in a hurry! But rattans are beautiful as well, and the great explorer Alfred Russel Wallace, with whom Charles Darwin first published the theory of evolution by natural selection, wrote of them quite poetically, saying: 'they vary the otherwise monotonous tree-tops with feathery crowns of leaves rising clear above them, and each terminated by an erect leafy spike like a lightening conductor'.

Wallace, though better known by many for his contributions to evolutionary theory, was fascinated by palms. He went to the Amazon in the mid-nineteenth century with Henry Walter Bates, to collect specimens for sale in the auction rooms of London. At the time, he was more interested in bugs and birds – plants, especially palms, were a full-time job to collect and didn't sell as well – but Wallace was a keen observer (one of the keenest ever), and soon realized that palms have a special place in the lives of people in the tropics. His first book, *Palm Trees of the Amazon and Their Uses*, detailed how important these trees were to the peoples of the region for 'so many daily wants, giving him his house, his food and his weapons'. Wallace's palm book was written from memory, for on his way back from collecting in the Amazon the ship on which he was travelling caught fire and sank in mid-Atlantic. He was lucky to escape with his life, but lost all his notes and collections, except for a few drawings of palms. Wallace went on to Southeast Asia after his return from the Amazon, and there his fascination with the palms continued (he saw they were equally important to the peoples of the Old World tropics). Although one often thinks of palms in terms of building materials – both the houses themselves and the roof thatch comes from palms in many parts of the tropics – they are also immensely important as food resources. Food is not only derived from the fruit of the tree (the dates we eat at Christmas are fruits from the palm *Phoenix dactylifera*; people in the Amazon boost their vitamin A intake by eating *agauje*, the scale-covered fruit of *Mauritia*; and coconuts are an important part of the diet of seaside dwellers worldwide), but also come from more surprising parts of the plant. One of the oddest of these is the sago palm (*Metroxylon*) of Southeast Asia.

To understand the use of sago palms, it is necessary first to delve into the life cycles of plants. We think of most plants as perennial (living for many years), flowering seasonally for much of their life once they have attained reproductive age: a rose has flowers year after year, pine trees have many cones every few years, and orchids shoot up flowers often throughout their lives. However, some plants flower only once, then die. Annuals such as poppies or love-in-a-mist are good examples (although their life

Wallichia caryotoides, Wallich Palm, Anon., Roxburgh Collection, c. 1791–1794

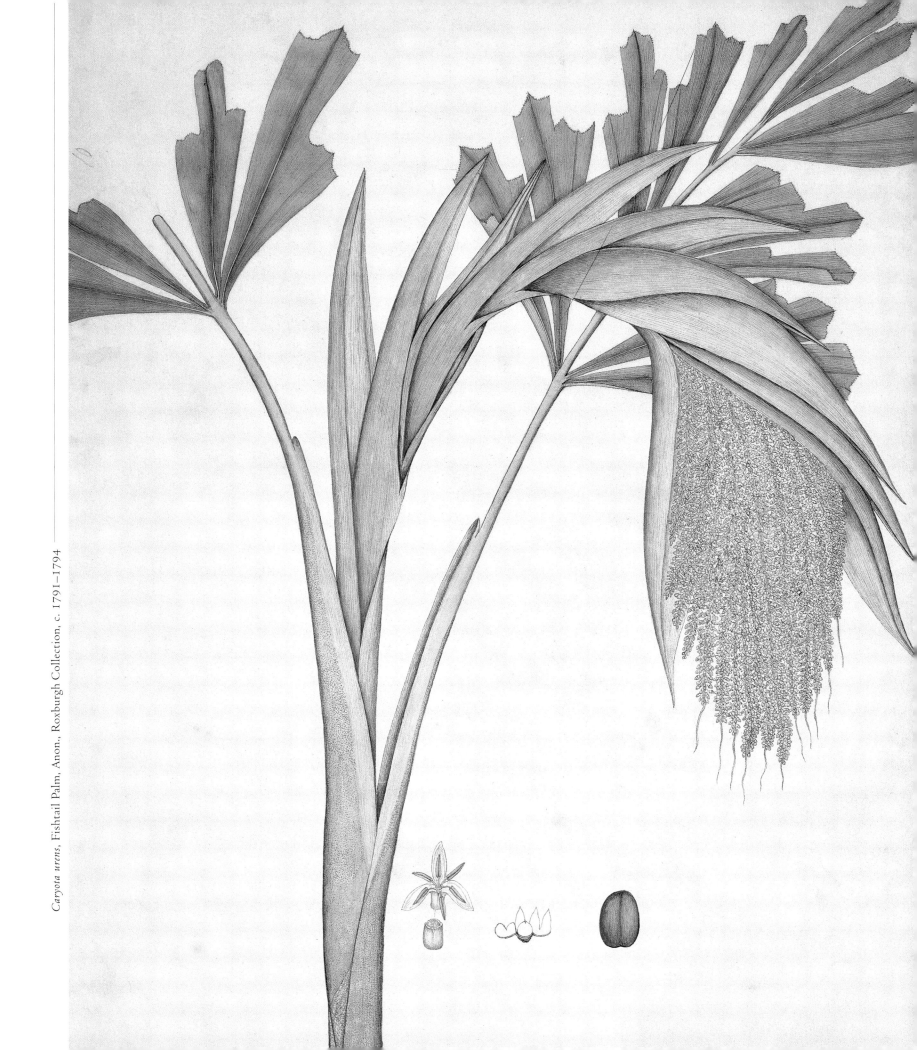

Page.1.

N.º 1

N.º 2

N.º 3

N.º 5

N.º 4

Wm Young Esqr Pinxit

Sabal palmetto, Palmetto, W. Young, 1767

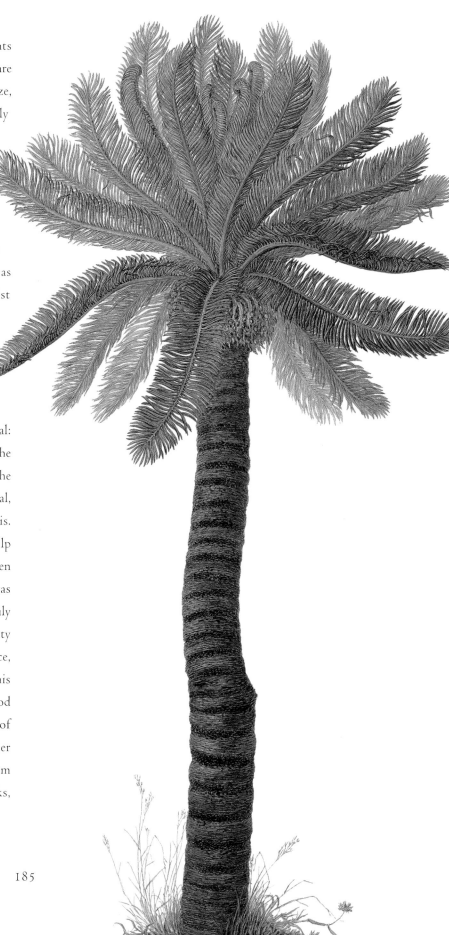

Cycas angulata, Cycad, Fer. Bauer, c. 1803–1814

before reproduction is short), but it is the large, long-lived plants that flower once and die that are truly amazing. These plants are described as monocarpic or hapaxanthic: they grow to 'adult' size, then live for many years producing no flowers or fruits, seemingly sterile. When the plant has completed its vegetative growth, it puts all its stored reserves into a single magnificent burst of flowering and setting fruit, then (exhausted of nutrients) dies. This way of life depends on an enormous build-up of nutrient reserves in order to fuel the burst of flowering and fruiting, and in many hapaxanthic palms, such as *Corypha*, the inflorescence produced during flowering is as big as the preceding crown of leaves; indeed, the great tropical biologist E.J.H. Corner characterized it as 'fantastic inflorescences like paleozoic attempts at forest making'. Human use of the sago palm, another monocarpic plant, takes advantage of the starch stored in the trunk in the years preceding flowering. A sago palm grows for perhaps fifteen or more years before it is ready to harvest (the timing of which is critical: too early and the yield is poor; too late and the crop is lost as the palm completes its life cycle). The best time to cut down the trunk is three years before flowering, so experience is essential, and where sago is a staple the villagers are adept at estimating this. Once ready, the trunk is cut down and the starch-rich pulp scooped out, pounded in water to release the starch grains, then either used immediately or dried to make sago flour. Wallace was amazed by the scale and efficiency of the sago harvest: 'It is truly an extraordinary sight to witness a whole tree trunk, perhaps twenty feet long [6m] and four or five [1.2–1.5m] In circumference, converted into food with so little labour and preparation.' This palm, taken advantage of by humans, is an incredibly efficient food source and was the basis for a great sago culture in the islands of Southeast Asia. Felling the trunk seems to be unsustainable – after all, it kills the plant – but most sago palms produce suckers from underground, thus perpetuating the individual by other trunks, which will either flower or be harvested in their turn.

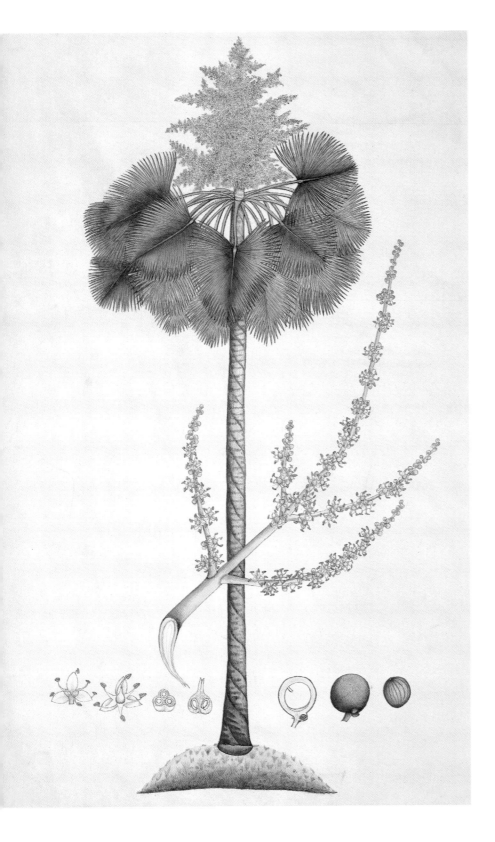

Corypha umbraculifera, Talipot Palm, Anon., Roxburgh Collection, c. 1791–1794

Monocarpy, or hapaxanthy, is the botanical equivalent of putting all your eggs in one basket. It seems counterproductive to produce your entire lifetime's reproductive effort in one huge bang – but evolutionarily it makes sense in some situations. Perhaps the huge number of flowers in the monocarpic palms attract more pollinators than more discreet inflorescences, thus increasing the chances of successful pollination; or maybe the flood of seeds into the environment from a mass fruiting event swamps seed predators, leaving more seeds behind that make it to maturity. In a variety of conditions, monocarpy is distinctly advantageous for the plant. Plants seem full of paradoxes.

Because palms are, for the most part, a single shoot growing from a single terminal growing point or bud, cutting them down kills the plant. *Euterpe edulis*, named after Euterpe, the graceful Greek muse of song and poetry, was for a long time the single largest source of wild-gathered heart of palm. Palm heart is a real delicacy, but doesn't taste quite so great when you realize that an entire plant was destroyed to get the growing bud for the luxury market. All palms have terminal buds that are tender and can be eaten, but those of *Euterpe* were thought to be the most delicious of all. It has become extinct in some places because the single stem is cut down for harvest, and this species, unlike the sago palm, does not form suckers. Brazilian botanists, however, are beginning to grow the plant in plantations and have been developing varieties that cluster in order to try to save this species in the wild. Other palms are also being brought into the palm-heart market – in Paraguay, the palm *Copernicia alba* occurs in huge populations in the grassy plains of the wet Chaco, where its seeds are dispersed by rheas, the American version of the ostrich. With the notion of sustainability in mind, palm hearts of *caranday* are beginning to be harvested in these areas.

What look like incredibly robust and tough plants can be surprisingly vulnerable, but with care and knowledge we can hope to share our world with these wonderful plants, which Linnaeus so aptly named as 'Principes' – true princes among plants.

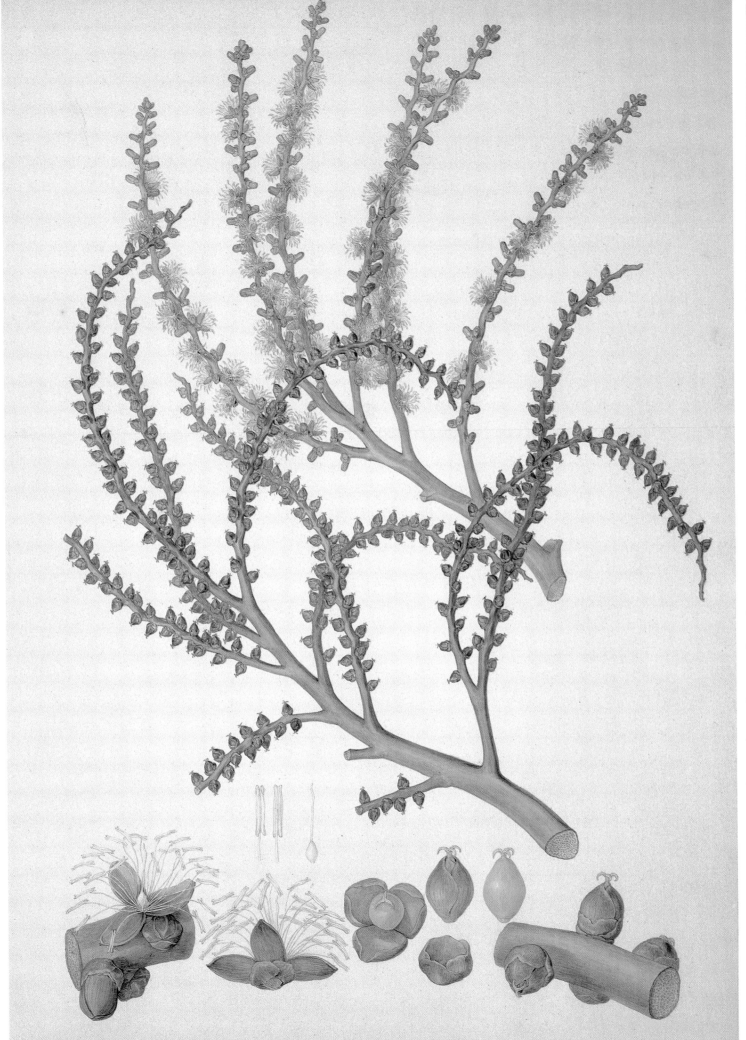

Ptychosperma elegans, Solitaire Palm, Fer. Bauer, c. 1803–1814

The leaf shape of the licuala palm is absolutely unmistakable. Looking a bit like a manically cut-up umbrella, its circular outline with wedge-shaped divisions occurs nowhere else in the palm family. In fact, some species even have undivided leaves, and in the forest understorey look rather like little green parasols.

Licuala Palm; Pala
Licuala peltata Roxb. (Arecaceae)
Anon. Fleming Collection
c. 1795–1805, watercolour with graphite on paper
372mm x 241mm (14⅝in x 9½in)

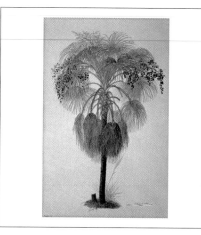

Livistona species are lovely palms — stately and erect, with large bunches of brightly coloured fruits. The leaf bases are sheathed with a net of woven fibres, and E.J.H. Corner (the great palm natural historian) has suggested that humans invented weaving from copying these palm-leaf bases. Ferdinand Bauer made his sketch (from which this painting was done) in January 1803, at Blue Mud Bay, Northern Territory.

Fan Palm
Livistona humilis R. Br. (Arecaceae)
Ferdinand Bauer
c. 1803–1814, watercolour on paper
527mm x 356mm (20¾in x 14in)

In 1803, the leaking Investigator was off Australia's north coast, the first European ship to follow the abandoned Dutch trading routes through the Torres Straits. It was new territory for naturalists, but frustrating, as Ferdinand wrote to Franz: 'We had high hopes of the Gulf of Carpentaria but found that the whole side facing east is very low-lying country with shallow water for a long distance so that our ship could not come close.'

Fan Palm
Livistona humilis R. Br. (Arecaceae)
Ferdinand Bauer
c. 1803–1814, watercolour on paper
524mm x 357mm (20⅝in x 14in)

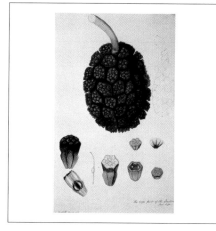

Pandans are very palm-like in habit. Like palms, they often have stilt roots, which are often thorny, and the inflorescences are enclosed in large boat-like spathes, but the similarities end there. Also called screw pines, pandans have long spear-shaped leaves that twist up the stem, and an aggregate fruit that looks like a pineapple, which is highly prized by birds and people alike.

Screw Pine
Pandanus species (Pandanaceae)
Anon. Fleming Collection
c. 1795–1805 watercolour with ink on paper
462mm x 287mm (18¼in x 11¼in)

A Tamil poem extols the 801 uses of the toddy palm, whose use extends far back into India's prehistory. Toddy, for which the palm is named, is a palm wine made from the juice of the young inflorescences. The inflorescence is tied up so it cannot open, then beaten to encourage the sap to flow. When tapping begins, each inflorescence produces about 2 litres (2 quarts) per day over the course of several months.

Wine Palm; Toddy; Palmyra
Borassus flabellifer L. (Arecaceae)
Anon. Fleming Collection
c. 1795–1805, watercolour on paper
467mm x 326mm (18¼in x 12¼in)

The coconut has been called 'nature's greatest gift to man'. When opened up, a green coconut will yield coconut juice (a delicious drink), but by the time the fruit is mature the water is gone. The water is part of the sequence of endosperm development: in the green stage the endosperm is gelatinous and slimy, but over time it hardens and forms the white coconut of commerce.

Coconut Palm
Cocos nucifera L. (Arecaceae)
Anon. Reeves Collection
c. 1820s, watercolour with bodycolour on paper
396mm x 493mm (15½in x 19½in)

William Roxburgh named the genus in honour of Nathaniel Wallich, his young Danish assistant. He also named the same palm Wrightea *in honour of William Wright, an eminent British botanist held captive by the Spanish in the Caribbean in the late nineteenth century, but* Wallichia *was published first, so remains the correct name – a fitting tribute to a man who, when he succeeded Roxburgh, turned the Calcutta garden into a place 'like Milton's Paradise'.*

Wallich Palm
Wallichia caryotoides Roxb. (Arecaceae)
Anon, Roxburgh Collection
c. 1791–1794, watercolour with ink on paper, bound in
volume, 480mm x 341mm (18¼in x 13½in)

Fishtail palms can grow to massive dimensions – the one in the Palm House at Kew's Royal Botanic Gardens had to be cut down when it hit the roof! In the forest, this doesn't pose a problem, but it can be difficult to collect good specimens. Even trained monkeys have problems with the fishtail palm: E.J.H. Corner's 'first botanical monkey died from collecting specimens' (the high concentration of oxalate crystals in the fruits makes them very caustic).

Fishtail Palm
Caryota urens L. (Arecaceae)
Anon. Roxburgh Collection
c. 1791–1794, watercolour with ink on paper
480mm x 340mm (18¼in x 13½in)

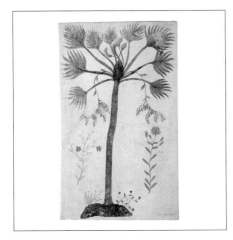

This fanciful and childishly (in the positive sense) exuberant painting of a palm tree, bedecked symmetrically with epiphytes of all sorts and colours, bears little resemblance to any real palm from the southeastern United States. One of the few native palms the artist would have been able to find in North Carolina would have been the palmetto (Sabal palmetto), a tall palm of brackish coastal areas.

Palmetto
Sabal palmetto (Walter) Lodd. ex Schult. & Schult. f.
(Arecaceae)
William Young, 1767, watercolour on paper
378mm x 234mm (14¼in x 9¼in)

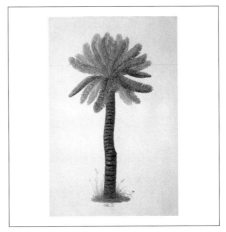

Although they look a little like palms, cycads are most definitely not palms; in fact, they are not even flowering plants. Among the most primitive of seed plants, they shared forests with the dinosaurs. Robert Brown gathered specimens on what he called Turtle Island (Bountiful Island) in the Gulf of Carpentaria, off Queensland. Bauer had to have been there, too, for this painting is accurate down to the kink in the stem.

Cycad
Cycas angulata R. Br. (Cycadaceae)
Ferdinand Bauer
c. 1803–1814, watercolour on paper
524mm x 355mm (20½in x 14in)

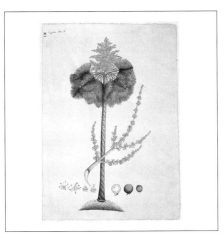

Like the sago palms, the talipot is monocarpic. The huge inflorescence develops after fifty to seventy years of vegetative growth, and can be 5–6m (16–20ft) high and more than 10m (33ft) across. The tiny fruits take over a year to develop, after which the palm dies. The investment this represents is enormous – literally – as these palms can be almost 30m (100ft) tall and 1m (3ft) in diameter before they flower!

Talipot Palm
Corypha umbraculifera L. (Arecaceae)
Anon. Roxburgh Collection
c. 1791-1794, watercolour on paper
480mm x 345mm (18¼in x 13½in)

Botanical palm paintings, like palm specimens, need to be in several parts. Ferdinand Bauer did three paintings for this palm – one of the whole plant with details of the leaves; another of a fruiting inflorescence; and this one, of the male inflorescence with details of both male and female flowers. By doing this, Bauer provided all the information one would ever need, and also to the appropriate scale.

Solitaire Palm
Ptychosperma elegans (R. Br.) Blume (Arecaceae)
Ferdinand Bauer
c. 1803–1814, watercolour on paper
525mm x 358mm (20½in x 14in)

Daisies, sunflowers, thistles and dandelions – Shakespeare's 'golden lads' – are all members of the composite family (Asteraceae). Aster one can easily understand, since the flowers are star-shaped and brilliant, but why composite? Look carefully at the 'flower' of a daisy or a sunflower and you will see that what looks from a distance like a single, brightly coloured flower is in fact an inflorescence (group of flowers), but one so tightly packed and congested that it takes on the appearance of a single entity. This characteristic inflorescence type, which is called a capitulum, is common to all the members of the composite family, but within the family the variations on this common theme are incredible. Because the overall impression of the capitulum is that of a single

the top of the tube, are highly irregular, variously fused and elongate, making an uneven structure that looks like a scoop. These peripheral ray florets are sometimes sterile, never setting seed, and appear to be there for decoration only. Surrounding the outer circle of ray florets are the phyllaries – modified bracts (leaves) that protect the capitulum when it is developing. Artichokes are the developing buds of a thistle, yet we eat the bases of the phyllaries, and discard the flowers!

Pluck off all the disk and ray flowers, and what one is left with is the receptacle, the flattened or dome-like structure upon which the flowers develop (everyone has seen an artichoke heart, for example). The receptacle is usually scaly or bristly; indeed, botanists

DAISIES & SUNFLOWERS

Thou thy wordly task hast done,
Home art gone, and te'en thy wages;
Golden lad and girls all must,
As chimney sweepers, come to dust.
CYMBELINE (WILLIAM SHAKESPEARE, ACT IV, SCENE II, LATE 1500S)

flower, it is conventional to call the individual flowers within the structure florets – they are flowers, but they are also very small. In the centre of a daisy, say, are small, tubular yellow florets, opening in sequence from the outside towards the centre, and one can clearly see the dusty yellow pollen from the open ones. These are called the disk florets – a good name, since they do look like a bright-yellow disk in the daisy's centre – all around which there is a ring of white ray florets that essentially looks just like the petals of a 'normal' flower. These ray florets vary in number (otherwise the game of 'He loves me, he loves me not' wouldn't exactly be much of a lottery!) and are tubular, just like the disk florets, but, instead of having a regular outline with five lobes of equal size at

are not entirely sure how to interpret these scales, as they could be scales associated with each flower or possibly bracts that have become scattered among the flowers. Regardless of their origin, though, they are vital when it comes to classifying within the Asteraceae family. One last peculiar feature of composite flowers is their lack of conventional sepals, since those small tubular florets sit right on top of the ovary, developing into a single-seeded fruit (sunflower seeds are a very good example of this). Crowning the fruit, however, is a structure called the pappus, a ring of hairs, scales or awns that is incredibly important in composite taxonomy – it is this that makes the dandelion parachute and the thistledown.

Members of the family show endless variations on this theme

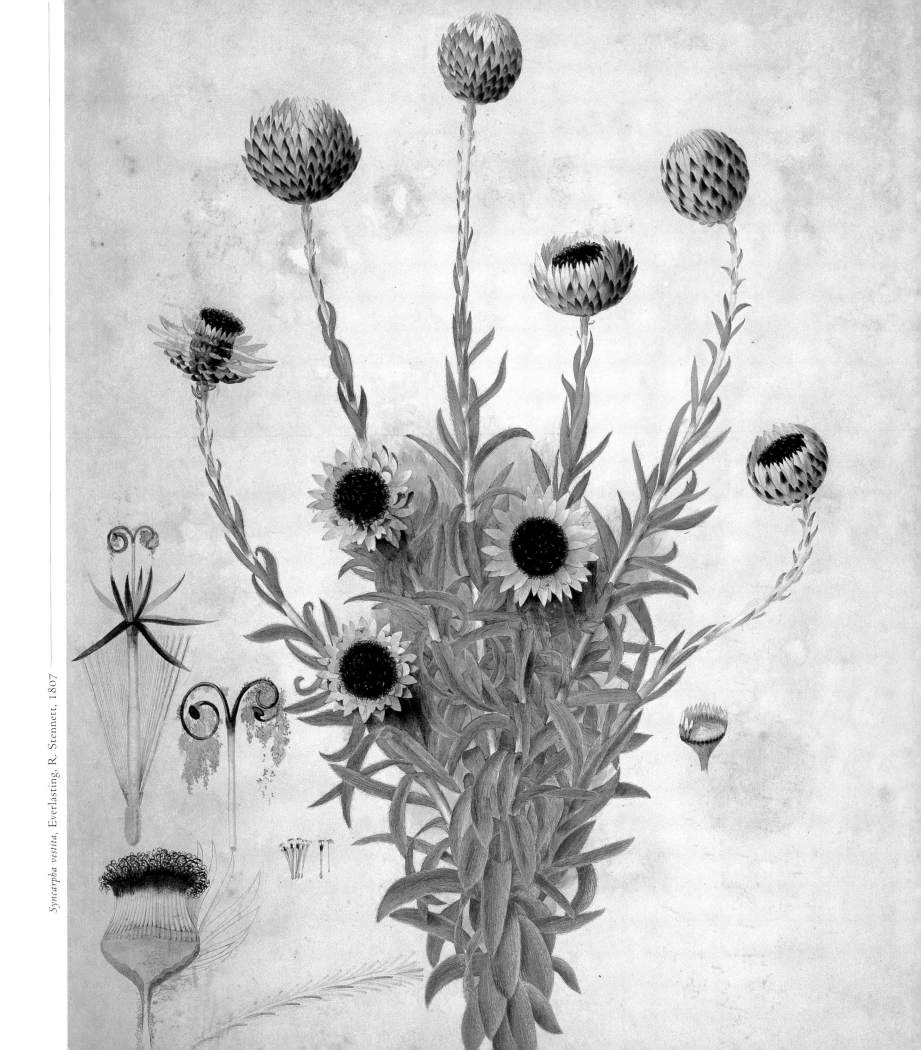

181

ANTHEMIS *Valentina....Sp. Pl. 1262.*

181.

of disk and ray florets. The Asteraceae is one of the largest families of flowering plants, with almost 25,000 species – a veritable treasure chest of diversity. Some composites, such as thistles, have only disk florets, and their bright-purple flowers are all regularly shaped. Daisies and sunflowers have a mixture of disk and ray florets, with the ray florets surrounding the central disk like the petals of a 'normal' flower. Some composites even have all ray florets: the dandelion is a puff of strap-shaped yellow florets. These different arrangements of ray and disk florets have been used to define groups within the family, for such a large and diverse set of plants becomes impossible to understand unless it can be divided logically into smaller and more manageable groups. This is how the science of taxonomy works – using the characteristics of the plants to define groups that consist of all the descendants of a common ancestor (monophyletic groups). This great structural diversity in the composite inflorescence makes this a fascinating task for those working with these amazing plants, for uncovering patterns in nature – be these patterns of relationship or of structure – is immensely exciting. Not only do taxonomists get to look at lovely organisms, but they also have the chance to work on the real-life equivalent of a treasure hunt, the treasure being knowledge of the evolutionary history of life.

The efficient packing of disk florets in the sunflower capitulum, for example, is almost dizzying: look closely and you will see seemingly changing patterns of spirals intersecting right and left. But it is not only botanists who have been fascinated by spiral patterns in composites, for they have also been the focus of mathematical interest, representing an elegant and beautiful example of Fibonacci numbers in nature. The man now known as Fibonacci was a Pisan living on the cusp of the twelfth and thirteenth centuries, who went by many names. 'Fibonacci' is a contraction of 'filius' ('son of'), and 'Bonaccio', his father's name or perhaps family name; family names (like Smith or Jones) were not as common in the Middle Ages as they are today. One of his names was Leonardo Pisano ('Leonardo of Pisa'), yet he also went

Calotis lappulacea, F.P. Nodder, 1780

by the name of Leonardo Bigollo (*bigollo* means 'traveller' or 'good-for-nothing'). We don't know if he considered his mathematical work to be trivial or if he was a well-travelled man, but certainly his mathematical work was of great value, he was one of the first to introduce the Hindu-Arabic number system (1, 2, 3, etc.) to Europe, for example. Fibonacci wrote *Liber abacci* (*Book of the Abacus*

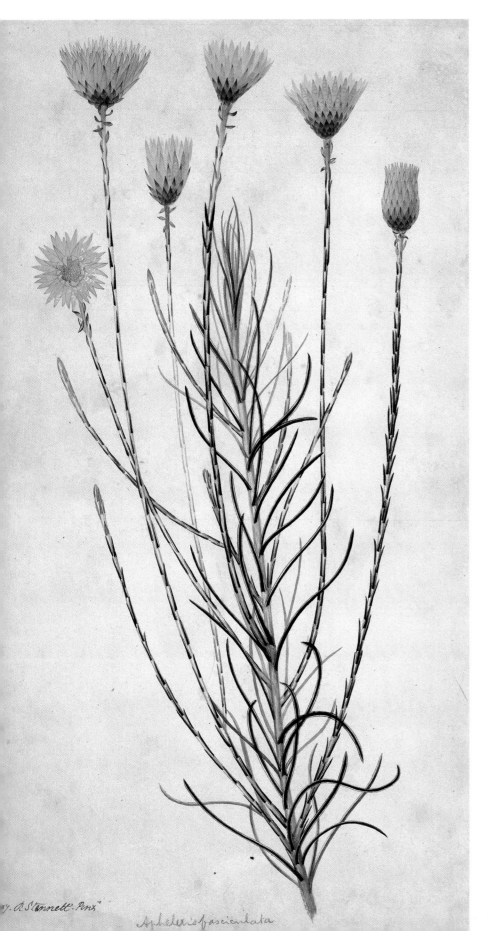

or *Book of Calculating*), published in 1202, in which he discussed the 'new' system and also outlined a problem for his readers as a means of practising their sums: 'a pair of rabbits are put in a field and if rabbits take a month to become mature and then produce a new pair every month after that, how many pairs will there be in twelve months' time?' The answer, assuming none died or escaped – for maths always entails making assumptions – involves a series of numbers (1, 1, 2, 3, 5, 8, 13, 21, 34…) where each successive number is the sum of the previous two. A nineteenth-century French mathematician, Edouard Lucas, saw the importance of this series and named them the 'Fibonacci numbers', a pattern that crops up in many surprising places – family trees, the numbers of relations a honeybee has, the generation of spiralling in seashells, the number of petals in flowers of different kinds…and in the packing of disk florets in composite heads. If you count those dizzying spirals of disk florets in the capitula carefully – first those going to the left, then those going to the right – you will see that, whatever that pair of numbers may be, they are always neighbours in the Fibonacci sequence. Though it seems a bit peculiar (a natural object 'following' an arcane mathematical sequence), it makes physical sense, as the packing of florets on the receptacle needs to be able to accommodate a wide range of capitula sizes, from the tiny capitula of the camomile to the dinner-plate-sized monsters of some sunflower varieties. By developing in this very precise way – a Fibonacci sequence pattern – the florets are optimally packed throughout the capitula at all stages (not too crowded at the middle, nor too sparse at the edges), and all the fruits or seeds have an equal chance of being the correct size for efficient dispersal and subsequent establishment. Flowers, after all, are the producers of the next generation of plants and, however enjoyable they might be, are not there just for our enjoyment. This optimal packing is generated by another amazing mathematical 'rule', for as each floret develops on the receptacle it follows a sequence: the next one to develop from the undifferentiated tissue of the very young receptacle is more or less at a 137.5° angle from

CENTAUREA *Glastifolia.* *Sp. Pl.* 1194. 34.

the previous one. This is how spirals are generated and the angle (not surprisingly) is called the Fibonacci angle.

If you divide each Fibonacci number by the one preceding it, the answer eventually becomes the same for any division – the number 1.618, the golden number (also sometimes called the golden ratio or golden mean). Funnily enough, each neighbour floret in a spiral is positioned approximately 0.618 of a turn from the preceding one, so if you go from the centre to the outside there are 1.618 florets per complete turn of the spiral. The golden mean is an irrational number – like pi (3.141592), it cannot be written as an exact fraction – and shows up in analyses of the design of the Pyramids, in much-loved works of art and architecture, as well as in many growth forms of the natural world (just like the Fibonacci numbers, of which it is a more universal constant). Its appearance in sunflower heads is not due to a mystical order in nature but instead to the physical constraints placed on the developing seed head. Seeds grow and need to be packed in a space efficiently so that this can happen throughout their lives attached to the parent plant, and developing in the sequence they do helps with that problem. All sorts of number patterns occur in nature, and are more like fascinating tendencies rather than laws. The reality of growing things means that the numerical relationships are not always as exact as in a model, but the patterns are so common they are intriguing and have been so throughout history.

Although the shaggy 'flowers' of *Chrysanthemum* seem not to have anything to do with the apparently mathematical precision of a sunflower head, they too are composites and, were we to look closely enough, their florets are probably also in Fibonacci spirals. Chrysanthemums have another fascination, however. Hated by some in the far northern hemisphere for their association with the darkening days of autumn, they are revered in China as symbols of longevity and the ability to overcome adversity. Like the chrysanthemum blooming in the autumn rather than in the crowded spring, the Confucian scholar would live as a high-minded recluse, withstanding disfavour and disapproval for a principled

stand on life. The first Chinese chrysanthemums had yellow flowers, and are mentioned as heralds of autumn as far back as the seventh century BCE. In the Tang dynasty of the eighth century CE, the culture and development of these plants really took off: white varieties started to appear, then purple ones were mentioned in poetry, and even used in flower arranging. All this development of horticultural varieties was due to selective breeding and cultivation, but the origins of the cultivated plant itself are not known. The cultivated chrysanthemum is a complex hybrid and most likely the result of the interbreeding of several wild species (the 'x' in its scientific name, *Chrysanthemum* x *morifolium*, indicates that it is a species of hybrid origin). Many centuries on, it may be impossible to ascertain just which wild species were involved in its origin. The great explosion in chrysanthemum varieties in China occurred between the late tenth and early nineteenth centuries, perhaps due to the export and cultivation of the plant in Japan and subsequent reimportation. A horticultural treatise on chrysanthemums, Liu Meng's *Ju Pu*, appeared in the very early tenth century – it seems that cultivation practices were a mixture of the very sophisticated and the extremely bizarre. Good husbandry was commonly practised; fertilization, pruning and grafting were common; but it

Helianthus mollis, Downy Sunflower, F.P. Nodder, 1776

was also believed that placing a whole withered flower in the soil in which new plants were to be grown was a way to induce variation. Maybe it worked sometimes (that is how most beliefs originate). Grafting techniques were sophisticated enough to enable horticulturalists to graft stocks of several varieties on to one rootstock, making peculiar-looking plants that apparently bore blooms of many colours. Shoots of cultivated varieties were grafted on to wild species of other composites, such as ragweeds, the resulting plant bearing large robust flowers, which to Scottish plant hunter Robert Fortune were 'rather curious objects to those who have seen them only on their own stems'. Yellow-flowered varieties were imported into Europe in the late seventeenth century, and by 1764 were in cultivation at the Chelsea Physic Garden in London, but were subsequently lost.

Chrysanthemums were reintroduced to Europe, many varieties via John Reeves of the East India Company in the early 1800s. When the infamous Opium War between Great Britain and China ended in 1842, China (via Hong Kong) was open to plant collection, and Reeves encouraged the Horticultural Society to send a collector. The society contracted the young Robert Fortune, recently hired as Superintendent of the Hothouse Departments (the greenhouses) at their gardens in Chiswick, West London. He was poorly paid, the collector's salary was still the same as that of decades earlier – £100 per annum. In less than eleven months, Robert Fortune was collecting in rich territory. The Horticultural Society's miserly treatment of Fortune meant that he only undertook one trip in their employ – his later collecting was done for the British East India Company, at a much higher wage. He spent nineteen years in China and Japan and was responsible for the introduction of many loved plants to British gardens – the Japanese anemone (*Anemone hupehensis* and its hybrids), the white wisteria, and the winter-flowering jasmine (*Jasminum nudiflorum*) were all collected and introduced via Fortune. Famously, he evaded travel restrictions on foreigners by dressing up in Chinese clothing (complete with shaved head and pigtail) in order to go collecting

in the nurseries of Soochow, renowned for their beautiful flowers. On the way, he slept in the boat, again to avoid attracting attention, but during the night all his clothing was stolen. Undeterred, he sent his servant out to buy new clothing and carried on. In the first set of plants he sent back to London there were two little chrysanthemums from which today's pompom varieties originated. In Japan, nearly two decades and a wealth of experience later, Fortune was visiting nurseries outside Tokyo when he came to one that was famous for its chrysanthemums. He saw they were very different from those he had collected in China and could revolutionize the cultivation of these plants in Europe. Carefully supervising the cutting off of the right 'suckers' (he knew all about grafting these varieties), he had them given to him in person – not sent to the British legation the next day, as he had arranged with the other things he bought. To make sure his plants reached England without mishap, Fortune often divided each consignment into three or four, sending them home on different boats or at separate times. Combined with his penchant for disguises, it is probably fair to say that Fortune was an innately suspicious man. His collections brought nearly 200 new plants into cultivation, including some incredible types of chrysanthemum.

Nowadays, chrysanthemums come in an astonishing range of shapes – from the tiny pompoms bred from Fortune's Chinese material to huge shaggy lion's-head varieties. Some of this variation has been induced by manipulation, since careful pruning can induce huge blooms. The colour range is also incredible – from the original yellow blossoms, we now have bright yellow, orange, burgundy, umber, purple and all shades of variation in between, and there are even green-flowered chrysanthemum varieties. Some cultivated sorts have both disk and ray florets, which makes them look like the annual chrysanthemums (the crown daisies), while other kinds have ray florets only, with the outer ones extravagantly enlarged and shaggy. All this variety is testament to the power of selection when it is applied to existing variation from nature. Human beings have clearly let their imaginations run riot with these amazing blooms.

Phaenocoma prolifera, Everlasting, R. Stennett, c. early 1800s

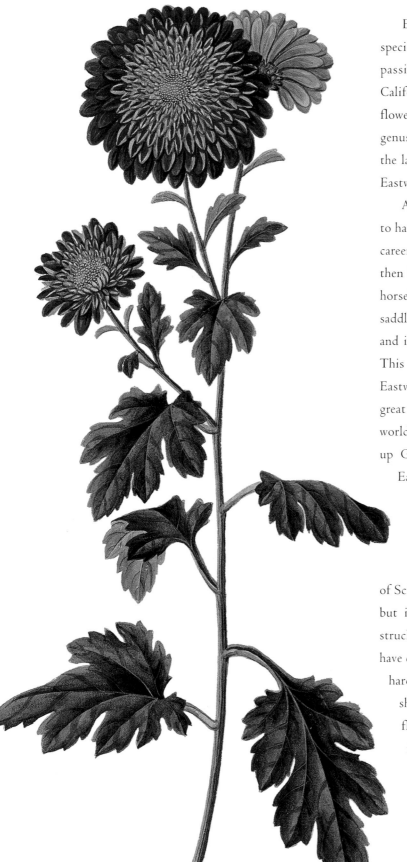

Extravagant and extreme as many composites seem, many wild species are small and rather insignificant. They can also arouse passions, in part for their associations with people. The Californian endemic shrub *Eastwoodia*, a plant with tiny yellow flowers and sticky leaves that is related to the rabbitbrushes of the genus *Chrysothamnus*, is named after one of the great naturalists of the late nineteenth and early twentieth centuries – botanist Alice Eastwood, whose life was filled with incident.

Attracted to plants as a small girl in Canada, she could be said to have studied botany for all her ninety-four years. She began her career as a collector in Colorado (first as a high-school student then later as a teacher), where she collected in the high Rockies by horseback, on foot, and often alone. She began by riding side-saddle, as young ladies should, but soon changed to riding astride, and in the process pioneered new clothing for female collectors! This is commonplace for women collectors today, of course, but Eastwood was doing this in the prim Victorian 1800s. When the great naturalist Alfred Russel Wallace (by then 60 years old and world-famous) travelled through Denver, who better to take him up Gray's Peak to see the alpine flora than the young Miss Eastwood? She later said that this was one of the great experiences of her life. Moving to California in 1892, she was invited by the incumbent curators Thomas and Kate Brandegee to occupy a post as joint curator of the expanding botanical collections at the California Academy of Sciences in San Francisco. She took over when they retired later, but in 1906, just when things were coming together, disaster struck. The earthquake that utterly destroyed San Francisco would have completely destroyed the herbarium Eastwood had worked so hard to build up had she not had the courage to enter the shaking building (the botanical collections were on the top floor) and rescue more than 1000 type specimens from the fire that then swept the district. Her attitude to the loss was typical of this strong and resilient woman: '[It] is a great loss to the scientific world and an irreparable loss to

Chrysanthemum x morifolium, Chrysanthemum, Anon., Reeves Collection, c. 1820s

California. My own destroyed work I do not lament, but it was a joy to me while I did it, and I can still have the same joy in starting it again.' Rebuild she did and, in collaboration with her assistant John Thomas Howell (described as 'a grand partnership'), Alice Eastwood collected more than 300,000 plants all over the American West to make a world-class collection. It is ironic that the tiny, insignificant composite genus *Eastwoodia* does not appear in the great *Manual of the Flowering Plants of California* written by her contemporary, Willis Linn Jepson. Jepson was a native Californian – a rarity in the middle of the nineteenty century. As a teenager he began to write the flora of his native region, a real botanist in the making. He went on to become the first to receive a doctorate in botany from the University of California – then a fledgling institution itself.

Jepson was an irascible man, even to his friends – he led a 'tragic life' according to his obituary in his own journal (*Madroño*), dominated by a 'fear that he would be robbed of a rightful place in posterity by the wilful chicanery of his "enemies"'. He was especially suspicious of the California Academy, upstart competitor to his institution (the University of California), and referred to the Academy as 'the enemy'. 'Not always cordial' about Eastwood in private, Jepson got on very civilly with her in public, and even came to the Academy to celebrate her eightieth birthday, sitting at her table. But they were not friends. Of all the California endemics not treated as such by Jepson in his 1926 *Manual*, all of them can be accounted for in other genera or are absent because they were described too late to have been known by Jepson, but not *Eastwoodia*! Perhaps omitting the eponymous memorial to Alice Eastwood from his life's work was a slip; maybe it was a subtle slight; but whatever the reason, plants arouse passions in the most extraordinary ways!

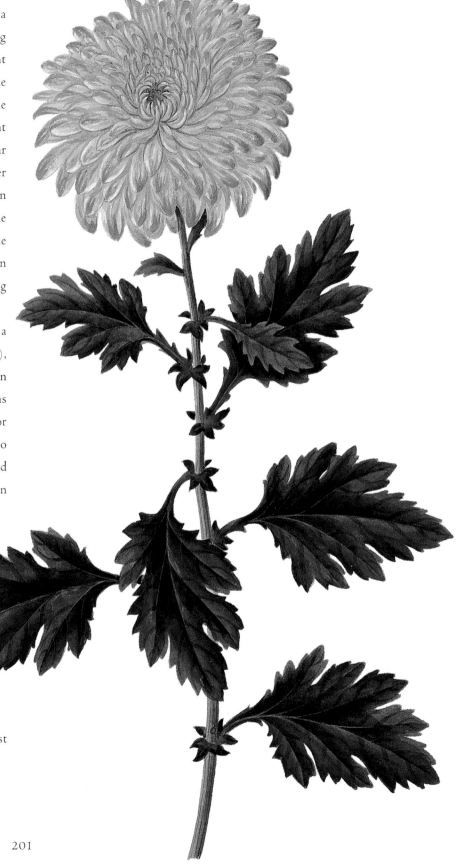

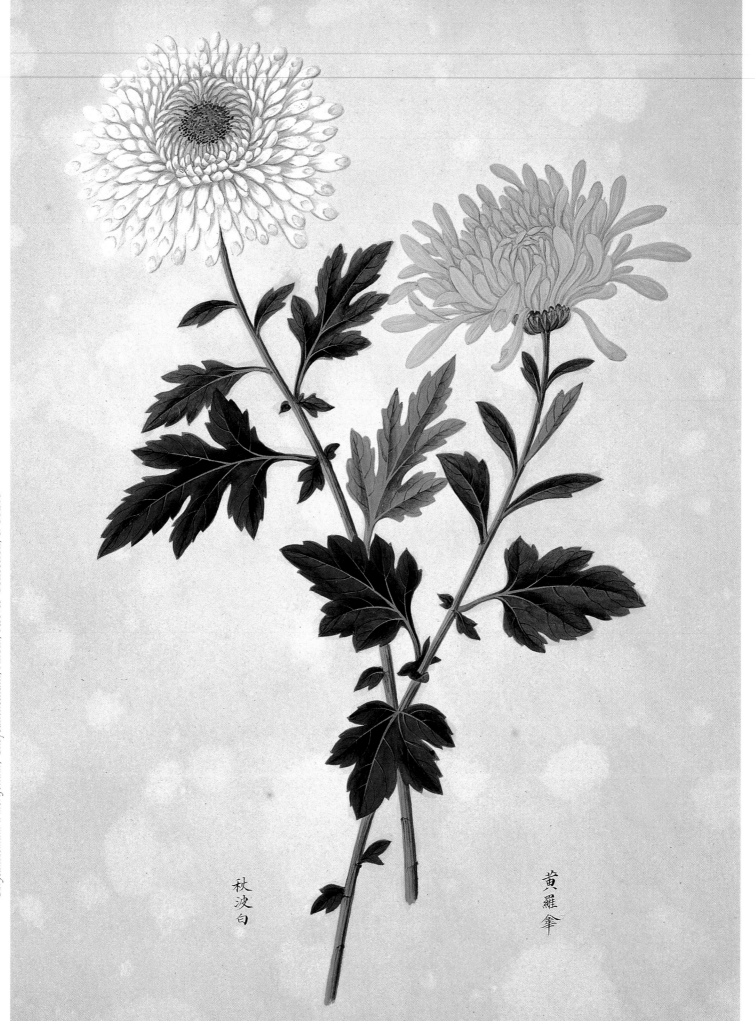

秋波白

黄羅傘

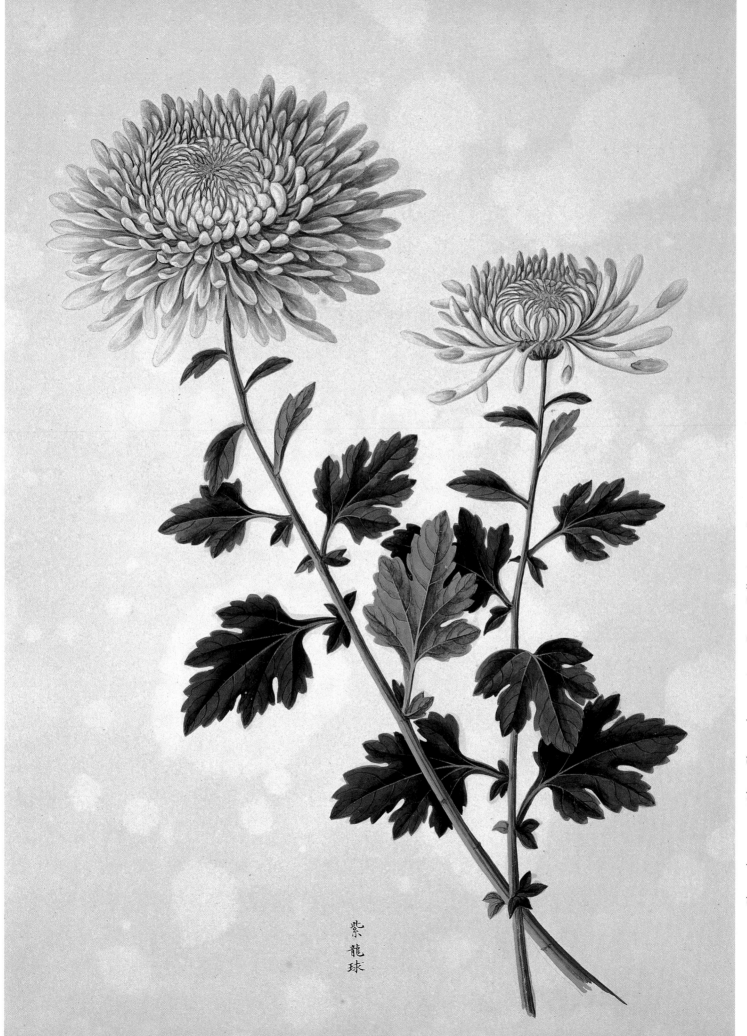

紫
龍
球

Chrysanthemum x morifolium, Chrysanthemum, Anon., Reeves Collection, c. 1820s

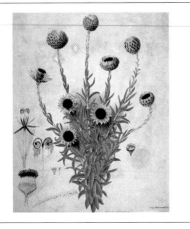

Vast stands of this plant on the Cape Peninsula have earned it its common name, for when they are in flower the ground appears white, as though it has been covered with snow. The white colour comes not from the flowers – which are purplish – but from the shiny, papery phyllaries or involucral bracts.

Everlasting; Cape Snow
Syncarpha vestita (L.) B. Nord. (Asteraceae)
Ralph Stennett
1807, watercolour with bodycolour on paper
527mm x 424mm (20¾in x 16¾in)

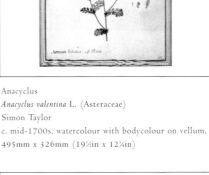

Alexandre Henri Gabriel de Cassini, the early nineteenth-century French founding father of synantherology, had a chequered career, passing through astronomy (which he gave up due to persecution of his family post-Revolution) to law. He studied daisies throughout his life, focusing on 'beings that were growing about me in abundance, with forms as varied as they are gracious, which I could mutilate, dissect and destroy without stirring my pity'.

Anacyclus
Anacyclus valentina L. (Asteraceae)
Simon Taylor
c. mid-1700s, watercolour with bodycolour on vellum,
495mm x 326mm (19½in x 12¾in)

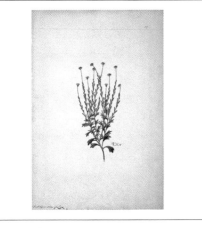

Not all the plants collected by Joseph Banks and Daniel Solander on the Endeavour voyage were big and showy. This tiny daisy from Botany Bay was not named until nearly 100 years after the botanists returned, laden with novelties, many of which were more showy and demanding of attention than this discrete plant.

Calotis lappulacea Benth. (Compositae)
Frederick Polydore Nodder, Cook Collection
1780, watercolour with ink on paper
540mm x 360mm (21¼in x 14¼in)

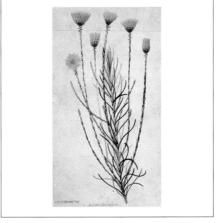

The everlastings are so called for their papery involucral bracts (or phyllaries) that surround the composite flower head. These translucent structures persist for a long time, and the heads can be dried for use in flower arranging. Sustainable harvesting of Cape wild flowers for this market provides employment for many people who otherwise might be forced to eke an unsustainable living from an unforgiving land.

Everlasting; Sewajaartjie
Edmondia sesamoides (L.) Hilliard (Asteraceae)
Ralph Stennett
1807, watercolour on paper
442mm x 251mm (17½in x 9¾in)

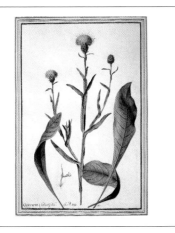

The gradual reduction in size of leaves up the stem, to bracts of the inflorescence to the flowers themselves, led the German botanist and playwright Johann Wolfgang von Goethe to hypothesize that the flower was just a modified shoot. He called this theory the metamorphosis of plants, stressing that the same organ changed according to its function and position.

Yellow Star Thistle
Centaurea glastifolia L. (Asteraceae)
Simon Taylor
c. mid-1700s, watercolour with bodycolour on vellum,
510mm x 340mm (20in x 13½in)

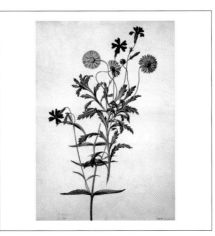

Gertrude Metz was one of several successors to Sydney Parkinson, working as a botanical artist for Sir Joseph Banks. After his triumph on the Endeavour, Banks became the grand man of British science and had his fingers in many pies, including gardening. This composition, which was done 'at Lee's garden', shows the South African daisy intertwined with the flowers of rose campion, Lychnis coronaria.

South African Daisy
Arctotis species (Asteraceae)
Gertrude Metz
1777, watercolour with bodycolour on vellum
537mm x 386mm (21¼in x 15¼in)

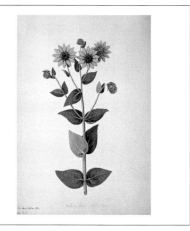

Painted in 'Mr. Lee's garden, 1776', this American species was establishing itself in European gardens just as the colonies were breaking away. True prairie plants, many species of sunflower are found in the midwestern part of the United States and Canada. Their bright-yellow flowers track the sun, moving to face its rays over the course of the day, so maximizing the heat on the developing seeds in the flower centre.

Downy Sunflower
Helianthus mollis Lam. (Asteraceae)
Frederick Polydore Nodder
1776, bodycolour on paper
525mm x 365mm (20¾in x 14¼in)

The detailed sketches of the disk florets from this amazing South African everlasting show clearly the derivation of the term 'synantherologist', used to describe a botanist studying daisies, sunflowers and their relatives. The five anthers of the floret are tightly joined at the sides to form a tube, through which the style and bilobed stigma protrude.

Everlasting; Rooisewejaartjie
Phaenocoma prolifera (L.) D. Don (Asteraceae)
Ralph Stennett
c. early 1800s, watercolour on paper
539mm x 435mm (21¼in x 17¼in)

Bud development (and thus flowering) in chrysanthemums is triggered by the lengthening of nights as autumn approaches. Adjusting the day–night balance in greenhouses allows growers to produce flowers all year round for the cut-flower market. In China they are still a seasonal flower, as they were in the eighteenth century, when the emperor's palace was decorated with chrysanthemums from autumn until the end of winter.

Chrysanthemum
Chrysanthemum x *morifolium* Ramat. (Asteraceae)
Anon. Reeves Collection.
c. 1820s, watercolour with bodycolour on paper
470mm x 375mm (18½in x 14¼in)

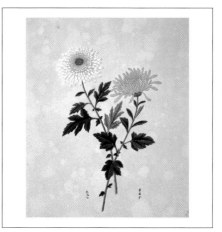

The Chinese characters in these paintings give the poetic common names of these prized cultivated plants: the yellow flower is called huang luo shan, *meaning 'yellow umbrella'; and the white flower bears the name of qiu bo bai ('white autumn waves'). Most Chinese chrysanthemum names refer to the shape and colour of the flowers.*

Chrysanthemum
Chrysanthemum x *morifolium* Ramat. (Asteraceae)
Anon. Reeves Collection.
c. 1820s, watercolour with bodycolour on paper
441mm x 375mm (17¼in x 14¼in)

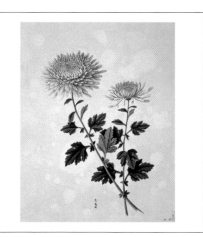

The huge flowers of zi long qiu – 'purple globose dragon' – are composed of all ray florets; no disk florets remain at the centre of the flower. Purple forms of the chrysanthemum were the last to be recorded in Chinese poetry, and perhaps for that reason they were especially prized. Huge flowers like this were forced by de-budding the lateral branches, so all the plant's energy was put into the single bloom.

Chrysanthemum
Chrysanthemum x *morifolium* Ramat. (Asteraceae)
Anon. Reeves Collection
c. 1820s, watercolour with bodycolour on paper
475mm x 378mm (18¼in x 14¼in)

To many people, the name 'passionflower' (*Passiflora*) conjures up the notion of romance. However, the 'passion' of the name is that of Passiontide (the last two weeks of Lent), so the flower has religious, rather than romantic, connotations. Many plants have been used as Christian symbols — roses and lilies are among the plants used in medieval times that have no mention in the Bible, and for this reason were not perhaps associated with the faith at the time of Jesus. As missionaries took Christianity around the world (by charity and by conquest), new symbols were needed for new lands — proof positive to the faithful that they were in the right, and that they were spreading the word of God. The passionflower is one such plant. Many versions of its story exist,

Indies, and in practice such licences were never granted. This odd policy was coupled with state financial support for inquiry into the natural history and ethnography. The sixteen-folio volumes on the natural history of Mexico assembled by Francisco Hernández (whose five-year expedition was sponsored by the Spanish government in 1570) languished in the library of the Escorial of Madrid until it burned down in 1671 and his labours were lost to the world of science. Fortunately, a few copies of some of the illustrations and text were made, and these were published in Rome in the mid-seventeenth century. Hernández died a frustrated man a year after his return from Mexico — not surprisingly, given that he had devoted two years of his own time and money to the study

PASSIONFLOWERS

It is immortal, but keeps death within;
Nobody has ever seen the bloom of a greater flower,
And if you long to know its name,
As it resembles Jesus, the flower is Christ.

FLOS PASSIONIS (SIGNOR F.B., IN JACOMO BOSIO, 1609)

which was surely changed as more and more species of this wonderful genus became known to European peoples. The 'flos passionis' became a symbol of Christian faith and belief only after the Spanish had set out to conquer the Indies…and stumbled across the Americas by mistake.

Scientifically or methodically gathered information about the plants of the new territories conquered by the Spanish was slow to come to Europe, as in 1556 an edict of the Crown prohibited the publication of any book containing information about the Spanish colonies — presumably in order to keep competitors, most notably the English, from knowing the extent of riches or profits available. To publish information required a licence from the Council of the

of the natural history of the New World after his government money ran out. Information about the plants and animals of the New World leaked out in bits and pieces, mostly via religious sources — in addition to conquistadors, the Spanish sent missionaries from many different monastic orders in order to spread the Christian faith to their new possessions.

In the early seventeenth century, a monastic scholar in Rome named Jacomo Bosio, writing a learned and pious treatise on the Cross of Calvary, was shown drawings of a most peculiar flower by an Augustinian friar of Mexican origin. At first he did not believe that the flower was real, as its form was so fantastic that he felt it must be exaggerated. Nothing like it had been seen in Europe and,

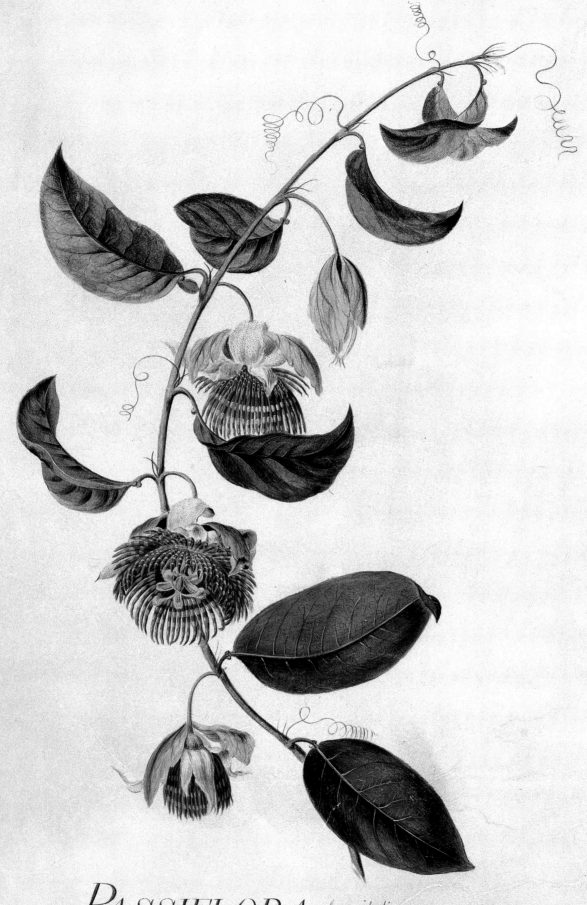

PASSIFLORA laurifolia.

foliis indivis,is ovatis integerrimis, petiolis biglandulosis involucris dentatis. Linn. sp. pl. p.1356.

Sydney Parkinson pinx: 1767

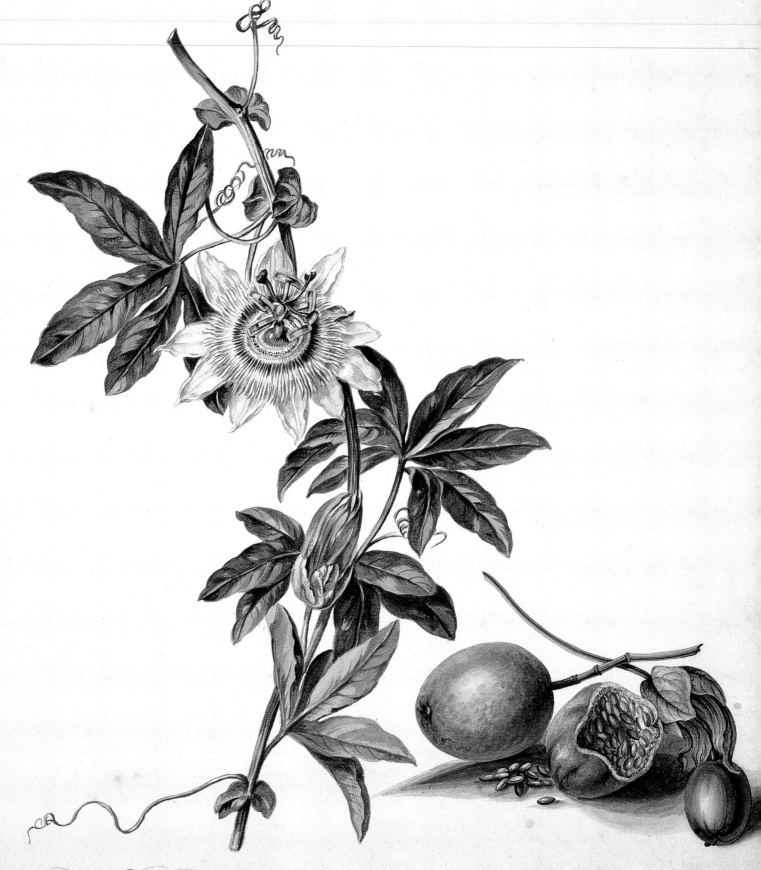

GRANADILLA; *Pentaphyllos flore coeruleo magno.* .*Boerh. Ind. .alt. II.* **SI**.

J. Van J. Huysum

even though the Jesuits travelling with the conquistadors in the New World noticed that the plants and animals were different enough for them to postulate a duality to Creation, Bosio could not quite believe it. To him, the flower seemed to represent yet another proof of the triumph of the Cross, the subject of his extensive treatise. Probably mindful of the sin of pride, he waited before including it in his work. However, as more drawings and descriptions came from Mexico via Jesuits passing through Rome, and drawings, essays and poems about the flower were circulated by a community of Dominicans from Bologna, Bosio was finally satisfied that this miraculous flower was genuine. In the end, the evidence he had at his disposal was overwhelming, and he felt that it was his duty to present the miraculous story of the passionflower to the world.

Bosio saw the flower as representing not only the Cross of Calvary, but also the past mysteries of the Passion. The form of the flower – which was incredible to anyone who had not seen one before – was laced with meaning. The central column represented the Cross itself, and the corona (ring of filaments inside the petals) radiating from its base represented the plaited and twisted crown of thorns, whose seventy-two filaments were the same as the seventy-two thorns in Christ's crown. The filaments were tipped with rose pink, showing the use of a scourge that drew blood from the body of Christ. The three stigmas topping the column represented the three nails driven into Christ's body, and the five blotches at the base of the column were the stains of the blood from Christ's five wounds. Some authors have interpreted these five blotches as the stamens, but Bosio's description is so far removed from the reality of *Passiflora* structure that it is rather difficult to tell! In Bosio's original description, the leaves were described as lance-shaped and marked with dark, round dots, representing the thirty pieces of silver paid to Judas Iscariot. Before the flower opens, it is a vaguely bell-shaped bud. The flowers remain open for a single day, then they close to a bell-shape again – Bosio felt that 'It may well be in HIS infinite wisdom it

pleased him to create it thus, shut up and protected, as though to indicate that the wonderful mysteries of the cross and of HIS passion were to remain hidden from the heathen people of these countries until the time preordained by HIS Highest Majesty.' The passionflower was seen as a sign of the 'Croce triofante' – the assurance of the ultimate triumph of Christianity.

At the time, people were deeply versed in the doctrine of signatures, where every plant had a special purpose and this purpose was revealed in its shape or form. Thus the passionflower's use as proof of the revealed truth of the wonderful and mysterious workings of God would have been implicitly believed by most in society. Later authors had to change the story to fit the species of *Passiflora* they had to hand (especially once plants of the genus were grown in Europe), but the essentials remained the same. In later versions, the petals and sepals, totalling ten, were said to represent the ten apostles present at the Crucifixion – Peter and Judas being absent – and the three large floral bracts were representative of the Trinity. By the late seventeenth century, *Passiflora caerulea* had been introduced to cultivation in Europe from southern Brazil. Its five-parted leaves became the hands of Jesus's prosecutors, and the tendrils were the cords that bound him. Today, this flower still holds a place in the symbolic 'language of the flowers', in symbolizing Christian faith and (more ironically) credulity.

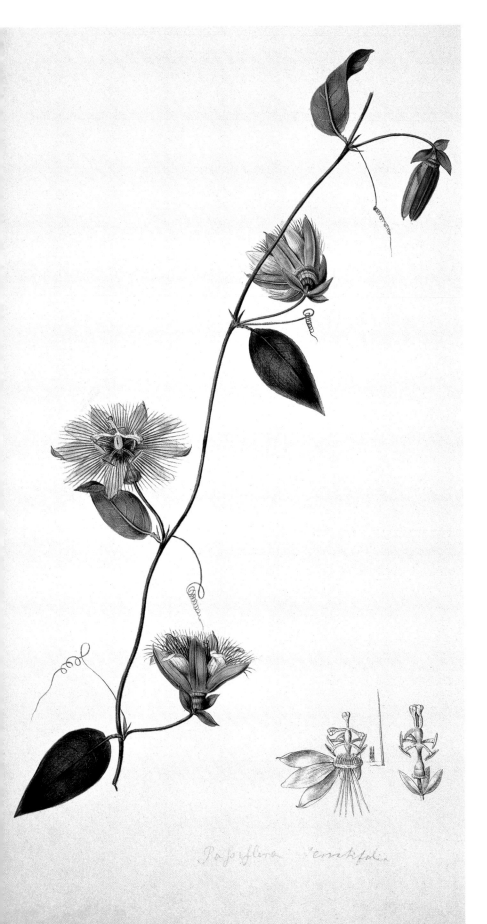

Passiflora serratifolia, Saw-edge-leaf Passionflower, J. Miller, 1772

Passionflowers are incredible, however, even to those not reading their structure for profound messages. The five sepals and five petals are standard enough for flowering plants, but the corona is quite spectacular. The corona in *Passiflora* is made up of outgrowths of the petals, at the point where the petals and sepals fuse to form a floral tube. Corona structure is important in passionflower taxonomy – species of *Passiflora* sometimes have a single row of corona filaments, but other species have up to seven or eight rows of varying length. Usually the outermost row is the longest and is often banded with colour, like the pink of Bosio's 'flos passionis'. Inner rows are usually shorter, are often darker in colour and sometimes have strange swollen tips or sword-like shapes. Inside the corona filaments is a sort of lid over the floral tube, hiding the copious nectar produced by all passionflowers from view and from the drying air. All that complexity is quite strange indeed, but emerging from the centre of the corona is a compound structure composed of fused flower parts that holds the reproductive parts of the flower – the ovary and stamens, high above the petals. This structure (the one that was likened to the Cross) is called the androgynophore, literally the 'pedestal upon which the male and female sit'. At the top of the androgynophore is the ovary, with three styles, each one tipped with a large (often bright green or yellow) stigma of receptive tissue where pollen germinates and grows to fertilize the ovules. Just beneath the ovary are five large stamens – the pollen-bearing, or male, reproductive parts. The anthers, where the pollen is held, are hinged in their centre, so that they can move whichever way they are pushed, and they look a little like plates on stalks. Maybe it is not so surprising that, with all that structural complexity, symbolism was found in such a flower.

Passiflora are justly famous for their fantastic flowers, but today they are known just as much for their fruits. These used to be only available in the tropics, and it was rare for a person in the northern hemisphere ever to have even tasted a pineapple (or even a banana), for transport was both difficult and expensive. Nowadays, however,

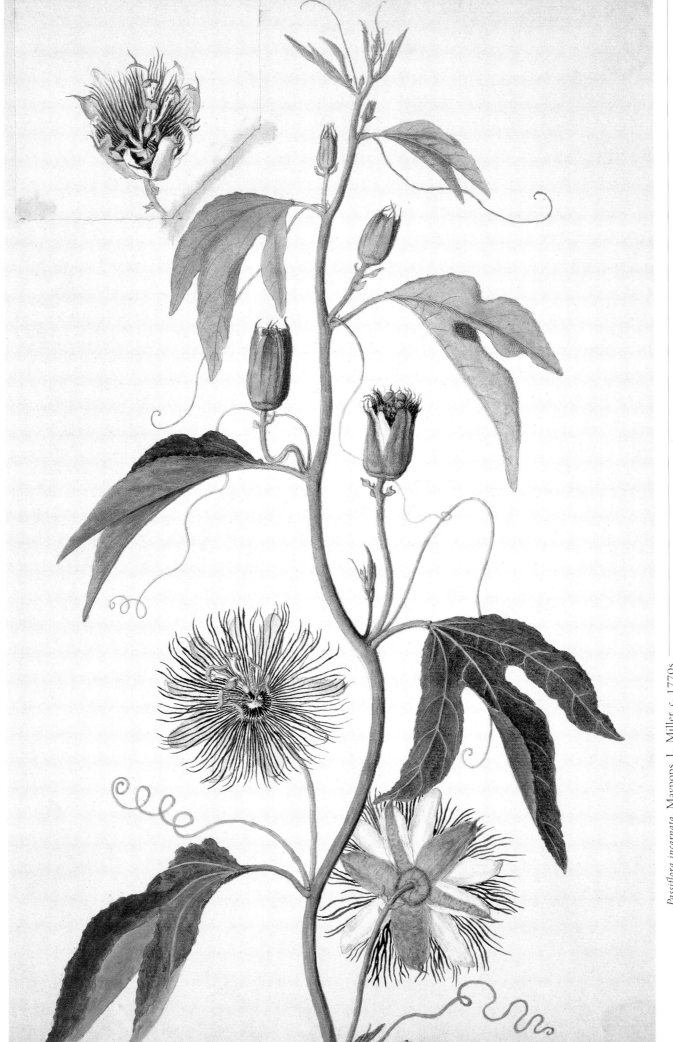

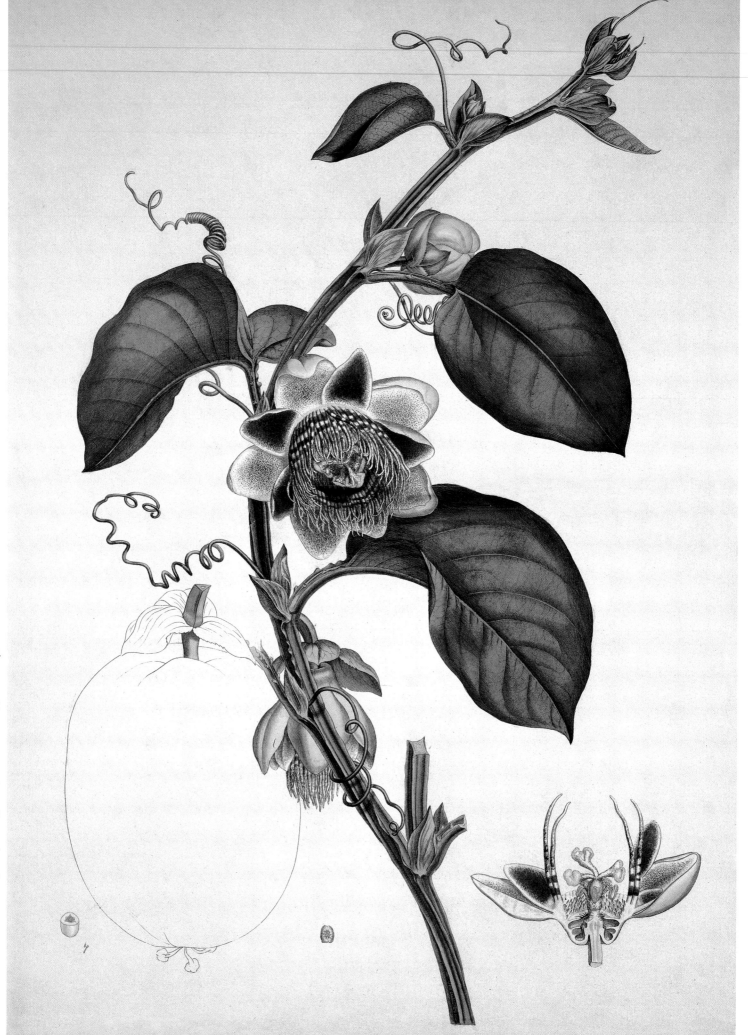

Passiflora quadrangularis, Water Lemon, J. Sowerby, c. 1800s

with refrigerated air transport and efficient methods of cold storage, tropical fruits are no longer an out-of-reach luxury. *Passiflora* fruits come in an incredible variety of sizes and colours – from tiny blackish-blue spheres about 1cm (½in) in diameter to the huge ellipsoid, melon-like fruits of the giant granadilla, *Passiflora quadrangularis*, which can weigh as much as 1kg (2lb). All passion fruit have seeds surrounded by a juicy pulp, which in many wild species is very acid but in the cultivated species is sweet. Four principal species of *Passiflora* are cultivated for their fruits, all of which are New World in origin. Commercially the most important species, by far, is *Passiflora edulis*, which is originally native to Brazil, but today is grown all over the tropics and subtropics, both for use as a fruit and within the juice industry. This species was commercially cultivated in tropical Australia in the nineteenth century, and by the 1960s growers in Hawaii were producing as much as 9000 tonnes (9900 tons) per year. Demand continues to increase as people all over the world develop a taste for these fruits; indeed, a number of varieties with different colours of rinds or pulp are being developed.

Humans are not the only animals that appreciate passionflower vines, however. Many different birds and bats eat the ripe fruits, going after the sweet pulp surrounding the seeds just as human beings do. Although passionflowers all conform to a basic overall floral plan, within the genus *Passiflora* there is enormous variety in size, colour and general shape of the flowers. This in part reflects the wide range of different pollinators that visit the flowers – some of the bright-red ones in the New World tropics are visited by hummingbirds; other species, with white flowers that are sweetly aromatic, are visited by bees; while still others, with pendulous flowers, with the corona forming a large cup, are apparently visited by bats. The structure of the passionflower – its large stigmas and large, versatile stamens mature at different times – maximizes the opportunity for cross-pollination by the animal that visits a flower and then visits another one of the same species. However, by far the most intimate

(or most specialized) relationship between passionflowers and another organism exists between the plants and a group of butterflies whose caterpillars feed only on their leaves.

The brightly coloured tropical heliconiine butterflies lay their eggs only on species of *Passiflora*. In the rainforests of the New World tropics, for example, one can see strikingly coloured red, black and yellow butterflies slowly fluttering through clearings and along trails, stopping to test plants constantly. When the female butterfly encounters a suitable egg-laying site, she tests the leaves, and appears to check the area out thoroughly as a good place to risk laying her eggs. If the plant is the right sort – for some heliconiines feed purely on small groups of related species of passionflower vines – she will deposit her yellowish-orange eggs there, usually on the young growing tip of the vine. When the caterpillar hatches, it will then begin to eat the new growth with great voracity – which is delicious for the caterpillar but not so beneficial for the vine (constantly having its growing tip eaten). This relationship is one of the classic cases of co-evolution, where interacting pairs of organisms influence each another through the course of evolution.

A large number of co-evolution cases are mutalistic – where both plant and insect benefit from the relationship – for example, in pollination systems both the pollinator and the pollinated get something. When only one partner in the interaction benefits, however, the relationship can be characterized as parasitic. In these types of interactions, an evolutionary 'arms race' can be seen, with each partner evolving defences against the other. Passionflower vines have evolved chemical defences against the butterfly larvae, but the heliconiine butterflies have circumvented these and the caterpillars are unaffected by the cocktail of toxic alkaloids found in *Passiflora* leaves. Despite being sedentary and apparently static organisms, the plants can fight back, however, and some species of *Passiflora* have vicious hooked hairs that rip into the bodies of the caterpillars, which causes them to bleed to death should they be unfortunate enough to be snagged. Another characteristic of

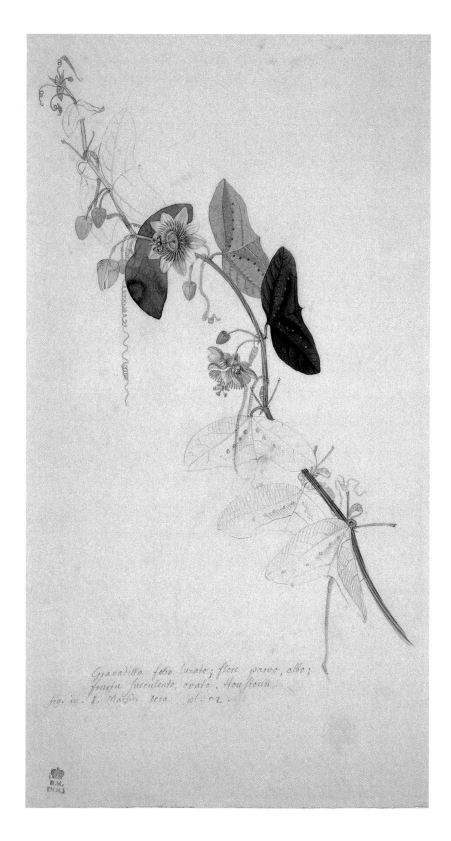

Granadilla folio lunato; flore parvo, albo;
fructu succulento, ovato. Houstoun...
fig. in. I. Martin deca. pl. 12.

Passiflora biflora, Batwing Passionflower, G.D. Ehret, c. 1760s

passion-flowers that is thought to be a defence against the heliconiine butterfly is the remarkable variety of leaf shapes found in the group. The idea is that if the female butterfly is looking for shape as the clue to where to lay her eggs, she might be confused by the variety of shapes in suitable plants, but butterflies use more than shape, extensively testing the leaves they land on, perhaps using chemical cues as well.

One characteristic of the heliconiine butterflies exploited by the passionflower vines in circumventing this parasitism is perhaps the most fantastic of all. Species of heliconiine butterflies that lay single eggs are cannibalistic: if one of these caterpillars encounters another egg or smaller caterpillar, it will eat it, so perhaps reducing competition for the food resource the vine represents. Therefore, a female butterfly needs to check carefully whether or not the plant already has yellowish-orange eggs on it before she lays her own. Some of the species of *Passiflora* used by these butterflies have glands on the leaves and leaf stalks that are amazingly like butterfly eggs – these 'egg mimics' are bright yellowish orange and are found on the new growth, just like real eggs. Experiments have shown that, while these fake eggs do not completely prevent the butterfly from laying eggs on a particular passionflower vine, they do 'force' her to lay her eggs away from the vulnerable growing tip of the plant, thus perhaps saving damage to that important part of the plant. It is clear that some of the amazing leaf characteristics of the passionflower are due to this evolutionary arms race between them and their specialist herbivores. But what will the next innovation be?

Butterflies may do great damage to growing passionflower vines, but they can be a boon for botanists looking for these elusive plants. *Passifloras* are quite difficult to find in the rainforest, as they can be extremely large vines that flower only in the forest canopy, so not readily accessible to the plant hunter searching on foot. One frequently encounters sterile individuals – young plants with only foliage, and neither flowers nor fruits – which makes them quite difficult to identify.

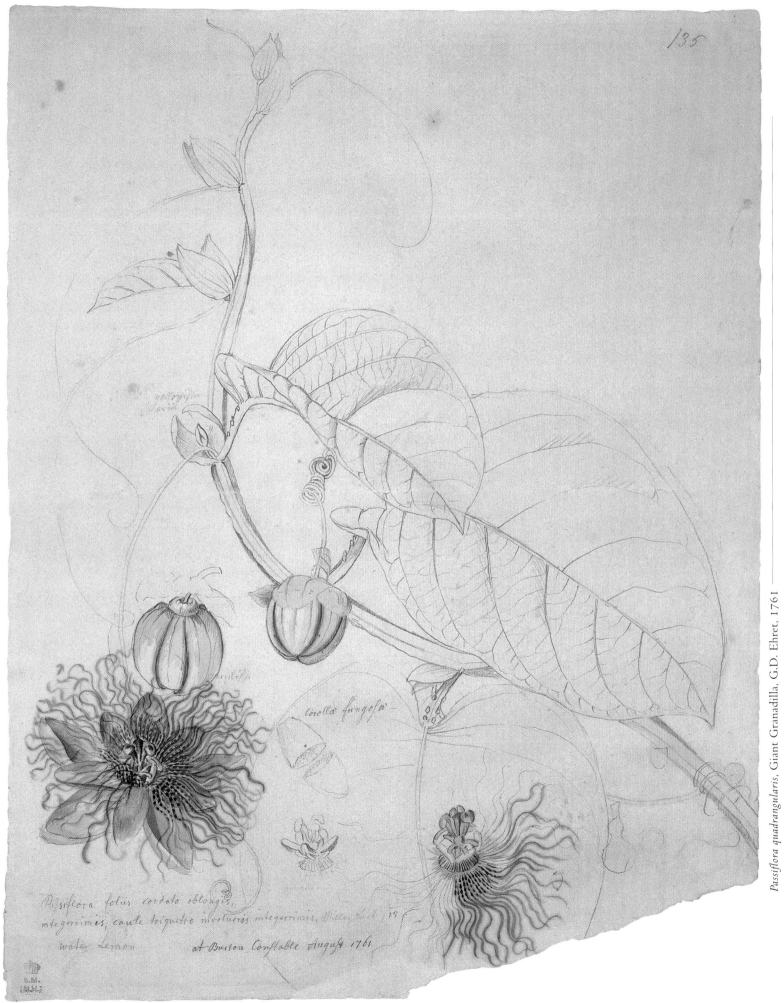

135

Passiflora quadrangularis, Giant Granadilla, G.D. Ehret, 1761

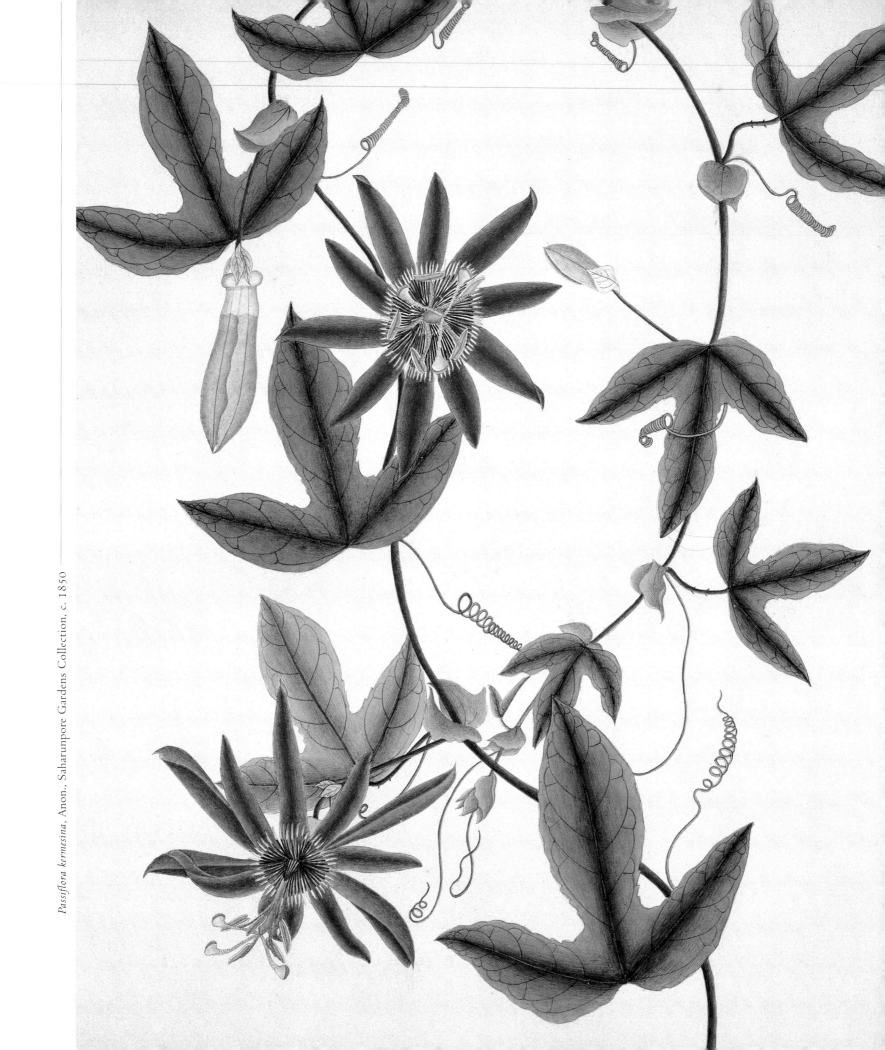

Passiflora kermesina, Anon., Saharunpore Gardens Collection, c. 1850

While plant collecting in Central America, I became quite interested in passionflowers, in part because my partner studied the butterflies that fed upon them. When we found a plant we could not identify, we would cultivate it until it flowered, and discovered many new species that way. But one species, frustratingly, eluded us entirely. We had seen it as a juvenile in many places – with its distinctive pale-green, almost waxy leaves constructed like small umbrellas, it was unmistakable. We had found that a particular heliconiine butterfly (*Eueides lineata*) fed on the leaves, which was in itself a novel discovery, as no one had ever known before what the caterpillars of that species ate. Everywhere we found the butterfly, we searched high and low for the passionflower (for we were certain it was a species new to science), but we could never find it in flower or fruit – only with those umbrella-shaped leaves.

To describe a new plant species scientifically, a botanist must carefully describe it – with both flowers and fruit, if possible – in order to demonstrate to the world that the species really does differ in kind from any other in its genus. Obviously it is a great thrill to discover something new, but it is also a responsibility, for it is important not to describe new species frivolously. Once the description has entered the published literature, it will be used by other botanists, horticulturalists and gardeners, and possibly for hundreds of years.

After weeks of frustrating searching, we stopped by the side of a road to have a look – not for our elusive passionflower, but for whatever else we might find – and there, fluttering by, were quite a few individuals of the butterfly that fed upon the new *Passiflora*. There were no plants to be seen, but we knew they just had to be there somewhere. One of us ventured into the thick undergrowth after something, and there it was – the *Passiflora*…in flower! It would not have mattered if it had possessed the tiniest flowers, but it was a real beauty – with large, sweetly fragrant flowers, it was well worth all the searching. However, we would never have found it without the presence of the butterflies, alerting us to the fact that there must be some plants nearby. I made specimens of the plant, and we all took photographs, and in honour of our butterfly 'guides' we named the new species of *Passiflora* after them – *Passiflora eueidipabulum*, 'food of *Eueides*'.

Years later, in Ecuador, we found another new relationship of plant and butterfly, *Heliconius telesiphe*. The larval food plant was a lovely, delicate vine with deep purplish leaves and quite spectacular flowers – unknown to science, although the butterflies could clearly find it easily – we named it *Passiflora telesiphe*. Insects are often named for the plants upon which they feed (*Cactoblastus cactorum* for example), but rarely the reverse. It is nice to be able to show, even if only to one's self, the links between species that are the structure of nature.

Finding passionflowers is a thrill. Because they are not mass-bloomers, one never sees them easily. They produce just one or two flowers at a time along the vining stem, snaking along the forest edge or in the canopy or in a clearing, so they are not easy to see. However, when you do find one, the single flower well repays the effort – incredible in its complexity and structure, one can look at it for ages and still see something new. To many, passionflowers still remain symbols, not of Christianity, but perhaps of the beauty and mystery of the world's rain-forests where so much diversity resides, hidden from view unless you look closely.

Passiflora aurantia, Orange Passionflower, F.P. Nodder, 1780

VERA EFFIGIE DELLA GRANDIGLIA, DETTA FIOR DELLA PASSIONE

Funera uix norant Christi crudelia Vates
Signaquix sensit carla Sybilla necis;

Quando parens Tellus campos dedit ante loquaces
Prescia uenturas promere flore notas.

Superior.

Permissu.

All'Ill.mo et Ecc.mo Sig.r Giouan Fabri Linceo, Filosofo, Medico Publico Lettore nello Studio di Roma et Semplicista di Nostro Signore

Qusta Pianta si rara, e degna di amiratione, gia molto è, che su ueduta in Italia, ma intagliata in legno, piu tosto p relatione, e fantasia, che a somiglanza della naturale; della quale io sono stato mai sempre curioso. Et inquesta mia uenuta in Roma essendomi da V.S. come diligentissima nelle cose della Natura stata dotata tal uera Effigie, ritratta della Piata che nel se cond.mo Giardino dell'Ill.mo et R.mo Sig.r Card. Farnese uiue, con altre marauighose p benesicio comune e de gli studiosi delle Piate, ho uoluto farla intagliar in Rame, e publicar sotto il dign.mo nome di V.S., gia ch da lei m'e puenuta, oltre l'obligo grande che le sengo ple sue rare qualita al mo do celebri. Coche la sego a graghr la come cosa sua, sperando da lei quslo prima la uera historia. Di Napoli a 20. di Deemb. 1619.

D.V.S. Ill.re et Ecc.ma aff.mo ser.re

F. Donato Eremita, Prefetto della Aromataria di S.ta Catherina a Fornello di Napoli

COPIA DEL FIORE, ET FRVTTO,
CHE NASCE NELLE INDIE OCCIDENTALI,
Qual di nouo è stato presentato alla Santità di N.S.P. Paolo V.

Del Sig. Dottor Giouanni Capponi.

Del Sig. Gismondi Santi.

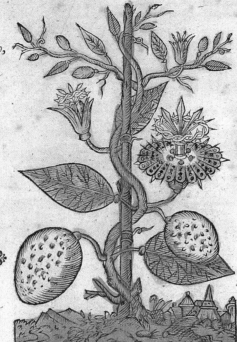

Questo Fior, che tu uedi, Anima pura,
 Mentre in Croce pendea Giesù traffitto,
Si di sangue, e di duol segnato, e scritto,
Per pietà del suo Dio formò Natura.
Stupido in così pia nobil fattura
 Tutte fissò le luci Auerno afflitto;
 E uide l'empio in questo Fior descritto
Lo scorno suo, la nostra alta uentura.
E per celar le sue uergogne altrui.
 De l'opposto Emispero infrà i tesori
Portollo in terra alor diuota à lui.
Mà che gli ualse? Or gl'Indi abitatori
 Di già pur sanno in Fè simili à noi
I tormenti di Dio legger ne' Fiori.

Là ne l'Occidentale Indico lito
 Sorge (pregio de' Campi) eccelso Fiore
Non per uirtù di Sol, non per humore
Di brina, ò per sospir d'aura gradito;
Ma de la Trina luce a' raggi uscito
 S'apre al fiato, che spira il gran Fattore;
 S'auuiua à nembi del diuin fauore,
Di beati rubin molli nodrito:
Così cred'io; non si doueau men degni
 Fabri à celeste Parto, in cui si scerne
Del Crocifisso Amor gli amari segni;
Nè teatro mortal glorie superne
 Aprir potea del Re di tutti i regni;
Nè Fior terren sanguigne poma eterne.

Di questa Pianta hà scritto Nicolò Monardes Medico di Siuiglia nella sua historia de Semplici del Mondo nouo, nel 3. lib. tradotto in latino da Carlo Clusio, e stampato in Anuersa l'anno 1593. à car. 423.

ALL'ILLVSTRISS. SIG. LA SIGNORA GIERONIMA
Consorte dell'Illustriss. Sig. il Signor Ottauian Malipiero.

MANDAI à i giorni passati alla stampa vna breue narratione con l'effigie del misteriosissimo Fiore dell'Indie Occidentali. Doppo hò hauto più chiara notitia d'alcuni particolari, spettanti all'historia; e per non defraudare le persone pie, e desiderose di sapere, hò pensato di ristampare l'istesso Fiore con nuouo, e più diligente intaglio, con la narratione alquanto più piena, e limitata; e per darle autorità, e splendore piglio ardire di farne dono à V.S. Illustriss. stimando che ella così gradirà questo Fiore, che ci rappresenta celesti misteri con l'opera, e frutto della nostra redentione; come con animo generoso, e pio hà dispregiato i caduchi, e fallaci del Mondo.

Nasce in molte parti più amene dell'Indie Occidentali, ma con maggiore abbondanza nel Balio di Cusco, già residenza de gl'Imperatori Indiani, & in quello di Lima, adesso Metropoli del Perù, oue riseggono i Vice Rè di S. Maestà Cattolica, una pianta chiamato Granadiglio, di fusto sottile, e lungo, come è le viti ne i paesi nostri; e così non da se stessa, ma con l'aiuto di palo, ò d'arbore si sostiene, abbracciando il suo sostegno, con ramosi tralci, ripieni di spesse, grandi, e verdi foglie, che rappresentano la figura della Lancia, che piagò il sacrosanto petto di Christo Signor nostro.

Da questa pianta nasce il Fiore misterioso quì figurato, la cui grandezza è come vna cosa delle nostre maggiori, di colore, nelle foglie, violato, fregiato di punti rossi, che paiono tante stille di sangue. Il campo di mezo è giallo; & hà nel seno cinque purpurei bottoncini, rotondi, come coralli, posti dall'Auttore della Natura, per figurarci le cinque principali piaghe del crocifisso Saluatore. Dal centro del circolo, che formano i sopradetti coralli, spunta vna colonnetta gialla, e rossa, con base, e capitello. In memoria della flagellatione alla Colonna del nostro Redentore. Dalla parte di sopra della colonnetta escono cinque verghette dell'istesso colore che auuiticchiandosi insieme formano una Corona spinosa di settantadue spine, come fù quella, che trafisse il capo del nostro Christo. Nel mezo di questa Corona stanno tre germogli di colore di ferro, che sembrano giusto trè chiodi, come quelli, che inchiodorono il Signore in Croce, la punta de i quali si posa sopra il capitello della colonnetta, da cui germogliano.

Tutto il corpo del Fiore hà sopra la foglia violata certe verghette gialle, che escono dal centro, che sono come raggi di splendore, & in punta ui sono alcune linette rosse. Sotto sono sette uerdi frondi, lunghe, strette, & acute, che custodiscono il Fiore quando è chiuso, e lo sostentano quando è aperto, il qual venuto à qualche maturità s'apre la mattina al nascere, e si chiude al tramontare del Sole.

Et il sopradetto Fiore è di soauissimo odore, più grato, e più confe-

rente del muschio; onde lo portano addosso gl'Indiani, per rendersi odoriferi. Si chiama il Fiore della Granadiglia, se bene rappresentando (come si vede) i misteri principali della Passione del Saluatore, è chiamato da quelli, che sono nella santa fede ammaestrati, il Fiore della Passione del Signore, sino da i fanciulli.

Da questo nasce il frutto di grandezza, e forma d'vn'vuouo delli maggiori. Et quando è maturo, hà la scorza facile à romperfi, bella, e vaga di colore giallo, dorato, tempestato di piccole macchie leonate. E pieno d'un liquore dolcissimo più del mele, di colore bianco, di tanta soauità, e gusto, che non c'è in Europa frutto, ò cibo artificiato, che con quello paragonar si possa. E quel, che più importa è sommamente salutifero al corpo; & in particolare gicueuole allo stomaco. E parmi, che con questo habbia uoluto Iddio significarci, che dalle spine, e tormenti della dolorosa Passione del suo benedetto Figlio, che quasi languido Fiore stè pendente in Croce, nasce il dolcissimo frutto della nostra redentione, e della vita eterna.

Nell'istessa pianta si ueggono tutto l'anno i fiori, & i frutti, che ogni mese maturano, cominciando à produrre, e poià maturare quelli, che sono più vicini alla radice.

Il seme di questo frutto è simile à quello del mellone, con questa differenza, che è alquanto nero, e tondetto. Si conseruano detti frutti, staccati dalla pianta lungo tempo, senza corromperfi. Et vno di questi Fiori è stato portato i mesi passati à Roma, e presentato alla Santità di Nostro Signore Papa Paolo Quinto; & alcuni graui Religiosi, che dal Perù sono stati à Roma, passando nel ritorno per Bologna, hanno dato di tutto il narrato fedele, e minuto ragguaglio, col testimonio d'altre autoreuoli persone, & in particolare d'un Gentil'huomo, nato, & alleuato nella Città di Lima, il quale di presente si troua allo studio in questa Città nel Collegio di Spagna.

In questo soggetto si stampa vn'opera, oue con prose, e con rime latine, e toscane si dichiara ingegnosamente, con molti belli, e misteriosi concetti, le proprietà, e significato del sopradetto Fiore, e frutto.

Per fine fò humilissima riuerenza à V. S. Illustrissima pregandole accrescimento di felicità per caparra dell'eterna gloria nel Cielo.

Di Venetia 20. di Agosto 1609.

Di V. Sig. Illustriss.

Humilissimo, & deuotissimo Seruitore

Donato Rasciotti.

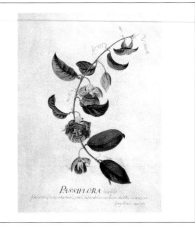

Paintings like this one, perhaps done from plants growing in Lee and Kennedy's nursery in Fulham, brought the young Sydney Parkinson to the attention of ardent natural philosopher Joseph Banks. Amiable, talented and conscientious, Parkinson was the perfect choice of artist for Banks' planned trip to visit the great Linnaeus in Sweden. In the end, however, they never went to Sweden, and travelled around the world instead.

Water Lemon; Golden Apple; Laurel-leaved Passionflower
Passiflora laurifolia L. (Passifloraceae)
Sydney Parkinson
1767, watercolour on vellum
448mm x 326mm (17⅝in x 12⅞in)

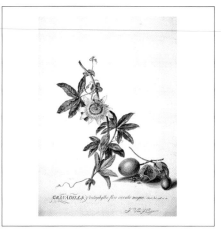

Passionflowers are not only cultivated for their lovely flowers, as the fruit is also a popular product of the plant. Passion fruit are easy to obtain in the supermarket today; the ones we usually see are purplish, but both yellow and purple types are also common. The hard rind encases the seeds, each of which is covered with a juicy acidic aril (the part that we eat).

Passion Fruit
Passiflora edulis L. (Passifloraceae)
Jacobus van Huysum, c. 1730s, watercolour with bodycolour and gum arabic on paper, bound in volume,
525mm x 365mm (20½in x 14¼in)

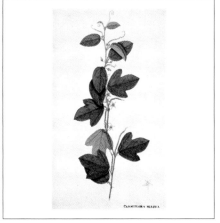

Not all passionflowers are large, 'in-your-face' types of blooms. Compared to its more strident cousins, the tiny white flowers of this species are inconspicuous in the extreme, but they still share the Passiflora ground plan. This species occurs (or was introduced) all over the world, despite its seemingly boring flowers.

Cork-barked Passionflower
Passiflora suberosa L. (Passifloraceae)
Anon. Fleming Collection
c. 1795–1805, watercolour on paper
452mm x 269mm (17¼in x 10½in)

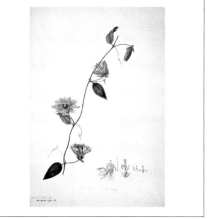

Related groups of passionflower species are fed upon by related groups of heliconiine butterflies, and are regularly cited as a classic example of co-evolution. Members of the alliance to which Passiflora serratifolia belong are fed upon by the caterpillars of the butterfly Heliconius melpomene. However, if you attempt to feed these leaves to the caterpillars of Heliconius erato they will die.

Saw-edge-leaf Passionflower
Passiflora serratifolia L. (Passifloraceae)
John Frederick Miller
1772, watercolour with graphite and ink on paper
553mm x 361mm (21¾in x 14¼in)

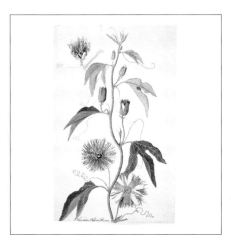

This species, which artist John Miller called the 'Virginia passion flower', is a native of the southern United States. Though related to the edible passion fruit, its taste is more acid and not as sweet. The leaves are fed upon by tropical butterflies that fly north for the summer; the caterpillars have to complete their life cycle and return to the south before winter sets in.

Maypops
Passiflora incarnata L. (Passifloraceae)
John Frederick Miller
c. 1770s, watercolour with graphite on paper
381mm x 247mm (15in x 9¾in)

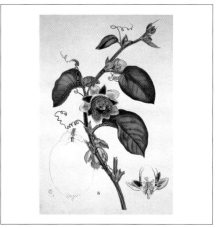

The huge fruits of Passiflora quadrangularis can be real vegetable giants. In 1835, a Mr John Miller of Bristol entered a fruit weighing nearly 4kg (8lb) in a local flower show. Needless to say, he won first prize! The plant's name, however, comes from its four-angled (or quadrangular) stem, which is seen clearly in Sowerby's engraving.

Water Lemon; Giant Granadilla
Passiflora quadrangularis L. (Passifloraceae)
James Sowerby
c. 1800s, hand-coloured engraving in watercolour on paper, 560mm x 393mm (22in x 15½in)

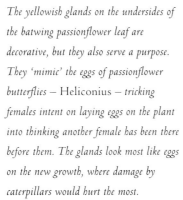

The yellowish glands on the undersides of the batwing passionflower leaf are decorative, but they also serve a purpose. They 'mimic' the eggs of passionflower butterflies – Heliconius – tricking females intent on laying eggs on the plant into thinking another female has been there before them. The glands look most like eggs on the new growth, where damage by caterpillars would hurt the most.

Batwing Passionflower; Two-flowered Passionflower
Passiflora biflora Lam. (Passifloraceae)
Georg Dionysius Ehret, Ehret Sketches
c. 1760s, watercolour with bodycolour and graphite on paper, 436mm x 273mm (17¼in x 10¾in)

The rind of the passion fruit is usually hard and brittle, but some varieties of the water lemon have a juicy, edible rind. Very few of the paintings of this species from the eighteenth century show the fruits. Perhaps they were boring compared to the extravagant sea-anemone-like flowers, or maybe these plants did not set fruit. This species is self-incompatible: you need two to tango.

Giant Granadilla; Water Lemon
Passiflora quadrangularis L. (Passifloraceae)
Georg Dionysius Ehret, Ehret Sketches
1761, graphite with watercolour on paper
423mm x 331mm (16¼in x 13in)

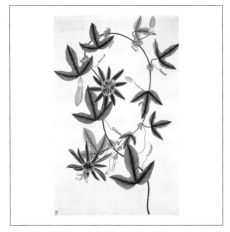

This species was first described in 1826 from plants grown in the botanic gardens of Berlin, originally from Rio de Janeiro. It had long been cultivated in Europe, and from there was taken to botanical gardens worldwide. Passiflora kermesina readily hybridizes with other species, and this eastern Brazilian native is involved in many of today's horticultural hybrids.

Passiflora kermesina Link & Otto (Passifloraceae)
Anon. Saharunpore Gardens Collection
c. 1850, watercolour on paper
463mm x 304mm (18¼in x 12in)

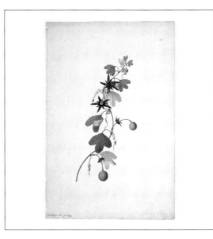

Sydney Parkinson's notes to himself about colour of flowers and leaves sometimes included instructions about corrections to the images. Of this Passiflora, collected on the Endeavour River, he wrote: 'leaves vivd grass green wi small veins the underside pale glaucus fruit pea green green tendrils brown the middle lobe to be made shorter'.

Orange Passionflower
Passiflora aurantia G. Forst. (Passifloraceae)
Frederick Polydore Nodder, Cook Collection
1780, watercolour on paper
545mm x 365mm (21½in x 14¼in)

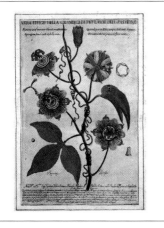

This engraving closely resembles the Brazilian species now cultivated all over the world, Passiflora edulis. The three-lobed leaves and the rings of corona filaments are more or less anatomically correct – the artist must have seen a living plant, he even got the flower colours right. The inset details of the seeds in the upper right show the arrangement around the outside of the ovary clearly.

Passiflora species (Passifloraceae)
Donato Eremita
1619, engraving with bodycolour on paper
332mm x 217mm (13in x 8½in)

This is the earliest engraving of a passionflower in the Natural History Museum collections. In it we can see the symbolism of Christianity emphasized – the stamens become the plaited crown of thorns, and the stigmas the three upright lance tips. This artist most probably drew the plant following a poetic description rather than from life, as the engraving resembles no living species of Passiflora!

Passiflora species (Passifloraceae)
Donato Rasciotti
1609, engraving with bodycolour on paper
383mm x 260mm (15in x 10¼in)

Conifers are not currently fashionable. Like skirt lengths, garden plants have their ups and downs, and in today's gardens there seems to be little room for the conifer. They grow too big, do not age well (becoming straggly and disorderly), and often suppress the growth of other plants beneath them, making them bad for biodiversity. As one of the gardening world's commentators said, 'jobs are hard to find these days' for these most fantastic of plants. This was not always so, for in the nineteenth century conifers were true celebrities, sought after and collected avidly all over the world. The land-owning English aristocrats went for them in a big way: the North American white pine (*Pinus strobus*), planted by both the Duchess of Beaufort at Badminton and the Viscount

England from the Calaveras Grove in California's Sierra Nevada mountains in 1853, he knew he was on to a good thing. A Californian bear hunter had stumbled upon the grove of gigantic trees in the foothills of the Sierra Nevada; describing the size of the trees to his companions, he was accused of being drunk and imagining things. Who could imagine trees whose girth was 25m (82ft) and whose sheer magnitude took one's breath away? Lobb heard the story at the newly formed California Academy of Sciences, and immediately realized the impact such a plant would have on the nursery trade back home in England. He returned early from a collecting voyage – risking the anger of his employers, the London horticultural giants Veitch & Sons – but knew that if he

CONIFERS

The resin droplets often seen on the wounded limbs of a pine tree broken by the north wind are tear drops shed by Pitys when she thinks of her youth, her lover Boreas, and most likely, of Pan... The origin of the legend of Pitys...is easy to understand; anyone can see that a pine tree weeps glistening tears.

THE STORY OF PINES (NICOLAS T. MIROV AND JEAN HASBROUK, 1976)

of Weymouth at Longleat in 1705, is still called the Weymouth pine in Britain today. The creation of the classic English landscape garden created a niche for structural plants; the conifers, evergreen and large, are nothing if not structural and permanent. The vogue for evergreens went as far as the establishment of pinetums (specialized gardens with only evergreen plants), the first of which was planted near Windsor in 1810 by an Englishman, Lord Grenville, but his pinetum preceded the burst of enthusiasm for conifers that led to the exploration of the western United States by some of England's greatest plant hunters.

By the mid-nineteenth century, conifers were all the rage, and when William Lobb brought seeds of the giant redwood back to

didn't hurry, someone else would get there before him. Although by the spring of 1854, Veitch & Sons were selling seedlings of the new tree for two guineas (£2.10/$3.40) each, Lobb had in fact lost the race (if race it was) to bring the giant sequoia to Europe. John Matthew, a Scottish laird, had also collected seed and distributed it among his friends. But in a way Lobb did 'win', for his seed formed the basis for the trade in this tremendous plant, the most massive tree known to gardeners of the time. Oddly, when cutivated in England the giant sequoia does not grow to the huge diameters it does in the United States (enough to tunnel under and drive an automobile through), but it still became a fad, and everyone with enough space just had to cultivate the plant. Controversy reigned

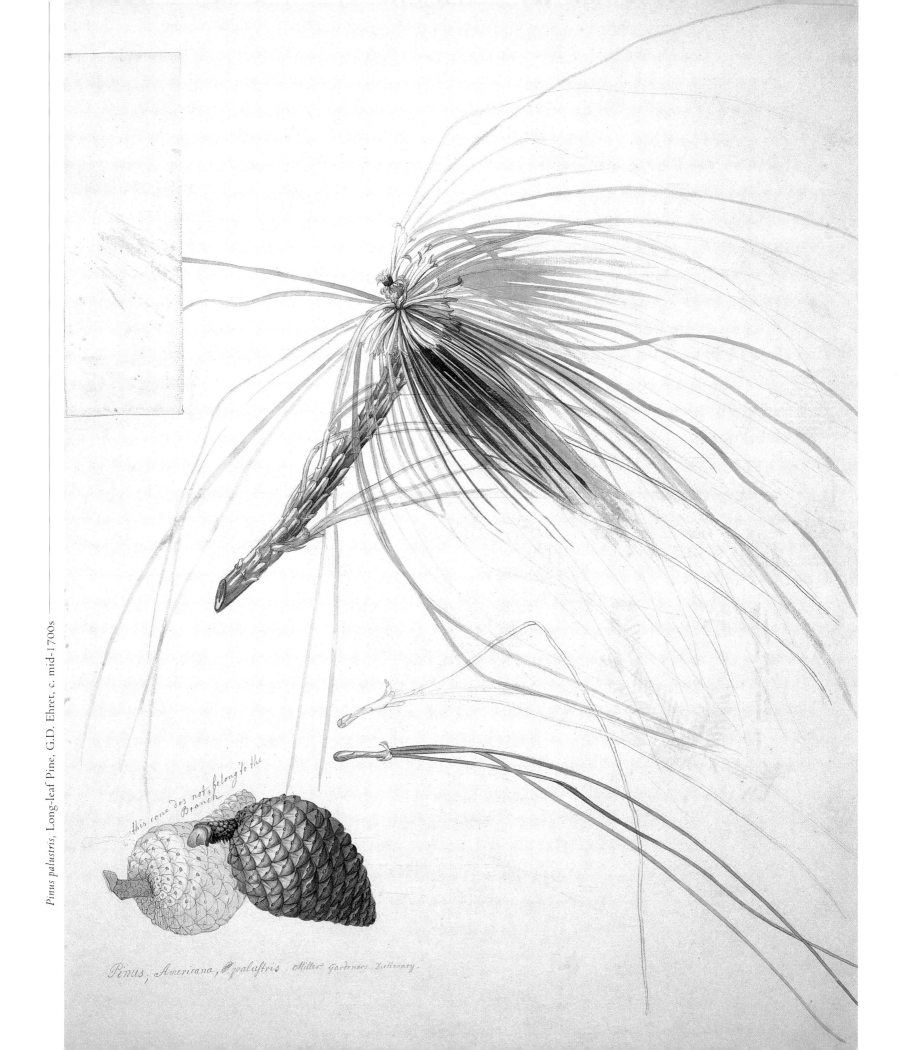

this cone does not belong to the Branch

Pinus, Americana, Ppaluftris. Miller Gardeners Dictionary.

Pinus palustris, Long-leaf Pine, G.D. Ehret, c. mid-1700s

"J. communis var suecica ?"
Fruit Dec. 18th 1804.

224

as to the scientific name of this new wonder — the English wanted to name it 'Wellingtonia' in honour of the recently deceased Duke of Wellington (a man of great stature, like the tree itself), but American botanists wanted to call it 'Washingtonia', to honour George Washington, a man of equally immense stature. John Lindley of London's Horticultural Society published the name *Wellingtonia gigantea*, thus apparently winning the battle, but unknown to him 'Wellingtonia' had already been used for a very different plant thirteen years earlier. By the rules of scientific naming, this made Lindley's name invalid, so in the end no one got their way. The correct scientific name for the giant redwood — not coined until 1939, nearly a century after its introduction to the horticultural trade — is *Sequoiadendron giganteum*. This is actually more fitting, as it reminds us of the sheer immensity of this organism and its relationship to its close cousin (also from California) the coastal redwood, *Sequoia sempervirens*.

Lobb had travelled to California following in the footsteps of David Douglas, the explorer whose name has always been associated with conifers. Douglas was a gardener at the Glasgow Botanical Garden in the early part of the nineteenth century and came to the attention of William Hooker, its director. In 1823, Hooker recommended Douglas to Joseph Sabine, Honorary Secretary of the consolidating Horticultural Society in London. The Society had been founded in 1804 for the serious business of discussing and writing about horticulture, and among its founders were John Wedgwood (of pottery fame); William Forsyth, gardener to King George III; and Sir Joseph Banks, President of the Royal Society. The greatness of these men meant that the Horticultural Society could, once its finances were secure, send explorers far and wide to search for new wonders for the gardens of its wealthy members. Sabine was the man whose administrative skills put the Society on a sound financial footing, and soon plants were constantly arriving from all over the world to the Society's gardens in Kensington. From here, they were sold to an avid membership. By the early 1820s, the Society began to send its own specialist collectors on

Juniperus communis, Juniper, Fr. Bauer, 1804

Cedrus libani, Cedar of LebAnon., G.D. Ehret, 1744

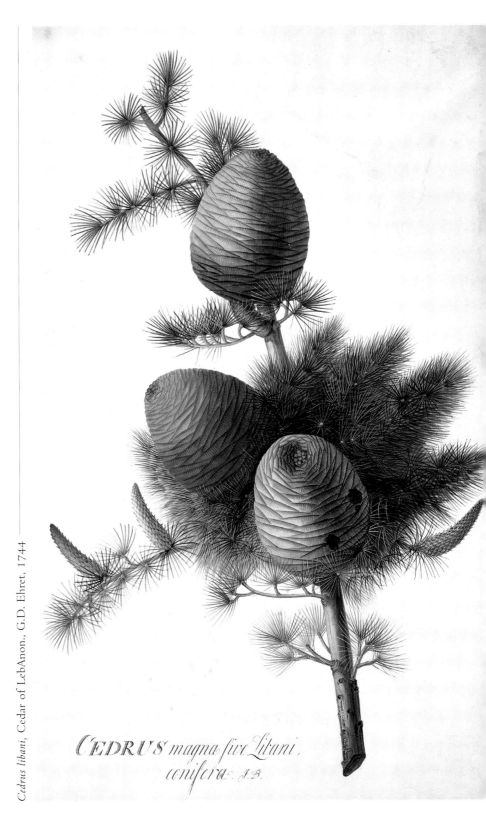

CEDRUS magna five Libani, conifera. J.B.

225

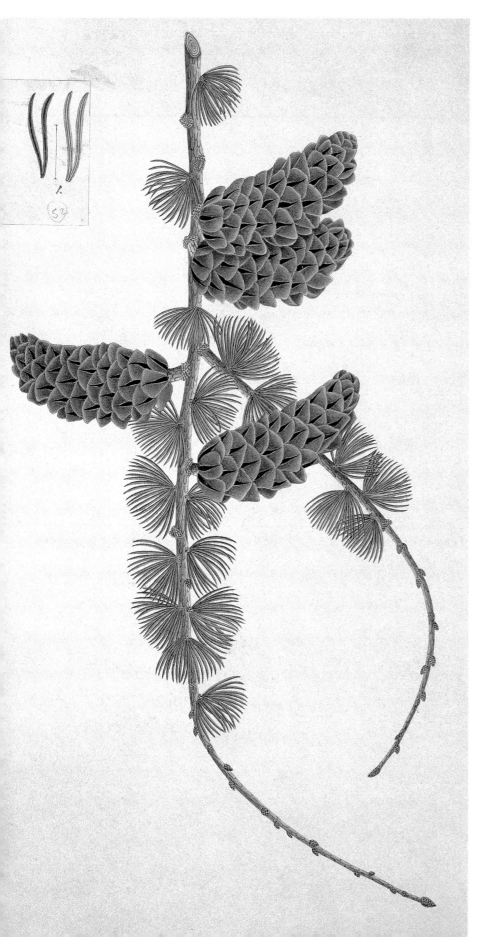

Larix griffithii, Sikkim Larch, Anon., Saharunpore Gardens Collection, 1855

expeditions, rather than relying on others to bring plants back. These men were usually tough and experienced. To be a gardener in the nineteenth century, one had to be resilient: they were poorly paid, given appalling living conditions and often laid off during bad weather. Douglas gave up his post at the Glasgow Botanic Garden at the age of 23, and embarked upon what have to be some of the most incredible adventures ever undertaken. Originally he was to be sent to China, from where many new and exciting introductions were coming, but due to its unstable political situation he was rerouted to North America. His task was to collect fruit trees and other interesting species (particularly oaks) that were needed to replace the many trees felled to make ships during England's wars with France. Douglas set off for the east coast of the recently independent United States, and his time there (six months) was an unqualified success. He returned late, but so many of his collections made it back alive and were botanically and horticulturally interesting that the Society realized they had a real treasure on their hands. His knowledge, energy, self-discipline and diplomacy combined to assure his prowess within the Society.

The treasures of the eastern United States commanded a good price, but the Society realized that the real frontier was even further west. In the 1790s, Captain George Vancouver had explored the Pacific Northwest by sea (giving his name to Vancouver Island along the way). On board his ship was the surgeon-naturalist Archibald Menzies, whose collections and descriptions sparked the imaginations of botanists throughout Europe. By 1805, Captains Merriwether Lewis and William Clark had crossed America on foot, following the Louisiana Purchase, the block purchase by Thomas Jefferson, from the French, of the western part of today's United States. They collected a few plants (some of enduring botanical and ethnographical interest, like the Native American tobacco, *Nicotiana quadrivalvis*) but also opened the door to the botanical riches of the mountainous, practically unknown West.

Douglas was dispatched by the Horticultural Society to the west coast of the United States territory. Given passage on the

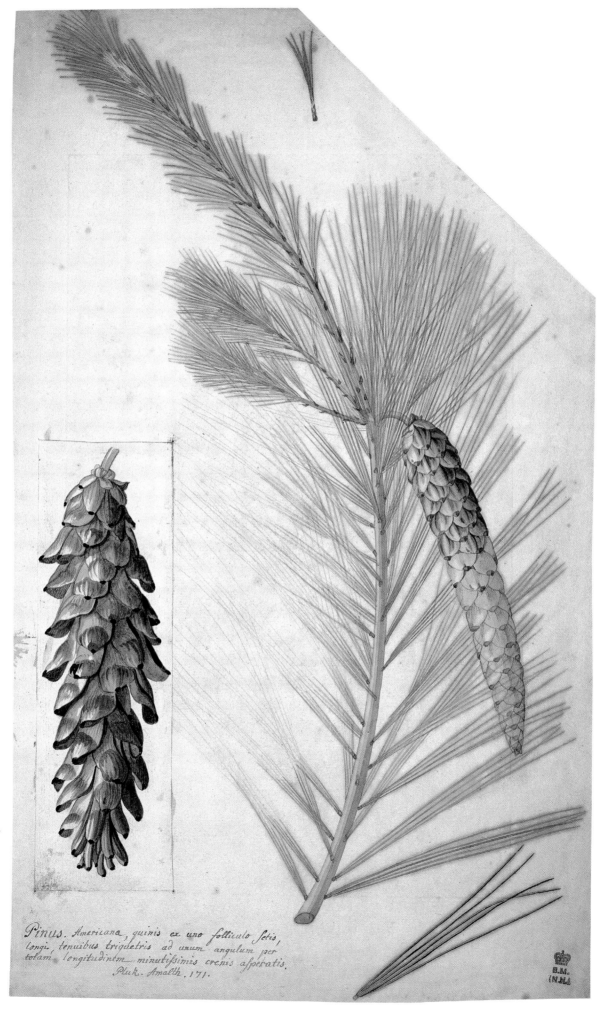

Pinus strobus, Eastern White Pine, G.D. Ehret, c. 1740s

Pinus. Americana, quinis ex uno folliculo setis, longi. tenuibus triqdetris ad unum angulum per totam longitudinem minutissimis crenis asperatis. *Pluk. Amalth.* 171.

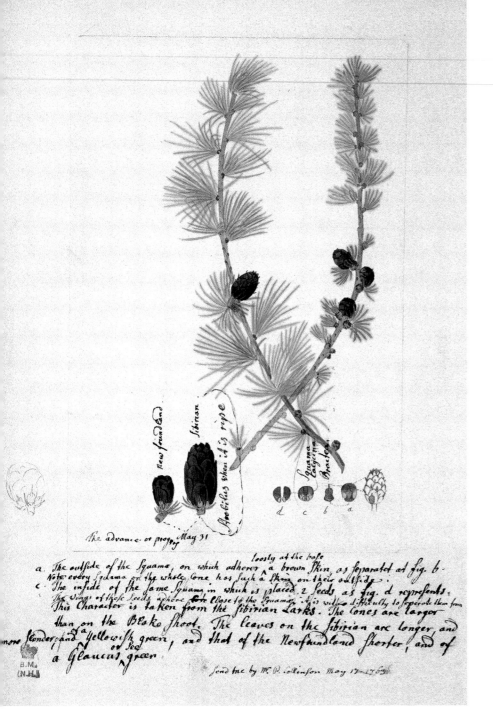

The advance or progress May 31

a. The outside of the Squama, on which adhers loosly at the base a brown Skin, as separated at fig. b. Note every Squama on the whole Cone has Such a Skin on their outside. c. The inside of the Same Squama in which is placed 2 Seeds as fig. d represents. the wings of those Seeds adhere so close to the Squama, it is with difficulty to seperate them from. This Character is taken from the Sibirian Larks. The Cones are larger than on the Blake Shoot. The leaves on the Sibirian are longer, and more slender, and a Yellowish green, and that of the Newfoundland shorter, and of a Glaucus green.

Send me by Mr P. Collinson May 17 1763

(2000 miles) up and down rivers such as the Willamette, and the Grand Rapids of the Columbia. At the end of his time, he decided to stay on rather than return with his plants to London. One of the first plants he collected is the reason we always associate his name with conifers, the Douglas fir. This tree epitomizes the primary-growth forests of the Pacific Northwest: tall and straight, it was (and still is) greatly prized for timber, so much so that old-growth forests, like those surely seen by Douglas when he stepped ashore on Vancouver Island, are now almost a thing of the past. Despite its common name, the Douglas fir was not one of his discoveries – a specimen of it had been collected by Archibald Menzies forty or so years earlier. Douglas collected cones and seed – he was, after all, in the horticultural trade – and from his gatherings the first of these trees were cultivated in Scotland (seed was distributed to anyone who wanted to grow the magnificent plant). Today the tree commemorates both men – Douglas in its common name, and Menzies in its scientific name, *Pseudotsuga menziesii*. The economic potential of the Douglas fir exceeded even Douglas's wildest dreams. He wrote that 'they form one of the most striking objects in nature… The wood may be found very useful.'

Staying behind in the Pacific Northwest, Douglas began to explore with a vengeance. He climbed the Blue Mountains that lie to the south and east of WallaWalla in what is now Washington State – the first European to do so – making the final ascent through deep snow, without snowshoes! The ascent in the blinding snow took its toll, and his eyesight began to deteriorate from the resultant inflammation. His guides were not keen on the relentless pace he set, but one of them convinced the rest that Douglas was a powerful medicine man and could turn them into grizzly bears at will – a powerful incentive for them to stay with him and help him with his work. During 1826 and 1827 Douglas crisscrossed the Northwest, covering some 5000km (3000 miles) and penetrating as far as Hudson Bay itself. He collected and collected, but undertook one truly epic journey in search of a particular conifer that had caught his imagination like no other: the sugar pine.

Hudson Bay Company's *Mary and Anne*, he was to land on the Oregon coast and ascend the Columbia River. Getting to the west coast of the American continent was an adventure in itself and took more than eight months! The collaboration of the Hudson Bay Company was critical to Douglas's time in the western regions – fur traders from the Company had established routes, posts, and had permanent staff (factors) who knew the locals and the region intimately. He collected for about a year, covering a mere 3000km

Right: *Larix laricina*, North American Larch; Left: *Larix sibirica*, Siberian Larch, G.D. Ehret, 1763

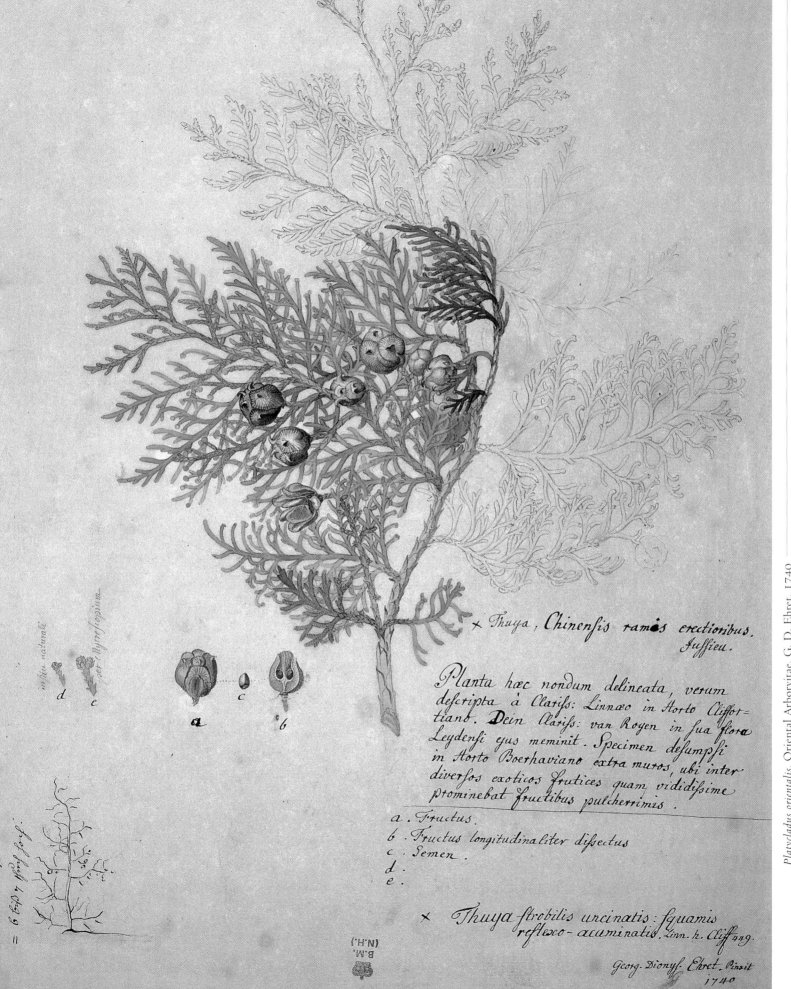

× *Thuya, Chinensis ramis erectioribus.* Jussieu.

Planta hæc nondum delineata, verum descripta à Clariss: Linnæo in Horto Cliffor-tiano. Dein Clariss: van Royen in sua flora Leydensi ejus meminit. Specimen desumpsi in Horto Boerhaviano extra muros, ubi inter diversos exoticos frutices quam vididissime prominebat fructibus pulcherrimis.

a. *Fructus.*
b. *Fructus longitudinaliter dissectus*
c. *Semen.*
d.
e.

× *Thuya strobilis uncinatis: squamis reflexo-acuminatis.* Linn. h. Cliff 449.

Georg. Dionys. Ehret. Pinxit
1740

Platycladus orientalis, Oriental Arborvitae, G. D. Ehret, 1740

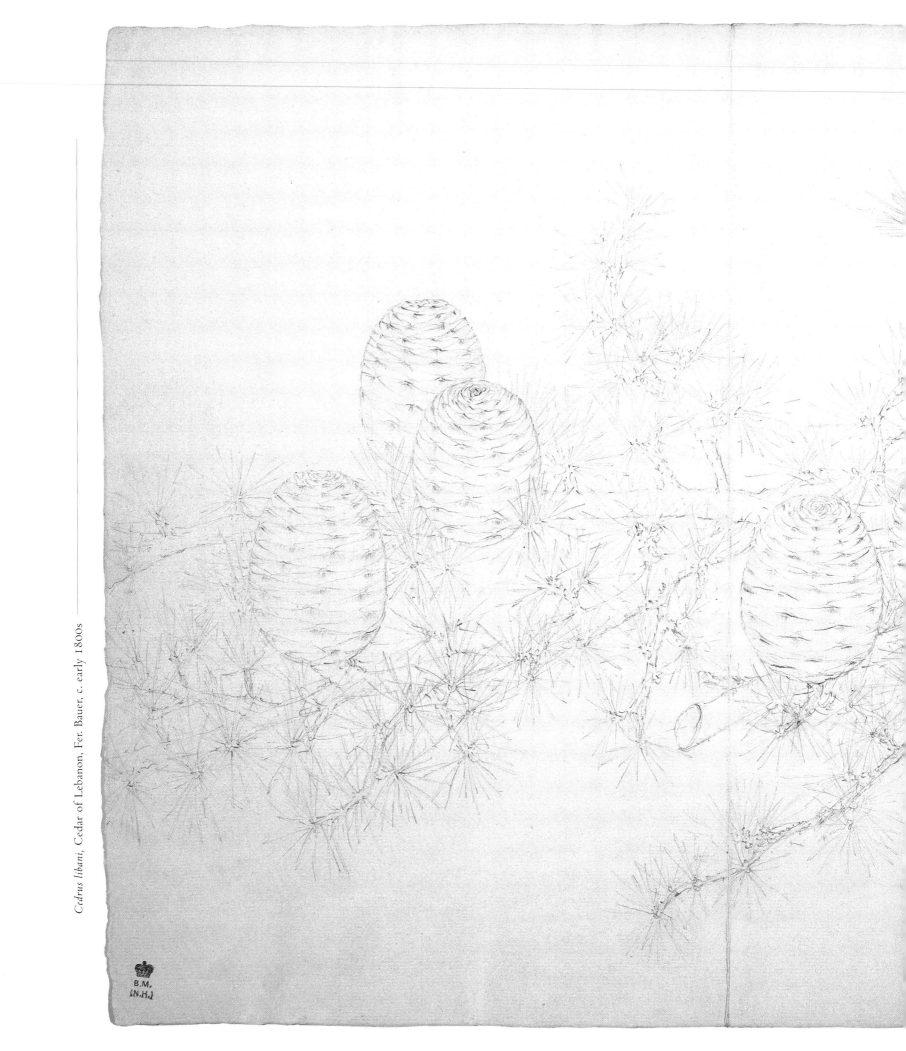

Cedrus libani, Cedar of Lebanon, Fer. Bauer, c. early 1800s

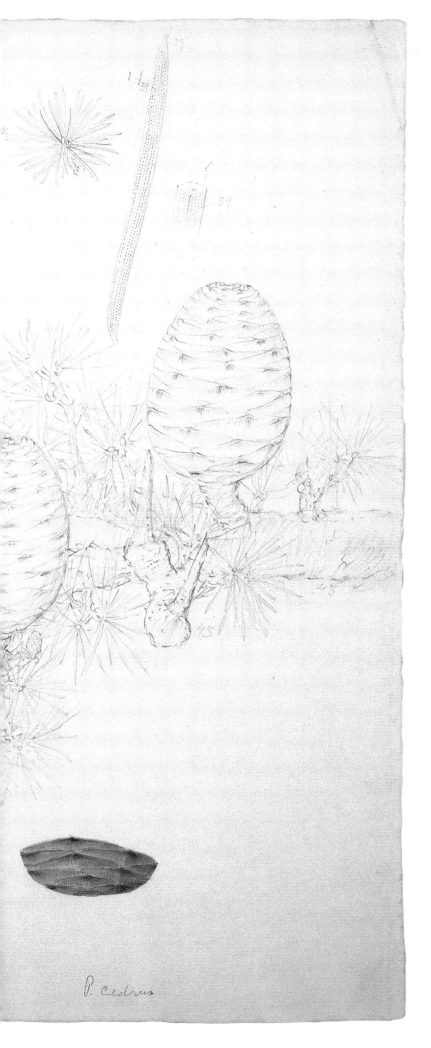

P. cistrus

During his travels on the Willamette River early on in his stay, he had seen the native peoples eating the seeds of a pine tree, which they said was remarkably large and occurred in the mountains to the south. At that time, he could not obtain any perfect seeds, and the pine was clearly to become an obsession. An explorer and trapper of his acquaintance, Jean-Baptiste Desportes McKay, collected a single cone for him, but this was still without a viable seed. This fired the resolute collector to go to the region for himself, and he wrote to Hooker how the Umpqua Indians used the glutinous resin as sugar and how the nuts were used as flour. The sheer size of the cone McKay brought him – 25cm by 40cm (10in by 16in) – fired him to find this tree for himself. He tentatively named it *Pinus lambertiana*, in honour of Aylmer Bourne Lambert, a botanical expert on pines, and set off into previously unexplored territory, with 'as little encumbrance as possible'. Trade goods such as tobacco were almost more important than clothing.

Douglas set out from Fort Vancouver on the Columbia River and went south, initially in the company of Hudson Bay trappers, but later on his own (the trappers had little interest in botany and were focused on the Company's business). As a companion, he had a young native man of unknown tribe who had been travelling with McKay and spoke some of the southern languages. When he reached the Umpqua River valley, he was hosted by local people, whose assistance proved essential when he fell into a gully and was left unconscious. They helped him back to his camp, and fed and cared for him until he recovered enough to begin to botanize again. Once he found the trees – by sketching the cone and showing it to an Indian who offered to accompany him – Douglas began to collect twigs by shooting them out of the tall trees. The noise of his shots attracted a war party of eight men, 'all painted with red earth, armed with bow, arrows, spears of bone and flint knives, and seemed to me anything but friendly'. He drew both his guns and faced them off, but after a few minutes of staring at one another the leader signalled that he wanted tobacco, which Douglas provided, and they parted company. Douglas got on with collecting

his samples – a cool customer, indeed – but alone, he had no one with whom to share the excitement of this most longed-for discovery. He later wrote to Hooker, ' I rejoice to tell you of a new species of *Pinus*, the most princely of the genus, perhaps even the grandest specimen of vegetation.' The discovery of this pine has to be one of the great moments of his life. His journey south took him a little less than two months, and during that time he fell into gullies, was plunged headlong into rivers by falling horses, attacked by grizzly bears, and on his return he and his companions lost their way. But he did reach his goal, and the seeds he sent back to the Horticultural Society grew. Ironically, the sugar pine was the least successful of Douglas's conifer introductions, as it does not grow well in Britain, so was not sought after by tree buyers. In his travels over western North America, Douglas discovered and introduced into cultivation seven of the seventeen native species of western North American pines, four firs (*Abies*), including the noble fir, the sitka spruce (*Picea sitchensis*) and, of course, the Douglas fir. His introductions laid the basis for the forestry industry in many parts of the world and changed the faces of gardens for ever. The vogue for landscape gardens depended on these evergreen trees and most of the ones we cultivate today were collected by Douglas.

Conifers are not only superlatives in the garden, but also record holders of the plant world. The tallest, largest and oldest plants are all conifers – an amazing feat for a group that has been around since long before the days of the dinosaurs. The largest living thing is said to be one of the giant sequoias: one *Sequoiadendron giganteum* is more than 3000 years old, and is estimated to weigh more than 2270 tonnes (2500 tons). The cross-section of the giant redwood housed in London's Natural History Museum has fascinated generations of schoolchildren, who look at the dates marked on its rings – the start of Islam, the crowning of Charlemagne, the signing of the Magna Carta, the Declaration of Independence... It was 1335 years old when it was cut down in 1892, but conifers can be far older. The oldest living thing is also a conifer. A bristlecone pine (*Pinus longaeva*) in the White Mountains of Nevada is thought to be more than 5000 years old, but unlike the giant redwood it is not tall and stately, but gnarled and twisted. These trees live in an extreme environment and persist by growing extremely slowly.

Conifers are found all over the world, from the vast forests of the Boreal zone to the high mountains of the tropics, and are in a way a relictual group of plants. Their heyday was in the Mesozoic era, more than 100 million years ago, before the angiosperms (flowering plants) came on to the scene. One amazing plant, *Metasequoia glyptostroboides*, the dawn redwood, was known for years as a fossil, then in the 1940s was discovered to be growing in south-central China – a true living fossil that is currently endangered on a global scale. Recently, a completely new genus of conifers, the Wollemi pine (*Wollemia nobilis*), was discovered in Tasmania. This proved to be a living dinosaur, with characteristics more like conifers known only from the fossil record than those alive today. In general, the great coniferous forests are found where flowering plants cannot attain great size, perhaps due to poor soil conditions, like on New Caledonia, or where the growing season is too short, such as in the Boreal regions of the northern hemisphere. Conifers often grow slowly and are persistent plants, which may explain their current unpopularity. Conifers are gymnosperms ('naked seeds') – in contrast to angiosperms, the seeds of conifers are not enclosed by a fruit, but are just held on top of a scale instead. The pine cone's woody scales are an example of this – each holds one or two seeds. The pine cone is the female inflorescence, or group of sexual structures, and if you look closely you can also

Picea glauca, White Spruce, G.D. Ehret, c. 1740s

an Pinus sylvestris, montana, tertia. 2 C.B.P.

Pinus mugo var. pumilio (Haenke) Zenari

Pinus mugo, European Mountain Pine, G.D. Ehret, c. 1740s

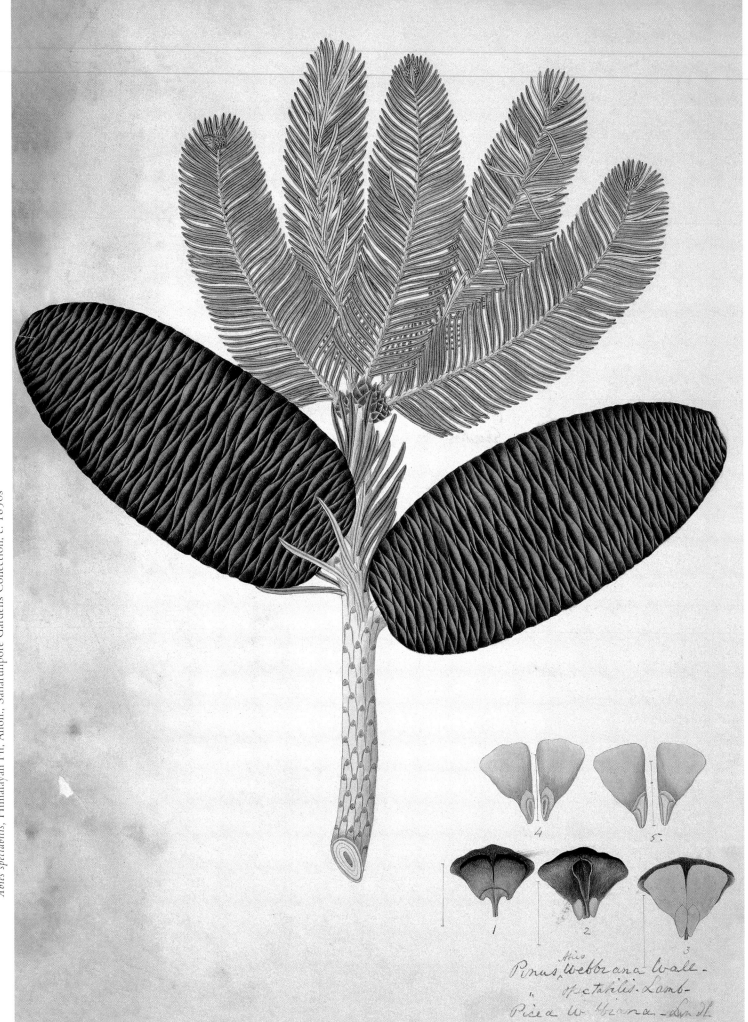

see the male inflorescences, smaller versions of the cone plan but with copious pollen rather than seeds. Pine trees are classic conifers, with evergreen, needle-like leaves and cones, but not all conifers have such features. The larches (*Larix*) and dawn redwood are deciduous, while species of *Araucaria* (monkey puzzles) and *Agathis* (kauri pines) are broad-leaved. Junipers have fleshy, berry-like fruits, and the yews go one step further, having a single seed with a fleshy aril – hardly cone-like, but structurally similar.

However, the main way we see conifers is probably as timber. Species of pine, fir, hemlock and spruce are prime producers, and in the southern hemisphere the kauris are an incredibly valuable resource. Human exploitation of these resources is as old as civilization: the Bible records the use of Cedars of Lebanon (*Cedrus libani*) for temple construction; the Polynesians used conifers for the canoes they used to explore and colonize the Pacific; and the Chinese used conifer wood for building and shipmaking millennia ago. It is only recently that our use of this resource has caused a problem for the conifers themselves, though. Timber is not the only product that comes from these trees – the paper industry is based on the fast-growing, 'cheap' conifers, and our appetite for paper is insatiable. 'Over-harvesting', habitat destruction and reforestation with aliens all contribute to the ever-increasing conservation problems experienced by conifer species. It may seem that if these trees, or those like them, have been around since the time of the dinosaurs, then surely they can withstand humankind. But the numbers are frightening. Of the 600 or so species of conifers recorded on Earth today, there is conservation concern for about 45 per cent of them, and at least 25 per cent are threatened with extinction. Although the tropical rainforests are of great global conservation concern, the temperate rainforests (all conifer-dominated) have also become a flagship – especially the old-growth forests of the Pacific Northwest, where David Douglas first saw the magnificent Douglas fir. Let's hope we can continue to share our planet with these amazing plants that have adapted so efficiently, lived so long, persisted so well and seen so much.

Pinus gerardiana, Pine, Anon., Saharunpore Gardens Collection, c. 1850s

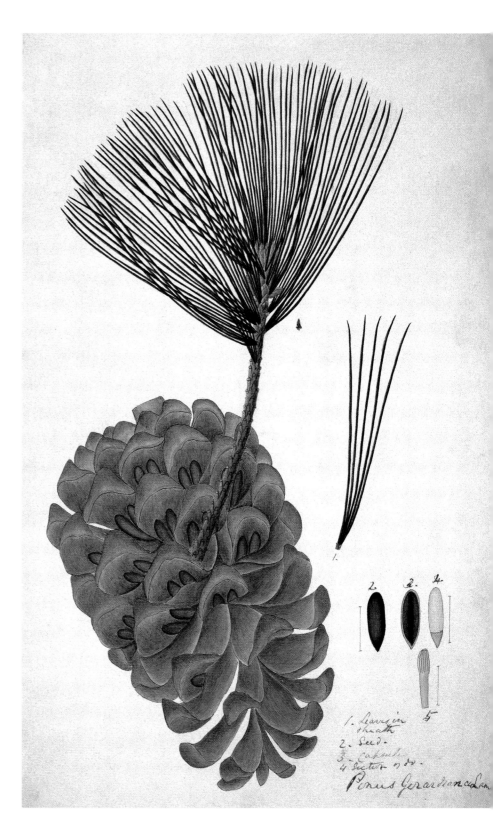

235

The long-leaf pine is found in the southern states of the United States, from Texas to the Carolinas. Its sturdy, strong wood is the standard against which other soft woods are judged, and in the timber trade it goes by the name of yellow-wood pine. The long-leaf pine's seedlings can withstand fire (a common occurrence in grassy pine forests of the region) by persisting in a 'grass stage' until conditions are right for growth.

Long-leaf Pine
Pinus palustris Miller (Pinaceae)
Georg Dionysius Ehret
c. mid-1700s, watercolour on paper
545mm x 433mm (21⅛in x 17in)

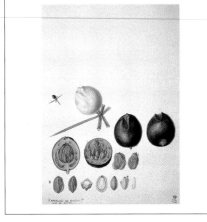

The juniper 'berry' is not a berry at all: the cone scales are more fleshy and highly modified compared to other, more 'normal' conifers. These fleshy scales are completely fused, presenting a juicy titbit to a passing bird. Humans use these 'berries' as well — they are the flavouring for gin, and give it the oily astringent taste beloved by some and hated by others.

Juniper
Juniperus communis L. (Cupressaceae)
Franz Bauer
1804, watercolour on paper
364mm x 260mm (14¼in x 10¼in)

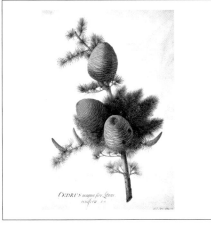

This luminous painting of the cedar of Lebanon does not really capture its wonderful growth form. In very old trees at the Royal Botanic Gardens at Kew, sometimes the branches spread out and reach all the way to the ground, forming fantastic, mystical hiding places and fantasy houses for children playing in the gardens.

Cedar of Lebanon
Cedrus libani A. Rich. (Pinaceae)
Georg Dionysius Ehret
1744, watercolour with bodycolour on vellum
490mm x 340mm (19¼in x 13½in)

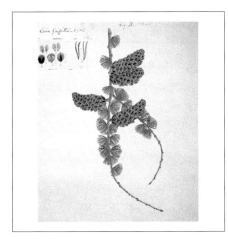

The larches are among the few deciduous conifers — species of Larix occur all around the far northern hemisphere. In the autumn, the clusters of needles turn golden and fall to the ground, while in the spring the new needles are a bright apple green, and the young female cones are pale pinkish — an amazing colour combination.

Sikkim Larch
Larix graffithii Hook. f. (Pinaceae)
Anon. Saharunpore Gardens Collection
1855, watercolour on paper
390mm x 324mm (15¼in x 12¼in)

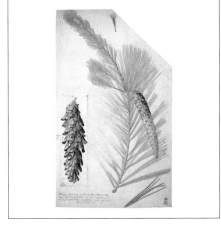

This watercolour and pencil sketch for the finished bodycolour on paper painting of Pinus strobus is full of life, and almost a photograph of a living tree. It has a spontaneity and liveliness that is missing from the more formalized and stylistic 'finished' work, and to me it captures the essence of Georg Ehret's love of his subjects – plants.

Eastern White Pine; Weymouth Pine
Pinus strobus L. (Pinaceae)
Georg Dionysius Ehret
c. 1740s, watercolour and pencil on paper
403mm x 247mm (15¼in x 9¼in)

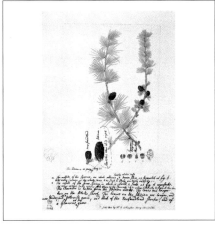

This sketch shows that Georg Ehret was not only a supremely talented artist, but also a keen observer of similarity and difference — a true comparative morphologist and botanist. Here he compares the shape and form of twigs of the American and Siberian larch 'sent to me by Mr. Collinson May 17th 1763' — accurate to the last detail. Not only is the sketch perfect, but it is also beautifully composed.

Right: North American Larch, *Larix laricina* (Du Roi) K. Koch; Left: Siberian larch, *Larix sibirica* (Pinaceae) Ledeb.
Georg Dionysius Ehret
1763, watercolour on paper
321mm x 200mm (12¼in x 7¼in)

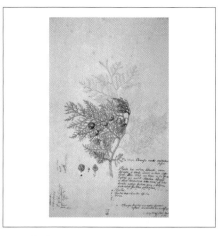

Georg Ehret received interesting plants from all his friends' and aquaintances' gardens. This sketch is labelled as 'obtained from Boerhaave's garden' (Herman Boerhaave was a Dutch physician and botanist living in Leiden). Ehret must have received the plant from Boerhaave, yet how and by what means is a mystery, for he corresponded with many European botanists and was sent plants from quite far afield.

Oriental Arborvitae
Platycladus orientalis (L.) Franco (Cupressaceae)
Georg Dionysius Ehret
1740, watercolour with graphite on paper
427mm x 265mm (16¼in x 10½in)

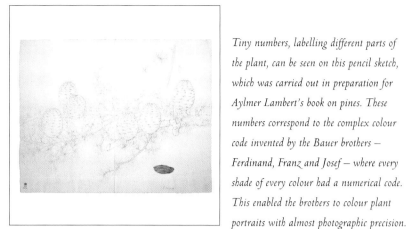

Tiny numbers, labelling different parts of the plant, can be seen on this pencil sketch, which was carried out in preparation for Aylmer Lambert's book on pines. These numbers correspond to the complex colour code invented by the Bauer brothers – Ferdinand, Franz and Josef – where every shade of every colour had a numerical code. This enabled the brothers to colour plant portraits with almost photographic precision.

Cedar of Lebanon
Cedrus libani A. Rich. (Pinaceae)
Sketches of Coniferae
Ferdinand Bauer, c. early 1800s, pencil with watercolour
on paper, 493mm x 385mm (19½in x 15¼in)

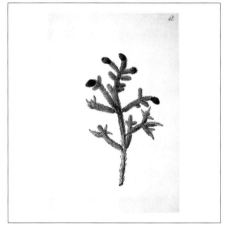

Species of Picea (spruces) are distinguished from those of Abies (firs) by the woody, peg-like leaf bases left after the needles have fallen and by the non-shattering pendulous cones. Spruces make perfect Christmas trees, with their bottle-brush-like branches and conical shapes. The traditional Christmas tree in northern Europe is Picea abies, the Norway spruce.

White Spruce
Picea glauca (Moench) Voss. (Pinaceae)
Georg Dionysius Ehret, Ehret Drawing Book
c. 1740s, watercolour on paper, bound in volume
524mm x 350mm (20½in x 13¼in)

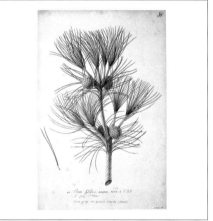

Not all pines are stately, tall, grand trees. The mountain pine rarely grows up, and more usually grows out, sprawling over mountain slopes in a low shrubby mass. It is generally described as a dwarf, but sometimes the mountain pine grows to be a small tree in sheltered places, which is rare and hard to establish in the harsh climate of the Alps.

European Mountain Pine
Pinus mugo Turra (Pinaceae)
Georg Dionysius Ehret, Ehret Drawing Book
c. 1740s, watercolour on paper, bound in volume
524mm x 350mm (20½in x 13¼in)

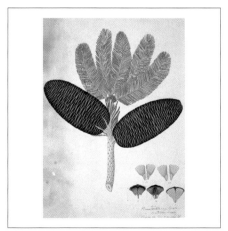

True firs belong to the genus Abies. They are distinguished from pines and spruces by their flattened branches, bearing needles that leave only a flat scar when they fall, and by their upright cones. The cones ripen in a year, and at maturity the scales and seeds are shed simultaneously. This leaves a naked stalk pointing skyward on the branch.

Himalayan Fir
Abies spectabilis (D. Don) Spach (Pinaceae)
Anon. Saharunpore Gardens Collection
c. 1850s, watercolour with bodycolour on paper
460mm x 333mm (18in x 13in)

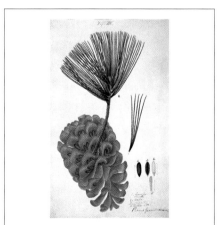

The genus Pinus used to include a variety of conifers that today are separated as genera in their own right, such as Cedrus or Picea. True pines can be recognized by their hard, woody cones and needles in bunches with a membraneous sheath at the base. Unlike the rest of the family Pinaceae, which is most diverse in China and Japan, the genus Pinus reaches its peak of diversity in the United States and Mexico.

Pine
Pinus gerardiana Wall. ex D. Don in Lambert (Pinaceae)
Anon. Saharunpore Gardens Collection
c. 1850s, watercolour on paper
383mm x 239mm (15in x 9½in)

It is ironic that the flower that has become the symbol of remembrance is the same flower that provides the drug that brings ultimate forgetfulness. The poppies of John McCrae's moving World War I poem 'In Flanders Fields' – staining the Flanders fields red as with blood – are *Papaver rhoeas*, which are common throughout northern Europe. The muddy, churned-up fields of the Western Front in the spring of 1915 were the perfect environment for the mass germination of millions of poppy seeds, and the graves of those who died lay in serried ranks in the Flanders fields, surrounded by floods of blood-red poppies. McCrae's poem, which established the poppy as the symbol of remembrance, is in fact a celebration of the power of human will ('If ye break faith

and hurt to the end of its days'. The poppy calyx has two or three sepals that protect the flower in bud but, when it opens, fall and are lost. The California poppy *Eschscholzia californica* – the state flower of California and the source of the rivers of orange in the foothills of the Sierra Nevada in spring – has fused sepals that are pushed off the expanding flower like a dunce's cap.

The great English gardener and landscape designer Gertrude Jekyll loved poppies. She was strongly influenced by John Ruskin and others in the Arts and Crafts movement, and her gardens epitomize the unity of art and nature. Jekyll's garden designs were plant-focused, the flowers themselves forming the structure of the place. Carefully composed drifts of colour looked natural, but were

POPPIES

Now it is well known that when there are many of these flowers together their odour is so powerful that anyone who breathes it falls asleep, and if the sleeper is not carried away from the scent of the flowers he sleeps on and on forever. But Dorothy did not know this, nor could she get away from the bright red flowers that were everywhere about; so presently her eyes grew heavy and she felt she must sit down to rest and to sleep.

THE WIZARD OF OZ (FRANK L. BAUM, 1900)

with us who die/We will not sleep, though poppies grow') – the will to remember from past mistakes and to keep faith from generation to generation.

The poppy flower is ephemeral, usually only open for a day or two, then the petals soon wither and fall to the ground. Despite the huge variety of plant forms in the poppy family, their flowers are all very similar: the delicate but showy petals surround a large boss of stamens and, as the flowers open, the petals emerge crumpled from the calyx, as if they have been stuffed like dirty clothes into a bucket. The Victorian poet and 'founder' of the Arts and Crafts movement, John Ruskin, likened the opening of a poppy flower to a deliverance from torture, adding: 'but it remains visibly crushed

designed specifically to integrate nature and architecture, the buildings of the site, in a way that was pleasing to the eye. In her own garden, at Munstead Wood in Surrey, Jekyll grew poppies in masses, and great swathes of scarlet Oriental poppies were interplanted with foaming white baby's breath. Her interest in poppies is commemorated in the 'Munstead Poppies' – colour varieties of the Iceland poppy, *Papaver nudicaule*. Visitors to Munstead Wood wrote that 'the orange-red shades are extremely brilliant and a number of flowering plants together light up the whole surroundings'. The massed ranks of delicate, satiny flowers must have created a shimmering focus to one of Gertrude Jekyll's trademark long borders, with subtle colour changes along it like a

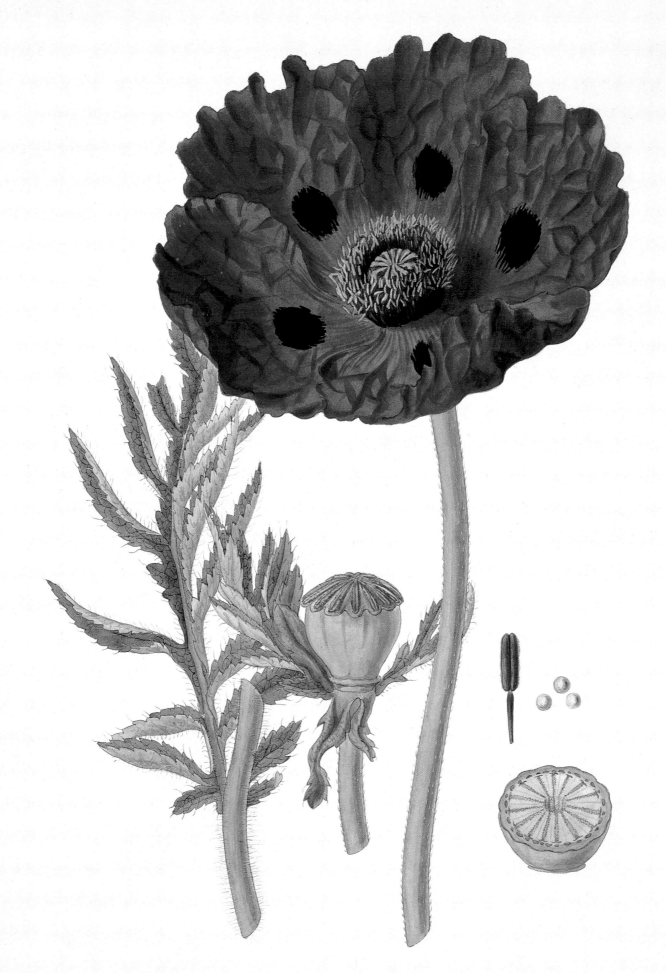

Papaver bracteatum, Oriental Poppy, J. Lindley, c. 1819–1820

Papaver bracteatum.

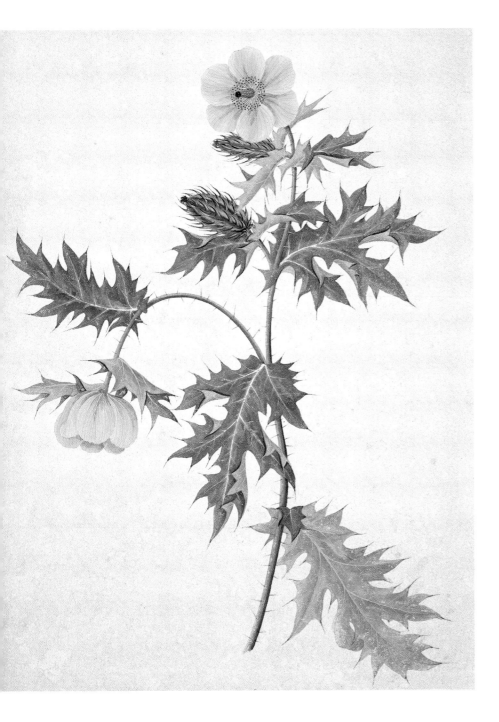

The fragile delicate flowers of the opium poppy, *Papaver somniferum* (the 'sleeping poppy', named by Linnaeus with reference to its powerful narcotic effects), also attracted the ever-creative Jekyll. She believed that by using 'rigid selection' annual plants like the opium poppy could be vastly improved in very short time frames. A variety of *Papaver somniferum* with double flowers, bearing double (or more) the number of petals of the wild species, the petals a delicate creamy pink, was named 'Munstead Cream Pink' in early twentieth-century seed catalogues. These beautiful poppies originated in her garden, the result of her practice of 'rigid selection', and photographs taken by her at the edge of Munstead Wood in the late 1880s show masses of peony-like *Papaver somniferum* growing in open sunny places. The opium poppies commonly grown in gardens today are usually double forms, with pink or mauve petals, but hundreds of variations on a theme exist, from white to near-black. The variety of beauty of these plants is matched by their chemical variation, as all contain the powerful narcotic opium. Though garden varieties contain very little opium to almost none at all, some types have very high concentrations.

The latex or juice that oozes from the cut stems and leaves of poppies is the source of opium, a drug known since ancient times. Opium and its derivatives, morphine and heroin, come from the latex of *Papaver somniferum*, which is also the species from which we get poppy seeds; indeed, it is said that the generic name *Papaver* comes from the sound made when chewing poppy seeds. Others suggest that the name comes from the ancient Celtic word *papa* ('pap'), derived from its use in putting fretful children to sleep. The soporific nature of poppies, particularly *Papaver somniferum*, was well-known to the ancients: Greek legends have Morpheus, the god of sleep (after whom morphine is named), crowning those he wished to send to sleep with poppies, and temples to him were decorated with carved poppies.

It is not clear which part of the plant was used first – the seed in cooking or the sleep-inducing latex – but it hardly matters, for what is clear is that the plant spread from its presumed original

wash – beginning with blues and whites, climaxing in the centre with 'brightest scarlet and crimson, coming to fullest strength in the Oriental Poppies', then passing to yellows, blues and whites again, and all within the space of about 25m (80ft).

Argemone mexicana, Mexican Prickly Poppy, Anon., Reeves Collection, c. 1820s

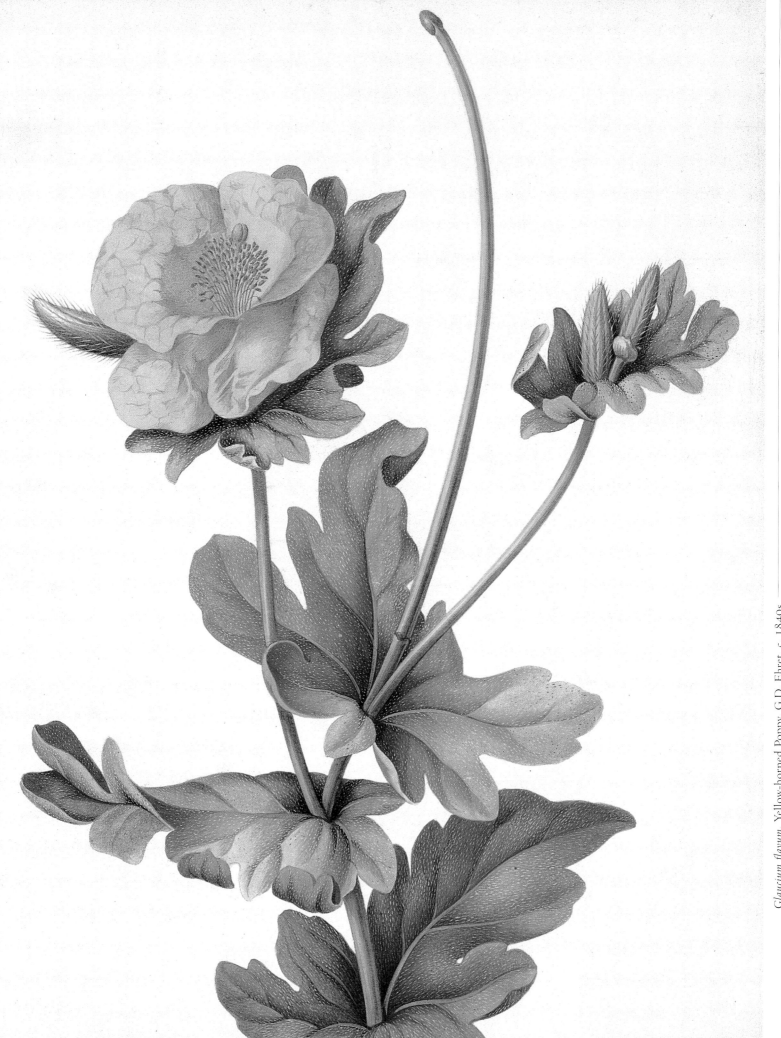

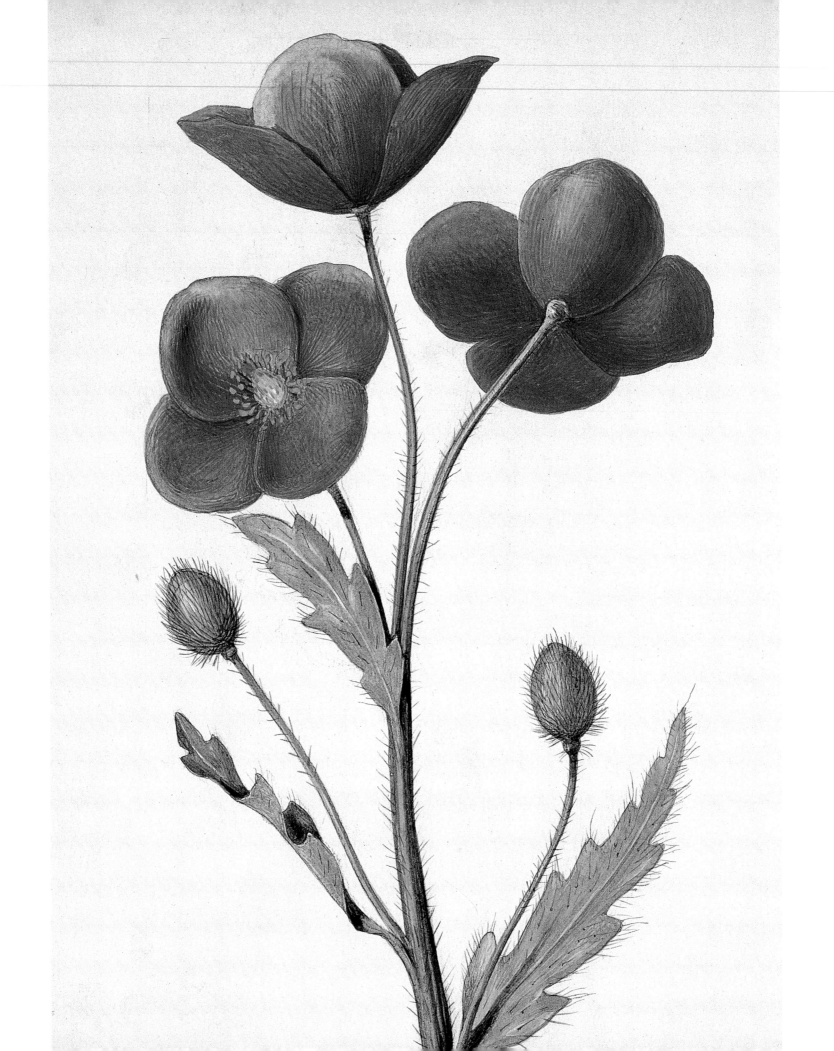

eastern Mediterranean range in Neolithic times and became cultivated throughout western and northern Europe. Its cultivation also spread eastwards towards India. The earliest known reference to this poppy is from 2000 BCE, in an Assyrian herbal. The painkilling properties of wine prepared from poppies were also well-known to the Greek physicians, and Hippocrates carefully documented the effects of 'poppy-wine'. A method of dulling pain certainly helped the development of medicinal practice, and this is another irony – the very substance that allows pain to be dulled and is crucial to the practice of modern medicine is also the source of pain and suffering through addiction and narcotic abuse.

Opium resin is extracted today much as it has been for thousands of years. The Greeks are credited with this discovery, as they are credited with the discovery of the medicinal uses of the resin itself. The resin is collected from the unripe seed capsules by making a series of angled incisions around the round capsule, from which the resin oozes and accumulates at the base of the fruit. Wounds made at sunset are said to produce the best product, as the night dew stimulates 'bleeding', and within twenty-four hours the latex hardens to a brownish mass and can be collected and stored in brown, gummy balls. This gum keeps for a long time, and is variously chemically modified to produce a wide variety of medicines and drugs. The resin is produced by the plant in specialized cells called laticifers, which are most concentrated near the surface of the capsule and in the upper stem, but all vegetative parts of the opium poppy exude a milky juice when cut. The quantity of latex produced by the plant varies enormously: it is said to be greater in warm climates and some strains of the species have much higher latex content than others. This is certainly the result of centuries of human selection for high levels of production – a process akin to natural selection, but operating over much shorter timescales.

Opium poppies are the ultimate in cash crops. It is easy to grow, and the returns are fantastic. An annual plant, *Papaver somniferum* will grow anywhere, and many of us find it self-sowing all over the garden, long after the first plants we cultivated have

died. Until recently, much of the opium available both legally and illegally came from the Golden Triangle, an area in the region of southwestern China and adjacent Burma. In another ironic coincidence, until the eighteenth century opium was considered more of a food and ornamental plant in China than a source of medicine or drugs. As a drug it was imported into China from India, where its use as a narcotic had a long history. The highly lucrative but terribly dangerous opium trade was controlled by the British East India Company, who exported opium from India to China in exchange for gold and silver, which was then used to buy tea and silks in China for export back to Europe at a fantastic profit. The Company also controlled the illegal trade in opium through the licensing of local smugglers, who traded up and down the Chinese coast, and passed the profits to the Company. Opium addiction increased astronomically in China during the eighteenth and nineteenth centuries, leading the Chinese government to ban its use and import, but the effectiveness of the ban was limited, largely due to the activities of the licensed smugglers. Conflict over the opium trade culminated in the Opium Wars between Britain and China, which were immensely destructive to both sides. China was ultimately forced to agree to opium imports but placed a heavy tax on them.

It is tragic that the luxury and expansion of the nineteenth century was fuelled by the misery of so many, and today more opium is traded illegally than legally (though the legal use of the drug is one of the cornerstones of modern medicine). Morphine eases the pain of many sufferers, but is only one of many different alkaloids in *Papaver somniferum*. Medicinal drugs based on opium have use as analgesics, sedatives and antispasmodics, as well as their more common use as soporifics (inducers of sleep). Illegal trade in opium is largely based on the use of the derivative heroin, a multi-million-dollar business

Meconopsis napaulensis, Blue Poppy, Anon., c. 1900s

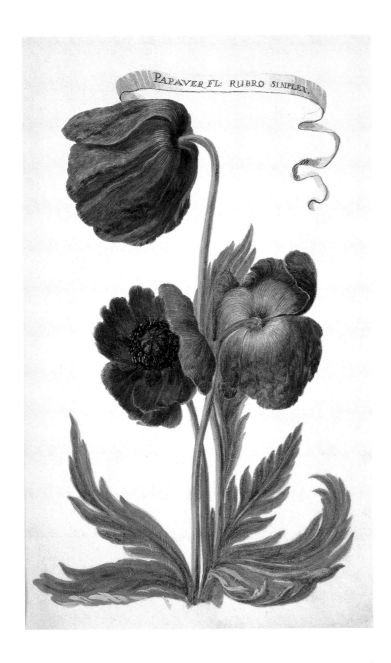

PAPAVER FL: RUBRO SIMPLEX.

huge markets of North America makes cultivation in Colombia and other Andean areas the logical move, but the cost is tremendous – not only costly in terms of human suffering due to addiction and the inherent social problems that brings, but also due to the deforestation of large remote areas of upland watershed (the very forests that provide towns and cities in the lowlands with water and protect them from flooding). These montane forests, so remote, also feed the great rivers of the Amazon basin, so helping to maintain the diversity of life not only within themselves but also in far-away areas.

Poppies have also fuelled another sort of addiction: the urge to explore and to discover novelties. Exploration is like a drug, for it exhilarates and excites, but is not destructive; instead, it brings knowledge with it and enriches our lives. As European gardeners realized that many plants from far-flung places could be profitably grown in their own gardens, a breed of explorers known as 'plant hunters' was born. These were men (women were not commonly involved in exploration in the early days, but there were notable exceptions!) who had botanical training and a thirst for adventure. They tended to be sponsored by botanical gardens, such as the Royal Botanical Gardens at Kew, or by seed companies and nurseries who directly marketed and developed the plant hunters' discoveries. By the early part of the twentieth century, Asia had become the treasure trove for European gardeners – following on from Joseph Dalton Hooker's discoveries in Sikkim, more and more remote parts of southwestern China and Tibet became a magnet for explorers in search of botanical novelty. Botanists had collected plants in these areas since the middle of the previous century, but the introduction of new and exotic plants to gardens depended on a supply of seed from which to propagate large numbers of plants for sale. Therefore, twentieth-century plant hunters were in search not only of new and exciting things, but also seed, and lots of it. One of the most intrepid of these early twentieth-century plant hunters was Frank Kingdon Ward, who spent forty-five years exploring the remotest corners of what are now Myanmar (then Burma), Tibet and Assam. The son of a

worldwide. Heroin is made from crude opium resin by a process of cooking and the addition of various chemical catalysts, and is quite a simple and inexpensive process. Today, opium poppies are grown in the Golden Triangle, but increasingly elsewhere in suitable habitat, such as in the mountain forests of Colombia. This is the most efficient cash crop in the world, so it is hardly any wonder so much land is being converted to its cultivation. Proximity to the

Papaver orientale, Oriental Poppy, J.G. Simula, 1720

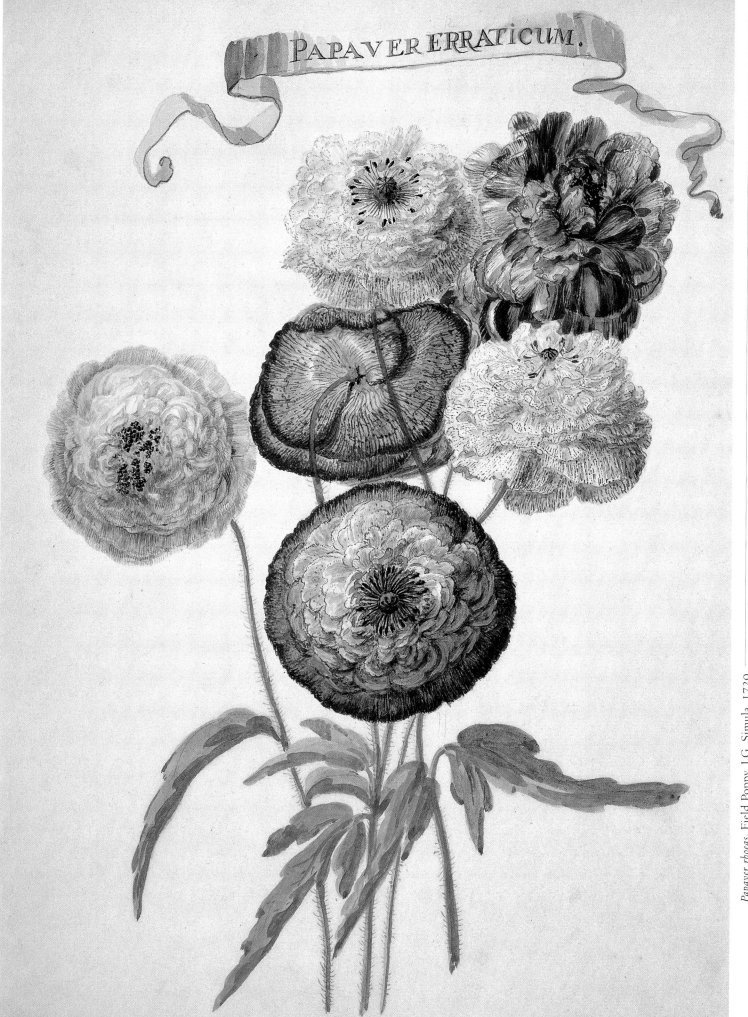

PAPAVER ERRATICUM.

Papaver rhœas, Field Poppy, J.G. Simula, 1720

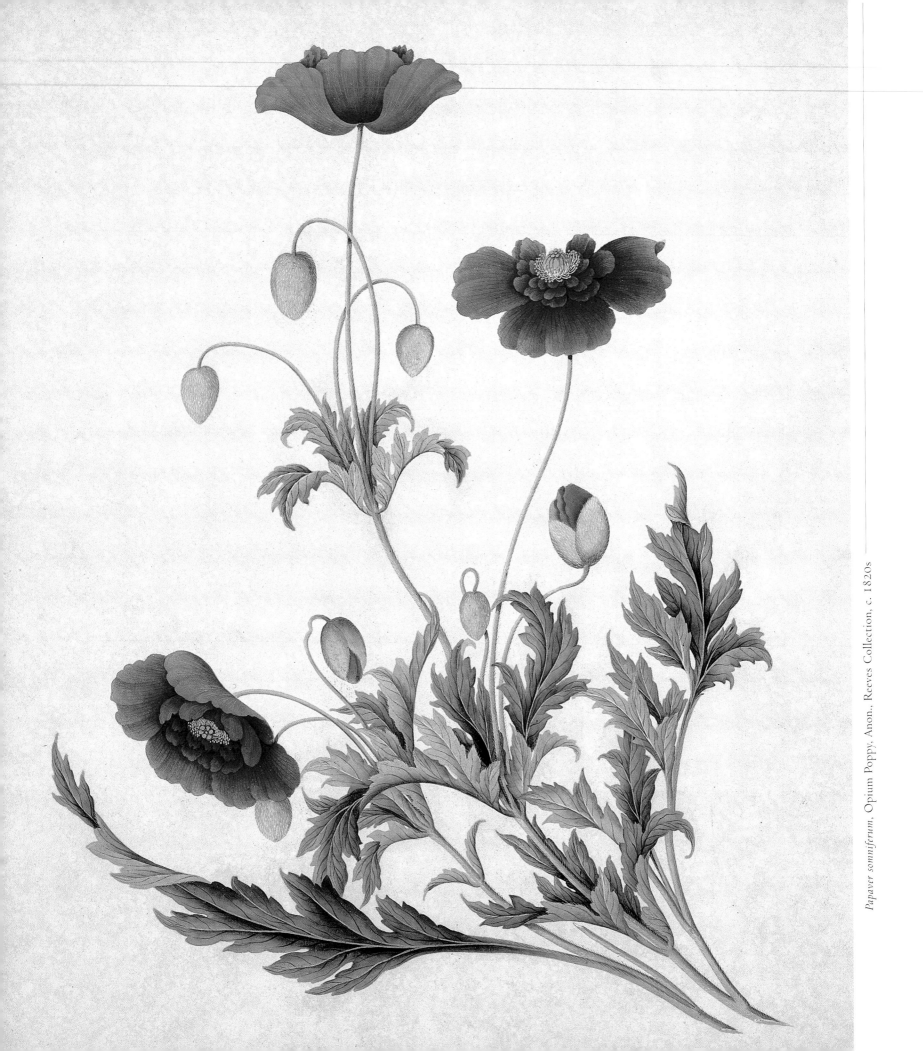

Botany professor at Cambridge, he developed a love of nature and a sense of adventure at an early age. As is often true with young naturalists, books (in his case, Schimper's *Plant Geography*) instilled in him a desire to visit the tropics. The romance of the tropical forests exerts a strong pull on many, Kingdon Ward included.

When Kingdon Ward finished his university education, he took the first job he could find that allowed him to travel to parts unknown, and in he sailed to China to take up a job as a teacher at the Shanghai Public School. At last he was in the lands of his dreams, and he spent most of his holidays exploring the tropical forests of Java and Borneo, following in the footsteps of the great zoologist Alfred Russel Wallace. Teaching didn't last long, though, and he was soon invited to become part of an American zoological expedition collecting animals in southwestern China. Well and truly bitten by the travel bug – for real this time, rather than out of books – Kingdon Ward impatiently taught at the school until something more to his liking came along. Good fortune knocked, and he was offered a job plant hunting in Yunnan in southern China, employed by the horticultural firm of Bees Limited (Liverpool) and charged with the collection of seed of plants for introduction to the gardens of the British Isles. He set off for the 'Land of the Blue Poppy', which was to become his home until his old age. He didn't even finish reading the letter offering him a job before deciding to accept it forthwith, so anxious was he to be off into the wilds again. Over his forty-five years of exploration Kingdon Ward wrote fourteen books, the first of which was *The Land of the Blue Poppy*. His writing has been characterized by some as 'unaccomplished', but it perfectly conveys the enthusiasm and impulsiveness of a man who would accept a job before fully reading the letter offering him the post. His transparent joy in his surroundings and in the people with whom he travelled – be they Tibetans, Chinese or hill tribespeople – make his books compulsive reading. No way was he a bored and sophisticated traveller…

Papaver orientale, Oriental Poppy, W. King, c. 1750s

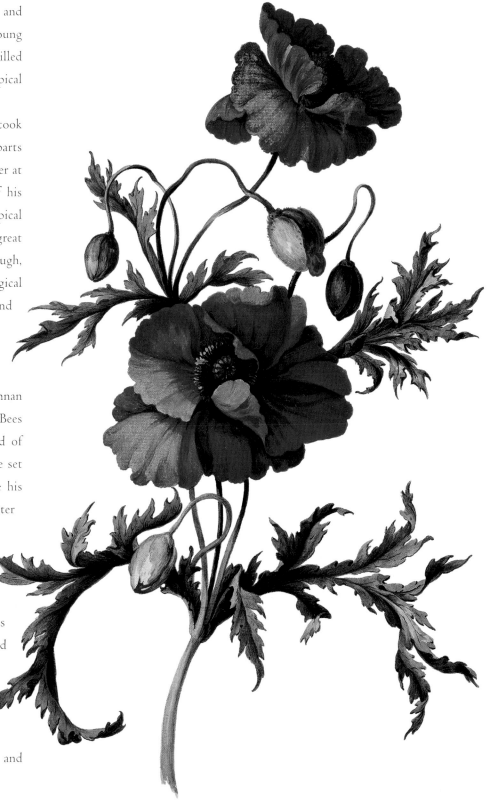

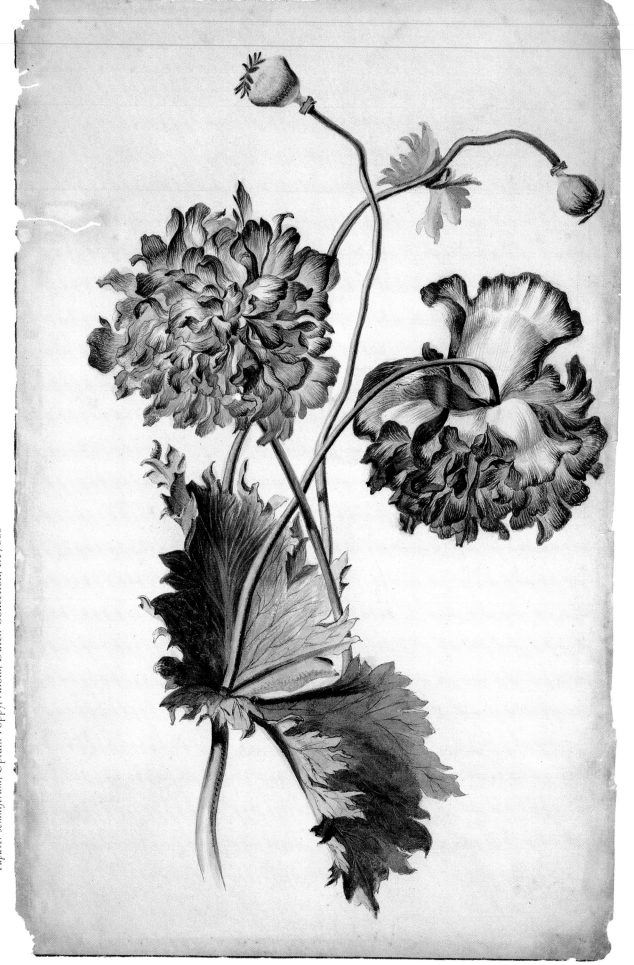

Papaver somniferum, Opium Poppy, Anon., Dutch Collection, c.1700s

Although his first journey was clearly in search of the blue poppy, it does not appear in the list of plants he brought back. It was another twenty-three years before he was able to collect enough good seed of *Meconopsis betonicifolia* to establish it firmly as a queen among garden plants. Blue poppies were first discovered by the French missionary Père Jean-Marie Delevay in Yunnan in 1886, and fragmentary specimens from populations in Tibet were collected by another botanist, but not enough seed was available to introduce these beautiful plants to the ordinary gardener. Poppies were firmly established as lovely garden plants, but to have a blue one was worth something indeed. Kingdon Ward collected quantities of seed in the summer of 1924, enabling the blue poppy to be grown by whoever wanted it, and was willing to tend to it carefully (it is not a spectacularly easy plant, like the opium poppy). One of the reasons Kingdon Ward was such a successful plant hunter was his phenomenal memory for places – to collect seed, one needs to return to a place where a plant has been seen blooming some months later, and with complete accuracy. Collecting seed was part of the adventure: 'It had become a point of honour to collect seed… Had it been a diamond as big and blue as the Koh-i-noor, I couldn't have taken more care of it. May it succeed!'

Kingdon Ward's collection of *Meconopsis betonicifolia* – his collection number 6862 from northern Burma – won an award of merit from the Royal Horticultural Society in 1935, something of which he was justly proud. The progeny of his collection were the first of this species of blue poppies to flower in cultivation, and still remain the most popular in our gardens. But there are other species of *Meconopsis*, some of which were introduced to cultivation earlier, but never attained the popularity of the blue poppy. The members of the genus *Meconopsis* do not all have the sky-blue flowers of *Meconopsis betonicifolia*. Species with yellow, purple and blood-red flowers are also cultivated, and most come from the Himalayan region. An exception is the Welsh poppy – *Meconopsis cambrica* – which graces damp walls and roadsides in Wales with its delicate, orange-yellow flowers.

Many of our common garden poppies are herbaceous and easy to grow from seed, but not all poppies are herbs. It may come as a surprise to find tree poppies, but one from California is a real prize. Not really a tree, more of a large shrub, it hails from sunny southern California, and seems a most unlikely plant to do well in the wet climate of Britain and Ireland. But this is where it was introduced to cultivation, and where it was named. The scientific name of this plant honours two Irishmen, who also happened to be great friends – Rev Dr T. Romney Robinson was an astronomer in Armagh, and Dr Thomas Coulter collected the plant for the first time in California in 1832. Both were friends of the botanist William Henry Harvey who, in his original description of the plant, wanted to name the plant for Coulter, to convey his great respect for the memory of Dr Coulter and his astounding discoveries during years of collecting in Mexico and southern California. Sadly, Alphonse de Candolle of Geneva had already used the name *Coulteria* for another plant, so Harvey contented himself with 'bestow[ing] upon this plant of his discovery, the name of one of his…most intimate friends…thus linking the names of Coulter and Romney Robinson as closely in the annals of science as their friendship was indissoluble'. *Romneya coulteri* was not brought into cultivation until forty or so years later but was instantly popular, and Gertrude Jekyll described it as a plant of 'supreme and stately beauty'.

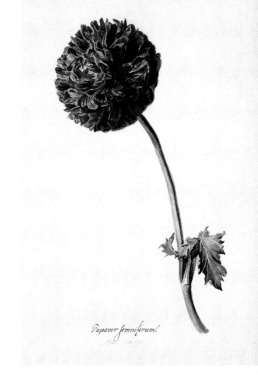

Papaver somniferum.

Poppies are a supreme example of the irony of nature – at once stately, delicate and fragile, their ephemeral beauty gives not a hint of their darker side.

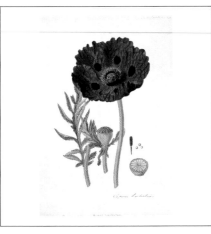

Lindley described Papaver bracteatum *in 1821, differentiating it from the common Oriental poppy by its more robust flowers, with bracts (or leafy structures) just below the flower. The two species are otherwise very similar, and may hybridize in gardens.* Papaver bracteatum *is native to rocky and scrubby plains in the Caucasus mountains, from Turkey to northern Iran.*

Oriental Poppy
Papaver bracteatum Lindl. (Papaveraceae)
John Lindley
c. 1819–1820, watercolour and bodycolour with gum
arabic on paper, 482mm x 334mm (19in x 13¼in)

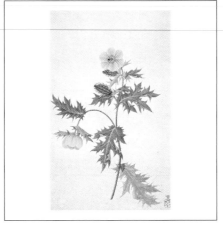

Argemone *comes from the Greek word for 'cataract of the eye'* (argema) *and the juice of this plant was thought to clear such mistiness in the eye. So what exactly was the sixteenth-century English herbalist John Gerard doing with his prickly poppies to say that they were 'so full of sharpe and venemous prickles, that whosoever had one of them in his throte, doubtless it would send him off packing to heaven or to hell'?*

Mexican Prickly Poppy
Argemone mexicana L. (Papaveraceae)
Anon. Reeves Collection
c. 1820s, watercolour with bodycolour on paper
370mm x 229mm (14½in x 9in)

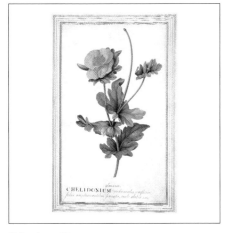

This poppy is a familiar sight by the sea in some parts of Britain and in the Mediterranean. In the seventeenth century it was thought to have great medicinal powers; indeed, John Gerard wrote that 'The root of horned Poppie boiled in water unto the comsumption of the one halfe, and drunke, provoketh urine, and openeth the stopping of the liver.'

Yellow-horned Poppy
Glaucium flavum Crantz (Papaveraceae)
Georg Dionysius Ehret
c. 1840s, watercolour with bodycolour on vellum
365mm x 222mm (14½in x 8¼in)

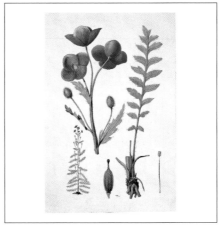

The deep blue of this poppy means that it is sometimes classified as Meconopsis wallichii, which is a separate species. Other populations of Meconopsis napaulensis have red, yellow or white flowers, but Wallich's form is the only sort with blue ones. Just what defines a species is to a certain extent a matter of opinion, and it is (and has been) a concept about which debate has swirled for more than a century.

Blue Poppy; 'Wallich's Form'
Meconopsis napaulensis DC. (or *Meconopsis wallichii* Hook.)
(Papaveraceae)
Anon. c. 1900s, watercolour on card
284mm x 192mm (11¼in x 7½in)

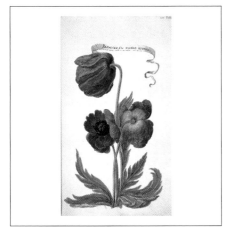

The lustrous red of the poppy petals, combined with the deep purplish black of the stamens and stigma, is an unusual colour combination in nature. In animals, red and black together often suggest danger — signifying that the creature is inedible or poisonous — but in a flower, this striking combination just draws the gardener nearer in order to relish the contrast.

Oriental Poppy
Papaver orientale L. (Papaveraceae)
Johann Gottfried Simula
1720, bodycolour on paper
455mm x 285mm (18in x 11¼in)

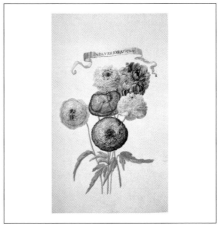

The blowsy double flowers of this cultivar of the field poppy are the result of human selection. In selecting for colour in poppies, the shade one wants must be preserved by removing plants bearing either the darker or lighter flowers before they exchange pollen (and therefore genes) with the desired shade. Left to themselves, garden populations of poppies will converge on an average pinkish hue.

Field Poppy; 'Papaver erraticum'
Papaver rhoeas L. (Papaveraceae)
Johann Gottfried Simula
1720, bodycolour on paper
455mm x 285mm (18in x 11¼in)

Although this painting depicts a delicate poppy somewhat resembling the field poppy (or Papaver rhoeas), the grouping of the flowers show that it is probably a red-flowered variety of the opium poppy. The wild ancestor of the opium poppy was more delicate, and most think it was a plant with pale purple flowers. This painting clearly depicts not this wild ancestor, but a Chinese cultivar, with double flowers.

Opium Poppy
Papaver somniferum L. (Papaveraceae)
Anon. Reeves Collection
c. 1820s, watercolour with bodycolour on paper
450mm x 359mm 17⅛in x 14⅛in)

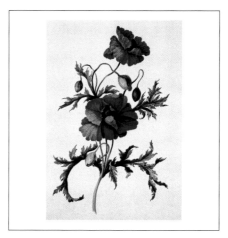

The Oriental poppies are a mixture of three species – Papaver orientale, Papaver bracteatum and Papaver pseudo-orientale. All three are native to western Asia, and the parentage of many garden varieties remains a mystery. In the wild, these three species are quite distinct, but in gardens it is another story. Humans have so changed the flowers they cultivate that they no longer truly resemble their wild progenitors.

Oriental Poppy
Papaver orientale L. (Papaveraceae)
William King
c. 1750s, watercolour with bodycolour on paper
333mm x 239mm (13in x 9½in)

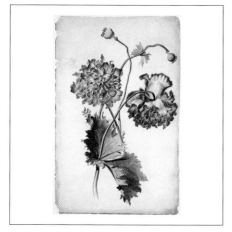

The delicate gradations of colour in some opium poppy petals has been likened to shot silk – a most precious fabric. Not only are the flowers beautiful, but the capsules are also used in flower arranging, as their salt-and-pepper-shaker shape is quite unusual. This pink-edged variety resembles a modern variety called 'Flemish Antique', a name that surely reflects its origins in the Dutch flower trade.

Opium Poppy
Papaver somniferum L. (Papaveraceae)
Anon. Dutch Collection
c. 1700s, watercolour with bodycolour on paper
425mm x 276mm (16⅛in x 10⅞in)

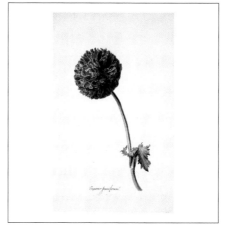

Extravagantly doubled, the peony-flowered types of the opium poppy have long been garden favourites. In this plant, the stamens have been entirely replaced by a closely packed mass of petals, resulting in a globe-shaped flower. Although the opium poppy usually has shades of purple or mauve, deep reds are highly prized (but unstable if left to interbreed with paler sorts).

Opium Poppy
Papaver somniferum L. (Papaveraceae)
J. Perkois, Dutch Collection
c. late 1700s, watercolour with bodycolour on paper
435mm x 276mm (17⅛in x 10⅞in)

When people in the northern hemisphere are asked to think of heathers and heaths, their response is likely to include a reference to Scotland. Knitted garments are 'heather-coloured' if they are muted and diffuse, and the entire effect is that of a misty day. But the great sweeps of pinkish-tinged scrub, the heathlands, are for the most part not a natural habitat. Heaths are largely the result of tree clearing on a massive scale: when the tree cover is destroyed on poor, acidic soil and either grazing animals or fire is used to prevent them being established, this is when heathland develops. The great expanses of heath in the northern part of Britain are part of the landscape's development along with humans. However, heath is not confined to the northern part of Britain, for

losses of what is an almost emblematic habitat. In comparison, Scotland's heaths have not fared so badly – the moorlands are conserved by sheep grazing and for grouse shooting.

Heather, *Calluna vulgaris*, had such a place in the daily lives of people in Scotland that when settlers emigrated to the Americas they took it with them, and the plant is now naturalized far beyond its native range. Heather was used in all aspects of daily life in the Highlands – for fuel and building material, for animal and human bedding. The leaves and flowers are highly fragrant; in fact, heather honey is a great delicacy and beekeepers in many parts of the world take their hives to the edges of moorland during the heather bloom. We know that heather ale was a traditional drink brewed in

HEATHERS

Sweet-brushing the dew from the brown heather bells
Her colour betray'd her on yon mossy fells;
Her plumage outlustr'd the pride o' the spring
And O! as she wanton'd sae gay on the wing.

THE BONIE MOOR-HEN (ROBERT BURNS, 1787)

much heathland existed in the south, in Dorset and Breckland on similarly acid and nutrient-poor soils with intense pressure from animals or fire. When common grazing rights were abolished in the nineteenth century and land was enclosed, much heathland returned to woodland, as animals no longer prevented the establishment of seedling trees. The widespread perception – a misperception if ever there was one – that heathland is wasteland means that much heathland has been built upon or otherwise developed. From being, at the end of the seventeenth century, about one quarter of the land surface of the island of Britain, heathlands now cover (in England at least) less than ⅓ of a percent of the land area – ⅕ of its original area, and representing huge

the Highlands at the time of the Picts, some 4000 years ago, for Neolithic drinking vessels found on the island of Rhum contain evidence of oats, barley and heather. Once one of the staple drinks of the Highlands, the art of making heather ale appears to have been lost, as by the eighteenth century it was all but confined to the island of Islay, where locals made ale with the 'tops of young heath'. The stage was then set for a dramatic revival as home brewing and the taste for real ale spread among an increasingly sophisticated drinking public. An old Gaelic recipe, revived and produced on a commercial scale by a Glasgow home brewer, uses the growing tips as part of the brewing process and filters the result through beds of heather tips – a remarkable rediscovery of

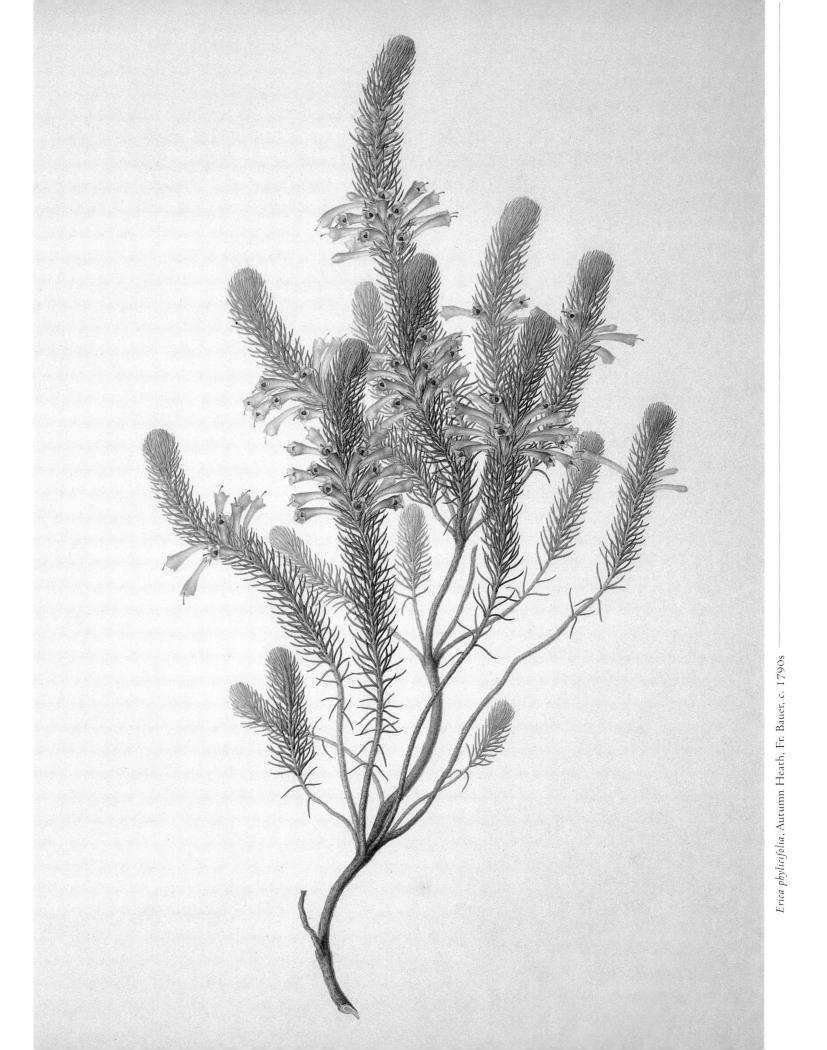

Erica phylicifolia, Autumn Heath, Fr. Bauer, c. 1790s

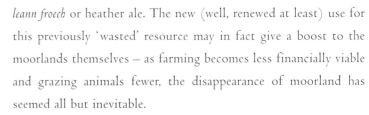

leann froech or heather ale. The new (well, renewed at least) use for this previously 'wasted' resource may in fact give a boost to the moorlands themselves – as farming becomes less financially viable and grazing animals fewer, the disappearance of moorland has seemed all but inevitable.

White heather – those lucky sprigs sold by street vendors on London's streets – is said to have been brought south to England from Scotland by Queen Victoria (from the Royal estates at Balmoral), but that is certainly an apocryphal tale, as botanists were recording white heather as early as the late sixteenth century, along with its reputation for giving luck not only to the finder but to anyone who had it in their possession. White forms of *Calluna* are found everywhere it grows, but the white heather grown for the 'lucky sprig' market comes from a variety of different plants – some *Calluna*, others in the genus *Erica*, such as *Erica lusitanica* from the Iberian peninsula. Both *Erica* and *Calluna* are members of the family Ericaceae, *Erieke* being the Greek name for these plants (meaning 'heath') used by Theophrastus in the fourth century BCE. The Ericaceae are an incredibly diverse family, occurring all over the world except Australia. In general, ericaceous plants occur in poor, acidic soils and all that have been studied have been shown to be dependent upon a fungal association (mycorrhizae) for growth. Other genera in the Ericaceae include *Rhododendron*, *Gaultheria* (wintergreen) and *Vaccinium* (blueberries and cranberries). The tiny urn-shaped flowers of the blueberries are so very different-looking to the large, open and showy ones of rhododendrons that one may be forgiven for imagining they had little to do with one another. Yet they do share some rather peculiar features that allow botanists to place them together in a family. Amongst these are upside-down anthers with poricidal openings and pollen released in tetrads (groups of four pollen grains) rather than as single tiny grains, as is common in other plants. The anthers of many of the genera, *Erica* among them, are wildly ornamented, with tails and awns. Some members of the family (in the broadest sense) have evolved total dependence on

Erica mammosa, Nine-pin Heath, Fr. Bauer, 1791

their fungal symbiont and are saprophytes, living on the nutrients released by the fungal associate from rotting leaf litter. Heathers have gone to another extreme in order to cope with their environment: their leaves are tiny and so in-rolled as to sometimes become small tubes, reducing the surface area for water loss to a minimum. This might not seem necessary in a habitat such as a Scottish or Dorset moorland, but of the more than 800 species in the genus *Erica*, only 21 occur in Europe, most of those in the dry regions around the Mediterranean Sea. Although many people's first word association with heather is Scotland, it really should not be, for the majority of species in the genus *Erica* occur in South Africa – its true centre of diversity.

There are more than 750 species of *Erica* in South Africa – with the proteas and the restionads, they are one of the three main constituents of fynbos, the characteristic and wonderful vegetation of the Cape region. The Cape fynbos has been described as a wonder of the world, a statement with which it would be difficult to disagree. Imagine an area the size of Portugal or the state of Virginia with more than 8000 native species of flowering plants, more than half of which are endemic (found nowhere else on earth). That specialness is incredible: in comparison, the flora of Great Britain, admittedly a depauperate region that was heavily glaciated in the past, has fewer than 2000 species of flowering plants, and only 20 of those occur nowhere else. Fynbos (literally meaning 'fine bush' in Dutch) is a scruffy-looking sort of habitat if one doesn't look too closely. The origin of the word is thought to have come from the early Dutch settlers' frustration with a local vegetation too fine and weak to be of any use for timber production, or perhaps refers to the predominance of small or fine-leaved shrubs in the region. Knowledge of the importance of fynbos to the original local inhabitats of the Cape region has all but been lost, for the San and Khoi-Khoi surely used fynbos plants. Four main vegetation elements make up the fynbos. Geophytes – herbaceous plants arising from bulbs (such as *Gladiolus* or *Amaryllis*) commonly bloom after fires, and are thus

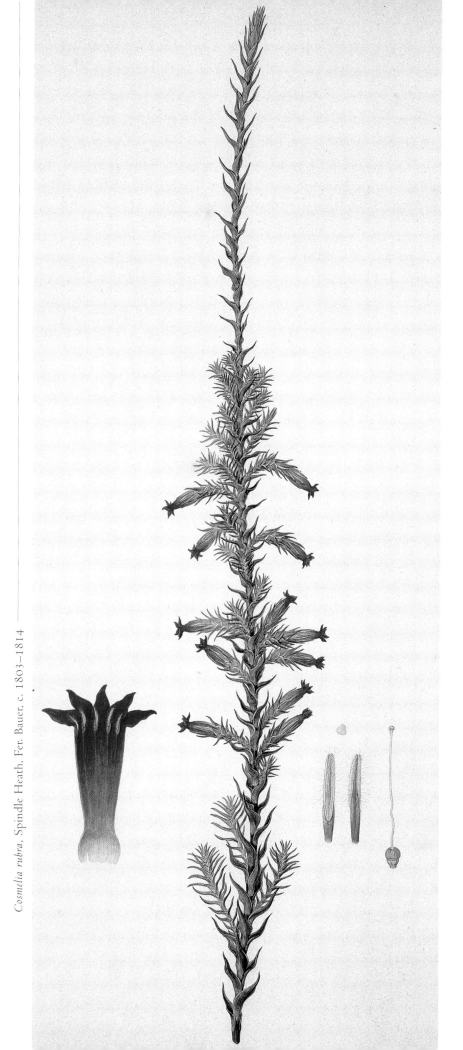

Cosmelia rubra, Spindle Heath, Fer. Bauer, c. 1803–1814

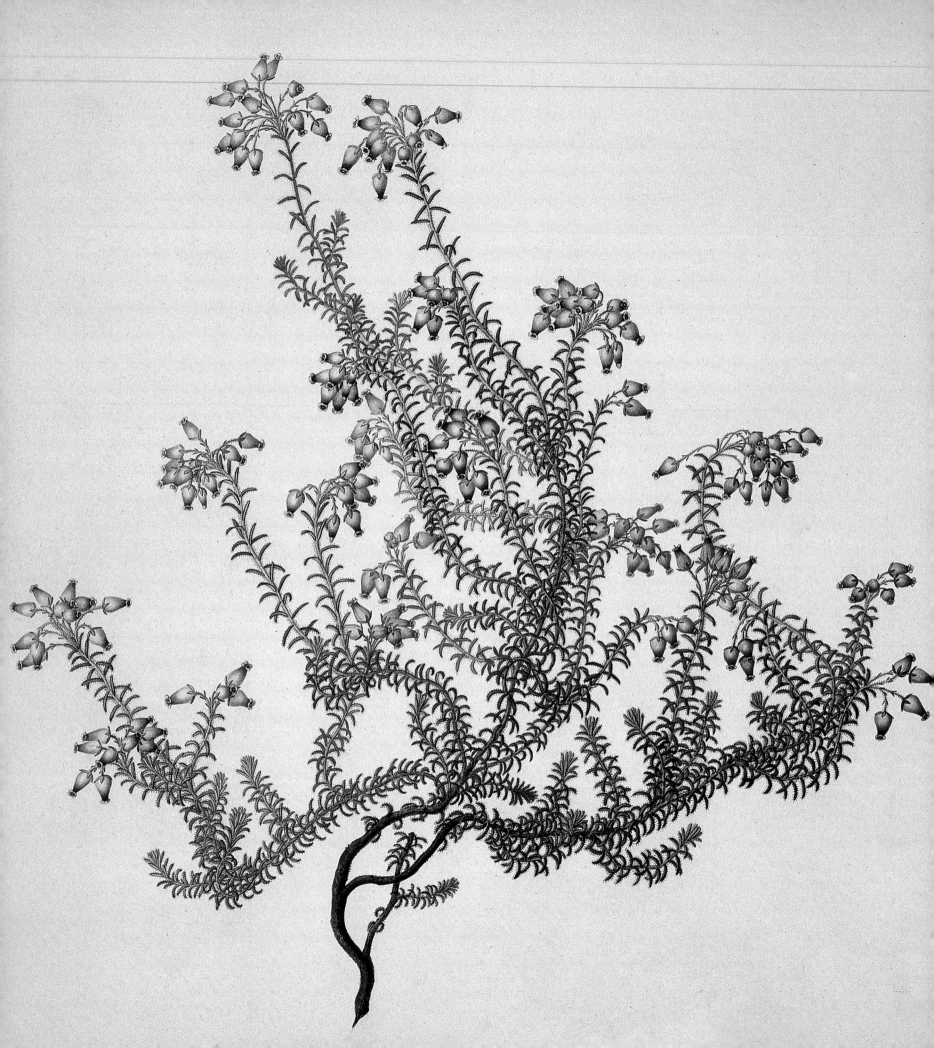

not seen as permanent features of the landscape. The three shrubby forms, seemingly more permanent and structural parts of the vegetation, are the proteoids, tall shrubs with large leaves; the restioids, wiry, grassy plants looking like the sedges of the north temperate zone; and the ericoids, heath-like shrubs with tiny leaves and thin whippy stems, including the many species of *Erica* but many other plants of similar structure and aspect. The flowers of the Cape heaths are a riot of form and colour. No mere discrete urn-shaped bells here, for colours range from the brightest red, to pink, white, bright yellow, lurid green, while some flowers are bi-coloured, or have stripes. Some even look like sweets. It is true that some are small and urn-shaped, but it is the sheer range of diversity that takes one's breath away. Some are pollinated by wind, others by small insects, still others by the sunbirds. Although from a distance the vegetation looks like the moorlands of Scotland, seen close to it is another world.

Since the Cape of Good Hope was one of the major stopping points for seafarers on their way to the riches of the East (the Spice Islands), it was one of the first extra-European habitats to be systematically explored botanically. Charles de l'Ecluse, also known as Carolus Clusius, a seventeenth-century botanist from Leiden in Holland, encouraged sailors to collect plants in 'that extreme and celebrated Promontory of Aethiopia commonly called the Cape of Good Hope' and, by the time Carl Linnaeus published his great flora of the world (*Species Plantarum*) in 1753, many species of fynbos plants were known. In *Species Plantarum* Linnaeus described twelve species of South African *Erica*, mostly from specimens sent back opportunistically by sailors or as the result of explorations into the interior by Dutch settlers. A Danish botanist, Paul Hermann, whose specimens collected in Sri Lanka in the 1680s resulted in the publication of the first catalogue of the plants of a tropical country – Linnaeus' *Flora Zeylanica* – had visited the Cape on his way to and from the East. One of his students had established a botanical garden in the Dutch colony and, from there, amazing plants came to tantalize the botanical world.

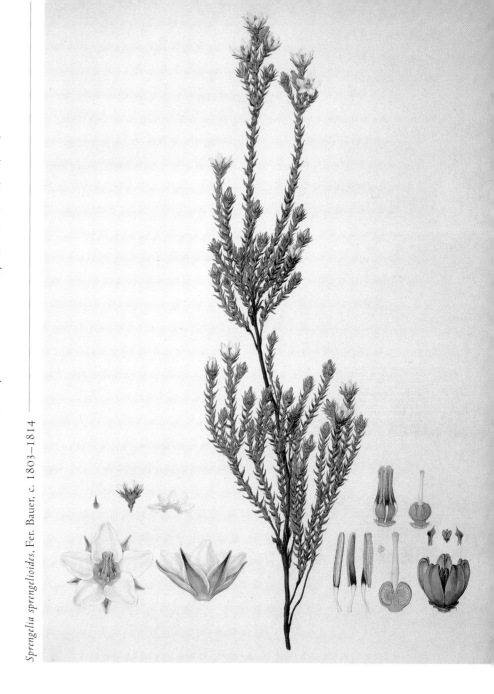

Erica glutinosa, Clammy Heath, Fr. Bauer, 1790

Sprengelia sprengelioides, Fer. Bauer, c. 1803–1814

By 1771, when Joseph Banks, Daniel Solander and James Cook stepped off the *Endeavour* in the Cape, on their return from the observation of the transit of Venus from Tahiti, the exploration of the coast of Australia and the circumnavigation of the globe, the rapidly growing colony in Cape Town already had an established botanical community. A series of scientifically minded governors, foremost among them Rijk Tulbagh, encouraged exploration and the establishment of a local botanic garden, from where plants were sent to the major Dutch gardens in Leiden and Amsterdam. In the early 1770s, two Swedish students of Linnaeus were living in the

colony – Anders Sparrman was the tutor to the children of the Dutch East India Company's Resident, and Carl Thunberg was practising his Dutch in order to go on to Japan (disguised as a Dutchman) to collect plants – the Japanese only allowed the Dutch to set foot on Japanese shores, and since Thunberg was a Swede it was necessary that he learn Dutch in order to achieve his goal. Landing in the Cape on 14 March 1771, Banks and Solander (who was by then seriously ill) only had two days in which to explore the riches of the Cape region. Apparently, Banks did not think much of the colonists or of the place itself, for his journals record his dislike of the system of slavery as practised in the colony – particularly the loads people carried on their heads and the absence of barrows. He must have seen enough of the vegetation to stimulate his interest, however, for he organized the collecting of one of the greatest collectors and early explorers of the South African flora.

When Captain Cook triumphantly returned from the voyage on the *Endeavour* in June 1771, having explored the coast of Australia, Banks appears to have taken a lot of the credit. The newspapers described the voyage as one in which 'Cook, of the Royal Navy, who sailed around the Globe with Messrs Solander, Banks etc.', which is hardly presenting the facts correctly. This misconception was probably in large part due to the extremely good relationship between Banks and King George III. The two men were close in same age and 'Farmer George' had much in common with Banks, certainly more than he had in common with the older seafaring Cook. The king had an interest in gardening – his mother had established a botanic garden at Kew and soon Banks was appointed 'Scientific Advisor on the Plant Life of the Dependencies of the Crown' – a sort of botanical adviser to the king and the first director of what would become the Royal Botanic Gardens at Kew. Banks persuaded the king that one of his goals should be to assemble the world's finest and most diverse collection of plants (a logical extension of having the finest and most diverse set of colonies) and that the collection should be

housed at Kew. But, in order to do this, collectors needed to be sent out to obtain material – just relying upon the random goodwill of others would not do any more.

When Cook was contracted by the Admiralty to undertake a second circumnavigation of the globe scheduled to leave in early 1772, Banks intended to accompany him, again collecting, but this time for the king. Plans fell through, largely due to Banks' grandiose ideas, which resulted in the construction of an edifice on the decks of the *Resolution* that was so large it nearly capsized the ship! Not content with having taken an entourage of eight aboard the *Endeavour*, Banks had been intent on taking a party of more than twenty, including astronomers, secretaries and draughtsmen (even an orchestra and a pack of greyhounds!). In the end, the cabins constructed on the decks of the *Resolution* had to be cut down to a size that would not founder the ship, and Banks refused to go at all. But Banks' refusal to sail achieved something that in the end would mean much more for knowledge of the South African flora. By pointing out 'the advantage that might accrue from sending out a smart under-gardener to the Cape to collect seeds and send home living plants', he convinced the king to send one of the young under-gardeners from Kew to the Cape as a plant collector for the gardens. One of the official naturalists on board the *Resolution*, Georg Forster, slightingly referred to this young man, Francis Masson, as a 'Scots garden hand', but Masson's even temperament and extraordinary skill at getting along with people, as well as his botanical expertise (that grew by the day while he collected in the Cape), meant that his time in the region was incredibly productive, and worth every penny of his £100 annual salary and £200 annual expense account.

Masson landed at the Cape on 30 October 1772, in a rapidly growing settlement at the base of Table Mountain, then known as Kaap, only later going by the name of Kaap Staad (Cape Town). He soon met up with Sparrman and Thunberg – a godsend for Thunberg, who by that time was experiencing money difficulties: the young, self-effacing young Masson, with enough money to buy

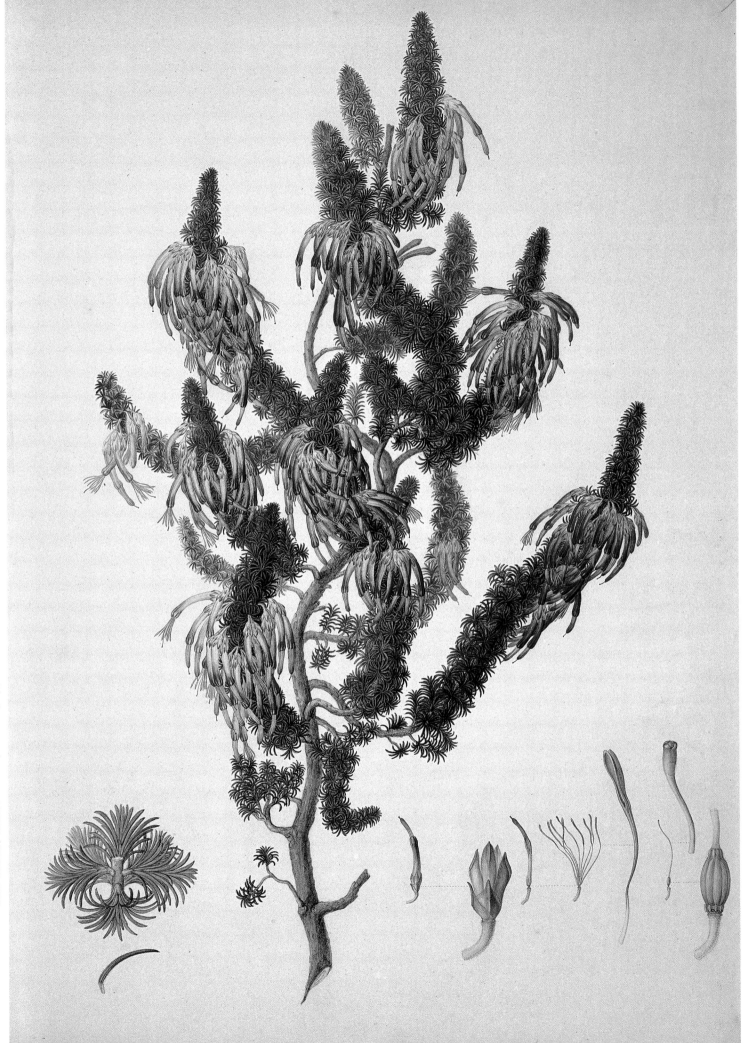

Erica Cantabrica flore
maximo, foliis Myrti subtus
incanis. Inst. R.H.

B.M.
(N.H.)

Erica? Ray Syn. p. 472. N.º 6.
Drawn at B. Septbr 10. 1766

a cart and oxen, was a boon indeed. Thunberg and Masson travelled together over the course of three years, taking journeys into the interior as far as the wild and inhospitable Karoo, where they got lost, had to spend a night out in the open with no food, during which they lost their horses, but eventually made it back to Cape Town and safety. In fact, the two men both wrote their own accounts of their trip, whose different tones underline their very distinct characters. In Thunberg's account, he is always the hero, rushing in and taking control of the situation, while Masson's account of his three years of collecting (a terse memorandum written to the President of the Royal Society, Sir John Pringle) is a masterpiece of understatement. Masson recounts the crossing of the pass in what was probably the Hottentot Hollands Mountains in a most matter-of-fact way: 'We attempted to cross the high ridge of mountains on the North side; but found it impracticable, having overturned our wagons on the side of a precipice, and greatly damaged them, which obliged us to return to a peasants' house to get them repaired.' Masson was impressed beyond measure with the vegetation, and he wrote of the hills being 'enamelled with flowers'. He was proud of the plants he had sent back to Kew that were successful: of heaths in particular, he wrote that 'It was on this journey that I collected the seed of the many beautiful species of erica which, I find, have succeeded so well in the Royal Garden at Kew.'

Masson returned to England in 1775, to great acclaim, at least from his patrons – he had really established Kew as a place on the botanical map. Banks wrote of his achievements in glowing terms: 'In the course of this Voyage, Mr. Masson collected & sent home a profusion of Plants unknown till that time to the Botanical Gardens in Europe…; by means of these, Kew Garden has in great measure attained to that acknowleg'd superiority which it now holds over every similar Establishment in Europe; some of which, as Trianon, Paris, Upsala, &c, till lately vyed with each other for preeminence, without admitting even a competition from any English Garden.'

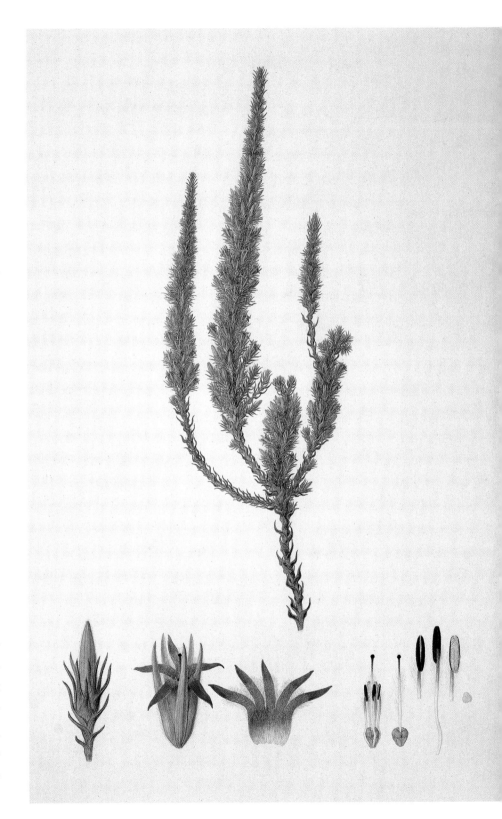

Andersonia caerulea, Foxtail, Fer. Bauer, c. 1803–1814

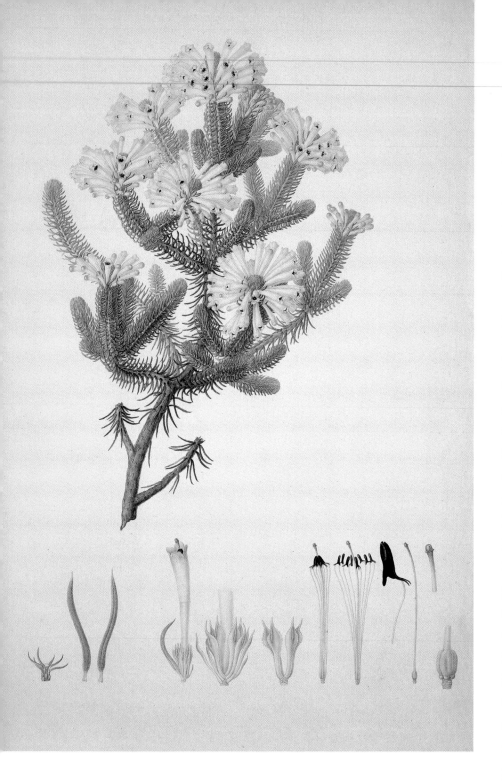

Disposition of the people here, that every social virtue is extinct.' It must have been difficult to be a simple botanist, interested only in plants, when all around you expected you to take sides. Trying to explain to people that all you want to do is collect plants results in incredulity on all sides, for surely there must be another motive – no one could possibly be so simple. Times really haven't changed all that much at all!

By 1786 Masson was once again in the Cape, but still in political difficulties. The Dutch had supported the American Revolution, and were (probably somewhat rightly) suspicious of British agents – even botanists – and the Dutch East India Company decreed that no stranger should be allowed to travel further than 60km (40 miles) from Cape Town. It is probably true that the mysterious Mr Patterson, supposedly collecting for Lord Strathmore, did report on Dutch military capability, but Masson concentrated on plants and plants alone. He stayed in the Cape region for another nine years, returning only just before the French Revolution occasioned the taking of the Cape by the British. Masson had feared for his collections during a period of anti-British resistance, and asked to be brought back to Kew. His twelve years in South Africa had a huge influence of British horticulture, for not only did they help to establish Kew as one of the major world players on the botanical stage but also stimulated new fashions for Cape heaths and pelargoniums (the 'geraniums' of horticulture). He took great care to look at soils and to think how to grow these wonderful plants in England. How sensible to have sent a gardener! Writing to Banks of *Erica*, he said that '*E. retorta, coronaria, pinastra, Massonii*, grows on the mountains in white sand produced from sandstone rocks which compose the mountains, and in England will require a Turf soil mixt with a little sharp white sand.'

What a shame that the fashion for these tender plants has long gone. Imagine the diversity of form and colour we might have with the Cape heaths rather than the muted, hardy heaths of the northern hemisphere.

The next year, Masson was sent out again – this time to the West Indies, and if possible to the 'Spanish Main'. It turned out to be an inauspicious time to be journeying to the American colonies and their adjacent territories, for Masson was caught up in the general regional turmoil surrounding the American Revolution. He wrote: 'The unfortunate turn of the times has so affected the

Erica longifolia, Vari-coloured Heath, Fr. Bauer, c. 1790s

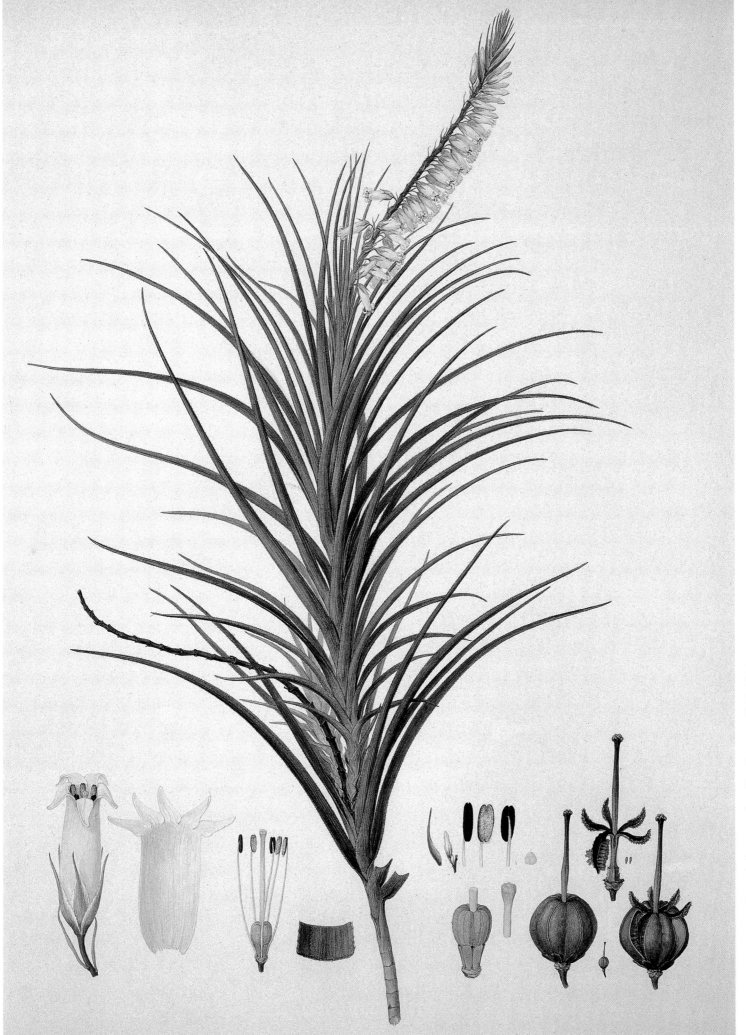

Dracophyllum secundum, Fer. Bauer, c. 1803–1814

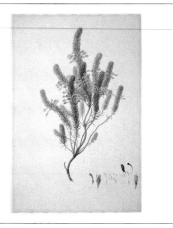

This species is sometimes classified as a pink-flowered version of Erica abietina, whose flowers are normally brilliant scarlet. The pink-flowered autumn heath is only found south of Table Mountain, on the Cape Peninsula. Botanists classify species based on shared features, and the fine details of floral structure are very much the same in the two flower-colour types. Opinions sometimes differ, however, even when faced with the same evidence.

Autumn Heather
Erica phylicifolia Salisb. (Ericaceae)
Franz Bauer
c. 1790s, watercolour on paper
524mm x 354mm (20½in x 14in)

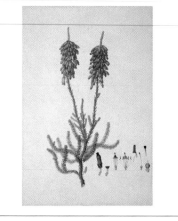

The brilliant-red flowers of the nine-pin heath are pollinated by sunbirds. These South African nectar-feeding specialists are exquisite iridescent creatures, and a flock of them foraging on a patch of heath vegetation is a sight to behold. The males sport flashes of green and orange, while the females are drab and brown (all the better to hide…).

Nine-pin Heath
Erica mammosa L. (Ericaceae)
Franz Bauer
1791, watercolour on paper
523mm x 354mm (20½in x 14in)

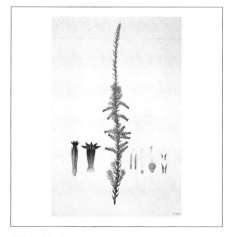

Robert Brown collected this plant in December 1801, at King George Sound, Western Australia. The genus Cosmelia is monotypic, which means that it includes a single species whose differences from other Epacridaceae are so marked that it deserves a genus of its own. It grows in sandy, peaty (acidic) soils on the far southwestern tip of the continent.

Spindle Heath
Cosmelia rubra R. Br. (Epacridaceae)
Ferdinand Bauer
c. 1803–1814, watercolour on paper
524mm x 353mm (20½in x 13¼in)

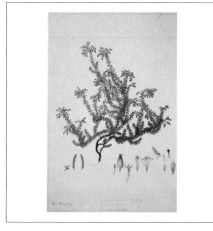

The whole Erica glutinosa plant is sticky to the touch, caused by tiny stalked glands on the leaves, stems and flowers, each of which secretes a sticky substance, which is also pungently smelly. This probably serves to deter herbivores, insects and mammals who might eat the precious leaf surface, thus decreasing the plant's ability to survive.

Clammy Heath
Erica glutinosa P.J. Bergius (Ericaceae)
Franz Bauer
1790, watercolour on paper
522mm x 352mm (20½in x 13¼in)

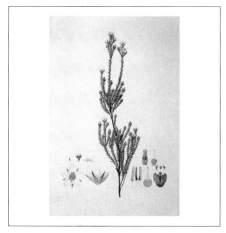

In Australia, the ecological equivalent of the heaths belong not to the family Ericaceae, but to the related family Epacridaceae. They have similarly diversified in the heathlands of Australia. This striking plant with its white and pink flowers was first collected 'inter Sydney & Botany Bay, Aug1 1803' and described by Robert Brown in the genus Ponceletia when he returned from the Investigator voyage.

Sprengelia sprengelioides (R. Br.) Druce (Epacridaceae)
Ferdinand Bauer
c. 1803–1814, watercolour on paper
524mm x 355mm (20½in x 14in)

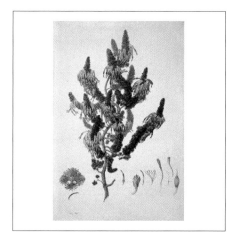

Bauer dated his painting 'Aug 1790', so was definitely made from material sent back from South Africa by Francis Masson. The bright-red curved flowers are pollinated in South Africa by sunbirds, who dart among the plants seeking nectar at the base of the long floral tubes. Their curved beaks exactly match the curvature of the heath flower, so both benefit from the association.

Crimson Heath
Erica coccinea P.J. Bergius (Ericaceae)
Franz Bauer
1790, watercolour on paper
524mm x 355mm (20½in x 14in)

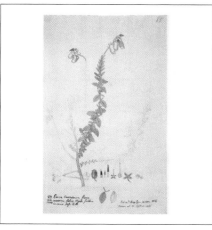

The genus Daboecia has only two species: one in the Azores, and the other with an odd disjunct European distribution. Daboecia cantabrica occurs on the north coast of Spain and adjacent France, then jumps the Bay of Biscay to find itself in the west of Ireland. Perhaps St Daboec, an Irish saint, took the plant from one Catholic nation to another.

Cantabrian Heath; St Daboec's Heath
Daboecia cantabrica (Huds.) K. Koch (Ericaceae)
Georg Dionysius Ehret
1766, watercolour and pencil on paper
317mm x 205mm (12½in x 8in)

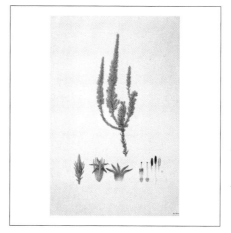

When Ferdinand Bauer was painting the Australian flora, the best way to make colours was by using natural products. The brilliant blues in the flowers of this striking plant probably come from ground lapis lazuli, a semi-precious stone from the Afghanistan region. Bauer ground his own colours – both on the Investigator voyage and back in London, he had little assistance.

Foxtail
Andersonia caerulea R. Br. (Epacridaceae)
Ferdinand Bauer
c. 1803–1814, watercolour on paper
525mm x 357mm (20¼in x 14in)

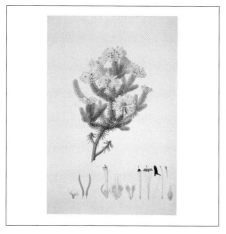

This lovely heath from the eastern half of the Cape Peninsula takes its common name from the incredible variability in its flower colour. The flowers can be white, yellow, orange, purple or greenish, and are also often bi-coloured, with a ring of white at the tip. The scientific name comes from the leaves, which are longer than those of many other Cape heaths.

Vari-coloured Heath
Erica longifolia Donn. (Ericaceae)
Franz Bauer
c. 1790s, watercolour on paper
522mm x 354mm (20½in x 14in)

The incredibly accurate depictions of Australian plants that mark the Investigator voyage were not done in the field. Bauer would have sketched this plant, annotating it using numbers from his complex colour chart so he could reproduce it accurately. Then later on, back in England, he would work the sketches up into finished paintings, helped by examination of herbarium specimens collected by Brown and plants grown in the gardens at Kew.

Dracophyllum secundum R. Br. (Epacridaceae)
Ferdinand Bauer
c. 1803–1814, watercolour on paper
525mm x 355mm (20½in x 14in)

In Greek and Roman mythology, Iris is the messenger of Juno, queen of the gods. She is goddess in her own right, and descends to earth bringing messages from Heaven on the rainbow, a glowing arc of colours down which she glides. The poet Ovid, writing at the time of the Roman Emperor Caesar Augustus and the birth of Christ, gives a Roman version of the story of the Flood, with Jupiter sending down rains to drown the human race, but Iris, acting as Juno's envoy, gathers the waters and refills the clouds. At the time, the ends of the rainbow were thought to gather the water that fell as rain and send it back to the clouds. Iris is clothed in robes of 1000 hues, and brings messages of hope to mortals. She is also a purifying force, for when Juno returns from irises. These can be seen in Roman mosaics and were apparently cultivated on a massive scale all around the Mediterranean Sea. The mourning iris, *Iris susiana*, with its peculiar, almost-black-and-white flowers, is thought to have been cultivated by the pharaohs of Egypt as a magical flower. After the fall of the Roman Empire and the rise of the Christian kingdoms in Europe, the iris retained its popularity, and was widely cultivated in monastery gardens. Arabian physicians also extolled the medicinal properties of the plant. Some time during the Middle Ages the flower became known as the ' fleur de luce' or 'fleur-de-lys'– and passed into heraldry as the emblem of French royalty. There is some debate about whether the fleur-de-lys is based upon the iris or a lily (*lys*

IRISES

Melted to one vast Iris of the West,
Where the Day joins past Eternity;
While, on the other hand, meek Dian's crest
Floats through the azure air — an island of the blest!

CHILDE HAROLD'S PILGRIMAGE (LORD BYRON, 1818, CANTO THE FOURTH, VERSE XXVII (1818)

her vengeful descent into Hell, in breach of divine convention, Iris 'purged her with sprinkled drops of cleansing rain'.

Iris plants were certainly known to the ancient Greeks and Romans: orris root, a delicately violet-scented powder used as a fragrance and in the spicing of wine, is made from the roots of *Iris pallida* or *Iris florentina*. In Greece, Theophrastus first named the plant after the goddess of the rainbow, perhaps showing that, even then, the flowers were of many hues. Stylized depictions of iris flowers can be found in Minoan art from the island of Crete, and peasants cultivated the plants as a valuable snake-bite cure, as well as for their use as remedies for stomach complaints and teething pains. The irises cultivated at the time of Christ were the bearded is the French for 'lily'), but irises were known as a form of lily at that time. Although both the lily and iris are monocotyledons – plants with one seedling leaf, leaves with parallel veins, and flowers with parts in threes – they differ significantly in terms of their leaf form and flower structure.

The iris leaves are the root of some of their many common names in English – such as *segg* or *gladwyn* (both Old English or Anglo-Saxon words meaning 'sword'). Leaves of all members of the iris family – the Iridaceae, which includes many genera and species found all over the world, but its highest diversity is in South Africa – are laterally compressed, and the base of the plant is flattened and stiff. The stiff leaves of many species do indeed

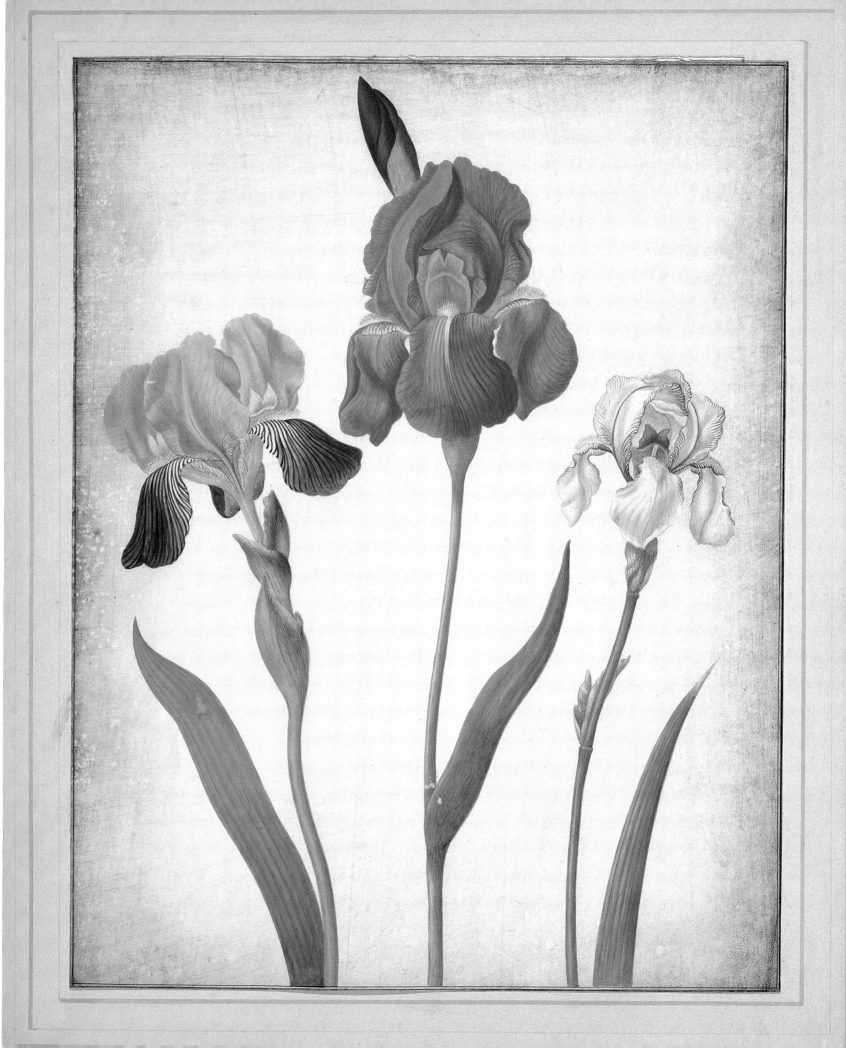

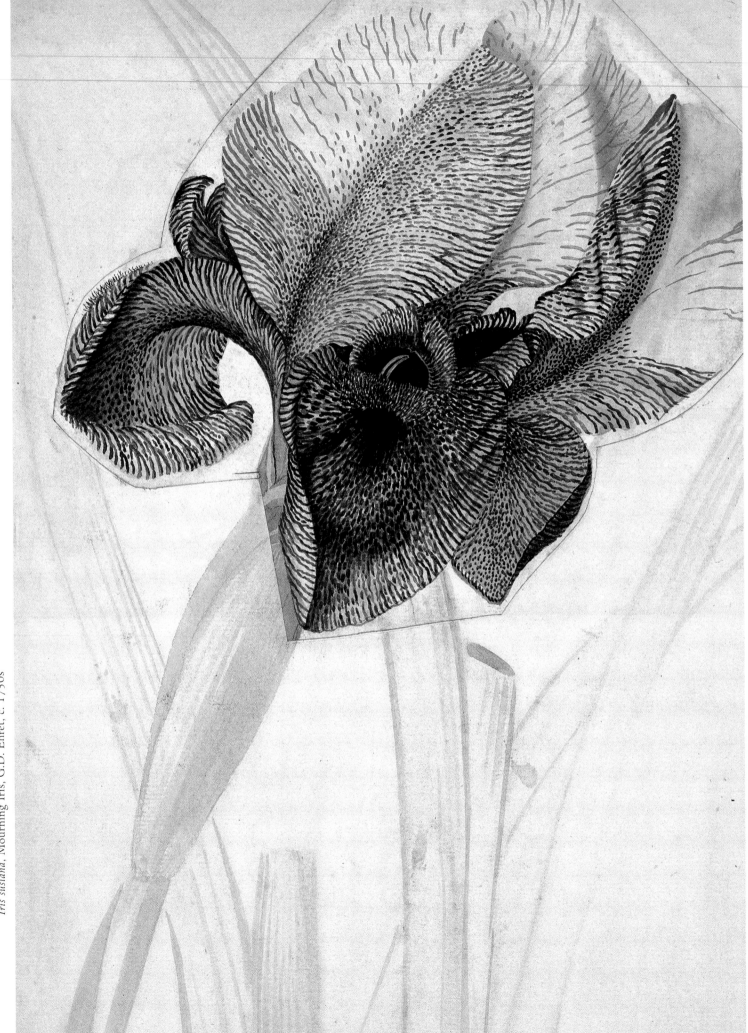

Iris susiana, Mourning Iris, G.D. Ehret, c. 1750s

resemble swords, but iris flowers differ so radically from those of other monocots, such as lilies, which usually have six undifferentiated 'tepals' and a similar number of stamens. At first glance, the flower of a cultivated iris is quite mystifying, for where are the stamens and what are all those petals doing, some up and some down? The typical iris flower has six tepals, just like a lily, but they are in two groups of three – the standards or the upward-oriented set of three, small in some species, huge in others like the mourning iris; and the 'falls' or downward-pointing set, which have a ridge along the central line that is often brightly coloured or 'bearded'. Above each of the falls there is a stiffer, somewhat fleshier petaloid structure called the crest, and this is where the stamens and stigma, the working parts of the pollination system of the iris, are to be found. The three crests are the three lobes of a single structure arising from the top of the inferior ovary and are essentially a modified style and stamens fused. In some species of the genus *Iris*, the crests and falls are held in such a way that they form three tubes, each with a landing platform signalled by the coloured ridge at the midline of the fall. A bee searching for nectar would go into the tunnel in search of nectar (held at the base of the floral tube, and copious in most irises) and be brushed on the back by the anthers and have pollen left on her, or touch the receptive stigma and effect cross-pollination. The intricacy of structure that is so apparent in *Iris* flowers has a utilitarian purpose as well as being pleasing to the eye.

The cultivated irises fall into three main categories which, though not necessarily taxonomically neat, are practically distinguishable. The first main division is between irises that have rounded bulbs as their underground storage organs, and those that have rhizomes (horizontal creeping stems). The bulbous irises have sometimes been taxonomically split as several different genera – with romantic names such as *Juno* and *Iridodictyum* – but they share so much with the rhizomatous cousins. These tiny plants, among the first to bloom in the spring, are native to a broad swathe of southern Europe and Asia, from southern France and Spain to

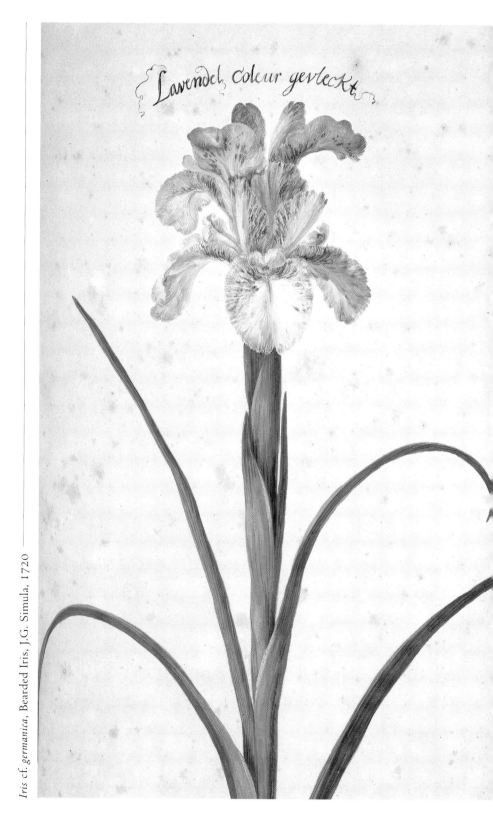

Iris cf. germanica, Bearded Iris, J.G. Simula, 1720

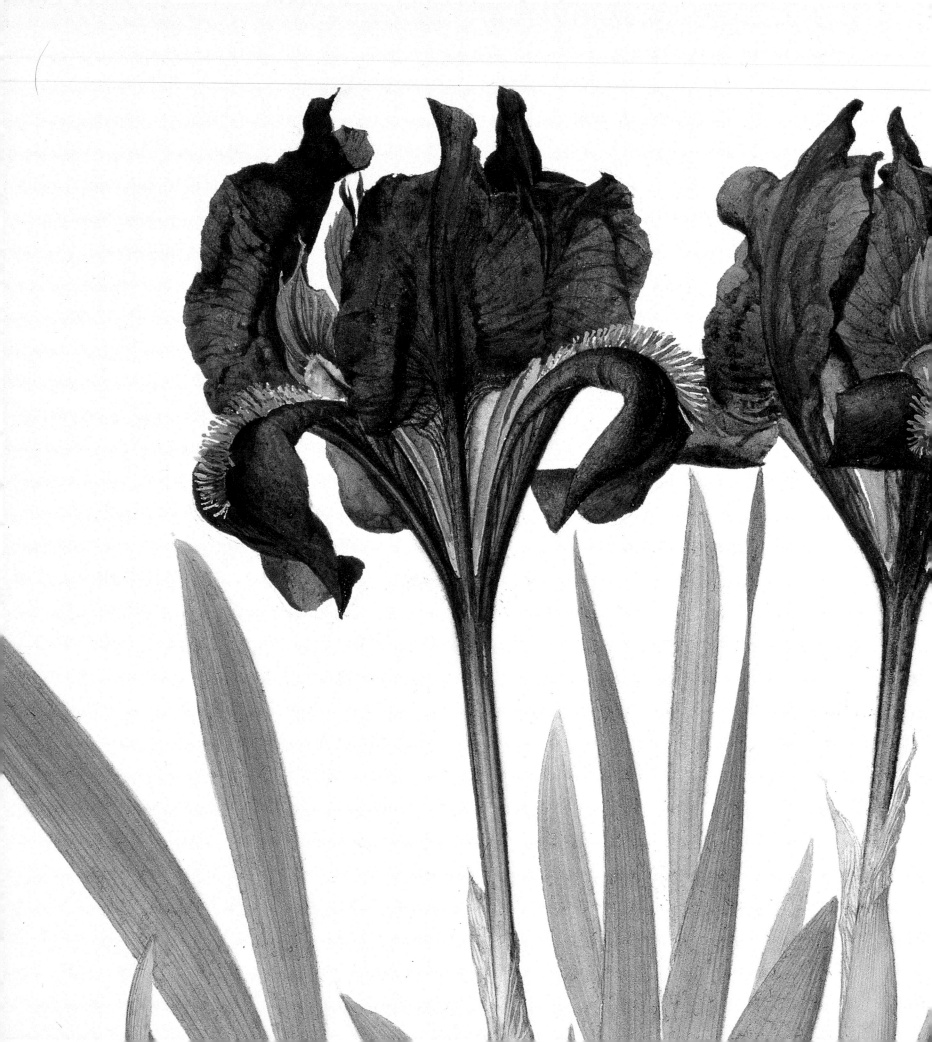

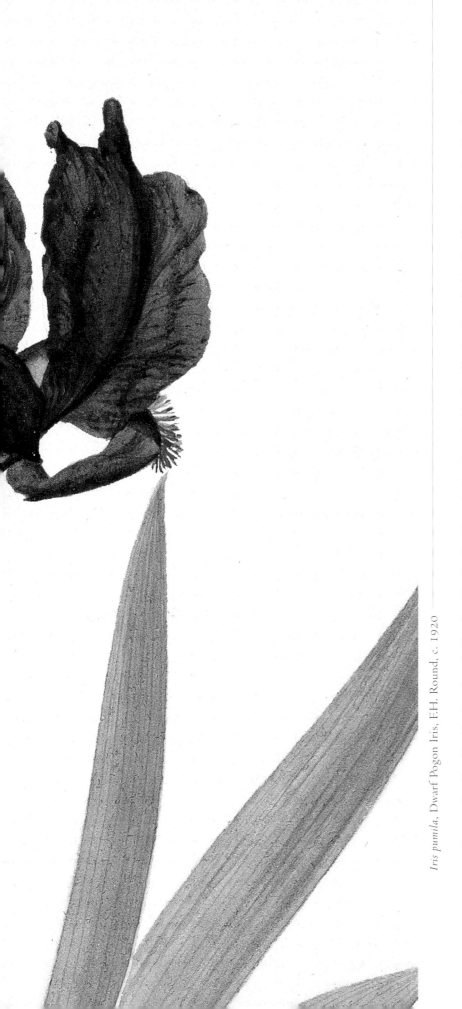

Iris pumila, Dwarf Pogon Iris, F.H. Round, c. 1920

Turkey and Israel to Central Asia. Dry, stony soils are their native habitat, and these seemingly delicate plants are in fact incredibly tough: some species can withstand freezing temperatures without damage to the flowers.

Rhizomatous *Iris* species are either bearded (*Pogoniris*) or beardless, also known as crested (Apogons) – in reference to the middle line of the fall, which is brightly coloured in almost all species, but in the bearded varieties has a brush of hairs that frequently contrasts markedly with the colour of the flower itself. The beard perhaps serves to catch any pollen that drops from the anthers and to prevent its wastage by brushing in on the undersides of bees as they visit the flowers in search of nectar. The bearded irises are native from the Mediterranean and on to Central Asia, and have spread far and wide in cultivation. Mr William Rickatson Dykes, a schoolmaster at Charterhouse School in southern England and an 'amateur' iris expert working in the early part of the twentieth century, expressed fascination with the fact that a red-purple variety of *Iris aphylla*, a Central European species, had 'by some unknown means…run wild in Kashmir'. Many of the plants that are known as species of bearded iris are in fact very old stabilized hybrids and the antiquity of iris cultivation makes their taxonomy extremely difficult. The lovely white species *Iris albicans* is probably native to the Arabian peninsula and was spread all over southern Europe in company with Islam. It was an important graveyard plant, and was later taken by the Spanish to the New World. Bearded irises have flowers in an incredible range of watercolour shades – purples, pinks and yellows, and almost every species or cultivar has an albino form as well. They truly are the flowers of the rainbow – and Byron's comparison of the evening sky (with its translucent wash-like quality) with an *Iris* is more apt now than ever before, as more and more colours are produced by ever-more-sophisticated hybridization.

It is the bearded irises that have contributed the blowsy standard petals to the cultivated forms, for the non-bearded irises (Apogons) are altogether more compact and more streamlined.

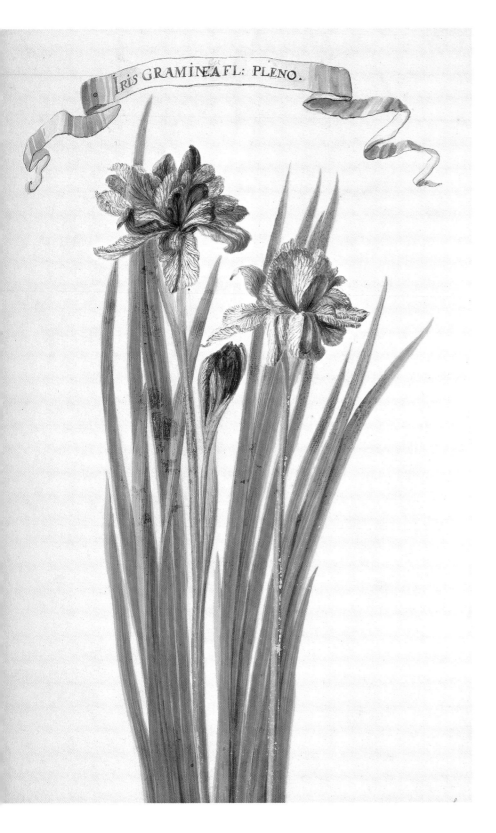

This is by far the most species-rich part of the genus, and has contributed five of the six main groups of iris used in creating garden hybrids (the sixth group contains the bearded types). The flowers of these irises have a smooth shiny centre to the fall, but the midline is marked with spectacular patches of brilliant colour or darkened veining. The five groups used in breeding come from all over the northern hemisphere, from Europe and continental Asia, Japan and North America.

Japanese irises are much loved in Japan and have been cultivated for more than 500 years. They are extremely flat flowers when compared to their bearded cousins with large, frilly and erect standards, but Japanese cultivated forms include doubles and very frilly varieties – all of them flat and dish-shaped. The wild species *Iris ensata* (formerly known as *Iris kaempferi*) is a lovely meadow plant, but is often pictured growing in the vicinity of temples and along small streams. The first European botanists to visit the kingdom of Japan were Engelbert Kaempfer, whose name is remembered in *Iris kaempferi,* and Carl Thunberg, who coined the name *Iris ensata.* The German botanist Philipp Franz Siebold, who visited Japan as part of a Dutch diplomatic mission in the mid-nineteenth century, decided to name the iris in honour of Kaempfer. The rules of botanical naming are based upon a principle of priority, where the oldest name – that proposed first in the botanical literature, published and distributed widely – is the correct name and takes precedence over other names for the same species. Thunberg, however, had named the same plant *Iris ensata* some sixty years earlier.

Poor old Kaempfer: not only is his iris no longer known by his name, but while he was in Japan in the late seventeenth century he was treated like a performing animal. Both Kaempfer and Thunberg were employed by the Dutch East India Company, who had established a trading base at Deshima – a tiny artificial island connected by a causeway to the mainland port of Nagasaki. Regulations placed upon the Dutch by the Japanese emperor were draconian: they were only allowed to send two or three ships a year

Iris sibirica, Siberian Iris, J.G. Simula, 1720

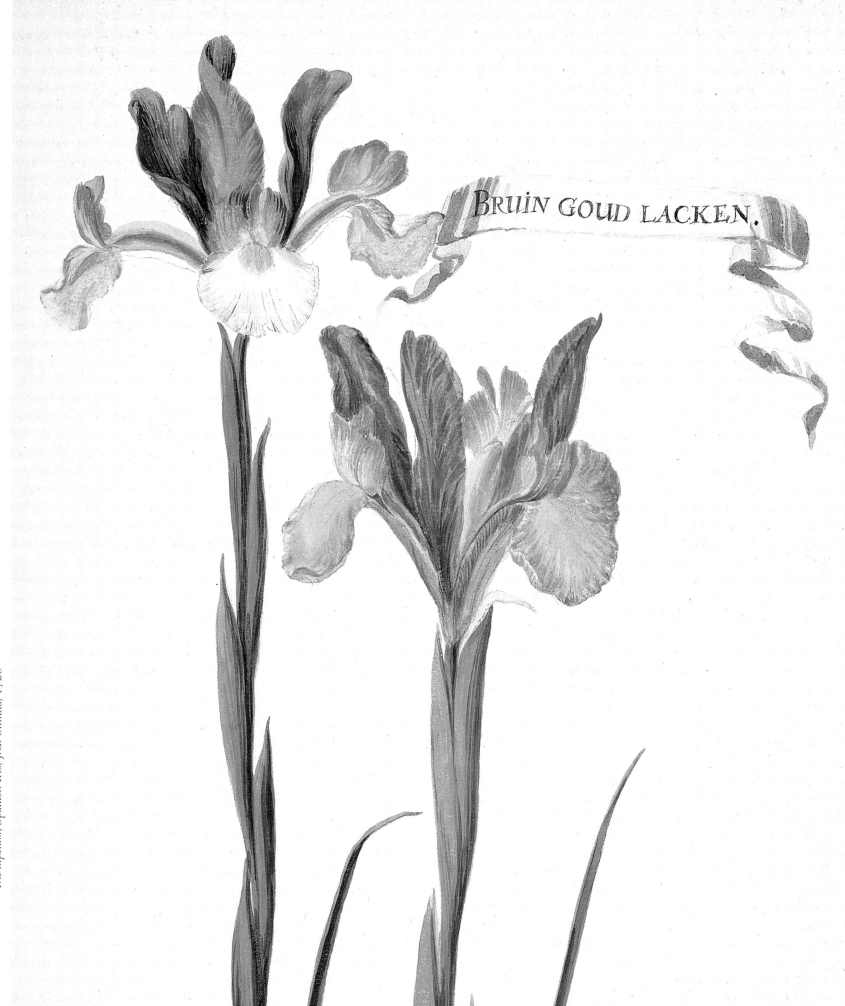

Bruin Goud Lacken.

Iris xiphium, Spanish Iris, J.G. Simula, 1720

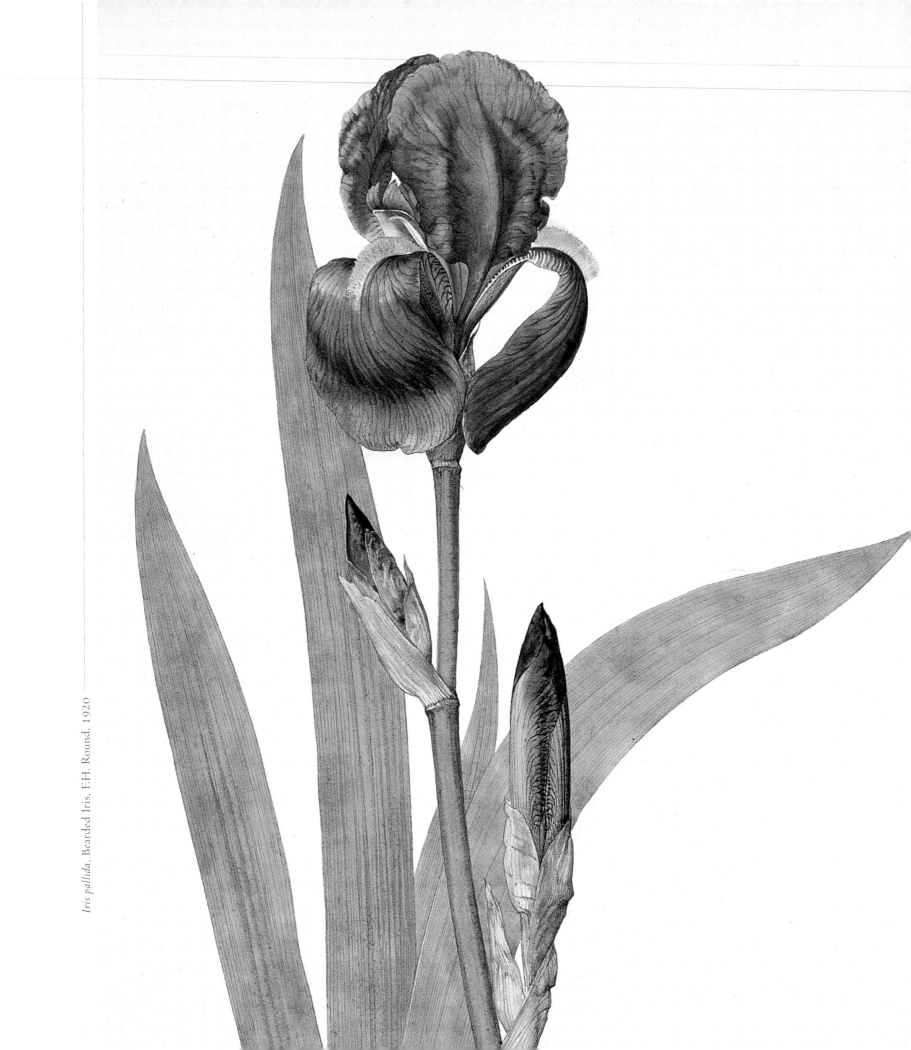

to Japan, and all operations (limited to twenty Europeans), all unarmed, were strictly supervised by an army of observers. The visitors were sworn not to fraternize with the Japanese by complex oaths sealed with ink and blood. Once a year they were expected to send gifts to the imperial court in Tokyo, and this was the only opportunity any European had to see any part of the country other than Deshima itself. Kaempfer went to Japan in 1690, and twice made the overland journey to Tokyo bearing gifts for the emperor. He was guarded by day, locked in at night and was made to sing and dance, showing European customs not only to the emperor and his consorts, but in the many palaces of the nobility along the way. He was, however, allowed to carry a box, into which he put pieces of plants to illustrate later. His Japanese escorts apparently thought this harmless, and they helped with the names and uses, offering a great deal of information to the curious Kaempfer. He published an account of his travels when he returned to Europe, one section of which is devoted to botany, with descriptions and illustrations of some 400 plants. Kaempfer provided the first glimpses of what was a completely unknown world scientifically, though Japan was not to be opened up to Europeans again until 1868, nearly 200 years later. He truly lived up to his Japanese *han*, or signature seal, of *Ken-pe-ru* (which, translated, means 'for the courageous, there is nothing impossible').

Carl Thunberg was a student of the Swedish botanist Carl Linnaeus, one of whose main aims was to send his pupils out into the world to collect plants and bring them back for his study and description. In 1776, Thunberg went to Japan, via South Africa and a journey of some five years. At the time of his visit, the strictures placed upon the Dutch traders were more severe on the trading front, but more relaxed on the social side. Thunberg was allowed to go ashore as often as he liked, but this could get expensive, as each time he went ashore he had to be accompanied (like Kaempfer) by up to 200 'minders', all of whom needed to be fed and entertained, but in the springtime of his visit he was botanizing as much as twice a week. His journey to Tokyo was a far more social affair than

Kaempfer's had been – he met many Japanese scientists, mostly doctors who wanted to consult him about their patients (whom he was not allowed to see), and astrologers. He was given books, Japanese herbals and maps, and once he returned to Sweden he maintained contact with his Japanese friends, who even sent him seeds and plants. Thunberg seems to have been a bouncy character, for he comments cheerily on everything in Japan, from the superiority of their roads to the beauty of the flora. He established a garden on Deshima, and when he left he took with him many living specimens of the Japanese flora, sent to the medical gardens in Amsterdam that were owned by the Dutch East India Company. Thunberg published his flora of Japan in 1784. Here he described for the first time, using the new system of naming established by Linnaeus (binomial nomenclature), *Iris ensata* – the Japanese iris.

Other groups of beardless iris used in the creation of garden hybrids are the grass irises of northern Asia – including *Iris sibirica*, which along with the bearded irises was cultivated in medieval gardens, and the lovely Chinese species *Iris chrysographes*, described by Dykes as 'of the richest dark red-purple, very velvety in texture, and set off by the central and broken flanking lines of gold, which suggested the name of the species'. Then there were the Steppe irises of the southern edge of the European and Asian temperate zone (especially species rich in the Caucasus), and two groups of North American irises, the Pacific Coast species and the Louisiana species. The Pacific Coast irises are native to the western United States, from California to Oregon, and are easy to cross with the Steppe irises, as they have the same base chromosome number. These California natives do extremely well in England, due to the wetness of the winter months. The Louisiana irises are plants of swampy ground, and

Iris latifolia, English Iris, A.H. Church, 1907

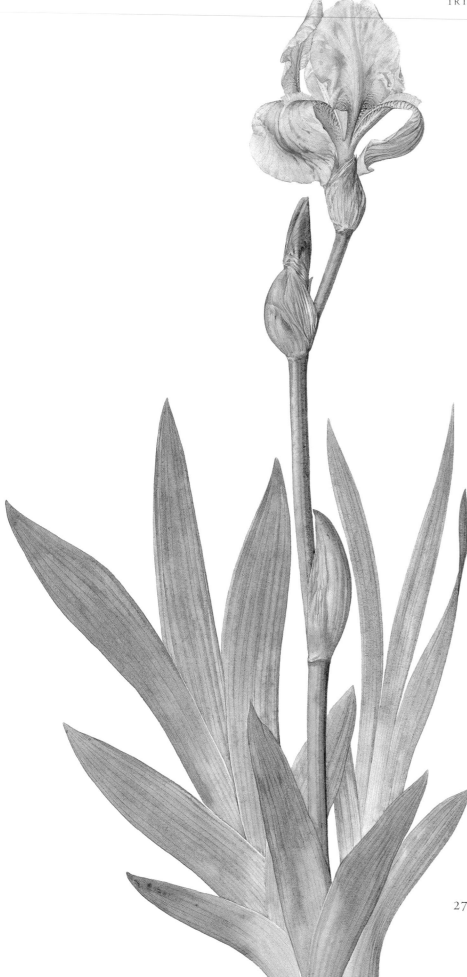

have among their species the 'terracotta'-coloured, naturally occurring hybrid *Iris nelsonii*. These irises hybridize freely in nature. The early twentieth-century American botanist Dr Edgar Anderson was fascinated by natural hybridization. He studied the swarms of hybrid forms and used the Louisiana irises – among other naturally hybridizing plants – to invent a way of studying and quantifying hybridization in nature, the hybrid index. Anderson's method of constructing hybrid indices was used for many years as a means of assessing intermediate morphology. Today, we can build on his beginnings by constructing chromosome maps and using DNA sequences to investigate hybridity.

Hybrids between the six groups are extremely rare, but they do occasionally occur: Dykes created one between a bearded species and a Steppe iris, but the resultant plants were sterile and could only be propagated vegetatively. Within the groups, however, crosses are easy and can occur in nature and in the garden. Most of the bearded irises grown in gardens are hybrids; and indeed many of the plants described as good species by earlier botanists were shown to be of hybrid origin when they were cultivated and used as the parents of further attempted crosses. Plants have been cross-bred for millennia, sometimes accidentally and (more often) on purpose. It was long thought that the ancients did not cross-pollinate flowers to create new varieties, and that they did not really understand plant reproduction at all, but this is almost certainly wrong, as it seems unbelievable that any people who were so dependent on plants for their food and medicine were not good observers as well. Today's plant breeders can create new varieties using an ever-increasing toolbox of techniques, from chromosome doubling to embryo culture, and iris breeders use these methods to create flowers with new colours and shapes, or just to try to see what they can do.

Nature has done a great deal with the iris, helped and hindered by humans over the centuries. The cultivated iris is a prime example of how the common names of plants can be fantastically out of step with the reality of their origins. For

Iris pallida, Bearded Iris, F.H. Round, 1920

276

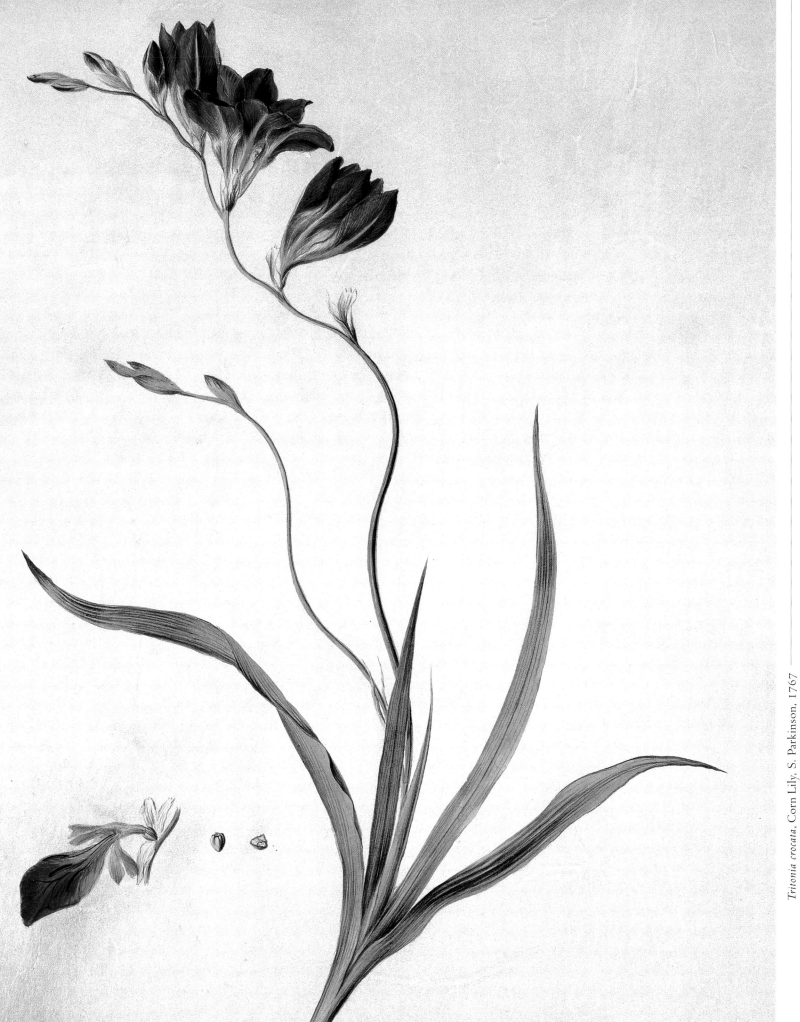

Tritonia crocata, Corn Lily, S. Parkinson, 1767

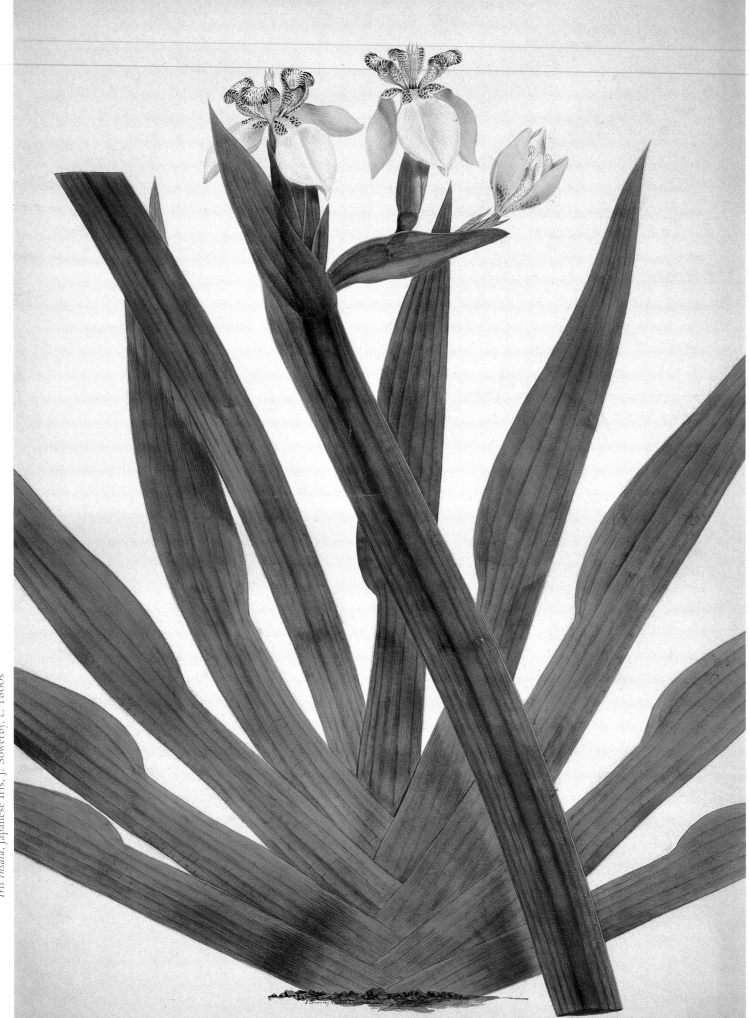

example, the German iris (*Iris germanica*), one of the earliest bearded irises of gardens, was named by Linnaeus for its supposed country of origin. Plants were found along the walls of medieval German castles, but the plants never gave true seed and, when breeders tried to use it as a parent for the development of new hybrids, these were invariably unsuccessful. The 'species' has a chromosome number of $2n=44$, suggesting to today's iris experts that it is an ancient hybrid between two native bearded irises, but no one is yet sure. The Florentine iris, *Iris florentina*, one of the sources of valuable and delicately scented orris root, is another such ancient hybrid.

The common names of plants are often misleading – as are scientific names sometimes. This is especially true when a name is coined to reflect origins. *Iris germanica* was found in Germany, but almost certainly did not have its origins there. Its origins, and its parents, are lost in the mists of time. Other species, however, despite their scientific 'misnomers', have stories that can be traced back to their roots. The bulbous English iris, described in the seventeenth century as *Iris anglica* – now correctly known as *Iris* (Xiphium) *latifolia* – was thought to be English, but in fact it was only English in a fleeting way. Sailors collected the bulbs in the Pyrenées, or traded for them in the northern ports of Spain, and brought them to Bristol, where they were again traded to continental (mostly Dutch) bulb growers. The famous Dutch irises are members of this same Xiphium group. These irises are the most commercially successful of all, as the flowers are easy to force, so they can be sold all year around. The beauty of irises is not only their endlessly changing flowers in sky-washed hues, but also the facility with which they cross and the readiness with which new types can be made. The dogged persistence of irises – through centuries of neglect, like *Iris germanica* along the walls of crumbling medieval castles, or *Iris albicans* in Islamic graveyards along the Mediterranean, by vegetative reproduction through rhizomes – surely shows us that not all good things are meant to disappear.

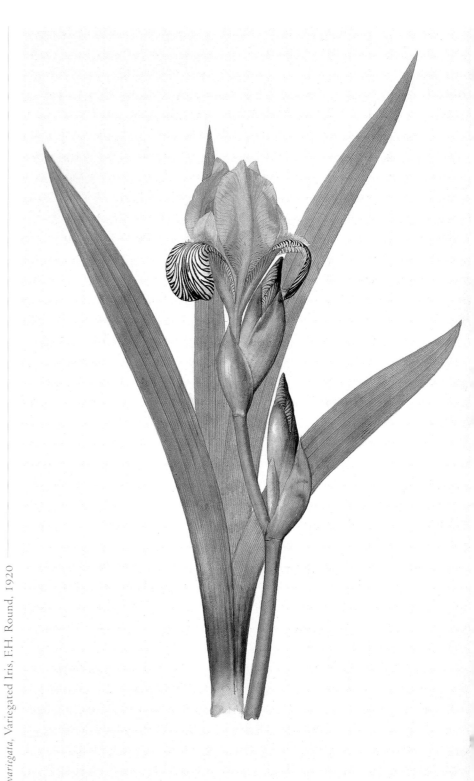

Iris variegata, Variegated Iris, F.H. Round, 1920

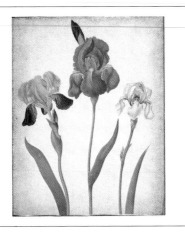

Sacheverell Sitwell, writing in the early twentieth century in praise of old-fashioned flowers, expressed his opinion with great certainty on the difference between nature and technology: 'The last engine, or motor or aeroplane is always the best, until the next one is made. But in music, in painting, or in the art of the florist…the first is nearly ever the best. Nothing that comes after is so good.'

Bearded Iris
Left: *Iris germanica* L.; Right: *Iris pallida* L. (Iridaceae)
Maria Sibylla Merrian, Dutch Collection
Late 1600s, bodycolour on vellum
336mm x 268mm (14½in x 10½in)

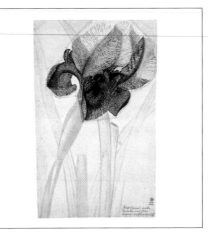

The spectacular mourning iris was probably introduced to Europe from the Turkish court by Ogier Ghiselin de Busbecq in 1573. He sent plants to the Viennese court and they spread from there – Iris susiana has been vegetatively propagated ever since and all the plants cultivated today are likely clones of that original introduction. This species is a probable product of cultivation and may never have occurred in the wild. Susan means 'iris' in Arabic.

Mourning Iris
Iris susiana L (Iridaceae)
Georg Dionysius Ehret
c. 1750s, watercolour on paper
360mm x 220mm (14¼in x 8¼in)

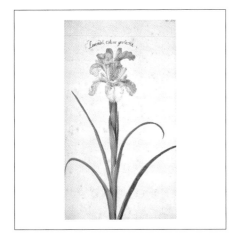

Painting in northern Germany, Johann Simula probably had access to a great many Dutch cultivars of popular flowers. This bizarre, almost deformed iris ('Lavandel coleur gerleckt') is probably of Dutch origin. The florists – flower breeders – of Holland specialized in tulips, irises and hyacinths, all of which they developed into hundreds of amazing cultivars.

Bearded Iris
Iris cf. *germanica* L. (Iridaceae)
Johann Gottfried Simula
1720, bodycolour on paper
455mm x 285mm (18¼in x 11¼in)

This tiny dwarf plant is one of the best known of the small pogon irises and is much used in iris breeding. Iris pumila itself is a species of hybrid origin, a cross between Iris pseudopumila and Iris attica – whose distributions overlap along the Adriatic in the former Yugoslavia. The hybrid was vigorous, and spread all over eastern Europe as far as the Urals.

Dwarf Pogon Iris
Iris pumila L. (Iridaceae)
Frank Howard Round
c. 1920, watercolour on card
341mm x 250mm (13½in x 9¼in)

Doubled irises like this one, labelled by Simula as 'Iris graminea flore pleno' ('Grassy-leaved iris with a full flower'), are no longer commonly found in cultivation. This is not surprising perhaps, for part of the beauty of the iris flower is in its arrangement of parts. This intricate arrangement is completely hidden when the doubling up occurs and turns the centre into a pompom-like mass.

Siberian Iris
Iris sibirica L. (Iridaceae)
Johann Gottfried Simula
1720, bodycolour on paper
455mm x 285mm (18¼in x 11¼in)

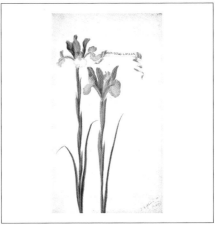

The xiphium irises are among the most prized for the cut-flower trade. This variety, 'Bruijn Goud Lacken', may be a plant of the species Iris xiphium, but could also be a hybrid between Iris xiphium and Iris tingitana, a related species from North Africa. Dutch flower breeders were active in improving irises, as they were with many other plants, and these hybrids are known as Dutch irises.

Spanish Iris
Iris xiphium L. (Iridaceae)
Johann Gottfried Simula
1720, bodycolour on paper
455mm x 285mm (18¼in x 11¼in)

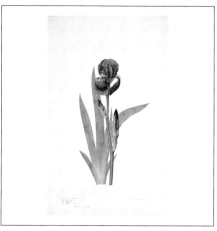

Both var. ciengialtii *and var.* illyrica *are subspecific divisions of* Iris pallida. *This plant, identified as 'Ciengialte illyrica Mt. Spaccato nr Trieste, Austria 1913, Bed I-3 Oundle' by Round, is possible evidence that those categories grade one into the other. The varietal differences are in plant stature and beard colour – in var.* ciengialtii *it is white, and in var.* illyrica *it is yellow.*

Bearded Iris
Iris pallida L. (Iridaceae)
Frank Howard Round
1920, watercolour on paper
544mm x 342mm (21½in x 13½in)

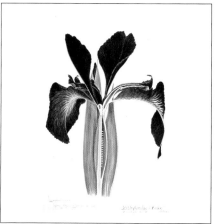

The English iris is a misnomer: it is an iris, but most certainly is not English. In the sixteenth century, Flemish herbalist Matthias de l'Obel saw plants of this iris near Bristol. He communicated his discovery to his botanical colleagues and the common name stuck. The plants he saw had been brought back from northern Spain by an English sailor: this species only grows in the Pyrénées.

English Iris
Iris latifolia Miller (Iridaceae)
Arthur Harry Church
1907, bodycolour with watercolour and gum arabic on Bristol board, 317mm x 209mm (12½in x 8¼in)

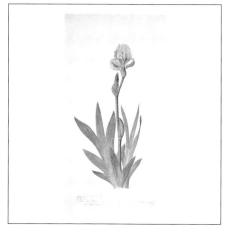

Round has labelled this painting 'Ciengialte illyrica (white) Mt. Spaccato nr Trieste, Austria 1913 WGD, Bed K78 Oundle'. William Dykes collected extensively in the Balkans just before World War I, and perhaps this is one of his collections, but what a volatile time to be travelling around Central Europe collecting plants!

Bearded Iris
Iris pallida L. (Iridaceae)
Frank Howard Round
1920, watercolour on paper
555mm x 291mm (21¼in x 11½in)

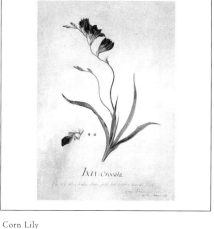

*The montbretias (*Tritonia *and a related genus in the Iridaceae,* Crocosmia) *are native to South Africa, a centre of diversity in the family Iridaceae. This may have been one of the last paintings young Sydney Parkinson did before he set out on his epic (and fatal) voyage aboard Captain Cook's* Endeavour. *The ship left Plymouth harbour on 25 August 1768, but on 26 January 1771 Parkinson died aboard ship in the Indian Ocean, west of Java.*

Corn Lily
Tritonia crocata (Thunb.) Ker Gawl (Iridaceae)
Sydney Parkinson
1767, watercolour on vellum
400mm x 285mm (15¼in x 11¼in)

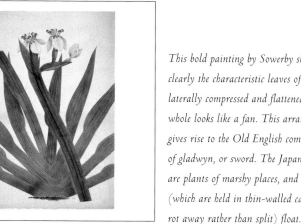

This bold painting by Sowerby shows clearly the characteristic leaves of irises – laterally compressed and flattened, so the whole looks like a fan. This arrangement gives rise to the Old English common name of gladwyn, or sword. The Japanese irises are plants of marshy places, and their seeds (which are held in thin-walled capsules that rot away rather than split) float.

Japanese Iris
Iris ensata Thunb. (Iridaceae)
James Sowerby
c. 1800s, watercolour with bodycolour on paper
506mm x 347mm (20in x 13¼in)

The Rothschild estates at Tring from which Round was sent these irises for painting – this one was probably collected by Dykes as 'variegata stanimaka, Bulgaria nr. Stribrny 1913, Bed F14 Tring' – were a haven for natural history. In 1937, they were passed to London's Natural History Museum by Walter, the second Baron Rothschild. Today, the museum's bird section is housed at Tring, along with a small museum focusing on the diversity of animal life.

Variegated Iris
Iris variegata L. (Iridaceae)
Frank Howard Round
1920, watercolour on paper
483mm x 355mm (19in x 14in)

The true blue of many gentian flowers is unusual among flowering plants: blues and reds in flowers are made by chemical compounds called anthocyanins, and different anthocyanins give the flower the blue and red shades we see. Although we think of them in terms of the deepest, darkest blues, however, gentians are by no means all this colour. In fact, they come in an astonishing range of colours – from white, to white with purple specks, to green with dark-green and purple stripes, to the 'hellish' dark blue of D.H. Lawrence's Bavarian gentians.

The dark colour of Lawrence's alpine gentian, as well as its lowly stature, led him to consider it the flower of death and a harbinger of bad news. This is not necessarily the case, though, for

named (appropriately) after the gentian itself. These compounds are among the most bitter substances known, so if the old adage 'If it tastes bad it must be good for you' is true, gentians must be terrific! Tonics prepared from gentian root have been used for stimulating the digestive system and enhancing appetite. Gentiopicrin causes a slight elevation of blood pressure, which is perhaps the reason for the digestive effects. Gentian distillations have also been used as a cure for malaria, as are many bitter plant substances – a tradition that probably goes back to before King Gentius. Magical uses, too, have their place: gentian root has been used as an antidote to poison, against witchcraft and as an antidote to love. Gentian schnapps is prepared from the roots of *Gentiana*

GENTIANS

Bavarian gentians, tall and dark, but dark
darkening, the daytime torch-like with the smoking blueness of Pluto's gloom,
ribbed hellish flowers erect, with their blaze of darkness spread blue,
blown flat into points, by the heavy white draught of the day.

BAVARIAN GENTIANS (D.H. LAWRENCE, 1929)

gentians have long been prized for their medicinal properties – the scientific name of the genus itself is said to come from the second-century BCE King Gentius of Illyria, who caused a remedy for the plague to be made from a decoction of the leaves and roots of the plant. This story comes from Dioscorides and Pliny, among the founders of the ancient Greek medicinal and botanical tradition, and Linnaeus (who named the genus) must surely have heard the story as well as known of these two great men's scientific works. The medicinal properties of gentians are based upon the fantastically bitter properties of all parts of the plant, but most particularly their dried roots. The chemical compounds responsible for this bitterness are the glycosides gentiopicrin and amarogentin,

lutea, the yellow gentian, and is definitely an acquired taste (as the bitterness takes some getting used to), but is supposed to be good for an upset stomach.

Gentians are the quintessential alpine plants: small, intensely beautiful and sometimes difficult to cultivate. Alpine plants have long appealed to the imagination, perhaps because they grow in open places, where the view is spectacular and one can see far into the distance, or perhaps just because they are small and can be seen, in all their glory, in one glance. European rock gardens began as places to grow plants from the high Alps, a tiny piece of the bright freshness of the mountains at home. Joseph Banks, for example, had a rock garden at the Chelsea Physic Garden in the eighteenth

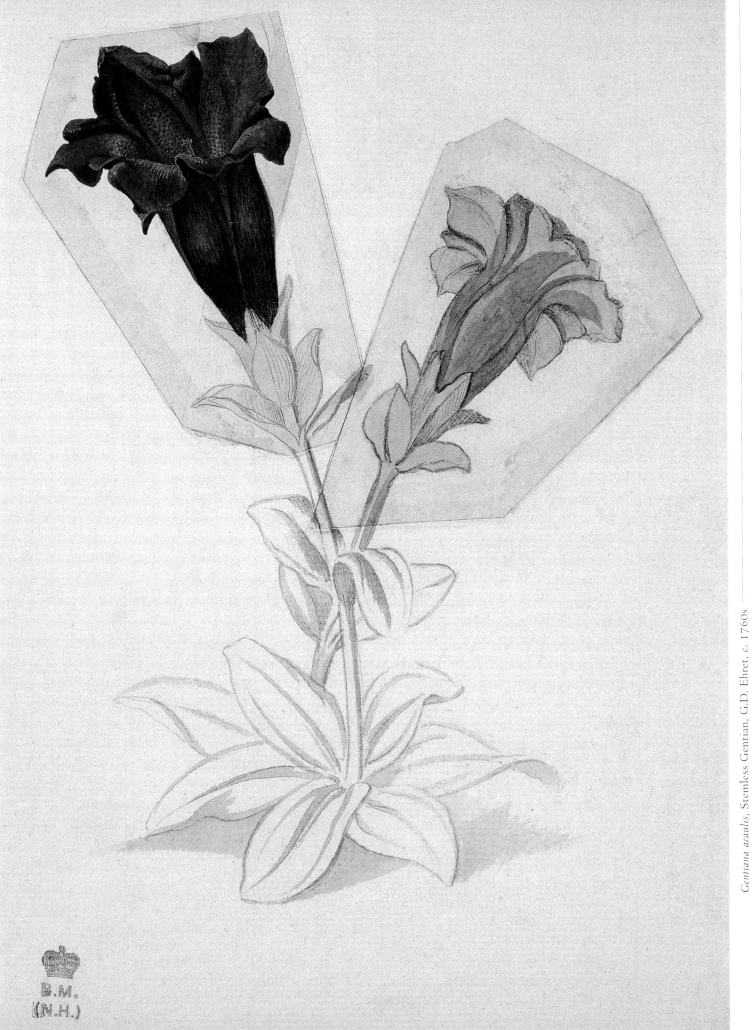

B.M.
(N.H.)

Gentiana acaulis, Stemless Gentian, G.D. Ehret, c. 1760s

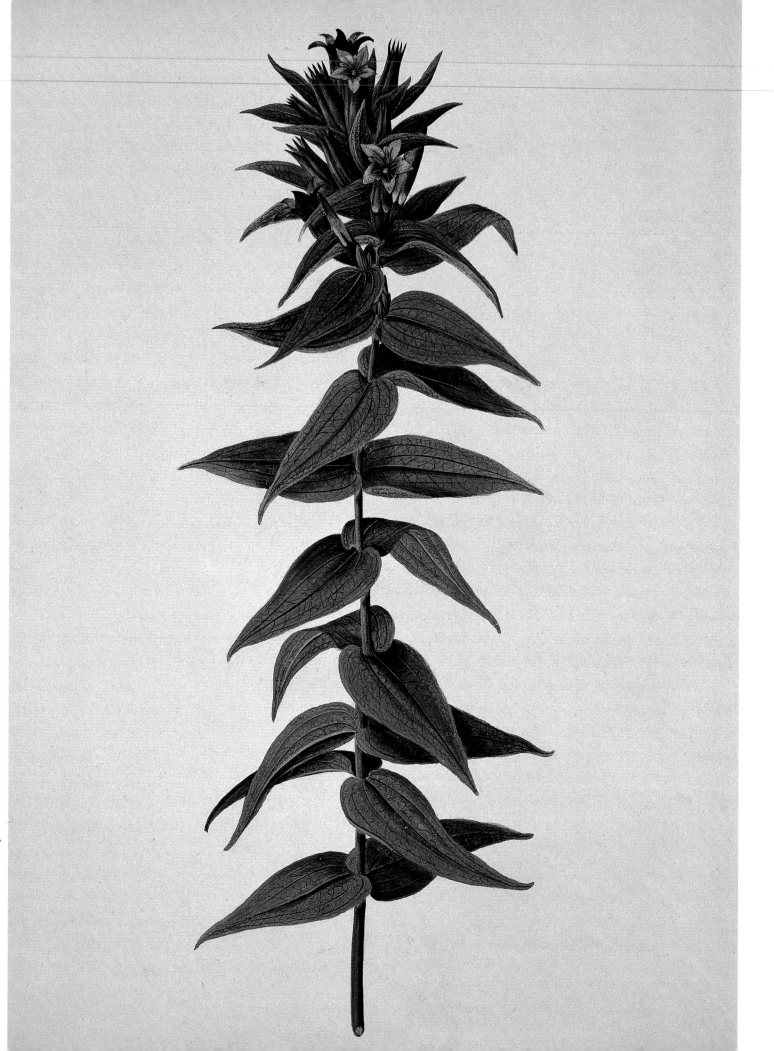

century, and plant hunting can be said to have begun in the Alps and other European mountains. The Central European mountains were a long way away for the ancient Greeks, but they knew plants from that area and used them in their medicine. Even early on, the Alps were relatively well-known botanically, and Carl Linnaeus described twenty-three species of gentians in his great work *Species Plantarum*. Rock gardens can be tricky things to get right, and many alpine plants have very specific requirements – even though in nature it looks like they grow readily wherever they find themselves. Even within the gentians, some species are lime-loving, and others acid-loving, while yet others need sun, or crave shade. This trickiness may be part of the attraction of these jewels for gardeners. Who among us can seriously resist a challenge, especially one where the results are so lovely?

Growing wild species can be challenging, but it is another challenge to create hybrids for the use of those gardeners who perhaps want an easy life, and who are attracted to the thought of growing the azure trumpets so reminiscent of the blue skies of the mountains. Many of the gentians cultivated in today's rock gardens are hybrids, often (but by no means always) less exacting than their wild progenitors. Species of gentians hybridize easily, and cross-pollination is relatively simple – pollen is transferred from one plant's stamens to another's stigma with a camel-hair brush. The ideal garden hybrid combines good characteristics of two different species, such as spring-flowering and extreme vigour. The deep-blue flowering gentians from the Alps are almost all spring-flowering, and are difficult to cultivate in rock gardens as their requirements are wildly different. Enter the autumn-flowering Chinese gentians, whose flowers are huge, brilliant blue and whose discovery presents as exciting a story as one could hope to find. The high mountains of the Himalayas still exert a powerful pull on the imagination – why else would trekking have become a multi-million-pound industry? Higher than the Alps, but similar to Europe in general climate, the Himalayas were a logical place to look for new plants for European gardens, and British seed

companies in the early twentieth century financed plant hunters to go there in search of treasure.

One such man was George Forrest, whose discovery of *Gentiana sino-ornata* made possible many of the wonderful hybrid gentians cultivated in the rock gardens of the twenty-first century. *Gentiana sino-ornata* is a fabulous plant: its solitary flowers are of the deepest royal blue, striped with darker purple on the outside, and are usually more than 6cm (2½in) long. Gazing into the trumpet, the pale base of the flower (striped with blue) only sets off the azure of the petals, so it is little wonder that Forrest was captivated by this lovely plant. The vigorous rosette of leaves and the habit of sending runners out from this rosette makes this species easy to propagate, and therefore also to maintain, in the garden. The species blooms in European gardens from September to December, and has been used as a parent in the hybridization of many of the most favoured cultivars.

Forrest, a Scotsman from Kilmarnock, was a natural plant hunter. He began work as a pharmacist's assistant, where he learned to use plants as medicines and some of the skills that helped him in his later life. When he came into a bit of money he packed his bags and went to Australia at the turn of the twentieth century, at the peak of the outback gold rush. He was just 18, and a hardy soul. When he returned to Scotland a few years later, he ended up

Gentiana pneumonanthe, Marsh Gentian, A.F. Happe, 1785

in the employment of Professor Sir Isaac Bayley Balfour, Regius Keeper (an appellation meaning 'director' – who says botany is not romantic or full of whimsy!) in the herbarium of the Royal Botanic Garden at Edinburgh. Forrest was a real individual, and was really much more at home out of doors than in an office. He lived outside the city and every day he walked to work – a mere 20km (12 mile) round-trip – and apparently refused to sit down while at work in the herbarium. Clearly, he was the logical man for Bayley Balfour to suggest to Mr Arthur Kilpin Bulley when he approached the Regius Keeper about plant hunting in China. Bulley, a wealthy cotton broker from Liverpool, was fascinated by the Chinese flora. He had met the famous Augustine Henry who, while in China in the 1880s as a Customs agent, had begun to be interested in botany when he was charged with the compilation of a report on the medicinal drugs used by the Chinese. Henry offered to collect specimens for the Royal Botanic Gardens at Kew, and these gatherings introduced many to the marvellous world of Chinese plants. Bulley had become enthused (by Henry) about obtaining Chinese plants for his new gardens near Neston on the Dee, but his attempts to obtain seeds from missionaries met with failure. In fact, he said that as a result of these efforts he had 'the best international collection of dandelions to be seen anywhere'. He needed to employ a collector of his own.

In August 1904, Forrest arrived in China (via Burma). Now Bulley's employee, and charged with collecting plant seeds in southeast Tibet and northwest Yunan for cultivation in Bulley's gardens, he spent the first few months of his stay in Tengyueh getting to grips with the place, making friends with the British Consul George Litton, who was also a keen and lively naturalist and lover of adventure. Together they set off on a trip to a French missionary station on the Mekong River, where the missionaries had been collecting some interesting plants, and Forrest determined to return the next summer to do some collecting of his own. The year 1905 was not a peaceful and pleasant time in this part of China, for the British army had invaded and taken over Lhasa, the

Gentiana acaulis, Stemless Gentian, G.D. Ehret, c. 1760s

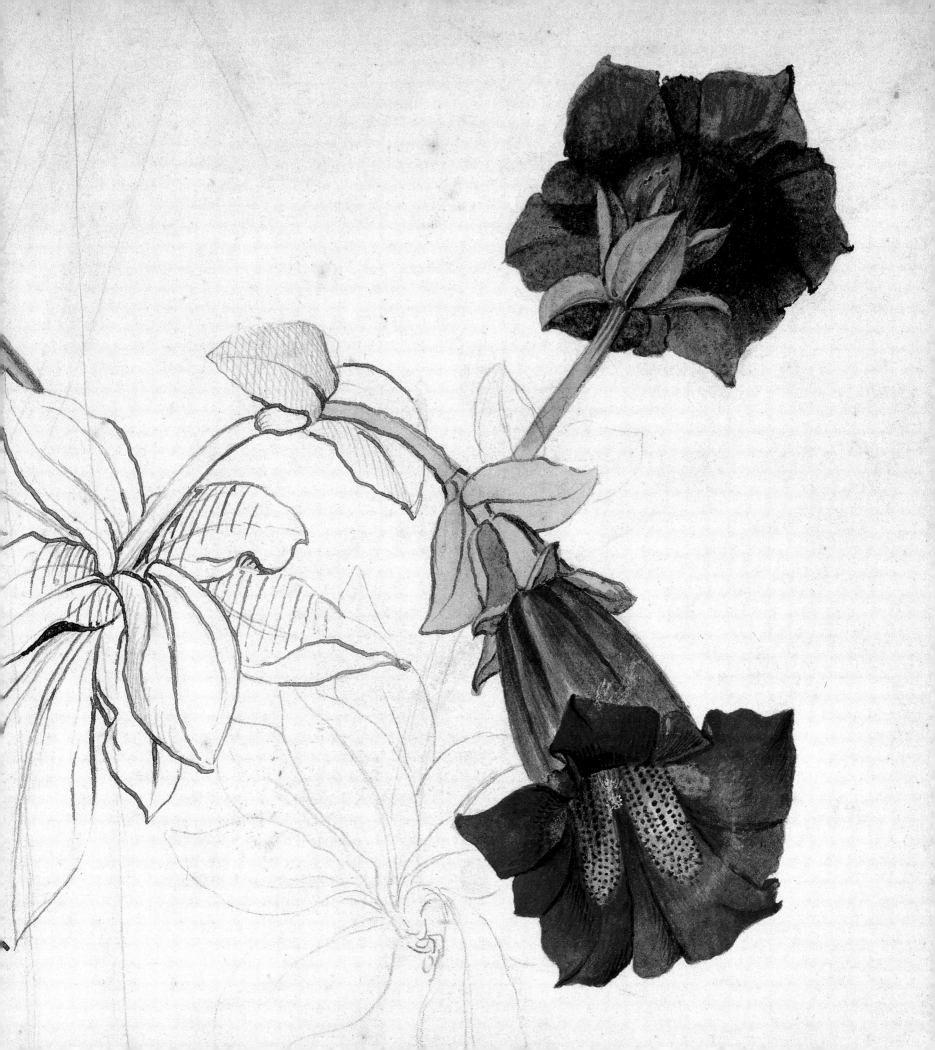

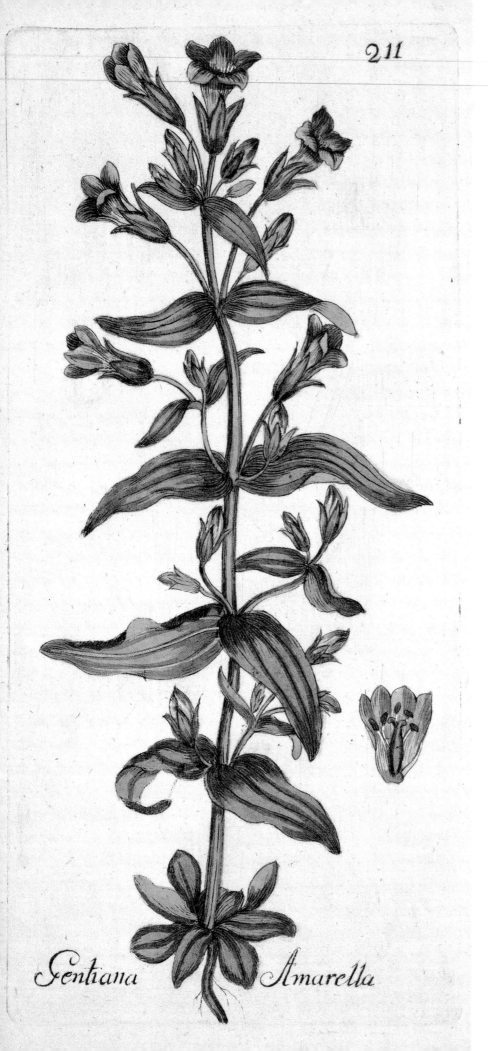

Gentiana Amarella

Holy City of Tibet, and the Chinese government was attempting to control the strategic Tibetan town of Batang. The Tibetan lamas were understandably enraged, and rose in revolt. First they executed the Chinese government official and all his followers in Batang, then the rebellion spread all along the Chinese–Tibetan border, where all missionaries were killed and their missions burned to the ground. Into this mayhem strolled Forrest, happily collecting in the hills just three days' walk south of Atuntze, a trading station on the border where Tibetans had massacred the entire Chinese garrison and all the local French missionaries. Forrest was the guest at another French Catholic mission and, as the insurgence came closer, it was decided that all would have to leave immediately. The lamas were known to bear deep antipathy against the mission in Tzekou, and a war party was at that time heading for the mission. The party that set out by night numbered around eighty individuals, and it is clearly not easy to maintain silence and secrecy with such a large number of people. Inevitably, some small noises betrayed the group to the lamas and their followers, and the fleeing missionaries, including Forrest, were pursued with murderous intent.

In the morning they saw a column of smoke – the remains of the mission – and discovered that they were surrounded and caught in a trap. The priests lost all hope and sat down and prepared to die. Being a man of action, Forrest felt the need to do something and climbed a hill to assess the situation. He saw the Tibetans closing in and, although he shouted a warning, the members of his party scattered, running straight into the arms of their pursuers, to certain death. In fact, only one member of the group survived, and one of the two elderly priests was killed then and there, while the other was slowly tortured by degrees over a number of days – a gruesome death. Forrest was extremely lucky: he jumped off the path while running from the Tibetans and fell into the forest and down a ravine. He waited for the Tibetans to find him, but they passed him by. He was well and truly stuck, however, for the valley was long and thin, and occupied at both ends by those intent on

Gentianella amarella, Felwort, A.F. Happe, 1785

killing all in their paths. For the next eight days Forrest was hunted like an animal, and it says much for his courage and resourcefulness that he managed to evade the hunting parties, who shot at him with poisoned arrows. He discarded his European boots early on (since they left telltale prints, and the lamas were expert trackers), and carried on barefoot. He had only a handful of food to live on, and by the ninth day he was hallucinating, from hunger or fear, or both. A village of Lissu people, a local tribe unrelated to the Tibetans or the Chinese, was situated in the centre of the valley. Forrest made his way there, intent on using his gun to obtain food from the villagers – by force, if necessary. Force was not required, however, and Forrest was helped by the villagers to reach another Lissu village, and thence over the high mountain passes to the relative safety of the valleys to the south. The journey was incredibly difficult, as Forrest was still barefoot, crossing forests and (once above snowline) scree slopes and glaciers. Probably most difficult of all for him, though, was passing up the flora – there is nothing more awful for a collector than to have to go by treasures one is never sure one will see again. Forrest said they were 'tramping over alps literally clothed with Primulas, Gentians, Saxifrages, Lilies, etc., for these unknown hillsides are a veritable botanists paradise'. How frustrating it must have been for him, in addition to the pain and suffering he endured! It is tempting to think that one of the gentians he tramped over barefoot on his epic journey to safety was *Gentiana sino-ornata*, but we can never be sure.

Once safe in a Chinese town, Forrest disguised himself as a Tibetan to avoid attention, and made his way back to the main town, Talifu, where he met George Litton. He had lost all his possessions, and a whole season's collecting. But Forrest was not a feeble person, and he immediately set out (with Litton) to collect in the Salween valley, a sheltered area that had a tropical microclimate, swarming with insects (particularly the mosquitoes that caused malaria). Many of the party became ill and, after their return to Tengyueh, Litton died of 'Salween blackwater fever', which must surely be malaria, and Forrest himself was extremely ill

for months. He not only collected himself, but also trained his men to collect and preserve the treasures they found, so when he was forced to return to Talifu they continued to collect on his behalf. Forrest returned to Scotland in 1906 with his methods all worked out. He knew where he wanted to go, trained a 'large and competent' staff of native helpers, and had established friendly relationships with the Chinese who politically controlled the region. All this in spite of his initial hardships and potentially traumatic first major collecting trip…

It was on Forrest's second trip to China, in 1910–1911, that he collected seed of *Gentiana sino-ornata*. Here he found the plant growing 'on boggy ground at a height of fourteen to fifteen thousand feet [4270m–4570m] in the summit of Nie Chang Pass in the Yunnan'. Seed sown from these gatherings was cultivated in Edinburgh and Ness, and flowered (to universal acclaim!) in 1912. Forrest then spent the next several decades collecting in the Tengyueh region, concentrating mostly on rhododendrons, for which there had flowered a mania in Britain, and many of his later trips were financed by the Rhododendron Society. He died of a heart attack in Tengyueh in 1932, while completing a journey that he felt would be 'a rather glorious and satisfactory finish to all my past years of labour'. During twenty-eight years of working in China, Forrest had collected many new and fabulous plants that are now in cultivation across the world, and had braved incredible dangers during his travels, of which those of his initial expedition were only the first.

Gardeners owe a huge debt to collectors, and plant hunters, such as George Forrest. They brought back jewels such as *Gentiana sino-ornata* that were not only treasures themselves but also became the basis for the gardens of the future.

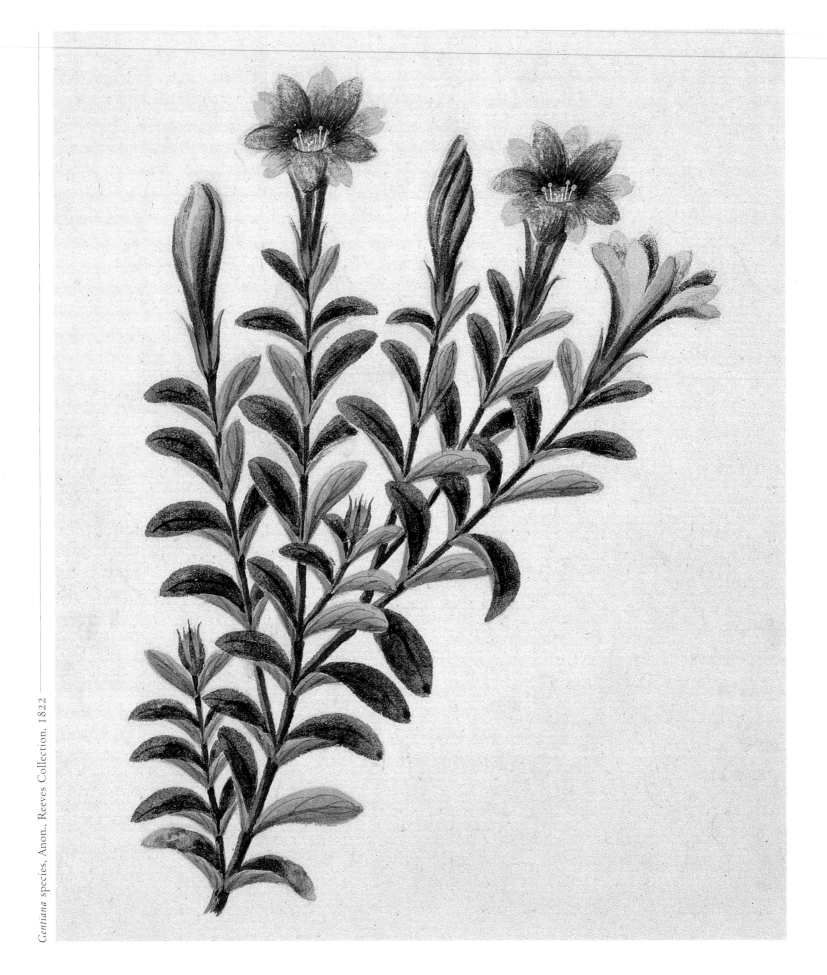

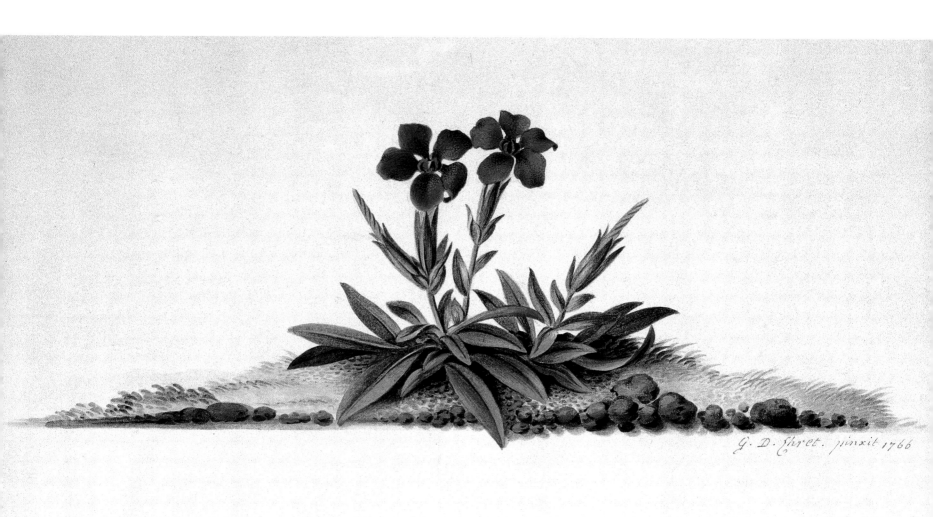

Georg Ehret's sketches of the stemless gentian are an expression of his getting to know a subject well. He experimented with angles and flower position, some are sketched from beneath and others from the side, with stems crossing at different angles. In the finished vellum painting at the Fitzwilliam Museum in Cambridge (England), there is only one flower – the one on the left of this sketch.

Stemless Gentian
Gentiana acaulis L. (Gentianaceae)
Georg Dionysius Ehret, Ehret Sketches
c. 1760s, watercolour on paper
231mm x 151mm (9in x 6in)

Unlike many of the smaller meadow gentians, the willow gentian is a woodland plant. Thriving in shade, its long stems arch under the weight of the flowers, and it is this arching habit that probably suggested its scientific name to Linnaeus. With its opposite leaves, it must have looked a bit like a blue milkweed.

Willow Gentian
Gentiana asclepiadea L. (Gentianaceae)
Frederick Polydore Nodder
c. 1770s, bodycolour on paper
522mm x 365mm (20½in x 14¼in)

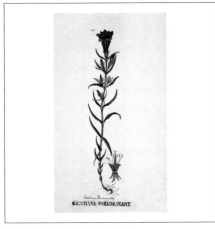

Although the bog or marsh gentian occurs all over Europe, it is on the decline in Britain and thus of interest to those seeking to preserve national biodiversity. Alternation of its habitat (damp heaths) by land drainage and afforestation means that places where this plant grows, though already rare, are becoming rarer still.

Marsh Gentian
Gentiana pneumonanthe L. (Gentianaceae)
Andreas Friederich Happe, 1785, hand-coloured engraving watercolour and bodycolour on paper, in bound volume, 366mm x 232mm (14½in x 9¼in)

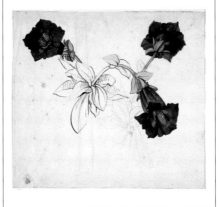

The stemless gentian is native to the high Alps and Pyrénées of Europe. This species has long been a favourite for the rock garden: completely lime-tolerant, it is more easily grown than many of its similarly spectacular Chinese relatives. The sapphire trumpets, flecked with bright green in the throat, appear in May and can measure as much as 5cm (2in).

Stemless Gentian
Gentiana acaulis L. (Gentianaceae)
Georg Dionysius Ehret, Ehret Sketches
c. 1760s, watercolour with bodycolour on vellum
243mm x 203mm (9½in x 8in)

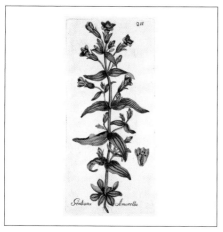

Members of the genus Gentianella are not found in cultivation, unlike their 'showier' cousins in the genus Gentiana. Perhaps they should be, though, as the fantastic fringes (on the edges or insides of the petals) that characterize the genus make the flowers objects of interest when seen close to.

Felwort; Autumn Gentian
Gentianella amarella (L.) Börner (Gentianaceae)
Andreas Friederich Happe, 1785, handcoloured engraving
watercolour and bodycolour on paper, in bound volume,
366mm x 232mm (14½in x 9¼in)

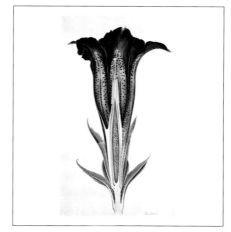

The intricate gradations of colour in the gentian's throat can been seen clearly only when the flower is opened out or cut in half. The yellowish tips to the paler flashes serve to accentuate the opening of the corolla throat, where a pollinator must aim if she (for these flowers are pollinated by bees, all of whom are female) wants to get at the nectar held deep in the bottom of the tube.

Stemless Gentian
Gentiana acaulis L. (Gentianaceae)
Arthur Harry Church
c. early 1900s, watercolour with bodycolour on Bristol
Board, 316mm x 192mm (12½in x 7½in)

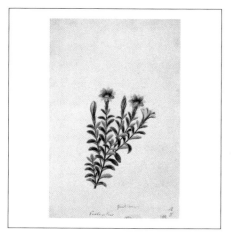

China is one of the centres of gentian species diversity; indeed, in the treatment of the genus for the recently published flora of China some 250 species of Gentiana are described. Identification depends upon knowledge of the internal structure of the flower, which is not available from the painting, lovely as it is. This is one reason herbarium specimens are essential for scientific study, for without them evidence as to identity is just not accessible.

Gentian
Gentiana species (Gentianaceae)
Anon. Reeves Collection
1822, watercolour on paper
184mm x 124mm (7¼in x 4¼in)

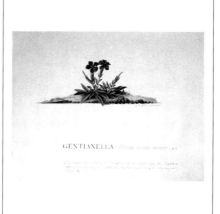

The exquisite blues of the gentians can make meadows look like lakes or, as Georg Ehret wrote on this sketch, like the clear-blue sky: 'This plant was drawn at Ratisbone [Regensburg, Germany] in the year 1732, the Meadows thiere are covered with this beautiful little plant, and appear like a blue sky'.

Spring Gentian
Gentiana verna L. (Gentianaceae)
Georg Dionysius Ehret, Ehret Sketches
1766, watercolour and bodycolour on vellum
470mm x 333mm (18½in x 13in)

The fantastic red and purple feathers and flames that appear as if by magic on tulips are not the result of man's interference with nature, but are a viral disease transmitted by aphids. In the 1920s, scientists working at the John Innes Horticultural Research Institute, England, discovered how tulip-breaking virus is transmitted. The bane of many gardeners, aphids feed exclusively on the sap in the phloem layer of plant stems. They insert their long, needle-like mouth parts carefully through the outer layers of the stem and tap directly into the phloem, where sugars produced by photosynthesis are translocated to the rest of the growing plant. Aphids not only deplete the energy necessary for vigorous plant growth but can also transmit diseases (mostly viral). Viruses

blues of flowers), without which the background colour shows through, pure white or yellow. Areas where the anthocyanins are still produced are sharply delimited, appearing as fine streaks: feathered tulips have the areas of colour broadest at the edges, streaking to the centre of the petals, while the main body of colour on flamed tulips occurs along the middle of the petals. Today's tulip growers try hard to prevent breaking but it was not always so.

Tulips came to Europe from Turkey, where they had long been prized by sultans and the nobility. Turkish tulips themselves were derived from wild species probably from Central Asia, but Turkey itself has its own native tulips – bulbous plants growing in harsh environments. Perhaps it is this derivation from a tough little

TULIPS

And flowers themselves were taught to paint.
The tulip, white, did for complexion seek, and learned to interline its cheek;
Its onion root they then so high did hold,
That one was for a meadow sold

THE MOWER AGAINST GARDENS (ANDREW MARVELL, 17TH CENTURY)

themselves were not 'discovered' until the late nineteenth century and their structure understood following the invention of the electron microscope, and there is still disagreement as to whether or not viruses are living creatures: they reproduce but not without taking over the genetic machinery of their host. There are many varied viral diseases of plants, but tulip-breaking virus is the only one known to have increased the infected plants' value.

Tulip plants infected by tulip-breaking virus have blotchy, mottled leaves and intricately and finely patterned petals, and appear as if hand-painted in pure colour. The variegated effect is caused by interference of the virus in the plant's production of anthocyanins (pigments responsible for producing the reds and

ancestor that has made the cultivated tulip such a mainstay of the garden, for it is easy to grow and takes what life or neglect throws at it, and thrives. The tulips prized by the sultans were very different in shape to those we cultivate today. These Ottoman flowers had thin waists and pointed petals that flipped out at their apices, which over time become shaped like daggers and needles. The cultivation of tulips was taken extremely seriously: it was not for anything that the sultan's head gardener was also the executioner-in-chief! The famed sultan Suleyman the Magnificent had robes embroidered with tulips, and even had a tulip as part of his emblem. Sixteenth-century Iznik ceramics celebrated the tulip in vibrant colour – first as the blues and greens of the Iznik style,

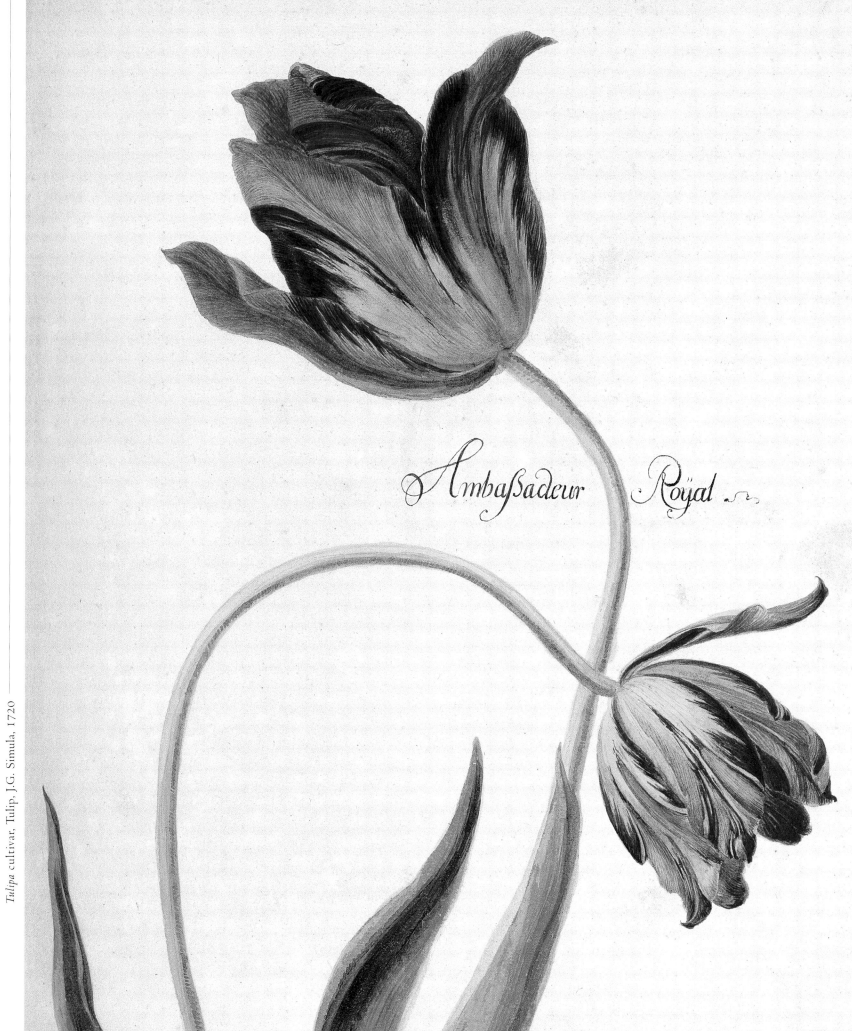

Ambaßadeur Royal

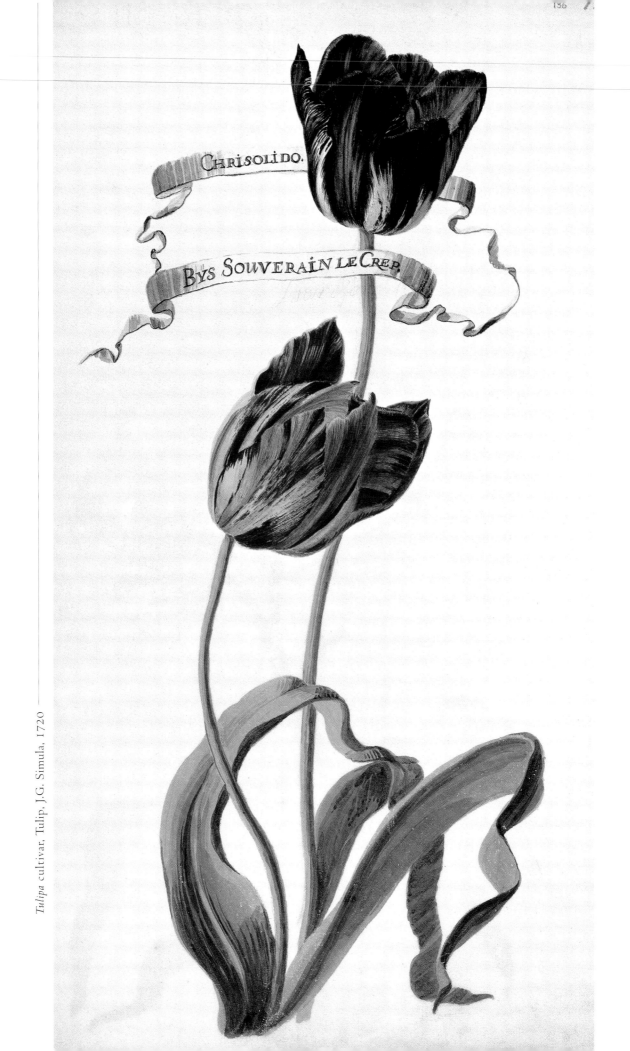

CHRISOLIDO.

BYS SOUVERAIN LE CREP.

Tulipa cultivar, Tulip. J.G. Simula, 1720

but later in vibrant red, just like the real thing. This red may have been created especially for the depiction of tulips, but only lasted a few decades. Perhaps the Turkish ceramicists were more interested in the shape of their flowers than their colour.

The variety and perfection of the tulip was pursued by careful and targeted breeding, and by the introduction of new wild species from the far-flung reaches of the Ottoman Empire. In Istanbul special florists' councils adjudicated on the admittance of new varieties of tulips to the official tulip list, and only the most beautiful were given lyrical and poetic names such as 'Matchless Pearl' or 'Light of the Mind'. These prize beauties were displayed as single blooms in special narrow-necked-vases called *laledan*. The Turkish name for the tulip is *lale*, derived from the Persian, and in Arabic script is composed of the same letters as Allah, the name of God. This alone enshrined the flower in the pantheon of the prized, but the manner in which it bowed its head when in full bloom – as if in modesty before God – shows how man, like the tulip, should behave. Gardeners planted tulips in order to help their souls ascend to heaven, and the image of the tulip was a symbol of safe return from war, an important part of Turkish culture during the incredible expansion of the Ottoman Empire. As the Turks moved into the Balkans, decimating the Serbs in Kosovo on the Field of the Blackbirds, the chroniclers of the battle likened the brightly coloured turbans of the Turkish dead to tulips blooming in profusion on the fields. As the Turks moved further into Europe, trade of all sorts increased, and what better to trade than prized cultivated flowers? The tulip's arrival in Europe cannot be dated accurately, and some native species of the genus *Tulipa* occur in the Savoy area of France. The flower that fascinated Europe's botanists and gardeners, however, was certainly the product of centuries of Turkish plant-breeding effort, not a *de novo* cultivation. 'Tulip' itself is derived from the Turkish word for 'turban' (*dulbend*), changed to *tulipan* (or *tulipam*) via a chain of Chinese whispers involving Ogier Ghislain de Busbecq, ambassador of the Holy Roman Empire to the Istanbul court. Anna Pavord suggested that the mixup between

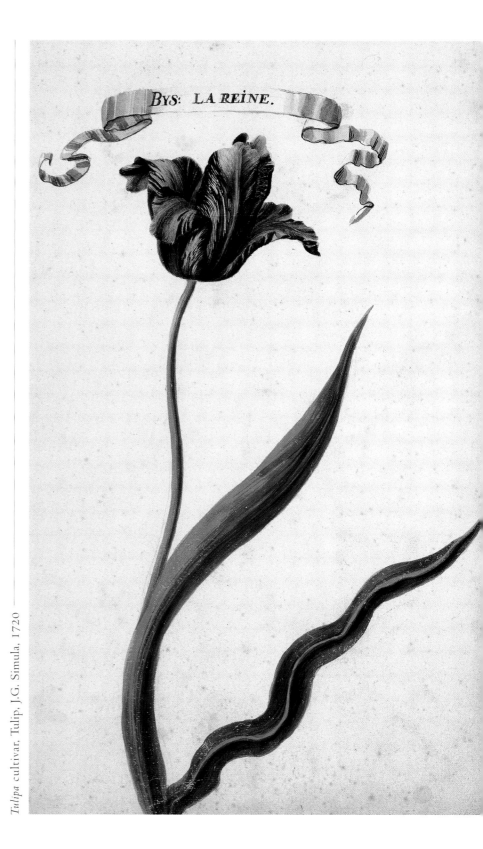

Tulipa cultivar, Tulip, J.G. Simula, 1720

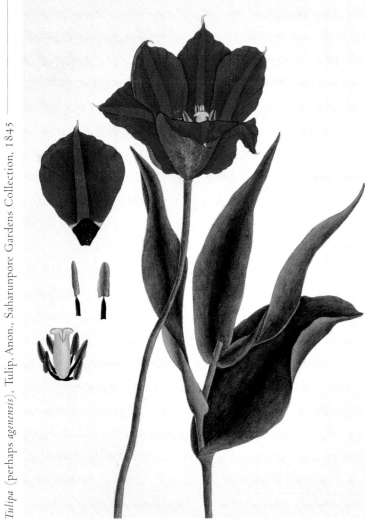

Tulipa (perhaps *agenensis*), Tulip. Anon., Saharunpore Gardens Collection, 1845

turcarum' in 1559, and by the middle of the century the well-connected botanist Charles de l'Ecluse (Carolus Clusius) was distributing tulip bulbs across Europe. As with many new introductions, the culinary and medicinal potential of the bulbs was also of interest: Clusius himself had some bulbs preserved in sugar and ate them as sweetmeats, and pronounced them far tastier than orchids. New plants were often thought to have aphrodisiac properties and tulips were no exception. They were thought to be good for cricks in the neck, but never really caught on as a foodstuff, perhaps due to their bitter onion-like taste. Clusius ended his days at the University of Leiden, in the Netherlands, where he took his knowledge of plants (including his prized tulips) in order to establish a world-class botanical garden for the newly victorious United Provinces, who had just defeated the forces of the Spanish and forced them to recognize the Protestant state. Money that was saved by not being at war was invested in the academic infrastructure of the new nation. In Leiden, Clusius produced a classification of the varieties of tulips, which he divided into thirty-four groups, based on the colours of the flowers and the arrangements of the leaves and petals. The variety of tulips cultivated was increased as new wild species were introduced from the East and as gardeners experimented with the types they already knew. Some sorts of flowers became favoured by tulipophiles – a class of people that arose as money became more available in the United Provinces. These favoured varieties were evenly sculpted and were eye-catchingly coloured; they were also often the varieties that had broken, or become infected by the tulip-breaking virus, and exhibited variegated patterns of breathtaking beauty that never again reverted to a solid colour. Something as lovely as a broken tulip – a unique occurrence – was rare and increasingly coveted by the growing ranks of tulip enthusiasts. That the broken plants were weaker and did not reproduce as reliably as 'breeders' (tulips with solid-coloured flowers) merely increased their mystique and value.

The most virulent form of tulip fever, tulipomania, appeared in the Netherlands in the mid-seventeenth century. A look at any of

turbans and flowers arose because the Turks often wore tulips in their turbans, and when Busbecq pointed at the flower asking its identity, his companions may have thought it was the headgear that was of interest. Though Busbecq is generally credited with the introduction of the cultivated tulip to northern Europe, the name 'tulip' was used before his travel diaries were published, so it is not clear when it was first introduced.

Tulips became all the rage regardless, spreading like wildfire throughout European gardens, talked about by botanists and flower lovers alike. Conrad Gesner, a Swiss botanist, described a 'Tulipa

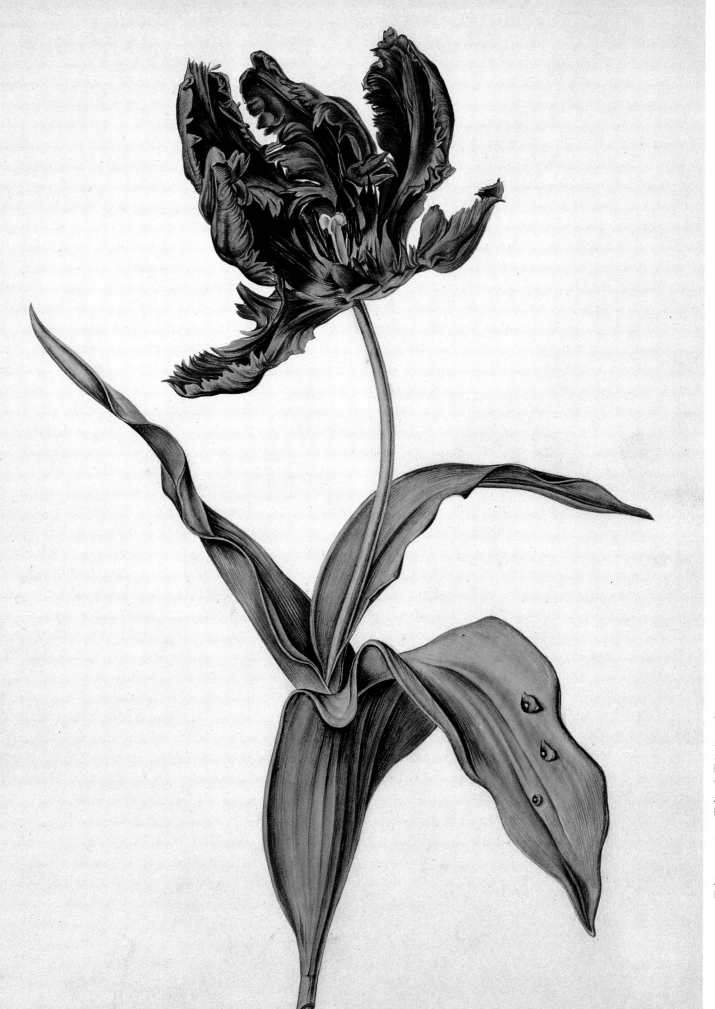

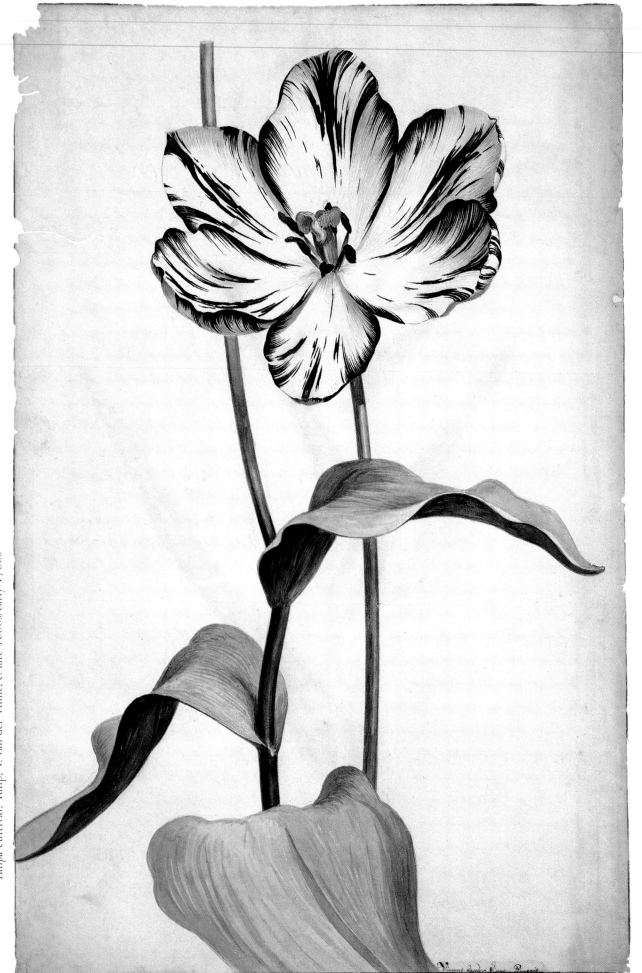

the flower paintings of the famous artists of the day, contemporaries of Rembrandt van Rijn, makes it clear that the broken (feathered or flamed) tulip flower was a real prize, worth capturing for ever in paint. The sheer unpredictability of when and what caused tulips to break made the flowers highly prized by all true connoisseurs. Another factor that established their value was their scarcity, for they do not reproduce as quickly as solid-coloured varieties, either by seed of by offsets. Tulips take seven years to grow from seed to flowering (a long time to wait to see if an experimental cross was worth making). Careful breeding and selection of the most exquisite specimens took years, and the results of the most recent successes were necessarily limited. Seed of a broken plant was generally unpredictable, but the offsets produced by all bulbs were true to type – that is, they produced flowers just like their parent – but a mature tulip produces offsets only slowly, and maybe as many as three years must pass before offset can be separated from parent bulb. The three main types of tulips coveted by Dutch collectors were the Rosen, with red markings on a white ground; the Violetten, with purple markings on a white ground; and the Bizarden, with red or violet markings on a yellow ground.

One of the most famous of all Dutch Rosen tulips was the 'Semper Augustus' – always scarce, and said to have been in the hands of a single connoisseur who refused to sell his bulbs at any price. But this control didn't last long, for soon a few offsets made their way on to the market, and fanned the flames of what was to be a real tulip craze. The fantastic sum of twelve times the annual wage of a carpenter was offered for a single bulb of 'Semper Augustus', and turned down flat. Tulips had always commanded a premium price, even the 'common' sorts. They were exotic, rare and mysterious, and the broken varieties were objects of exceptional beauty. All probably would have remained well if the trade had been confined to enthusiasts and those who had some knowledge of gardening and botany, but money talks, and in the mid-seventeenth century in the Netherlands the tulip trade was one of the few into

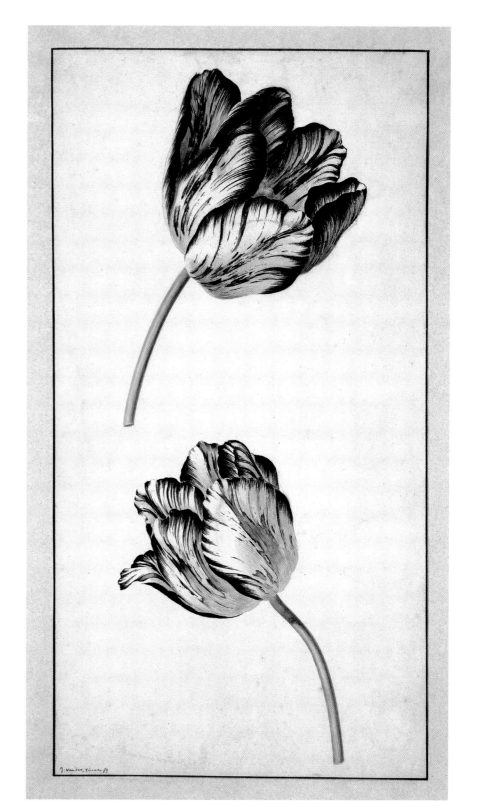

Tulipa cultivar, Tulip, J. van der Vinne, c. late 1600s/early 1700s

301

which anyone could join with minimal investment. Tulips themselves contributed to the perceived ease of gain, the toughness inherited from their wild ancestors made them relatively easy to grow, and some growers soon became wealthy men.

Before the real tulip craze struck, the tulip trade was a seasonal affair. Buyers were able to examine their purchases in bloom, and took possession when the bulbs were 'lifted' (taken out of the ground) for the winter. It seemed like easy money – take a simple bulb and turn it into money over a single winter – so the trade appealed to the gamblers in Dutch society and those of the

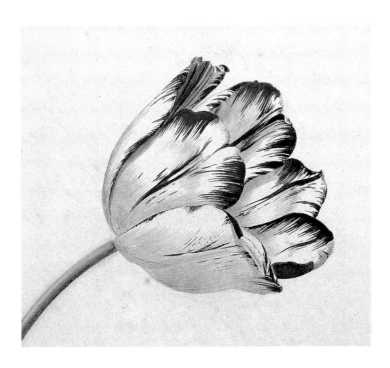

increasingly desperate artisan class. There was money to be made, and at the time everyone in Holland was out to make it. Unlike the rest of Europe, where a peasant was born of peasants and remained one all his or her life down through the generations, what became known later in the United States as a 'self-made man' was more than a theoretical possibility in the seventeenth-century United Provinces. Never mind that most who tried to climb up the social scale ended up farther down it that where they had begun, for the

possibility was always there. The lure of potential riches was potent. The Dutch were also well-known for their gambling, and wagers were placed on anything at all – the weather, battles, even the appearance of pillars in Rome. Lotteries were very common, and rich merchants risked all on chancey voyages to the East Indies in the nutmeg trade. No wonder the tulip trade took off – prices were rising and it was ludicrously easy to grow tulips. Easy money.

The frenzy to get into the tulip trade and the general scarcity of the actual objects of interest relative to demand meant that a new breed of tulip dealers (or florists) sprang up who did not cultivate the plants themselves but acted as middlemen, buying tulips merely to sell them on. This progressed to the florists selling tulips not yet in their possession but still in the ground, so turning the trade into one not of bulbs, but of bits of paper – promissory notes (notes promising to pay a fixed price for the goods to a specified person on some fixed day in the future). These seventeenth-century Dutch tulip traders created a futures market, where they gambled on the future price of tulips. The trade in paper meant that the business could go on all year around, and it became increasingly complex and labyrinthine: the whole tulip market depended on the price becoming ever higher, and because the commodity in question was a living thing (a tulip bulb) buyers had no idea what they might get, come lifting time. They were gambling on a living thing, and on someone else's care of it. Most of this trade went on in taverns, under the influence of copious quantities of alcohol – hardly the best conditions for keeping one's head and remaining cautious. The tulip frenzy peaked in 1636–37, and during that time fantastic prices were paid for the rarest varieties. Houses were offered in exchange for a bulb to be lifted next year, and single bulbs changed hands for many times the annual wage of an average artisan. Mike Dash details the goods that could be bought with the price of a single one of the more expensive varieties: eight pigs, four oxen, twelve sheep, 24 tons (24.5 tonnes) of wheat, 48 tons (49 tonnes) of rye, two barrels of wine, four barrels of expensive beer, 2 tons (2 tonnes) of butter, 1000lb (455kg) of cheese, a silver cup, clothes, a bed complete with bedding

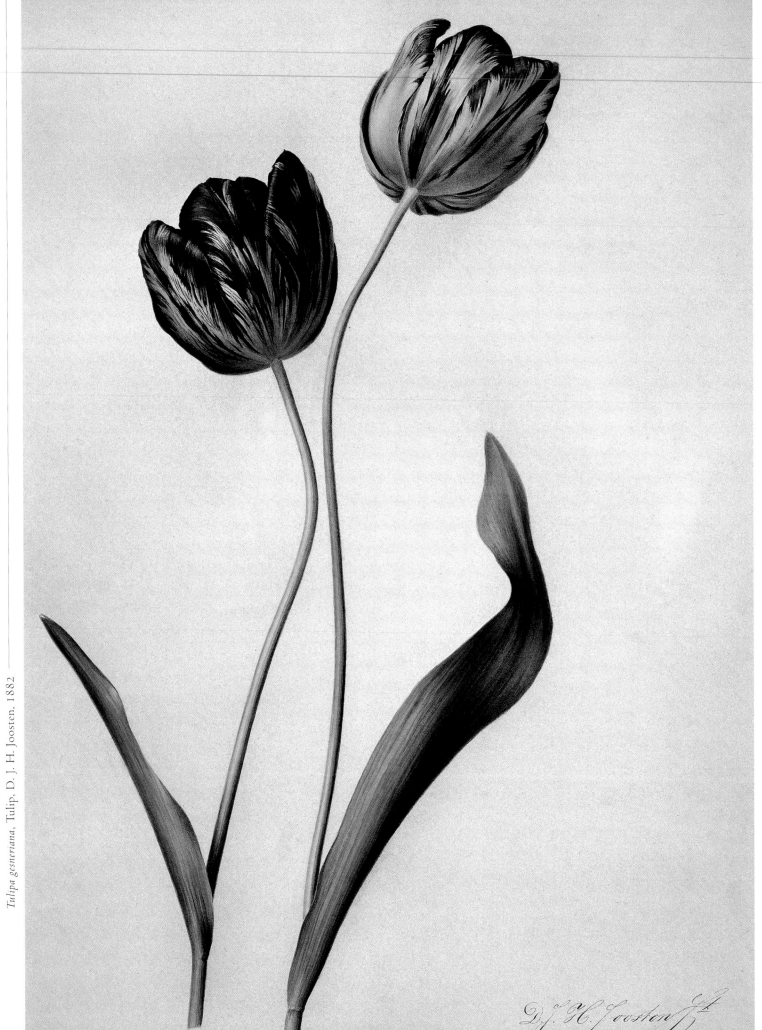

Tulipa gesneriana. Tulip, D. J. H. Joosten, 1882

and mattress, and a ship! It is thought that the tulip trade was worth about three times the value of the Dutch East India Company, the greatest trading organization in Europe at the time.

But it all ended with a bang – seemingly at once, in a single moment. Haarlem was the centre of the trade, and it was there that one day in February 1637 not a single buyer could be found for bulbs at any price, no matter how low. The crash was spectacular and seemed instant throughout the United Provinces, although in reality it took a few months for the effects to be felt all over. The rapidity with which bulbs (or promissory notes) were being traded and the actual scarcity of bulbs themselves combined to cause the implosion of the trade, and the probable destitution of the many who were involved. Most traders got lucky, however, probably because the chains of buying and selling, sometimes for parts of bulbs only, were so complex that it would have taken decades to work out who owed what to whom. The state of Holland intervened and suggested that debts be cancelled and that a minimum be handed over, but only if possible. Yet some cases were relentlessly pursued, such as that of the artist Jan van Goyen, who paid and paid for his dabbling in the bulb trade, with money and paintings, but never succeeded in cancelling his debt. He is certainly the inspiration for the artist Jan van Loos in Deborah Moggach's *Tulip Fever*, who goes into the tulip trade to finance his escape with his lover, but is caught by his creditors just as he is about to take possession of a 'Semper Augustus' bulb. He sends his servant, who returns drunk from the tavern where tulip deals are struck, having eaten the 'onion' he found in the parcel he was given at the inn.

After the collapse of Holland's tulip market, many in Europe turned against the flower, but eventually it came to symbolize Holland and vast areas are devoted to the cultivation of today's popular, mass-produced varieties, all self-coloured and in a variety of shapes and colours. Its tulip trade now accounts for about half of Holland's cultivated land, and over two million bulbs are exported annually. Today's tulips breed like rabbits, producing offsets rapidly, unlike the prized broken varieties of the past (which were kept in cultivation by enthusiasts who were in tulips for love, not the money). In the nineteenth century, florists' societies were established in England among the skilled working classes, and flowers were grown and shown in competitions. Members of these societies worked with bulbs from the continent, establishing their own standards for flower shape and colouring. By the late 1700s, the standard shape for the florist's tulip was the rounded, globose tulip we know today. Like the Dutch tulips, three main classes of finely broken flowers were recognized: Bizarres, any colour of flames or feathers on a yellow ground; Bybloemens, with mauve, purple or 'black' markings on a white ground; and the rarer Roses, with scarlet, pink or crimson streaks on a white ground. Only one of these societies still exists: the Wakefield and North of England Tulip Society. Members exchange bulbs (the buying and selling of virally infected bulbs is prohibited), keeping many varieties from the eighteenth and nineteenth centuries in cultivation. Such enthusiasts also produce new varieties by selecting tulips for form, creating the 'breeder', then breaking these plants to produce flowers with striking patterns. Broken bulbs flower most strikingly beneath shade and (true to the tulip's nature) the best-marked flowers are often produced on plants grown in poorer conditions. Flowers are shown as single blooms, as the Ottoman Empire sultans appreciated them.

Although times change and flower shapes go in and out of fashion, the tulip itself endures. True tulipomania is still to be found, and – in contrast to the tulip frenzy of the seventeenth century – it flourishes where people truly relish the unpredictable and endless variety of nature.

Tulipa cultivar, Tulip, A. J. Bramdt, c. 18th century

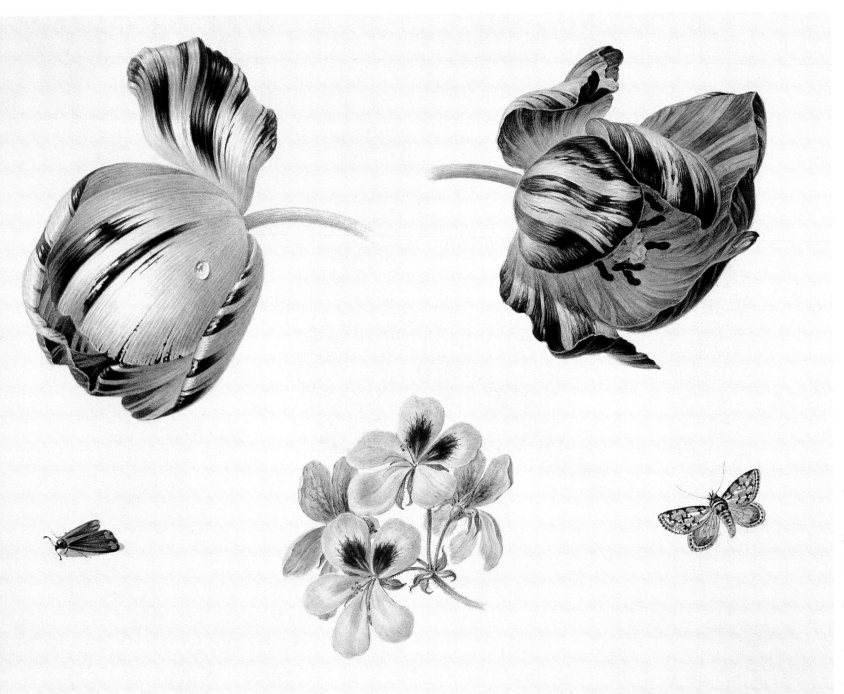

Tulipa cultivar, Tulip, M. J. Barbiers, c. 1800s

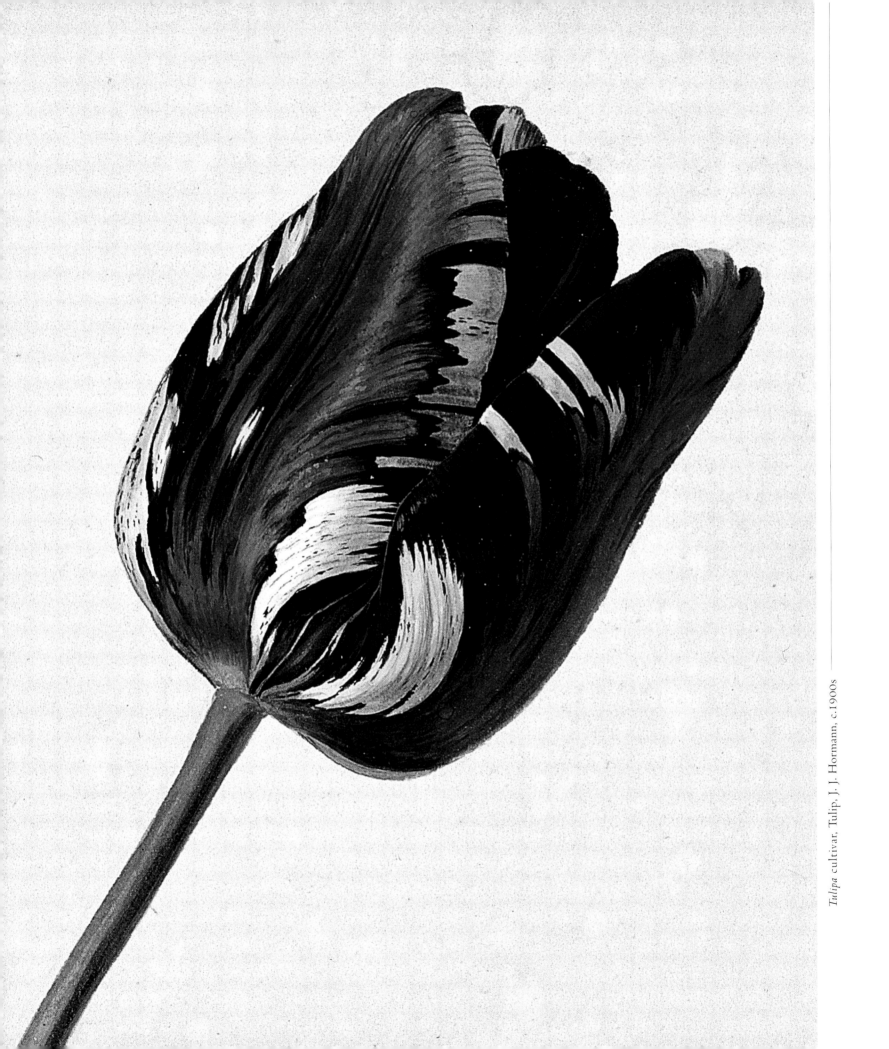

Tulipa cultivar, Tulip, J. J. Hormann, c.1900s

The 'Ambassadeur Royale' depicted here is a 'Bizarre' broken tulip, and has red mottlings on a bright-yellow ground. This colour combination was not as prized as the red on white, or purple on white, broken tulips – probably because they occurred more commonly and did not have quite the rarity value.

Tulip
Tulipa cultivar (Liliaceae)
Johann Gottfried Simula
1720, bodycolour on paper
455mm x 285mm (18in x 11¼in)

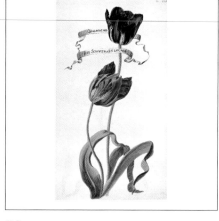

Simula's Flora Exotica contains paintings of flowers that were cultivated in the gardens of the Count of Dernatt. These two tulips – 'Chrisolido' and 'Bys: Souverain Le Crep.' – could well be of Flemish origin, and were obtained via Dutch middlemen who distributed tulips throughout northern Europe in the eighteenth century.

Tulip
Tulipa cultivar (Liliaceae)
Johann Gottfried Simula
1720, bodycolour on paper
455mm x 285mm (18in x 11¼in)

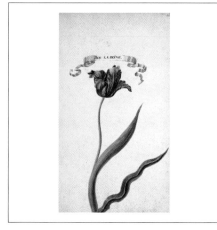

The French varietal name of this 'Bizarre' or 'Bissart' tulip – 'Bys: La Reine' – perhaps indicates that it is of Flemish origin. Although darkly veined with purple, the background is yellow. In the eighteenth century, Flemish tulip breeders sold their varieties through Dutch intermediaries, getting a better price than they would at home.

Tulip
Tulipa cultivar (Liliaceae)
Johann Gottfried Simula
1720, bodycolour on paper
455mm x 285mm (18in x 11¼in)

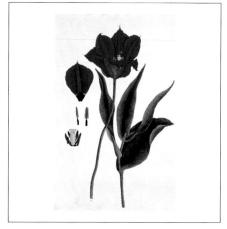

Lovely as the wild species and 'breeder' tulips are, it is easy to see why the broken flowers held such a hypnotic fascination for tulip fanciers. Rare, unusual and bizarre (in the true, not the tulip breeders', sense of the word), the virally infected flowers had a rarity and peculiarity value that species tulips just did not match.

Tulip
Tulipa (perhaps *agenensis*) (Liliaceae)
Anon. Saharunpore Gardens Collection
1845, watercolour with bodycolour on paper
367mm x 232mm (14½in x 9¼in)

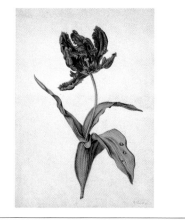

The fringed, laciniate petals of the parrot-type tulips look like a mistake. These peculiar types perhaps first appeared in France in the mid-seventeenth century, where they were described by a French tulip grower as 'of an uncommon Shape, of several colours and frightful to look upon; for which Reason they are called 'Monsters'.

Tulip; Parrot Type
Tulipa gesneriana L. (Liliaceae)
J. Teixeira, Dutch Collection
1820, bodycolour with watercolour on paper
370mm x 266mm (14½in x 10½in)

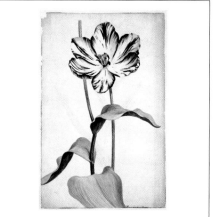

This variety name of this deep-purple 'Bybloemen' tulip is not indicated by the flower painter. It does, however, look very like 'Louis XVI', the most celebrated tulip of the nineteenth century. Raised in Flanders in 1776 by an unknown amateur, in 1789 this lovely tulip was offered for sale in Holland for the (then) astounding price of 250 guilders a bulb.

Tulip
Tulipa cultivar (Liliaceae)
Vincent van der Vinne, Dutch Collection
c. late 1600s/early 1700s, bodycolour with watercolour on paper, 416mm x 272mm (16½in x 10¼in)

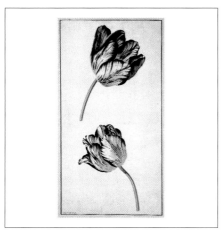

The 'Rose' tulip varieties – broken flowers with red markings on a pure white background – were the rarest of the broken tulip varieties, so were also the most valuable and prized. The famous 'Semper Augustus' was a 'Rose' – these two delicately feathered tulips are of a similar quality. Possessing a tulip of this sort was the height of chic, a real status symbol.

Tulip
Tulipa cultivar (Liliaceae)
Jean van der Vinne, Dutch Collection
c. late 1600s/early 1700s, bodycolour with watercolour
on paper, 431mm x 255mm (17in x 11¼in)

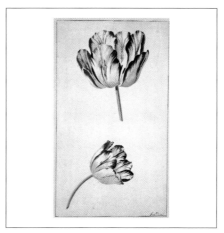

The tradition of the tulepboeken ('tulip books') so emblematic of the Dutch fascination, both during the frenzy of tulipomania and afterwards, had a parallel in the tulip's homeland. The only tulip book known from the Ottoman Empire was done in the eighteenth century, and contains some fifty tulip varieties, with such poetic names as 'Roman's Spear' and 'One That Increases Joy'.

Tulip
Tulipa cultivar (Liliaceae)
Jean van der Vinne, Dutch Collection
c. late 1600s/early 1700s, bodycolour with watercolour
on paper, 431mm x 255mm (17in x 11¼in)

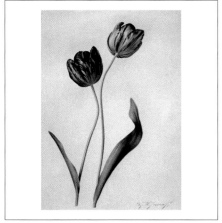

This scientific name was given by Carl Linnaeus, the eighteenth-century botanist, to a miscellaneous group of old Dutch tulip cultivars. The true origin of the cultivated tulip in Europe is shrouded in mystery, but certainly involves some hybridization between various wild species. This painting, although done in the late nineteenth century, is in the style of the previous century.

Tulip
Tulip gesneriana L. (Liliaceae)
D.J.H. Joosten, Dutch Collection
1882, bodycolour with watercolour on paper
444mm x 322mm 17½in x 12¼in)

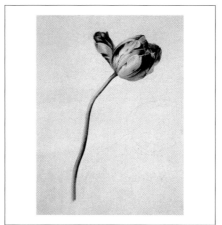

This dark-purple-flamed 'Bybloemen'-type tulip shows the globose shape so prized by the growers of English florists' tulips. The English fashion for broken tulips was already well established by John Gerard's time, in the late seventeenth century. He recorded tulips that were 'striped confusedly', but in England the crazy fever that characterized the Dutch 'tulipomania' never quite got going.

Tulip
Tulipa cultivar (Liliaceae)
A. J. Bramdt, Dutch Collection
c. 1700s, watercolour with graphite on paper
263mm x 203mm (10½in x 8in)

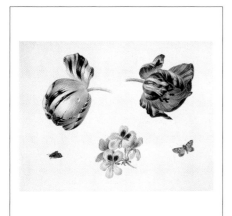

The composition of this painting, including several elements, is in keeping with the iconographic tradition of the Dutch school of flower painting that flourished in the mid-seventeenth century. The painting includes not only broken tulips, one 'Bizarre' and one 'Bybloemen', but also a cluster of Pelargonium (geranium) flowers and two moths – both apparently drawn from life and extremely accurate.

Tulip
Tulipa cultivar (Liliaceae)
M.J. Barbiers, née Snabilie, Dutch Collection
c. 1800s, watercolour with bodycolour on paper
243mm x 319mm (9½in x 12½in)

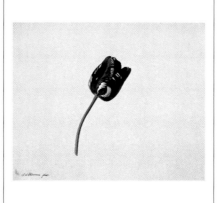

The extremely dark flowers of this 'Bybloemen' tulip were never as popular as the lighter sorts that showed more of the background colour. A truly perfect broken tulip had a pure colour base, with either feathers or flames of colour interrupting the clear background. Any muddiness of colour, in either the markings or the ground, eliminated the flower from the running.

Tulip
Tulipa cultivar (Liliaceae)
J.J. Hormann, Dutch Collection
c. 1900s, bodycolour with watercolour on paper
193mm x 242mm (7½in x 9½in)

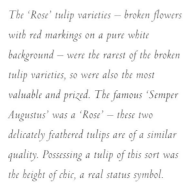

It is vitally important for plants to reach the light, and thus the energy, to produce food. Trees achieve this by massive erect growth, but vines grow up to reach the light by an incredible variety of methods. To grow vertically, vines need to do two main things — first they must make contact with a surface to climb up and, second, they need to anchor themselves during ascent. Some plants climb with the help of hooks on leaves or stems, others by aid of tiny rootlets that adhere to the surface, but the majority of climbing plants can be put into two categories — those that climb with the aid of tendrils, and those that twine spirally around a support without attaching themselves to it. Tendrils are extraordinary structures. They can be derived from many different

regular movement of the whip-like shoot tip) made these plants seem very unplantlike, and more like animals in their apparently purposeful movement. This sweeping through the air is called circumnutation. The anatomy of the leader (the terminal, unsupported portion of the stem) is quite different from that of the rest of the vine. The leader usually sits straight up and rigid, a rigidity due not to woodiness but its flexible core surrounded by a more rigid exterior, like a bendy pipe. The weight of the elongating shoot is thus hydrostatically supported, and this anatomy may also have a role in circumnutation, where the leader grows vertically while sweeping in great arcs through the air, seemingly 'looking' for a support. This rhythmic sweeping motion is endogenously driven

MORNING-GLORIES

The morning glory!
It has taken the well bucket,
I must ask elsewhere for water.

KAGA NO CHIYO, BUDDHIST NUN AND HAIKU MASTER (1703–75)

plant parts — modified leaves, branches or inflorescences. The spiral contraction of the tendrils serves to draw the plant closer to the support, and also improves flexibility to the entire arrangement (the spiral twisted structure gives with movement, a biomechanically sophisticated shock absorber!). The twiners, on the other hand, do not attach themselves physically to a support, but grow vertically by spiralling the entire shoot around it. This may seem to be a less efficient way of getting up into a canopy, but just look at the way bindweeds or morning-glories cover surfaces, often reaching high into the canopy. It appears to work pretty well indeed.

The way climbers twine has been of interest to many for a long while. The apparent behaviour of a twiner seeking its support (the

(the exact mechanism driving this is still being investigated), but seems to have something to do with signalling between cells due to changes in water pressure, resulting in changes in cell shape over time. Complex cellular mechanisms drive what appears to be a directed behaviour. It seems obvious (though this is not a good thing to assume, for the 'obvious' answer is rarely the right one) that circumnutation increases the shoot's probability of encountering a support, but no one has studied this in the field.

One of the most famous people to have interested themselves in the behaviour of vines was the evolutionist Charles Darwin. In 1875, he published the first of his books on plants, *The Movements and Habits of Climbing Plants*, hot on the heels of his controversial

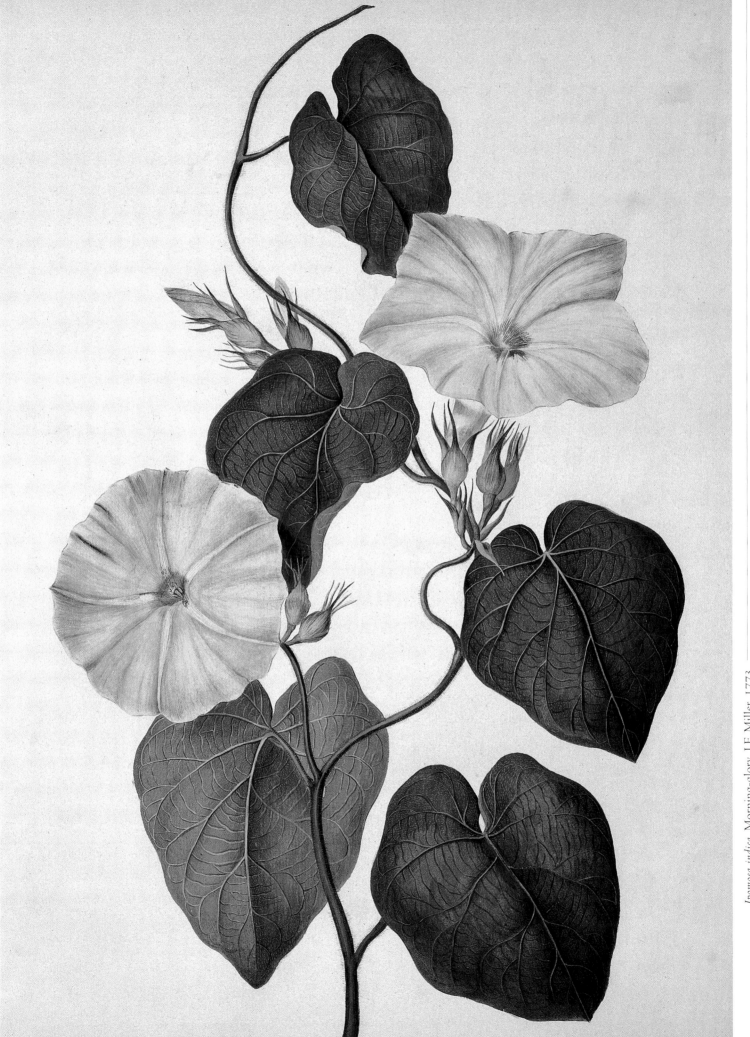

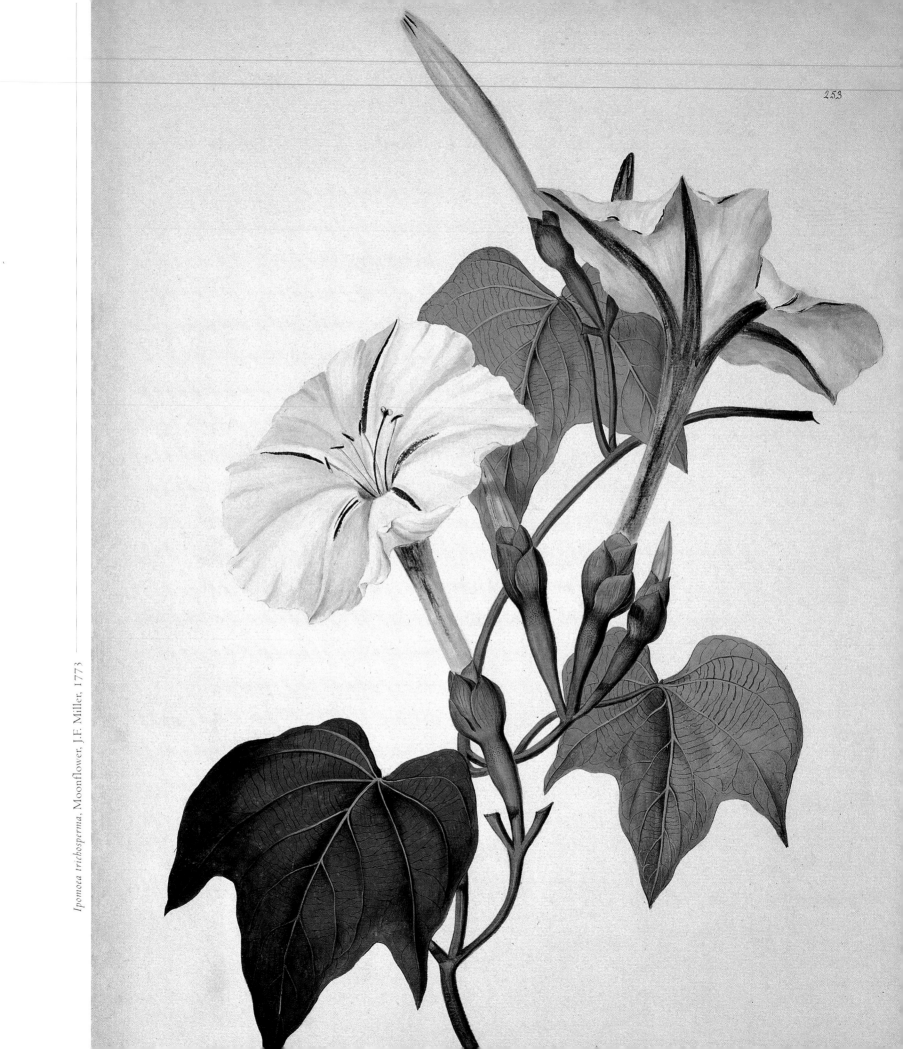

253

Ipomoea trichosperma, Moonflower, J.F. Miller, 1773

Descent of Man and its companion, *The Expression of Emotions in Man and Animals*. With his son Francis, he grew hundreds of plants – truly a labour of love. Perhaps plants were an antidote to the controversy surrounding his works about our own species, for plants don't talk back, they just grow and grow. By the 1870s Darwin was in his late sixties, and an invalid much of the time. Although he was always intellectually spritely and innovative, by this time his physical state had deteriorated considerably. He was fascinated by the vines of the rainforest, but his detailed observations of just how plants achieved such movements was started from his bed: 'To ascertain more precisely what amount of movement each internode underwent, I kept a potted plant, during the night and the day, in a well-warmed room to which I was confined by illness. A long shoot projected beyond the upper end of the supporting stick and was steadily revolving.' His incredible mental energy and dedication to finding things out never ceases to amaze. Who among us would use the opportunity of illness to begin observations on the movements of plants? Most people would be more inclined to slump in bed, consumed with self-pity or sipping hot drinks!

Darwin and his son measured the period and circumference of the circumnutation of many different plants, finding that in general the leader revolved around a circle in something between two and three hours, night and day. This of course varied between species: a plant of hops (*Humulus lupulus*) made circles at remarkably regular intervals of between two hours and two hours and twenty minutes, while plants of the morning-glory (*Ipomoea purpurea*) described circles every four to five hours. Other moved even faster: 'a Convolvulus made two revolutions at the average of 1 hr. 42 m[inutes], and a *Phaseolus vulgaris* [bean] three at the average of 1 hr. 57 m.' They grew many different climbers and observed that the rate of circumnutation was retarded by low temperature, went faster in bright light and did not respond to physical contact. They rubbed the internodes, banged on tables, tried all sorts of different supports and even cut leaders off and put them in pots of water – all in order to observe better the way in which plants move. Francis even apparently serenaded the plants on his bassoon, to see if vibration had an effect on their inexorable spiralling! This sort of detailed, seemingly unfocused observation was a type of natural history at which Darwin excelled. His ability to amass facts, then to order them in accordance with his observations and the observations of others, allowed him to develop his ground-breaking ideas. The synthetic thought processes that led to *On the Origin of Species* began with just such detailed observations as those he undertook on the movements of plants later on in his life. Some have argued that this broad curiosity about just what happens has largely disappeared from today's more focused and money-driven science. Curiosity has certainly paid off in the past, so it would be a shame if it were to go altogether.

He also observed something all others interested in vines had also seen – that some plants twine from left to right and others from right to left. An old ballad recounts the romance between a woodbine (honeysuckle) and a morning-glory – she twining to the right, he to the left. Their offspring were erect, and fell over – an unnatural union. Darwin observed that in a very few cases the direction of twining was reversed – a plant of *Ipomoea* first went one way, then switched, then back again – but this is unusual, as twiners usually stick to one revolution direction: morning-glory species twine in either one direction or the other, and the direction is the same for all members of any given species. This is the common situation in all vining plants, confirmed by the Darwins with their experiments at Downe. The twining habits of morning-glories gave the family its scientific name (from *convolvere*, meaning 'to entwine') and the common names of many of the members of the

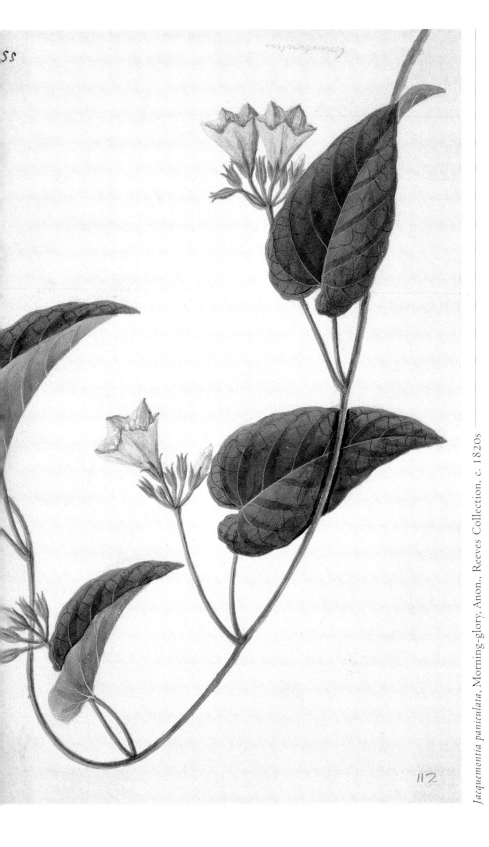

Jacquemontia paniculata, Morning-glory, Anon., Reeves Collection, c. 1820s

Convolvulaceae refer to this entrapping growth form. Bindweed (*Convolvulus arvensis*) is the only vine among the world's most pernicious weeds, whereas the hedge bindweed of Britain is *Calystegia sepium*, whose strangling abilities and pervasive roots are commemorated in its common names, Devil's Guts and Robin-run-the-hedge. However, other common names refer to its lovely flowers.

'Morning-glory' refers surely to the spectacular display put on by these twiners, for a bank covered by these plants is a brilliant show first thing in the morning. The flowers of most morning-glories, such as *Ipomoea purpurea*, open very early in the morning and last but a single day; indeed, many of the 500-plus species of *Ipomoea* have this day-flowering habit, but the spectacular *Ipomoea alba* bears white or purple fragrant flowers that open at night. Linnaeus called these plants *Ipomoea Bona-Nox,* which roughly translates as 'beautiful night-bindweeds'. Morning-glory flowers all have a similar shape, twisted and regularly folded in the bud, that open out to flaring trumpets of a wide range of colours from white to red and yellow. In a pleasing twist, morning-glory buds are always beautifully symmetrically twisted, providing an artistic addition to the twining stems. When at their peak of flowering in midsummer, morning-glories can be dripping with blossom.

In Japan they are symbols of summer and thousands of pots of morning-glories are sold at Tokyo's *Asagao-ichi* (Morning-Glory Fair). Japan and China's morning-glory is *Ipomoea nil* and, although it has long appeared on Chinese pottery, most spectacularly on blue and white fifteenth-century Ming vases, it is in Japan where the cultivation of morning-glories reached its peak. Introduced from China to Japan in the eighth century (reputedly for its medicinal properties), many spectacular variants of *Ipomoea nil* have been bred there over the centuries: double forms, different shades of blue, purple and white, huge flowers. The Imperial morning-glories were popular in the seventeenth and eighteenth centuries, reaching their peak of popularity during the Meiji period, when the Imperial capital was moved from Kyoto to Edo, which was then renamed Tokyo. The morning-glory festival flourished during the 1880s

Left: *Ipomoea nil;* Right: *Merremia* cf. *umbellata*, Morning-Glory, Anon., Reeves Collection, c. 1820s

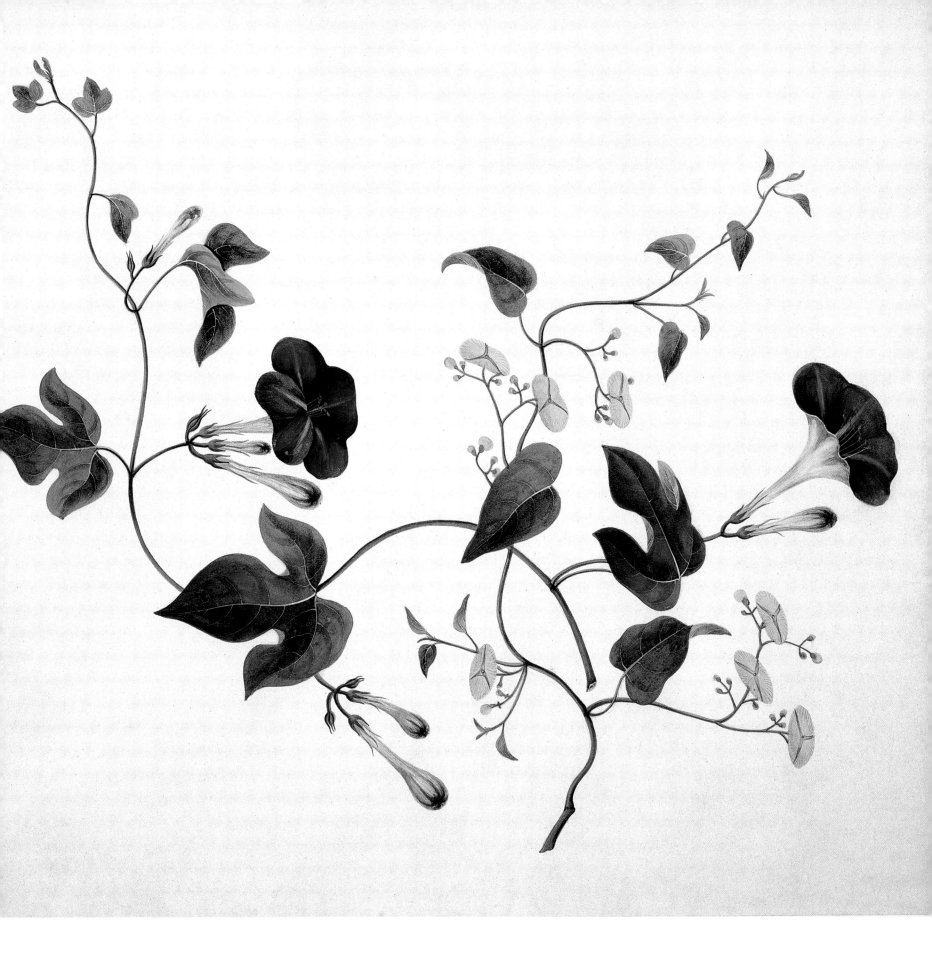

315

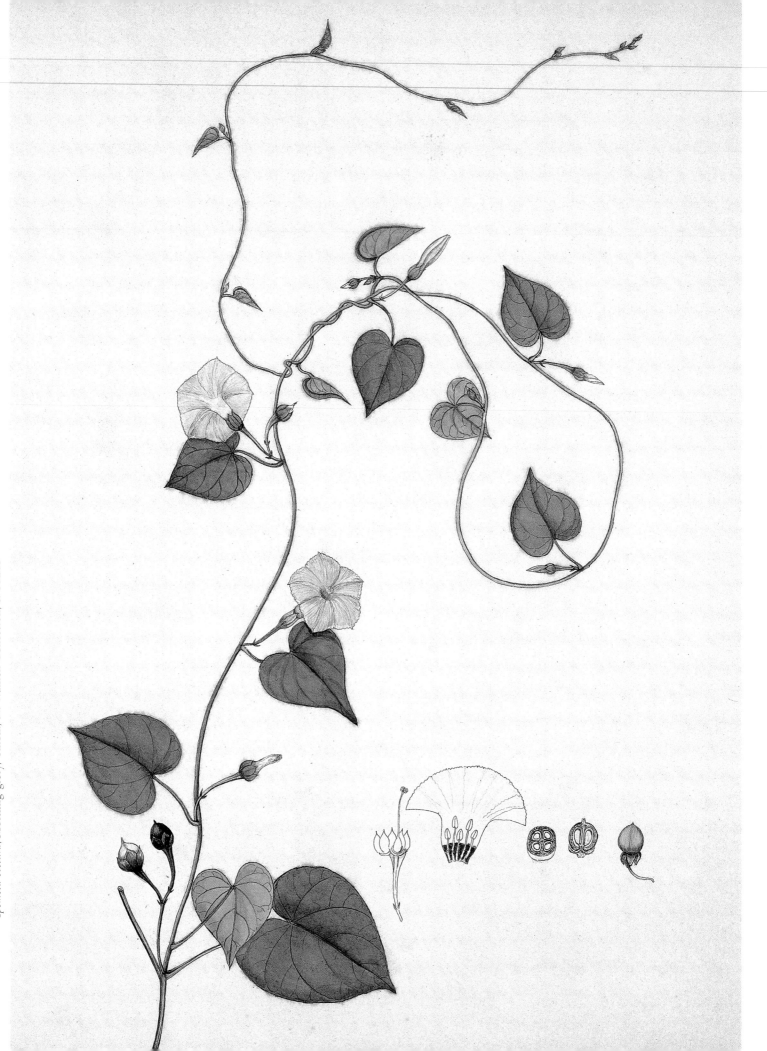

and 1890s, but land pressures in the Tokyo area caused its decline in the early twentieth century. Local merchants revived the festival in the years following World War II, and for three days in July the Tokyo's Iriya district is awash with morning-glories. The Japanese celebrate summer with this most ephemeral and summery of flowers, and home delivery means they can be sent to friends or family direct from the fair, bringing luck to the recipient.

Morning-glories grow anywhere. There are both tropical and temperate forms and, in the days before air conditioning and fans, were often used in hotter climates as quick-growing shades for verandahs and porches. A curtain of bluey-purple flowing vine is much more beautiful than a humming, square box in the window! The morning-glory family is extremely diverse in dry parts of the world; in fact, they are important members of the herbaceous vine flora in deserts, especially in Australia and the Americas. Many of these desert species (like the pernicious weed *Convolvulus arvensis*) have large storage roots, but others are ephemeral annuals.

Mexico is an area of high morning-glory diversity, but there the plants were not only prized from their beauty but were also culturally vital. The Spanish physician Francisco Hernández, who travelled to Mexico in the years following the Spanish Conquest, recorded the use of a plant called *ololiuqui* in divination. Early post-Conquest observers of the use of *ololiuqui* wrote that 'natives …communicate with the devil…when they become intoxicated with ololiuqui, and they are deceived by the various hallucinations which they attribute to the deity which they say resides in the seeds'. Hernández, who was a keen observer, wrote that 'when the priests wanted to communicate with their gods and to receive a message from them, they use this plant to produce a delirium, during which a thousand visions and satanic hallucinations appeared to them.' Even accounting for the strong Christian disapproval, this was clearly a plant used for communication with the spirit world. For centuries, the true identity of *ololiuqui* was a mystery; some suggested it was a member of the nightshade family (like *Datura*, whose flowers look very morning-glory-like). This identification

was widely (but not universally) accepted until Richard Evans Schultes, the great Harvard botanist who devoted his life to the study of New World ethnobotany, collected some plants of a morning-glory called *Turbina corymbosa* cultivated in Oaxaca, Mexico, whose seeds were being used for divination. This clinched the identity of *ololiuqui* – a look back at the early illustrations showed them to be unmistakably morning-glories, with a twining habit, heart-shaped leaves and those distinctive flowers.

In the 1950s, self-experimentation by Humphrey Osmond, an American psychiatrist, revealed that ingesting the seeds led to apathy and listlessness, then followed by visions, and a relaxed feeling of well-being. However, others did not believe there was any effect. Yet, despite having been identified botanically, *ololiuqui* remained an enigma.

When another botanist working in Oaxaca found people ingesting the jet-black seeds of another morning-glory (*Ipomoea tricolor*) as a narcotic, it was clear that these plants were psychoactive. But what was the active chemical? The active alkaloids in both these morning-glories turned out to be a real surprise, for they were ergot alkaloids, previously only known from fungi such as *Claviceps* or *Penicillium*. The Swiss chemist Albert Hofmann isolated several different ergot alkaloids from both *Turbina* and *Ipomoea tricolor* in the early 1960s, but the main constituent of both was lysergic acid amide, or ergine. Hofmann ascertained the effect of these compounds by self-experimentation – he self-administered both main constituents, ergine and isoergine, in their pure forms, and it became clear that both alkaloids had pyschotomimetic effects (that is, they were capable of inducing psychotic symptoms). Oddly,

Hofmann had synthesized a potent hallucinogen from lysergic acid in the late 1930s. Known as d-lysergic acid diethylamide, or LSD, it differs from the compounds occurring natural in *ololiuqui* by a few chemical substitutions. The effects of the cocktail of alkaloids found in *ololiuqui*, however, include a marked narcotic effect – Hofmann found that ergine and isoergine both induced a relaxed, sleepy feeling, while LSD is a pure hallucinogen, a hundred times stronger and with a most specific effect. The plants being used in Mexico were culturally significant and ritually important: a source of power and help, not for recreation.

When the presence of hallucinogenic ergot alkaloids in these plants became widespread knowledge, ingesting morning-glory seeds became popular, as Schultes put it, among 'certain fringe groups in European and American society'. The source of 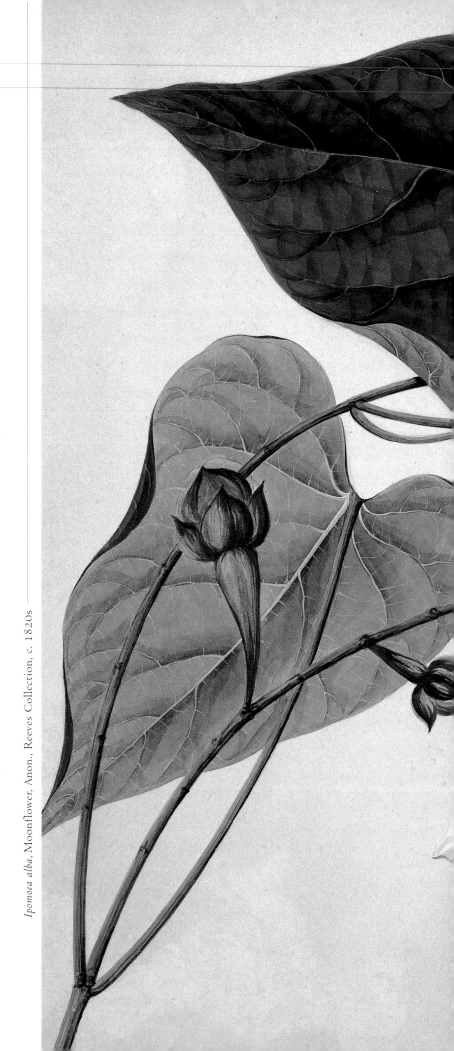 these seeds was the horticultural trade, as you could just go down to the corner garden shop and buy a packet of morning-glory seeds, although abuse of the seeds became so serious that measures were taken in many places to restrict the sale of seeds to the public. Actually, it is surprising it was so popular, for those around at the time relate that, most often, people who chewed morning-glory seeds became quite nauseous and threw up. Many horticultural varieties have no hallucinogenic effects, but it is not true (as some have suggested) that the effects of morning-glories are a myth. Several other members of the family have entered the botanical drug scene as substitutes for LSD, and most morning-glories tested have had some ergot alkaloid content. Schultes wondered why the use of morning-glories in divination had not been found outside Mexico, for it seems inconceivable that a drug of this power remained unexploited all over the world: 'The perplexing ethnobotanical question is why, with hallucinogenic compounds geographically and phylogenically [phylogenetically] so widespread in the Convolvulaceae, have aborigines outside of Mexico never employed

Ipomoea alba, Moonflower, Anon., Reeves Collection, c. 1820s

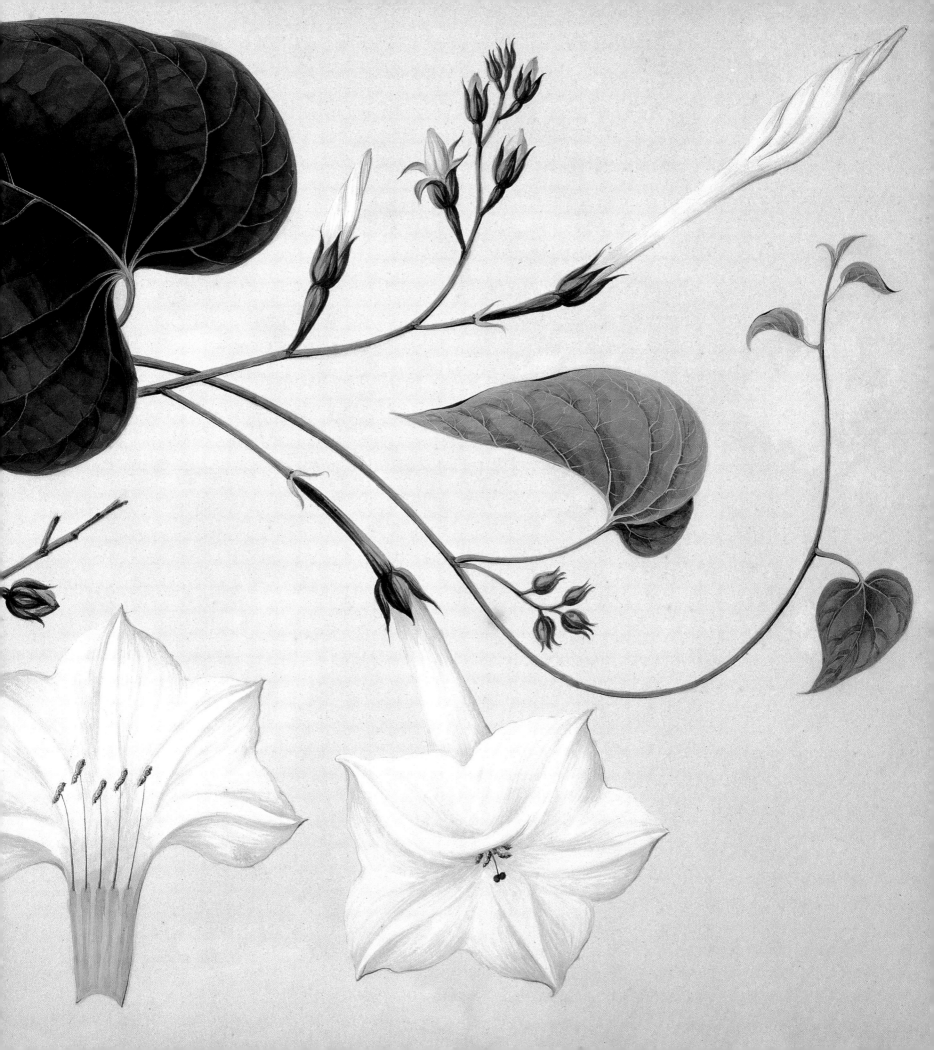

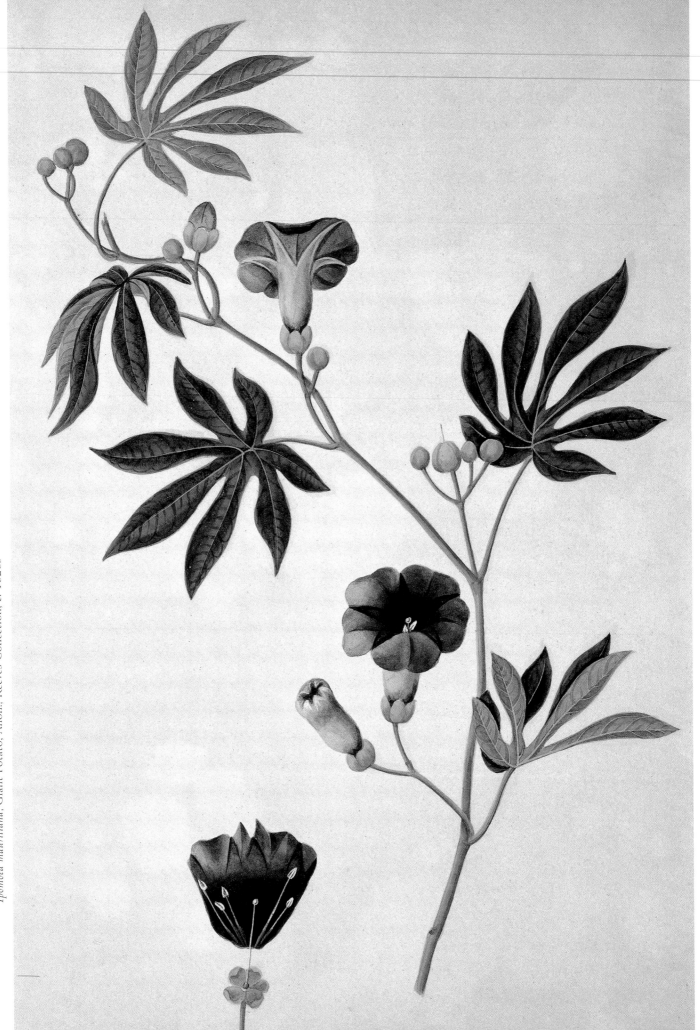

these plants for their psychotomimetic effects? Or, have they?' Here is a real mystery, illustrative of the relationships people have with plants – sporadic, seemingly random and, above all, highly individualized.

Another mysterious morning-glory is the sweet potato (or yam in the southern United States), *Ipomoea batatas*. The sweet potato is a tuberous-rooted morning-glory with glorious purplish pink flowers, and has nothing to do with the potato. Unknown in the wild, it is a pentaploid cultivar and is probably originally native to South and Central America, its widespread cultivation throughout the Pacific fascinating those interested in the migration of peoples over the globe. Sweet potatoes were the staple crop on Rapa Nui (Easter Island) and were characterized as the fuel for building the giant stone statues, the *moai*. The Norwegian scientist-explorer Thor Heyerdahl became intrigued by both the prevailing wind direction (east to west) and the prevalence of sweet potato cultivation in Polynesia while working on the flora and fauna of the remote island of Fatu Hiva in the Marquesas Islands. He speculated that these two observations were evidence that the Polynesians had migrated not from Asia, as was commonly thought, but from South America instead. In 1947, he built a balsawood craft, the *Kon-Tiki*, and set sail from the coast of Peru to prove his point. One hundred and one days later, he and his crew landed on the island of Raroia in Polynesia, to show that it was possible. Possibilities, however, don't mean that something happened that way, of course, and geneticists have recently shown – using genes both from female lineages (mitochondria) and male lineages (Y chromosomes) – that the Polynesians are related to the peoples of Asia not to those of South America, and are now turning their attentions to the sweet potato. One day its mysteries, like those of the peoples who depend on it, will become clear.

Intoxicating, ephemeral and mysterious, morning-glories grow quickly into the human imagination. They are almost a symbol of the multifaceted relationships that people have with the plants in their environments.

Ipomoea pandurata, Man-root, S. Taylor, c. mid-1700s

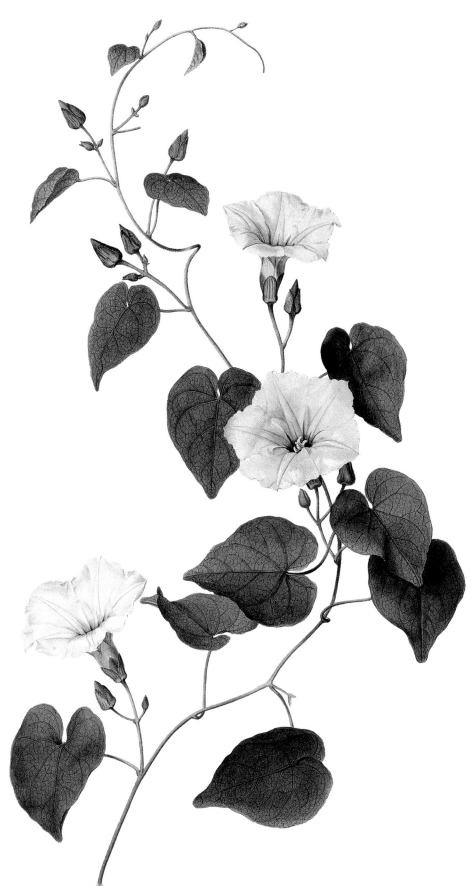

Collected along the Endeavour River in eastern Australia, the flowers of this morning-glory were described by the Endeavour artist Sydney Parkinson as 'pale blue wi a cast of pink appearing like lilac colour turning very pale at the tube which is white outside'. His detailed descriptions and careful sketches with colour indications allowed Banks' artists back in London to reproduce the work accurately.

Morning-glory
Ipomoea indica (Burman f.) Merrill (Convolvulaceae)
John Frederick Miller, Cook Collection
1773, watercolour with ink on paper
535mm x 360mm (21in x 14¼in)

Sydney Parkinson, Banks' artist, wrote notes to accompany his sketches from which these finished paintings were made: 'The upper side of the flower, stamina & stile white the nerves on the underside ting'd wi Crimson which fades away into the tube which is ting'd wi green the upper side of the leaves grass wi pale prominent veins the underside Glaucus & pale wi dark veins & prom. nerves pet. stalk & calyx stain'd purple.'

Moonflower
Ipomoea trichosperma Blume (Convolvulaceae)
John Frederick Miller, Cook Collection
1773, watercolour with ink on paper
535mm x 360mm (21in x 14¼in)

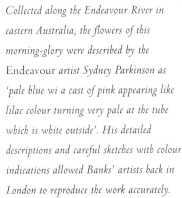

In China, one common name for Ipomoea nil *is* lieye qian niu, *meaning 'divided leaf to lead an ox'. This relates to the legend of a farmer who, having been cured of a fatal disease by the seeds of the morning glory, led his prized possessions (his cattle) to the fields where it grew in order to give thanks to the plant.*

Morning-glory
Ipomoea nil (L.) Roth (Convolvulaceae)
Anon. Reeves Collection
c. 1820s, watercolour on paper
193mm x 124mm (7½in x 4¼in)

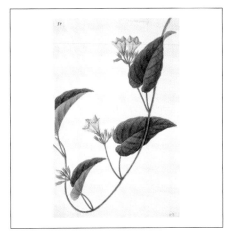

The identity of this morning-glory is uncertain, but it looks very like plants of Ipomoea purpurea, *with several flowers borne at the top of a long stalk. The differences between genera and species in the morning-glory family are to be found in details of the stigmas and other flower structures, but without details the best we can do is guess at the identity of the plants in these paintings.*

Morning-glory
Jacquemontia paniculata (Burman f.) Hallier f. (Convolvulaceae) Anon. Reeves Collection
c. 1820s, watercolour on paper
193mm x 124mm (7½in x 4¼in)

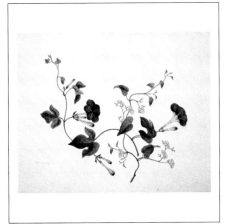

This Chinese composition is more stylistic than botanical. Although the plants are more or less identifiable, the details of the flowers are extremely sketchy — the Merremia *flowers are really just yellow disks of colour, for example. However, the composition of intertwining stems captures the habit of morning-glories perfectly.*

Morning-glory
Left: *Ipomoea nil* (L.) Roth (Convolvulaceae); Right:
Merremia cf. *umbellata* (L.) H. Hallier (Convolvulaceae)
Anon. Reeves Collection, c. 1820s, watercolour on paper
373mm x 463mm (14¾in x 18¼in)

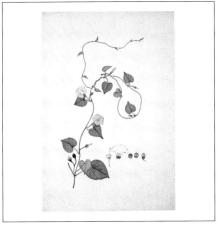

We usually think of morning-glory flowers as blue or white — like the varieties of Ipomea trifida *'Pearly Gates' or 'Heavenly Blue' — but many genera and species of morning-glory, such as this one, have yellow flowers. Nathaniel Wallich collected and described many plants from northern India and Nepal, and the botanical accuracy of this painting suggests he trained the artist well.*

Morning-glory
Ipomoea obscura (L.) Ker Gawl. (Convolvulaceae)
Anon. Nathaniel Wallich Collection
c. 1820s, watercolour with ink on paper
483mm x 332mm (19in x 13in)

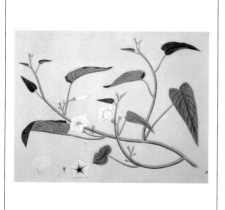

The leaves and stems of water spinach are used in stir-fry cooking, and for that reason it is often introduced in ponds in subtropical areas. However, this is a mistake, for the plants are tremendously invasive, soon choking waterways, outcompeting native aquatic vegetation and providing an ideal breeding ground for mosquitoes. The USDA classifies it as a Federal Noxious Weed.

Chinese Water Spinach; Swamp Cabbage
Ipomoea aquatica Forssk. (Convolvulaceae)
Anon. Reeves Collection
c. 1820s, watercolour with bodycolour on paper
359mm x 467mm (14¼in x 18⅛in)

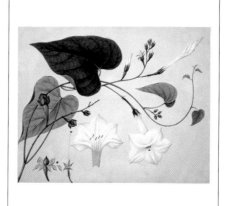

The moonflower is probably native to the Americas but has long since escaped, and now behaves as a native plant in the tropics and subtropics of both hemispheres. Any plant with qualities appreciated by humans — such as the glorious night-time scent of these flowers — is quickly carried with them wherever they go, which makes analysis of just what is and is not native very difficult.

Moonflower
Ipomoea alba L. (Convolvulaceae)
Anon. Reeves Collection
c. 1820s, watercolour with bodycolour on paper
365mm x 465mm (14½in x 18¼in)

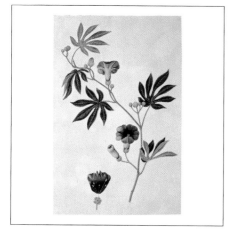

The tuberous roots of this plant, called bhilaykand or bhuyikohada in Hindi, are used in Ayurvedic medicine to treat problems of pitta and vata — two of the three rosas, psychological and physiological attributes of the human body. Pitta is translated as 'bile' and vata as 'wind'. Pitta is responsible for all physiochemical activities of the body, such as metabolism and the production of heat and energy, while vata governs movement and sensation.

Giant Potato; Kiribadu; Likam
Ipomoea mauritiana Jacq. (Convolvulaceae)
Anon. Reeves Collection
c. 1820s, watercolour on paper
374mm x 246mm (14¼in x 9⅝in)

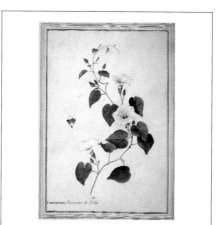

Not all paintings are done on paper or on canvas. Many eighteenth-century botanical artists greatly valued vellum as a medium on which to paint. Made from animal skin (usually goat or sheep), vellum was washed, shaved and stretched to varying thicknesses. The resulting substrate was creamy-white and gave a beautiful luminosity to the finished work, but one had to take care, as mistakes had to be scraped off.

Man-root
Ipomoea pandurata (L.) G. Mey. (Convolvulaceae)
Simon Taylor
c. mid-1700s, watercolour with bodycolour on vellum
460mm x 320mm (18in x 12½in)

ABOUT SCIENTIFIC NAMES

Botanists classify plants in various of ways, but here I have used three nested categories: families, genera (singular is genus) and species. Families are made up of genera that share features they have all inherited from a common ancestor. In botany, family names end in the suffix '-aceae' – all magnolias, for example, are members of the family Magnoliaceae. Some people still use the now-outdated family names with different endings, such as Cruciferae for what we now know as Brassicaceae, or Palmae instead of Arecaceae. This may seem like change for change's sake, but it allows non-specialists to know just what level in the hierarchy we are talking about. A genus is a more narrowly defined grouping that contains species that share characteristics and a single species has unique characters that distinguish it from all other organisms.

Scientific names of plants and animals are based on Latin, which may seem archaic. One reason for using Latin is that it was the language of scholarship in the beginning of the scientific age, but there is a more important reason for the use of scientific names. Plants or animals may have many common names, depending on where you are. For example, plants with the scientific name *Endymion non-scriptus* (L.) Gaertn. are called bluebells in England, but in the United States and Scotland the common name 'bluebell' refers to members of the genus *Campanula* (in a completely different family). In China, *Magnolia liliiflora* is known as *Mu-lan* but in the English-speaking world as 'lily-flowered magnolia'. Scientific names make discussions about organisms international.

In the early days of taxonomy, scientists referred to organisms using long Latin polynomials or phrase names, the first word of which was the name of the genus. Carl Linnaeus, father of modern botany, revolutionized the way we name plants and animals when he introduced a system of 'trivial names', single-word designations that (in combination with the genus) could serve as a sort of shorthand for the longer, more complicated phrase names. Today these trivial names are what we refer to as the genus and species names of plants and animals. By convention, both the genus and species name are italicized (the family name is most often not) and genus names are capitalized, while species names (or species epithets) almost never are. Our own scientific name, for example, is *Homo* (the genus) *sapiens* (the species) of the family Pongidae.

The scientific naming of plants is governed by the *International Code of Botanical Nomenclature*, a set of rules and recommendations voted upon by the entire botanical community every six years at international congresses. Botanists have been adapting and refining their code of nomenclature (naming) for nearly 200 years, and it has evolved with worldwide use. One rule in the *Code* that is sometimes a bone of contention between gardeners and botanists is the principle of priority. Priority is simple: the oldest name – that which was coined first – is the one that is 'legally' correct and the one we should use. This can be irritating when names with a long history of use in society at large suddenly get changed because an older name has been unearthed. 'Magnolia denudata' had been widely used for the lily-flowered magnolia until someone found that the species name 'heptapetala' had been published earlier. The name would have had to change, but for the *Code*'s clever 'get-out' of conservation and rejection, which allows botanists to propose a name for conservation, so it then becomes the correct name over all earlier names, or rejection, whereby it is rejected as a correct name for ever. These rules can be used when stability of usage is threatened, preserving the status quo, but the reasons and justification have to be good. These decisions are not taken lightly! Another reason names change is because ideas about relationships change, mostly relating to membership of one genus or another. For example, take the scientific name of the tomato. First described by Linnaeus as *Solanum lycopersicum*, it was later given its own genus by Philip Miller, who called it *Lycopersicon esculentum*. Today, we know that the tomato and its relatives are nested within the genus *Solanum* (they are, in fact, most closely related to potatoes), so we again call it *Solanum lycopersicum*. This sort of name change reflects an increase in our knowledge, a scientific advance in knowledge about relationships even though we are using Linnaeus' original name.

As well as being understandable across cultures, scientific names of plants must also be uniquely identifiable, so taxonomists also add the surname of the person who coined the scientific name. For example, Robert Brown named a species of the palm genus *Livistona* as new to science and called it *Livistona humilis*, so when referring to this plant by its full scientific name we call it *Livistona humilis* R. Br. (standard abbreviation of 'Robert Brown'). This differentiates it from any other '*Livistona humilis*', for we know we are referring to Robert Brown's name. We may think that no botanist would use a previously used name but it has happened more often than we might think! Today's computerized indices mean there is no excuse for using an already-used name. An author's name in parentheses means that he or she originally described the species in a different genus: for example, botanist Eduard Frederich Poeppig originally described the royal waterlily as *Euryale amazonica*, so its name was *Euryale amazonica* Poeppig. Later botanists decided it was sufficiently different from other *Euryale* species to warrant being in another genus, and the name *Victoria regia* had been used. But the species name *amazonica* is older than the species name *regia* – it has priority – so the correct name for the waterlily becomes *Victoria amazonica* (Poepp.) Sowerby, as John Sowerby was the one who finally sorted this all out and made the correct combination of genus and species names. For ease of reading, I have used names without their authors, but to be truly correct one should also include the author. Keeping careful track of names, with the people responsible for them, enables taxonomists to pursue their trade and is the basis for the common language of biology.

BIOGRAPHIES

JUDITH MAGEE, THE NATURAL HISTORY MUSEUM, LONDON, UK

FRANZ BAUER, 1758–1840. Feldsberg, Austria

The father of Franz Bauer was court painter to the Prince of Liechtenstein, and Franz with two of his brothers followed their father's career and became artists. As boys, all three sons were employed by Dr Norbert Boccius to draw the wild plants of the Valtice area where they lived. Boccius educated the boys in botanical drawing, teaching them to depict plants in a scientifically accurate manner. Franz Bauer visited London in 1788 with the intention of travelling on to Paris; however, he was offered a position as botanical illustrator at the Botanic Gardens at Kew by Sir Joseph Banks, which he duly accepted. Bauer became the first paid botanical artist at Kew Gardens, where he remained until his death in 1840. Franz Bauer is technically one of the most sophisticated of all botanical artists. He became a highly skilled botanist and created some of the most detailed studies of plant structure using a microscope. He and his brother are considered two of the greatest botanical artists of all time.

FERDINAND BAUER, 1760–1826 Feldsberg, Austria

Like his father and elder brother, Ferdinand became a professional artist. In 1785 he was introduced to John Sibthorp, Sherardian Professor of Botany at Oxford, who was planning an expedition to the Levant and who promptly engaged Bauer as the artist for the expedition. In 1801, Bauer was appointed as the natural history painter on the expedition to survey the coast of Australia in the *Investigator* under Captain Matthew Flinders. Bauer spent almost four years in Australia sketching and painting well over 2000 plants and animals. On his return to England, he produced life-size watercolours of plants to accompany the first flora of Australia by the botanist Robert Brown. His watercolours of the flora and fauna of Australia are considered to be some of the finest ever produced. Bauer returned to live in Vienna in 1814.

JAMES BOLTON, 1735–1799 Sowerby, Yorkshire, England

Bolton was a weaver's son, and is believed also to have earned his living at that trade in his early life. He was a self-taught botanist and artist, and in later life learned to make engravings of his works. His brother Thomas was also an accomplished artist of natural history. The two brothers acquired large collections of natural history specimens and possessed an extensive knowledge of botany. James was particularly interested in the lower plants and produced a large collection of drawings of mosses, fungi and ferns. He became well-known and respected by many of the scientists and naturalists of the day. The brothers were patronized by the Duchess of Portland and corresponded with men such as Peter Collinson, Philip Miller and James Edward Smith, founder of the Linnaean Society. James travelled extensively in northern England collecting, recording and drawing the plants of the region. In 1778

he moved to Halifax, where he remained till his death in 1799.

PETER BROWN, fl. 1758–1799

It is not certain if Peter Brown studied as a pupil of Georg Ehret, but he was most certainly influenced by the great artist. Brown exhibited at the Free Society of Artists and the Royal Academy between 1766 and 1791. Most of his compositions were of flowers but he also painted birds, one of which was the American Avocet for Thomas Pennant's *Arctic Zoology* (1784–5). At the height of his success, he became court painter to the Prince of Wales.

ARTHUR HARRY CHURCH, 1865–1937 Plymouth, England

Church attended University College, Aberystwyth after inheriting £100 ($150) on the death of his mother. Four years later he won a scholarship to Queen's and Jesus colleges, Oxford, where in 1894 he graduated with First Class Honours in Botany. He continued to work as a demonstrator in the Department of Botany at Jesus College until 1930. Church specialized in comparative plant morphology and was a master of microtechnique. His work in theoretical and practical botany is considered by many as revolutionary and his artwork is no less original. His watercolour drawings depicting plant structure were made to accompany his book *Types of Floral Mechanism*, published in 1908. These images – meticulous in detail, sharp and brilliantly coloured – contrast perfectly with his black-and-white cross-sections of the flower.

JOHANN CHRISTOPH DIETZSCH, 1710–1768 Nuremberg, Germany

Dietzsch belonged to a large family of artists, most of whom were flower painters, although Dietzsch himself also painted landscapes. His birthplace, Nuremberg, was one of the most important centres for botanical art in the eighteenth century and the Dietzsch family were well-known and highly respected. Dietzsch, his father and two of his sisters all worked at the court in Nuremberg. The hallmark of the Dietzsch family was that of preparing their paintings on a dark-brown or black background, which gave a particularly strong contrast and emphasized the bright colours used for the subject.

DUTCH COLLECTION

By the eighteenth century Dutch flower painting embraced botanical studies as well as the traditional grander displays of bouquets. Here the aim was to provide scientific accuracy as well as depicting the beauty of the plant. Two families that figured largely in botanical studies were the van Huysum and van der Vinne families. Both were large in number, and many of their members were flower painters. The tulip as subject for such artwork was one that had been popular since the mid-seventeenth century, when what was called

'tulipomania' swept through northern Europe. Some of these drawings are perfectly finished, with added dewdrops resting on the delicately coloured petals as in M.J. Barbiers' watercolours. Representations of peonies, iris and tulips have been selected from the Natural History Museum collection of Dutch watercolours.

GEORG DIONYSIUS EHRET, 1708–1770 Heidelberg, Germany

Ehret was the son of a gardener and was himself apprenticed as a gardener for several years. He taught himself the technique of watercolour and at the age of 23 decided to become a painter and botanist. After a great deal of hardship he was finally recognized by a Nuremberg Physician, Christopher Jacob Trew, who became Ehret's patron and lifelong friend. In 1736 Ehret visited Holland, where he met the Swedish scientist Linnaeus and worked with him on the *Hortus Cliffortianus* (1738). Ehret eventually settled in London, preferring English gardens that were full of 'true and exotic plants' to those of the Dutch. Here he became known as one of the greatest botanical artists of his day, producing a vast quantity of drawings of newly introduced plants from all over the world, on paper and on vellum. In 1757, Ehret became the only foreigner on the English list of Fellows of the Royal Society.

WALTER HOOD FITCH, 1817–1892 Glasgow, Scotland

Fitch moved to London and became the resident botanical artist at the Royal Botanic Gardens, Kew and is considered to be one of the most prolific of all botanical artists. He was the major contributor of drawings to Curtis's *Botanical Magazine* between 1834 and 1877, and also lithographed his own work. His other major works included drawings for Hooker's *Icones Plantarum* (1836–76); *Rhododendrons of Sikkin-Himalaya* (1849–51) and H.J. Elwes's *Monograph of the Genus Lilium* (1877–80). Fitch wrote a series of articles on botanical illustration that were published in the *Gardeners' Chronicle* in 1869. In 1880, Prime Minister Benjamin Disraeli granted Fitch a Civil List pension of £100 ($150) per annum.

JOHN FLEMING, 1747–1829

Fleming was a surgeon serving in the Indian Medical Service in Bengal. In 1793, he was appointed temporary Superintendent of Calcutta Botanic Garden after the death of Colonel Kyd. Like many physicians of the day, Fleming was not only a medical doctor but also a botanist. His main interest lay in medicinal and economic plants that led to extended plant-collecting trips throughout parts of India. The drawings that make up the Fleming Collection are selected copies from over 2000 images drawn by local Indian artists for William Roxburgh. Roxburgh, with the support of Sir Joseph Banks and financial assistance from the East India Company, began publishing fasicles of his book that came to be known by the title *Plants of the Coast of Coromandel* (1795–1819) The original drawings were completed by the mid-1790s. Copies of the drawings were made for Roxburgh's friends, which

included John Fleming, and date from the 1790s through to the early 1800s. The Fleming Collection consists of around 1160 drawings that were purchased by the Natural History Museum in 1882.

ANDREAS FRIEDERICH HAPPE, 1733–1802 Aschersleben, Germany

Happe was a German naturalist and artist who worked at the Berlin Academy of Sciences. The images reproduced in this book come from his six-volumed work *Botanica Pharmaceutica* (1785) and are two of the five hand-coloured engravings appearing in the main text of this book, all others being original artwork.

JACOBUS VAN HUYSUM, 1687–1740 Amsterdam, Holland

Jacobus was the younger brother of the great Dutch flower painter, Jan van Huysum. He lived in England for the last twenty years of his life, completing illustrations for John Martyn's *Historia Plantarum Rariorum* (1728–36) and the *Catalogus Plantarum* (1730) for the Society of Gardeners. Some of his time was spent with the botanical artist Ehret, and the bound volume of Huysum's drawings in the Natural History Museum include some by Ehret. As well as a botanical illustrator, Huysum was employed to make copies of old masters, but his artistic talent never came close to matching that of his older brother.

IDM COLLECTION

The collection consists of some 600 botanical illustrations dating from the early nineteenth century. The plants depicted are those grown in the botanical gardens of India at the time, but not necessarily indigenous to the country. Many of the plants were introduced by collectors and botanists travelling from as far afield as China, the Malay archipelago and Sumatra. As with the Fleming and Saharunpore Gardens collections, the artists for these drawings are unknown.

WILLIAM KILBURN, 1745–1818 Dublin, Ireland

Kilburn started his working life in a calico printing factory where he learnt the art of engraving. While he was still young he moved to London with his family soon after his father had died. Here he met William Curtis who employed him as an artist and engraver for his work *Flora Londinensis*. Kilburn was also one of the main artists for the early volumes of *Curtis's Botanical Magazine*. According to James Edward Smith, Kilburn used camera obscura for some of his artwork. In 1777 he left the employment of Curtis and returned to the commercial world of calico printing as a textile designer. He became very successful creating floral designs for his printed textiles.

WILLIAM KING, fl. 1750s–1760s Totteridge, England

King was a contemporary of Ehret and, like him, drew many of his flowers in the garden of Peter Collinson at Mill Hill, north London. He exhibited his flower paintings at London's Free Society of Artists.

JOHN LINDLEY, 1799–1865 Norfolk, England

Lindley began his career working as an assistant in the library of Sir Joseph Banks and later at the Horticultural Society of London. He was primarily a botanist and was appointed Professor of Botany at University College London from 1829 to 1860 and considered the drawing of living specimens as an essential part of that study. He became a FLS in 1820, a FRS in 1828 and was co-founder of *The Gardeners' Chronicle* with Sir Joseph Paxton in 1841. Lindley also served as the Secretary of the Royal Horticultural Society from 1858 to 1863. The Lindley Library at the Royal Horticultural Society is named for him.

OLGA MAKRUSHENKO, Moscow, Russia

Makrushenko is a young artist living in Moscow whose work is constructed using airbrush overlay techniques. Her work captures the spirit and vitality of plants that is often absent in contemporary botanical illustration. The work was purchased directly from the artist by the Natural History Museum in 2001 after a successful appeal to the Museum Membership, and represents the first artwork of the new century to be added to its botanical art collection.

MARGARET MEEN, fl. 1770–1820s Suffolk, England

Meen moved to London some time in the 1770s to teach flower and insect painting. She exhibited her work as a botanical artist at the Royal Academy 1775–85, and also in 1810 at the Watercolour Society, of which she was a member. She spent much of her time drawing the plants at the Royal Botanic Gardens, Kew. In 1790 she published the first number of *Exotic Plants from the Royal Gardens at Kew*, which she dedicated to Queen Charlotte. The intention was to publish two numbers a year, but succeeding issues never materialized.

ANNA MARIA SIBYLLA MERIAN, 1647–1717 Frankfurt, Germany

Merian was the daughter of an engraver and after her father died her mother remarried an artist, so Maria was surrounded by artists from an early age. Maria herself married an artist, and in 1670 moved with him to Nuremberg, where she worked as a flower painter. Unhappy in her marriage, she later left her husband, taking their daughter with her to live in Amsterdam. In 1699, with a stipend from the Dutch government, they set sail for Surinam, where she remained for two years collecting and painting insect and plant life. On her return, she published *Butterflies and Moths of Surinam* (1705) and was commissioned to draw flowers and insects for a number of admirers of her work, including Peter the Great. Some of the greatest eighteenth-century scientists (such as Linnaeus) studied her drawings and the specimens she had collected.

GERTRUDE METZ, fl. 1775 Bonn, Germany

Like many of the German botanical artists, Metz moved to London where she worked from 1775 to 1793 for Sir Joseph Banks. She recorded the new plants flowering in the Royal Gardens at Kew and in the nursery garden at Hammersmith that belonged to James Lee and Lewis Kennedy. This nursery was one of two of the most important nurseries cultivating newly introduced plants from around the world.

JOHN FREDERICK MILLER, fl. 1770–1790s London, England

John Miller was the son of Johann Sebastian Mueller who settled in London in 1744 from Nuremberg and was himself a botanical artist. John Frederick was recognised as a competent artist by Sir Joseph Banks who employed him, together with other artists, to complete Sydney Parkinson's sketches from the voyage of the *Endeavour* (1768–71). In 1772, he accompanied Sir Joseph Banks to Iceland and drew many of the plants collected on this voyage.

FREDERICK POLYDORE NODDER, fl. 1770–1800

In 1776, John Frederick Miller, his brother James and John Cleveley left Banks' employ, and Nodder was brought in to redraw and complete the remaining Sydney Parkinson sketches. He worked as the sole watercolourist for some five years in the company of three engravers in an attempt to complete Banks' *Florilegium of the Endeavour Voyage*. Nodder also contributed to Erasmus Darwin's *Botanic Garden* (1789), Thomas Martyn's *Thirty eight plates with explanations intended to illustrate Linnaeus's System of Vegetables* (1794), and *Flora Rustica* (1792–4), in which he completed the engravings as well as the drawings. He was appointed botanical painter to Queen Charlotte in 1785 and exhibited at the Royal Academy.

SYDNEY PARKINSON, 1745–1771 Edinburgh, Scotland

Parkinson was born into a Quaker family and was apprenticed as a young man to a woollen draper. His talent as an artist came to the attention of Sir Joseph Banks, who employed Parkinson as an artist to draw the plant specimens collected from Newfoundland and to copy the drawings from Ceylon by John Loten. Banks also sent Parkinson to the Botanic Gardens at Kew to draw. Parkinson accompanied Banks on the voyage of the *Endeavour* in 1768 as one of two artists. He completed a great many drawings of both plants and animals from the Pacific, but died from the combined effects of dysentery and malaria in the later part of the return journey.

PASSIFLORA

Some of the images of this plant are from a collection of broadsheets, and (with the Happe gentians) are the only engravings included in the main text. They have been chosen because of their interesting presentation and early dates. They include engravings from the original artwork of Fra. Donato d'Eremita, 1619 and Tobia Aladini, 1620.

CLARA POPE, c. 1768–1838

Clara Pope exhibited at the Royal Academy between 1796 and 1838. Her flower paintings were all on a large and spectacular scale, and it was these that

brought her fame when she exhibited them at the Academy. She illustrated Samuel Curtis' *Monograph on the Genus Camellia* in 1919 and his *Beauties of Flora* (1806–20). In her early years as an artist she painted miniatures while also working as an artist's model. Later she executed full-length portraits and taught art to the daughters of the aristocracy, but her most accomplished work remains her flower painting of peonies, camellias and roses that emanate colour and vibrancy.

JOHN REEVES, 1774–1856 West Ham, England

John Reeves arrived in Canton, China in 1812 as an Inspector of Teas for the Honorable East India Company. Canton was the only port in China open to the west at that time, and all activities of European traders were under strict control of the Manchu officials. Trade was permitted only during the winter months. From April to August, European traders moved to Macao – during this period Reeves had time to devote to his interest in natural history. He served three tours in Canton for about five years each, his last tour ending in 1831. In 1817, the Horticultural Society of London accepted an offer from Reeves to supply drawings as well as specimens of plants. Reeves arranged for native Chinese artists to work under his supervision, drawing many exotic plants never before seen in the West. The collection held at the Natural History Museum includes over 900 botanical drawings, by various artists.

T. REICHEL, fl. 1787

The collection of drawings by Reichel in the Natural History Museum consists of eleven watercolours that were executed in Madras between 1787 and 1789. The Madras Botanic Garden was one of three important gardens in India owned by the East India Company.

FRANK HOWARD ROUND, 1878–1958

Round was the assistant drawing master at Charterhouse and completed his drawings of *Iris* species after his teaching each day. The collection of *Iris* drawings held in the Botany Library of the Natural History Museum were made for the Hon Nathaniel Charles Rothschild (1877–1923). Rothschild had a splendid garden at his home in Ashton Wold and a fine collection of *Iris* species growing both there and at his brother's home in Tring, and it was these plants that Round illustrated. The plants would be sent in batches of three or four through the post, and were therefore not always in the best condition on arrival. The drawings date from 1911 through to 1920.

WILLIAM ROXBURGH, 1751–1815 Craigie, Ayrshire, Scotland

Roxburgh was a medical doctor who went to work for the East India Company and was stationed at Madras in 1776. His interest and love of botany led him to become the Superintendent at the Samalkot Botanic Garden (1781–93) and later Superintendent at the Calcutta Botanic Garden and chief botanist of the East India Company (1793–1813). Roxburgh retained a painter who was constantly employed in drawing plants, to which Roxburgh gave accurate descriptions. These drawings were presented to the East India Company and a selection of them made up the contents of Roxburgh's published work *Plants of the Coast of Coromandel* (1795–1819). The palms that feature in this book are some of the original drawings that were made for Roxburgh in the late 1780s and early 1790s.

SAHARUNPORE GARDEN

The Botanic Garden at Saharunpore lay more than 1200km (800 miles) northwest of Bengal, south of the Siwalik Hills and the Himalayas. It was the most important botanical garden after Calcutta. In 1823, John Forbes Royle (1798–1858) was appointed as Surgeon to the East India Company and its two hospitals in Saharunpore, and as Superintendent of the Company's garden. The plants grown in the garden were for medicinal purposes. Royle employed collectors to find plants from Kashmir and Kunawar and commissioned local artists to complete drawings of these plants. He left the Garden to return to England in 1831, but succeeding superintendents continued to have drawings made of new species acquired by the Garden. The watercolours in the Saharunpore Gardens Collection of the Natural History Museum are those made under the supervision of Deputy Surgeon-General William Jameson (1815–83). These were completed some time in the 1850s.

JOHANN GOTTFRIED SIMULA, fl. 1720s

In 1720, Simula produced *Flora Exotica* for the Count of Dernatt in northern Germany. Bound together as a single volume, it contains gouache paintings of more than 1000 flowers that were in cultivation at the time. Florilegiums such as Simula's were not intended as scientific works but as 'picture books of garden flowers'. Some of the plants are set in a landscape background together with insects, and most of them are named, thereby providing a valuable record of the principal horticultural varieties of the period.

LILLIAN SNELLING, 1879–1972 Kent, England

Snelling was a student of the Royal College of Art where she studied lithography. In 1916 she became the botanical artist to Sir Isaac B. Balfour, Regius Keeper of the Royal Botanic Garden in Edinburgh where she remained until 1921. She then moved to London and was appointed principal artist and lithographer at the Royal Botanic Gardens, Kew where she worked as illustrator for *Curtis's Botanical Magazine*. This was a position she held for some thirty years. Her watercolours are brilliantly sharp, graceful and scientifically accurate.

JAMES SOWERBY, 1757–1822 London, England

Sowerby was a prodigious artist, producing a considerable number of drawings for *Curtis's Botanical Magazine* (1788–) *Flora Londinensis* (1777–87), Aiton's *Hortus Kewensis* (1789) and more than 2500 drawings for *English Botany* (1790–1814), written by James Edward Smith. He also produced works of

his own, including 440 drawings for *Coloured Figures of British Fungi* (1795–1815). Sowerby studied art at the Royal Academy Schools and soon took up flower painting, but had to depend on teaching for several years before he was employed by Curtis to make drawings for the *Botanical Magazine*. He was the first in a large family of botanical artists, and became an accomplished scientist in many fields of natural history. He was an excellent artist and learned to become a skilful engraver.

GERARD VAN SPAENDONCK, 1746–1822 Tilburg, Holland

At the age of 10, Spaendonck was apprenticed to a firm of interior decorators in Antwerp, and it was here that he studied painting with the Flemish painter Herreyns the Elder. Spaendonck became a successful painter and by 1770 had established himself in Paris. By 1774, he had been appointed '*peintre en miniature du roi* (king's miniature painter) and *professeur des fleurs* at the Musée du Jardin du Roi. As official court flower painter, he followed in the footsteps of Nicolas Robert and Claude Aubriet, and later handed over this role to his pupil, Pierre Joseph Redouté. The drawings from the collection held in the Museum are on Dutch paper, dated 1769. Wilfred Blunt believed that these drawings were made just before Spaendonck left for France or soon after his arrival in Paris.

RALPH STENNETT, fl. 1800s Bath, England

Stennett was a natural history draughtsman who exhibited at the Royal Academy in 1803. His interest lay in natural history as a whole, not just in botanical drawings.

SIMON TAYLOR, 1742–1796

Taylor trained as a botanical artist and spent much of his time painting rare plants at Kew. He produced work for Lord Bute and later for the Duchess of Portland and John Fothergill, a man who employed several artists to draw plants from his garden. Much of Taylor's work was produced on vellum and his style was very similar to that of Ehret, though he never quite achieved the lightness of paint application that Ehret exhibited in his work. After Ehret's death in 1770, John Ellis (writing to Linnaeus) considered Taylor as the next best artist worth employing, declaring that 'he does it tolerably well'.

MARGARET TEBBS, 1948– Middlesex, England

Margaret Tebbs is a professional freelance illustrator who has worked on a wide range of publications. Between 1969 and 1991, she worked in the Botany Department of the Natural History Museum as a curator and taxonomist, producing several accounts of Piperaceae for *Flora Mesoamericana* and other publications. She has travelled extensively, visiting herbaria in Europe and North America and collecting plants in Central America. As an illustrator, much of her work is commissioned by the Royal Botanic Gardens, Kew. Tebbs also works for the Botanical Society of the British Isles, and for foreign publications such as the floras of Egypt, Ethiopia and Somalia. Her

publications have included *Flora of Egypt*, volumes I to III (1999–2002), *The Leguminosae of Madagascar* (2002) and, somewhat closer to home, *The Wild Flowers of Britain and Europe* (1993).

ELIZABETH TWINING, 1805–1889 London, England

Elizabeth Twining was born into the famous and wealthy tea family that enabled her to pursue her interest in botany and love of painting. From a very young age she was taught art and drawing, and became a very accomplished painter of plants. By 1849, she had published two volumes of her drawings, *Illustrations of the Natural Order of Plants*. Twining spent a good deal of her time attending the poor and destitute. She refurbished her local alms house in Twickenham, established the Twining Hospital that provided medical care for the poor, and founded the Bedford Home for Girls. When not involved in her philanthropic work, she dedicated herself to botany and drawing, visiting the Royal Botanic Gardens, Kew for subjects for her art work.

NATHANIEL WALLICH, 1786–1854 Copenhagen, Denmark

Wallich was a physician and botanist who travelled to India in the early 1800s. He became the Superintendent at the Calcutta Botanic Garden in 1817, a post he held with some interruptions until 1846. His plant collecting was extensive, with visits to Nepal, Singapore, Penang and the Cape, as well as throughout India. In addition to plants, Wallich also amassed a large collection of botanical drawings by Indian artists. Many of these drawings were reproduced in Wallich's publications, such as *Plantae asiaticae rariores* (1829–32) and *Tentamen florae napalensis illustratae* (1824–6).

WILLIAM YOUNG, 1742–1785 Cassel Hesse, Germany

William Young travelled with his parents to America, arriving in Philadelphia in 1744. By 1755 the family had bought a farm at Kingsessing, about 6km (4 miles) from Philadelphia, and they became the neighbours of John Bartram. Bartram had by then built a botanical garden on the banks of the Schuylkill River and a successful trade in seeds and plants to European customers. By 1761, William Young – influenced by the success of John Bartram's seed trade – decided to take up the business himself and became a plant collector and nurseryman. With great daringness and ingenuity, he sent a package containing rare and exotic seeds from America to the young, newly wedded and German-speaking Queen Charlotte. Charlotte took William to her heart and arranged for him to be brought to England and trained in botany. He was appointed the Queen's botanist, with an annual salary of £300 ($450). He completed some 300 drawings on 96 sheets of paper. These were bound and dedicated to the king and queen. Young continued to trade in plants and seeds until 1785, when he tragically fell to his death and drowned at Gunpowder Creek, Maryland while on a plant-hunting expedition.

SELECTED BIBLIOGRAPHY

Anderson, E.F. 2001. *The Cactus Family*. Timber Press, Portland, Oregon.

Anderson, E.F., S. Arias Montes & N.P. Taylor. 1994. *Threatened Cacti of Mexico*. Royal Botanic Gardens, Kew, Richmond, Surrey.

Attenborough, D. 1995. *The Private Life of Plants: A Natural History of Plant Behaviour*. BBC Books, London.

Bailey, L.H. 1977. *Manual of Cultivated Plants* (17th printing). Macmillan Publishing Co, New York.

Bartlett, M. 1981. *Gentians* (revised edition). Alphabooks, Sherbourne, Dorset.

Bates, D.M. 1965. Notes on the cultivated Malvaceae 1. *Hibiscus. Baileya* 13: 57–96; Notes on the cultivated Malvaceae 1. *Hibiscus* (concluded). *Baileya* 13: 97–130.

Blanchard, J.W. 1990. *Narcissus: A Guide to Wild Daffodils*. Alpine Garden Society, Woking, Surrey.

Bonta, M.M. 1991. *Women in the Field: America's Pioneering Women Naturalists*. Texas A&M Press, College Station.

Bradlow, F.R. (introduction and annotations). 1994. *Francis Masson's Account of Three Journeys at the Cape of Good Hope, 1772–1775*. Tablecloth Press, Cape Town.

Bremer, K. 1994. *Asteraceae: Cladistics and Classification*. Timber Press, Portland, Oregon.

Brown, D. 2000. *Aroids: Plants of the Arum Family* (2nd edition). Timber Press, Portland, Oregon.

Burbidge, F.W. 1875. *The Narcissus: Its History and Culture*. L. Reeve & Co, London.

Callaway, D.J. 1994. *Magnolias*. B.T. Batsford Ltd, London.

Campbell-Culver, M. 2001. *The Origins of Plants; The Plants and People That Have Shaped Britain's Garden History Since the Year 1000*. Headline Book Publishing, London.

Carlquist, S. 1974. *Island Biology*. Columbia University Press, New York/London.

Chapman, G.P. 1996. *The Biology of Grasses*. CAB International, Wallingford.

Chin, H.F. 1986. *The Hibiscus: Queen of Tropical Flowers*. Tropical Press Sdn. Bhd, Kuala Lumpur.

Coats, A.M. 1969. *The Plant Hunters*. McGraw-Hill Book Company, New York/St Louis/London.

Cobb, J.L.S. 2989. *Meconopsis*. Christopher Helm, London, and Timber Press, Portland, Oregon.

Corner, E.J.H. 1966. *The Natural History of Palms*. Weidenfeld & Nicolson, London.

Cowling, R. & D. Richardson. 1995. *Fynbos: South Africa's Unique Floral Kingdom*. Fernwood Press, Cape Town.

Dakin, S.B. 1954. *The Perennial Adventure: A Tribute to Alice Eastwood 1859–1953*. California Academy of Sciences, San Francisco.

Dampier, W. 1998. *A New Voyage Around the World: Adventures of an English Buccaneer* (first published by James Knapton in London, 1697). Hummingbird Press, London.

Dannenfeldt, K.H. 1968. *Leonhard Rauwolf: Sixteenth Century Physician, Botanist and Traveller*. Harvard University Press, Cambridge, Massachusetts.

Darwin, C. 1875. *The Movements and Habits of Climbing Plants*. John Murray, London.

Dash, M. 1999. *Tulipomania*. V. Gollancz, Orion Books, London.

Davidse, G., T.R. Soderstrom & R.P. Ellis. 1986. *Pohlidium petiolatum* (Poaceae: Centotheceae), a new genus and species from Panama. *Systematic Botany* 11: 131–44.

Desmond, A. & J. Moore. 1991. *Darwin*. Michael Joseph, London.

Dillistone, G. (editor and compiler). [1931.] *Dykes on Iris: A Reprint of the Contributions of the Late W.R. Dykes L.-es-L., to Various Journals and Periodicals During the Last 20 Years of His Life*. Published and printed for The Iris Society by C. Baldwin, Grosvenor Printing Works, Tunbridge Wells.

Dorf, P. 1956. *Liberty Hyde Bailey: An Informal Biography*. Cornell University Press, Ithaca.

Farjon, A. & Page, C.N. (compilers). 1999. *Conifers. Status Survey and Conservation Action Plan*. IUCN/SSC Conifer Specialist Group. IUCN Gland Switzerland and Cambridge, UK.

Farrelly, D. 1996. *The Book of Bamboo*. Thames & Hudson, London.

Fearnley-Whittingsall, J. 1999. *Peonies: The Imperial Flower*. Weidenfeld & Nicolson, London.

Fisher, J. 1982. *The Origins of Garden Plants*. Constable, London.

Fisher, J. 1986. *The Companion to Roses*. Viking, Penguin Books Ltd, London.

Fryxell, P.A. 1988. Malvaceae of Mexico. *Systematic Botany Monographs* 25: 1–522.

Fryxell. P.A. 1978. *The Natural History of the Cotton Tribe*. Texas A&M University Press, College Station/London.

George, A.S. 1996. *The Banksia Book* (3rd edition). Kangaroo Press, New South Wales.

Gilbert, L.E. 1982. The coevolution of a butterfly and a vine. *Scientific American* 247: 110–21.

Goethe, J.W. von 1989 (reprint, translated from the German by B. Mueller). *Goethe's Botanical Writings*. Ox Bow Press, Woodbridge, Connecticut.

Grey-Wilson, C. 2000. *Poppies: A Guide to the Poppy Family in the Wild and in Cultivation* (2nd edition). B.T. Batsford Ltd, London.

Hallam, A. 1994. *An Outline of Phanerozoic Biogeography*. Oxford University Press, Oxford (Oxford Biogeography series no. 10).

Hamilton, Jill, Duchess of & J. Bruce. 1998. *The Flower Chain: The Early Discovery of Australian Plants*. Kangaroo Press/Simon & Schuster, New South Wales.

Hanks, G.R. (ed.) 2002. *Narcissus and Daffodil*. Taylor & Francis, London.

Hunt, D. (ed.) 1998. *Magnolias and Their Allies*. International Dendrological Society/The Magnolia Society, Sherbourne.

Jefferson-Brown, M.J. 1951. *The Daffodil*. Faber & Faber Ltd, London.

Jepson, W.L. 1926. *A Manual of the Flowering Plants of California*. University of California Press, Berkeley.

Jepson, W.L. 1926. *A Manual of the Flowering Plants of California*. University of California Press, Berkeley.

Judziewicz, E. J. & T. R. Soderstrom. 1989. Morphological, anatomical and taxonomic studies in *Anomochloa* and *Streptochaeta* (Poaceae: Bambusoideae). *Smithsonian Contributions to Botany* 68: 1–52.

Kingdon Ward, F. 1913. *The Land of the Blue Poppy: Travels of a Naturalist in Eastern Tibet*. Cambridge University Press, Cambridge.

Kingdon Ward, F. 1937. *Plant Hunter's Paradise*. Jonathan Cape, London.

Knapp, S. & J. Mallet. 1984. Two new species of *Passiflora* (Passifloraceae) from Panama, with comments on their natural history. *Annals of the Missouri Botanical Garden* 71: 1068–74.

Knott, R. 2002. *Fibonacci Numbers, the Golden Section and*

the Golden String. www.mes.surrey.ac.uk/Personal
/R.Knott/Fibonacci/fibonat.html

Köhlein, F. 1981. *Iris* (translated from the German by
Mollie Comingford Peters). Christopher Helm,
London.

Köhlein, F. 1991. *Gentians* (edited by J. Jermyn,
translated from the German by D. Winstanley).
Christopher Helm/A. & C. Black, London, and
Timber Press, Portland, Oregon.

Lawson, G. 1851. *The Royal Water-lily of South America
and the Water-lilies of Our Own Land: Their History and
Cultivation.* James Hogg, Edinburgh.

Leese, O. & M. Leese. 1959. *Desert Plants – Cacti and
Succulents in the Wild and in Cultivation.* W.H. & L.
Collingridge Ltd, London, and Transatlantic Arts
Inc, Florida.

Lewington, A. 1990. *Plants for People.* The Natural
History Museum, London.

McClure, F.A. 1966. *The Bamboos: A Fresh Perspective.*
Harvard University Press, Cambridge,
Massachusetts.

Mabey, R. 1996. *Flora Britannica.* Sinclair-Stevenson,
London.

Manniche, L. 1989. *An Ancient Eygptian Herbal.*
University of Texas Press, Austin.

Mason, H.L. 1947. Willis Linn Jepson (obituary).
Madroño 9: 61–4.

Mathew, B. 1981. *The Iris.* B.T. Batsford Ltd, London.

Maunder, M., M.M. Bruegmann & V. Caraway. 2002. A
future for the Hawaiian flora? *Plant Talk* 28: 19–23.

Mauremootoo, J. & R. Payendee. 2002. Against the
odds: restoring the endemic flora of Rodrigues.
Plant Talk 28: 26–8.

Merlin, M.D. 1984. *On the Trail of the Ancient Opium
Poppy.* Fairleigh University Press, London/Toronto.

Mirov, N.T. & J. Hasbrouk. 1976. *The Story of Pines.*
Indiana University Press, Bloomington.

Mitchell, A.L. & S. House. 1999. *David Douglas:
Explorer and Botanist.* Aurum Press, London.

Moggach, D. 2000. *Tulip Fever.* Vintage, London.

Musgrave, T., C. Gardner & W. Musgrave. 1998. *The
Plant Hunters: Two Hundred Years of Adventure and
Discovery Around the World.* Seven Dials/Cassell & Co,
London.

Needham, J. 1986. *Science and Civilisation in China* vol.
6. *Biology and Biological Technology, Part 1. Botany.*

Cambridge University Press, Cambridge.

Niklas, K.J. 1994. *Plant Biomechanics: An Engineering
Approach to Plant Form and Function.* University of
Chicago Press, Chicago/London.

Oliver, I. & T. Oliver. *A Field Guide to the Ericas of the
Cape Peninsula.* Protea Atlas Project, National
Botanical Institute, Sharenet, Cape Town.

Paterson-Jones, C. 2000. *The Protea Family in Southern
Africa.* Struik Publishers (Pty) Ltd, Cape Town.

Pavord, A. 1999. *The Tulip.* Bloomsbury, London.

Peterson, R. 1980. *The Pine Tree Book: Based on the
Arthur Ross Pinetum in Central Park.* The Brandywine
Press, Inc, New York.

Phillips, R. & M. Rix. 1993. *The Quest for the Rose.*
BBC Books, London.

Principes – the journal of the International Palm Society
(today called *Palms*); in particular the H.E. Moore,
Jr Memorial Volume, vol. 26 (1982).

Putz, F.E. & H.A. Mooney (eds) 1991. *The Biology of
Vines.* Cambridge University Press, Cambridge.

Rebelo, T. 2000. *A Field Guide to the Proteas of the Cape
Peninsula.* National Botanical Institute, Protea Atlas
Project, Sharenet, Cape Town.

Recht, C. & Wetterwald, M.F. 1992. *Bamboos*
(translated from the German). B.T. Batsford Ltd.
London.

Rose, G. & P. King. 1990. *The Love of Roses: From Myth
to Modern Culture.* Quiller Press, London.

Rowley, G.D. 1997. *The History of Succulent Plants.*
Strawberry Press, Mill Valley, California.

Schultes, R.E. & A. Hofmann. 1980. *The Botany and
Chemistry of Hallucinogens.* Charles C. Thomas,
Springfield, Illinois.

Sitwell, S. 1939. *Old Fashioned Flowers.* Country Life
Ltd, London.

Soderstrom, T.R., K.W. Hilu, C.S. Campbell & M.E.
Barkworth (eds.) 1987. *Grass Systematics and
Evolution.* Smithsonian Institution Press,
Washington, DC.

Stuart, D. 2002. *The Plants That Shaped Our Gardens.*
Frances Lincoln, London.

Swindells, P. 1983. *Waterlilies.* Croom Helm,
London/Canberra, and Timber Press, Portland,
Oregon.

Tooley, M. & P. Armander (eds) 1995. *Gertrude Jekyll:
Essays on the Life of a Working Gardener.* Michaelmas

Books, Witton-le-Wear, County Durham.

Treseder, N.G. 1978. *Magnolias.* Faber & Faber Ltd,
London.

Uhl, N.W. & J. Dransfield. 1987. *Genera Palmarum: A
Classification of Palms Based on the Work of Harold E.
Moore, Jr.* The L.H. Bailey Hortorium/The
International Palm Society, Allen Press, Lawrence.

Underhill, T.L. 1971. *Heaths and Heathers:* Calluna,
Daboecia *and* Erica. David & Charles, Newton
Abbot.

Valder, P. 1999. *The Garden Plants of China.* Weidenfeld
& Nicolson, London.

Vanderplank, J. 1996. *Passion Flowers* (2nd edition).
Cassell Publishers Ltd, London.

Wallace, A.R. 1853. *Palm Trees of the Amazon and Their
Uses.* Van Voorst, London.

Wang Lianying *et al.* (The Peony Association of China).
1998. *Chinese Tree Peony* (translated from the
Chinese by Wu Jiang Mei). China Forestry
Publishing House, Beijing.

Wilson, F.D. & M.Y. Menzel. 1964. Kenaf (*Hibiscus
cannabinus*) and roselle (*Hibiscus sabdariffa*). *Economic
Botany* 18: 80–91.

INDEX

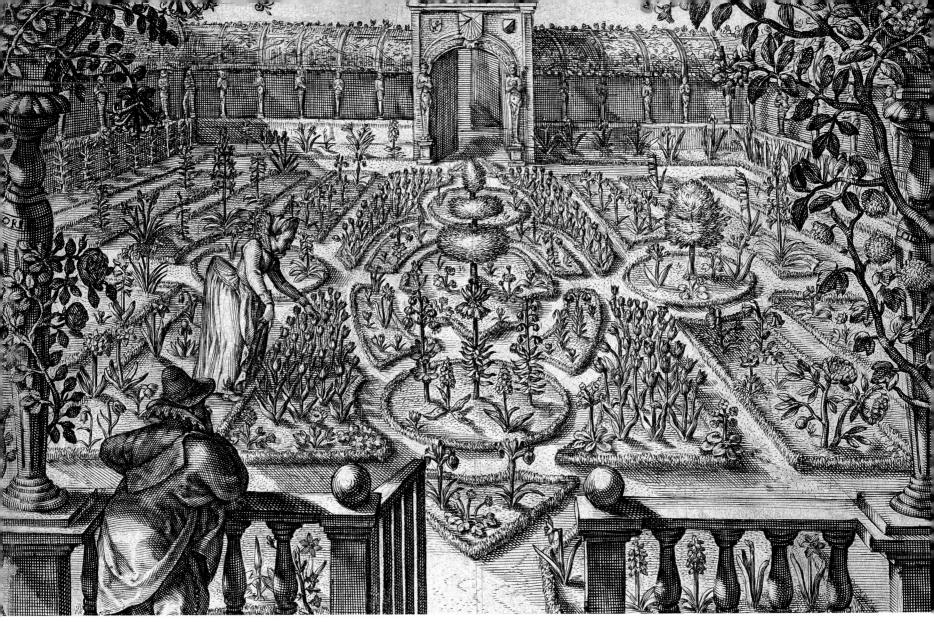

Hortus Floridus, Garden, Crispian van de Passe, 1614

ACKNOWLEDGEMENTS

I could never have done this book without the help and advice of many people, most importantly my colleagues in the Botany Department in the Museum. They have put up with endless peculiar questions about plants and botanical exploration with great good humour and tolerance. My special thanks goes to my collaborator in this venture, Judith Magee of the Botany Library, without whom I could never have even begun. Her biographies of artists enrich greatly the stories I have told. Pat Hart of the museum's photographic Unit skillfully photographed the images used here. I am also grateful to my botanical colleagues who have helped me with the identification of these images (often not an easy task), especially Gerrit Davidse of the Missouri Botanical Garden; Simon Mayo and Nick Hind of the Royal Botanic Garden at Kew; George Staples of the Bishop Museum; Jim Mallet of University College London;

Jenni Stewart of the NHM Zoology Department; and Mike Gilbert and Chris Humphries of the NHM Botany Department. Bob Press, Vanessa Pike, Charlie Jarvis, Joanna Glyde, Rachel Craddock, Sarah Hoyle, Debbie Chapman, Jenni Stewart and Kristy Jones – all from the Museum – read various pieces of the text, and their insightful comments have greatly improved it. All mistakes and misinterpretations are my own. Lynn Millhouse of NHM Publishing and David Shannon of Scriptum Editions have kept me to deadlines, always a problematic task! My greatest thanks, however, go to my family: my parents-in-law, Philip and Mary Mallet, in whose house in Kent much of the text was written; and my husband and children – Jim, Alfred, Isabel and Victor Mallet – whose lives have been totally overtaken with stories about plants.